PANATI'S EXTRAORDINARY ORIGINS OF EVERYDAY THINGS

Books by Charles Panati

SUPERSENSES

THE GELLER PAPERS
(editor)

LINKS
(a novel)

DEATH ENCOUNTERS

BREAKTHROUGHS

THE SILENT INTRUDER
(with Michael Hudson)

THE PLEASURING OF RORY MALONE
(a novel)

THE BROWSER'S BOOK OF BEGINNINGS

PANATI'S EXTRAORDINARY ORIGINS OF
EVERYDAY THINGS

PANATI'S EXTRAORDINARY ENDINGS OF
PRACTICALLY EVERYTHING AND EVERYBODY

PANATI'S EXTRAORDINARY ORIGINS OF EVERYDAY THINGS

Charles Panati

PERENNIAL LIBRARY

Harper & Row, Publishers, New York
Grand Rapids, Philadelphia, St. Louis, San Francisco
London, Singapore, Sydney, Tokyo

Designer: Erich Hobbing

Library of Congress Cataloging-in-Publication Data

Panati, Charles, 1943–
 Panati's extraordinary origins of everyday things.

 "Perennial Library."
 Includes index.
 1. Encyclopedias and dictionaries. I. Title. II. Title: Panati's extraordinary origins of everyday things.
AG6.P37 1989 031 89-45180
ISBN 0-06-096419-7 (pbk.)

02 03 04 05 RRD H 30 29 28

To 443 Sail and The Crew:
Rob, Bruce, Richard, Bill, and Stan

Contents

Chapter 1 From Superstition 1
 Superstitions, 1 • Rabbit's Foot, 3 • Horseshoe, 4 •
 Wishbone, 5 • Knock Wood, 6 • Four-Leaf Clover,
 8 • Crossed Fingers, 8 • Thumbs Up, 9 • "God
 Bless You," 10 • Broken Mirror, 11 • Number
 Thirteen, 11 • Black Cat, 13 • Flip of a Coin, 15 •
 Spilling Salt, 15 • Umbrella Indoors, 16 • Walking
 Under a Ladder, 17 • Evil Eye, 17 • Stork Brings
 Baby, 19 • Covering a Yawn, 19 •

Chapter 2 By Custom 21
 Marriage Customs, 21 • Wedding Ring, 22 •
 Diamond Engagement Ring, 22 • Ring Finger, 24 •
 Marriage Banns, 25 • Wedding Cake, 25 •
 Throwing Shoes at the Bride, 26 • Honeymoon,
 28 • Wedding March, 28 • White Wedding Dress
 and Veil, 29 • Divorce, 30 • Birthdays, 31 •
 Birthday Cake and Candles, 33 • "Happy Birthday
 to You," 34 • Death Traditions, 35 • Hearse, 37 •
 Hands Joined in Prayer, 38 • Rosary, 39 • Halo,
 40 • Amen, 41 • Handshake, 42 •

Contents

Chapter 3 On the Calendar 45

New Year's Day, 45 • Groundhog Day, 49 • St.
Valentine's Day, 50 • St. Patrick's Day, 53 • Easter,
55 • April Fool's Day, 58 • Mother's Day, 58 •
Father's Day, 60 • Halloween, 62 • Thanksgiving,
64 • Christmas, 67 • Mistletoe, 68 • Christmas
Tree, 69 • Christmas Cards, 71 • Santa Claus, 72 •
Rudolph, the Red-Nosed Reindeer, 75 •

Chapter 4 At the Table 76

Table Manners, 76 • Fork, 78 • Spoon, 79 • Knife,
80 • Napkin, 81 • Chopsticks, 83 • Western
Etiquette Books, 83 • Children's Manners, 85 •
Emily Post, 87 • Wedgwood Ware, 88 • Stainless-
Steel Cutlery, 89 • Table Talk, 91 •

Chapter 5 Around the Kitchen 96

Kitchen, 96 • Kitchen Range, 98 • Porcelain Pots
and Pans, 100 • Aluminum Ware, 101 • S.O.S.
Pads, 102 • Dishwasher, 103 • Home Water
Softeners, 104 • Teflon Utensils, 105 • Brown
Paper Bag, 107 • Friction Match, 108 • Blender,
111 • Aluminum Foil, 113 • Food Processor, 114 •
Can Opener, 115 • Thermos Bottle, 116 • Toaster,
117 • Whistling Teakettle, 119 • Coffeepot, 119 •
Pressure Cooker, 121 • Disposable Paper Cup,
122 • Pyrex, 124 • Microwave Oven, 125 • Plastic,
126 • Tupperware, 129 •

Chapter 6 In and Around the House 131

Central Heating, 131 • Indoor Lighting, 133 •
Candle, 134 • Gaslight, 135 • Electric Light, 136 •
Vacuum Cleaner, 138 • Clothes Iron, 143 • Clothes
Washer and Dryer, 146 • Sewing Machine, 147 •
Wallpaper, 149 • Ready-Mixed Paint, 150 •
Linoleum, 151 • Detergent, 152 • Chlorine Bleach,
155 • Glass Window, 156 • Home Air-Cooling
System, 159 • Lawn, 160 • Lawn Mower, 162 •
Burpee Seeds, 163 • Rubber Hose, 164 •
Wheelbarrow, 166 •

Contents

Chapter 7　For the Nursery　168

Fairy Tales, 168 • "Sleeping Beauty," 170 • "Little
Red Riding Hood," 171 • "Cinderella," 172 •
"Puss in Boots," 173 • "Hansel and Gretel," 175 •
"Snow White and the Seven Dwarfs," 176 • "The
Princess on the Pea," 176 • "Goldilocks and the
Three Bears," 177 • "Bluebeard," 178 • *Dracula*,
179 • *Frankenstein*, 180 • *The Wonderful Wizard of
Oz*, 181 • Nursery Rhymes, 182 • Mother Goose,
182 • "Hush-a-Bye, Baby," 183 • "Ride a Cock-
Horse," 184 • "Baa, Baa, Black Sheep," 185 •
"Little Boy Blue," 185 • "The First Day of
Christmas," 186 • "Cock-a-Doodle-Doo!" 186 •
"Hark, Hark," 187 • "There Was a Little Girl,"
187 • "Hey Diddle Diddle," 187 • "Humpty
Dumpty," 188 • "Jack and Jill," 188 • "Jack Be
Nimble," 189 • "This Is the House That Jack
Built," 189 • "Little Jack Horner," 189 •
"Ladybird, Ladybird," 191 • "London Bridge,"
191 • "See-Saw, Margery Daw," 192 • "Mary Had
a Little Lamb," 193 • "Mary, Mary," 193 • "Three
Blind Mice," 194 • "Old Mother Hubbard," 194 •
"Little Miss Muffet," 195 • "Ring-a-Ring o'
Roses," 196 • "Sing a Song of Sixpence," 196 •
Children's Literature, 197 •

Chapter 8　In the Bathroom　199

Bathroom, 199 • Spas, 200 • Modern Flush Toilet,
203 • Toilet Paper, 204 • Kleenex Tissues, 206 •
Toothbrush, 208 • Nylon-Bristle Toothbrush, 209 •
Toothpaste, 210 • Dentures, 213 • Razor, 214 •
Safety Razor, 215 • Electric Shaver, 216 • Soap,
217 • Shampoo, 219 •

Chapter 9　Atop the Vanity　221

Cosmetics, 221 • Eye Makeup, 223 • Rouge, Facial
Powder, Lipstick, 224 • Beauty Patch and Compact,
225 • Nail Polish, 226 • Creams, Oils, Moisturizers,
227 • Cold Cream, 227 • Mirror, 229 •
Hair Styling, 231 • Modern Hair Coloring, 233 •

Contents

Wigs, 234 • Hairpin, 236 • Hair Dryer, 236 •
Comb, 237 • Perfume, 238 • Cologne, 242 •
Avon, 243 •

Chapter 10 Through the Medicine Chest 245
Medication, 245 • Vaseline, 247 • Listerine, 248 •
Band-Aid, 250 • Witch Hazel, 251 • Vick's
VapoRub, 252 • Deodorants, 254 •
Antiperspirants, 255 • Antacids, 256 • Alka-
Seltzer, 257 • Cough Drops, 258 • Suntan
Lotion, 260 • Eye Drops, 261 • Dr. Scholl's Foot
Products, 262 • Laxatives, 263 • Eyeglasses, 264 •
Sunglasses, 267 • Contact Lenses, 268 •
Stimulants, 269 • Sedatives, 271 • Aspirin, 272 •

Chapter 11 Under the Flag 274
Uncle Sam, 274 • Johnny Appleseed, 277 •
American Flag, 278 • Pledge of Allegiance, 280 •
Washington, D.C., 281 • Mount Rushmore, 282 •
Boy Scouts of America, 284 • Girl Scouts of
America, 285 • "Yankee Doodle," 286 • "The
Star-Spangled Banner," 287 • "America the
Beautiful," 288 • "The Marines' Hymn," 288 •
"Dixie," 289 • West Point Military Academy,
290 • Statue of Liberty, 291 •

Chapter 12 On the Body 294
Shoes, 294 • Boots, 296 • High Heels, 297 •
Sneakers, 298 • Pants, 299 • Blue Jeans, 302 •
Shirt, 303 • Necktie, 305 • Suit, 306 • Tuxedo,
307 • Hats, 308 • Top Hat, 309 • Gloves, 310 •
Purse, 311 • Handkerchief, 311 • Fan, 312 •
Safety Pin, 313 • Button, 314 • Zipper, 316 •
Velcro, 317 • Umbrella, 318 • Modern Rainwear,
320 • Bathing Suit, 321 • Off-the-Rack Clothes,
323 • Designer Labels, 324 •

Chapter 13 Into the Bedroom 326
Bedroom, 326 • Spring Mattress, 329 • Electric
Blanket, 331 • Birth Control, 331 • Condom, 334 •

Contents

Vasectomy; Sperm and Egg, 336 • The Pill,
336 • Nightgown and Pajamas, 338 • Underwear,
339 • Brassiere, 341 • Hosiery, 343 • Stockings,
344 • Nylon Stockings, 346 • Sex-Related Words,
347 •

Chapter 14 From the Magazine Rack 349

Magazines in America, 349 • *Ladies' Home
Journal,* 352 • *Good Housekeeping,* 353 •
Cosmopolitan, 354 • *Vogue,* 355 • *House Beautiful,*
356 • *National Geographic,* 357 • *Scientific
American,* 358 • *Life,* 359 • *Look,* 360 • *Ebony,*
361 • *Esquire,* 361 • *Reader's Digest,* 362 • *TV
Guide,* 363 • *Time,* 364 • *Newsweek,* 366 •

Chapter 15 At Play 368

Marbles, 368 • Tops, 369 • Hula Hoop, 370 •
Yo-Yo, 371 • Kite, 371 • Frisbee, 372 • Rattles,
373 • Teddy Bear, 374 • Crossword Puzzle, 375 •
Board Games, 376 • Parcheesi, 377 • Monopoly,
378 • Scrabble, 379 • Silly Putty, 379 • Slinky,
380 • Toys That Glow in the Dark, 381 • Roller
Skates, 382 • Piggy Bank, 382 • Firecrackers,
383 • Dolls, 384 •

Chapter 16 In the Pantry 388

Potato Chip, 388 • Pretzel, 389 • Popcorn, 390 •
Peanuts, 392 • Cracker Jack, 395 • Hot Dog,
396 • Hamburger, 399 • Sandwich, 400 • Melba
Toast, 401 • Ketchup, 401 • Pasta, 405 •
Pancake, 406 • Betty Crocker, 409 • Duncan
Hines, 410 • Pie, 410 • Cookie, 411 • Animal
Cookies, 412 • Graham Cracker, 413 • Chocolate
Chip Cookie, 414 • Doughnut, 415 • Chewing
Gum, 416 • Ice Cream, 418 • Ice Cream Cone,
421 •

References 422

Index 443

PANATI'S EXTRAORDINARY ORIGINS OF EVERYDAY THINGS

Chapter 1

From Superstition

Superstitions: 50,000 Years Ago, Western Asia

Napoleon feared black cats; Socrates the evil eye. Julius Caesar dreaded dreams. Henry VIII claimed witchcraft trapped him into a marriage with Anne Boleyn. Peter the Great suffered a pathological terror of crossing bridges. Samuel Johnson entered and exited a building with his right foot foremost.

Bad-luck superstitions still keep many people from walking under a ladder, opening an umbrella indoors, or boarding an airplane on Friday the thirteenth. On the other hand, these same people, hoping for good luck, might cross their fingers or, knock wood.

Superstitious beliefs, given their irrational nature, should have receded with the arrival of education and the advent of science. Yet even today, when objective evidence is valued highly, few people, if pressed, would not admit to secretly cherishing one, or two, or many superstitions. Across America, tens of thousands of lottery tickets are penciled in every day based on nothing more or less than people's "lucky" numbers.

Perhaps this is how it should be, for superstitions are an ancient part of our human heritage.

Archaeologists identify Neanderthal man, who roamed throughout Western Asia fifty thousand years ago, as having produced the first superstitious (and spiritual) belief: survival in an afterlife. Whereas earlier *Homo sapiens* abandoned the dead, Neanderthals buried their dead with ritual

1

funerals, interring with the body food, weapons, and fire charcoals to be used in the next life.

That superstition and the birth of spirituality go hand in hand is not surprising. Throughout history, one person's superstition was often another's religion. The Christian emperor Constantine called paganism superstition, while the pagan statesman Tacitus called Christianity a pernicious, irrational belief. Protestants regarded the Catholic veneration of saints and relics as superstitious, while Christians similarly viewed Hindu practices. To an atheist, all religious beliefs are superstitions.

Today there seems to be no logical reason why a wishbone symbolizes good luck while a broken mirror augurs the opposite. But in earlier times, every superstition had a purposeful origin, a cultural background, and a practical explanation.

Superstitions arose in a straightforward manner. Primitive man, seeking answers for phenomena such as lightning, thunder, eclipses, birth, and death, and lacking knowledge of the laws of nature, developed a belief in unseen spirits. He observed that animals possessed a sixth sense to danger and imagined that spirits whispered secret warnings to them. And the miracle of a tree sprouting from a seed, or a frog from a tadpole, pointed to otherworldly intervention. His daily existence fraught with hardships, he assumed that the world was more populated with vengeful spirits than with beneficent ones. (Thus, the preponderance of superstitious beliefs we inherited involve ways to protect ourselves from evil.)

To protect himself in what seemed like a helter-skelter world, ancient man adopted the foot of a rabbit, the flip of a coin, and a four-leaf clover. It was an attempt to impose human will on chaos. And when one amulet failed, he tried another, then another. In this way, thousands of ordinary objects, expressions, and incantations assumed magical significance.

In a sense, we do the same thing today. A student writes a prize-winning paper with a certain pen and that pen becomes "lucky." A horseplayer scores high on a rainy day and weather is then factored into his betting. We *make* the ordinary extraordinary. In fact, there's scarcely a thing in our environment around which some culture has not woven a superstitious claim: mistletoe, garlic, apples, horseshoes, umbrellas, hiccups, stumbling, crossed fingers, rainbows. And that's barely the beginning.

Though we now have scientific explanations for many once-mysterious phenomena, daily life still holds enough unpredictability that we turn, especially in times of misfortune, to superstitions to account for the unaccountable, to impose our own wishes on world vicissitudes. So, thumbs up, fingers crossed, with luck, here are the ancient origins of many of our most cherished irrational beliefs. Cross my heart.

Rabbit's Foot: Pre–600 B.C., Western Europe

Adhering strictly to early tradition, a person in search of luck should carry the foot of a hare, the rabbit's larger cousin. Historically, it was the hare's foot that possessed magical powers. However, most early European peoples confused the rabbit with the hare, and in time the feet of both animals were prized as potent good luck charms.

The luck attributed to a rabbit's foot stems from a belief rooted in ancient totemism, the claim, predating Darwinism by thousands of years, that humankind descended from animals. Differing from Darwinism, however, totemism held that every tribe of people evolved from a separate species of animal. A tribe worshiped and refrained from killing its ancestral animal and employed parts of that animal as amulets, called totems.

Remains of totemism are with us today.

In biblical literature, totemism is the origin of many dietary laws prohibiting consumption of certain animals. It has also given us the custom of the sports mascot, believed to secure luck for a team, as well as our penchant for classifying groups of people by animal images or traits. On Wall Street, there are bulls and bears; in government, hawks and doves; and in politics, elephants and donkeys. We may have abandoned the practice of physically carrying around our identifying totems, but they are with us nonetheless.

Folklorists have not yet identified the "Hare" tribal society that gave the early inhabitants of Western Europe, sometime before 600 B.C., the rabbit foot amulet. They have ample evidence, though, of why this lagomorph became a symbol of good luck, not bad.

The rabbit's habit of burrowing lent it an aura of mystery. The Celts, for instance, believed that the animal spent so much time underground because it was in secret communication with the netherworld of numina. Thus, a rabbit was privy to information humans were denied. And the fact that most animals, including humans, are born with their eyes closed, while rabbits enter the world with eyes wide open, imbued them with an image of wisdom: for the Celts, rabbits witnessed the mysteries of prenatal life. (Actually, the hare is born with open eyes; the rabbit is born blind. And it is the rabbit that burrows; hares live aboveground. Confusion abounded.)

It was the rabbit's fecundity, though, that helped to give its body parts their strongest association with good luck and prosperity. So prolific was the animal that early peoples regarded it as an outstanding example of all that was procreative in nature. To possess any part of a rabbit—tail, ear, foot, or dried innards—assured a person's good fortune. Interestingly, the foot was always the preferred totem, believed to be luckier than any other body part.

Why the foot? Folklorists claim that long before Freudian sexual inter-

A blacksmith who forged horseshoes possessed white magic against witchery. Lest its luck drain out, a horseshoe is hung with pointed ends upward.

pretations existed, man, in his cave drawings and stone sculptures, incorporated the foot as a phallic symbol, a totem to foster fertility in women and a cornucopian harvest in the fields.

Horseshoe: 4th Century, Greece

Considered the most universal of all good luck charms, the horseshoe was a powerful amulet in every age and country where the horse existed. Although the Greeks introduced the horseshoe to Western culture in the fourth century and regarded it as a symbol of good fortune, legend credits St. Dunstan with having given the horseshoe, hung above a house door, special power against evil.

According to tradition, Dunstan, a blacksmith by trade who would become the Archbishop of Canterbury in A.D. 959, was approached one day by a man who asked that horseshoes be attached to his own feet, suspiciously cloven. Dunstan immediately recognized the customer as Satan and explained that to perform the service he would have to shackle the man to the wall. The saint deliberately made the job so excruciatingly painful that the bound devil repeatedly begged for mercy. Dunstan refused to release him until he gave his solemn oath never to enter a house where a horseshoe was displayed above the door.

From the birth of that tale in the tenth century, Christians held the horseshoe in high esteem, placing it first above a doorframe and later moving it down to middoor, where it served the dual function of talisman and door knocker. Hence the origin of the horseshoe-shaped knocker. Christians

once celebrated St. Dunstan's feast day, May 19, with games of horseshoes.

For the Greeks, the horseshoe's magical powers emanated from other factors: horseshoes were made of iron, an element believed to ward off evil; and a horseshoe took the shape of a crescent moon, long regarded as a symbol of fertility and good fortune. The Romans appropriated the object both as a practical equestrian device and as a talisman, and their pagan belief in its magical powers was passed on to the Christians, who gave the superstition its St. Dunstan twist.

In the Middle Ages, when the fear of witchcraft peaked, the horseshoe assumed an additional power.

It was believed that witches traveled on brooms because they feared horses, and that any reminder of a horse, especially its iron shoe, warded off a witch the way a crucifix struck terror in a vampire. A woman accused of witchcraft was interred with a horseshoe nailed atop her coffin to prevent resurrection. In Russia, a blacksmith who forged horseshoes was himself credited with the ability to perform "white magic" against witchery, and solemn oaths pertaining to marriage, business contracts, and real estate were taken not on a Bible but upon anvils used to hammer out horseshoes.

The horseshoe could not be hung just any way. It had to be positioned with points upward, lest its luck drain out.

In the British Isles, the horseshoe remained a powerful symbol of luck well into the nineteenth century. A popular Irish incantation against evil and illness (originating with the St. Dunstan legend) went: "Father, Son, and Holy Ghost, Nail the devil to a post." And in 1805, when British admiral Lord Horatio Nelson met his nation's foes in the Battle of Trafalgar, the superstitious Englishman nailed a horseshoe to the mast of his command ship, *Victory*. The military triumph—commemorated in London's Trafalgar Square by Nelson's Column, erected in 1849—ended Napoleon's dream of invading England. The horseshoe may have brought luck to the British people, but Nelson himself lost his life in the battle.

Wishbone: Pre-400 B.C., Etruria

Two people, making secret wishes, tug on opposite ends of the dried, V-shaped clavicle of a fowl. For the person who breaks off the larger piece, a wish comes true. The custom is at least 2,400 years old, and it originated with the Etruscans, the ancient people who occupied the area of the Italian peninsula between the Tiber and Arno rivers, west and south of the Apennines.

A highly cultured people, whose urban civilization reached its height in the sixth century B.C., the Etruscans believed the hen and the cock to be soothsayers: the hen because she foretold the laying of an egg with a squawk; the cock because his crow heralded the dawn of a new day. The "hen oracle," through a practice of divination known as alectryomancy, was consulted for answers to life's most pressing problems. A circle, traced on the

ground, was divided into about twenty parts, representing letters of the Etruscan alphabet. Grains of corn were placed in each sector, and a sacred hen was set in the center of the circle. Her pecking at the corn generated a sequence of letters, which a high priest interpreted as answers to specific questions—a sort of living Ouija board.

When a sacred fowl was killed, the bird's collarbone was laid in the sun to dry. An Etruscan still wishing to benefit from the oracle's powers had only to pick up the bone and stroke it (not break it) and make a wish; hence the name "wishbone."

For more than two centuries, Etruscans wished on unbroken clavicles. We know of this superstition from the Romans, who later adopted many Etruscan ways. Roman writings suggest that the practice of two people's tugging at a clavicle for the larger half sprang from a simple case of supply and demand: too few sacred bones, too many people wishing for favors.

Why did the Etruscans not regard all the thin bones of a fowl's skeleton as wishbones? That could have solved the problem of scarcity. According to Roman legend, the Etruscans chose the V-shaped clavicle for a symbolic reason: it resembles the human crotch. Thus, a symbol of the repository of life was employed to unravel life's mysteries.

In all, we have inherited more than the Etruscan wishbone superstition. Etymologists claim that the expression "get a lucky break" initially applied to the person winning the larger half in a wishbone tug-of-war.

It was the Romans who brought the wishbone superstition to England, where the bone itself became known as a "merrythought," for the "merry" wishes people typically made. Breaking the clavicle of a chicken was a well-established British tradition by the time the Pilgrims reached the New World. Finding the wooded northeastern shore of America populated with wild turkeys, which possessed clavicles similar to those of chickens, the Pilgrims instituted the turkey wishbone custom, making it part of Thanksgiving festivities. Colonial folklore holds that wishbones were snapped at the first Thanksgiving, celebrated in 1621. (See "Thanksgiving," page 64.) Thus, by a circuitous route, an ancient Etruscan superstition became part of an American celebration.

Knock Wood: 2000 B.C., North America

Children who play tree tag, in which touching a tree signifies safety, are unwittingly enacting a four-thousand-year-old custom begun by the Indians of North America.

In the modern game of tag, the base of any tree serves as a safe haven. Historically, though, the tree to touch was an oak, venerated for its strength, stately height, and numinous powers. Furthermore, when a person today ventures a hopeful prediction and superstitiously knocks wood, that wood ought only to be, traditionally, oak.

Cults surrounding the oak tree are ancient. They sprang up independently

Cock and hen, ancient oracles. The expression "lucky break" applied to a person winning the larger half in a wishbone tug-of-war.

among the North American Indians around 2000 B.C. and later among the Greeks. Both cultures, observing that the oak was struck frequently by lightning, assumed it was the dwelling place of the sky god (the Indians) and the god of lightning (the early Greeks).

The North American Indians carried their superstitious belief one step further. They held that boasting of a future personal accomplishment, battle victory, or windfall harvest was bad luck, a virtual guarantee that the event would never occur. A boast, deliberate or inadvertent, could be neutralized from sinister retribution by knocking on the base of an oak tree. In effect, the person was contacting the sky god, seeking forgiveness.

In Europe during the Middle Ages, Christian scholars argued that the knock-wood superstition originated in the first century A.D. and stemmed from the fact that Christ was crucified on a wooden cross. To knock wood hopefully was supposedly synonymous with a prayer of supplication, such as: "Lord, let my wish come true." But modern scholars claim that there is no more truth to that belief than to the onetime boast that every Christian cathedral on the European continent possessed a piece of wood from the true cross. Thus, the Catholic veneration of wooden crucifix relics did not originate the custom of regarding wood with awe; rather, it mimicked, modified, and reinforced a much older, pagan view.

Other cultures revered, knocked on, and prayed to different kinds of trees. Whereas the American Indians and the early Greeks favored the oak, for the Egyptians the sycamore was sacred, and for ancient Germanic tribes the tree of choice was the ash. The Dutch, with a purist bent, adhered to the knock-wood superstition, but for them the kind of wood was unimportant; what mattered was that the wood be unvarnished, unpainted, uncarved, in every way unadorned. Tree cults were commonplace throughout history,

7

and they are the point of origin of many modern superstitious practices, such as kissing beneath mistletoe. (See page 68.)

In America, our custom of knocking on wood to keep a boast from boomeranging descended not from the homegrown American Indian superstition but from the later Greek belief, passed on to the Romans and then to the Britons. In time, when oak was not conveniently at hand, a rap on any type of wood sufficed. And in today's high-tech world of plastics and laminates, the knock-wood superstition persists, even though real wood, of any kind, is not always in arm's reach.

Four-Leaf Clover: 200 B.C., British Isles

More than any other factor, the rarity of the four-leaf clover (normally, the clover is a three-leaf plant) made it sacred to the sun-worshiping Druid priests of ancient England.

The Druids, whose Celtic name, *dereu-wid,* means "oak-wise" or "knowing the oak tree," frequented oak forests as worshiping grounds. They believed that a person in possession of a four-leaf clover could sight ambient demons and through incantations thwart their sinister influence. Our information on the origin of this good luck charm (as well as on other beliefs and behaviors of that learned class of Celts who acted as priests, teachers, and judges) comes mainly from the writings of Julius Caesar and from Irish legend.

Several times a year, Druids assembled in sacred oak forests throughout the British Isles and Gaul. There they settled legal disputes and offered human sacrifices for any person who was gravely ill or in danger of death from forthcoming battle. Huge wicker cages filled with men were burned. Though Druid priests preferred to sacrifice criminals, during periods of widespread law and order they incinerated the innocent. The immortality of the soul, and its transferal after death to a newborn, was one of their principal religious doctrines. Before terminating the forest ritual, Druids collected sprigs of mistletoe (believed to be capable of maintaining harmony within families) and scouted for rare clover.

Four-leaf clovers are no longer rare. In the 1950s, horticulturists developed a seed that sprouts *only* clover with four lobes. The fact that today they are grown in greenhouses by the millions and cultivated by the score on kitchen windowsills not only strips the tiny herb of the uniqueness that is its luck but usurps the thrill and serendipity of finding one.

Crossed Fingers: Pre-Christian Era, Western Europe

If you cross your fingers when making a wish, or if you tell a friend, "Keep your fingers crossed," you're partaking of an ancient custom that required the participation of *two* people, intersecting index fingers.

The popular gesture grew out of the pagan belief that a cross was a

symbol of perfect unity; and that its point of intersection marked the dwelling place of beneficent spirits. A wish made on a cross was supposed to be anchored steadfastly at the cross's intersection until that desire was realized. The superstition was popular among many early European cultures.

Interestingly, the notion of trapping a fantasy until it becomes a reality is found in another ancient European superstition: tying a string around the finger. Today we label the practice a "memory aid," a means of "psychological association" in which the string serves merely as a reminder of a task to be performed. To the Celts, the Romans, and the Anglo-Saxons, however, the string was thought to physically prevent the idea from escaping the body.

Originally, in crossing fingers for good luck, the index finger of a well-wisher was placed over the index finger of the person expressing the wish, the two fingers forming a cross. While one person wished, the other offered mental support to expedite the desire. As time elapsed, the rigors of the custom eased, so that a person could wish without the assistance of an associate. It sufficed merely to cross the index and the middle fingers to form an X, the Scottish cross of St. Andrew.

Customs once formal, religious, and ritualistic have a way of evolving with time to become informal, secular, and commonplace. As the ancient "knock oak" custom generalized to "knock wood" to today's "knock whatever is handy," so the "crossed fingers" of friends degenerated to a wisher crossing his own fingers and finally to today's expression "I'll keep my fingers crossed," with the well-wisher never actually doing so, and no one expecting him or her to.

Thus, what was once deliberate and symbolic becomes reflexive and insignificant—though not obsolete. The contemporary street custom among young boys of hooking index fingers as a means of agreement on a deal is similar in form and content to the ancient and original crossed fingers of friends.

Thumbs Up, Thumbs Down: 500 B.C., Etruria

Today a "thumbs up" gesture is an expression of approval, courage, or stick-to-itiveness. But to a fourth-century B.C. Etruscan gladiator it meant something more: literally, "Spare his life." And whereas "thumbs down" today suggests disapproval, in Etruscan times the disapproval was invariably terminal.

While the meaning of the Etruscan "rule of the thumb" was adopted by the Romans and is the proximate origin of our modern gesture, the Egyptians developed a thumb language with meanings closer to our own. The Egyptian "thumbs up" signified hope or victory, while "thumbs down" meant ill will or defeat.

Why, though, in these cultures did the thumb become the signaling finger? Roman historians in the time of Julius Caesar offered the first written

explanation for the gestures. They observed that an infant often enters the world with its thumbs tucked within clutched fists. As the baby gradually responds to stimuli in its environment, the hands slowly unfold, releasing the thumbs upward. As if to come full circle, at the time of death the hands often contract, enclosing the downturned thumbs. Thus, to the Romans, "thumbs up" became an affirmation of life, "thumbs down" a signal for death.

"God Bless You": 6th Century, Italy

"*Gesundheit,*" say Germans; "*Felicità,*" say Italians; Arabs clasp hands and reverently bow. Every culture believes in a benediction following a sneeze. The custom goes back to a time when a sneeze was regarded as a sign of great personal danger.

For centuries, man believed that life's essence, the soul, resided in the head and that a sneeze could accidentally expel the vital force. This suspicion was reinforced by the deathbed sneezing of the sick. Every effort was made to hold back a sneeze, and an inadvertent or unsuppressed sneeze was greeted with immediate good luck chants.

Enlightenment arrived in the fourth century B.C. with the teachings of Aristotle and Hippocrates, the "father of medicine." Both Greek scholars explained sneezing as the head's reaction to a foreign or offensive substance that crept into the nostrils. They observed that sneezing, when associated with existing illness, often foretold death. For these ill-boding sneezes, they recommended such benedictions as "Long may you live!" "May you enjoy good health!" and "Jupiter preserve you!"

About a hundred years later, Roman physicians extrapolated the lore and superstition surrounding a sneeze.

The Romans preached the view that sneezing, by an otherwise healthy individual, was the body's attempt to expel the sinister spirits of later illnesses. Thus, to withhold a sneeze was to incubate disease, to invite debility and death. Consequently, a vogue of sneezing swept the Roman Empire and engendered a host of new post-sneeze benedictions: "Congratulations" to a person having robustly executed a sneeze; and to a person quavering on the verge of an exhalation, the encouraging "Good luck to you."

The Christian expression "God bless you" has a still different origin. It began by papal fiat in the sixth century, during the reign of Pope Gregory the Great. A virulent pestilence raged throughout Italy, one foreboding symptom being severe, chronic sneezing. So deadly was the plague that people died shortly after manifesting its symptoms; thus, sneezing became synonymous with imminent death.

Pope Gregory beseeched the healthy to pray for the sick. He also ordered that such well-intended though leisurely phrases as "May you enjoy good health" be replaced with his own more urgent and pointed invocation, "God bless you!" And if no well-wisher was around to invoke the blessing, the sneezer was advised to exclaim aloud, "God help me!"

Pope Gregory's post-sneeze supplications spread throughout Europe, hand in hand with the plague, and the seriousness with which a sneeze was regarded was captured in a new expression, which survives to this day: "Not to be sneezed at." Today we voice it after a declamation in order to emphasize the gravity of our statement. But without knowledge of the expression's history, the words themselves are puzzlingly vague.

Broken Mirror: 1st Century, Rome

Breaking a mirror, one of the most widespread bad luck superstitions still extant, originated long before glass mirrors existed. The belief arose out of a combination of religious and economic factors.

The first mirrors, used by the ancient Egyptians, the Hebrews, and the Greeks, were made of polished metals such as brass, bronze, silver, and gold, and were of course unbreakable. By the sixth century B.C., the Greeks had begun a mirror practice of divination called catoptromancy, which employed shallow glass or earthenware bowls filled with water. Much like a gypsy's crystal ball, a glass water bowl—a *miratorium* to the Romans—was supposed to reveal the future of any person who cast his or her image on the reflective surface. The prognostications were read by a "mirror seer." If one of these mirrors slipped and broke, the seer's straightforward interpretation was that either the person holding the bowl had no future (that is, he or she was soon to die) or the future held events so abysmal that the gods were kindly sparing the person a glimpse at heartache.

The Romans, in the first century A.D., adopted this bad luck superstition and added their own twist to it—our modern meaning. They maintained that a person's health changed in cycles of seven years. Since mirrors reflect a person's appearance (that is, health), a broken mirror augured seven years of ill health and misfortune.

The superstition acquired a practical, economic application in fifteenth-century Italy. The first breakable sheet-glass mirrors with silver-coated backing were manufactured in Venice at that time. (See "Mirror," page 229.) Being costly, they were handled with great care, and servants who cleaned the mirrors of the wealthy were emphatically warned that to break one of the new treasures invited seven years of a fate worse than death. Such effective use of the superstition served to intensify the bad luck belief for generations of Europeans. By the time inexpensive mirrors were being manufactured in England and France in the mid-1600s, the broken-mirror superstition was widespread and rooted firmly in tradition.

Number Thirteen: Pre-Christian Era, Scandinavia

Surveys show that of all bad luck superstitions, unease surrounding the number thirteen is the one that affects most people today—and in almost countless ways.

The French, for instance, never issue the house address thirteen. In Italy,

11

Norse god Balder (right), source of the number thirteen superstition; Norse goddess Frigga, crowned with crescent moon, source of the Friday the thirteenth superstition; American dollar bill symbols incorporate numerous items numbering thirteen.

the national lottery omits the number thirteen. National and international airlines skip the thirteenth row of seats on planes. In America, modern skyscrapers, condominiums, co-ops, and apartment buildings label the floor that follows twelve as fourteen. Recently, a psychological experiment tested the potency of the superstition: A new luxury apartment building, with a floor temporarily numbered thirteen, rented units on all other floors, then only a few units on the thirteenth floor. When the floor number was changed to twelve-B, the unrented apartments quickly found takers.

How did this fear of the number thirteen, known as triskaidekaphobia, originate?

The notion goes back at least to Norse mythology in the pre-Christian era. There was a banquet at Valhalla, to which twelve gods were invited. Loki, the spirit of strife and evil, gate-crashed, raising the number present to thirteen. In the ensuing struggle to evict Loki, Balder, the favorite of the gods, was killed.

This is one of the earliest written references to misfortune surrounding the number thirteen. From Scandinavia, the superstition spread south throughout Europe. By the dawn of the Christian era, it was well established in countries along the Mediterranean. Then, folklorists claim, the belief was resoundingly reinforced, perhaps for all time, by history's most famous

12

meal: the Last Supper. Christ and his apostles numbered thirteen. Less than twenty-four hours after the meal, Christ was crucified.

Mythologists have viewed the Norse legend as prefiguring the Christian banquet. They draw parallels between the traitor Judas and Loki, the spirit of strife; and between Balder, the favorite god who was slain, and Christ, who was crucified. What is indisputable is that from the early Christian era onward, to invite thirteen guests for dinner was to court disaster.

As is true with any superstition, once a belief is laid down, people search, consciously or unconsciously, for events to fit the forecast. In 1798, for instance, a British publication, *Gentlemen's Magazine,* fueled the thirteen superstition by quoting actuarial tables of the day, which revealed that, on the average, one out of every thirteen people in a room would die within the year. Earlier and later actuarial tables undoubtedly would have given different figures. Yet for many Britons at the time, it seemed that science had validated superstition.

Ironically, in America, thirteen should be viewed as a *lucky* number. It is part of many of our national symbols. On the back of the U.S. dollar bill, the incomplete pyramid has thirteen steps; the bald eagle clutches in one claw an olive branch with thirteen leaves and thirteen berries, and in the other he grasps thirteen arrows; there are thirteen stars above the eagle's head. All of that, of course, has nothing to do with superstition, but commemorates the country's original thirteen colonies, themselves an auspicious symbol.

Friday the Thirteenth. Efforts to account for this unluckiest of days have focused on disastrous events alleged to have occurred on it. Tradition has it that on Friday the thirteenth, Eve tempted Adam with the apple; Noah's ark set sail in the Great Flood; a confusion of tongues struck at the Tower of Babel; the Temple of Solomon toppled; and Christ died on the cross.

The actual origin of the superstition, though, appears also to be a tale in Norse mythology.

Friday is named for Frigga, the free-spirited goddess of love and fertility. When Norse and Germanic tribes converted to Christianity, Frigga was banished in shame to a mountaintop and labeled a witch. It was believed that every Friday, the spiteful goddess convened a meeting with eleven other witches, plus the devil—a gathering of thirteen—and plotted ill turns of fate for the coming week. For many centuries in Scandinavia, Friday was known as "Witches' Sabbath."

Black Cat: Middle Ages, England

As superstitions go, fear of a black cat crossing one's path is of relatively recent origin. It is also entirely antithetical to the revered place held by the cat when it was first domesticated in Egypt, around 3000 B.C.

All cats, including black ones, were held in high esteem among the ancient Egyptians and protected by law from injury and death. So strong was cat idolatry that a pet's death was mourned by the entire family; and both rich and poor embalmed the bodies of their cats in exquisite fashion, wrapping them in fine linen and placing them in mummy cases made of precious materials such as bronze and even wood—a scarcity in timber-poor Egypt. Entire cat cemeteries have been unearthed by archaeologists, with mummified black cats commonplace.

Impressed by the way a cat could survive numerous high falls unscathed, the Egyptians originated the belief that the cat has **nine lives.**

The cat's popularity spread quickly through civilization. Sanskrit writings more than two thousand years old speak of cats' roles in Indian society; and in China about 500 B.C., Confucius kept a favorite pet cat. About A.D. 600, the prophet Muhammad preached with a cat in his arms, and at approximately the same time, the Japanese began to keep cats in their pagodas to protect sacred manuscripts. In those centuries, a cat crossing a person's path was a sign of *good* luck.

Dread of cats, especially black cats, first arose in Europe in the Middle Ages, particularly in England. The cat's characteristic independence, willfulness, and stealth, coupled with its sudden overpopulation in major cities, contributed to its fall from grace. Alley cats were often fed by poor, lonely old ladies, and when witch hysteria struck Europe, and many of these homeless women were accused of practicing black magic, their cat companions (especially black ones) were deemed guilty of witchery by association.

One popular tale from British feline lore illustrates the thinking of the day. In Lincolnshire in the 1560s, a father and his son were frightened one moonless night when a small creature darted across their path into a crawl space. Hurling stones into the opening, they saw an injured black cat scurry out and limp into the adjacent home of a woman suspected by the town of being a witch. Next day, the father and son encountered the woman on the street. Her face was bruised, her arm bandaged. And she now walked with a limp. From that day on in Lincolnshire, all black cats were suspected of being witches in night disguise. The lore persisted. The notion of witches transforming themselves into black cats in order to prowl streets unobserved became a central belief in America during the Salem witch hunts.

Thus, an animal once looked on with approbation became a creature dreaded and despised.

Many societies in the late Middle Ages attempted to drive cats into extinction. As the witch scare mounted to paranoia, many innocent women and their harmless pets were burned at the stake. A baby born with eyes too bright, a face too canny, a personality too precocious, was sacrificed for fear that it was host to a spirit that would in time become a witch by day, a black cat by night. In France, thousands of cats were burned monthly until King Louis XIII, in the 1630s, halted the shameful practice. Given the number of centuries in which black cats were slaughtered throughout

14

Europe, it is surprising that the gene for the color black was not deleted from the species . . . unless the cat does possess nine lives.

Flip of a Coin: 1st Century B.C., Rome

In ancient times, people believed that major life decisions should be made by the gods. And they devised ingenious forms of divination to coax gods to answer important questions with an unequivocal "yes" or "no." Although coins—ideally suited for yes/no responses—were first minted by the Lydians in the tenth century B.C., they were not initially used for decisionmaking.

It was Julius Caesar, nine hundred years later, who instituted the heads/tails coin-flipping practice. Caesar's own head appeared on one side of every Roman coin, and consequently it was a *head*—specifically that of Caesar—that in a coin flip determined the winner of a dispute or indicated an affirmative response from the gods.

Such was the reverence for Caesar that serious litigation, involving property, marriage, or criminal guilt, often was settled by the flip of a coin. Caesar's head landing upright meant that the emperor, in absentia, agreed with a particular decision and opposed the alternative.

Spilling Salt: 3500 B.C., Near East

Salt was man's first food seasoning, and it so dramatically altered his eating habits that it is not at all surprising that the action of spilling the precious ingredient became tantamount to bad luck.

Following an accidental spilling of salt, a superstitious nullifying gesture such as throwing a pinch of it over the left shoulder became a practice of the ancient Sumerians, the Egyptians, the Assyrians, and later the Greeks. For the Romans, salt was so highly prized as a seasoning for food and a medication for wounds that they coined expressions utilizing the word, which have become part of our language. The Roman writer Petronius, in the *Satyricon*, originated "not worth his salt" as opprobrium for Roman soldiers, who were given special allowances for salt rations, called *salarium*—"salt money"—the origin of our word "salary."

Archaeologists know that by 6500 B.C., people living in Europe were actively mining what are thought to be the first salt mines discovered on the continent, the Hallstein and Hallstatt deposits in Austria. Today these caves are tourist attractions, situated near the town of Salzburg, which of course means "City of Salt." Salt purified water, preserved meat and fish, and enhanced the taste of food, and the Hebrews, the Greeks, and the Romans used salt in all their major sacrifices.

The veneration of salt, and the foreboding that followed its spilling, is poignantly captured in Leonardo da Vinci's *The Last Supper*. Judas has spilled the table salt, foreshadowing the tragedy—Jesus' betrayal—that was

to follow. Historically, though, there is no evidence of salt having been spilled at the Last Supper. Leonardo wittingly incorporated the widespread superstition into his interpretation to further dramatize the scene. The classic painting thus contains two ill-boding omens: the spilling of salt, and thirteen guests at a table.

Umbrella Indoors: 18th Century, England

Bad luck superstitions surrounding the umbrella began with the Egyptians, who imparted their intricately designed umbrellas of papyrus and peacock feathers with religious significance. These early umbrellas were never intended to protect against rain (which was rare and a blessing in arid Egypt), but served as sunshades in the blistering heat of day. (See "Umbrella," page 318.)

The Egyptians believed that the canopy of the sky was formed by the body of the celestial goddess Nut. With only her toes and fingertips touching the earth, her torso spanned the planet like a vast umbrella. Man-made umbrellas were regarded as small-scale earthly embodiments of Nut and suitable only to be held above the heads of nobility. The shade cast by an umbrella outdoors was sacred, and for a commoner to even accidentally step into it was considered sacrilegious, a harbinger of bad luck. (This belief was reversed by the Babylonians, who deemed it an honor to have even a foot fall into the umbra of the king's sunshade.)

Folklorists claim that the superstitious belief that opening an umbrella indoors augurs misfortune has a more recent and utilitarian origin. In eighteenth-century London, when metal-spoked waterproof umbrellas began to become a common rainy-day sight, their stiff, clumsy spring mechanism made them veritable hazards to open indoors. A rigidly spoked umbrella, opening suddenly in a small room, could seriously injure an adult or a child, or shatter a frangible object. Even a minor accident could provoke unpleasant words or a serious quarrel, themselves strokes of bad luck in a family or among friends. Thus, the superstition arose as a deterrent to opening an umbrella indoors.

Today, with the ubiquitousness of radio, television, and newspaper weather forecasts, the umbrella superstition has again been altered. No longer is it really considered a bad luck omen to open an umbrella indoors (though it still presents a danger). Rather, on a morning when rain is in the forecast, one superstitious way to assure dry skies throughout the day is to set off for work toting an umbrella. On the other hand, to chance leaving the umbrella at home guarantees getting caught in a downpour. Subtle, unobtrusive, and even commonplace, superstitious beliefs infiltrate our everyday conversations and actions.

Walking Under a Ladder: 3000 B.C., Egypt

Here is one superstition whose origin appears to be grounded in obvious and practical advice: walking under a ladder, after all, should be avoided since a workman's plummeting tool could become a lethal weapon.

The true origin of the superstition, though, has nothing to do with practicality. A ladder leaning against a wall forms a triangle, long regarded by many societies as the most common expression of a sacred trinity of gods. The pyramid tombs of the pharaohs, for example, were based on triangular planes. In fact, for a commoner to pass through a triangulated arch was tantamount to defiance of a sanctified space.

To the Egyptians, the ladder itself was a symbol of good luck. It was a ladder that rescued the sun god Osiris from imprisonment by the spirit of Darkness. The ladder was also a favorite pictorial sign to illustrate the ascent of gods. And ladders were placed in the tombs of Egyptian kings to help them climb heavenward.

Centuries later, followers of Jesus Christ usurped the ladder superstition, interpreting it in light of Christ's death: Because a ladder had rested against the crucifix, it became a symbol of wickedness, betrayal, and death. Walking under a ladder courted misfortune. In England and France in the 1600s, criminals on their way to the gallows were compelled to walk under a ladder, while the executioner, called the Groom of the Ladder, walked around it.

Ancient cultures invariably had antidotes to their most feared superstitions. For a person who inadvertently walked under a ladder, or who was forced to do so for convenience of passage, the prescribed Roman antidote was the sign of the *fico*. This nullifying gesture was made by closing the fist and allowing the thumb to protrude between the index and middle fingers. The fist was then thrust forward at the ladder. Any person interested in applying the antidote today should be aware that the *fico* was also a Roman phallic gesture, believed to be the precursor of the extended middle finger, whose accompanying incantation is not all that different in sound from *fico*.

Evil Eye: Antiquity, Near East and Europe

A "dirty look," a "withering glance," "if looks could kill," and "to stare with daggers" are a few common expressions that derive from one of the most universal of fears, the evil eye.

It has been found in virtually all cultures. In ancient Rome, professional sorcerers with the evil eye were hired to bewitch a person's enemies. All gypsies were accused of possessing the stare. And the phenomenon was widespread and dreaded throughout India and the Near East. By the Middle Ages, Europeans were so fearful of falling under the influence of an evil glance that any person with a dazed, crazed, or canny look was liable to be burned at the stake. A case of cataracts could spell death.

The evil eye is one of the most universally dreaded bad luck beliefs, found in virtually all cultures.

How did such a belief originate independently among so many different peoples?

One of the most commonly accepted theories among folklorists involves the phenomenon of pupil reflection: If you look into a person's eyes, your own minuscule image will appear in the dark of the pupil. And indeed, our word "pupil" comes from the Latin *pupilla,* meaning "little doll."

Early man must have found it strange and frightening to glimpse his own image in miniature in the eyes of other tribesmen. He may have believed himself to be in personal danger, fearing that his likeness might lodge permanently in, and be stolen by, an evil eye. This notion is reinforced by the belief among primitive African tribes less than a century ago that to be photographed was to permanently lose one's soul.

The Egyptians had a curious antidote to an evil stare—kohl, history's first mascara. Worn by both men and women, it was applied in a circle or oval about the eyes. (See "Eye Makeup," page 223.) The chemical base was antimony, a metal, and while soothsayers prepared the compound for men to smear on, women concocted their own antimony formulas, adding preferred secret ingredients.

Why should mascara be an evil-eye antidote?

18

No one today is certain. But darkly painted circles around the eyes absorb sunlight and consequently minimize reflected glare into the eye. The phenomenon is familiar to every football and baseball player who has smeared black grease under each eye before a game. The early Egyptians, spending considerable time in harsh desert sunlight, may have discovered this secret themselves and devised mascara not primarily for beautifying purposes, as is the standard belief, but for practical and superstitious ones.

Stork Brings Baby: Antiquity, Scandinavia

To account for the sudden appearance of a new baby in a household, Scandinavian mothers used to tell their children that a stork brought it. And to account for the mother's much-needed bed rest, the children were told that before the bird departed, it bit the mother's leg.

The need to offer young children some explanation for the arrival of a new baby (especially in a time when infants were born at home) is understandable. But why a stork?

Early Scandinavian naturalists had studied storks and their nesting habits on home chimney stacks. The birds, in their long, seventy-year life span, returned to the same chimney year after year, and they mated monogamously. Young adult birds lavished great attention and care on elderly or infirm parents, feeding them and offering their extended wings for support. In fact, the ancient Romans, impressed with the stork's altruistic behavior, passed legislation called *Lex Ciconaria,* the "Stork's Law," compelling children to care for their aged parents. The Greeks were equally impressed. Their term *storge,* the origin of our word "stork," means "strong natural affection."

Thus, the stork's gentleness, along with the convenience of its nesting in a home's chimney, made it an ideal creature to deliver a new arrival down the chimney. For centuries, the old Norse legend was popular throughout Scandinavia. It was nineteenth-century Danish writer Hans Christian Andersen, through his fairy tales, who popularized the myth worldwide.

Covering a Yawn: Antiquity, Middle East

Today, covering the mouth when yawning is considered an essential of good manners. But the original custom stemmed not from politeness but from fear—a fear that in one giant exhalation the soul, and life itself, might depart the body. A hand to the lips held back the life force.

Ancient man had accurately observed (though incorrectly interpreted) that a newborn, struggling to survive, yawns shortly after birth (a reflexive response to draw additional oxygen into the lungs). With infant mortality extraordinarily high, early physicians, at a loss to account for frequent deaths, blamed the yawn. The helpless baby simply could not cover its mouth with a protective hand. Roman physicians actually recommended

An ancient belief that the breath of life might escape the body during a yawn established the custom of covering the mouth.

that a mother be particularly vigilant during the early months of life and cover any of her newborn's yawns.

Today it is also considered good manners when yawning to turn one's head. But courtesy had nothing to do with the origin of the custom, nor with the apology that follows a yawn. Ancient man had also accurately observed that a yawn is contagious to witnesses. Thus, if a yawn was dangerous to the yawner, this danger could be "caught" by others, like the plague. The apology was for exposing friends to mortal danger.

Modern science has explained the yawn as the body's sudden need for a large infusion of oxygen, especially on awakening, when one is physically exhausted, and in the early stages of strenuous exercise. But there still is no physiological accounting for the contagiousness of yawning. We know only that the sight of a person yawning goes to the visual center of the brain and from there is transmitted to the yawn center. Why such a particular pathway should exist is as mysterious to us today as was the yawn itself to ancient man.

Chapter 2

By Custom

Marriage Customs: A.D. 200, Northern Europe

Among the Germanic Goths, a man married a woman from within his own community. When women were in short supply, he captured his bride-to-be from a neighboring village. The future bridegroom, accompanied by a male companion, seized any young girl who had strayed from the safety of her parental home. Our custom of a **best man** is a relic of that two-man, strong-armed tactic; for such an important task, only the best man would do.

From this practice of abduction, which literally swept a bride off her feet, also sprang the later symbolic act of **carrying the bride over the threshold** of her new home.

A best man around A.D. 200 carried more than a ring. Since there remained the real threat of the bride's family's attempting to forcibly gain her return, the best man stayed by the groom's side throughout the marriage ceremony, alert and armed. He also might serve as a sentry outside the newlyweds' home. Of course, much of this is German folklore, but it is not without written documentation and physical artifacts. For instance, the threat of recapture by the bride's family was perceived as so genuine that beneath the church altars of many early peoples—including the Huns, the Goths, the Visigoths, and the Vandals—lay an arsenal of clubs, knives, and spears.

The tradition that the bride stand to the left of the groom was also more

than meaningless etiquette. Among the Northern European barbarians (so named by the Romans), a groom placed his captured bride on his left to protect her, freeing his right hand, the sword hand, against sudden attack.

Wedding Ring: 2800 B.C., Egypt

The origin and significance of the wedding ring is much disputed. One school of thought maintains that the modern ring is symbolic of the fetters used by barbarians to tether a bride to her captor's home. If that be true, today's double ring ceremonies fittingly express the newfound equality of the sexes.

The other school of thought focuses on the first actual bands exchanged in a marriage ceremony. A finger ring was first used in the Third Dynasty of the Old Kingdom of Egypt, around 2800 B.C. To the Egyptians, a circle, having no beginning or end, signified eternity—for which marriage was binding.

Rings of gold were the most highly valued by wealthy Egyptians, and later Romans. Among numerous two-thousand-year-old rings unearthed at the site of Pompeii is one of a unique design that would become popular throughout Europe centuries later, and in America during the Flower Child era of the '60s and '70s. That extant gold marriage ring (of the type now called a **friendship ring**) has two carved hands clasped in a handshake.

There is evidence that young Roman men of moderate financial means often went for broke for their future brides. Tertullian, a Christian priest writing in the second century A.D., observed that "most women know nothing of gold except the single marriage ring placed on one finger." In public, the average Roman housewife proudly wore her gold band, but at home, according to Tertullian, she "wore a ring of iron."

In earlier centuries, a ring's design often conveyed meaning. Several extant Roman bands bear a miniature key welded to one side. Not that the key sentimentally suggested a bride had unlocked her husband's heart. Rather, in accordance with Roman law, it symbolized a central tenet of the marriage contract: that a wife was entitled to half her husband's wealth, and that she could, at will, help herself to a bag of grain, a roll of linen, or whatever rested in his storehouse. Two millennia would drag on before that civil attitude would reemerge.

Diamond Engagement Ring: 15th Century, Venice

A Venetian wedding document dated 1503 lists "one marrying ring having diamond." The gold wedding ring of one Mary of Modina, it was among the early betrothal rings that featured a diamond setting. They began a tradition that probably is forever.

The Venetians were the first to discover that the diamond is one of the

hardest, most enduring substances in nature, and that fine cutting and polishing releases its brilliance. Diamonds, sets in bands of silver and gold, became popular for betrothal rings among wealthy Venetians toward the close of the fifteenth century. Rarity and cost limited their rapid proliferation throughout Europe, but their intrinsic appeal guaranteed them a future. By the seventeenth century, the diamond ring had become the most popular, sought-after statement of a European engagement.

One of history's early diamond engagement rings was also its smallest, worn by a two-year-old bride-to-be. The ring was fashioned for the betrothal of Princess Mary, daughter of Henry VIII, to the dauphin of France, son of King Francis I. Born on February 28, 1518, the dauphin was immediately engaged as a matter of state policy, to assure a more intimate alliance between England and France. Infant Mary was presented with the veriest vogue in rings, which doubtless fit the tiny royal finger for only a short time.

Though the origin of the diamond engagement ring is known, that of betrothal rings in general is less certain. The practice began, though, well before the fifteenth century.

An early Anglo-Saxon custom required that a prospective bridegroom break some highly valued personal belonging. Half the token was kept by the groom, half by the bride's father. A wealthy man was expected to split a piece of gold or silver. Exactly when the broken piece of metal was symbolically replaced by a ring is uncertain. The weight of historical evidence seems to indicate that betrothal rings (at least among European peoples) existed before wedding rings, and that the ring a bride received at the time of proposal was given to her again during the wedding ceremony. Etymologists find one accurate description of the engagement ring's intent in its original Roman name, *arrhae,* meaning "earnest money."

For Roman Catholics, the engagement ring's official introduction is unequivocal. In A.D. 860, Pope Nicholas I decreed that an engagement ring become a required statement of nuptial intent. An uncompromising defender of the sanctity of marriage, Nicholas once excommunicated two archbishops who had been involved with the marriage, divorce, and remarriage of Lothair II of Lorraine, charging them with "conniving at bigamy." For Nicholas, a ring of just any material or worth would not suffice. The engagement ring was to be of a valued metal, preferably gold, which for the husband-to-be represented a financial sacrifice; thus started a tradition.

In that century, two other customs were established: forfeiture of the ring by a man who reneged on a marriage pledge; surrender of the ring by a woman who broke off an engagement. The Church became unbending regarding the seriousness of a marriage promise and the punishment if broken. The Council of Elvira condemned the parents of a man who terminated an engagement to excommunication for three years. And if a

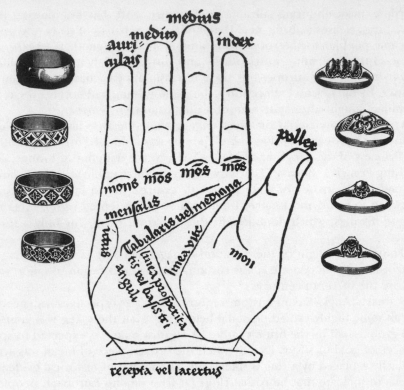

A wedding ring symbolizes the fetters used to tether a captive bride to her new home. The ring finger, adjacent to the pinky, was thought to contain a "vein of love" connecting to the heart.

woman backed out for reasons unacceptable to the Church, her parish priest had the authority to order her into a nunnery for life. For a time, "till death do us part" began weeks or months before a bride and groom were even united.

Ring Finger: 3rd Century B.C., Greece

The early Hebrews placed the wedding ring on the index finger. In India, nuptial rings were worn on the thumb. The Western custom of placing a wedding ring on the "third" finger (not counting the thumb) began with the Greeks, through carelessness in cataloguing human anatomy.

Greek physicians in the third century B.C. believed that a certain vein, the "vein of love," ran from the "third finger" directly to the heart. It became the logical digit to carry a ring symbolizing an affair of the heart.

24

The Romans, plagiarizing Greek anatomy charts, adopted the ring practice unquestioningly. They did attempt to clear up the ambiguity surrounding exactly what finger constituted the third, introducing the phrase "the finger next to the least." This also became the Roman physician's "healing finger," used to stir mixtures of drugs. Since the finger's vein supposedly ran to the heart, any potentially toxic concoction would be readily recognized by a doctor "in his heart" before being administered to a patient.

The Christians continued this ring-finger practice, but worked their way across the hand to the vein of love. A groom first placed the ring on the top of the bride's index finger, with the words "In the name of the Father." Then, praying, "In the name of the Son," he moved the ring to her middle finger, and finally, with the concluding words "and of the Holy Spirit, Amen," to the third finger. This was known as the Trinitarian formula.

In the East, the Orientals did not approve of finger rings, believing them to be merely ornamental, lacking social symbolism or religious significance.

Marriage Banns: 8th Century, Europe

During European feudal times, all public announcements concerning deaths, taxes, or births were called "banns." Today we use the term exclusively for an announcement that two people propose to marry. That interpretation began as a result of an order by Charlemagne, king of the Franks, who on Christmas Day in A.D. 800 was crowned Emperor of the Romans, marking the birth of the Holy Roman Empire.

Charlemagne, with a vast region to rule, had a practical medical reason for instituting marriage banns.

Among rich and poor alike, a child's parentage was not always clear; an extramarital indiscretion could lead to a half-brother and half-sister marrying, and frequently did. Charlemagne, alarmed by the high rate of sibling marriages, and the subsequent genetic damage to the offspring, issued an edict throughout his unified kingdom: All marriages were to be publicly proclaimed at least seven days prior to the ceremony. To avoid consanguinity between the prospective bride and groom, any person with information that the man and woman were related as brother or sister, or as half-siblings, was ordered to come forth. The practice proved so successful that it was widely endorsed by all faiths.

Wedding Cake: 1st Century B.C., Rome

The wedding cake was not always eaten by the bride; it was originally thrown at her. It developed as one of many fertility symbols integral to the marriage ceremony. For until modern times, children were expected to follow marriage as faithfully as night follows day; and almost as frequently.

Wheat, long a symbol of fertility and prosperity, was one of the earliest grains to ceremoniously shower new brides; and unmarried young women

were expected to scramble for the grains to ensure their own betrothals, as they do today for the bridal bouquet.

Early Romans bakers, whose confectionery skills were held in higher regard than the talents of the city's greatest builders, altered the practice. Around 100 B.C., they began baking the wedding wheat into small, sweet cakes—to be eaten, not thrown. Wedding guests, however, loath to abandon the fun of pelting the bride with wheat confetti, often tossed the cakes.

According to the Roman poet and philosopher Lucretius, author of *De rerum natura* ("On the Nature of Things"), a compromise ritual developed in which the wheat cakes were crumbled over a bride's head. And as a further symbol of fertility, the couple was required to eat a portion of the crumbs, a custom known as *confarreatio,* or "eating together." After exhausting the supply of cakes, guests were presented with handfuls of *confetto*—"sweet meats"—a confetti-like mixture of nuts, dried fruits, and honeyed almonds, sort of an ancient trail mix.

The practice of eating crumbs of small wedding cakes spread throughout Western Europe. In England, the crumbs were washed down with a special ale. The brew itself was referred to as *bryd ealu,* or "bride's ale," which evolved into the word "bridal."

The wedding cake rite, in which tossed food symbolized an abundance of offspring, changed during lean times in the early Middle Ages. Raw wheat or rice once again showered a bride. The once-decorative cakes became simple biscuits or scones to be eaten. And guests were encouraged to bake their own biscuits and bring them to the ceremony. Leftovers were distributed among the poor. Ironically, it was these austere practices that with time, ingenuity, and French contempt for all things British led to the most opulent of wedding adornments: the multitiered cake.

The legend is this: Throughout the British Isles, it had become customary to pile the contributed scones, biscuits, and other baked goods atop one another into an enormous heap. The higher the better, for height augured prosperity for the couple, who exchanged kisses over the mound. In the 1660s, during the reign of King Charles II, a French chef (whose name, unfortunately, is lost to history) was visiting London and observed the cake-piling ceremony. Appalled at the haphazard manner in which the British stacked baked goods, often to have them tumble, he conceived the idea of transforming the mountain of bland biscuits into an iced, multitiered cake sensation. British papers of the day are supposed to have deplored the French excess, but before the close of the century, British bakers were offering the very same magnificent creations.

Throwing Shoes at the Bride: Antiquity, Asia and Europe

Today old shoes are tied to newlyweds' cars and no one asks why. Why, of all things, shoes? And why *old* shoes?

Originally, shoes were only one of many objects tossed at a bride to wish

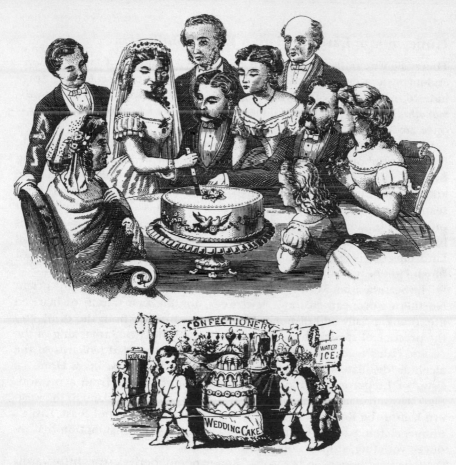

The wedding cake was once tossed at a bride as a symbol of fertility. The multi-tiered confection is a French creation.

her a bounty of children. In fact, shoes were preferred over the equally traditional wheat and rice because from ancient times the foot was a powerful phallic symbol. In several cultures, particularly among the Eskimos, a woman experiencing difficulty in conceiving was instructed to carry a piece of an old shoe with her at all times. The preferred shoes for throwing at a bride—and later for tying to the newlyweds' car—were old ones strictly for economic reasons. Shoes have never been inexpensive.

Thus, the throwing of shoes, rice, cake crumbs, and confetti, as well as the origin of the wedding cake, are all expressions for a fruitful union. It is not without irony that in our age, with such strong emphasis on delayed childbearing and family planning, the modern wedding ceremony is replete with customs meant to induce maximum fertility.

Honeymoon: Early Christian Era, Scandinavia

There is a vast difference between the original meaning of "honeymoon" and its present-day connotation—a blissful, much-sought seclusion as prelude to married life. The word's antecedent, the ancient Norse *hjunotts-manathr*, is, we'll see, cynical in meaning, and the seclusion it bespeaks was once anything but blissful.

When a man from a Northern European community abducted a bride from a neighboring village, it was imperative that he take her into hiding for a period of time. Friends bade him safety, and his whereabouts were known only to the best man. When the bride's family abandoned their search, he returned to his own people. At least, that is a popular explanation offered by folklorists for the origin of the honeymoon; honeymoon meant hiding. For couples whose affections were mutual, the daily chores and hardships of village life did not allow for the luxury of days or weeks of blissful idleness.

The Scandinavian word for "honeymoon" derives in part from an ancient Northern European custom. Newlyweds, for the first month of married life, drank a daily cup of honeyed wine called mead. Both the drink and the practice of stealing brides are part of the history of Attila, king of the Asiatic Huns from A.D. 433 to 453. The warrior guzzled tankards of the alcoholic distillate at his marriage in 450 to the Roman princess Honoria, sister of Emperor Valentinian III. Attila abducted her from a previous marriage and claimed her for his own—along with laying claim to the western half of the Roman Empire. Three years later, at another feast, Attila's unquenchable passion for mead led to an excessive consumption that induced vomiting, stupor, coma, and his death.

While the "honey" in the word "honeymoon" derives straightforwardly from the honeyed wine mead, the "moon" stems from a cynical inference. To Northern Europeans, the term "moon" connoted the celestial body's monthly cycle; its combination with "honey" suggested that all moons or months of married life were not as sweet as the first. During the sixteenth and seventeenth centuries, British prose writers and poets frequently employed the Nordic interpretation of honeymoon as a waxing and waning of marital affection.

Wedding March: 19th Century, England

The traditional church wedding features two bridal marches, by two different classical composers.

The bride walks down the aisle to the majestic, moderately paced music of the "Bridal Chorus" from Richard Wagner's 1848 opera *Lohengrin*. The newlyweds exit to the more jubilant, upbeat strains of the "Wedding March" from Felix Mendelssohn's 1826 *A Midsummer Night's Dream*.

The custom dates back to the royal marriage, in 1858, of Victoria, princess

of Great Britain and empress of Germany, to Prince Frederick William of Prussia. Victoria, eldest daughter of Britain's Queen Victoria, selected the music herself. A patron of the arts, she valued the works of Mendelssohn and practically venerated those of Wagner. Given the British penchant for copying the monarchy, soon brides throughout the Isles, nobility and commoners alike, were marching to Victoria's drummer, establishing a Western wedding tradition.

White Wedding Dress and Veil: 16th Century, England and France

White has denoted purity and virginity for centuries. But in ancient Rome, yellow was the socially accepted color for a bride's wedding attire, and a veil of flame-hued yellow, the *flammeum,* covered her face. The bridal veil, in fact, predates the wedding dress by centuries. And the facial veil itself predates the bridal veil.

Historians of fashion claim that the facial veil was strictly a male invention, and one of the oldest devices designed to keep married and single women humble, subservient, and hidden from other males. Although the veil at various times throughout its long history also served as a symbol of elegance and intrigue, modesty and mourning, it is one article of feminine attire that women may never have created for themselves.

Originating in the East at least four thousand years ago, veils were worn throughout life by unmarried women as a sign of modesty and by married women as a sign of submissiveness to their husbands. In Muslim religions, a woman was expected to cover her head and part of her face whenever she left the house. As time passed, rules (made by men) became stricter and only a woman's eyes were permitted to remain uncovered—a concession to necessity, since ancient veils were of heavy weaves, which interfered with vision.

Customs were less severe and formal in Northern European countries. Only abducted brides wore veils. Color was unimportant, concealment paramount. Among the Greeks and the Romans by the fourth century B.C., sheer, translucent veils were the vogue at weddings. They were pinned to the hair or held in place by ribbons, and yellow had become the preferred color—for veil and wedding gown. During the Middle Ages, color ceased to be a primary concern; emphasis was on the richness of fabric and decorative embellishments.

In England and France, the practice of wearing white at weddings was first commented on by writers in the sixteenth century. White was a visual statement of a bride's virginity—so obvious and public a statement that it did not please everyone. Clergymen, for instance, felt that virginity, a marriage prerequisite, should not have to be blatantly advertised. For the next hundred fifty years, British newspapers and magazines carried the running controversy fired by white wedding ensembles.

The veil was a male invention to keep women subservient and hidden from other males. A bride's white wedding ensemble is of comparatively recent origin; yellow was once the preferred color.

By the late eighteenth century, white had become the standard wedding color. Fashion historians claim this was due mainly to the fact that most gowns of the time were white; that white was *the* color of formal fashion. In 1813, the first fashion plate of a white wedding gown and veil appeared in the influential French *Journal des Dames*. From that point onward, the style was set.

Divorce: Antiquity, Africa and Asia

Before there can be a formal dissolution of marriage, there has to be an official marriage. The earliest extant marriage certificate was found among Aramaic papyri, relics of a Jewish garrison stationed at Elephantine in Egypt in the fifth century B.C. The contract is a concise, unadorned, unromantic bill of sale: six cows in exchange for a healthy fourteen-year-old girl.

Under the Romans, who were great legal scholars, the marriage certificate mushroomed into a complex, multipage document of legalese. It rigidly stated such terms as the conditions of the dowry and the division of property

upon divorce or death. In the first century A.D., a revised marriage certificate was officially introduced among the Hebrews, which is still used today with only minor alterations.

Divorce, too, began as a simple, somewhat informal procedure. In early Athens and Rome, legal grounds for the dissolution of a marriage were unheard of; a man could divorce his wife whenever like turned to dislike. And though he needed to obtain a bill of divorce from a local magistrate, there are no records of one ever having been denied.

As late as the seventh century, an Anglo-Saxon husband could divorce his wife for the most far-flung and farfetched of reasons. A legal work of the day states that "A wife might be repudiated on proof of her being barren, deformed, silly, passionate, luxurious, rude, habitually drunk, gluttonous, very garrulous, quarrelsome or abusive."

Anthropologists who have studied divorce customs in ancient and modern societies agree on one issue: Historically, divorce involving mutual consent was more widespread in matrilineal tribes, in which the wife was esteemed as the procreative force and the head of the household. Conversely, in a patrilineal culture, in which the procreative and sexual rights of a bride were often symbolically transferred to the husband with the payment of so-called bridewealth, divorce strongly favored the wishes and whims of the male.

Birthdays: 3000 B.C., Egypt

It is customary today to celebrate a living person's birthday. But if one Western tradition had prevailed, we'd be observing annual postmortem celebrations of the *death* day, once a more significant event.

Many of our birthday customs have switched one hundred eighty degrees from what they were in the past. Children's birthdays were never observed, nor were those of women. And the decorated birthday cake, briefly a Greek tradition, went unbaked for centuries—though it reappeared to be topped with candles and greeted with a rousing chorus of "Happy Birthday to You." How did we come by our many birthday customs?

In Egypt, and later in Babylonia, dates of birth were recorded and celebrated for male children of royalty. Birthday fetes were unheard of for the lower classes, and for women of almost any rank other than queen; only a king, queen, or high-ranking nobleman even recognized the day he or she was born, let alone commemorated it annually.

The first birthday celebrations in recorded history, around 3000 B.C., were those of the early pharaohs, kings of Egypt. The practice began after Menes united the Upper and Lower Kingdoms. Celebrations were elaborate household feasts in which servants, slaves, and freedmen took part; often prisoners were released from the royal jails.

Two ancient female birthdays are documented. From Plutarch, the first-century Greek biographer and essayist, we know that Cleopatra IV, the last

31

member of the Ptolemaic Dynasty to rule Egypt, threw an immense birthday celebration for her lover, Mark Antony, at which the invited guests were themselves lavished with royal gifts. An earlier Egyptian queen, Cleopatra II, who incestuously married her brother Ptolemy and had a son by him, received from her husband one of the most macabre birthday presents in history: the slaughtered and dismembered body of their son.

The Greeks adopted the Egyptian idea of birthday celebrations, and from the Persians, renowned among ancient confectioners, they added the custom of a sweet birthday cake as hallmark of the occasion. The writer Philochorus tells us that worshipers of Artemis, goddess of the moon and the hunt, celebrated her birthday on the sixth day of every month by baking a large cake of flour and honey. There is evidence suggesting that Artemis's cake might actually have been topped with lighted candles, since candles signified moonlight, the goddess's earthward radiance.

Birthdays of Greek deities were celebrated monthly, each god hailed with twelve fetes a year. At the other extreme, birthdays of mortal women and children were considered too unimportant to observe. But when the birthday of the man of the house arrived, no banquet was deemed too lavish. The Greeks called these festivities for living males *Genethlia,* and the annual celebrations continued for years after a man's death, with the postmortem observances known as *Genesia.*

The Romans added a new twist to birthday celebrations. Before the dawn of the Christian era, the Roman senate inaugurated the custom (still practiced today) of making the birthdays of important statesmen national holidays. In 44 B.C., the senate passed a resolution making the assassinated Caesar's birthday an annual observance—highlighted by a public parade, a circus performance, gladiatorial combats, an evening banquet, and a theatrical presentation of a dramatic play.

With the rise of Christianity, the tradition of celebrating birthdays ceased altogether.

To the early followers of Christ, who were oppressed, persecuted, and martyred by the Jews and the pagans—and who believed that infants entered this world with the original sin of Adam condemning their souls—the world was a harsh, cruel place. There was no reason to celebrate one's birth. But since death was the true deliverance, the passage to eternal paradise, every person's death day merited prayerful observance.

Contrary to popular belief, it was the death days and not the birthdays of saints that were celebrated and became their "feast days." Church historians interpret many early Christian references to "birthdays" as passage or birth into the afterlife. "A birthday of a saint," clarified the early Church apologist Peter Chrysologus, "is not that in which they are born in the flesh, but that in which they are born from earth into heaven, from labor to rest."

There was a further reason why early church fathers preached against celebrating birthdays: They considered the festivities, borrowed from the

Egyptians and the Greeks, as relics of pagan practices. In A.D. 245, when a group of early Christian historians attempted to pinpoint the exact date of Christ's birth, the Catholic Church ruled the undertaking sacrilegious, proclaiming that it would be sinful to observe the birthday of Christ "as though He were a King Pharaoh."

In the fourth century, though, the Church began to alter its attitude toward birthday celebrations—and it also commenced serious discussions to settle the date of Christ's birth. The result, of course, marked the beginning of the tradition of celebrating Christmas. (See page 67.) It was with the celebration of Christ's nativity that the Western world returned to the celebration of birthdays.

By the twelfth century, parish churches throughout Europe were recording the birth dates of women and children, and families were observing the dates with annual celebrations. Around this time, the birthday cake reemerged, now topped with candles.

Birthday Cake and Candles: Late Middle Ages, Germany

As we've seen, the custom of a birthday cake was observed for a brief time in ancient Greece. It reemerged among German peasants in the Middle Ages, and through a new kind of celebration, a *Kinderfeste,* held specifically for a young child, or *Kind.* In a sense, this marked the beginning of children's birthday parties, and in many ways a thirteenth-century German child received more attention and honor than his or her modern-day counterpart.

A *Kinderfeste* began at dawn. The birthday child was awakened by the arrival of a cake topped with lighted candles. The candles were changed and kept lit throughout the day, until after the family meal, when the cake was eaten. The number of candles totaled one more than the child's age, the additional one representing the "light of life." (Belief that the candle symbolizes life is found throughout history. Macbeth speaks of life as a "brief candle," and the proverb cautions against "burning the candle at both ends.") The birthday child also received gifts and selected the menu for the family meal, requesting his or her favorite dishes.

Our custom of making a wish and blowing out the candles also stems from the German *Kinderfeste.* Birthday candles were to be extinguished in a single breath, and the wish, if it was to come true, had to remain a secret.

German birthday lore has one custom we do not observe today: the Birthday Man, a bearded elf who brought well-behaved birthday children additional gifts. Although the Birthday Man never achieved the stature of a Santa Claus or an Easter Bunny, his image could still be purchased in the form of a German doll well into the early part of this century.

The child's birthday party began with the thirteenth-century German kinder-feste. Worship of Artemis (right), goddess of the moon, initiated the use of candles on celebratory cakes.

"Happy Birthday to You": 1893, Kentucky

This melody, regarded as the most frequently sung music in the world, was first published in an 1893 book, *Song Stories of the Kindergarten,* under the title "Good Morning to All."

Written by two sisters from Louisville, Kentucky, the tune was never intended to be sung at a birthday celebration, but was a morning classroom welcome to youngsters. Through theft, it became a birthday tradition.

Mildred Hill, who composed the song's melody, was a church organist, concert pianist, and authority on Negro spirituals. Born in Louisville in 1859, she died in Chicago at age fifty-seven, a few years before her tune received its "happy birthday" wording.

Mildred's sister, Patty Smith Hill, born in 1868, wrote the song's lyrics while principal of the Louisville Experimental Kindergarten school, where her sister taught. As one of the country's first kindergartens to apply modern methods of education to young children, the school, and the Hill sisters, were honored in an educational exhibition at the Chicago World's Fair of 1893.

With a lifelong interest in teaching children, Dr. Patty Smith Hill came to Columbia University's Teachers College in 1906. Three years later, she became head of the Department of Kindergarten Education. Though Dr. Hill was a professor emeritus at Columbia and won a host of honors before her death in New York City in 1946, she will probably always be best remembered for her contribution to "Happy Birthday to You."

The Hill sisters copyrighted their "Good Morning to All" song on October 16, 1893. But it appeared without authorization in a songbook edited by a Robert H. Coleman, and published by him in Dallas on March 4, 1924. While the song bore its original title and first-stanza lyrics, Coleman altered the second stanza's opening to read "Happy birthday to you." And through Coleman, the Hill sisters' line "Good morning, dear children" became "Happy birthday, dear [name]."

Over the next decade, the song was published several times, often with minor alterations in its lyrics. By 1933, its widely accepted title was "Happy Birthday to You." A year later, when the birthday tune was belted out nightly in a Broadway musical, *As Thousands Cheer,* a third Hill sister, Jessica, tired of the blatant theft and total absence of royalties, took the case to court. She won. The Hill family owned the melody. They were entitled to royalties every time the song was performed commercially.

Most people, worldwide, were shocked to learn that the familiar tune was copyrighted. Western Union, which had sent some half a million singing birthday greetings via telephone and singing messengers, ceased offering the selection. It was dropped from *As Thousands Cheer.* And when Broadway backers of another show, *Angel in the Wings*—which had opened with a score containing the tune—found that they would have to pay the Hill family royalties for every performance, the show's composer penned another melody. And in the later hit play *Happy Birthday,* its star, Helen Hayes, spoke the lyrics so the producers could avoid royalty payments.

Dr. Patty Smith Hill died at age seventy-eight, after a long illness, aware that she and her sister had started a modern, worldwide birthday tradition.

Death Traditions: 50,000 Years Ago, Western Asia

The earliest evidence of a funeral tradition has been traced to Western Asia's Neanderthal man, a member of our own classification, *Homo sapiens.*

Illustrations often depict the Neanderthal as a primitive creature with a heavy brow, thick, large nose, and brutish expression. Actually, many Neanderthals possessed classic European features and fair, hairless skin. From unearthed skulls, archaeologists calculate that Neanderthals had a brain capacity equivalent to our own.

Neanderthals began the practice of burying their dead with ritual funerals. They interred the deceased's body, along with food, hunting weapons, and fire charcoals, and strewed the corpse with an assortment of flowers A Neanderthal grave discovered in Shanidar, Iraq, contained the pollen of eight different flowers. Even fifty thousand years ago, man associated fire with funerals, for there is evidence of torches at Neanderthal gravesites, though their meaning remains unknown. Much later, the ancient Romans believed that flaming funeral torches guided the departed soul to its eternal abode; our word "funeral" derives from the Latin *funus,* "torch."

In addition to the word "funeral," the Romans gave us the modern

Fear of spirit possession by the dead led to the practice of wearing black at a funeral.

practice of candles at death services. Lighted candles around the body supposedly frightened away spirits eager to reanimate the corpse and take possession of it. Since the spirits' domain was darkness, they were thought to shun light.

As we are about to see, it was fear of the spirit world, more than respect for the beloved deceased, that served as the origin for most of our modern death traditions.

Black for Mourning. We say we wear black to a funeral as a sign of respect for the deceased. But it was *fear* of a dead relative, foe, or stranger that formalized black as the standard color of mourning in the Western world. The custom is ancient.

Early man believed that without continual vigilance, the spirit of the dead reentered and possessed the body of the living. Anthropological evidence suggests that primitive white men painted their bodies black at funerals to disguise themselves from spirits. And there is more recent proof, in this century and the last, of black African tribes coating their bodies the opposite color, chalk white, to evade recognition and possession by the recently deceased.

Extrapolating from black body paint, anthropologists arrive at black funeral attire—which in many societies was worn by the closest relatives of the deceased for weeks or months as protective camouflage. The veil covering a mourner's face originated from this fear. In Mediterranean countries, a widow wore a veil and black clothing for a full year to hide from her husband's prowling spirit. There is, after all, nothing intrinsically re-

36

spectful about the color black, but for a white-skinned person it is the antithetical mask.

Coffin. Our word "coffin" comes from the Greek *kophinos,* meaning "basket." It was in baskets woven of plaited twigs that the ancient Sumerians, about 4000 B.C., interred their dead. But again, it was fear of the deceased that accounted for the origin of a coffin in the first place.

In Northern Europe, drastic measures served to prevent the dead from haunting the living. Frequently, a dead man's body was bound and his feet and head were amputated. To further handicap him, en route to the gravesite a circuitous course was followed so he could not retrace the path to his former home. In many cultures, the dead were carted from the house not through the once-familiar front door, but via a hole in the wall cut out for the occasion and closed up immediately afterward.

While burial six feet underground was viewed as a good precaution, entombment first in a wooden coffin was even safer. Nailing down the lid afforded additional protection. Not only were many early coffins secured with numerous nails (far too many, archaeologists contend, merely to prevent a lid from sliding off during a procession), but once the coffin was lowered into the ground, a large, heavy stone was placed atop the lid before soil was shoveled in. A larger stone topped off the closed grave, giving birth to the practice of the **tombstone.**

Later in history, of course, relatives affectionately inscribed a family member's tombstone and respectfully visited the gravesite. But before these civilities arose, family and friends never ventured near their dead.

Hearse: 16th Century, England

A hearse was originally not a vehicle to transport the dead to a final resting place but an ancient agricultural implement—a rake. The route from rake to hearse is not straightforward.

After a Roman farmer plowed his fields, he raked the land with a *hirpex,* a triangular tool of wood or iron with spikes attached to one side. In 51 B.C., when the Romans, under Caesar, completed their conquest of Gaul, they introduced the *hirpex* (Latin for "rake") to Western Europe. Inhabitants of the British Isles called the tool a "harrow." The name changed again in the eleventh century when the Normans invaded England, giving "harrow" the pronunciation *herse.*

The conquering Normans observed that the raking device, when inverted, resembled their ecclesiastical candelabra. In time, the church's candelabra was renamed *herse,* and as additional candles were incorporated to honor a growing list of saints and to celebrate new holidays, the *herse* grew larger and larger.

The church candelabra, resting on the altar, had always been an integral part of a funeral service. The larger ones now were placed over the bier

during the services for distinguished people. By the fifteenth century, the rake's progress was such that it measured six feet long, skewered scores of candles, and was a masterpiece of craftsmanship. Now it rode on the lid of a coffin during a funeral cortege. In the next century, in England, the entire wheeled cart drawing the coffin became known as a "hearse," the later British spelling of *herse*. Thus, the agricultural rake became the funereal wheeled cart or hearse. The route from wheeled cart to limousine is far more straightforward.

It is interesting to note that the snail's pace of a funeral cortege is not only a mark of respect for the dead. It recalls earlier days, when lighted candles were a ceremonious part of a funeral march. For no matter how reverently slowly the mourners chose to stride, the solemnity of their pace was also influenced by the practical need to keep the candles burning. This pedestrians' pace still suggests a limit to the motored hearse's speed.

Hands Joined in Prayer: 9th Century, Europe

For our ancestors, one of the most ancient and reverential gestures that accompanied prayer was the spreading of arms and hands heavenward. In time, the arms were pulled in, folded across the breast, wrists intersecting above the heart. Each of these gestures possesses an intrinsic logic and obviousness of intent: God resided in the heavens; the heart was the seat of emotions.

The still later practice of joining hands in an apex seems less obvious, if not puzzling.

It is mentioned nowhere in the Bible. It appeared in the Christian Church only in the ninth century. Subsequently, sculptors and painters incorporated it into scenes that predated its origin—which, it turns out, has nothing to do with religion or worship, and owes much to subjugation and servitude.

Religious historians trace the gesture back to the act of shackling a prisoner's hands together. Although the binding vines, ropes, or handcuffs continued to serve their own law-and-order function, the joined hands came to symbolize man's submission to his creator.

Substantial historical evidence indicates that the joining of hands became a standard, widely practiced gesture long before it was appropriated and formalized by the Christian Church. Before waving a white flag signaled surrender, a captured Roman could avert immediate slaughter by affecting the shackled-hands posture.

For the early Greeks, the gesture held the magic power to bind occult spirits until they complied with a high priest's dictates. In the Middle Ages, feudal lords adopted the joining of hands as an action by which their vassals did homage and pledged fealty.

From such diverse practices, all with a common intent, Christianity assumed the gesture as a sign of man's total obedience to divine authority.

Later, many writers within the Christian Church offered, and encouraged, a more pious and picturesque origin: joined hands represented a church's pointed steeple.

Rosary: Pre–500 B.C., India

The term "rosary," meaning "wreath of roses," first appeared in fifteenth-century Europe. But the practice of reciting prayers on a string of knots or beads goes back to the Indic priests of the Middle East prior to 500 B.C. It also developed in the Western world before the dawn of Christianity—and for a very practical reason.

According to many early religions, the frequent repetition of a prayer was believed to increase its efficacy. To beseech the gods, *the* God, or a saint for deliverance from, say, a plague by reciting a prayer a hundred times was twice as effective as saying the same prayer only fifty times. Many religions prescribed the exact number of repetitions of a specific prayer. For instance, the traveling Knights of Templar, founded in the year 1119 to fight in the Crusades, could not attend regular church services and were required to recite the Lord's Prayer fifty-seven times a day; on the death of a fellow knight, the number increased to a hundred times a day for a week.

Quite simply, to count and pray simultaneously, even with the aid of the fingers, is practically impossible; assistance was required. And the rosary was the perfect memory aid. It was referred to in Sanskrit as the "remembrancer," and in European languages as the *calculi* and the *numeralia*.

For many peoples, simple memory aids sufficed: strings of fruit pits, dried berries, bones, knotted cords. Priests of the Greek Church tallied their numerous genuflections and signs of the cross with cords of a hundred knots. Wealthy people strung together precious stones, trinkets of glass, and nuggets of gold.

Europeans even referred to a knot, berry, or pit as a prayer; our word "prayer" comes from the Anglo-Saxon for "bead," *bede*, which in turn derived from *biddan*, "to ask."

In the eleventh century, the Anglo-Saxon gentlewoman Lady Godiva, famous for her tax-protesting nude ride through Coventry, England, bequeathed to a monastery "a circlet of gems which she had threaded on a string, in order that by fingering them one by one, as she successively recited her prayers, she might not fall short of the exact number."

It was in the following century that the rosary was popularized in the Catholic Church by the Spanish Saint Dominic, founder of the Friars Preachers, which evolved into the Dominican order of priests. In an apparition, the Virgin Mary asked him to preach the rosary "as a spiritual remedy against heresy and sin."

Etymologists offer two possible origins for the word "rosary" itself. Many early rosaries had beads carved of rosewood and were known as wreaths

of roses. An alternate theory holds that the linguistic origin is found in the French for "bead," *rosaire*. In many Mediterranean countries, rosaries were simply called "the beads."

Halo: Antiquity, Europe and Asia

The luminous circle of light used for centuries by artists to crown the heads of religious figures was originally not a Christian symbol but a pagan one— and was itself the origin of the royal crown.

Early writings and drawings are replete with references to nimbuses of light surrunding the heads of deities. In ancient Hindu, Indian, Greek, and Roman art, gods emit a celestial radiance about the head. Early kings, to emphasize their special relationship to a god, and the divine authority thus invested in them, adopted a crown of feathers, gems, or gold. Roman emperors, convinced of their divinity, seldom appeared in public without a symbolic orb. And the crown of thorns thrust upon Christ's head was intended as a public mockery of his heavenly kingship.

Through extensive use over time, the circle of light lost its association with pagan gods and became a valid ecclesiastical symbol in its own right for many faiths—with one notable exception. Fathers of the early Catholic Church, perspicacious of the halo's pagan roots, deliberately discouraged artists and writers from depiction or mention of celestial auras. (Illustrated manuscripts from the Middle Ages reveal the religious admonitions to have been less than one hundred percent effective.)

Historians trace the Church's gradual adoption of the halo, around the seventh century, to a prosaic, utilitarian function it served: as a kind of umbrella to protect outdoor religious statuary from precipitation, erosion, and the unsightly droppings of birds. Such haloes were large circular plates of wood or brass.

During these centuries, the halo was known by a variety of names— except "halo."

Etymologists trace the origin of the word to neither its pagan roots nor Christian recognition. Millennia before Christ, farmers threshed grain by heaping the sheaves over hard terrain and driving a team of oxen round and round over them. The circuits created a circular track, which the Greeks called a *halos,* literally "circular threshing floor." In the sixteenth century, when astronomers reinterpreted the word, applying it to the auras of refracted sunlight around celestial bodies, theologians appropriated it to describe the crown surrounding a saint's head.

Thus, as one modern religious historian observes, "The halo combines traditions of Greek farming, the Roman deification of megalomaniac rulers, medieval astronomy and an early protective measure against dirt and inclement weather."

Amen: 2500 B.C., Egypt

One of the most familiar and frequently used of all religious words, "amen" appears in both early Christian and Moslem writings. The word makes thirteen appearances in the Hebrew Bible; 119 in the New Testament.

To the Hebrews, the word meant "so it is"—expressing assent or agreement, and also signifying truth. Thus, a Hebrew scholar terminating a speech or sermon with "amen" assured his audience that his statements were trustworthy and reliable.

The word originated in Egypt, around 2500 B.C. To the Egyptians, *Amun* meant "the hidden one" and was the name of their highest deity, at one time worshiped throughout the Middle East. As later cultures invoked the god Jupiter with the exclamation "By Jove!" the Egyptians called on their deity: "By Amun!" It was the Hebrews who adopted the word, gave it a new meaning, and passed it on to the Christians.

The origins of other common religious words:

Pew. To draw an analogy with a 1960s civil rights issue, a pew was originally the church's equivalent of the front of the bus.

Our designation of the long seats found in many churches comes from the French *puie,* meaning "raised place" or "balcony." The French word, in turn, originated from the Latin *podium,* an amphitheater's balcony reserved for prominent families and royalty.

In colonial America, the European tradition was continued. Certain church seats were cordoned off so Christian families of stature could appreciate sermons on the equality of mankind without having to mix with families of lesser stature. These segregated rows were called "pews." As the ropes gradually yielded to a doctrine of democracy, the term "pew" came to apply to all rows in a church.

Reverend. The word has been associated with clergymen since the seventeenth century in England. The designation, from the Latin *reverendus,* meaning "worthy of respect," was given by British townspeople to their local minister as a gesture of respect for his spiritual leadership.

Pastor. From the Latin for "shepherd," since a minister traditionally has been viewed as the shepherd of his flock. Christ often referred to himself as the "Good Shepherd," willing to lay down his life for his sheep.

Parson. In colonial America, farmers had little time for education. If they needed certain book information, they turned to the one person in the region esteemed for his formal learning: the minister. Reverently, he was referred to as "the town person," which when spoken with a heavy New England accent became "the town parson."

41

Evangelist. The term comes from the Greek *evangelion,* meaning "welcome message," for the traveling preacher was regarded as God's messenger, the bearer of good news.

The four writers of the Gospels—Matthew, Mark, Luke, and John—were known as the Four Evangelists. Later, the term was applied to the religious circuit riders who traveled on horseback to their assigned churches in the western frontier of the United States during the 1890s.

Monsignor. The term derives from *monseigneur,* French for "my lord."

Monk. From the Latin *monachus,* meaning "one who lives alone." Many of the oldest historical records, sacred and secular, are writings of monks, who were among the relatively few learned people of the Dark Ages.

Abbot. When Christ prayed to Almighty God, he referred to him as "abba," which comes from the Hebrew *Ab,* meaning "Father." St. Paul, emphasizing the theme, urged Christians to employ the term when addressing the Lord. Gradually, the head of a monastery was addressed as "Abbot," to signify that he was the monks' spiritual father.

Nun. In Sanskrit, *nana* meant "mother"; in Latin, *nonna* was "child's nurse"; in Greek, *nanna* was "aunt"; and the Coptic word *nane* meant "good." All precursors of "nun," they say much about the vocation itself. The word for the nun's traditional garb, the "habit," is derived from the Latin *habitus,* meaning "appearance" or "dress."

Vicar. The term comes from the same root as the word "vicarious," and it connotes a "substitute" or "representative." Vicars are Christ's representatives on earth, and the Pope bears the title "Vicar of Christ."

The word "**pontiff**" stems from the Latin *pontifex,* meaning "bridge builder," for one of the pontiff's principal functions is to build a bridge between God and humankind.

The word "**see,**" as in "Holy See," is a corruption of the Latin *sedes,* meaning "seat." It refers to the official headquarters (or seat) of the bishop of Rome, the highest level of church authority. The Pope's residence was known as the "Holy Seat," or "Holy See."

Handshake: 2800 B.C., Egypt

In its oldest recorded use, a handshake signified the conferring of power from a god to an earthly ruler. This is reflected in the Egyptian verb "to give," the hieroglyph for which was a picture of an extended hand.

In Babylonia, around 1800 B.C., it was required that the king grasp the

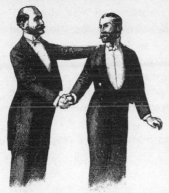

The handshake once symbolized the transferral of authority from a god to a king. A fifteenth-century woodcut combines the musical tones "so" and "la" with Latin words to form Sola fides sufficit, *suggesting good faith is conveyed through a handshake.*

hands of a statue of Marduk, the civilization's chief deity. The act, which took place annually during the New Year's festival, served to transfer authority to the potentate for an additional year. So persuasive was the ceremony that when the Assyrians defeated and occupied Babylonia, subsequent Assyrian kings felt compelled to adopt the ritual, lest they offend a major heavenly being. It is this aspect of the handshake that Michelangelo so magnificently depicted on the ceiling of the Sistine Chapel.

Folklore offers an earlier, more speculative origin of the handshake: An ancient villager who chanced to meet a man he didn't recognize reacted automatically by reaching for his dagger. The stranger did likewise, and the two spent time cautiously circling each other. If both became satisfied that the situation called for a parley instead of a fight to the death, daggers were reinserted into their sheaths, and right hands—the weapon hands—were extended as a token of goodwill. This is also offered as the reason why women, who throughout history were never the bearers of weapons, never developed the custom of the handshake.

Other customs of greeting have ancient origins:

The gentlemanly practice of **tipping one's hat** goes back in principle to ancient Assyrian times, when captives were required to strip naked to demonstrate subjugation to their conquerors. The Greeks required new servants to strip from the waist up.

Removing an article of clothing became a standard act of respect. Romans approached a holy shrine only after taking their sandals off. And a person of low rank removed his shoes before entering a superior's home—a custom the Japanese have brought, somewhat modified, into modern times. In England, women took off their gloves when presented to royalty. In fact,

two other gestures, one male, one female, are remnants of acts of subjugation or respect: the **bow** and the **curtsy;** the latter was at one time a full genuflection.

By the Middle Ages in Europe, the symbol of serfdom to a feudal lord was restricted to baring the head. The implicit message was the same as in earlier days: "I am your obedient servant." So persuasive was the gesture that the Christian Church adopted it, requiring that men remove their hats on entering a church.

Eventually, it became standard etiquette for a man to show respect for an equal by merely tipping his hat.

Chapter 3

On the Calendar

New Year's Day: 2000 B.C., Babylonia

Our word "holiday" comes from the Middle English *halidai,* meaning "holy day," for until recently, humankind's celebrations were of a religious nature.

New Year's Day is the oldest and most universal of all such "holy day" festivals. Its story begins, oddly enough, at a time when there was as yet no such thing as a calendar year. The time between the sowing of seeds and the harvesting of crops represented a "year," or cycle.

The earliest recorded New Year's festival was staged in the city of Babylon, the capital of Babylonia, whose ruins stand near the modern town of al-Hillah, Iraq. The new year was celebrated late in March, at the vernal equinox, when spring begins, and the occasion lasted eleven days. Modern festivities pale by comparison. Initiating events, a high priest, rising two hours before dawn, washed in the sacred water of the Euphrates, then offered a hymn to the region's chief god of agriculture, Marduk, praying for a bountiful new cycle of crops. The rump of a beheaded ram was rubbed against the temple walls to absorb any contagion that might infest the sacred edifice and, by implication, the next year's harvest. The ceremony was called *kuppuru*—a word that appeared among the Hebrews at about the same time, in their Day of Atonement festival, Yom Kippur.

Food, wine, and hard liquor were copiously consumed—for the enjoyment they provided, but more important, as a gesture of appreciation to Marduk for the previous year's harvest. A masked mummers' play was enacted on the sixth day, a tribute to the goddess of fertility. It was followed

A high priest presiding over a New Year's celebration, once a religious observance staged in spring to mark the start of a new agricultural season. Julius Caesar moved the holiday to the dead of winter.

by a sumptuous parade—highlighted by music, dancing, and costumes—starting at the temple and terminating on the outskirts of Babylon at a special building known as the New Year House, whose archaeological remains have been excavated.

How New Year's Day, essentially a seed-sowing occasion, shifted from the start of spring to the dead of winter is a strange, convoluted tale spanning two millennia.

From both an astronomical and an agricultural standpoint, January is a perverse time for symbolically beginning a crop cycle, or new year. The sun stands at no fiduciary place in the sky—as it does for the spring and autumn equinoxes and the winter and summer solstices, the four solar events that kick off the seasons. The holy day's shift began with the Romans.

Under an ancient calendar, the Romans observed March 25, the beginning of spring, as the first day of the year. Emperors and high-ranking officials, though, repeatedly tampered with the length of months and years to extend their terms of office. Calendar dates were so desynchronized with astronomical benchmarks by the year 153 B.C. that the Roman senate, to set many public occasions straight, declared the start of the new year as January 1. More tampering again set dates askew. To reset the calendar to January 1 in 46 B.C., Julius Caesar had to let the year drag on for 445 days, earning it the historical sobriquet "Year of Confusion." Caesar's new calendar was

46

eponymously called the Julian calendar.

After the Roman conversion to Christianity in the fourth century, emperors continued staging New Year's celebrations. The nascent Catholic Church, however, set on abolishing all pagan (that is, non-Christian) practices, condemned these observances as scandalous and forbade Christians to participate. As the Church gained converts and power, it strategically planned its own Christian festivals to compete with pagan ones—in effect, stealing their thunder. To rival the January 1 New Year's holiday, the Church established its own January 1 holy day, the Feast of Christ's Circumcision, which is still observed by Catholics, Lutherans, Episcopalians, and many Eastern Orthodox sects.

During the Middle Ages, the Church remained so strongly hostile to the old pagan New Year's that in predominantly Catholic cities and countries the observance vanished altogether. When it periodically reemerged, it could fall practically anywhere. At one time during the high Middle Ages—from the eleventh to the thirteenth centuries—the British celebrated New Year's on March 25, the French on Easter Sunday, and the Italians on Christmas Day, then December 15; only on the Iberian peninsula was it observed on January 1.

It is only within the past four hundred years that January 1 has enjoyed widespread acceptance.

New Year's Eve. From ancient times, this has been the noisiest of nights.

For early European farmers, the spirits who destroyed crops with disease were banished on the eve of the new year with a great wailing of horns and beating of drums. In China, the forces of light, the Yang, annually routed the forces of darkness, the Yin, when on New Year's Eve people gathered to crash cymbals and explode firecrackers. In America, it was the seventeenth-century Dutch, in their New Amsterdam settlement, who originated our modern New Year's Eve celebration—though the American Indians may have set them a riotous example and paved the way.

Long before settlers arrived in the New World, New Year's Eve festivities were observed by the Iroquois Indians, pegged to the ripening of the corn crop. Gathering up clothes, furnishings, and wooden household utensils, along with uneaten corn and other grains, the Indians tossed these possessions of the previous year into a great bonfire, signifying the start of a new year and a new life. It was one ancient act so literal in its meaning that later scholars did not have to speculate on its significance.

Anthropologist Sir James Frazer, in *The Golden Bough*, described other, somewhat less symbolic, New Year's Eve activities of the Iroquois: "Men and women, variously disguised, went from wigwam to wigwam smashing and throwing down whatever they came across. It was a time of general license; the people were supposed to be out of their senses, and therefore not to be responsible for what they did."

The American colonists witnessed the annual New Year's Eve anarchy of

47

the Indians and were not much better behaved themselves, though the paucity of clothes, furnishings, and food kept them from lighting a Pilgrims' bonfire. On New Year's Eve 1773, festivities in New York City were so riotous that two months later, the legislature outlawed firecrackers, home-made bombs, and the firing of personal shotguns to commemorate all future starts of a new year.

Mummers' Parade. Bedecked in feathered plumes and strutting to the tune "Oh, Dem Golden Slippers," the Mummers make their way through the streets of Philadelphia, led by "King Momus," traditional leader of the parade. This method of welcoming in the New Year is of English, Swedish, and German derivation.

Modern mumming is the European practice of going from house to house dressed in costumes and presenting plays for money or treats. As the practice developed in eighteenth-century England and Ireland, a masked man, designated the "champion" (in ancient mumming rites, the "god"), is slain in a mock fight, then resurrected by a masked "doctor" (originally, "high priest"). The ancient mumming ceremony, staged in spring, symbolized the rebirth of crops, and its name comes from the Greek *mommo,* meaning "mask."

The Swedes adopted British mumming. And they enriched it with the German New Year's tradition of a street festival, marching bands, and the pagan practice of parading in animal skins and feathers. The Swedes who settled along the Delaware River established the practice in America, which in Philadelphia turned into the spectacular Mummers' Day Parade.

Tournament of Roses. This famous Pasadena, California, parade was started on January 1, 1886, by the local Valley Hunt Club. Members decorated their carriages with flowers, creating what the club's charter described as "an artistic celebration of the ripening of the oranges in California." (The intent is not dissimilar to that of the ancient Babylonians, who marked the new year with a parade and the sowing of seeds.) In the afternoon, athletic events were staged.

The Rose Bowl football game became part of the festivities in 1902, but the following year, chariot races (a Roman New Year's event) provided the main sports thrills. It wasn't until 1916 that the football game returned, to become the annual attraction. Since then, New Year's parades, parties, pageants, and bowl games have proliferated and occupy a large share of today's celebrations—the very kinds of secular events that for centuries equated celebrating New Year's with sinning.

New Year's Resolutions. Four thousand years ago, the ancient Babylonians made resolutions part of their New Year's celebrations. While two of the most popular present-day promises might be to lose weight and to quit

The lore of a groundhog (left) predicting the start of spring began in Germany where the forecasting animal was actually a badger (right).

smoking, the Babylonians had their own two favorites: to pay off outstanding debts and to return all borrowed farming tools and household utensils.

New Year's Baby. The idea of using an infant to symbolize the start of a new cycle began in ancient Greece, about 600 B.C. It was customary at the festival of Dionysus, god of wine and general revelry, to parade a babe cradled in a winnowing basket. This represented the annual rebirth of that god as the spirit of fertility. In Egypt, a similar rebirth ceremony was portrayed on the lid of a sarcophagus now in a British museum: Two men, one old and bearded, the other in the fitness of youth, are shown carrying an infant in a winnowing basket.

So common was the symbol of the New Year's babe in Greek, Egyptian, and Roman times that the early Catholic Church, after much resistance, finally allowed its members to use it in celebrations—if celebrators acknowledged that the infant was not a pagan symbol but an effigy of the Christ Child.

Our modern image of a baby in a diaper with a New Year's banner across its chest originated in Germany in the fourteenth century. Celebrated in folk songs and illustrations of the day, the diapered tot was brought to America by German immigrants.

Groundhog Day: 16th Century, Germany

Horniness and hunger are the actual elements that determine a groundhog's behavior when it emerges in winter from months of hibernation.

Quite simply, if on awakening a groundhog is sexually aroused and famished, he'll stay aboveground and search for a mate and a meal. If, on the other hand, these appetites are still dulled from his winter torpor, he'll return to his burrow for a six-week doze. Weather has nothing to do with it.

As to the folklore concerning the animal's seeing his shadow, that orig-

49

inated with sixteenth-century German farmers. And the original animal of German legend was not a groundhog—a fifteen-inch-long woodchuck, *Marmota monax*, with coarse red-brown fur. Rather, it was a badger, a sixteen-to-twenty-eight-inch-long, broad-backed, carnivorous mammal of the genera *Taxidea* and *Meles*, with thick, short legs, and long claws on its forefeet.

The switch from badger to groundhog did not result from mistaken identity. German immigrants who settled in the nineteenth century in Punxsutawney, Pennsylvania—a small town in the heart of the Allegheny plateau, eighty-five miles northeast of Pittsburgh—found that the area had no badgers. It did, however, have hordes of groundhogs, which the immigrants conveniently fitted to their folklore.

Weather did come to play one key role in the legend:

At Punxsutawney's latitude, a groundhog emerges from its hibernating burrow in February. Had the immigrants settled a few states south, where it's warmer, they would have found the groundhog waking and coming aboveground in January; in the upper Great Lakes region, the cold delays his appearance until March. Thus, it was the latitude at which the German immigrants settled that set Groundhog Day as February 2.

German folklore dictated that if the day was sunny and the groundhog (badger) was frightened by his shadow back into hibernation, then farmers should refrain from planting crops, since there would be another six weeks of winter weather. Scientific studies have dashed that lore. The groundhog's accuracy in forecasting the onset of spring, observed over a sixty-year period, is a disappointing 28 percent—though, in fairness to the groundhog, the figure is no worse than the estimate of a modern weatherman.

St. Valentine's Day: 5th Century, Rome

The Catholic Church's attempt to paper over a popular pagan fertility rite with the clubbing death and decapitation of one of its own martyrs is the origin of this lovers' holiday.

As early as the fourth century B.C., the Romans engaged in an annual young man's rite of passage to the god Lupercus. The names of teenage women were placed in a box and drawn at random by adolescent men; thus, a man was assigned a woman companion, for their mutual entertainment and pleasure (often sexual), for the duration of a year, after which another lottery was staged. Determined to put an end to this eight-hundred-year-old practice, the early church fathers sought a "lovers' " saint to replace the deity Lupercus. They found a likely candidate in Valentine, a bishop who had been martyred some two hundred years earlier.

In Rome in A.D. 270, Valentine had enraged the mad emperor Claudius II, who had issued an edict forbidding marriage. Claudius felt that married men made poor soldiers, because they were loath to leave their families for battle. The empire needed soldiers, so Claudius, never one to fear unpopularity, abolished marriage.

Valentine, bishop of Interamna, invited young lovers to come to him in secret, where he joined them in the sacrament of matrimony. Claudius learned of this "friend of lovers," and had the bishop brought to the palace. The emperor, impressed with the young priest's dignity and conviction, attempted to convert him to the Roman gods, to save him from otherwise certain execution. Valentine refused to renounce Christianity and imprudently attempted to convert the emperor. On February 24, 270, Valentine was clubbed, stoned, then beheaded.

History also claims that while Valentine was in prison awaiting execution, he fell in love with the blind daughter of the jailer, Asterius. Through his unswerving faith, he miraculously restored her sight. He signed a farewell message to her "From Your Valentine," a phrase that would live long after its author died.

From the Church's standpoint, Valentine seemed to be the ideal candidate to usurp the popularity of Lupercus. So in A.D. 496, a stern Pope Gelasius outlawed the mid-February Lupercian festival. But he was clever enough to retain the lottery, aware of Romans' love for games of chance. Now into the box that had once held the names of available and willing single women were placed the names of saints. Both men and women extracted slips of paper, and in the ensuing year they were expected to emulate the life of the saint whose name they had drawn. Admittedly, it was a different game, with different incentives; to expect a woman and draw a saint must have disappointed many a Roman male. The spiritual overseer of the entire affair was its patron saint, Valentine. With reluctance, and the passage of time, more and more Romans relinquished their pagan festival and replaced it with the Church's holy day.

Valentine Cards. Traditionally, mid-February was a Roman time to meet and court prospective mates. The Lupercalia had established the practice. While no one reinstated the Lupercian lottery (under penalty of mortal sin), Roman young men did institute the custom of offering women they admired and wished to court handwritten greetings of affection on February 14. The cards acquired St. Valentine's name.

As Christianity spread, so did the Valentine's Day card. The earliest extant card was sent in 1415 by Charles, duke of Orleans, to his wife while he was a prisoner in the Tower of London. It is now in the British Museum.

In the sixteenth century, St. Francis de Sales, bishop of Geneva, attempted to expunge the custom of cards and reinstate the lottery of saints' names. He felt that Christians had become wayward and needed models to emulate. However, this lottery was less successful and shorter-lived than Pope Gelasius's. And rather than disappearing, cards proliferated and became more decorative. **Cupid,** the naked cherub armed with arrows dipped in love potion, became a popular valentine image. He was associated with the holiday because in Roman mythology he is the son of Venus, goddess of love and beauty.

The earliest extant Valentine's Day card, c. 1415, sent by Charles, duke of Orleans, to his wife while he was imprisoned in the Tower of London.

By the seventeenth century, handmade cards were oversized and elaborate, while store-bought ones were smaller and costly. In 1797, a British publisher issued "The Young Man's Valentine Writer," which contained scores of suggested sentimental verses for the young lover unable to compose his own. Printers had already begun producing a limited number of cards with verses and sketches, called "mechanical valentines," and a reduction in postal rates in the next century ushered in the less personal but easier practice of mailing valentines. That, in turn, made it possible for the first time to exchange cards anonymously, which is taken as the reason for the sudden appearance of racy verse in an era otherwise prudishly Victorian. The burgeoning number of obscene valentines caused several countries to ban the practice of exchanging cards. In Chicago, for instance, late in the nineteenth century, the post office rejected some twenty-five thousand cards on the ground that they were not fit to be carried through the U.S. mail.

The first American publisher of valentines was printer and artist Esther Howland. Her elaborate lace cards of the 1870s cost from five to ten dollars, with some selling for as much as thirty-five dollars. Since that time, the valentine card business has flourished. With the exception of Christmas, Americans exchange more cards on Valentine's Day than at any other time of year.

XXX for Kisses. Lovers who affectionally sign "XXX"s to valentine cards and letters are usually unaware that the custom goes back to the early

52

Christian era, when a cross mark, or "X," conveyed the force of a sworn oath.

The cross was, of course, a religious symbol. Not only did it refer to the cross of Calvary; it also was the first letter of the Greek word for Christ, *Xristos.*

In the days when few people could write, their signature cross, or "X," was a legally valid mark. To emphasize their complete sincerity in an accord, they often kissed the mark, as a Bible was frequently kissed when an oath was sworn upon it.

It was this practice of kissing the "X" that led to its becoming a symbol of a kiss. During World War II, the British and American governments both forbade men in the armed forces from putting "XXX"s on their letters, afraid that spies within the services might begin sending clandestine messages coded as kisses.

St. Patrick's Day: A.D. 493, Ireland

Patrick, patron saint of Ireland, was born in either Scotland, England, Wales, or France, but definitely not in Ireland. His given name was not Patrick but Maewyn. Or Succat. He barely became bishop of Ireland, because his superiors felt he lacked the finesse and scholarship the position called for. Nonetheless, he did do something that made him a saint and merited him a holy day—now more of a holiday.

Many facts about Patrick have been distorted under the weight of Irish folklore.

He was born about A.D. 385, most likely in a small village near the mouth of the Severn River in what is now Wales. The region was part of the vast Roman Empire. He was by the locale of his birth Romano-Briton, by parentage a Roman Catholic; by his own later admission, until age sixteen he was covetous, licentious, materialistic, and generally heathen.

When he was sixteen, a group of Irish marauders raided his village and carried off Patrick and hundreds of other young men and women to be sold as slaves. For six years, he toiled as a sheepherder in County Antrim, Ireland, and it was during this period of slavery and solitude that he felt an increasing awareness of God. One of his two published works, *Confession,* in which he renounces his heathen bent, begins: "I, Patrick, a sinner, the most rustic and the least of all the faithful . . ."

Escaping Ireland and slavery, he spent a dozen idyllic, studious years at a monastery in Gaul under the tutelage of St. Germain, bishop of Auxerre. Germain instilled in Patrick the desire to convert pagans to Christianity.

As a priest, Patrick planned to return to pagan Ireland as its first bishop. But his monastery superiors felt that the position should be filled by someone with more tact and learning. They chose St. Palladius. Patrick importuned for two years, until Palladius transferred to Scotland. By the time he was

appointed Ireland's second bishop, he had already adopted the Christian name Patrick.

His imposing presence, unaffected manner, and immensely winning personality aided him in winning converts, which aggravated Celtic Druid priests. A dozen times they arrested him, and each time he escaped. Eventually, he traveled throughout Ireland, founding monasteries, schools, and churches, which would in time transform the non-Christian country into the Church's proud "Isle of Saints."

After thirty years of exemplary missionary work, Patrick retired to Saul in County Down, where he died on March 17, his commemorated "death day," in or about the year 461. He is believed to be buried in Downpatrick, and many pilgrims each year visit a local tombstone, carved with a "P," which may or may not mark his grave.

Shamrock. Among the less authenticated lore surrounding St. Patrick are the tales that he raised people from the dead and kindled fire from snow, and that from a hilltop he delivered a sermon that drove the snakes from Ireland.

However, one of the more historically cogent stories concerning St. Patrick explains how the shamrock came to be associated with the celebration of his holy day.

One central church doctrine Patrick repeatedly preached to converts was that of the Trinity: the belief that three Gods—the Father, the Son, and the Holy Ghost—coexist in a single entity but are nonetheless separate and distinct. Once, struggling in a sermon to convey the complexity by way of analogy, Patrick glanced to the ground and spotted a three-leafed shamrock. Holding up the herb, he asked his audience to imagine the three leaves as representing the Father, Son, and Holy Ghost, and the stem as the single Godhead from which they proceeded. In homage, after Patrick's death, his converts wore a shamrock as a religious symbol on his feast day.

The first public celebration of St. Patrick's Day in America was in 1737, sponsored by the Charitable Irish Society of Boston. Oddly enough, the society was a Protestant organization, founded that year to assist ill, homeless, and unemployed Irishmen.

Fifth Avenue Parade. The largest of all worldwide St. Patrick's Day parades is the one up New York City's Fifth Avenue. It began in 1762 as a proud display of Irish heritage, when the city was still confined to the lower tip of the island.

As the city spread uptown, the parade followed, higher and higher, until at one time it ran as far north as the area that is now Harlem. Over two hundred thousand people annually have taken part in this enormous showing of the green, a number that would have delighted the parade's original organizers, Irish veterans of the Revolutionary War. For the group, com-

posed of both Catholics and Presbyterians, conceived the parade as a defiant public display against "nutty people who didn't like the Irish very much." They took to the streets to "show how many there were of them."

Easter: 2nd Century, Rome

Easter, which in the Christian faith commemorates the Resurrection of Christ and consequently is the most sacred of all holy days, is also the name of an ancient Saxon festival and of the pagan goddess of spring and off-spring, Eastre. How a once tumultuous Saxon festival to Eastre was transformed into a solemn Christian service is another example of the supreme authority of the Church early in its history.

Second-century Christian missionaries, spreading out among the Teutonic tribes north of Rome, encountered numerous heathen religious observances. Whenever possible, the missionaries did not interfere too strongly with entrenched customs. Rather, quietly—and often ingeniously—they attempted to transform pagan practices into ceremonies that harmonized with Christian doctrine. There was a very practical reason for this. Converts publicly partaking in a Christian ceremony—and on a day when no one else was celebrating—were easy targets for persecution. But if a Christian rite was staged on the same day as a long-observed heathen one, and if the two modes of worship were not glaringly different, then the new converts might live to make other converts.

The Christian missionaries astutely observed that the centuries-old festival to Eastre, commemorated at the start of spring, coincided with the time of year of their own observance of the miracle of the Resurrection of Christ. Thus, the Resurrection was subsumed under the protective rubric Eastre (later spelled Easter), saving the lives of countless Christians.

For several decades, Easter was variously celebrated on a Friday, Saturday, or Sunday. Finally, in A.D. 325, the Council of Nicaea, convened by the emperor Constantine, issued the so-called Easter Rule: Easter should be celebrated on "the first Sunday after the first full moon on or after the vernal equinox." Consequently, Easter is astronomically bound never to fall earlier than March 22 or later than April 25.

At this same council, Constantine decreed that the cross be adopted as the official symbol of the Christian religion.

Easter Bunny. That a rabbit, or more accurately a hare, became a holiday symbol can be traced to the origin of the word "Easter." According to the Venerable Bede, the English historian who lived from 672 to 735, the goddess Eastre was worshiped by the Anglo-Saxons through her earthly symbol, the hare.

The custom of the Easter hare came to America with the Germans who immigrated to Pennsylvania in the eighteenth and nineteenth centuries.

From Pennsylvania, they gradually spread out to Virginia, North and South Carolina, Tennessee, New York, and Canada, taking their customs with them. Most eighteenth-century Americans, however, were of more austere religious denominations, such as Quaker, Presbyterian, and Puritan. They virtually ignored such a seemingly frivolous symbol as a white rabbit. More than a hundred years passed before this Teutonic Easter tradition began to gain acceptance in America. In fact, it was not until after the Civil War, with its legacy of death and destruction, that the nation as a whole began a widespread observance of Easter itself, led primarily by Presbyterians. They viewed the story of resurrection as a source of inspiration and renewed hope for the millions of bereaved Americans.

Easter Eggs. Only within the last century were chocolate and candy eggs exchanged as Easter gifts. But the springtime exchanging of *real* eggs—white, colored, and gold-leafed—is an ancient custom, predating Easter by many centuries.

From earliest times, and in most cultures, the egg signified birth and resurrection.

The Egyptians buried eggs in their tombs. The Greeks placed eggs atop graves. The Romans coined a proverb: *Omne vivum ex ovo,* "All life comes from an egg." And legend has it that Simon of Cyrene, who helped carry Christ's cross to Calvary, was by trade an egg merchant. (Upon returning from the crucifixion to his produce farm, he allegedly discovered that all his hens' eggs had miraculously turned a rainbow of colors; substantive evidence for this legend is weak.) Thus, when the Church started to celebrate the Resurrection, in the second century, it did not have to search far for a popular and easily recognizable symbol.

In those days, wealthy people would cover a gift egg with gilt or gold leaf, while peasants often dyed their eggs. The tinting was achieved by boiling the eggs with certain flowers, leaves, logwood chips, or the cochineal insect. Spinach leaves or anemone petals were considered best for green; the bristly gorse blossom for yellow; logwood for rich purple; and the body fluid of the cochineal produced scarlet.

In parts of Germany during the early 1880s, Easter eggs substituted for birth certificates. An egg was dyed a solid color, then a design, which included the recipient's name and birth date, was etched into the shell with a needle or sharp tool. Such Easter eggs were honored in law courts as evidence of identity and age.

Easter's most valuable eggs were hand crafted in the 1880s. Made by the great goldsmith Peter Carl Fabergé, they were commissioned by Czar Alexander III of Russia as gifts for his wife, Czarina Maria Feodorovna. The first Fabergé egg, presented in 1886, measured two and a half inches long and had a deceptively simple exterior. Inside the white enamel shell, though, was a golden yolk, which when opened revealed a gold hen with ruby eyes. The hen itself could be opened, by lifting the beak, to expose a

Easter egg rolling in Germany (left); Easter procession in Holland. Once a pagan feast honoring Eastre, *goddess of spring and offspring, it later came to represent the Resurrection of Christ.*

tiny diamond replica of the imperial crown. A still smaller ruby pendant hung from the crown. The Fabergé treasures today are collectively valued at over four million dollars. Forty-three of the fifty-three eggs known to have been made by Fabergé are now in museums and private collections.

Hot Cross Buns. Traditionally eaten at Easter, the twice-scored biscuits were first baked by the Saxons in honor of Eastre. The word "bun" itself derives from *boun*, Saxon for "sacred ox," for an ox was sacrificed at the Eastre festival, and the image of its horns was carved into the celebratory cakes.

The Easter treat was widespread in the early Western world. "Hot cross buns" were found preserved in the excavations at the ancient city of Herculaneum, destroyed in A.D. 79 along with Pompeii by the eruption of Mount Vesuvius.

Early church fathers, to compete with the pagan custom of baking ox-marked cakes, used in numerous celebrations, baked their own version, employing the dough used for the consecrated host. Reinterpreting the ox-horn image as a crucifix, they distributed the somewhat-familiar-looking buns to new converts attending mass. In this way, they accomplished three

objectives: Christianized a pagan cake; gave the people a treat they were accustomed to; and subtly scored the buns with an image that, though decidedly Catholic, at a distance would not dangerously label the bearer "Christian." The most desirable image on today's hot cross buns is neither an ox horn nor a cross, but broad smears of glazed frosting.

April Fool's Day: 1564, France

Many different explanations have been offered for the origins of April Fool's Day, some as fanciful as April Fool jokes themselves.

One popular though unlikely explanation focuses on the fool that Christ's foes intended to make of him, sending him on a meaningless round of visits to Roman officials when his fate had already been sealed. Medieval mystery plays frequently dramatized those events, tracing Christ's journey from Annas to Caiaphas to Pilate to Herod, then back again to Pilate. (Interestingly, many cultures have a practice, predating Christianity, that involves sending people on "fool's errands.")

The most convincing historical evidence suggests that April Fooling originated in France under King Charles IX.

Throughout France in the early sixteenth century, New Year's Day was observed on March 25, the advent of spring. The celebrations, which included exchanging gifts, ran for a week, terminating with dinners and parties on April 1.

In 1564, however, in beginning the adoption of the reformed, more accurate Gregorian calendar, King Charles proclaimed that New Year's Day be moved back to January 1. Many Frenchmen who resisted the change, and others who merely forgot about it, continued partying and exchanging gifts during the week ending April 1. Jokers ridiculed these conservatives' steadfast attachment to the old New Year's date by sending foolish gifts and invitations to nonexistent parties. The butt of an April Fool's joke was known as a *poisson d'Avril,* or "April fish" (because at that time of year the sun was leaving the zodiacal sign of Pisces, the fish). In fact, all events occurring on April 1 came under that rubric. Even Napoleon I, emperor of France, was nicknamed "April fish" when he married his second wife, Marie-Louise of Austria, on April 1, 1810.

Years later, when the country was comfortable with the new New Year's date, Frenchmen, fondly attached to whimsical April Fooling, made the practice a tradition in its own right. It took almost two hundred years for the custom to reach England, from which it came to America.

Mother's Day: 1908, Grafton, West Virginia

Though the idea of setting aside a day to honor mothers might seem to have ancient roots, our observance of Mother's Day is not quite a century old. It originated from the efforts of a devoted daughter who believed that

grown children, preoccupied with their own families, too often neglect their mothers.

That daughter, Miss Anna Jarvis, a West Virginia schoolteacher, set out to rectify the neglect.

Born in 1864, Anna Jarvis attended school in Grafton, West Virginia. Her close ties with her mother made attending Mary Baldwin College, in Stanton, Virginia, difficult. But Anna was determined to acquire an education. Upon graduation, she returned to her hometown as a certified public school teacher.

The death of her father in 1902 compelled Anna and her mother to live with relatives in Philadelphia. Three years later, her mother died on May 9, leaving Anna grief-stricken. Though by every measure she had been an exemplary daughter, she found herself consumed with guilt for all the things she had not done for her mother. For two years these naggings germinated, bearing the fruit of an idea in 1907. On the second Sunday in May, the anniversary of her mother's death, Anna Jarvis invited a group of friends to her Philadelphia home. Her announced idea—for an annual nationwide celebration to be called Mother's Day—met with unanimous support. She tested the idea on others. Mothers felt that such an act of recognition was long overdue. Every child concurred. No father dissented. A friend, John Wanamaker, America's number one clothing merchant, offered financial backing.

Early in the spring of 1908, Miss Jarvis wrote to the superintendent of Andrews Methodist Sunday School, in Grafton, where her mother had taught a weekly religion class for twenty years. She suggested that the local church would be the ideal location for a celebration in her mother's honor. By extension, all mothers present would receive recognition.

So on May 10, 1908, the first Mother's Day service was held in Grafton, West Virginia, attended by 407 children and their mothers. The minister's text was, appropriately, John 19, verses 26 and 27, Christ's parting words to his mother and a disciple, spoken from the cross: "Woman, behold thy son!" and "Behold thy Mother!"

At the conclusion of that service, Miss Jarvis presented each mother and child with a flower: a **carnation,** her own mother's favorite. It launched a Mother's Day tradition.

To suggest that the idea of an annual Mother's Day celebration met with immediate public acceptance is perhaps an understatement. Few proposed holidays have had so much nationwide support, so little special-interest-group dissension. The House of Representatives quickly passed a Mother's Day resolution. However, one Midwestern senator came off like Simon Legree. "Might as well have a Father's Day," the Congressional Record states. "Or a Mother-in-Law's Day. Or an Uncle's Day." The resolution stalled in the Senate.

A determined Anna Jarvis then began what has been called one of the most successful one-person letter-writing campaigns in history. She con-

tacted congressmen, governors, mayors, newspaper editors, ministers, and business leaders throughout the country, everyone of importance who would listen. Listen they did, responding with editorials, sermons, and political orations. Villages and towns, cities and states, began unofficial Mother's Day observances. By 1914, to dissent on the Mother's Day issue seemed not only cynical but un-American. Finally, the Senate approved the legislation, and on May 8, 1914, President Woodrow Wilson signed a proclamation designating the second Sunday in May as Mother's Day.

Although the British had long paid tribute to mothers on the fourth Sunday of the Lenten season, known as "Mothering Sunday," it took the American observance to give the idea worldwide prominence. Within a few years after President Wilson's proclamation, almost every country had a Mother's Day. By every measure, though, the United States outdoes all the others. On Mother's Day, Americans now purchase 10 million bouquets of flowers, exchange 150 million greeting cards, and dine at restaurants more than at any other time of the year. A third of all American families take Mother out to dinner on her day.

Though Anna Jarvis triumphed in her campaign for a Mother's Day, her personal life did not have a happy ending. Disillusioned by a disastrous love affair, she vowed never to marry and, childless, came to view each Mother's Day as a painful personal mockery. And as commercialization encroached upon what had been intended as a religious observance, she became litigious, initiating lawsuits against companies seeking to profit from Mother's Day. The suits failed, and Anna Jarvis became a recluse. Within a short time, she exhausted her savings and lost her family home; a blind sister, Elsinore, to whom she had devoted her life, died. These misfortunes undermined her own health, and in November 1944 she was forced to seek public assistance. Realizing her desperate plight, friends provided funds so she could spend her final years in a private sanitarium. Deaf, ailing, and nearly blind, the woman whose efforts brought happiness to countless mothers died in 1948, childless and alone, at the age of eighty-four.

Father's Day: June 19, 1910, Spokane, Washington

The idea for an official Father's Day celebration came to a married daughter, seated in a church in Spokane, Washington, attentive to a Sunday sermon on Mother's Day in 1910—two years after the first Mother's Day observance in West Virginia.

The daughter was Mrs. Sonora Smart Dodd. During the sermon, which extolled maternal sacrifices made for children, Mrs. Dodd realized that in her own family it had been her father, William Jackson Smart, a Civil War veteran, who had sacrificed—raising herself and five sons alone, following the early death of his wife in childbirth. For Mrs. Dodd, the hardships her father had endured on their eastern Washington farm called to mind the unsung feats of fathers everywhere.

Her proposed local Father's Day celebration received strong support from the town's ministers and members of the Spokane YMCA. The date suggested for the festivities, June 5, Mrs. Dodd's father's birthday—a mere three weeks away—had to be moved back to the nineteenth when ministers claimed they need extra time to prepare sermons on such a new subject as Father.

Newspapers across the country, already endorsing the need for a national Mother's Day, carried stories about the unique Spokane observance. Interest in Father's Day increased. Among the first notables to support Mrs. Dodd's idea nationally was the orator and political leader William Jennings Bryan, who also backed Mother's Day. Believing that fathers must not be slighted, he wrote to Mrs. Dodd, "too much emphasis cannot be placed upon the relation between parent and child."

Father's Day, however, was not so quickly accepted as Mother's Day. Members of the all-male Congress felt that a move to proclaim the day official might be interpreted as a self-congratulatory pat on the back.

In 1916, President Woodrow Wilson and his family personally observed the day. And in 1924, President Calvin Coolidge recommended that states, if they wished, should hold their own Father's Day observances. He wrote to the nation's governors that "the widespread observance of this occasion is calculated to establish more intimate relations between fathers and their children, and also to impress upon fathers the full measure of their obligations."

Many people attempted to secure official recognition for Father's Day. One of the most notable efforts was made in 1957, by Senator Margaret Chase Smith, who wrote forcefully to Congress that "Either we honor both our parents, mother and father, or let us desist from honoring either one. But to single out just one of our two parents and omit the other is the most grievous insult imaginable."

Eventually, in 1972—sixty-two years after it was proposed—Father's Day was permanently established by President Richard Nixon. Historians seeking an ancient precedent for an official Father's Day observance have come up with only one: The Romans, every February, honored fathers—but only those deceased.

In America today, Father's Day is the fifth-largest card-sending occasion, with about 85 million greeting cards exchanged.

Mother-in-Law's Day. Few people, including mothers-in-law, realize that the fourth Sunday in October, according to a resolution passed by the U.S. House of Representatives in 1981, is set aside to honor mothers by marriage. To date, the resolution has not been adopted by the Senate, nor is there any recent activity to do so. Nonetheless, the greeting card industry continues to promote the idea and estimates that each year about 800,000 cards are given to mothers-in-law.

61

Grandparent's Day. As a result of legislation signed by President Jimmy Carter in 1978, Grandparent's Day is the Sunday after Labor Day. The person primarily responsible for pushing through the bill was a sixty-five-year-old grandparent from Atlanta, Georgia: Michael Goldgar.

Goldgar got the idea for the national holiday while visiting an elderly aunt confined to a nursing home. Through conversations, he learned that most of the home's residents were grandparents. The majority of them had living children, but they preferred the relatively independent life in the home over a more dependent and burdensome existence they felt would come from moving in with a child. For Goldgar, this brought to mind earlier times in history, when grandparents were the nucleus of an extended family, respected for their accumulated wisdom. The nursing home experience, coupled with his regret that so many families were being disrupted through divorce, led him to begin a grass-roots movement for a Grandparent's Day.

Using eleven thousand dollars from his own savings, Goldgar commenced his first of seventeen trips to Washington, D.C., to lobby for legislation. After a seven-year struggle, he succeeded in getting a day honoring grandparents signed into law. Today Americans send their grandparents more than four million greeting cards a year.

Halloween: 5th Century B.C., Ireland

Even in ancient times, Halloween was a festival for witches, goblins, and ghosts, as well as for lighting bonfires and playing devilish pranks.

What has changed over the centuries are the reasons for dressing up ghoulishly, lighting fires, and acting mischievous. Now these things are done for fun—and by children; in the past, they were done in deathly earnest—and by adults.

Named "All Hallows Eve," the festival was first celebrated by the ancient Celts in Ireland in the fifth century B.C. On the night of October 31, then the official end of summer, Celtic households extinguished the fires on their hearths to deliberately make their homes cold and undesirable to disembodied spirits. They then gathered outside the village, where a Druid priest kindled a huge bonfire to simultaneously honor the sun god for the past summer's harvest and to frighten away furtive spirits.

The Celts believed that on October 31, all persons who had died in the previous year assembled to choose the body of the person or animal they would inhabit for the next twelve months, before they could pass peacefully into the afterlife. To frighten roving souls, Celtic family members dressed themselves as demons, hobgoblins, and witches. They paraded first inside, then outside, the fireless house, always as noisy and destructive as possible. Finally, they clamored along the street to the bonfire outside town. A villager, deemed by appearance or mannerism to be already possessed, could

Halloween customs originated as a means of frightening away spirits eager to possess the living. The earliest American mischief night pranks: overturning outhouses and unhinging front gates.

be sacrificed in the fire as a lesson to other spirits contemplating human possession.

The Romans adopted Celtic Halloween practices, but in A.D. 61 they outlawed human sacrifice, substituting the Egyptian custom of effigies (called *ushabti* by the Egyptians, who buried scores of statuettes with a pharaoh in place of his living attendants, once entombed with their king). In time, as belief in spirit possession waned, the dire portents of many Halloween practices lightened to ritualized amusement.

Irish immigrants fleeing their country's potato famine in the 1840s brought to America with them the Halloween customs of costume and mischief. The favorite pranks played by New England Irish youths on "mischief night" were overturning outhouses and unhinging front gates.

The Irish also brought with them a custom that New England agriculture forced them to modify. The ancient Celts had begun the tradition of a sort of jack-o'-lantern, a large turnip hollowed out and carved with a demon's face and lighted from inside with a candle. Immigrants found few turnips in their new land but numerous fields of pumpkins. Whereas the Pilgrims had made the edible part of the pumpkin a hallmark of Thanksgiving, the Irish made the outer shell synonymous with Halloween.

It was also the Irish who originated the term **jack-o'-lantern,** taken from Irish folklore. As the legend goes, a man named Jack, notorious for his drunken and niggardly ways, tricked the devil into climbing up a tree. Quickly carving a cross into the tree's trunk, Jack trapped Satan until he

swore he'd never again tempt Jack to sin. Upon his death, Jack found himself barred from the comforts of heaven for his repeated sinning, and also refused entrance to the heat of hell from an unforgiving Satan. Condemned to wander in frigid darkness until Judgment Day, he implored the devil for burning embers to light his way. Though Satan had embers in surplus, he allotted Jack a single coal that would last an agonizingly short time. Putting the ember into a turnip he had chewed hollow, he formed Jack's lantern.

Trick or Treat. The most widely accepted theory on the origins of trick-or-treating traces the practice to the ninth-century European custom of "souling."

On All Soul's Day, Christians walked from village to village begging for square biscuits with currants, called soul cakes. The beggars promised to offer up prayers for the dead relatives of the donors, the number of prayers to be proportional to the donors' generosity. The quantity of prayers a dead person amassed was significant in a practical way, for limbo was the penitential layover stop on the journey to heaven, and sufficient prayer, even by an anonymous individual, greatly shortened the stay.

Thanksgiving: 1621, Plymouth, Massachusetts

Though the Pilgrims held the first Thanksgiving dinner, our celebration of the holiday today is due in large part to the tireless efforts of a nineteenth-century female editor of a popular ladies' magazine.

The 102 Pilgrims who sailed on board the *Mayflower,* fleeing religious oppression, were well acquainted with annual thanksgiving day celebrations. The custom was ancient and universal. The Greeks had honored Demeter, goddess of agriculture; the Romans had paid tribute to Ceres, the goddess of corn; while the Hebrews had offered thanks for abundant harvests with the eight-day Feast of Tabernacles. These customs had never really died out in the Western world.

The Pilgrims, after a four-month journey that began in Holland, landed at Plymouth on December 11, 1620. Confronted with severe weather, and a plague that killed hundreds of local Indians, they had by the fall of 1621 lost forty-six of their own members, mainly to scurvy and pneumonia. The survivors, though, had something to be thankful for. A new and bountiful crop had been harvested. Food was abundant. And they were alive, in large part thanks to the assistance of one person: an English-speaking Pawtuxet Indian named Squanto, who was to stay by their side until his death two years later.

As a boy, Squanto had been captured by explorers to America and sold into slavery in Spain. He escaped to England, spent several years working for a wealthy merchant, and, considerably Anglicized, returned to his native Indian village just six months before the Pilgrims landed. He had helped them build houses and to plant and cultivate crops of corn and barley. In

the fall of 1621, the Pilgrims elected a new governor, William Bradford, and proclaimed a day of thanksgiving in their small town, which had seven private homes and four communal buildings.

According to Governor Bradford's own history, *Of Plimoth Plantation,* the celebration lasted three days. He sent "four men fowling," and the ducks and geese they brought back were added to lobsters, clams, bass, corn, green vegetables, and dried fruit.

The Pilgrims invited the chief of the Wampanoag tribe, Massasoit, and ninety of his braves, and the work of preparing the feast—for ninety-one Indians and fifty-six settlers—fell to only four Pilgrim women and two teenage girls. (Thirteen women had died the previous winter.)

The first Thanksgiving Day had all the elements of modern celebrations, only on a smaller scale. A parade of soldiers, blasting muskets and trumpeting bugles, was staged by Captain Myles Standish, later to be immortalized in Longfellow's "The Courtship of Miles Standish." The ninety Indian braves competed against the settlers in foot races and jumping matches. And after the Indians displayed their accuracy with bow and arrow, the white men, with guns, exhibited their own breed of marksmanship.

Turkey, Cranberries, and Pumpkin Pie. The six women who prepared the first Thanksgiving Day meal worked with the meager resources at hand. But they produced a varied menu, with many of the elements that have since come to be traditional holiday fare.

Despite popular legend, two major staples of a modern Thanksgiving meal—turkey and pumpkin pie—may not have been enjoyed at the Pilgrims' banquet.

Though Governor Bradford sent "four men fowling," and they returned with "a great store of wild Turkies," there is no proof that the catch included the bird we call a turkey. Wild turkeys did roam the woods of the Northeast, but in the language of the seventeenth-century Pilgrims, "turkey" simply meant any guinea fowl, that is, any bird with a featherless head, rounded body, and dark feathers speckled white.

It is certain, however, that the menu included venison, since another Pilgrim recorded that Chief Massasoit sent braves into the woods, who "killed five Deere which they brought to our Governour." Watercress and leeks were on the table, along with bitter wild plums and dried berries, but there was no apple cider, and no milk, butter, or cheese, since cows had not been aboard the *Mayflower.*

And there was probably no pumpkin pie. Or bread as we'd recognize it. Stores of flour from the ship had long since been exhausted and years would pass before significant quantities of wheat were successfully cultivated in New England. Without flour for a pie crust, there could be no pie. But the Pilgrims did enjoy pumpkin at the meal—boiled.

The cooks concocted an ersatz bread. Boiling corn, which was plentiful, they kneaded it into round cakes and fried it in venison fat. There were

fifteen young boys in the company, and during the three-day celebration they gathered wild cranberries, which the women boiled and mashed into a sauce for the meal's meats.

The following year brought a poor harvest, and boatloads of new immigrants to house and feed; the Pilgrims staged no Thanksgiving feast. In fact, after that first plentiful and protracted meal, the Pilgrims never regularly celebrated a Thanksgiving Day.

A National Holiday. October 1777 marked the first time all the thirteen colonies joined in a common thanksgiving celebration, and the occasion commemorated the patriotic victory over the British at Saratoga. It, too, however, was a one-time affair.

The first national Thanksgiving proclamation was issued by President George Washington in 1789, the year of his inauguration, but discord among the colonies prevented the executive order from being carried out. For one thing, many Americans felt that the hardships endured by a mere handful of early settlers were unworthy of commemoration on a national scale—certainly the brave new nation had nobler events that merited celebration. On this theme, President Thomas Jefferson went so far as to actively condemn a national recognition of Thanksgiving during his two terms.

The establishment of the day we now celebrate nationwide was largely the result of the diligent efforts of magazine editor Sarah Josepha Hale.

Mrs. Hale started her one-woman crusade for a Thanksgiving celebration in 1827, while she was editor of the extremely popular Boston *Ladies' Magazine.* Her hortatory editorials argued for the observance of a national Thanksgiving holiday, and she encouraged the public to write to their local politicians.

When *Ladies' Magazine* consolidated with the equally successful *Godey's Lady's Book* of Philadelphia, Mrs. Hale became the editor of the largest periodical of its kind in the country, with a readership of 150,000. Her new editorials were vigorous and patriotic, and their criticism of dissenters was caustic.

In addition to her magazine outlet, over a period of almost four decades she wrote hundreds of letters to governors, ministers, newspaper editors, and each incumbent President. She always made the same request: that the last Thursday in November be set aside to "offer to God our tribute of joy and gratitude for the blessings of the year."

Finally, national events converged to make Mrs. Hale's request a reality.

By 1863, the Civil War had bitterly divided the nation into two armed camps. Mrs. Hale's final editorial, highly emotional and unflinchingly patriotic, appeared in September of that year, just weeks after the Battle of Gettysburg, in which hundreds of Union and Confederate soldiers lost their lives. In spite of the staggering toll of dead, Gettysburg was an important victory for the North, and a general feeling of elation, together with the clamor produced by Mrs. Hale's widely circulated editorial,

prompted President Abraham Lincoln to issue a proclamation on October 3, 1863, setting aside the last Thursday in November as a national Thanksgiving Day.

Since then, there has been one controversial tampering with that tradition. In 1939, President Franklin D. Roosevelt shifted Thanksgiving back one week, to the third Thursday in November—because store merchants requested an increase in the number of shopping days between Thanksgiving and Christmas.

This pleased the merchants but just about no one else. Vehement protests were staged throughout the country. Millions of Americans, in defiance of the presidential proclamation, continued to celebrate Thanksgiving on the last Thursday in November—and they took the day off from work. Protests grew even louder the following year. Not wanting to go down in history as the Grinch who stole Thanksgiving, in the spring of 1941 Roosevelt publicly admitted he had made an error in judgment and returned the holiday to the last Thursday in November. The merchants countered by offering sales and discounts, thus beginning the annual practice of promoting Christmas earlier and earlier.

Christmas: A.D. 337, Rome

As a holy day and a holiday, Christmas is an amalgam of the traditions from a half-dozen cultures, accumulated over centuries. A turkey dinner and a decorated tree, Christmas cards and Santa Claus, yule logs, mistletoe, bells, and carols originated with different peoples to become integral parts of December 25, a day on which no one is certain Jesus Christ was born.

The idea to celebrate the Nativity on December 25 was first suggested early in the fourth century, the clever conceit of church fathers wishing to eclipse the December 25 festivities of a rival religion that threatened the existence of Christianity.

It is important to note that for two centuries after Christ's birth, no one knew, and few people cared, exactly when he was born. Birthdays were unimportant; death days counted. Besides, Christ was divine, and his natural birth was deliberately played down. As mentioned earlier, the Church even announced that it was sinful to contemplate observing Christ's birthday "as though He were a King Pharaoh."

Several renegade theologians, however, attempted to pinpoint the Nativity and came up with a confusion of dates: January 1, January 6, March 25, and May 20. The latter eventually became a favored date because the Gospel of Luke states that the shepherds who received the announcement of Christ's birth were watching their sheep by night. Shepherds guarded their flocks day and night only at lambing time, in the spring; in winter, the animals were kept in corrals, unwatched. What finally forced the issue, and compelled the Church to legitimize a December 25 date, was the burgeoning popularity of Christianity's major rival religion, Mithraism.

On December 25, pagan Romans, still in the majority, celebrated Natalis Solis Invicti, "Birthday of the Invincible Sun God," Mithras. The cult originated in Persia and rooted itself in the Roman world in the first century B.C. By A.D. 274, Mithraism was so popular with the masses that Emperor Aurelian proclaimed it the official state religion. In the early 300s, the cult seriously jeopardized Christianity, and for a time it was unclear which faith would emerge victorious.

Church fathers debated their options.

It was well known that Roman patricians and plebeians alike enjoyed festivals of a protracted nature. The tradition was established as far back as 753 B.C., when King Romulus founded the city of Rome on the Palatine Hill. Not only the Roman observance of Natalis Solis Invicti occasioned December feasts and parades; so, too, did the celebration of the Saturnalia, in honor of Saturn, god of agriculture. The Church needed a December celebration.

Thus, to offer converts an occasion in which to be pridefully celebratory, the Church officially recognized Christ's birth. And to offer head-on competition to the sun-worshipers' feast, the Church located the Nativity on December 25. The mode of observance would be characteristically prayerful: a mass; in fact, Christ's Mass. As one theologian wrote in the 320s: "We hold this day holy, not like the pagans because of the birth of the sun, but because of him who made it." Though centuries later social scientists would write of the psychological power of group celebrations—the unification of ranks, the solidification of collective identity, the reinforcement of common objectives—the principle had long been intuitively obvious.

The celebration of Christmas took permanent hold in the Western world in 337, when the Roman emperor Constantine was baptized, uniting for the first time the emperorship and the Church. Christianity became the official state religion. And in A.D. 354, Bishop Liberius of Rome reiterated the importance of celebrating not only Christ's death but also his birth.

Mistletoe: 2nd Century B.C., British Isles

The custom of embracing under a sprig of mistletoe, if not actually kissing under it, originated in ancient Britain around the second century B.C., among the Druids, the learned class of the Celts.

Two hundred years before Christ's birth, the Druids celebrated the start of winter by gathering mistletoe and burning it as a sacrifice to their gods. Sprigs of the yellow-green plant with waxy white berries were also hung in homes to ensure a year's good fortune and familial harmony. Guests to a house embraced under the auspicial sprig. Twigs of the evergreen outside a house welcomed weary travelers. And if enemies chanced to meet under a tree that bore mistletoe (a parasite on deciduous and evergreen trees), they were required to lay down their arms and forget their differences for a day.

The Druids named the parasitic plant *omnia sanitatem*, meaning "all heal," and prescribed it for female infertility and as an antidote for poison. Gathering mistletoe was an occasion for great ceremony, and only sprigs that grew on sacred oak trees were collected—by the highest-ranking priest, and with a gold knife, an event later dramatized in Bellini's opera *Norma*.

Mistletoe was a plant of hope, peace, and harmony not only for the Celts but also for the Scandinavians, who called it *mistilteinn*. Its name derived from *mista*, meaning "dung," since the evergreen is propagated by seeds in birds' excrement. For the Scandinavians, mistletoe belonged to Frigga, goddess of love, and the kissing custom is thought to be rooted in this romantic association.

In the ancient world, mistletoe was also a decorative green. During the Roman feasts of Natalis Solis Invicti and Saturnalia, patricians and plebeians bound sprigs into boughs and festively draped the garlands throughout the house. With the official recognition of Christmas on December 25 in the fourth century, the Church forbade the use of mistletoe in any form, mindful of its idolatrous associations. As a substitute, it suggested **holly**. The sharply pointed leaves were to symbolize the thorns in Christ's crown and the red berries drops of his blood. Holly became a Nativity tradition.

The Christian ban on mistletoe was in effect throughout the Middle Ages. And surprisingly, as late as the present century, there were churches in England that forbade the wearing of mistletoe sprigs and corsages during services.

Poinsettia. The adoption of the poinsettia as the Christmas flower is relatively recent, dating from 1828.

Native to Mexico, the plant, a member of the spurge family, has small yellow flowers surrounded high up by large, tapering red leaves, which resemble petals and are often mistaken for them. At least as early as the eighteenth century, Mexicans called the plant "flower of the blessed night," because of its resemblance to the Star of Bethlehem. This is the first association between the plant and Christmas.

In 1828, Dr. Joel Roberts Poinsett, the first United States ambassador to Mexico, brought the plant into the States, where it was renamed in his honor. By the time of his death in 1851, the poinsettia's flaming red color had already established its Christmas association.

Christmas Tree: 8th Century, Germany

The custom of a Christmas tree, undecorated, is believed to have begun in Germany, in the first half of the 700s.

The earliest story relates how British monk and missionary St. Boniface (born Winfrid in A.D. 680) was preaching a sermon on the Nativity to a tribe of Germanic Druids outside the town of Geismar. To convince the idolators that the oak tree was not sacred and inviolable, the "Apostle of

Germany" felled one on the spot. Toppling, it crushed every shrub in its path except for a small fir sapling. A chance event can lend itself to numerous interpretations, and legend has it that Boniface, attempting to win converts, interpreted the fir's survival as a miracle, concluding, "Let this be called the tree of the Christ Child." Subsequent Christmases in Germany were celebrated by planting fir saplings.

We do know with greater authority that by the sixteenth century, fir trees, indoors and out, were decorated to commemorate Christmas in Germany. A forest ordinance from Ammerschweier, Alsace, dated 1561, states that "no burgher shall have for Christmas more than one bush of more than eight shoes' length." The decorations hung on a tree in that time, the earliest we have evidence of, were "roses cut of many-colored paper, apples, wafers, gilt, sugar."

It is a widely held belief that Martin Luther, the sixteenth-century Protestant reformer, first added lighted candles to a tree. Walking toward his home one winter evening, composing a sermon, he was awed by the brilliance of stars twinkling amidst evergreens. To recapture the scene for his family, he erected a tree in the main room and wired its branches with lighted candles.

By the 1700s, the *Christbaum,* or "Christ tree," was a firmly established tradition. From Germany the custom spread to other parts of Western Europe. It was popularized in England only in the nineteenth century, by Prince Albert, Queen Victoria's German consort. Son of the duke of Saxe-Coburg-Gotha (a duchy in central Germany), Albert had grown up decorating Christmas trees, and when he married Victoria, in 1840, he requested that she adopt the German tradition.

The claim of the Pennsylvania Germans to have initiated the Christmas tree custom in America is undisputed today. And it's in the diary of Matthew Zahm of Lancaster, Pennsylvania, under the date December 20, 1821, that the Christmas tree and its myriad decorations receive their first mention in the New World.

It is not surprising that, like many other festive Christmas customs, the tree was adopted so late in America. To the New England Puritans, Christmas was sacred. The Pilgrims' second governor, William Bradford, wrote that he tried hard to stamp out "pagan mockery" of the observance, penalizing any frivolity. The influential Oliver Cromwell preached against "the heathen traditions" of Christmas carols, decorated trees, and any joyful expression that desecrated "that sacred event."

In 1659, the General Court of Massachusetts enacted a law making any observance of December 25 (other than a church service) a penal offense; people were fined for hanging decorations. That stern solemnity continued until the nineteenth century, when the influx of German and Irish immigrants undermined the Puritan legacy. In 1856, the poet Henry Wadsworth Longfellow commented: "We are in a transition state about Christmas here in New England. The old Puritan feeling prevents it from being a cheerful

hearty holiday; though every year makes it more so." In that year, Christmas was made a legal holiday in Massachusetts, the last state to uphold Cromwell's philosophy.

Interestingly, *Godey's Lady's Book*, the women's publication of the 1800s that did so much to nationalize Thanksgiving, also played a role in popularizing festive Christmas practices. Through its lighthearted and humorous drawings, its household-decorating hints, its recipes for Christmas confections and meals, and its instructions for homemade tree ornaments, the magazine convinced thousands of housewives that the Nativity was not just a fervent holy day but could also be a festive holiday.

Xmas. The familiar abbreviation for Christmas originated with the Greeks. *X* is the first letter of the Greek word for Christ, Xristos. By the sixteenth century, "Xmas" was popular throughout Europe. Whereas early Christians had understood that the term merely was Greek for "Christ's mass," later Christians, unfamiliar with the Greek reference, mistook the *X* as a sign of disrespect, an attempt by heathen to rid Christmas of its central meaning. For several hundred years, Christians disapproved of the use of the term. Some still do.

Christmas Cards: 1843, England

A relatively recent phenomenon, the sending of commercially printed Christmas cards originated in London in 1843.

Previously, people had exchanged handwritten holiday greetings. First in person. Then via post. By 1822, homemade Christmas cards had become the bane of the U.S. postal system. That year, the Superintendent of Mails in Washington, D.C., complained of the need to hire sixteen extra mailmen. Fearful of future bottlenecks, he petitioned Congress to limit the exchange of cards by post, concluding, "I don't know what we'll do if it keeps on."

Not only did it keep on, but with the marketing of attractive commercial cards the postal burden worsened.

The first Christmas card designed for sale was by London artist John Calcott Horsley. A respected illustrator of the day, Horsley was commissioned by Sir Henry Cole, a wealthy British businessman, who wanted a card he could proudly send to friends and professional acquaintances to wish them a "merry Christmas."

Sir Henry Cole was a prominent innovator in the 1800s. He modernized the British postal system, managed construction of the Albert Hall, arranged for the Great Exhibition in 1851, and oversaw the inauguration of the Victoria and Albert Museum. Most of all, Cole sought to "beautify life," and in his spare time he ran an art shop on Bond Street, specializing in decorative objects for the home. In the summer of 1843, he commissioned Horsley to design an impressive card for that year's Christmas.

Horsley produced a triptych. Each of the two side panels depicted a good

71

deed—clothing the naked and feeding the hungry. The centerpiece featured a party of adults and children, with plentiful food and drink (there was severe criticism from the British Temperance Movement).

The first Christmas card's inscription read: "merry Christmas and a happy New Year to you." "Merry" was then a spiritual word meaning "blessed," as in "merry old England." Of the original one thousand cards printed for Henry Cole, twelve exist today in private collections.

Printed cards soon became the rage in England; then in Germany. But it required an additional thirty years for Americans to take to the idea. In 1875, Boston lithographer Louis Prang, a native of Germany, began publishing cards, and earned the title "father of the American Christmas card."

Prang's high-quality cards were costly, and they initially featured not such images as the Madonna and Child, a decorated tree, or even Santa Claus, but colored floral arrangements of roses, daisies, gardenias, geraniums, and apple blossoms. Americans took to Christmas cards, but not to Prang's; he was forced out of business in 1890. It was cheap penny Christmas postcards imported from Germany that remained the vogue until World War I. By war's end, America's modern greeting card industry had been born.

Today more than two billion Christmas cards are exchanged annually— just within the United States. Christmas is the number one card-selling holiday of the year.

Santa Claus: Post–4th Century, Europe, Asia, America

The original Santa Claus, St. Nicholas, was born in the ancient southeastern Turkish town of Lycia early in the fourth century. To show his piety as a child, he adopted a self-imposed twice-weekly fast (on Wednesdays and Fridays). Then, upon the early death of his parents, he fully dedicated his life to Christ, entering a Lycian seminary. It was on a boat journey to Palestine that he is supposed to have extended his arms and stilled a violent sea, the first of his many miracles. Later, he would become the patron saint of sailors.

At an early age, Nicholas was appointed bishop of Myra, in Asia Minor. His success in winning converts, and his generosity toward the poor, incensed Roman officials. During a great Christian persecution, he was imprisoned and tortured under orders of the despotic Roman emperor Gaius Diocletianus. The ruler, after a reign of terror and profligacy, abruptly abdicated at age sixty in favor of the simple life of farming and raising cabbages. This pleased many Romans and was most fortunate for Nicholas. The new emperor, Constantine (who would later convert to Christianity), freed the bishop. And when Constantine convened the first Church council at Nicaea in 325, Nicholas attended as a prominent member. He is believed to have died on December 6, 342, and eventually was adopted as the patron saint of Russia, Greece, and Sicily.

Two aspects of St. Nicholas's life led to his becoming Santa Claus: His generosity was legend, and he was particularly fond of children. We know this primarily through Roman accounts of his patronage of youth, which eventually led to his becoming the patron saint of children. Throughout the Middle Ages, and well beyond, he was referred to by many names— none of them Santa Claus.

Children today would not at all recognize the St. Nick who brought gifts to European children hundreds of years ago—except perhaps for his cascading white beard. He made his rounds in full red-and-white bishop's robes, complete with twin-peaked miter and crooked crozier. He was pulled by no fleet-footed reindeer, but coaxed an indolent donkey. And he arrived not late on Christmas Eve but on his Christian feast day, December 6. The gifts he left beside the hearth were usually small and disappointing by today's standards: fruit, nuts, hard candies, wood and clay figurines. They were better, though, than the gifts later European Santas would leave.

During the Protestant Reformation of the sixteenth century, St. Nicholas was banished from most European countries. Replacing him were more secular figures, such as Britain's Father Christmas and France's Papa Noël. Neither was known as a lavish gift-giver to children, who in general were not at center stage at that point in history. Father Christmas, for instance, was more the fictive sponsor of adult fetes concerned with *amor*.

The Dutch kept the St. Nicholas tradition alive. As the "protector of sailors," St. Nicholas graced the prow of the first Dutch ship that arrived in America. And the first church built in New York City was named after him.

The Dutch brought with them to the New World two Christmas items that were quickly Americanized.

In sixteenth-century Holland, children placed wooden shoes by the hearth the night of St. Nicholas's arrival. The shoes were filled with straw, a meal for the saint's gift-laden donkey. In return, Nicholas would insert a small treat into each clog. In America, the limited-volume shoe was replaced with the expandable stocking, hung by the chimney with . . . expectations. "Care" would not come until 1822.

The Dutch spelled St. Nicholas "Sint Nikolass," which in the New World became "Sinterklass." When the Dutch lost control of New Amsterdam to the English in the seventeenth century, Sinterklass was Anglicized to Santa Claus.

Much of modern-day Santa Claus lore, including the reindeer-drawn sleigh, originated in America, due to the popularity of a poem by a New York theology professor.

Dr. Clement Clarke Moore composed "The Night Before Christmas" in 1822, to read to his children on Christmas Eve. The poem might have remained privately in the Moore family if a friend had not mailed a copy of it (without authorial attribution) to a newspaper. It was picked up by other papers, then it appeared in magazines, until eventually every line of

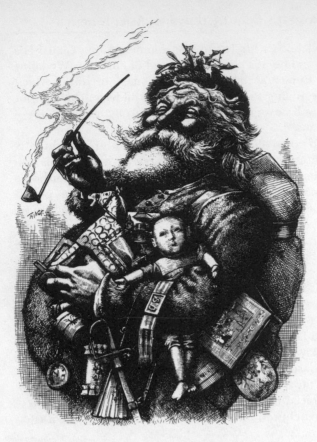

Cartoonist Thomas Nast, who published this drawing in Harper's Weekly, *January 1, 1881, established the prototype for the modern Santa Claus.*

the poem's imagery became part of the Santa legend. Dr. Moore, a classical scholar, for many years felt that to acknowledge having written a child's poem might damage his professional reputation; as a result, he did not publicly admit authorship until 1838, by which time just about every child across the country could recite the poem by heart.

It was in America that Santa put on weight. The original St. Nicholas had been a tall, slender, elegant bishop, and that was the image perpetuated for centuries. The rosy-cheeked, roly-poly Santa is credited to the influential nineteenth-century cartoonist Thomas Nast. From 1863 until 1886, Nast created a series of Christmas drawings for *Harper's Weekly*. These drawings, executed over twenty years, exhibit a gradual evolution in Santa—from the pudgy, diminutive, elf-like creature of Dr. Moore's immortal poem to the bearded, potbellied, life-size bell ringer familiar on street corners across America today. Nast's cartoons also showed the world how Santa spent his entire year—constructing toys, checking on children's behavior, reading their requests for special gifts. His images were incorporated into the Santa lore.

Rudolph, the Red-Nosed Reindeer: 1939, Chicago

"Rollo, the Red-Nosed Reindeer." "Reginald, the Red-Nosed Reindeer." Both names were considered for the most famous reindeer of all. And the now traditional Christmas song began as a poem, a free handout to department store shoppers.

In 1939, the Montgomery Ward department store in Chicago sought something novel for its Santa Claus to distribute to parents and children. Robert May, an advertising copywriter for the store, suggested an illustrated poem, printed in a booklet, that families would want to save and reread each holiday season.

May conceived the idea of a shiny-nosed reindeer, a Santa's helper. And an artist friend, Denver Gillen, spent hours at a local zoo creating whimsical sketches of reindeer at rest and at play. Montgomery Ward executives approved the sketches and May's poem, but nixed the name Rollo. Then Reginald. May considered other names to preserve the alliteration, and finally settled on Rudolph, the preference of his four-year-old daughter. That Christmas of 1939, 2.4 million copies of the "Rudolph" booklet were handed out in Montgomery Ward stores across the country.

"Rudolph" was reprinted as a Christmas booklet sporadically until 1947. That year, a friend of May's, Johnny Marks, decided to put the poem to music. One professional singer after another declined the opportunity to record the song, but in 1949, Gene Autry consented. The Autry recording rocketed to the top of the *Hit Parade*. Since then, three hundred different recordings have been made, and more than eighty million records sold. The original Gene Autry version is second only to Bing Crosby's "White Christmas" as the best-selling record of all time.

Rudolph became an annual television star, and a familiar Christmas image in Germany, Holland, Denmark, Sweden, Norway, England, Spain, Austria, and France—many of the countries whose own lore had enriched the international St. Nicholas legend. Perhaps most significantly, "Rudolph, the Red-Nosed Reindeer" has been called by sociologists the only new addition to the folklore of Santa Claus in the twentieth century.

Chapter 4

At the Table

Table Manners: 2500 B.C., Near East

Manners are a set of rules that allow a person to engage in a social ritual—or to be excluded from one. And table manners, specifically, originated in part as a means of telling a host that it was an honor to be eating his or her meal.

Etiquette watchers today claim that dining standards are at an all-time low for this century. As a cause, they cite the demise of the traditional evening meal, when families gathered to eat and parents were quick to pounce on errant behavior. They also point to the popularity of ready-to-eat meals (often consumed quickly and in private) and the growth of fast-food restaurants, where, at least among adolescents, those who display table manners can become social outcasts. When young people value individual statement over social decorum, manners don't have a chance.

Evidence of the decline comes from surprisingly diverse quarters. Army generals and corporate executives have complained that new recruits and MBA graduates reveal an embarrassing confusion about formal manners at the table. This is one reason cited for the sudden appearance of etiquette books on best-seller lists.

The problem, though, is not new. Historians who chart etiquette practices claim that the deterioration of formal manners in America began a long time ago—specifically, and ironically, with Thomas Jefferson and his fondness for equality and his hatred of false civility. Jefferson, who had impeccable manners himself, often deliberately downplayed them. And during

From The Instructions of Ptahhotep, *c. 2500 B.C., history's first code of correct behavior. To ingratiate one to a superior, the author advises: "Laugh when he laughs."*

his presidency, he attempted to ease the rules of protocol in the capital, feeling they imposed artificial distinctions among people created equal.

But before manners can be relaxed or abused, they have to be conceived and formalized, and those processes originated centuries ago.

Early man, preoccupied with foraging for food, which was scarce, had no time for manners; he ate stealthily and in solitude. But with the dawn of agriculture in the Near East, about 9000 B.C., man evolved from hunter-gatherer to farmer. He settled down in one place to a more stable life. As food became plentiful, it was shared communally, and rules were developed for its preparation and consumption. One family's daily habits at the table became the next generation's customs.

Historical evidence for the first code of correct behavior comes from the Old Kingdom of Egypt, in a book, *The Instructions of Ptahhotep* (Ptahhotep was grand vizier under the pharaoh Isesi). Written about 2500 B.C., the manuscript on manners now resides in a Paris antiquities collection.

Known as the "Prisse papyrus"—not that its dictates on decorum are prissy; an archaeologist by that name discovered the scrolls—the work predates the Bible by about two thousand years. It reads as if it was prepared as advice for young Egyptian men climbing the social ladder of the day. In the company of one's superior, the book advises, "Laugh when he laughs." It suggests overlooking one's quiddities with a superior's philosophy, "so thou shalt be very agreeable to his heart." And there are numerous references to the priceless wisdom of holding one's tongue, first with a boss: "Let thy mind be deep and thy speech scanty," then with a wife: "Be silent, for it is a better gift than flowers."

By the time the assemblage of the Bible began, around 700 B.C., Ptahhotep's two-thousand-year-old wisdom had been well circulated throughout the Nile delta of Egypt and the fertile crescent of Mesopotamia. Religious scholars have located strong echoes of *The Instructions* throughout the Bible, especially in Proverbs and Ecclesiastes—and particularly regarding the preparation and consumption of food.

Fork: 11th Century, Tuscany

Roman patricians and plebeians ate with their fingers, as did all European peoples until the dawning of a conscious fastidiousness at the beginning of the Renaissance. Still, there was a right and a wrong, a refined and an uncouth, way to go about it. From Roman times onward, a commoner grabbed at his food with five fingers; a person of breeding politely lifted it with *three* fingers—never soiling the ring finger or the pinkie.

Evidence that forks were not in common use in Europe as late as the sixteenth century—and that the Roman "three-finger rule" still was—comes from an etiquette book of the 1530s. It advises that when dining in "good society," one should be mindful that "It is most refined to use only three fingers of the hand, not five. This is one of the marks of distinction between the upper and lower classes."

Manners are of course relative and have differed from age to age. The evolution of the fork, and resistance against its adoption, provides a prime illustration.

Our word "fork" comes from the Latin *furca,* a farmer's pitchfork. Miniatures of these ancient tools, the oldest known examples, were unearthed at the archaeological site of Catal Hoyuk in Turkey; they date to about the fourth millennium B.C. However, no one knows precisely what function miniature primitive pitchforks served. Historians doubt they were tableware.

What is known with certainty is that small forks for eating first appeared in eleventh-century Tuscany, and that they were widely frowned upon. The clergy condemned their use outright, arguing that only human fingers, created by God, were worthy to touch God's bounty. Nevertheless, forks in gold and silver continued to be custom made at the request of wealthy Tuscans; most of these forks had only two tines.

For at least a hundred years, the fork remained a shocking novelty. An Italian historian recorded a dinner at which a Venetian noblewoman ate with a fork of her own design and incurred the rebuke of several clerics present for her "excessive sign of refinement." The woman died days after the meal, supposedly from the plague, but clergymen preached that her death was divine punishment, a warning to others contemplating the affectation of a fork.

In the second century of its Tuscan incarnation, the two-prong fork was introduced to England by Thomas à Becket, Archbishop of Canterbury and British chancellor under Henry II. Renowned for his zeal in upholding ecclesiastical law, Becket escaped England in 1164 to avoid trial by the lay courts; when he returned six years later, after pardon by the king, the archbishop was familiar with the Italian two-tined dining fork. Legend has it that noblemen at court employed them preferentially for dueling.

By the fourteenth century, the fork in England was still nothing more than a costly, decorative Italian curiosity. The 1307 inventory of King

Edward I reveals that among thousands of royal knives and hundreds of spoons, he owned a mere seven forks: six silver, one gold. And later that century, King Charles V of France owned only twelve forks, most of them "decorated with precious stones," none used for eating.

People were picking up their food in a variety of accepted ways. They speared it with one of a pair of eating knives, cupped it in a spoon, or pinched it with the correct three fingers. Even in Italy, country of the fork's origin, the implement could still be a source of ridicule as late as the seventeenth century—especially for a man, who was labeled finicky and effeminate if he used a fork.

Women fared only slightly better. A Venetian publication of 1626 recounts that the wife of the doge, instead of eating properly with knife and fingers, ordered a servant to "cut her food into little pieces, which she ate by means of a two-pronged fork." An affectation, the author writes, "beyond belief!" Forks remained a European rarity. A quarter century later, a popular etiquette book thought it necessary to give advice on something that was not yet axiomatic: "Do not try to eat soup with a fork."

When, then, did forks become the fashion? And why?

Not really until the eighteenth century, and then, in part, to emphasize class distinction. With the French Revolution on the horizon, and with revolutionaries stressing the ideals of "Liberty, Equality, and Fraternity," the ruling French nobility increased their use of forks—specifically the four-tined variety. The fork became a symbol of luxury, refinement, and status. Suddenly, to touch food with even three bare fingers was gauche.

An additional mark distinguishing classes at the dining table was individual place settings—each aristocrat present at a meal received a full complement of cutlery, plates, and glasses. Today, in even the poorest families, separate dining utensils are commonplace. But in eighteenth-century Europe, most people, and certainly the poorer classes, still shared communal bowls, plates, and even drinking glasses. An etiquette book of that period advises: "When everyone is eating from the same dish, you should take care not to put your hand into it before those of higher rank have done so." There were, however, two table implements that just about everyone owned and used: the knife and the spoon.

Spoon: 20,000 Years Ago, Asia

Spoons are millennia older than forks, and never in their long history did they, or their users, suffer ridicule as did forks and their users. From its introduction, the spoon was accepted as a practical implement, especially for eating liquids.

The shape of early spoons can be found in the origin of their name. "Spoon" is from the Anglo-Saxon *spon*, meaning "chip," and a spoon was a thin, slightly concave piece of wood, dipped into porridge or soupy foods not liquid enough to sip from a bowl. Such spoons have been unearthed

in Asia dating from the Paleolithic Age, some twenty thousand years ago. And spoons of wood, stone, ivory, and gold have been found in ancient Egyptian tombs.

Upper-class Greeks and Romans used spoons of bronze and silver, while poorer folk carved spoons of wood. Spoons preserved from the Middle Ages are largely of bone, wood, and tin, with many elaborate ones of silver and gold.

In Italy during the fifteenth century, "apostle spoons" were the rage. Usually of silver, the spoons had handles in the figure of an apostle. Among wealthy Venetians and Tuscans, an apostle spoon was considered the ideal baptismal gift; the handle would bear the figure of the child's patron saint. It's from this custom that a privileged child is said to be born with a silver spoon in its mouth, implying, centuries ago, that the family could afford to commission a silver apostle's spoon as a christening gift.

Knife: 1.5 Million Years Ago, Africa and Asia

In the evolution to modern man, *Homo erectus*, an early upright primate, fashioned the first standardized stone knives for butchering prey. Living 1.5 million years ago, he was the first hominid with the ability to conceive a design and then labor over a piece of stone until the plan was executed to his liking. Since that time, knives have been an important part of man's weaponry and cutlery. They've changed little over the millennia, and even our word "knife" is recognizable in its Anglo-Saxon antecedent, *cnif.*

For centuries, most men owned just one knife, which hung at the waist for ready use. One day they might use it to carve a roast, the next to slit an enemy's throat. Only nobles could afford separate knives for warfare, hunting, and eating.

Early knives had pointed tips, like today's steak knives. The round-tip dinner knife, according to popular tradition, originated in the 1630s as one man's attempt to put an end to a commonplace but impolite table practice.

The man was Armand Jean du Plessis, better known as Duc de Richelieu, cardinal and chief minister to France's Louis XIII. He is credited with instituting modern domestic espionage, and through iniquitous intrigues and shrewd statesmanship he catapulted France to supreme power in early seventeenth-century Europe. In addition to his preoccupation with state matters and the acquisition of personal authority, Richelieu stressed formal manners, and he bristled at one table practice of the day. During a meal, men of high rank used the pointed end of a knife to pick their teeth clean—a habit etiquette books had deplored for at least three hundred years. Richelieu forbade the offense at his own table and, according to French legend, ordered his chief steward to file the points off house knives. Soon French hostesses, also at a loss to halt the practice, began placing orders for knives like Richelieu's. At least it is known factually that by the close of

the century, French table settings often included blunt-ended knives.

Thus, with the knife originating 1.5 million years ago, the spoon twenty thousand years ago, and the fork in the eleventh century, the full modern-day complement of knife, fork, and spoon took ages to come together at the table. And though we take the threesome for granted today, just two hundred years ago most inns throughout Europe and America served one, or two, but seldom all three implements. When wealthy people traveled, they carried with them their own set of cutlery.

Crossing Knife and Fork. The custom of intersecting a knife and fork on a plate at the conclusion of a meal began in seventeenth-century Italy. Today some people regard it as a practical signal to a hostess or waitress that we've finished eating. But it was introduced by Italian nobility as a religious symbol—a cross. The gesture was considered not only good manners but also a pious act of thanksgiving for the bounty provided by the Lord.

Napkin: Pre–500 B.C., Near East

The small napkins of paper and cloth that we use to dab our lips and protect our laps would never have sufficed centuries ago, when the napkin served a more functional purpose. To put it simply: eating a multicourse meal entirely with the fingers—whether three fingers or five—made a napkin the size of a towel essential. And the first napkins were indeed full-size towels.

Later called "serviettes," towel-like napkins were used by the ancient Egyptians, the Greeks, and the Romans to wipe food from their hands. And to further cleanse the hands during a meal, which could last many hours, all three cultures used **finger bowls,** with water scented by such flowers and herbs as rose petals and rosemary. For the Egyptians, the scent—almond, cinnamon, or orange blossom; myrrh, cassia, or spike-nard—was tailored to the course being consumed.

During the sixth-century B.C. reign of Tarquinius Superbus, the seventh and last king of Rome, Roman nobility instituted a second use for the napkin—as a sort of doggie bag. Guests at a banquet were expected to wrap delicacies from the table in serviettes to take home. To depart empty-handed was unmannerly.

Preserved documents reveal the onetime splendor of the serviette. In Italy in the 1680s, there were twenty-six favored shapes in which dinner napkins were folded for various persons and occasions; these included Noah's Ark (for clergymen), a hen (for the noblewoman of highest rank present), chicks (for the other women), plus carp, tortoises, bulls, bears, and rabbits.

A 1729 etiquette book clearly states the many uses of a large serviette: "For wiping the mouth, lips, and fingers when they are greasy. For wiping

the knife before cutting bread. For cleaning the spoon and fork after using them." The same book then zeros in on a fine point: "When the fingers are very greasy, wipe them first on a piece of bread, in order not to spoil the serviette too much."

What undermined the reign of the towel-size serviette (and for that matter, the finger bowl) was the fork. Once forks were adopted to handle food, leaving fingers spotless, the large napkin became redundant. Napkins were retained, but in smaller size and to wipe the mouth.

British folklore records an additional use of the napkin, which arose in the eighteenth century. A tailor by the name of Doily—legend does not record his Christian name—opened a linen shop on the Strand in London. One of his specialty items was a small circular napkin trimmed in delicate lace, to be used to protect a tablecloth when serving desserts. Customers called Mr. Doily's napkins just that—"Doily's napkins"—and through frequent use of the phrase, the article became known as a **doily.**

The original size and function of the serviette is evinced in the etymology of the word "napkin." It derives from the Old French *naperon,* meaning "little tablecloth." The English borrowed the word *naperon* but applied it to a large cloth tied around the waist to protect the front of the body (and to wipe the hands on); they called it *a napron.* Due to a pronunciation shift involving a single letter, *a napron* became "an apron." Thus, a napkin at one time or another has been a towel, a tablecloth, a doily, and an apron. After surviving all that colorful, controversial, and convoluted history, the noble napkin today has reached the lowly status of a throwaway.

Additional examples of our tableware have enjoyed a long history and contain interesting name origins. Several pieces, for instance, were named for their shapes. A **dish** still resembles its Roman namesake, the *discus,* and is still sometimes hurled.

Bowl simply comes from the Anglo-Saxon word *bolla,* meaning "round." And the Old French word for "flat," *plat,* echoes in **plate** and **platter.**

It is the original clay composition of the **tureen** that earned it its name. Old French for "clay" is *terre,* and during the Middle Ages, French housewives called the clay bowl a "terrine."

The Sanskrit word *kupa* meant "water well" and was appropriately adopted for the oldest of household drinking vessels, the **cup.** And **glass** derives from the ancient Celtic word *glas,* for "green," since the color of the first crude and impure British glass was green.

Some name origins are tricky. Today a **saucer** holds a cup steady, but for many generations it was a special small dish for holding sauces (including salt) to flavor meats. Although it was popular in Europe as early as 1340, only mass production in the machine age made the saucer inexpensive enough to be merely in service to a cup.

And the object upon which all of the above items rest, the **table,** derived its name from the Latin *tabula,* meaning "board," which was what a table was, is, and probably always will be.

Chopsticks: Antiquity, China

During the late Middle Ages, Europeans were confronted with a new vogue: cutting food at the table into small, bite-size pieces. They found the custom, recently introduced by merchants trading with China, tedious and pointlessly fastidious. Unknown to thirteenth-century Europeans was the Oriental philosophy dictating that food be diced—not at the table, but in the kitchen before it was served.

For centuries, the Chinese had taught that it was uncouth and barbaric to serve a large carcass that in any way resembled the original animal. In addition, it was considered impolite to expect a dinner guest to struggle through a dissection that could have been done beforehand, in the kitchen, out of sight. An old Chinese proverb sums up the philosophy: "We sit at table to eat, not to cut up carcasses." That belief dictated food size, which in turn suggested a kind of eating utensil. Chopsticks—of wood, bone, and ivory—were perfectly suited to conveying the precut morsels to the mouth, and the Chinese word for the implements, *kwai-tsze,* means "quick ones." Our term "chopsticks" is an English phonetic version of *kwai-tsze.*

In the Orient, the father of etiquette was the fifth-century philosopher Confucius—who, despite popular misconceptions, neither founded a religion nor formulated a philosophical system. Instead, motivated by the social disorder of his time, he posited principles of correct conduct, emphasizing solid family relationships as the basis of social stability. The Oriental foundation for all good manners is taken to be Confucius's maxim "What you do not like when done to yourself, do not do to others."

Western Etiquette Books: 13th Century, Europe

During the dark days of the Middle Ages, when barbarian tribes from the north raided and sacked the civilized nations of Southern Europe, manners were people's least concern. Formal codes of civility fell into disuse for hundreds of years. It was the popularity of the eleventh-century Crusades, and the accompanying prestige of knighthood, with its own code of chivalry, that reawakened an interest in manners and etiquette.

One new court custom, called "coupling," paired a nobleman with a lady at a banquet, each couple sharing one goblet and one plate. Etymologists locate the practice as the source of a later expression for cohorts aligned in any endeavor, said to "eat from the same plate."

The rebirth of strict codes of behavior is historically documented by the appearance, starting in thirteenth-century Europe, of etiquette books. The

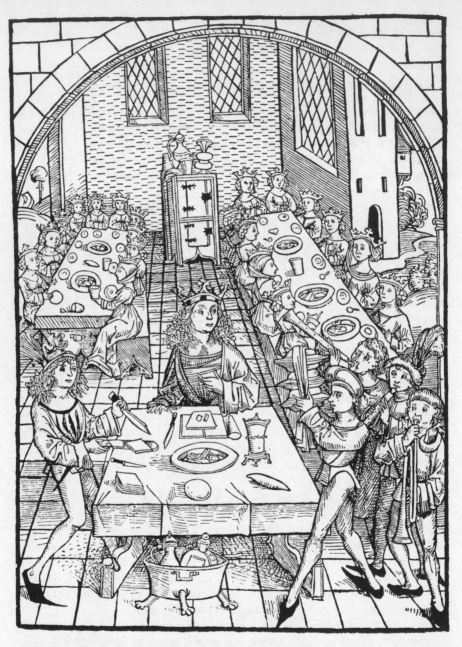

The Crusades and the prestige of knighthood occasioned a rebirth in etiquette. A cultured person ate with three fingers; a commoner with five.

upper class was expanding. More and more people had access to court, and they wanted to know how to behave. The situation is not all that different from the twentieth-century social phenomenon of upward mobility, also accompanied by etiquette books.

Here is a sampling of the advice such books offered the upwardly mobile through the centuries. (Keep in mind that what the etiquette writers caution people *against* usually represents the behavioral norm of the day.)

13th Century

- "A number of people gnaw a bone and then put it back in the dish—this is a serious offense."
- "Refrain from falling upon the dish like a swine while eating, snorting disgustingly and smacking the lips."
- "Do not spit over or on the table in the manner of hunters."
- "When you blow your nose or cough, turn round so that nothing falls on the table."

14th Century

- "A man who clears his throat when he eats, and one who blows his nose in the tablecloth, are both ill-bred, I assure you."
- "You should not poke your teeth with your knife, as some do; it is a bad habit."
- "I hear that some eat unwashed. May their fingers be palsied!"

15th Century

- "Do not put back on your plate what has been in your mouth."
- "Do not chew anything you have to spit out again."
- "It is bad manners to dip food into the salt."

During these centuries, there was much advice on the proper way of blowing one's nose. There were of course no tissues, and handkerchiefs had still not come into common use. Frowned upon was the practice of blowing into a tablecloth or coat sleeve. Accepted was the practice of blowing into the fingers. Painters and sculptors of the age frankly reproduced these gestures. Among the knights depicted on the tombstone of French king Philip the Bold at Dijon, France, one is blowing his nose into his coat, another, into his fingers.

Children's Manners: 1530, Netherlands

The one book that is credited more than any other with ushering manners out of an age of coarseness and into one of refinement is a 1530 treatise—so popular following its publication that it went through thirty editions in the author's lifetime, qualifying it as an outstanding best-seller of the six-

Table manners should be instilled in the young, the philosophy espoused by Erasmus of Rotterdam, whose etiquette book became a best-seller and a standard school text.

teenth century. The author, Christian philosopher and educator Erasmus of Rotterdam, the greatest classical scholar of the northern Humanist Renaissance, had hit on a theme ripe for discussion: the importance of instilling manners at an early age.

Titled *De civilitate morum puerilium,* or *On Civility in Children,* his text continued to be reprinted into the eighteenth century, and spawned a multitude of translations, imitations, and sequels. It became a standard school-book for the education of boys throughout Europe. While upwardly mobile adults were struggling to break ingrained habits and acquire proper manners, Erasmus pointed out that the easiest, most painless place to begin is in childhood. Manners ought to be not a patina over coarse adult actions but a foundation upon which a child can erect good behavior.

Here is a sampling of Erasmus's advice (some of it is coarse by today's standards):

- "If you cannot swallow a piece of food, turn round discreetly and throw it somewhere."
- "Retain the wind by compressing the belly."
- "Do not be afraid of vomiting if you must; for it is not vomiting but holding the vomit in your throat that is foul."
- "Do not move back and forth on your chair. Whoever does that gives the impression of constantly breaking or trying to break wind."
- "Turn away when spitting lest your saliva fall on someone. If anything purulent falls on the ground, it should be trodden upon, lest it nauseate someone."
- "You should not offer your handkerchief to anyone unless it has been freshly washed. Nor is it seemly, after wiping your nose, to spread out your handkerchief and peer into it as if pearls and rubies might have fallen out of your head."

- "To lick greasy fingers or to wipe them on your coat is impolite. It is better to use the tablecloth or the serviette."
- "Some people put their hands in the dishes the moment they have sat down. Wolves do that."

If some of Erasmus's advice seems laughable today, we should pause to consider at least one admonition from an etiquette book in our own century. On the only way to eat large lettuce leaves: "They must be cut with the blunt edge of the fork—never, never with a knife."

Emily Post: 1922, United States

European etiquette was based on precedence and dominated by the doctrine of exclusivity. American manners, on the other hand, were founded on the bedrock of equality and freedom. In the country's short history, many hundreds of etiquette books were published, most having little effect on the vast majority of Americans. Etiquette—the practice and the word— was for society folk. In fact, no etiquette writer had ever got the public to pay serious attention to the subject of manners until Emily Post. She caused something of a revolution. Almost overnight, her name became synonymous with correct behavior.

In 1922, purchasers of Emily Post's new, landmark book rarely asked for it by title, let alone its full title, *Etiquette: The Blue Book of Social Usage.* It sufficed to ask for "Emily Post." The book zoomed to the top of the nonfiction best-seller list, pushing Papini's *Life of Christ* into second place and sharing the number one spot with Sinclair Lewis's *Babbitt,* a novel that, ironically, highlighted social ineptitude. Everyone was reading Emily Post and in any social situation asking, "What would Emily Post say?"

But why was the book so widely received?

As Erasmus's volume had appeared at the dawn of the Renaissance, Emily Post's arrived when society was at another abruptly upward transformation. In the 1920s, the old standards were crumbling under the impact of the automobile, worldwide telephone communications, the movies, and general postwar prosperity and euphoria. The social trend for millions of Americans was upward and, as in Erasmus's day, people were desperate to know how to behave in higher, if not high, society.

Emily Post had not intended to write an etiquette book. She was a prize-winning novelist and newspaperwoman from Tuxedo Park, New York. She had a loathing for the pretensions of virtually all etiquette books of her day and had often suggested to friends that someone should write an honest, unaffected treatment of American manners. A friend, Frank Crowninshield, then editor of *Vanity Fair,* goaded her with a copy of a recently published etiquette book that exuded snobbishness and elitism. Further, the book

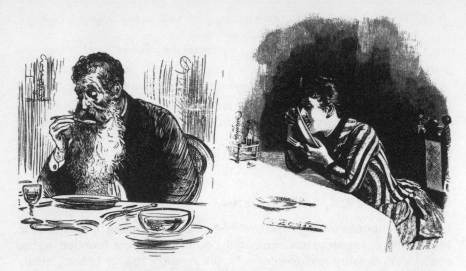

Manners change with time. In America, formal etiquette was regarded antithetical to the principles of equality and individual freedom.

was being promoted in accordance with a new trend in American advertising: an attempt to embarrass people into believing they needed certain products. For instance, the book claimed that not only were Americans ignorant of which fork to use and when, but they suffered from slovenliness, halitosis, body odor, and total social ineptitude.

Even before she finished the gift book, Emily Post decided to write a no-nonsense, lighthearted, egalitarian manual of her own. And that she did. By 1945, *Etiquette* had sold 666,000 copies, and "Post, Emily" had become a dictionary entry.

Wedgwood Ware: 18th Century, England

Although pottery had been fashioned and fired for thousands of years, by the 1700s there were still no mass-produced, identical plates, bowls, cups, and saucers. A craftsman could produce an exquisitely delicate, multihued plate—or a whole series of plates, handmade and hand painted—but there was no way to ensure that each item and its color would be consistently the same. In fact, pieces from a set of high-quality dinnerware often varied from yellowish cream to pearl white. One determined man, Josiah Wedgwood, born in 1730 into a family of potters from Staffordshire, England, would soon change that.

The youngest of twelve children, Wedgwood received only rudimentary schooling before his father died, forcing him to work in the family pottery plant at age nine. While still a child, Wedgwood began exploring new ways to color clay—first by trial and error, then by painstaking chemical methods.

The idea of tampering with the family's proven pottery formulas so infuriated his brothers that Josiah opened a rival pottery business in 1759.

As his own master, Wedgwood experimented with new glazes, clay additives, and firing techniques, keeping meticulous research notes so a particularly promising process could be exactly duplicated.

His systematic tenacity paid off. In the early 1760s, he perfected a method for uniformly coloring the popular earthenware of the day. Throughout Europe, the results were heralded as a major breakthrough. And the simple elegance of Wedgwood ware—delicate neoclassical figures applied in white, cameolike relief on a tinted background—captured the changing taste of European aristocrats, who were moving away from the ornate clutter of baroque and rococo designs.

Wedgwood's high-quality, perfectly reproducible dinnerware arrived at the right time in history. With the industrial revolution under way in England, steam power and inexpensive factory labor greatly increased the availability of his product.

Wedgwood's plates came to the attention of England's royal court. In 1765, he was commissioned to make a tea service for Queen Charlotte. An instinctive self-promoter, Wedgwood was keenly aware of the publicity value of royal patronage. He sought and received permission to christen his service "Queen's Ware." If orders were brisk before, now it seemed that every aristocrat in Europe desired to own full place settings. From Russia, Empress Catherine commissioned service for two hundred guests—a total of 952 pieces of Queen's Ware.

Despite his personal wealth and friendships with European nobility, Wedgwood remained a man of strong democratic views. He publicly supported the American Revolution and was outspoken in his opposition to slavery; an "antislavery cameo" he produced showed a slave in chains and bore the inscription "Am I not a man and a brother?"

Josiah Wedgwood died in 1795, leaving a large part of his estate to his daughter, Susannah Wedgwood Darwin, whose son, Charles, would one day be even more renowned than his grandfather.

Stainless-Steel Cutlery: 1921, United States

Until the early part of this century, knives, forks, and spoons were the bane of the average housewife, for great effort was required to keep them shining. Flatware was made of a compound of carbon and steel, which yielded a sturdy, durable product but one that quickly discolored. To retain a semblance of its original luster, table cutlery had to be routinely rubbed with a dry cork and scouring powder or with steel wool.

The great cutlery breakthrough came with the development of stainless steel.

As early as 1820, a French metallurgist, L. Berthier, observed that when

Stainless steel liberated home-makers from the weekly polishing of flatware, while Bakelite handles (right) offered protection from burns.

carbon steel was combined with an alloy like chrome, it yielded a rust-resistant metal. Not fully appreciating the significance of his discovery, Berthier abandoned the research. It was continued by British scientists, who in 1913 alloyed the pure element chromium with a variant of Berthier's carbon steel (called 35-point carbon steel) and produced steel that held its luster and merited the name stainless. The following year, Krupp, the German steel and munitions manufacturers, introduced a stainless steel containing chromium and nickel. At first, in Britain and Germany, the metal's industrial applications overshadowed its culinary possibilities. Not until 1921, at the Silver Company of Meriden, Connecticut, was the first stainless-steel dinnerware produced—not forks or spoons, but knives, and in a pattern the company named "Ambassador."

The glistening flatware was its own best advertisement. American hotels and restaurants, calculating the hours and dollars spent polishing carbon steel, ordered all their kitchen and dining room cutlery in stainless steel. Magazine ads appeared that seemed to promise the impossible: "No tarnish! No rust! No plating to wear off—it's solid gleaming stainless steel!" By the 1930s, Gimbel's and Macy's in New York were offering stainless-steel flatware at nineteen cents apiece. And a further incentive to purchase the new product was the introduction of handles—in pastel and two-tone colors—

made of a durable new heat-resistant plastic called Bakelite. Even among the wealthy, stainless-steel flatware became a formidable contender for silver's long-held position of prestige at the table.

Table Talk: Antiquity to Present

"Bottoms Up!" "Here's looking at you!" "Mud in your eye!" "Cheers!"

The traditional things we say at the table—including toasts and grace—often originated in earlier times and for purposes that may not seem obvious or purposeful today. The same is true for table- and food-related expressions. A husband who is a ham may bring home the bacon, and his wife, a cold turkey, may make him eat humble pie. They may both take the cake. How did such customs and phrases originate? Well, let's talk turkey.

Making a Toast. Anyone who has ever drunk a toast to a friend's health or good fortune may have wondered how the word "toast" came to designate a ceremony that involves no roasted slice of bread.

The custom of a host drinking to a friend's health originated with the Greeks, as early as the sixth century B.C., and for a highly practical reason: to assure guests that the wine they were about to consume was not poisoned.

Spiking wine with poison had long been a preferred way to dispose of a political rival or suspected enemy, or to circumvent divorce. Thus, a host sipped the first wine poured from a decanter, and satisfied of its safety, the guests raised their glasses and drank. This drinking in sequence—guests following host—came to symbolize a sort of pledge of friendship and amity.

The Romans adopted the Greek penchant for poisoning (the ambitious Livia Drusilla, empress of Rome in the first century B.C., made something of a science of the practice) and the custom of drinking as a pledge of friendship. The Roman custom of dropping a burnt piece of toast into a cup of wine is the origin of the verbal usage. The practice continued into Shakespeare's time. In Shakespeare's *Merry Wives of Windsor,* Falstaff orders a jug of wine and requests "put toast in't."

For many years, it was assumed that the Roman slice of toast was a piece of spiced or sugared bread, added to wine for sweetening. More recently, it was scientifically shown that charcoal can reduce a liquid's acidity, and that a blackened piece of bread added to an inferior, slightly vinegary wine can render it more mellow and palatable—something the Romans may have discovered for themselves. Our word "toast" comes from the Latin *tostus,* meaning "parched" or "roasted."

In summary: The Greeks drank to a friend's health; the Romans flavored the drink with toast; and in time, the drink itself became a "toast."

In the early eighteenth century, the custom of drinking a toast took a new twist. Instead of drinking to a friend present at a dinner, the toast was drunk to the health of a celebrated person, particularly a beautiful woman—

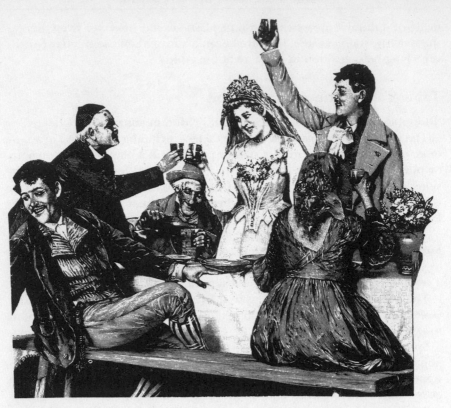

Toasting arose as a goodwill gesture to prove a libation was not spiked with poison. In England, toasting a celebrated woman elevated her to being the "toast of the town."

whom the diners might never have met. In *The Tatler* of June 4, 1709, Sir Richard Steele mentions that British men were so accustomed to toasting a beautiful woman that "the lady mentioned in our liquor has been called a *toast.*" In Steele's lifetime, a celebrated or fashionable Briton became known as the "toast of the town."

In the next century, drinking toasts acquired such popularity in England that no dinner was complete without them. A British duke wrote in 1803 that "every glass during dinner had to be dedicated to someone," and that to refrain from toasting was considered "sottish and rude, as if no one present was worth drinking to." One way to effectively insult a dinner guest was to omit toasting him or her; it was, as the duke wrote, "a piece of direct contempt."

Saying Grace. The custom of offering a prayer before a meal did not

originate as an expression of thanksgiving for the food about to be consumed. That came later—after the dawn of agriculture, when civilization's first farmers began to pray to their gods for bountiful harvests.

In earlier times, nomadic tribes were not always certain of the safety of the food they found. Meat quickly rotted, milk soured, and mushrooms, berries, and tubers could often be poisonous. Since nomads changed habitats frequently, they were repeatedly confronted with new sources of food and determined their edibility only through trial and error. Eating could be hazardous to one's health, resulting in cramps, fever, nausea, or death.

It is believed that early man initially prayed to his gods before eating to avert any deleterious influence the found or foraged food might have on him. This belief is reinforced by numerous later accounts in which peoples of the Middle East and Africa offered sacrifices to gods before a feast— not in thanksgiving but with deliverance from poisoning in mind. Later, man as a farmer grew his own crops and raised cattle and chickens—in short, he knew what he ate. Food was safer. And the prayers he now offered before a meal had the meaning we are familiar with today.

Bring Home the Bacon. Though today the expression means either "return with a victory" or "bring home cash"—the two not being unrelated—in the twelfth century, actual bacon was awarded to a happily married couple.

At the church of Donmow, in Essex County, England, a flitch of cured and salted bacon used to be presented annually to the husband and wife who, after a year of matrimony, proved that they had lived in greater harmony and fidelity than any other competing couple. The earliest recorded case of the bacon award dates from 1445, but there is evidence that the custom had been in existence for at least two hundred years. Exactly how early winners proved their idyllic cohabitation is unknown.

However, in the sixteenth century, each couple that came forward to seek the prize was questioned by a jury of (curiously) six bachelors and six maidens. The couple giving the most satisfactory answers victoriously took home the coveted pork. The prize continued to be awarded, though at irregular intervals, until late in the nineteenth century.

Eat One's Hat. A person who punctuates a prediction with "If I'm wrong, I'll eat my hat" should know that at one time, he or she might well have had to do just that—eat hat. Of course, "hat" did not refer to a Panama or Stetson but to something more palatable—though only slightly.

The culinary curiosity known as a "hatte" appears in one of the earliest extant European cookbooks, though its ingredients and means of preparation are somewhat vague. "Hattes are made of eggs, veal, dates, saffron, salt, and so forth," states the recipe—but they could also include tongue, honey, rosemary, kidney, fat, and cinnamon. The book makes it clear that the concoction was not particularly popular and that in the hands of an

amateur cook it was essentially uneatable. So much so that a braggart who backed a bet by offering to "eat hatte" had either a strong stomach or confidence in winning.

Give the Cold Shoulder. Today this is a figurative expression, meaning to slight a person with a snub. During the Middle Ages in Europe, however, "to give the cold shoulder" was a literal term that meant serving a guest who overstayed his welcome a platter of cooked but cold beef shoulder. After a few meals of cold shoulder, even the most persistent guest was supposed to be ready to leave.

Seasoning. Around the middle of the ninth century, when French was emerging as a language in its own right, the Gauls termed the process of aging such foods as cheese, wine, or meats *saisonner.* During the Norman Conquest of 1066, the French invaders brought the term to England, where the British first spelled it *sesonen,* then "seasoning." Since aging food, or "seasoning" it, improved the taste, by the fourteenth century any ingredient used to enhance taste had come to be labeled a seasoning.

Eat Humble Pie. During the eleventh century, every member of a poor British family did not eat the same food at the table. When a stag was caught in a village, the tenderest meat went to its captor, his eldest son, and the captor's closest male friends. The man's wife, his other children, and the families of his male friends received the stag's "umbles"—the heart, liver, tongue, brain, kidneys, and entrails. To make them more palatable, they were seasoned and baked into an "umble pie." Long after the dish was discontinued (and Americans added an *h* to the word), "to eat humble pie" became a punning allusion to a humiliating drop in social status, and later to any form of humiliation.

A Ham. In the nineteenth-century heyday of American minstrelsy, there existed a popular ballad titled "The Hamfat Man." Sung by a performer in blackface, it told of a thoroughly unskilled, embarrassingly self-important actor who boasted of his lead in a production of *Hamlet.*

For etymologists, the pejorative use of "ham" in the title of an 1860s theater song indicates that the word was already an established theater abbreviation for a mediocre actor vain enough to tackle the role of the prince of Denmark—or any role beyond his technical reach. "The Hamfat Man" is credited with popularizing the slurs "ham actor" and "ham."

Take the Cake. Meaning, with a sense of irony, "to win the prize," the American expression is of Southern black origin. At cakewalk contests in the South, a cake was awarded as first prize to the person who could most imaginatively strut—that is, cakewalk. Many of the zany walks are known

to have involved tap dancing, and some of the fancier steps later became standard in tap dancers' repertoires.

"Let Them Eat Cake." The expression is attributed to Marie Antoinette, the extragavant, pleasure-loving queen of Louis XVI of France. Her lack of tact and discretion in dealing with the Paris proletariat is legend. She is supposed to have uttered the famous phrase as a retort to a beggar's plea for food; and in place of the word for "cake," it is thought that she used the word for "crust," referring to a loaf's brittle exterior, which often broke into crumbs.

Talk Turkey. Meaning to speak candidly about an issue, the expression is believed to have originated from a story reported in the nineteenth century by an employee of the U.S. Engineer Department. The report states:
"Today I heard an anecdote that accounts for one of our common sayings. It is related that a white man and an Indian went hunting; and afterwards, when they came to divide the spoils, the white man said, 'You take the buzzard and I will take the turkey, or, I will take the turkey and you may take the buzzard.' The Indian replied, 'You never once said turkey to me.' "

Chapter 5

Around the Kitchen

Kitchen: Prehistory, Asia and Africa

If a modern housewife found herself transported back in time to a first-century Roman kitchen, she'd be able to prepare a meal using bronze frying pans and copper saucepans, a colander, an egg poacher, scissors, funnels, and kettles—all not vastly different from those in her own home. Kitchenware, for centuries, changed little.

Not until the industrial revolution, which shook society apart and reassembled it minus servants, did the need arise for machines to perform the work of hands. Ever since, inventors have poured out ingenious gadgets— the dishwasher, the blender, Teflon, Tupperware, S.O.S. pads, aluminum foil, friction matches, the humble paper bag, and the exalted Cuisinart— to satisfy a seemingly unsaturable market. The inventions emerged to fill a need—and now fill a room in the house that has its own tale of origin and evolution.

In prehistoric times, man prepared food over an open fire, using the most rudimentary of tools: stone bowls for liquids, a mortar and pestle for pulverizing salt and herbs, flint blades for carving meat roasted on a spit. One of the earliest devices to have moving parts was the flour grinder. Composed of two disk-shaped stones with central holes, the grinder accepted grain through the top hole, crushed it between the stones, then released flour through the bottom hole.

In the Near East, the primitive kitchen was first modernized around 7000 B.C. with the invention of **earthenware,** man's earliest pottery. Clay pots and baking dishes then as now ranged in color from creamy buff to burnt

96

Terriers were trained as "spit runners" to relieve a cook from the tedium of hand-cranking a turnspit.

red, from ash gray to charcoal black. An item of any desired size or shape could be fashioned, fired by kiln, and burnished; and a wide collection of the earliest known kitchen pottery, once belonging to a Neolithic tribe, was unearthed in Turkey in the early 1960s. Bowls, one of the most practical, all-purpose utensils, predominated; followed by water-carrying vessels, then drinking cups. A clay food warmer had a removable bowl atop an oil lamp and was not very different in design from today's models, fired by candles.

Throughout the Greek and Roman eras, most kitchen innovations were in the realm of materials rather than usage—gold plates, silver cups, and glass bottles for the wealthy; for poorer folk, clay plates, hollowed rams' horn cups, and hardwood jugs.

A major transformation of the kitchen began around A.D. 700. Confronted by the hardships of the Middle Ages, extended families banded together, life became increasingly communal, and the kitchen—for its food and the warmth offered by its fire—emerged as the largest, most frequented room in the house.

One of the valued kitchen tools of that time was the turnspit. It was to survive as the chief cooking appliance for nearly a thousand years, until the revolutionary idea in the late 1700s of roasting meat in an oven. (Not that the turnspit has entirely disappeared. Many modern stoves include an electrically operated rotary spit, which is also a popular feature of outdoor barbecues.)

In the turnspit's early days, the tedious chore of hand-cranking a roast led to a number of innovations. One that today would incense any animal lover appeared in England in the 1400s. A rope-and-pulley mechanism led from the fired spit to a drum-shaped wooden cage mounted on the wall. A small dog, usually a terrier, was locked in the cage, and as the dog ran, the cage revolved and cranked the spit. Terriers were actually trained as

"spit runners," with hyperactive animals valued above others. Gadgets were beginning to make their mark.

A century later, in Italy, Leonardo da Vinci devised a thoroughly humane self-turning spit, powered by heat ascending the chimney. A small turbine wheel, built into the chimney, connected to the fired spit. Rising heat rotated the wheel with a speed proportional to the ferocity of the flames. But the centuries-old concept of cooking directly above an open fire was about to be replaced by a revolutionary cooking innovation: the enclosed range.

Kitchen Range: 17th Century, England

Bricking up the kitchen inglenook around the hearth formed the earliest range, which had a heated top surface and side hobs for keeping a kettle or saucepan warm.

In 1630, British inventor John Sibthrope patented a large metal version of such a device, which was fired by coal, a substance that would soon replace wood as the domestic fuel. But the idea of cooking above an enclosed fire instead of above or in an open flame was slow to catch on. And the cooking process itself was slower, since an intermediate element, the range-top, had to be heated.

An American-born innovator set out to develop a compact, efficient range but instead produced two other kitchen appliances.

Count von Rumford of Bavaria was born Benjamin Thompson in Woburn, Massachusetts, in 1753. Loyal to the British crown, Thompson served as a spy during the American Revolution, and in 1776 he fled to London, leaving his wife and daughter behind. Knighted by King George III, Thompson studied physics in England, with special emphasis on the application of steam energy. His experiments led to his invention of the double boiler and the drip coffee maker. But his work on a compact kitchen range was interrupted by state business.

Entering the Bavarian civil service, Thompson was appointed the country's grand chamberlain. In between instituting numerous social reforms, he found time to modernize James Watt's steam engine and to popularize the potato—long regarded as animal fodder and sustenance for the poor—as a European table food among the upper classes. But his dream of producing a compact, closed-top cooking range became a reality in someone else's hands. In 1802, while the then-renowned Sir Benjamin Thompson was establishing the Rumford professorship at Harvard University, British iron founder George Bodley patented a cast-iron even-heating range with a modern flue, which became the prototype of British and American kitchen ranges until the present century.

Gas and Electric Ranges. The same year that George Bodley brought out his closed-top, coal-powered range, German inventor Frederick Albert Winson cooked history's first meal by gas.

Gas ranges, c. 1890, the year the electric range debuted. Whereas gas models once leaked fumes and exploded, early electric ranges, with crude temperature controls, could incinerate a meal.

Winson's device was makeshift, designed merely to demonstrate gas's cooking possibilities and its cleanliness compared to coal fires. Many of the experimental gas ranges that followed were hazards, leaking fumes and exploding. Thirty years would pass before a truly practical and safe gas range was manufactured in Europe; American homes would not have the clean-cooking innovations in any significant number until the 1860s.

Once homemakers felt safe and comfortable cooking with gas, they were reluctant to abandon it for the kitchen's newest innovation, the electric range.

The first electric stoves appeared in 1890, and they made almost any meal cooked on them a disaster. With only the crudest of thermostats, heat control was not so much a matter of low, medium, or high as of raw or incinerated. And the price for this unpredictability was steep, since inexpensive home electric rates would not become a reality until the late 1920s. In addition, many homes in parts of America had yet to be wired for electric power. The electric stove proved to be even less popular than the early gas stove had been, and it took longer to become a standard feature of the American kitchen, never superseding gas, as had once been the prediction.

Gadget. It was during the early years of electric power that any small, handy item for the kitchen acquired the name "gadget," a word that did not exist prior to 1886. Although the word—as well as the idea it conveys—sounds American to its core, according to popular legend it is French. And

if we were to pronounce it correctly, we would be naming the man who gave us the eponym.

Monsieur Gaget was a partner in the French construction firm of Gaget, Gauhier & Cie., which built the Statue of Liberty to the design specifications of sculptor Frédéric-Auguste Bartholdi. For the statue's inauguration ceremonies in 1886, Gaget conceived the idea of selling miniature Liberty souvenirs to Americans living in Paris. Americans abroad bought the replicas and began referring to them as "gadgets," mispronouncing Gaget's name. Consequently, the 1986 centennial of the Statue of Liberty also marked the one hundredth birthday of the word "gadget," though possibly only Monsieur Gaget's descendants celebrated that event.

Porcelain Pots and Pans: 1788, Germany

The first real cooking utensil made in America was a 1642 cast-iron pot, the now-famous Saugus Pot, produced at the Saugus Iron Works in the old Massachusetts city of Lynn. The crudely fashioned, three-legged pot—with a lid and a one-quart capacity—marked the beginning of the kitchenware industry in America, for prior to that time every metallic item in a colonist's kitchen was a British import.

Just as American foundries were beginning to produce black cast-iron pots with rough exteriors, the German kitchenware industry was moving toward something totally unheard of—and seemingly impractical—for cooking: porcelain. In 1750, inventor Johann Heinrich Gottlob von Justy suggested coating the coarse exterior of iron pots and pans with the smooth, lustrous enamel glazes long used on jewelry. His critics contended that the delicacy of porcelain enamel would never withstand kitchen usage. Von Justy countered with the indisputable fact that hundreds of ancient porcelain artifacts had retained their brilliance and hardness for centuries; some Egyptian ornaments dated back to 1400 B.C.

For a while, the technical problems of annealing a heat-resistant porcelain to cast iron seemed insurmountable. But in 1788, the Konigsbronn foundry in Württemberg produced the first kitchen pots with a shimmering white enamel finish. The development ushered in a new era in culinary ware, providing homemakers with a wide range of utensils that cleaned more easily than anything previously known. Porcelain was the Teflon of the eighteenth century. One early advertisement punned: "No longer can the pot call the kettle black."

But the porcelain innovators had not anticipated one surprising public reaction. The glistening pots, pans, and ladles were simply too attractive to use for cooking only. Thus, for a number of years, German housewives proudly displayed their porcelainware as objets d'art—on knickknack shelves, atop pianos, and on windowsills for passersby to appreciate.

The British, in sharp contrast, took the artful German breakthrough and

gave it a highly practical if thoroughly mundane application: they produced the first porcelain-enamel bedpans and urine bottles for hospitals and homes. Again, it was the material's nonstick, nonstain surface that contributed to the utensils' rapid acceptance.

It was not until the final year of the American Civil War that porcelain-enamel cooking utensils were manufactured in the United States—initially in three cities: Sheboygan, Wisconsin; Woodhaven, New York; and St. Louis, Missouri.

Aluminum Ware: Early 19th Century, France

While the Germans were cooking in porcelain and the British were using it to sanitize homes and hospitals, Napoleon Bonaparte in France was serving his guests on the world's first aluminum plates—which then cost more than gold ones. The newly mined metal sold for six hundred dollars a pound, and by the 1820s Europe's nobility was packing away some of its goldware and silverware to highlight aluminum plates, cups, and cutlery.

Aluminum, however, rapidly lost its social luster. Aggressive mining of the metal, coupled with electric extraction techniques, caused its price to plummet to $2.25 a pound in 1890. Despite the lower price, American homemakers had yet to discover the advantages of cooking with aluminum. Two events—a technical advance and a department store demonstration—would soon change that.

On February 23, 1886, twenty-two-year-old inventor Charles Martin Hall, a recent college graduate in science, was experimenting with aluminum in his laboratory in Oberlin, Ohio. Hall's notebooks record that on that day he perfected a procedure for inexpensively producing an aluminum compound that could be cast into cookware. Hall founded his own company and began manufacturing lightweight, durable, easy-to-clean cooking utensils that yielded a remarkably even distribution of heat and retained their sheen. Their durability suggested a trademark name: **Wear-Ever.**

Hall's products met formidable opposition. American housewives were reluctant to abandon their proven tinware and ironware, and the country's major department stores refused to stock the new product, whose benefits sounded too fantastical to be true. The turning point came in the spring of 1903. At the persuasion of a buyer, the renowned Wanamaker's store in Philadelphia staged the first public demonstration of aluminum's cooking abilities. Hundreds of women watched in amazement as a professional chef cooked apple butter *without stirring*. Once the onlookers were allowed to step forward and assure themselves that the ingredients had not stuck to the pan or burned, orders poured in for aluminum cookware. By the time of Charles Hall's death in 1914, his line of Wear-Ever products had spawned a new aluminum-cookware industry, transformed the American kitchen, and rewarded Hall with a personal fortune of thirty million dollars.

S.O.S. Pads: 1917, San Francisco

In 1917, Edwin W. Cox of San Francisco was a door-to-door salesman whose line of merchandise included the new, highly touted aluminum cookware. Sales were mediocre; West Coast housewives had not yet been sold on the latest in pan technology. Cox found it difficult even to get into a kitchen to demonstrate his products. He needed a gimmick. So, in the best salesmen's tradition, he decided to offer each potential client a free introductory gift for allowing him to display his line.

From experience, Cox knew that a major cooking complaint was the way food stuck to pans. Why not develop a pad that combined the abrasiveness of steel wool and the cleansing ability of soap?

In his own kitchen, Cox hand-dipped small, square steel-wool pads into a soapy solution. When each pad dried, it was redipped, and the process was diligently repeated until every pad was saturated with dried soap.

As he began calling on housewives, he found that the yet-unnamed pads opened doors—and boosted sales. Each woman received one free sample. Most women asked for more. Many called his home to learn where additional pads might be purchased. Within a few months, demand for the pads outgrew Cox's ability to dip and dry them in his kitchen. Edwin Cox stopped selling pots and pans and went into the business of manufacturing soap pads.

In need of a catchy name for the new product, Cox turned to the housewife he knew best—his wife. In her own kitchen, Mrs. Cox referred to the pads as "S.O.S." for "Save Our Saucepans," and because she believed (incorrectly) that the letters stood for the universal distress call at sea, "Save Our Ship." Needless to say, Mr. Cox took his wife's suggestion—though S.O.S. is a misnomer on two counts.

The actual Morse code distress signal, accepted by international agreement among the world's nations, is not an acronym for "Save Our Ship," "Save Our Souls," or any other popular salvation phrase. In fact, it is not an abbreviation for anything.

When New York University art professor Samuel Morse, a painter turned inventor, devised his telegraphy code in 1835, he attempted to choose combinations of dots and dashes that were relatively easy to memorize. A few years later, when the international committee sought a distress signal that would be easy to recall in a time of crisis, and could be transmitted by an amateur with only the slightest knowledge of Morse code, they decided on a simple combination of threes: three letters, each represented by three marks. Three, they felt, was a universally favored number.

In Morse code, only two letters of the alphabet are represented by three identical marks: three dashes for *O*, three dots for *S*. Thus, the universal distress signal (and the name of the soap pads) could have been "OSO." Dashes, however, are longer electrical signals to transmit than dots. An

urgent message should be broadcast as quickly as possible and consume as little as necessary of the transmitting device's energy. Consequently, the only three-letter, three-dot, three-dash, rapid, energy-efficient call for assistance could be "SOS." Without punctuation. Mrs. Cox's error, though, has not hurt the sale of soap pads.

Dishwasher: 1886, Shelbyville, Illinois

"If nobody else is going to invent a dishwashing machine, I'll do it myself."

With that determined proclamation, Josephine Cochrane, wife of an Illinois politician in the 1880s, set out to invent a major kitchen appliance—though not because Mrs. Cochrane was fed up with the humdrum chore of dirty dishes; she was a wealthy woman, with a full staff of servants. A blueblood from Chicago, living in the small prairie town of Shelbyville, Illinois, Josephine Cochrane frequently gave formal dinners and she *was* fed up with dishwashing servants breaking her expensive china. Every party ended with more shattered dishes, which took months to replace by mail. A machine seemed like the ideal solution.

In a woodshed adjoining her home, Josephine Cochrane measured her dinnerware, then fashioned individual wire compartments for plates, saucers, and cups. The compartments fastened around the circumference of a wheel that rested in a large copper boiler. As a motor turned the wheel, hot soapy water squirted up from the bottom of the boiler and rained down on the dinnerware. The design was crude but effective, and it so impressed her circle of friends that they dubbed the invention the "Cochrane Dishwasher" and placed orders for machines for their kitchens. They, too, viewed the device as a solution to the vexing problem of irresponsible help.

Word spread. Soon Josephine Cochrane was receiving orders from Illinois hotels and restaurants, where volume dishwashing—and breakage—was a continual and costly problem. Realizing that she had hit upon a timely invention, Mrs. Cochrane patented her design in December 1886; her washer went on to win the highest award at the 1893 Chicago World's Fair for, as the citation read, "the best mechanical construction, durability, and adaptation to its line of work."

Hotels and restaurants remained the best customers for Josephine Cochrane's large-capacity dishwashers. But in 1914, the company she had founded came out with a smaller machine, for the average American home. To management's astonishment, the average American housewife was unimpressed with the labor-saving device.

Part of this reluctance was technological. In 1914, many homes lacked the quantity of scalding water a dishwasher then required. The entire contents of a family's hot-water tank might be insufficient to do just the dinner dishes. Furthermore, in many parts of the country the water was "hard," containing dissolved minerals that prevented soap from sudsing enough to

spray-clean the dishes. Elbow power was required to get dinnerware sparkling.

But there was another problem that no one in Mrs. Cochrane's company had anticipated. Josephine Cochrane, who had never washed a dish, assumed that American housewives viewed dishwashing as a disagreeable chore. However, when her executives polled housewives, hoping to learn why the home models weren't selling, they discovered that while numerous household duties were dreaded (principally laundering the family clothes), dishwashing was not one of them. Quite the contrary. The majority of the women questioned in 1915 reported that doing dinner dishes was a welcome relaxer at the end of a hard day.

Mrs. Cochrane's company (which later would merge with an Ohio manufacturing firm to produce the popular Kitchenaid dishwasher) adopted another advertising angle: A major reason for purchasing a dishwasher was the proven fact that a machine could use water far hotter than the human hand could bear. Thus, dishwashers not only got plates and glasses cleaner; they also killed more germs. Sales still did not appreciably improve. The home market for dishwashers would not become profitable until the early 1950s, when postwar prosperity made leisure time, glamour, and an emerging sense of self, independent from husband and children, major concerns of the American housewife.

Home Water Softeners: 1924, St. Paul, Minnesota

One feature that home owners in many parts of America take for granted today is soft water—that is, tap water which has been treated to remove ions of calcium and magnesium so they will not form an insoluble residue in pipes and will not link up with soap to form an unsightly, dandruff-like precipitate on dishes and clothes.

Soft water, though, did not flow in every home's pipes in the early part of this century (and it still doesn't). In many parts of the country, water was "hard." And hard water, as we have seen, was one reason for the slow sales of early dishwashing machines. One man had a profound effect on the quality of America's water.

Emmett Culligan did not set out to invent water softeners. He wanted to be a wealthy real estate tycoon and was headed in that direction until disaster rerouted him.

In his hometown, Porter, Minnesota, the twenty-four-year-old Culligan bore the nickname "Gold Dust," for the sizable fortune he had amassed in real estate since leaving college in his sophomore year. His forte was unwanted prairie land, which he would sow to flax, selling field and crop at a handsome profit. Before he turned thirty, his landholdings were worth a quarter of a million dollars.

Then in 1921, a severe farm recession drove down the price of agricultural products and precipitated a rash of farm failures. The value of Culligan's

property plummeted. Unable to repay loans, he declared bankruptcy and moved his wife and newborn infant to his parents' home in St. Paul.

One afternoon, Emmett Culligan encountered a boyhood friend who had been experimenting with ways to soften water, a challenge that had intrigued many inventors. Culligan's friend demonstrated his "conditioning machine." It used a natural sand, zeolite, to filter ions of magnesium and calcium from hard water.

The friend explained that the zeolite exchange resin contained sodium ions that literally swapped places in water with the undesirable ions. When the zeolite became exhausted—that is, when most of its exchangeable sodium had been replaced by magnesium and calcium—it could be restored by washing with a strong solution of common table salt, sodium chloride.

Intrigued by the principle, Culligan borrowed a bag of zeolite. At home, he poured the chemical into a perforated coffee tin and passed hard tap water through it. Then he used the filtered water to wash his baby's diapers. Their resulting softness convinced him and his wife that any parent made aware of the improvement would never again put an infant into a hard-water-washed diaper. On the spot, he resolved to stage a business comeback based on water softeners.

Culligan launched his water softener firm in 1924, producing filtering machines that sold for two hundred dollars. Despite the steep price, sales were impressive and the "Gold Dust" boy was back in the money.

Surviving another setback (the market crash of 1929), he devised a marketing strategy based on the telephone company's practice of leasing equipment to sell a service. Home owners could rent an expensive water-softening machine for a modest monthly fee of two dollars.

Culligan's business grew quickly, and by 1938 he had franchises throughout the Northeast. A decade later, the dealership network was national. Homemakers used filtered water to hand- and machine-wash clothes and dishes, with noticeable improvements in both. Then a clever ad campaign, featuring a hard-water housewife shouting, "Hey Culligan Man!" swept the country. Acquiring the popularity of the latter-day "Where's the beef?" the phrase helped turn home water softeners into a multimillion-dollar business.

Teflon Utensils: 1954, France

Although Teflon was the serendipitous discovery of an American chemist, it took the cooking ingenuity of the French to produce the world's first nonstick Teflon frying pan. Once the item was, so to speak, hot in Paris, American manufacturers, who had disbelieved the possibility of a no-stick cooking surface, scrambled to place orders.

The Teflon tale begins with a small dinner in Baltimore in 1958. Thomas Hardie, foreign correspondent for United Press International, accepted an invitation to the home of a friend who had recently returned from Paris.

The meal was prepared in an amazing French skillet to which not a particle of food stuck—even though the friend had avoided using butter or oil. Hardie marveled at the pan's coating, which he learned the French called Tefal, though the product was an American "plastic" manufactured for industrial purposes by Du Pont under the name Teflon. Why, wondered Hardie, wasn't such a pan available in America?

Hardie flew to France.

At the Tefal factory outside Paris, he met the company's president, Marc Gregoire. Gregoire had first heard of Teflon in the early 1950s—also through a friend, one who had devised a way to affix a thin layer of the Du Pont plastic to aluminum for industrial applications. An avid fisherman, Gregoire began coating his tackle with the substance to minimize sticking and tangling. His wife conceived the idea of coating cookware. At her request, he coated one of her frying pans, then another. That was several years before Hardie's arrival. Now French stores were selling more than a million Tefal-coated pans a year.

Hardie returned to the United States with several pans and even greater disbelief that the miracle product had not yet hit America's shores. For the next two years, he called on every major cooking-utensil manufacturer in the country. Not one expressed the slightest interest. Convinced that an American market existed for Teflon cookware, he cabled Gregoire to ship him three thousand pans. When they arrived, he sent a complimentary sample and instructions to one hundred major department stores. Not a single buyer placed an order. No one believed the pans were stick-free.

Eventually, he persuaded the housewares buyer at Macy's Herald Square store in New York City to take two hundred pans. Priced at $6.94, the pans went on sale December 15, 1960, during one of the city's severest snowstorms. Seventeen inches of snow blanketed the city and the mercury quavered at nine degrees Fahrenheit. Nonetheless, New Yorkers weathered the blustery elements in such numbers that Macy's' stock sold out in two days. The store clamored for more pans. And so did American housewives. When the Paris factory could no longer meet the American demand, Hardie formed his own company and in 1961 built a highly automated factory in Timonium, Maryland. By this time, every American kitchen utensils manufacturer was planning its own line of Teflon-coated cookware.

A new item had entered the kitchen.

All this activity delighted Dr. Roy Plunkett, the soft-spoken Du Pont chemist who had accidentally discovered Teflon, while experimenting with coolant gases, the kind used in refrigerators and air conditioners.

On the morning of April 6, 1938, at Du Pont's laboratory in New Jersey, Plunkett examined a container that had been stored overnight. It should have held a very cold gas, but instead he found the new gas had congealed to form a waxy solid that had affixed itself to the container's wall. He was amazed at its slipperiness and utter imperviousness to all sorts of corrosive chemicals he subjected it to.

He named the compound Teflon, short for its chemical name: tetrafluoroethylene.

The Guinness Book of World Records would later list Teflon as the slipperiest substance on earth, having the "lowest coefficient of static and dynamic friction of any known solid." The slipperiness has been measured as equivalent to that of two wet ice cubes rubbing against each other in a warm room. After ten years of further research, the Du Pont chemical was introduced for industrial applications in 1948. Never was there talk at that time about putting it on frying pans.

Today Teflon is used in space suits and computer microchips, it replaces arteries of the human heart and serves as a heat shield during a rocket's reentry into the earth's atmosphere. And Teflon has also been applied to the Statue of Liberty's fifteen thousand joints to slow her aging. Around the home, a Teflon coating on light bulbs minimizes shattering, and on a car's brakes it reduces the wear and tear of friction. For his discovery, Dr. Roy Plunkett was inducted into the National Inventors' Hall of Fame in 1985.

Brown Paper Bag: 1883, Philadelphia

There are few things simpler and more functional than the paper bag. Picasso painted on them. The artist Saul Steinberg has used them to create elaborate masks. And Americans consume them at the rate of forty billion a year. As simple and indispensable as the paper bag is, the invention as we know it today—with its convenient flat bottom and pleated sides—is, surprisingly, only one hundred years old.

Charles Stilwell, the inventor of the brown paper grocery bag, was born on October 6, 1845, in Fremont, Ohio. He enlisted in the Union Army at age seventeen, and served in the Civil War. It was shortly after his discharge that Stilwell began to tinker with inventions, and one of his earliest successes, in the summer of 1883, was the first machine to produce paper bags. Bags existed before Stilwell's time, but they were pasted together by hand; their V-shaped bottoms prevented them from standing on their own; and they were not easily collapsible or conveniently stackable.

Stilwell's design was a marvel of simple engineering. He named the flat-bottom, pleated-sides bag S.O.S., for "Self-Opening Sack" (the bag could open instantly to its full shape with a snap of the wrist). And its pleats, or gussets, which allowed the bag to open quickly, also permitted it to collapse and stack neatly. But the feature that endeared it to grocers and market baggers was its ability to stand upright, fully opened, by itself.

The biggest boom to the Stilwell bag came with the birth of the American supermarket in the early 1930s. Never had a single store offered a wider selection of foods and household products—all to be carted away in humble brown sacks. As supermarkets multiplied in response to the country's expanding population, demand for Stilwell's flat-bottom bags grew propor-

Hand-gluing paper bags and boxes. A machine to mass-produce flat-bottom grocery bags was patented in 1883.

tionally. Versatility, strength, and low cost made them a nationwide, then worldwide, institution. Today America's 28,680 supermarkets alone purchase 25 billion bags a year.

Charles Stilwell died on November 25, 1919, in Wayne, Pennsylvania, but not before his fertile mind had invented a machine for printing on oilcloth, a movable map for charting stars, and at least a dozen other brainstorms. The masterpiece of his career, though, is patent number 279,505, the machine that made the bag at once indispensable and disposable.

Friction Match: 1826, England

Homo erectus, a forerunner of modern man, accidentally discovered fire through the friction generated by two sticks rubbed together. But 1.5 million years would pass before a British chemist, John Walker, produced instantaneous fire through the friction of a match rubbed over a coarse surface. Ironically, we know more today about *Homo erectus* than we do about John Walker, who also made his discovery by accident.

Other inventors and scientists had attempted to make matches. The first friction device of note was the Boyle match.

In 1669, an alchemist from Hamburg, Hennig Brandt, believed he was on the verge of transforming an olio of base metals into gold, when instead he produced the element phosphorus. Disappointed, he ignored the discovery, which came to the attention of British physicist Robert Boyle. In 1680, Boyle devised a small square of coarse paper coated with phosphorus, along with a splinter of wood tipped with sulfur. When the splinter was

drawn through a folded paper, it burst into flames. This marked the first demonstration of the principle of a chemical match. However, phosphorus was scarce in those days, so matches were relegated to the status of a costly, limited-quantity novelty. They disappeared before most Europeans—who kindled fires with sparks from flint striking steel—knew they had existed.

The year 1817 witnessed a more dramatic attempt to produce a striking match. A French chemist demonstrated to university colleagues his "Ethereal Match." It consisted of a strip of paper treated with a compound of phosphorus that ignited when exposed to air. The combustible paper was sealed in an evacuated glass tube, the "match." To light the match, a person smashed the glass and hastened to kindle a fire, since the paper strip burned for only the length of a breath. The French match was not only ethereal but ephemeral—as was its popularity.

Enter John Walker.

One day in 1826, Walker, the owner of an apothecary in Stockton-on-Tees, was in a backroom laboratory, attempting to develop a new explosive. Stirring a mixture of chemicals with a wooden stick, he noticed that a tear-shaped drop had dried to the stick's tip. To quickly remove it, he scraped the drop against the laboratory's stone floor. The stick ignited and the friction match was born in a blaze.

According to Walker's journal, the glob at the end of his stick contained no phosphorus, but was a mixture of antimony sulfide, potassium chlorate, gum, and starch. John Walker made himself several three-inch-long friction matches, which he ignited for the amusement of friends by pulling them between a sheet of coarse paper—as alchemist Hennig Brandt had done two centuries earlier.

No one knows if John Walker ever intended to capitalize on his invention; he never patented it. But during one of his demonstrations of the three-inch match in London, an observer, Samuel Jones, realized the invention's commercial potential and set himself up in the match business. Jones named his matches Lucifers. Londoners loved the ignitable sticks, and commerce records show that following the advent of matches, tobacco smoking of all kinds greatly accelerated.

Early matches ignited with a fireworks of sparks and threw off an odor so offensive that boxes of them carried a printed warning: "If possible, avoid inhaling gas. Persons whose lungs are delicate should by no means use Lucifers." In those days, it was the match and not the cigarette that was believed to be hazardous to health.

The French found the odor of British Lucifers so repellent that in 1830, a Paris chemist, Charles Sauria, reformulated a combustion compound based on phosphorus. Dr. Sauria eliminated the match's smell, lengthened its burning time, but unwittingly ushered in a near epidemic of a deadly disease known as "phossy jaw." Phosphorus was highly poisonous. Phosphorus matches were being manufactured in large quantities. Hundreds of factory workers developed phossy jaw, a necrosis that poisons the body's bones,

especially those of the jaw. Babies sucking on match heads developed the syndrome, which caused infant skeletal deformities. And scraping the heads off a single pack of matches yielded enough phosphorus to commit suicide or murder; both events were reported.

As an occupational hazard, phosphorus necrosis plagued factory workers in both England and America until the first nonpoisonous match was introduced in 1911 by the Diamond Match Company. The harmless chemical used was sesquisulfide of phosphorus. And as a humanitarian gesture, which won public commendation from President Taft, Diamond forfeited patent rights, allowing rival companies to introduce nonpoisonous matches. The company later won a prestigious award for the elimination of an occupational disease.

The Diamond match achieved another breakthrough. French phosphorus matches lighted with the slightest fiction, producing numerous accidental fires. Many fires in England, France, and America were traced to kitchen rodents gnawing on match heads at night. The Diamond formula raised the match's point of ignition by more than 100 degrees. And experiments proved that rodents did not find the poisonless match head tempting even if they were starving.

Safety Match. Invented by German chemistry professor Anton von Schrotter in 1855, the safety match differed from other matches of the day in one significant regard: part of the combustible ingredients (still poisonous) were in the head of the match, part in the striking surface on the box.

Safety from accidental fire was a major concern of early match manufacturers. However, in 1892, when an attorney from Lima, Pennsylvania, Joshua Pusey, invented the convenience he called a **matchbook,** he flagrantly ignored precaution. Pusey's books contained fifty matches, and they had the striking surface on the *inside* cover, where sparks frequently ignited other matches. Three years later, the Diamond Match Company bought Pusey's patent and moved the striking surface to the outside, producing a design that has remained unchanged for ninety years. Matchbook manufacturing became a quantity business in 1896 when a brewing company ordered more than fifty thousand books to advertise its product. The size of the order forced the creation of machinery to mass-manufacture matches, which previously had been dipped, dried, assembled, and affixed to books by hand.

The brewery's order also launched the custom of advertising on matchbook covers. And because of their compactness, their cheapness, and their scarcity in foreign countries, matchbooks were also drafted into the field of propaganda. In the 1940s, the psychological warfare branch of the U.S. military selected matchbooks to carry morale-lifting messages to nations held captive by the Axis powers early in World War II. Millions of books with messages printed on their covers—in Burmese, Chinese, Greek, French, Spanish, Dutch, Italian, and English—were dropped by Allied

planes behind enemy lines. And prior to the invasion of the Philippines, when native morale was at a wartime low, American aircraft scattered four million matchbooks bearing the promise: "I Shall Return—Douglas MacArthur."

Today Americans alone strike more than five hundred billion matches a year, about two hundred billion of those from matchbooks.

Blender: 1922, Racine, Wisconsin

Popular legend has it that Fred Waring, the famous 1930s bandleader of the "Pennsylvanians," invented the blender to liquefy fruits and vegetables for a relative suffering from a swallowing ailment.

Though this is not entirely correct, the bandleader did finance the development and marketing of a food liquefier named the Waring Blendor— which he insisted be spelled with an *o* to distinguish his machine from the competition. And it was the promotional efforts of his Waring Mixer Corporation, more than anything else in the 1930s, that acquainted the American public with the unique new blending device.

But Fred Waring never had a relative with a swallowing problem. And his interest in the blender was not to liquefy meals but to mix daiquiris, his favorite drink. In fact, the Waring Blendor, which sold in the '30s for $29.95, was pitched mainly to bartenders.

The actual inventor of the blender (initially known as a "vibrator") was Stephen J. Poplawski, a Polish-American from Racine, Wisconsin, who from childhood displayed an obsession with designing gadgets to mix beverages. While Waring's blender was intended to mix daiquiris, Poplawski's was designed to make malted milk shakes, *his* favorite drink. Opposite as their tastes were, their paths would eventually intersect.

In 1922, after seven years of experimentation, Poplawski patented a blender, writing that it was the first mixer to have an "agitating element mounted in the bottom of a cup," which mixed malteds when "the cup was placed in a recess in the top of the base."

Whereas Fred Waring would pitch his blender to bartenders, Stephen Poplawski envisioned his mixer behind the counter of every soda fountain in America. And Racine, Poplawski's hometown, seemed the perfect place to begin, for it was home base of the Horlick Corporation, the largest manufacturer of the powdered malt used in soda fountain shakes. As Poplawski testified years later, during a 1953 patent litigation and after his company had been purchased by Oster Manufacturing, "In 1922 I just didn't think of the mixer for the maceration of fruits and vegetables."

Enter Fred Waring.

On an afternoon in the summer of 1936, the bandleader and his Pennsylvanians had just concluded one of their Ford radio broadcasts in Manhattan's Vanderbilt Theater, when a friend demonstrated one of Poplawski's blenders for Waring. This device, the friend claimed, could become a stan-

111

Mixers, c. 1890, that predate the blender and food processor. (Left to right) Magic Milk Shake Vibrator, Egg Aerater, Egg Beater.

dard feature of every bar in the country. He sought Fred Waring's financial backing, and the bandleader agreed.

The mixer was redesigned and renamed, and in September of 1936 it debuted at the National Restaurant Show in Chicago's Furniture Mart as the Waring Blendor. Highlighted as a quick, easy method for mixing frothy daiquiris and other iced bar drinks, and with beverage samples dispensed, Waring's device attracted considerably more attention than Stephen Poplawski's malted milk machine.

The Waring Blendor really caught the American public's eye when the Ron Rico Rum Company launched a coast-to-coast campaign, instructing bartenders and home owners on the exotic rum drinks made possible by the blender. Ironically, by the early 1950s, blenders had established themselves so firmly in public and home bars and in restaurants that attempts to market them for kitchen use—for cake mixes, purees, and sauces—met with abysmal failure. To reeducate the homemaker, Fred Waring took to the road, demonstrating his blender's usefulness in whipping up his own recipes for hollandaise sauce and mayonnaise. Still, the public wanted daiquiris.

Determined to entice the housewife, the Waring company introduced designer-colored blenders in 1955. An ice crusher attachment in 1956. A coffee grinder head in 1957. And the following year, a timing control. Sales increased. As did blender competition.

The Oster company launched an intensive program on "Spin Cookery," offering entire meals developed around the blender. They opened Spin Cookery Schools in retail stores and mailed housewives series of "Joan Oster Recipes."

In the late 1950s, an industry war known as the "Battle of the Buttons" erupted.

The first blenders had only two speeds, "Low" and "High." Oster doubled the ante with four buttons, adding "Medium" and "Off." A competitor

introduced "Chop" and "Grate." Another touted "Dice" and "Liquify." Another "Whip" and "Puree." By 1965, Oster boasted eight buttons; the next year, Waring introduced a blender with nine. For a while, it seemed as if blenders were capable of performing any kitchen chore. In 1968, a housewife could purchase a blender with fifteen different buttons—though many industry insiders conceded among themselves that the majority of blender owners probably used only three speeds—low, medium, and high. Nonetheless, the competitive frenzy made a prestige symbol out of blenders (to say nothing of buttons). Whereas in 1948 Americans purchased only 215,000 blenders (at the average price of $38), 127,500,000 mixers were sold in 1970, and at a low price of $25 a machine.

Aluminum Foil: 1947, Louisville, Kentucky

It was the need to protect cigarettes and hard candies from moisture that led to the development of aluminum wrap for the kitchen.

In 1903, when the young Richard S. Reynolds went to work for his uncle the tobacco king R. R. Reynolds, cigarettes and loose tobacco were wrapped against moisture in thin sheets of tin-lead. After mastering this foil technology, in 1919 R.S. established his own business, the U.S. Foil Co., in Louisville, Kentucky, supplying tin-lead wraps to the tobacco industry, as well as to confectioners, who found that foil gave a tighter seal to hard candies than did wax paper. When the price of aluminum (still a relatively new and unproven metal) began to drop in the late '20s, R. S. Reynolds moved quickly to adapt it as a cigarette and candy wrap.

Reynolds believed that lightweight, noncorrosive aluminum had a bright future, and soon his expanded company, Reynolds Metals, offered home owners an impressive list of firsts: aluminum siding and windows, aluminum boats, and a competitive line of aluminum pots, pans, and kitchen utensils. But the product that introduced most Americans to the benefits of aluminum was Reynolds's 1947 breakthrough: 0.0007-inch-thick aluminum foil, a spin-off of the technological know-how he had acquired in over two decades of developing protective wraps.

Lightweight, nonrusting, nontoxic, paper-thin, the product conducted heat rapidly, sealed in moisture, and for refrigerating foods it was odorproof and lightproof. Homeware historians claim that few if any products this century were more rapidly and favorably welcomed into American homes than aluminum foil. In fact, the kitchen wrap, with its remarkable properties, is credited with winning Americans over to all sorts of other aluminum products.

Today aluminum has an almost unimaginable number of applications: in the space program; in the fields of medicine, construction, and communications; in the soft-drink and canning industries. Given the scientific convention of characterizing ages of technological development by reference to the predominant metal of the time—as with the Iron Age and the Bronze

Age—archaeologists centuries hence may identify the Aluminum Age, which dawned circa 1950, ushered in by the inhabitants of North America with a foil used in the ritual preservation of their foods.

Food Processor: 1947, England

No one could have predicted a decade earlier that the Cuisinart and scores of less expensive imitations would transform 1980s America into a food processor society. When the Cuisinart was unveiled at the Chicago House-wares Show in January 1973, the country's department store buyers failed to see the machine as anything more than a souped-up blender with a high-class price tag. After all, blender sales then were near their all-time peak, and their price was at a then all-time competitive low.

In England and France, however, the food processor was already an invaluable kitchen appliance for many professional and amateur chefs. De-signed by British inventor Kenneth Wood, and marketed in 1947 as the Robot Kenwood Chef, the first powerful machine came with a variety of fitted accessories: juice squeezer, pasta wheel, flour mill, can opener, slicer, shredder, mixer, mincer, and centrifuge. Wood's versatile food processor, though, was not the prototype for the American Cuisinart. That would come from France.

In 1963, French inventor and chef Pierre Verdun introduced his own processor, the Robot-coup. It consisted of a cylindrical tank with an inner knife revolving close to the bottom and walls. The device was popular with professional chefs, and to tap the home market, Verdun created the more compact, streamlined Magimix in 1971.

That year, a retired electronics engineer from Connecticut, Carl Sontheimer, who was an amateur chef, was scouting a Paris housewares show in search of a spare-time project. Impressed with the compact machine that could grind, chop, mince, slice, puree, pulverize, mix, and blend, Sontheimer secured U.S. distribution rights and shipped a dozen processors to Connecticut.

At home, he analyzed the machine's strengths and shortcomings, incor-porated improvements, and turned each revamped device over to his wife for kitchen testing. Christening his best design Cuisinart, he readied it for the 1973 Chicago Housewares Show.

Undaunted by the Cuisinart's tepid reception from houseware buyers, Sontheimer undertook a personal cross-country campaign to convince America's best-known chefs and food writers of the machine's potential. Sontheimer was not surprised that every person who took the time to test the Cuisinart became a food processor disciple, spreading the word by mouth, newspaper column, or magazine article. As sales steadily increased, competing manufacturers offered food processors with refinements and attachments, recalling the blender's "Battle of the Buttons" era. By the late 1970s, the Cuisinart alone was selling at the rate of a half-million ma-

chines a year. Blenders still sold in handsome numbers, but the food processor had, ironically, largely relegated the blender to Fred Waring and Stephen Poplawski's original intention—mixing drinks.

Can Opener: 1858, Waterbury, Connecticut

It seems hard to believe that a half century elapsed between the birth of the metal can and the dawn of the first practical can opener. How, during those fifty years, did people open canned foods?

The can—or "tin cannister," as it was first called—was developed in England in 1810 by British merchant Peter Durand and used to supply rations to the Royal Navy under a government contract. Though it was introduced as a means of food preservation in America as early as 1817, the can was virtually ignored until 1861, when the twenty-three Northern states of the Union fought the eleven Southern states of the Confederacy. The American Civil War, with its resultant need for preserved military rations, popularized the can in the United States the way the War of 1812 had done in Britain. By 1895, canned foods were a familiar sight on American grocery store shelves.

But despite Peter Durand's great ingenuity in having devised canned foods, he overlooked entirely the need for a special device to get into a can. British soldiers in 1812 tore open canned rations with bayonets, pocket knives, or, all else failing, rifle fire. A can of veal taken on an Arctic expedition in 1824 by British explorer Sir William Parry carried the instructions: "Cut round on the top with a chisel and hammer." In fact, some warfare historians make the earnest claim that the bayonet, first designed by a blacksmith in the French city of Bayonne, was intended for use not as a weapon but as a can opener.

Even the Englishman William Underwood, who in the early 1800s established in New Orleans America's first cannery, saw no need to produce a special device for opening his product. His advice, standard for the day, was to employ whatever tools were available around the house.

Not all this oversight, however, was due to widespread stupidity on two continents. In truth, early cans were large, thick-walled, often made of iron, and sometimes heavier than the foods they contained; Sir William Parry's can of veal weighed, when empty, more than a pound. Only when thinner cans of steel, with a rim round the top, came into general use, in the late 1850s, did a can opener have the possibility of being a simple device.

The first patented can opener (opposed to home tools and weapons) was the 1858 invention of Ezra J. Warner of Waterbury, Connecticut. Still, it was a cumbersome, forbidding device. Part bayonet, part sickle, its large curved blade was driven into a can's rim, then forceably worked around its periphery. A slip could draw more than an ouch. American families, already adept at their own can-opening procedures, ignored Warner's invention—which was kept from extinction only through its adoption by the U.S. military

(as a can opener) during the Civil War.

The can opener as we appreciate it today—with a cutting wheel that rolls round the can's rim—was the brainchild of American inventor William W. Lyman, who patented the device in 1870. Revolutionary in concept and design, it won immediate acclaim, and in its long history underwent only one major improvement. In 1925, the Star Can Opener Company of San Francisco modified Lyman's device by adding a serrated rotation wheel—named the "feed wheel," since the can being opened rotated, for the first time, *against* the wheel. The basic principle continues to be used on modern can openers, and it was the basis of the first electric can opener, introduced in December 1931.

Thermos Bottle: 1892, England

The vacuum thermos bottle, a picnic plus, was developed not to maintain the temperature of hot coffee or iced lemonade but to insulate laboratory gases. It was a nineteenth-century scientific apparatus that found its way into twentieth-century homes.

"Dewar's flask," as it was called in the 1890s, was never patented by its inventor, the British physicist Sir James Dewar. He viewed his breakthrough vessel as a gift to the scientific community, and his original container is on display at London's Royal Institute. As simple as the vacuum-walled thermos bottle is in principle, it was two hundred years in the making.

The insulating properties of a vacuum were understood in 1643 when Italian physicist Evangelista Torricelli invented the mercury barometer, forerunner of all thermometers. Early problems with the thermos involved maintaining the vacuum once it was created, and employing a thermally nonconductive material (like rubber, virtually unknown to most Europeans in the first half of the seventeenth century) to seal all points of contact between the inner and outer vessels.

James Dewar, in 1892, successfully constructed a container with insulated inner and outer glass walls sealing an evacuated space; and to further diminish heat transfer by radiation, he silvered the inner glass. Scientists used Dewar's flask to store vaccines and serums at stable temperatures, and even to transport rare tropical fish. Dewar's gift to the British scientific establishment would become his German assistant's ticket to fortune.

Laboratory vacuum flasks were manufactured for Dewar by a professional glass blower, Reinhold Burger, partner in a Berlin firm specializing in glass scientific apparatus. It was Burger who realized the vacuum bottle's broad commercial applications, and designing a smaller home version, with a metal exterior to protect the delicate glass walls (absent from Dewar's model), he secured a German patent in 1903. Seeking a name for his flask, and hoping to drum up publicity at the same time, Burger promoted a contest, offering a cash prize for the most imaginative suggestion. The winning entry was Thermos, Greek for "heat."

An American businessman, William B. Walker, traveling in Berlin in 1906, was impressed with the thermos and within three months was importing thermoses into the United States. Campers, hunters, and housewives purchased them so quickly that Walker secured German patent rights and set up his own manufacturing operation, the American Thermos Bottle Company of New York. A quart-size thermos sold for $7.50; the pint size for $5.00.

What contributed to the thermos's rapid acceptance, say industry leaders, was the fact that the flasks were used and praised by notable men in history. President William Taft used a thermos in the White House; Sir Ernest Shackleton carried one to the South Pole; Lieutenant Robert Peary brought one to the North Pole; Sir Edmund Hillary took one up Mount Everest; and thermoses flew with the Wright brothers and Count Zeppelin. Pictured in the hands of prominent men, invariably commented upon in newspapers and in magazine articles on exploration, the thermos, without Madison Avenue's assistance, received a tremendous amount of favorable press in a relatively short time. And from the American public's standpoint, if a thermos was dependable enough to take to the farthest reaches of the globe, surely it would keep soup warm on a picnic.

Until July 1970, the word "Thermos" was a patented trademark. It was only after a lengthy court battle between rival manufacturers that the U.S. courts ruled that "thermos has become and is now a generic term in the English language."

Toaster: 1910, United States

Ever since the Egyptians began baking bread, around 2600 B.C., man has eaten toast, although the reasons for parching bread today are different from those of the past.

The Egyptians toasted bread not to alter its taste or texture but to remove moisture, as a form of preservation. Quite simply, a parched slice of bread, harboring fewer molds and spores, had a longer shelf life in the Egyptian kitchen.

For over four thousand years, people throughout the world toasted bread as the Egyptians had: skewered on a prong and suspended over a fire. Even the device that eighteenth-century Britons and Americans called a "toaster" was nothing more than two long-handled forks, crudely connected, that sandwiched the bread over the flames. Given the vagaries of the fireplace, each slice of toast was guaranteed a unique appearance.

A contraption heralded in the nineteenth century as a toasting revolution did not significantly alter the nonuniformity of slices of toast. Named the Toaster Oven, it was the first regularly manufactured toaster in America. Constructed as a cage of tin and wire, it sat over the opening in a coal-powered stove and held four slices of bread tilted toward the center. Rising heat from the fire gradually darkened one side of the bread, which was

watched diligently. Then the bread was turned over.

The arrival of electricity, and later of timers, changed all that.

Electric toasters appeared soon after the turn of the century—skeletal, naked-wire structures, without housing or shells. They lacked heat controls, so bread still had to be watched moment to moment. But the great advantage of the electric toaster was that in order to enjoy a slice of toast at any time of day, a person did not have to fire up the entire stove. This feature was prominently touted in the summer of 1910, in a Westinghouse advertisement in the *Saturday Evening Post* announcing the company's electric model: "Breakfast without going into the kitchen! Ready for service any hour of the day or night." The copy promised that by simply plugging a toaster into a wall socket, the owner could prepare toast in "any room in the home." The luxury caught on; many wealthier families installed a toaster in each bedroom. These status symbols, selling for $8.95, still required that individual slices of bread be watched and flipped manually from side to side.

Pop-up Toaster. This convenience had its beginning in a plant in Stillwater, Minnesota, where, during World War I, a master mechanic, Charles Strite, decided to do something about the burnt toast served in the company cafeteria. To circumvent the need for continual human attention, Strite incorporated springs and a variable timer, and he filed the patent for his pop-up toaster on May 29, 1919.

Receiving financial backing from friends, Strite oversaw production of the first one hundred hand-assembled toasters, which were shipped to the Childs restaurant chain. Every machine was returned, each requiring some sort of mechanical adjustment. The restaurants, however, which were in the volume toast business, loved the pop-up principle and waited patiently for Strite to iron out the bugs in his invention.

The first pop-up toaster for the home, the Toastmaster, arrived on the scene in 1926. It had a timing adjustment for the desired degree of darkness, and when the toast reached the preselected state, it was ejected, rather forcefully. The device stirred so much public interest that March 1927 was designated National Toaster Month, and the advertisement running in the March 5 issue of the *Saturday Evening Post* promised: "This amazing new invention makes perfect toast *every time!* Without watching! Without turning! Without burning!"

That was not entirely true.

The machine's overall operating temperature grew hotter and hotter with each subsequent slice of bread toasted. The first slice, when Toastmaster was coolest, was underdone. The second and third slices were usually as desired. The fourth and later ones grew darker and darker. In fine print, the operating manual recommended running the toaster once without bread, just to warm it up; then, later, letting it cool down slightly. But these were quiddities, to be ironed out by technicians. The automatic toaster had arrived.

Whistling Teakettle: 1921, Germany

Teakettles were used by primitive societies, as were whistles. Among Mayan ruins, archaeologists have unearthed two-thousand-year-old clay pots with multiple whistle spouts. When water pours out of one hole, another emits a faint, thin whistling noise. Whether or not the devices were history's first whistling teakettles is unknown. But history does record that in 1921, while touring a German teakettle factory, Joseph Block, a retired cookware executive from New York, conceived such an idea.

Growing up in New York, Block had watched his father design a pressurized potato cooker that whistled at the end of the cooking cycle. Years later, at the Westphalia, Germany, teakettle plant, that memory spontaneously awakened in Block's mind and suggested a variation. Intrigued by the idea, the Germany factory produced thirty-six whistling teakettles— which went on sale at Wertheim's department store in Berlin at nine o'clock one morning and sold out by noon.

The following year, the kettle debuted in America, at a Chicago housewares fair. For the duration of the week-long show, Joseph Block kept at least one demonstration kettle whistling continuously. The sound drove store buyers to other exhibits, but not before many of them placed orders. Wanamaker's in New York took forty-eight kettles and discovered that the whistling one-dollar novelty attracted customers in droves from other counters into the housewares department. And the retired Joseph Block found himself back in business, selling department stores across the nation 35,000 whistling teakettles a month.

Block was the first to admit that his invention made no great contribution to the American kitchen, but it did bring a smile of amusement to the lips of those who stopped to listen to the high-pitched sound, especially children—who may have duplicated the reaction of Mayan children to their pots that whistled.

Coffeepot: 1800, France

Coffee has been a favorite food (the beans were chewed for four hundred years) and beverage ever since its discovery by an Ethiopian goatherder named Kaldi in A.D. 850. But no commercial device such as a coffeepot existed for brewing ground beans until the introduction of the French biggin in 1800. During those intervening centuries, in the many countries that prodigiously consumed coffee, people prepared the drink simply by boiling ground beans in water and pouring the mixture through a filter of their own design. Bags of grounds came with the standard instruction to boil until the coffee "smelled good."

The biggin, simple as it was, became a welcome kitchen accessory.

Created by nineteenth-century French pharmacist R. Descroisilles, it consisted of two slender metal containers—available in tin, copper, or pew-

119

The quest for a perfect cup of coffee. The Filter Pot, c. 1870, modeled on the Biggin; Coffee Warmer; Coffee Boiler (lower right), in which grounds were boiled until the brew "smelled good," then the liquid was strained.

ter—separated by a plate containing holes, the filter. Around 1850, French manufacturers introduced the first porcelain-enameled biggins.

The first American adaptation of the biggin was patented in 1873. The single-chamber cylinder contained a filter that was pressed down through the mixture of grounds and hot water, forcing the grounds to the bottom of the vessel. Unfortunately, filters were not always flush with the container's walls, and a gritty drink might result. The problem annoyed one woman enough to drive her to invent a better cup of coffee.

Melitta. In 1907, Mrs. Melitta Bentz of Germany began experimenting with different materials to place between the two chambers of a biggin-like coffeepot. A circle of cotton fabric cut out and placed over the pot's own metal filter worked for a time, but the fabric soon shredded. She hit on a near-perfect kind of heavy-duty, porous paper in 1908 when she cut out a disk from a desk ink blotter, and the Melitta filter system was on its way toward commercial development.

In America at that time, sales of all kinds of coffeepots were slow and manufacturers conceived an idea that would be popular until the late '20s—the combination of several functions into one appliance. A prime and successful example was the Armstrong company's Perc-O-Toaster. It toasted bread, baked waffles, and perked coffee. But it was the percolator part that Americans loved best, and it was the percolator that in America won out over all competing types of coffeepot in the first half of this century.

120

Chemex. Next in the never-ending quest for the perfect cup of coffee came the Chemex, in 1940. The brainchild of a German chemist, Dr. Peter Schlumbohm, it embodied the Bauhaus design philosophy: a table must be a table, a chair a chair, and a coffeepot should do nothing except make great coffee.

Schlumbohm, who immigrated to America in 1939, adapted a trusty piece of scientific laboratory equipment: a heat-tempered Pyrex pot. He added no more than an inverted conical top that held filter paper and a measured amount of finely ground coffee beans.

At first, major appliance makers turned down Schlumbohm's design. Chemex, they argued, looked too simple to actually work. Finally, he persuaded a buyer for Macy's Herald Square store in New York City to take a Chemex home overnight and prepare coffee with it the next morning. Before noon, he received a phone call and an order for a hundred pots.

Corning Glass, developers of Pyrex, agreed to produce Chemex, but by then World War II was in full force and the company notified Schlumbohm that they could not legally manufacture a new product without priority clearance from the War Production Board. The determined inventor wrote directly to President Roosevelt, heading his letter, "*Minima rex non curat,*" "a king does not bother with details"—then adding, "*Sed President curat et minima,*" "but a President cares even about details." A lover of good coffee, Roosevelt permitted Chemex to go into production.

A wartime clearance to produce the novelty of an all-glass coffeemaker, at a time when almost all metal-coffeepot production had ceased, was more than Dr. Schlumbohm had dreamed. Although he acquired some two hundred patents for technological devices throughout his lifetime, none would achieve the success of his simplest invention of all.

Pressure Cooker: 1679, England

At a London dinner party on the evening of April 12, 1682, the august members of the Royal Society sat down to a meal such as they—or anyone else—had never eaten before. Cooked by the invited guest, thirty-five-year-old French inventor Denis Papin, a pioneer of steam power, the evening's fare was prepared in Papin's latest marvel, the "steam digester."

Papin, an assistant to the renowned Irish physicist Robert Boyle, formulator of the laws governing gases, had developed his steam digester in 1679. It was a metal container with a safety valve and a tightly fitting lid, which increased internal steam pressure, raising a cooking liquid's boiling point.

Following the historic meal, the Royal Society's esteemed architect, Christopher Wren, wrote that thanks to the steam digester, "the oldest and hardest Cow-Beef may now be made as tender and savoury as young and

choice meat"; one wonders what was served at the meal. Wren oversaw the publication of a booklet, "A New Digester," which offered recipes for steam-cooking mutton, beef, lamb, rabbit, mackerel, eel, beans, peas, cherries, gooseberries, plums, pike, and pigeon.

In the booklet, Papin astutely observed that pressure cooking preserved more of a food's natural flavor and nutritive value. Other contributors demonstrate the "bandwagon effect" of attempting to employ a new invention for a multiplicity of purposes. The authors offer methods for steam-cooking desserts, punches, hot toddies, and puddings.

History's first pressure cooker bombed—figuratively and literally. Not only did the majority of Londoners not take favorably to the idea of steamed pike and pigeon, but those who purchased a digester and attempted its recipes often ended up with the evening's meal on the kitchen wall. The temperature vicissitudes of an open fire were no match for Papin's imperfect safety valve. Several serious accidents were reported. Except for scientific applications (as autoclaves), pressure vessels were forgotten for about a hundred fifty years. It was French emperor Napoleon Bonaparte who was responsible for the pressure cooker's reemergence.

In 1810, Napoleon, proclaiming that "an army moves on its stomach," was desperate to find a means of supplying preserved food to his troops. The government offered a handsome prize for a solution to the problem. Employing a modification of Papin's pressure cooker, French chef Nicholas Appert developed the first practical method for cooking, sterilizing, and bottling foods. For his preservation technique, Appert won the prize of twelve thousand francs, and his methods reawakened interest in pressure cooking.

Manufacturers today claim that although pressure cookers, incorporating high safety standards, sell in respectable numbers, the public's main resistance to them is the same as it was in Papin's day: fear of an explosion.

Disposable Paper Cup: 1908, New England

The small waxed paper cup that serves so well as a disposable drinking glass and an individual ice cream container—to mention only two of its applications—originated out of one man's frustrated attempts to market an unlikely product: a drink of water. The penny drink of water never achieved popularity, but the specially designed throwaway cup that held the water started an industry.

The paper cup story begins in 1908, when an enterprising inventor, Hugh Moore, produced a porcelain vending machine to dispense a cup of pure, chilled drinking water. Similar to the later glass-tank office cooler, Moore's Penny Water Vendor had three separate compartments: an upper one for ice, a middle one for water, and a lower part to hold discarded cups. Each machine bore a sign stating that no sanitary cup was ever reused. Water was the commodity being sold, the cup an incidental.

In New York, the Anti-Saloon League immediately endorsed Moore's water vendor. The League ran ads stating that each day thousands of parched men, desiring nothing stronger than a drink of water, were driven into saloons, where they were faced with "terrible temptation." Water vending machines on public street corners was the path back to sobriety.

Several water vending machines were set up at transfer points of New York City trolley lines, but no one bought Moore's water. Discouraged, Moore wondered if it was possible to save his newly formed American Water Supply Company of New England.

Opportunity appeared in the guise of a public health officer, Dr. Samuel Crumbine. In those days, people drank water in most public places not from individual glasses but from a tin sipper, which was seldom washed, never sterilized, and used indiscriminately by the diseased and the healthy. Dr. Crumbine had already begun an ardent crusade for a law banning public drinking sippers. The entrepreneuring Moore and the health-conscious Crumbine could help each other. There was a niche—a chasm—for the disposable paper cup.

Financial backing was hard to obtain. Everyone Moore approached scoffed at the thought of a disposable cup turning a profit, and most people disbelieved the health threat from communal tin sippers. Fortunately, Moore met a wealthy hypochondriac, a New York banker with a longtime dread of the sipper, who promptly invested $200,000 in the venture. Virtually overnight, in 1909, the American Water Supply Company of New England was reincarnated as the Public Cup Vendor Company.

The scientific climate for success could not have turned balmier. That same year, Kansas passed the first state law abolishing the sipper, concluding that "disease was communicated to well persons who drank from the same cup as did, for instance, tubercular persons." And a biology professor at Lafayette College placed scrapings from several public sippers under a microscope and published a report on the alarming varieties of germs present.

State after state began passing laws prohibiting the use of communal sippers and recommending that individual drinking vessels be used in public places. Moore again changed his company's name, this time to the Individual Drinking Cup Company. Railroads, schools, and offices started to buy disposable paper cups, which now were regarded as a symbol of health. "Health" became the public byword, and for a third time Moore renamed his company, to Health Kups. Today, we might be purchasing ice cream in Health Kups had Moore not eventually tired of that name and sought something with a less antiseptic ring.

Dixie Cup. Hugh Moore's neighbor in the building where he manufactured Health Kups was the Dixie Doll Company. One day in 1919, while attempting to dream up a catchy new name for his organization, Moore glanced at his neighbor's sign and recalled a story he had heard as a boy.

In New Orleans before the Civil War, a bank note valued at ten dollars was called a *dix,* French for "ten." Riverboat men referred to the notes as "dixies," and they would announce that they were heading downriver "to pick up some dixies." Etymologists believe this legend is the origin of the word "dixie," as well as the sobriquet for the South, Dixie Land.

For Hugh Moore, Dixie had all the qualities he sought in a name. It had brevity and a symmetrical handsomeness in print, and it tripped easily off the tongue. Whereas Moore's previous and short-lived company names had been calculated to capitalize on public sentiment, the Dixie Cup Company, the only one to arrive in a spontaneous rush of inspiration, survived.

The name change came just as the ice cream industry was seeking a way to increase Americans' consumption of their product. Ice cream was sold only in bulk. A person could buy an individual soda, an individual candy bar, but ice cream only came in a package large enough to feed an entire family. Moore's company perfected the two-and-a-half-ounce cup with a flat, pull-up lid fitting into a locking circumferential groove. It gave the industry, and ice cream lovers everywhere, the first individual-size servings.

The association between Hugh Moore's cup and the dessert became so strong that by 1925, adults and children ordered individual prepackaged ice cream by the generic name Dixie Cup. Moore had finally hit on the right product with the right name, and had been in the right place at the right time.

Pyrex: 1915, Corning, New York

Etymologists, pursuing the ancient roots of contemporary words, often tell the tale that Pyrex, the heat-tempered glass, was named by its creator, Jesse Littleton, for the Greek word *pyra,* meaning "hearth." Logical as that sounds, the remarkable glass actually derived its name from a much humbler source: the word "pie," since the first Pyrex product to be manufactured by Corning Glass Works was a circular nine-inch pie plate.

It is a cake, though, not a pie, that begins the Pyrex story.

On a morning in 1913, Dr. Jesse Littleton arrived at his laboratory at the Corning Glass Works in Corning, New York, carrying a chocolate cake, which he offered to his co-workers. It was delicious, they acknowledged between bites, but cake for breakfast?

As Littleton later recounted, he said: "You fellows laughed at me when I suggested that you could cook in glass, so I've brought you first-hand evidence." The previous evening, Littleton had sawed off the bowl-shaped bottom of a glass battery jar and asked his wife to bake a cake in it. The noncorrosive, heat-tempered glass had been developed in Germany at the end of the nineteenth century and had already found several industrial applications. But no one before Littleton had thought of baking in it.

Corning introduced the first line of Pyrex ovenware in 1916, and as if to convince scientific skeptics of the capabilities of tempered glass, one of

the earliest advertisements ran in *National Geographic*. The public, impressed by the novelty of baking in glass, purchased over 4.5 million Pyrex items in the year 1919 alone—despite the fact that this early glassware was thick, heavy, slightly discolored, and marred by numerous internal hairline cracks and bubble blisters.

But cooking involves more than baking, and Littleton realized that if Pyrex was to become a major contender in the cookware field, it would have to withstand the stove top's open flame.

For more than a decade, technicians experimented with ways of strengthening the glass—for example, by rapid air-chilling, or by immersion in cold oil baths. After numerous failures, they hit on the technique of slightly altering the composition of the glass itself. Months of patient testing followed, in which Corning scientists boiled and fried more than eighteen thousand pounds of potatoes in glass vessels.

Finally, in 1936, Corning announced a line of flame-resistant Pyrex. Now glass utensils could be used for cooking as well as baking. The perfection of heat-tempered and flame-tempered ware laid the technical groundwork for a greater challenge: child-tempered, unbreakable dinnerware that had the look and feel of fine china. After years of experimentation, and tens of thousands of broken plates, the product debuted in 1970 as Corelle Ware.

Microwave Oven: 1952, United States

Microwave cooking can accurately be described as the first absolutely new method of preparing food since *Homo erectus*'s discovery of fire a million and a half years ago. The claim is justified by the fact that in microwave cooking there is no application of fire, or of a fiery element, direct or indirect, to the food. Pure electromagnetic energy agitates the water molecules in food, producing sufficient heat for cooking.

The electronic tube that produces microwave energy—a magnetron—was in use a decade before the birth of the microwave oven. It was the ingenious 1940 invention of Sir John Randall and Dr. H. A. Boot, perfected at England's Birmingham University. The thoughts of the two scientists were focused not on how to roast a turkey but on how to cook the Nazis' goose. For the magnetron was essential to Britain's radar defenses during World War II.

Thoughts of cooking with the internal heat of microwaves did not occur until after the war years—and then entirely as a result of an accident.

One day in 1946, Dr. Percy Spencer, an engineer with Raytheon Company, was testing a magnetron tube when he reached into his pocket for a candy bar. He discovered that the chocolate had melted to a soft, gooey mess. Well aware that microwaves generate heat, he wondered if the candy had been critically close to radiation leaking from the tube. He'd sensed no heat. Too intrigued to be irritated over a pair of soiled trousers, he sent

out for a bag of popcorn kernels, placed them near the tube, and within minutes, kernels were popping over the laboratory floor.

The following morning, Spencer brought a dozen raw eggs to the laboratory. He cut a hole in a pot, placed an egg inside, and aligned the hole with the magnetron. A curious colleague, leaning a bit too close, ended up with egg on his face. Spencer immediately realized that the egg had cooked from the inside out, pressure having caused the shell to burst. If an egg could be cooked so quickly and unconventionally with microwaves, thought Spencer, why not other foods?

Raytheon set out to develop a commercial microwave oven, and within a few years announced the Radar Range—which in size more closely resembled a refrigerator, though its actual cooking space was quite modest. The Radar Range suffered from a problem characteristic of all electronic devices before the advent of microminiaturization: most of its bulk housed vacuum tubes, cooling fans, and a Medusan tangle of wires. Although some Radar Ranges sold to restaurants, from the consumer standpoint the product was unmemorable.

Not until 1952 could a home owner purchase a domestic microwave oven. Produced by the Tappan Company, the oven had two cooking speeds, an on-off switch, and a twenty-one-minute timer; it retailed for $1,295. Despite the steep price tag, the Tappan oven, and later the Hotpoint model, generated unprecedented enthusiasm at houseware shows throughout the '50s. American homemakers had not yet become microwave cooking converts in large numbers, but sales of the ovens, year by year, had already begun the steady upward trend that has yet to abate.

Plastic: 1900, United States

In plastic's early days, the product seemed at times like a science fiction movie prop. Plastic strainers washed in hot water twisted and curled. Plastic refrigerator storage bowls exposed to cold cracked open. Plastic trays for flatware melted and oozed in a sunny kitchen.

People complained that plastic was ersatz, and bad ersatz at that. In a way, they were right.

Plastic was actually developed as an inexpensive substitute for ivory. The plastics industry in America was born in 1868, when a serious shortage of ivory prompted a New England manufacturer of ivory billiard balls to offer a ten-thousand-dollar prize for a suitable substitute.

A young printer from Albany, New York, John Wesley Hyatt, met that challenge and won the prize with a product he christened Celluloid and registered as a trademark in 1872.

Hyatt did not actually develop Celluloid himself but acquired the British patent for it in 1868 from a Birmingham professor of natural science, Alexander Parkes. Around 1850, Parkes was experimenting with a labo-

Celluloid shirtfronts, cuffs, collars, and comb. Developed as a substitute for ivory, Celluloid ushered in the era of synthetic-fabric clothing such as acrylic sweaters, polyester pants, and nylon stockings.

ratory chemical, nitrocellulose. Mixing it with camphor, he discovered that the compound formed a hard but flexible transparent material, which he called Parkesine. He teamed up with a manufacturer to produce it, but there was no market in the early 1850s for the thin, transparent plastic film—which in a short time would revolutionize still photography and give birth to the field of cinematography. Dr. Parkes was only too glad to sell patent rights for the useless novelty to John Hyatt.

With his prize money, Hyatt began manufacturing ersatz-ivory billiard balls in Newark, New Jersey. But he almost immediately realized that Celluloid was too versatile a compound for only one application.

By 1890, Celluloid was a household word in America. Men shot Celluloid billiard balls while wearing high, "wipe-clean" Celluloid collars, cuffs, and shirtfronts. Women proudly displayed their Celluloid combs, hand mirrors, and jewelry. The elderly began to wear the first Celluloid dental plates, and children were playing with the world's first Celluloid toys. Ivory had never enjoyed such popularity.

Celluloid was the world's first plastic and its heyday was hastened by two monumental developments. American inventor George Eastman introduced Celluloid photographic film in his Kodak cameras in 1889, and then Thomas Edison conceived of Celluloid strips as just the thing to make motion pictures.

In any room-temperature application, the world's first plastic performed admirably; the science fiction nightmares occurred only after manufacturers

introduced plastic into the extreme hot and cold temperatures of the kitchen.

A new plastics breakthrough, though, was just over the horizon: Bakelite, a seemingly indestructible material that could be produced in a rainbow of designer colors—and would lead to the development of nylon stockings and Tupperware.

Bakelite. Celluloid was developed as an ivory substitute; Bakelite was conceived as a durable replacement for rubber, for when rubber was used on the handle of a frying pan, or as the head of an electrical plug for a toaster or an iron, it dried out and cracked. Bakelite's creator, Leo Hendrik Baekeland, would become famous as the "father of plastics," responsible for the modern plastics industry.

Born in Belgium in 1863 and trained in the latest organic chemistry techniques at the University of Ghent, Baekeland transformed everything he touched into an imaginative, practical marvel. One of his early triumphs after settling in Yonkers, New York, was a photographic paper that allowed the taking of pictures in indoor artificial light instead of the strong sunlight previously required. He sold the paper to George Eastman of Kodak in 1899 for three-quarters of a million dollars, confirming his faith in the opportunities available in America.

Equipping himself with an elaborate home laboratory, Baekeland began the search for a rubber substitute. A notebook entry in June 1907, commenting on a certain mixture of phenols, formaldehyde, and bases, reveals that he had hit upon something special: "solidified matter yellowish and hard . . . looks promising . . . it will be worth while to determine how far this mass is able to make moulded materials. . . . [It may] make a substitute for celluloid and for hard rubber."

A later entry records: "I consider these days very successful work. . . . Have applied for a patent for a substance which I shall call Bakelite."

Bakelite was the first in a long line of so-called thermoset plastics— synthetic materials that, having been shaped under heat and pressure, become rock hard and resistant to heat, acids, and electric currents. And the fact that it could be tinted in a variety of hues increased its popularity. In shades of black and deep brown, Bakelite became the handles of kitchen pots and pans, the heads of electrical plugs, and the dials of radios. And in the '20s, Bakelite fit right in with the flowing lines and glossy finishes of art deco design. The toast of society as well as industry, Leo Hendrik Baekeland appeared on the cover of *Time* magazine in September 1924. Plastic, once the ugly duckling of the housewares industry, had become its darling.

With the chemistry gleaned from the development of Celluloid and Bakelite, a whole new lines of household products entered the marketplace. The everyday, commonplace products—all synthetic polymers—are notable because their raw materials are utterly original in history. Whereas man for 100,000 years had employed his innate ingenuity to shape nature's

rocks, woods, and minerals into useful tools and utensils, with the start of the twentieth century he used his acquired learning to fashion long chains of molecules, called polymers, that were unknown to his predecessors, unavailable in nature, and probably unique in the five-billion-year life of the planet—if not in the fifteen-billion-year history of the universe.

In the chronological (and rapid) order of their debuts, giving early applications, the miracle plastics were:

- Cellophane, 1912—a transparent food wrap
- Acetate, 1927—soap dishes, bathroom tumblers
- Vinyl, 1928—tablecloths, garment bags, shower curtains
- Plexiglas, 1930—wall partitions, windows, boats
- Acrylics, 1936—novelty items, sweaters
- Melmac, 1937—dinnerware
- Styrene, 1938—drinking glasses, refrigerator egg trays
- Formica, 1938—kitchen countertop laminate; developed as a substitute *for mica,* a naturally occurring, heat-resistant mineral
- Polyester, 1940—clothing
- Nylon, 1940—toothbrush handles and bristles (see page 209), stockings (see page 346)

Tupperware: 1948, United States

To assume that Tupperware, developed by Massachusetts inventor Earl S. Tupper, is nothing more than another type of plastic container is to underestimate both the Dionysian fervor of a Tupperware party and the versatility of polyethylene, a synthetic polymer that appeared in 1942. Soft, pliant, and extremely durable, it ranks as one of the most important of household plastics.

Among polyethylene's earliest molders was Du Pont chemist Earl Tupper, who since the 1930s had had the dream of shaping plastics into everything from one-pint leftover bowls to twenty-gallon trash barrels. Tupper immediately grasped the important and lucrative future of polyethylene.

In 1945, he produced his first polyethylene item, a seven-ounce bathroom tumbler. Its seamless beauty, low cost, and seeming indestructibility impressed department store buyers. A year later, a trade advertisement announced "one of the most sensational products in modern plastics," featuring Tupper's tumblers "in frosted pastel shades of lime, crystal, raspberry, lemon, plum and orange, also ruby and amber."

Next Tupper developed polyethylene bowls, in a variety of sizes and with a revolutionary new seal: slight flexing of the bowl's snug-fitting lid caused internal air to be expelled, creating a vacuum, while external air pressure reinforced the seal.

Plastic kitchen bowls previously were rigid; Tupper's were remarkably pliant. And attractive. The October 1947 issue of *House Beautiful* devoted

a feature story to them: "Fine Art for 39 cents."

As good a businessman as he was a molder, Earl Tupper took advantage of the windfall national publicity afforded Tupperware. He devised a plan to market the containers through in-home sales parties. By 1951, the operation had become a multimillion-dollar business. Tupperware Home Parties Inc. was formed and retail store sales discontinued. Within three years, there were nine thousand dealers staging parties in the homes of women who agreed to act as hostesses in exchange for a gift. The firm's 1954 sales topped $25 million.

Satisfied with the giant industry he had created, Earl Tupper sold his business to Rexall Drugs in 1958 for an estimated nine million dollars and faded from public view. Eventually, he became a citizen of Costa Rica, where he died in 1983.

Chapter 6

In and Around the House

Central Heating: 1st Century, Rome

There was a time when the hearth and not the cathode-ray tube was the heart of every home. And though it would seem that electronic cathode-ray devices like television, video games, and home computers most distinguish a modern home from one centuries ago, they do not make the quintessential difference.

What does are two features so basic, essential, and commonplace that we take them for granted—until deprived of them by a blackout or a downed boiler. They are of course lighting and central heating. A crisis with these, and all of a home's convenience gadgets offer little convenience.

Roman engineers at the beginning of the Christian era developed the first central heating system, the hypocaust. The Stoic philosopher and statesman Seneca wrote that several patrician homes had "tubes embedded in the walls for directing and spreading, equally throughout the house, a soft and regular heat." The tubes were of terra cotta and carried the hot exhaust from a basement wood or coal fire. Archaeological remains of hypocaust systems have been discovered throughout parts of Europe where Roman culture once flourished.

The comfort of radiative heating was available only to the nobility, and with the fall of the Roman Empire the hypocaust disappeared for centuries. During the Dark Ages, people kept warm by the crude methods primitive man used: gathering round a fire, and wrapping themselves in heavy cloaks of hide or cloth.

Louvre, Paris. Before its conversion into an art museum, the royal palace on the Seine boasted one of the first modern hot-air systems for central heating.

In the eleventh century, huge centrally located fireplaces became popular in the vast and drafty rooms of castles. But since their construction allowed about eighty percent of the heat to escape up the chimney, people still had to huddle close to the fire. Some fireplaces had a large wall of clay and brick several feet behind the flames. It absorbed heat, then reradiated it when the hearth fire began to die down. This sensible idea, however, was used only infrequently until the eighteenth century.

A more modern device was employed to heat the Louvre in Paris more than a century before the elegant royal palace on the Seine was converted into an art museum. In 1642, French engineers installed in one room of the Louvre a heating system that sucked room-temperature air through passages around a fire, then discharged the heated air back into the room. The air, continually reused, eventually became stale. A hundred years would pass before inventors began devising ways to draw in fresh outdoor air to be heated.

The first major revolution in home heating to affect large numbers of people arrived with the industrial revolution in eighteenth-century Europe.

Steam energy and steam heat transformed society. Within a hundred years of James Watt's pioneering experiments with steam engines, steam, conveyed in pipes, heated schools, churches, law courts, assembly halls, horticultural greenhouses, and the homes of the wealthy. The scalding surfaces of exposed steam pipes severely parched the air, giving it a continual

odor of charred dust, but this trifling con was amply outweighed by the comforting pro, warmth.

In America at this time, many homes had a heating system similar to the Roman hypocaust. A large coal furnace in the basement sent heated air through a network of pipes with vents in major rooms. Around 1880, the system began to be converted to accommodate steam heat. In effect, the coal furnace was used to heat a water tank, and the pipes that had previously carried hot air now transported steam and hot water to vents that connected to radiators.

Electric Heater. In the decade following home use of Edison's incandescent lamp came the first electric room heater, patented in 1892 by British inventors R. E. Crompton and J. H. Dowsing. They attached several turns of a high-resistance wire around a flat rectangular plate of cast iron. The glowing white-orange wire was set at the center of a metallic reflector that concentrated heat into a beam.

The principle behind the device was simple, but the success of the electric heater rested completely on homes' being wired for electricity, an occurrence prompted almost entirely by Edison's invention. Improved models of the prototype electric heater followed rapidly. Two of note were the 1906 heater of Illinois inventor Albert Marsh, whose nickel-and-chrome radiating element could achieve white-hot temperatures without melting; and the 1912 British heater that replaced the heavy cast-iron plate around which the heating wire was wrapped with lightweight fireproof clay, resulting in the first really efficient portable electric heater.

Indoor Lighting: 50,000 Years Ago, Africa and Europe

"The night cometh, when no man can work." That biblical phrase conveyed earlier peoples' attitude toward the hours of darkness. And not until late in the eighteenth century would there be any real innovation in home lighting. But there were simply too many hours of darkness for man to sleep or remain idle, so he began to conceive of ways to light his home artificially.

First was the oil lamp.

Cro-Magnon man, some fifty thousand years ago, discovered that a fibrous wick fed by animal fat kept burning. His stone lamps were triangular, with the wick lying in a saucerlike depression that also held the rank-smelling animal fat. The basic principle was set for millennia.

Around 1300 B.C., Egyptians were lighting their homes and temples with oil lamps. Now the base was of sculpted earthenware, often decorated; the wick was made from papyrus; and the flammable material was the less malodorous vegetable oil. The later Greeks and Romans favored lamps of bronze with wicks of oakum or linen.

Until odorless, relatively clean-burning mineral oil (and kerosene) became

widely available in the nineteenth century, people burned whatever was cheap and plentiful. Animal fat stunk; fish oil yielded a brighter flame, but not with olfactory impunity. All oils—animal and vegetable—were edible, and in times of severe food shortage, they went into not the family lamp but the cooking pot.

Oil lamps presented another problem: Wicks were not yet self-consuming, and had to be lifted regularly with a forceps, their charred head trimmed off. From Roman times until the seventeenth century, oil lamps often had a forceps and a scissors attached by cord or chain.

To enable him to work throughout the night, Leonardo da Vinci invented what can best be described as history's first high-intensity lamp. A glass cylinder containing olive oil and a hemp wick was immersed in a large glass globe filled with water, which significantly magnified the flame.

There was, of course, one attractive alternative to the oil lamp: the candle.

Candle: Pre–1st Century, Rome

Candles, being entirely self-consuming, obliterated their own history. Their origins are based, of necessity, on what early people wrote about them.

It appears that the candle was a comparative latecomer to home illumination. The earliest description of candles appears in Roman writings of the first century A.D.; and Romans regarded their new invention as an inferior substitute for oil lamps—which then were elaborately decorative works of art. Made of tallow, the nearly colorless, tasteless solid extract from animal or vegetable fat, candles were also edible, and there are numerous accounts of starving soldiers unhesitantly consuming their candle rations. Centuries later, British lighthouse keepers, isolated for months at a time, made eating candles almost an accepted professional practice.

Even the most expensive British tallow candles required regular half-hour "snuffing," the delicate snipping off of the charred end of the wick without extinguishing the flame. Not only did an unsnuffed candle provide a fraction of its potential illumination, but the low-burning flame rapidly melted the remaining tallow. In fact, in a candle left untended, only 5 percent of the tallow was actually burned; the rest ran off as waste. Without proper snuffing, eight tallow candles, weighing a pound, were consumed in less than a half hour. A castle, burning hundreds of tallow candles weekly, maintained a staff of "snuff servants."

Snuffing required great dexterity and judgment. Scottish lawyer and writer James Boswell, the biographer of Samuel Johnson, had many occasions to snuff tallow candles, not all successfully. He wrote in 1793: "I determined to sit up all night, which I accordingly did and wrote a great deal. About two o'clock in the morning I inadvertently snuffed out my candle . . . and could not get it re-lumed."

Reluming a candle, when the household fire had been extinguished, could be a time-consuming chore, since friction matches had yet to be invented.

Cervantes, in *Don Quixote,* comments on the frustrations of reluming a candle from scraps of a fire's embers. Snuffing tallow candles so often extinguished them, it is not surprising that the word "snuff" came to mean "extinguish."

Up until the seventeenth century, part of a theatrical troupe consisted of a "snuff boy." Skilled in his art, he could walk onto a stage during a scene's emotional climax to clip the charred tops from smoking candles. While his entrance might go ignored, his accomplishment, if uniformly successful, could receive a round of applause.

The art of snuffing died out with the widespread use of semi-evaporating beeswax candles late in the seventeenth century. Beeswax was three times the price of tallow, and the wax candles burned with a brighter flame. British diarist Samuel Pepys wrote in 1667 that with the use of wax candles at London's Drury Lane Theater, the stage was "now a thousand times better and more glorious."

The Roman Catholic Church had already adopted the luxury of beeswax candles, and the very rich employed them for special occasions that called for extravagance. Household records of one of the great homes of Britain show that during the winter of 1765, the inhabitants consumed more than a hundred pounds of wax candles a month.

Luxury candles during the next century would be the glossy white beeswax candle from England; a hard, yellow vegetable tallow from China; and the green bayberry-scented candle from the northeastern coast of America.

Gaslight: 19th Century, England

Three thousand years ago, the Chinese burned natural gas to evaporate brine and produce salt. And in parts of Europe, early fire-worshiping tribes erected their temples around natural gas jets, igniting them to produce eternal flames.

But lighting homes with gas did not occur until the nineteenth century—about two hundred years after Belgian chemist Jan Baptista van Helmont first manufactured coal gas. A scientist and a mystic, who believed in the existence of a philosopher's stone for transforming base metals to gold, Helmont bridged alchemy and chemistry. His work on coal gas encouraged the French chemist Antoine Lavoisier to consider lighting Paris streets with gaslamps; Lavoisier even constructed a prototype lamp in the 1780s. But before his plans could be carried out, he was guillotined during the French Revolution.

Not until the world's first gas company was established in London in 1813 did home gaslamps become a reality. Advances were rapid. German scientist Robert von Bunsen diminished the annoying flickering of a pure gas flame by premixing gas with air. And to greatly intensify gas's illumination, a student of Bunsen's developed the gas mantle in 1885. Constructed of thread dipped in thorium and cerium nitrate, the mantle, when initially

lit, had its thread consumed, leaving behind a skeleton of carbonized compounds, which glowed a brilliant greenish white. By 1860, gas illuminated homes, factories, and city streets. Gas was such a clean, efficient, inexpensive source of lighting that it seemed improbable that any other mode of illumination would, or could, replace the gaslamp.

Electric Light: 1878–79, England and America

Although Thomas Edison is rightly regarded as the father of the incandescent lamp, his was not the first. British inventors had been experimenting with electric lights more than a half century before Edison perfected his bulb.

The basis of the incandescent lamp is a filament, in an evacuated glass chamber, that glows white-hot when current is passed through it. Inventor Joseph Swan in England, and Edison in the United States, both hit on the idea of using carbon for the filament. Swan patented his lamp in 1878; Edison registered his patent in 1879. Edison, though, in setting up a system of electric distribution, took the incandescent bulb out of the laboratory and into the home and street. The Pearl Street Power Station in New York City was the first to supply public electricity on consumer demand. By December 1882, 203 Manhattan customers, individuals and businesses, were living and working by the light from 3,144 electric lamps.

These privileged pioneers had to be satisfied with an average bulb life of only 150 hours (compared with 2,000 hours today). But by early 1884, Edison had perfected a 400-hour bulb, and two years later, one that burned for 1,200 hours.

The electric lamp, despite its great convenience, had a slow start. People were curious; they flocked to demonstrations to observe a bulb glowing, but few home owners ordered electric installation. After seven years of operation, the Edison company had gone from 203 customers to 710. But the electric bulb was an invention that could not fade away. Although electric rates began decreasing, it was favorable word of mouth, from home owners and businesses that tried electric illumination, that generated a snowballing of orders. At the turn of the century, ten thousand people had electric lights. Ten years later, the number was three million and climbing.

As for Thomas Edison and Joseph Swan, they sued each other for patent violation, but eventually joined forces and cofounded an electric company.

Neon Light. A colorless, odorless, tasteless gas, deriving its name from the Greek *neos,* meaning "new," neon was discovered in 1898 by two English chemists, William Ramsay and Morris Travers. They puzzled at the gas's natural red-orange glow and attempted to alter its color chemically. But it was a Frenchman, physicist Georges Claude, who perfected the neon tube in 1909 and used it the following year to illuminate the Grand Palace in Paris. Claude demonstrated that employing a gas, rather than a rigid,

fixed filament, enabled neon bulbs to glow regardless of their length or configuration.

Neon's advertising value was quickly appreciated. A publicist, Jacques Fonseque, persuaded Claude to prepare a line of tubing that proclaimed the name of a client's business. In 1912, the first neon sign blazed on Paris's Boulevard Montmartre. It read (in French), "The Palace Hairdresser," and glowed a red orange. Only later did scientists discover that by altering the gas and placing powders inside the tube, they could produce a full spectrum of colors.

Fluorescent Tube. After nearly sixty years of lighting American homes, the incandescent bulb encountered in the 1930s its greatest rival: the strip light or fluorescent lamp. The battle between the two bulbs would in the end turn out to be a near draw, with both fixtures sometimes illuminating the same room in the house. The fluorescent's harsher, less flattering glare would win out in the bathroom; the incandescent's frosted softness would prevail in the bedroom; and in the kitchen, the tube and the bulb would often share honors.

The first attempt at producing fluorescence was made by the French physicist Antoine-Henri Becquerel, discoverer of radioactivity in uranium. As early as 1859, he coated the inside of a glass tube with a chemical—a phosphor—which fluoresced under electric current. Many scientists began work along the same lines, and soon dozens of gases and minerals were known to glow in an electric field. It was this research that led Ramsay and Travers to discover neon.

The first effective fluorescent lamp was developed in the United States in 1934, by Dr. Arthur Compton of General Electric. Operated by lower voltages, the tube was more economical than the incandescent bulb; and where the incandescent bulb could waste up to 80 percent of its energy in generating heat, not light, the fluorescent tube was so energy-efficient that it was named a "cold light."

Many people glimpsed their first fluorescent light at the 1939 New York World's Fair, where General Electric had white and colored tubes on display. Within fifteen years, the fluorescent light slightly edged out the incandescent bulb as the chief source of electric lighting in the United States. The victory was due not to home owners' preference for fluorescent's eerie glow, but to businesses' desire to cut lighting costs in the workplace.

Flashlight. The utilitarian flashlight originated as a turn-of-the-century novelty item known as the "electric flowerpot." Had the American public enthusiastically purchased electric flowerpots, the flashlight might have been a longer time coming.

When Russian immigrant Akiba Horowitz arrived in New York in the 1890s, he Americanized his name to Conrad Hubert and landed a job with Joshua Lionel Cowen, the man who would one day create Lionel trains.

Cowen had already invented and abandoned an electric doorbell (people complained of the unacceptability of its protracted ring) and an electric fan (which threw a slight breeze); when he hired Conrad Hubert, Cowen had just perfected the electric flowerpot. It consisted of a slender battery in a tube with a light bulb at one end. The tube rose up through the center of a flowerpot and illuminated a plant.

Hubert believed in the commercial potential of the electric flowerpot and convinced his boss to sell him patent rights. When the novelty failed to attract buyers, Hubert found himself with a large overstock. Attempting to salvage a portion of his investment, he separated the lights from the pots, lengthened the design of the cylinder, and received his own U.S. patent for a "portable electric light."

The convenient light which, with a flick of the wrist, could be flashed in any direction sold so well that Conrad Hubert started the Eveready Flashlight Company. When he died in 1928, Hubert was able to leave a gift of six million dollars to charity.

As for Joshua Lionel Cowen, he expressed no bitterness. For after a long line of failed inventions, he, too, struck it rich. He redesigned the small motor of the almost breezeless fan and placed it in a set of miniature trains.

Vacuum Cleaner: 1901, England

In 1898, an aspiring young inventor, H. Cecil Booth, attended an exhibition at London's Empire Music Hall, where an American was demonstrating a new "dust-removing" machine. A metal box topped with a bag of compressed air, the device forced air down into a carpet, causing dirt and dust to billow up into the box.

Booth was unimpressed. A lot of dust missed the box and resettled on the carpet. Questioning the inventor about the possibility of sucking up dust instead, Booth was told that many people had tried but none had succeeded.

Booth thought about suction for several days. Then, as he later wrote of his own invention, "I tried the experiment of sucking with my mouth against the back of a plush seat in a restaurant in Victoria Street." He choked violently on dust but was inspired.

The secret, Booth realized, would be to find the right kind of filtering bag to pass air and trap dust. At home, he lay on the floor and, with various kinds of fabrics over his lips, experimented. Dust seemed to be collected nicely by a tightly woven cloth handkerchief. He patented his suction cleaner in 1901.

That first commercial vacuum cleaner was huge, the size of a modern refrigerator. With a pump, a dust-collecting chamber, and the power unit, it had to be transported on a dolly, pulled along London streets from an office to a theater to a private home. To operate the cleaner, one man steered the dolly while another manned the long, flexible hose. Even when

the first home models were later constructed, two people would still be required to operate them—usually the housewife and a daughter.

The vacuum cleaner greatly improved sanitation and health. Tons of germ-laden dust were removed from theater seats, from home and shop floors. One of Booth's first assignments was to vacuum the vast blue expanse of carpet in Westminster Abbey for the 1901 coronation of Edward VII. The church's cleaning staff gaped in disbelief at the quantity of hidden dust extracted by Booth's machine.

During World War I, Booth received a commission to haul several of his vacuum machines to the Crystal Palace, the famous pavilion of London's 1851 exhibition. Naval reserve men quartered in the building were falling sick and dying from spotted fever. Doctors, helpless to halt the contagion, suspected that germs were being inhaled on dust particles. For two weeks, fifteen of Booth's machines sucked up dust from the floors, walls, staircases, and girders of the building; twenty-six truckloads of it were carted away and buried. The vacuum cleaner put an end to the spotted-fever epidemic.

Among early commercial vacuum cleaners in America, at least two—Regina and Hoover—were particularly notable for their quality and success. Each trade name became a household word, and each cleaner originated in its inventor's desperate effort to survive: one, a failing business; the other, failing health.

Regina. In 1892, a German immigrant and manufacturer of music boxes, Gustave Brachhausen, opened the Regina Music Box Company in Rahway, New Jersey. The hand-crafted items were exquisite and the company prospered, employing at one point 175 technicians and tallying annual sales of two million dollars. Regina, in fact, developed a monopoly on American-made music boxes and even exported them to Europe.

Only five miles from the Rahway factory, Thomas Edison had invented the phonograph, which was already beginning to replace the music box as a source of entertainment in America's homes. Regina's fortunes started to slide. Brachhausen, in a frantic attempt to remain solvent, manufactured player pianos one year, printing presses another, and he even challenged Edison head-on with a line of phonographs. But the device that finally saved the Regina Music Box Company was a vacuum cleaner. The Regina Vacuum Cleaner Company made its last music box in 1919.

Hoover Portable. Versions of H. Cecil Booth's vacuum machine were in use in the United States during the early years of this century, some of them superior in design. They were a luxury enjoyed by the wealthy, and their operation required two servants. The idea for a small, handy portable model came to James Murray Spangler, an aging, unsuccessful inventor with a severe allergy to dust.

In 1907, debts forced Spangler to accept a position as janitor of a department store in Canton, Ohio. The store seemed to have miles of rugs

and carpeting to be cleaned, and the dust stirred up by the mechanical sweeper issued to Spangler set off paroxysms of sneezing and coughing. He could not afford to quit. With necessity motivating invention, Spangler began to experiment with devices for "dustless cleaning."

His first makeshift vacuum used an old electric fan motor placed atop a soap box, which had its cracks sealed with adhesive tape. The dust bag was a pillow case. Spangler patented that invention in the spring of 1908 and with loans from friends formed the Electric Suction Sweeper Company. His finances remained shaky until he sold a cleaner to Susan Hoover, the wife of a prosperous Ohio executive who manufactured leather goods and automobile accessories.

Mrs. Hoover was impressed with the machine. So, too, was her husband, William, who had been contemplating expanding his business. Before the close of 1908, William Hoover had permanently solved Spangler's financial problems by purchasing rights to manufacture the suction sweeper. In one corner of Hoover's leather goods factory, three technicians assembled five vacuum cleaners a day.

To market the product, Hoover placed a two-page advertisement in the December 5, 1908, issue of the *Saturday Evening Post*. The copy offered readers the chance to use an electric suction sweeper for a free ten-day home trial. Hundreds of homemakers responded, and by letter Hoover notified each one that her trial sweeper was being delivered to a local merchant (whom he had yet to contact). Then he wrote to selected store owners, offering them a commission for every machine a home owner purchased. If a woman returned a machine, the merchant was entitled to keep it as a free sample. Store owners readily accepted the shipments of Hoover's vacuum cleaners, and soon he had a nationwide network of dealers. James Spangler became Hoover's superintendent of production.

Whereas H. Cecil Booth's first commercial vacuum resembled a refrigerator, Hoover's first portable home model looked like a bagpipe mated with a breadbox. Nonetheless, it embodied all the basic principles, and some of the accessories, of modern-day cleaners. By the 1920s, the names Hoover and Regina conjured up images of modern twentieth-century housecleaning.

The vacuum was a landmark homeware invention. Its salient feature was that for the first time in the history of housekeeping, dust was removed from the great dust-collectors—rugs, carpets, curtains, and upholstered cushions—while the items remained in place in the house. Previously, to prevent dust from resettling on furnishings, items were hauled outdoors, hung over lines and leaned against fences, and whipped. This annual ritual, spring cleaning, could often be a week-long chore that disrupted a family's routine. With the arrival of the vacuum cleaner, every daily or weekly cleaning became in effect a spring cleaning.

Carpet Sweeper. Before there were vacuum machines to suck dust from

For millennia the only improvement in brooms was in the neatness of their tufted heads. Liberation from the broom came in the 1870s with the invention of the mechanical carpet sweeper.

carpets, there was the mechanical carpet sweeper, which whisked away debris. In its heyday, the sweeper was considered a breakthrough, liberating homemakers from the shortcomings of its predecessor, the broom.

For millions of American housewives, broom liberation arrived in 1876, with the carpet sweeper invented by a husband and wife from Michigan. Anna and Melville Bissell operated a glassware shop in downtown Grand Rapids. Allergic to dust, they both suffered from the dust-laden straw in which glassware shipments were packed. Melville Bissell's hobby was inventing mechanical gadgets, and he began to develop a sweeper with a rotary head and a box to collect dust.

Bissell was not the first to attempt to perfect a sweeper, for home or street. As far back as 1699, a British patent was issued to inventor Edmund Heming for "a new machine for sweeping the streets of London." Consisting of a large circular brush connected to the revolving wheels of a horse-drawn cart, the contraption raised clouds of dust, which were exceeded in unpleasantness only by the clouds of protest from residents along the streets that the machine purportedly cleaned.

Smaller models had been attempted for the home but had not proved particularly popular. The Bissell carpet sweeper arrived at a point in medical history when dust and dirt had been labeled dangerous, if not deadly. Pasteur had recently posited his germ theory of illness, incriminating airborne dust as a carrier of bacteria. And Florence Nightingale was revolutionizing hospital hygiene, preaching that "air can be soiled just like water." The medical atmosphere generated almost an obsession with personal and home hygiene. The Bissell sweeper caught on so widely in America and Europe that by 1890, people spoke of "Bisselling the carpet." Queen Victoria ordered Bissells for Buckingham Palace, and Turkish sultans and Arabian sheiks Bisselled their Oriental rugs. But in the end, what the Bissell had done to the broom, the electric vacuum cleaner did to the Bissell and all its imitators.

Broom and Fuller Brush. Until the twentieth century, with the introduction of synthetic fibers, the brooms and brushes used in America and Europe differed only in neatness from those used by early man: a bundle of twigs, or the tuft from a corn plant, clipped and secured to a handle. One transformation to hit the broom industry in the early 1900s came knocking on doors in the form of the Fuller Brush man.

Alfred Carl Fuller arrived in the United States from Nova Scotia in 1903. His assets were seventy-five dollars and a Bible; his liabilities, a daydreaming mind and an irresponsible nature. Fired from three jobs back home, Fuller landed a position as ticket collector for Boston's elevated railway but was dismissed when he took a train on a joyride and crashed it. Subsequently, he was fired as a stablehand for neglecting the horses, then discharged as a messenger for repeatedly losing packages. Fuller claimed that he had never liked the idea of working for other people, and in 1905 he began his own business, selling brushes door to door.

In a rented room in Hartford, Connecticut, he labored late into the night constructing wire and bristle brushes, ideal for cleaning the nooks and crannies of late-nineteenth-century homes. During the day, he peddled the brushes for fifty cents apiece. To his amazement, he turned out to be a gifted salesman, and by 1910 he employed a staff of twenty-five men to market his wares.

Then the buzz of the vacuum cleaner sounded the knell of the broom and all such whisking devices. The brush and broom industry attempted to fight back. In the July 1919 issue of *House Furnishing Review,* store buyers were informed that housewives had been brainwashed into believing that "sweeping is drudgery. What a misconception!" Then the copy boasted: "The medical profession, in numerous instances, advises women to take up housework, especially sweeping, to offset their ills. Sweeping," it concluded, "is exercise of a highly beneficial nature." And to offset the then-current association that a genteel woman uses a vacuum cleaner while only a harridan

clings to her broom, the industry adopted the slogan: "Sweep, and still be sweet."

In the meantime, Fuller had begun expanding his line to include a wide artillery of household cleaning products. The versatility enabled the company to survive handsomely. When Alfred Fuller retired as president in 1943, annual sales topped ten million dollars, and the Fuller Brush man had become a familiar part of the American scene.

Clothes Iron: 4th Century B.C., Greece

Smooth, wrinkle-free clothing has been a symbol of refinement, cleanliness, and status for at least 2,400 years—although the desired effect was never easy to achieve. All early irons employed pressure; only some used heat to remove creases and impart pleats to washed garments.

The Greeks in the fourth century B.C. bore down on a "goffering iron," a cylindrical heated bar, similar to a rolling pin, which was run over linen robes to produce pleats. Two centuries later, the Romans were pressing garments and creating pleats with a hand-held "mangle," a flat metal mallet that literally hammered out wrinkles. With such devices, ironing was more than just a tedious, time-consuming chore; it was slaves' work—and was done by slaves.

Even the warring tenth-century Vikings of Northern Europe prized wrinkle-free garments, often pleated. They employed an iron in the shape of an inverted mushroom, which was rocked back and forth on dampened fabric. Fashion historians claim that it was the difficulty in producing pleats that made them a clothing distinction between upper and lower classes. Peasants did not have the time to iron in rows of creases; pleats became an outward statement of owning slaves or servants.

By the fifteenth century, wealthier European homes had a "hot box" iron, with a compartment for heated coals or a single fired brick. Poorer families still used the "flat" iron, a piece of metal with a handle, which was periodically heated over a fire. The tremendous disadvantage of the flat iron was that the soot it collected from fireplace flames could be transferred to clothes.

Once gas lighting was introduced into homes in the nineteenth century, many inventors produced gas-heated irons, which tapped into a family's gas line. But the frequency with which the irons leaked, exploded, and started home fires made wrinkled clothes preferable. The real boom in ironing came with the installation of electric lines into the home.

Electric Iron. On June 6, 1882, New York inventor Henry W. Weely received the first United States patent for an electric iron. Although Weely's concept of heat-resistant coils was imaginative, the iron itself was impractical. It heated up (slowly) only while plugged into its stand, and cooled down

Ironing was exhausting when models weighted up to fifteen pounds. (Top to bottom) Detachable walnut handle and three iron heads so that two were heating atop a stove while one was in use; heater, placed above a burner, to hold four flatirons; hot box iron containing fired charcoals.

(quickly) once disconnected from the stand and in use. Most of the operator's time was spent in reheating the iron. Even a better design could not have gotten around the problem that in the early 1880s only a few hundred American homes had electricity.

With the burgeoning growth of power companies around the turn of the century, a wide array of electric irons competed for housewives' attention. Although today it would seem hard to conceive of models weighing in excess of ten pounds as labor-saving devices (the heaviest tipped the iron-board at fifteen pounds), it was as such that electric irons were promoted by advertisers and greeted by homemakers.

Electric irons also suffered from a problem that undermined all electrical appliances in those years, with the sole exception of the light bulb. Home electricity had been conceived of almost exclusively in terms of powering incandescent lights. Consequently, as late as 1905, most power companies turned on their generators only at sunset, and they turned them off at

144

daybreak. Thus, a family wishing to benefit from such new conveniences as the electric toaster, the electric percolator, the electric clock, and the electric iron had to do so during the night. The purr of progress was silenced by the rising sun.

One electric utility man, Earl Richardson, set out to rectify the drawbacks of both home electricity and the electric iron, a device he was attempting to refine.

A meter reader for an Ontario, California, power company, Richardson polled homemakers on his weekly rounds. He learned that they would gladly switch to electric irons if the appliances were lighter and could be used during daylight hours. He persuaded several housewives to try his home-made lighter-weight irons, and he convinced his plant supervisors to experiment with generating electricity round-the-clock for one day, Tuesday, the day most of his customers claimed they ironed.

The supply-and-demand experiment paid off. As housewives ironed every Tuesday, consuming increasing amounts of electricity, the plant gradually extended the hours that its generators operated.

Homemakers, though, had one complaint about Earl Richardson's trial irons: a nonuniform distribution of heat along the iron's flat plate, with a "hot point." In 1906, when Earl Richardson decided to manufacture irons, he already had the name for his product.

Steam Iron. By the mid-1920s, American households were buying more than three million electric irons a year, at an average price of six dollars. Thus in 1926, when the first electric steam irons went on sale in New York City department stores for ten dollars, they were considered a nonessential appliance—despite the claim that their trickling moisture would prevent the scorching of clothes. Since conscientious ironing would also prevent scorching, and at a savings of four dollars, steam irons were not an immediate success. They caught on in the 1940s, when clothing manufacturers introduced a dizzying array of synthetic fabrics that, while stainproofed and permanently pressed, could melt like wax under a hot dry iron.

Within the housewares industry, the late 1940s marked the outbreak of what was called the "holy war."

Whereas the first steam irons had only one hole, those that appeared in the '40s had two, then four, then eight. Holes became a marketing ploy. If eight holes were good, reasoned Westinghouse, sixteen were surely twice as appealing. Proctor-Silex discreetly upped the ante to seventeen. Sunbeam escalated the battle with a thirty-six-hole steam iron. The holes, of course, got smaller and smaller. For a while, Westinghouse seemed to be pushing some upper limit of perforation technology with its sixty-five-hole iron. But Sears, determined to win the war, came out with a seventy-hole model. Then, without fanfare, the Presto debuted with eighty holes. Now it was impossible to scorch clothes with a steam iron, since they came off the

ironing board damp, if not wet. Like plants, clothes were being misted. And "misting" became the new marketing ploy.

Clothes Washer and Dryer: 1800s, England and France

For centuries, people on sea voyages washed their clothes by placing the dirty laundry in a strong cloth bag, tossing it overboard, and letting the ship drag the bag for hours. The principle was sound: forcing water through clothes to remove dirt. Early hand-operated washing machines attempted to incorporate the same principle through the use of a "dolly"—a device resembling an upside-down milkmaid's stool, which fitted into a tub and pummeled clothes, squeezing water out, then permitting it to seep back in.

So numerous were the inventions devised to lessen the drudgery of washing clothes that the origin of the washing machine is unclear, though it is generally agreed that in the early 1800s, in Western Europe, the concept of placing laundry in a wooden box and tumbling the box by means of a hand-operated crank was beginning to catch on. Mothers and daughters took turns cranking the box's handle hour after hour.

The rotating-drum concept carried over to the clothes dryers of the day.

A typical dryer, invented in France in 1800 by a M. Pochon, was known as the "ventilator." Hand-wrung clothes were placed, damp, in a circular metal drum pierced with holes, and as a handle was cranked the drum rotated above an open fire. Depending on the strength of the fire and the height of the flames, clothes would either dry slowly or burn, and they always acquired the aroma of the hearth, and sometimes its soot. None of these hand-cranked dryers ever threatened to obsolete the clothesline.

The first electric clothes washers, in which a motor rotated the tub, were introduced in England and America around 1915. For a number of years, the motor was not protectively encased beneath the machine. Water often dripped into it, causing short-circuits, fires, and jolting shocks.

Touted in advertisements as "automatic," the early electric clothes washers were anything but. Many washers were manually filled with buckets of water and also drained by hand. Clothes were removed saturated with water, and the wash "cycle" continued until the operator decided to pull the machine's plug. Not until 1939 did washers appear that were truly automatic, with timing controls, variable cycles, and preset water levels. Liberation from one of the most ancient of household chores came late in history.

Steam-powered sewing machine of questionable advantage.

Sewing Machine: 1830, France

The eyed needle appeared astonishingly early in man's past. Needles of ivory, bone, and walrus tusks have been found in Paleolithic caves inhabited about forty thousand years ago. In a sense, the invention of the eyed needle ranks in importance with that of the wheel and the discovery of fire. One altered man's eating habits, another his mode of transportation, while the needle forever changed the way he dressed.

But from that ancient Paleolithic era until the year 1830, men and women sewed by hand. An experienced tailor could make about thirty stitches a minute. By comparison, the first sewing machine, crude and inefficient as it was, made two hundred stitches a minutes.

That machine, creating a simple, single-thread stitch, was produced in 1830 by a tailor from Lyon, France, Barthélemy Thimmonier. The machine's speed so impressed the government that within a short time Thimmonier had eighty machines in operation, turning out military uniforms—until an angry mob, composed of professional tailors who viewed the machine as a threat to their livelihood, stormed Thimmonier's factory, destroying all the machines and nearly killing their inventor. Thimmonier fled to the town of Amplepuis, where he died in poverty, but his concept of a machine that sewed lived on in numerous versions.

147

The development of the modern sewing machine—with a double-thread, lock-stitch system—came chiefly from two Bostonians.

Elias Howe and Isaac Singer. Elias Howe was a struggling Boston machinist with a wife and three children to support. One day in 1839, he overheard his boss tell a customer that a fortune was assured to anyone who could invent a machine that sewed. The idea became Howe's obsession.

At first, Howe carefully observed his wife's hands sewing, then attempted to produce a machine to duplicate her stitching motions. When that failed, he decided to devise a new kind of stitch, one equally sturdy but within the capabilities of machine design.

He patented his sewing machine in September 1846, and began demonstrating it to potential manufacturers. The machine sewed in a straight line for only a short distance before the cloth had to be repositioned, but it formed two hundred fifty firm stitches a minute. Impressed as American manufacturers were, they balked at the machine's three-hundred-dollar price tag, and they also feared the threats made by organized groups of tailors and seamstresses.

Destitute, and disillusioned with American enterprise, Howe and his family sailed for England in 1847. Two years later, with even less money and bleaker prospects for a future, the family sailed back to America, Howe earning their passage as ship's cook. Arriving in New York City, he was startled to discover that stores were advertising sewing machines like his own, for about a hundred dollars. He legally contested the patents of the various manufacturers—in particular, the patent belonging to another Boston machinist, Isaac Singer.

Singer's machine was superior to Howe's. It had a straight needle that moved up and down (Howe's needle was curved and moved horizontally); it had an adjustable lever that held the fabric in place, enabling the machine to sew a long straight or curved seam; and it had a foot-operated treadle (Howe's had a hand-driven wheel). But Singer's machine formed the special stitch patented by Howe.

A flamboyant, ambitious businessman, uninterested in acquiring fame as the sewing machine's inventor, Singer refused to come to an out-of-court agreement with Howe. He was supporting a wife and two children, plus a mistress and six additional children. He informed his lawyers, "I don't give a damn for the invention. The dimes are what I'm after."

As the court case dragged on, another American inventor came forward who had devised a sewing machine eleven years before Howe. The prolific Walter Hunt was a genius with a wide assortment of inventions to his credit, among them the safety pin, which he had created in three hours (he sold the patent rights for four hundred dollars to repay a fifteen-dollar debt). Hunt had never patented or publicized his sewing machine, afraid that the invention would put tailors out of business. By the time of the Howe-Singer

court battle in 1853, Hunt's machine was a rusty piece of disassembled junk.

The judge presiding over the case decided that the dimes Singer was after had to be shared—not with Walter Hunt but certainly with Elias Howe. For every sewing machine manufactured, Howe received a royalty. Before he died in 1867, at age forty-eight, the formerly impoverished machinist was collecting royalties of more than four thousand dollars a week. His one regret was that his wife, long his staunchest supporter, who never doubted the commercial potential of the sewing machine, had died before he made a penny from his invention.

Wallpaper: 15th Century, France

Wallpaper originated in the latter part of the fifteenth century as a relatively inexpensive substitute for densely woven, richly embroidered tapestries. Bearing stenciled, hand-painted, or printed designs, it developed shortly after the rise of paper mills in Europe.

The earliest preserved examples date from the year 1509. Because the Chinese had developed papermaking centuries earlier, it was long assumed that wallpaper was an Oriental invention, but its actual birthplace was France.

Heavy tapestries had been popular since Roman times, not merely as decorative hangings but also because full-length wall coverings, in vast castles and stately homes, effectively minimized drafts. They were so costly that even the most profligate monarchs trundled entire sets on their seasonal peregrinations from castle to castle. Less expensive substitutes were tried; the most popular was embossed and gilded leather, introduced in the eleventh century by the Arabs. But thick decorative paper, pasted to a wall, was even less costly, and as good an insulator from the cold.

As modern-day Con-Tact paper is printed to imitate certain surfaces, so early wallpaper, by the late sixteenth century, represented more expensive wall finishings. A British advertisement of the period conveys an idea of the simulated surfaces available: "We selleth all sorts of Paper Hangings for Rooms . . . Flock Work, Wainscot, Marble, Damask, etc." In fact, early wallpaper was admired precisely because it authentically yet inexpensively simulated the appearance of more costly materials.

Flocking, a process in which powdered wool or metal was scattered over a predesigned and gummed paper, achieved great popularity in the next century. Examples are extant from as early as 1680. Prized at the same time was the distinctly different painted Chinese wallpaper, called "India paper." It bore images of birds and flowers against brightly colored backgrounds. The paper was valued for its absence of repetitive design: every vertical strip of wallpaper plastered about a room was unique, creating a dizzying effect. In the seventeenth century, French supremacy in wallpaper

execution was nearing its apex, with exquisite designs of country landscapes and classical architectural forms, employing columns and friezes. Ironically, what began as inexpensive ersatz tapestry became in a short time a costly art form.

Ready-Mixed Paint; 1880s, United States

Although painted interior house walls were popular since about 1500 B.C.—and paint itself had been known for some twenty thousand years—the first commercial, ready-mixed paints did not appear until 1880. Home owners or professional painters had been preparing their own bases and blending their own colors, and paint was usually applied by a professional. Ready-mixed paints would create the entirely new phenomenon of the "do-it-yourself" painter.

Paint for decorative purposes existed thousands of years before its use as a protective interior and exterior coating was conceived. Early peoples of Europe, Africa, and the Americas used paints of iron oxides to decorate caves, temples, and homes. The Egyptians prepared yellow and orange pigments from soil and imported the dyes indigo and madder to make blue and red. By 1000 B.C., they had developed paints and varnishes based on the gum of the acacia tree (gum arabic). The mixtures contributed to the permanence of their art and also were used as protective coatings and sealants on wooden warships. Yet paint as a preservative for exposed surfaces did not come into common use until the Middle Ages.

Medieval paints used such raw materials as egg whites, and craftsmen kept their formulas secret and their products expensive. City streets bore evidence of the craftsman's art, with colorful tradesmen's signs and shop facades. The two favorite shades for signs in those centuries were red and blue. Still, the average home went unpainted. Even in the seventeenth century, when white lead paint became widely available, ordinary houses—and such essential structures as bridges—remained unpainted for another hundred years.

It was the large-scale manufacture of linseed oil from the flax plant and of pigment-grade zinc oxide that produced a rapid expansion of the paint industry. In the nineteenth century, for the first time, paint pigment and the liquid that carried it were combined *before* the paint was marketed. The concept was revolutionary.

Sherwin-Williams. A major pioneer in the field of ready-mixed paint was Henry Alden Sherwin, who in creating a new industry changed the way we decorate our homes.

In 1870, when Sherwin informed his partners in a paint component business that he was going ahead with plans for a ready-mixed paint, they responded that the time had come to dissolve the young firm of Sherwin,

Dunham and Griswold. Home owners, they argued, mixed their own paint and knew what colors they wanted.

Sherwin believed that factory-crafted paint, benefiting from standardized measurements and ingredients, would be consistently superior to the hit-or-miss home-mixed kind. He located a new partner, Edward Williams, who shared that conviction, and after ten years of painstaking development—grinding pigments fine enough to remain suspended in oil—the Sherwin-Williams Company of Cleveland, Ohio, introduced the world's first ready-mixed paint in 1880.

Professional and amateur painters gladly abandoned the chore of combining their own white lead base, linseed oil, turpentine, and coloring pigments. And Sherwin encouraged Americans to become do-it-yourself painters inside and outside their homes. To bolster this new market, the company, through its local distributors, guided home owners through the labors of surface preparation, preliminary coatings, color aesthetics, and the appropriate choice of brushes and clean-up materials. The public discovered that commercial paint did more than protect a surface; it rejuvenated a home.

What home and furniture restorers would discover decades later was that the first ready-mixed paint created a painting frenzy. It became voguish to cover over carved wooden mantels, window and door moldings, paneled walls and beamed ceilings of walnut, mahogany, oak, ebony, and other inherently rich woods. Antique armoires, hutches, and settles were painted. Today these surfaces are being stripped by owners who, engaged in a labor of love, question: "Why did anyone ever paint this piece?"

Linoleum: 1860, England

We tend to take decorative and protective floor coverings in the home for granted; few people, except by choice or poverty, walk on bare boards. But if we examine paintings, drawings, and the written record back to as recently as the middle of the eighteenth century, it becomes apparent that except in the wealthiest of homes, families walked only on bare floors.

Carpets and rugs had of course existed for centuries. Mats made of dry stalks and tendrils covered the dirt and stone floors of Sumerian homes five thousand years ago. The Egyptians wove carpets of linen, ornamented by brightly colored sewn-on patches of wool. The Chinese perfected a knotted silk-pile carpet backed by cotton. And before the eighth century B.C., elaborately patterned Oriental carpets decorated the royal palaces of central and western Asia.

What did not exist until the 1860s was a cheap, hard-wearing, mass-produced, easy-to-clean floor covering. Specifically, one made from flax (*linum* in Latin) and oil (*oleum*). Today linoleum has been relegated largely to bathroom and kitchen floors, but that was not always its place in the home.

Inventors had been searching for an inexpensive floor covering. In 1847, Scottish chemist Michael Narin mixed oily paint with cork fibers and produced a slick linoleum-like product, but his process was lengthy and costly. Around the same time, British chemist Elijah Galloway cooked cork powder and shreds of rubber, which yielded a hard but somewhat sticky rubber flooring he named "kamptulicon." In the 1860s, kamptulicon was laid in selected rooms of the British House of Parliament, but its cost and consistency could not compete with another British inventor's creation. By oxidizing linseed oil with resin and cork dust on a flax backing, Frederick Walton produced history's first successful synthetic floor covering, known then as a "resilient floor."

A Briton had invented linoleum. But it took an American to introduce it into every room in the home.

In 1860, Frederick Walton obtained a British patent for his linoleum-making process. The same year, an industrious twenty-four-year-old American, Thomas Armstrong, decided to supplement his meager wages as a shipping clerk in a Pittsburgh glass plant by investing his savings of three hundred dollars in a machine that cut cork stoppers for bottles.

Shaving corks for various-size bottles generated huge mounds of cork dust, which the frugal Armstrong hated to waste. When he heard that a new floor covering, which was rapidly gaining in popularity in England, was manufactured from cork dust and often backed with sheets of cork, Armstrong revamped his business. By 1908, he was selling Armstrong linoleum. But unlike its forerunner, available in a few somber, solid colors, Armstrong linoleum offered home owners a spectrum of hues and patterns that rivaled those found in woven carpets. And unlike linoleum's British inventor, who saw only the utilitarian side of his creation, Armstrong promoted his bright, cheery patterns as a way to "beautify the home."

The "linoleum carpet," as the wall-to-wall coverings were called, became the new desideratum for the modern American home. An early advertisement summed up both the manufacturer's and the public's sentiment: "In many of the finest homes, you will find linoleum in every room. Not gaudy oil cloth, but rich, polished linoleum carpets."

Detergent: 1890s, Germany

All detergents are soaps, but not all soaps are detergents. That distinction is not trifling but paramount at a practical level to anyone who has, in a pinch, laundered clothes or washed his or her hair with a bar of hand soap.

Soap forms a precipitate in water that leaves a ring around the bathtub, a whitish residue on glassware, a sticky curd in the washing machine's rinse water, and a dull, lusterless plaque on hair. Furthermore, clothes washed in ordinary soap often develop yellow stains when ironed.

These undesirable properties occur because soap, which has been in use for 3,500 years, reacts with minerals and acids naturally present in water

A selection of medicinal and toilet soaps available in the nineteenth century. Soap changed little from Phoenician times until the invention of detergents.

to form insoluble molecules that refuse to be rinsed away. Synthetic detergents were specifically engineered in the 1890s to overcome this problem. They were first produced in quantity by the Germans during World War I. This was done for a practical, wartime reason: so that the precious fats that go into making ordinary soap could be used as lubricants for military vehicles and weapons.

To understand the revolution caused by detergents, it is necessary to examine the evolution and importance of soap as a world commodity.

Soap has always been made with fats. The Phoenicians in 600 B.C. concocted the world's first soap by blending goat fat with wood ash. Inveterate traders who sailed the Mediterranean, the Phoenicians introduced soap to the Greeks and the Romans, and according to the Roman writer Pliny the Elder, sold it as a laxative to the Gauls.

Soap manufacturing was a flourishing business in eleventh-century Venice, and at one point in history the tax on soap was so high that people secretly manufactured their own bars in the darkness of night. The nineteenth-century German chemist Baron Justus von Liebig argued that the wealth of a nation and its degree of civilization could be measured by the quantity of soap it consumed.

It was during von Liebig's time that the first commercial **cleanser** appeared. Adding to soap abrasive, nondissolving substances—something as fine as talc or chalk, or as coarse as pumice or ground quartz—produced an excellent scouring material. With a chick on the front of a red-and-yellow wrapper, Bon Ami, invented in 1886, became one of the most popular of the early heavy-duty cleansers.

Chemists by then had begun to unravel the mystery of how soap cleans. Soap is composed of molecules with two distinctly different arms: one arm "loves" to grasp onto water molecules, while the other arm "fears" water and latches onto molecules of dirt or grease. Thus, when rinse water is washed away, it takes with it dirt and grease. Chemists dubbed soap's water-loving arm "hydrophilic" and its water-fearing arm "hydrophobic." But soap's preeminence as an all-purpose cleansing agent was about to be challenged.

In 1890, a German research chemist, A. Krafft, observed that certain short-chained molecules, themselves not soapy substances, when coupled with alcohol, lathered up like soap. Krafft had produced the world's first detergent, but at that time the discovery excited no one and remained merely a chemical curiosity.

Then came World War I. The Allied blockade cut off Germany's supply of natural fats used to manufacture lubricants. Soap's fats were substituted, and soap itself became a scarce commodity in the country. Two German chemists, H. Gunther and M. Hetzer, recalled Krafft's chemical curiosity and concocted the first commercial detergent, Nekal, which they believed would serve only as a wartime substitute for soap. But the detergent's advantages over soap quickly became apparent. By 1930, much of the industrialized world was manufacturing a wide range of synthetic detergents that left no scum, no residue, and were far superior in many respects to soap.

A very popular all-purpose household detergent of that period was Spic-and-Span. Though a thoroughly modern product, it derived its name from a sixteenth-century Dutch expression used by sailors in speaking of a new ship: *Spiksplinternieuw,* meaning the ship was new in every spike and splinter of wood. The British later Anglicized the phrase to "Spick and Spannew," and U.S. sailors Americanized it to "spic and span." The sailor's expression "spic and span" entered the vernacular once it became a trade name, and has since applied to anything spotlessly clean or brand new.

In 1946, the first successful clothes-washing detergent for the home debuted. Trade named Tide, it appeared just when every housewife in America was deciding she could not live without an automatic washing machine. Tide's success was rapid and it became the forerunner of the many delicate detergents that would soon crowd supermarket shelves.

Whiteners and Brighteners. Although it did not require arm-twisting advertising to convince homemakers that for many jobs detergent was superior to soap, one factor that helped launch early detergents was the addition of fluorescent brightening agents that were supposed to get a garment "whiter than white."

It was another German chemist, Hans Krais, who in 1929 conceived the idea of combining tiny trace quantities of fluorescent substances, actually dyes, into detergents.

These chemicals enter a garment's fibers during a wash and do not pull free during rinsing. They become part of the body of the fabric. And they produce their brightening magic through a simple chemical process. When the garment is worn in sunlight, the fluorescent substances convert the sun's invisible ultraviolet rays into slightly bluish visible light. This causes the garment to reflect more light than it otherwise would. The net effect is that the garment appears brighter, though it is no cleaner.

Hans Krais recognized an additional advantage to the fluorescent chemicals. The tone of the extra light reflected from them lies toward the blue

side of the spectrum, and thus complements any natural yellowishness present in the fibers, making them look not only brighter but also whiter. The German chemical company I. G. Farben—which had manufactured Nekal—received the first patents for "optical brighteners" as well.

Detergents have by no means ousted soap from the field of personal hygiene, but in industrialized countries, consumption of detergents exceeds that of soaps three to one. Today the country with the highest per capita consumption of soap and detergents is the United States; it is followed closely by Switzerland and West Germany. The countries with the lowest soap consumption are Finland, Greece, and Ireland. (See also "Soap," page 217.)

Chlorine Bleach: 1744, Sweden

From the earliest written records, there is evidence that people bleached their clothing five thousand years ago, although the process was tedious and protracted and required considerable space—often entire fields, where clothes were laid out in the sun to whiten and dry.

The Egyptians, in 3000 B.C., produced—and highly prized—white linen goods; the naturally brownish fabric was soaked in harsh alkaline lyes. Timing was critical to prevent the garment from decomposing into shreds.

In the thirteenth century, the Dutch emerged as the leading exponents of the bleaching craft, retaining a near monopoly of the industry until the eighteenth century. Most European fabric that was to be used in making white garments was first sent to Holland to be bleached. The Dutch method was only slightly more sophisticated than the one employed by the ancient Egyptians.

Dutch dyers soaked fabric in alkaline lyes for up to five days. They then washed it clean and spread it on the ground to dry and sun-fade for two to three weeks. The entire process was repeated five or six times; then, to permanently halt the "eating" effect of the alkaline lye, the chemical was neutralized by soaking the fabric in a bath of buttermilk or sour milk, both being acidic. The complete process occupied entire fields and ran on for several months.

By the early eighteenth century, the British were bleaching bolts of fabric themselves. The only real difference in their method was that dilute sulfuric acid was substituted for buttermilk. A new and simple chemical bleaching compound was needed and many chemists attempted to produce it. In 1774, Swedish researcher Karl Wilhelm Scheel found the base chemical when he discovered chlorine gas, but it took another chemist, Count Claude Louis Berthollet, who two decades later would be appointed scientific adviser to Napoleon, to realize that the gas dissolved in water to produce a powerful bleach.

In 1785, Berthollet announced the creation of *eau de Javel*, a pungent solution he perfected by passing chlorine gas through a mixture of lime,

potash, and water. But *eau de Javel* was never bottled and sold; instead, every professional bleacher of that era had to combine his own ingredients from scratch, and the chlorine gas was highly irritating to the tissues of the eyes, nose, and lungs. Bleaching now required less time and space, but it involved an occupational hazard.

The situation was improved in 1799. A Scottish chemist from Glasgow, Charles Tennant, discovered a way to transform *eau de Javel* into a dry powder, ushering in the era of bleaching powders that could simply be poured into a wash. The powders not only revolutionized the bleaching industry; they also transformed ordinary writing paper: For centuries it had been a muddy yellowish-brown in color; Tennant's chlorine bleach produced the first pure-white sheets of paper. By 1830, Britain alone was producing 1,500 tons of powdered bleach a year. Whites had never been whiter.

Glass Window: A.D. 600, Germany

The Romans were the first to draw glass into sheets for windows, around 400 B.C., but their mild Mediterranean climate made glass windows merely a curiosity. Glass was put to more practical purposes, primarily in jewelry making.

Following the invention of glass blowing, around 50 B.C., higher-quality glass windows were possible. But the Romans used blown glass to fashion drinking cups, in all shapes and sizes, for homes and public assembly halls. Many vessels have been unearthed in excavations of ancient Roman towns.

The Romans never did perfect sheet glass. They simply didn't need it. The breakthrough occurred farther north, in the cooler Germanic climates, at the beginning of the Middle Ages. In A.D. 600, the European center of window manufacturing lay along the Rhine River. Great skill and a long apprenticeship were required to work with glass, and those prerequisites are reflected in the name that arose for a glassmaker: "gaffer," meaning "learned grandfather." So prized were his exquisite artifacts that the opening in the gaffer's furnace through which he blew glass on a long rod was named a "glory hole."

Glassmakers employed two methods to produce windows. In the cylinder method, inferior but more widely used, the glassmaker blew molten silica into a sphere, which was then swung to and fro to elongate it into a cylinder. The cylinder was then cut lengthwise and flattened into a sheet.

In the crown method, a specialty of Normandy glassmakers, the craftsman also blew a sphere, but attached a "punty" or solid iron rod to it before cracking off the blowing iron, leaving a hole at one end. The sphere would then be rapidly rotated, and under centrifugal force the hole would expand until the sphere had opened into a disk. Crown glass was thinner than cylinder glass, and it made only very small window panes.

During the Middle Ages, Europe's great cathedrals, with their towering

Gaffers producing glass windows by two ancient methods.

stained-glass windows, monopolized most of the sheet glass manufactured on the Continent. From churches, window glass gradually spread into the houses of the wealthy, and still later, into general use. The largest sheet, or plate, of cylinder glass that could be made then was about four feet across, limiting the size of single-plate windows. Improvements in glass-making technology in the seventeenth century yielded glass measuring up to thirteen by seven feet.

In 1687, French gaffer Bernard Perrot of Orléans patented a method for rolling plate glass. Hot, molten glass was cast on a large iron table and spread out with a heavy metal roller. This method produced the first large sheets of relatively undistorted glass, fit for use as full-length mirrors.

Fiberglass. As its name implies, fiberglass consists of finespun filaments of glass made into a yarn that is then woven into a rigid sheet, or some more pliant textile.

Parisian craftsman Dubus-Bonnel was granted a patent for spinning and weaving glass in 1836, and his process was complex and uncomfortable to execute. It involved working in a hot, humid room, so the slender glass threads would not lose their malleability. And the weaving was performed with painstaking care on a jacquard-type fabric loom. So many contemporaries doubted that glass could be woven like cloth that when Dubus-Bonnel submitted his patent application, he included a small square sample of fiberglass.

Safety Glass. Ironically, the discovery of safety glass was the result of a

glass-shattering accident in 1903 by a French chemist, Édouard Benedictus.

One day in his laboratory, Benedictus climbed a ladder to fetch reagents from a shelf and inadvertently knocked a glass flask to the floor. He heard the glass shatter, but when he glanced down, to his astonishment the broken pieces of the flask still hung together, more or less in their original contour.

On questioning an assistant, Benedictus learned that the flask had recently held a solution of cellulose nitrate, a liquid plastic, which had evaporated, apparently depositing a thin coating of plastic on the flask's interior. Because the flask appeared cleaned, the assistant, in haste, had not washed it but returned it directly to the shelf.

As one accident had led Benedictus to the discovery, a series of other accidents directed him toward its application.

In 1903, automobile driving was a new and often dangerous hobby among Parisians. The very week of Benedictus's laboratory discovery, a Paris newspaper ran a feature article on the recent rash of automobile accidents. When Benedictus read that most of the drivers seriously injured had been cut by shattered glass windshields, he knew that his unique glass could save lives.

As he recorded in his diary: "Suddenly there appeared before my eyes an image of the broken flask. I leapt up, dashed to my laboratory, and concentrated on the practical possibilities of my idea." For twenty-four hours straight, he experimented with coating glass with liquid plastic, then shattering it. "By the following evening," he wrote, "I had produced my first piece of Triplex [safety glass]—full of promise for the future."

Unfortunately, auto makers, struggling to keep down the price of their new luxury products, were uninterested in the costly safety glass for windshields. The prevalent attitude was that driving safety was largely in the hands of the driver, not the manufacturer. Safety measures were incorporated into automobile design to prevent an accident but not to minimize injury if an accident occurred.

It was not until the outbreak of World War I that safety glass found its first practical, wide-scale application: as the lenses for gas masks. Manufacturers found it relatively easy and inexpensive to fashion small ovals of laminated safety glass, and the lenses provided military personnel with a kind of protection that was desperately needed but had been impossible until that time. After automobile executives examined the proven performance of the new glass under the extreme conditions of battle, safety glass's major application became car windshields.

"Window." There is a poetic image to be found in the origin of the word "window." It derives from two Scandinavian terms, *vindr* and *auga,* meaning "wind's eye." Early Norse carpenters built houses as simply as possible. Since doors had to be closed throughout the long winters, ventilation for smoke and stale air was provided by a hole, or "eye," in the roof. Because the wind frequently whistled through it, the air hole was called the "wind's

eye." British builders borrowed the Norse term and modified it to "window." And in time, the aperture that was designed to let in air was glassed up to keep it out.

Home Air-Cooling System: 3000 B.C., Egypt

Although the ancient Egyptians had no means of artificial refrigeration, they were able to produce ice by means of a natural phenomenon that occurs in dry, temperate climates.

Around sundown, Egyptian women placed water in shallow clay trays on a bed of straw. Rapid evaporation from the water surface and from the damp sides of the tray combined with the nocturnal drop in temperature to freeze the water—even though the temperature of the environment never fell near the freezing point. Sometimes only a thin film of ice formed on the surface of the water, but under more favorable conditions of dryness and night cooling, the water froze into a solid slab of ice.

The salient feature of the phenomenon lay in the air's low humidity, permitting evaporation, or sweating, which leads to cooling. This principle was appreciated by many early civilizations, which attempted to cool their homes and palaces by conditioning the air. In 2000 B.C., for instance, a wealthy Babylonian merchant created his own (and the world's first) home air-conditioning system. At sundown, servants sprayed water on the exposed walls and floor of his room, so that the resultant evaporation, combined with nocturnal cooling, generated relief from the heat.

Cooling by evaporation was also used extensively in ancient India. Each night, the man of the family hung wet grass mats over openings on the windward side of the home. The mats were kept wet throughout the night, either by hand or by means of a perforated trough above the windows, from which water trickled. As the gentle warm wind struck the cooler wet grass, it produced evaporation and cooled temperatures inside—by as much as thirty degrees.

Two thousand years later, after the telephone and the electric light had become realities, a simple, effective means of keeping cool on a muggy summer's day still remained beyond the grasp of technology. As late as the end of the last century, large restaurants and other public places could only embed air pipes in a mixture of ice and salt and circulate the cooled air by means of fans. Using this cumbersome type of system, the Madison Square Theater in New York City consumed four tons of ice a night.

The problem bedeviling nineteenth-century engineers was not only how to lower air temperature but how to remove humidity from warm air—a problem appreciated by ancient peoples.

Air-Conditioning. The term "air-conditioning" came into use years before anyone produced a practical air-conditioning system. The expression is credited to physicist Stuart W. Cramer, who in 1907 presented a paper on

159

humidity control in textile mills before the American Cotton Manufacturers Association. Control of moisture content in textiles by the addition of measured quantities of steam into the atmosphere was then known as "conditioning the air." Cramer, flipping the gerundial phrase into a compound noun, created a new expression, which became popular within the textile industry. Thus, when an ambitious American inventor named Willis Carrier produced his first commercial air conditioners around 1914, a name was awaiting them.

An upstate New York farm boy who won an engineering scholarship to Cornell University, Carrier became fascinated with heating and ventilation systems. A year after his 1901 graduation, he tackled his first commercial air-cooling assignment, for a Brooklyn lithographer and printer. Printers had always been plagued by fluctuations in ambient temperature and humidity. Paper expanded or contracted; ink flowed or dried up; colors could vary from one printing to the next.

A gifted inventor, Carrier modified a conventional steam heater to accept cold water and fan-circulate cooled air. The true genius of his breakthrough lay in the fact that he carefully calculated, and balanced, air temperature and airflow so that the system not only cooled air but also removed its humidity—further accelerating cooling. Achieving this combined effect earned him the title "father of modern air-conditioning." With the groundwork laid, progress was rapid.

In 1919, the first air-conditioned movie house opened in Chicago. The same year, New York's Abraham and Straus became the first air-conditioned department store. Carrier entered a profitable new market in 1925 when he installed a 133-ton air-conditioning unit at New York's Rivoli Theater. Air-conditioning proved to be such a crowd pleaser in summer that by 1930 more than three hundred theaters across America were advertising cool air in larger type than their feature films. And on sweltering days, people flocked to movies as much to be cooled as to be entertained. By the end of the decade, stores and office buildings were claiming that air-conditioning increased workers' productivity to the extent that it offset the cost of the systems. Part of that increase resulted from a new incentive for going to work; secretaries, technicians, salesclerks, and executives voluntarily arrived early and left late, for home air-conditioning would not become a widespread phenomenon for many years.

Lawn: Pre-400 B.C., Greece

Grass is by far humankind's most important plant. It constitutes one quarter of the earth's vegetation and exists in more than seven thousand species, including sugarcane, bamboo, rice, millet, sorghum, corn, wheat, barley, oats, and rye. However, in modern times, "grass" has become synonymous with "lawn," and a form of the ancient once-wild plant has evolved into a suburban symbol of pride and status.

The garden of medieval times was a blend of herbs, vegetables, and wildflowers.

Each year, Americans sift and sprinkle one million tons of chemical fertilizers on their lawns to keep them lush and green. We also toss uncounted tons of lime, potash, and bone meal to fix soil pH, ensuring brightly colored flowering shrubs, bulbs, and plants. About one hundred gallons of water a day are consumed by the average American home, with no insignificant portion of that being sprayed on front, back, and side lawns.

But we weren't always so ardent about our lawns.

The meticulously manicured, weed-free, crabgrass-proof lawn is largely a modern phenomenon. In the mid-1800s, when American novelist Nathaniel Hawthorne visited England—where the rage for solid-green lawns was in full cry—he was distressed by the vista's artificiality and pretension. He wrote home that he longed for the more natural American front yard, rich in its varieties of weeds, nettles, clovers, and dandelions. This "natural look," in fact, is the earliest recorded vogue in lawns.

The classical Greek garden of 400 B.C. boasted a small plot of mixed green grasses and weeds. Commingled with these were wildflowers, planted to resemble a miniature natural meadow. Hand watering was a time-consuming chore and lawns were kept small and easily manageable. Two hundred years later, the Persians were celebrated for their small, intricate flower gardens, where stretches of green grass were used only to offset the flowers' colors. Grass was background, not foreground. And in the Middle Ages, lawns, as depicted in tapestries, paintings, and illustrated manuscripts, were festooned with delicate wildflowers, with grass kept to an accenting minimum.

For centuries before the invention of the lawn mower, grass went uncut. A tall, free-growing, weedy plot of green was regarded as a thing of beauty. While Hawthorne longed for the naturalness of the American lawn, poet Walt Whitman sang the praises of grass as "the beautiful uncut hair of graves." Perhaps it is not surprising that lawn weeds were tolerated, if not cultivated, since truly weed-free grass seed had yet to be developed. Moreover, animal manure—the most common form of garden fertilizer for centuries—was replete with undigested weed seeds. Fertilizing a lawn was equivalent to sowing weeds.

In the 1800s, with the growing popularity in the British Isles and Holland of golf and bowling (the latter originally an outdoor lawn game), closely cropped turfs became a necessity. Lawn mowing was often achieved by flocks of grazing sheep. The sheep, though, were soon to be replaced with a mechanical, man-made contrivance.

Lawn Mower: 1830, England

In one of those ironies where a man's surname seems to predestine his professional calling, the lawn mower was the creation of a British gardener named Budding.

As foreman in an English textile plant, Edwin Budding was familiar with a new rotary shearing machine used to cut nap off cotton cloth. In the 1820s, he wondered if the machine could be adapted to shear his own yard, and for the British "bowling green," a grassy turf down a stand of stately trees. By 1830, in Stroud, Gloucestershire, Budding was ready to patent his machine "for cropping or shearing the vegetable surface of lawns, grass-plots and pleasure grounds." The device was a nineteen-inch roller mower that employed the principle of a set of rotating cutters operating against fixed ones—a rather straightforward adaptation of the method for shearing nap at the textile factory where Budding worked.

One popular grass-cutting method in Budding's time was the centuries-old technique of scything. It required that grass first be dampened to give it "body" against the blow from a scythe. Consequently, Budding stressed that his mechanical mower would cut dry grass. And he advertised in 1832 that "Country gentlemen will find in using my machine an amusing, useful and healthful exercise." To his disappointment, country gentlemen were unimpressed with the rotary lawn-mowing invention, preferring to take their exercise by swinging a scythe.

Large, horse-drawn versions of Budding's mower were tried on British country estates in the 1860s. But gardeners and estate owners objected to hoof scars (which had to be patched up) and horse droppings (which had to be picked up). The horse-drawn rotary mower was no real time-saver.

When the cost of hand-pushed rotary mowers began to drop, around the 1880s, their popularity increased among average home owners in Britain and America. The mowers became the preferred way to cut grass, despite

(Clockwise) Scythe cutting blade; hand-held grass sickle; rotary blade mower and grass catcher; mower after Budding's 1830s' model.

several attempts by inventors and manufacturers to introduce steam-powered mowers.

The first major improvement over the manual rotary device was developed in 1919 by an American army colonel, Edwin George. Installing the gasoline motor from his wife's washing machine in a walk-behind, roller-blade lawn cutter, George produced the first **gasoline-powered lawn mower.** It was the advent of inexpensive mowers in general, and especially of the gasoline-powered invention of Edwin George, that helped popularize the vogue of manicured lawns among the middle class.

The lawn seed business in America also experienced a significant turning point around this time. An inexpensive, genuinely weed-free grass seed was perfected by an Ohio farmer, Orlando Mumford Scott, a man whose surname would become synonymous with an extensive line of home gardening products. Scott, and the company he formed, also produced the first home-lawn fertilizer designed specifically to provide the nutritional requirements of grass, Turf Builder (in 1928); and the first combined grass fertilizer and chemical weed killer, Weed and Feed (in 1946).

But it was Scott's weed-free grass seed, combined with the convenience of the gasoline-powered mower, that launched the greening of American lawns. The roots of a grass movement were under way.

Burpee Seeds: 1880s, Philadelphia

One man more than any other—a poultry farmer named Washington Atlee Burpee—was responsible for adding splashes of color to the American lawn. What Orlando Mumford Scott did for grass, W. A. Burpee did for flowers.

Before his name became a commonplace adjective for flower and vegetable seeds, Burpee was something of a poultry prodigy. In the 1860s, as

a young boy living in Philadelphia, he took up the hobby of breeding chickens, geese, and turkeys. By the time he entered high school, he was contributing insightful articles to leading poultry trade journals of the day. And before graduating, he operated a purebreed-poultry mail-order business out of his parents' home, offering not only his own fowl but also his own breeding manuals.

The business expanded to include purebreed livestock. And the twenty-year-old Burpee, to provide his customers with the proper food for their pedigreed animals, in 1878 began to offer special, high-quality seeds in his catalogues. Much to his surprise, more orders poured in for seeds than for animals. Within two years, he was heavily promoting seeds for tomatoes, cucumbers, turnips, lettuce, and other vegetables.

By the turn of the century, livestock and fowl were a minor sideline in a catalogue devoted to vegetables, fruits, and flowers. The catalogues themselves, which at one time ran up to two hundred pages, became popular reading material. They contained not only trustworthy gardening advice but also colorful anecdotes of Burpee's worldwide travels in pursuit of the biggest and tastiest produce. Throughout America, numerous families named their sons Washington Atlee, and on Burpee's cross-country seed-hunting trips, he'd visit his young namesakes and present them with gifts. Millions of American home owners were planting their lawns with Scott's weed-free grass and their vegetable and flower beds with Burpee's high-quality seeds.

After Burpee's death in 1915, his family led a campaign to have the American marigold, their father's favorite, adopted as the country's national flower. They later even christened a new marigold the "Senator Dirksen," in honor of the Illinois legislator's efforts on the flower's behalf. That campaign failed, and America did not have a national flower until 1986, when President Ronald Reagan signed legislation adopting the rose.

Rubber Hose: 1870s, United States

The watering can is used today almost exclusively on small indoor plants, and even then the process of repeatedly filling the container is tedious. But before the development of the garden hose, almost all watering of lawns, flower beds, and vegetable gardens, regardless of their size, was done with a can. The rubber garden hose (and fire hose) was not only a time-saving godsend; it was the first practical rubber item manufactured—before automobile tires and weatherized raingear—and in many ways, it marked the birth of the rubber industry.

Rubber was a new and novel material in sixteenth-century Europe. The first rubber balls, made by the American Indians, were introduced to Spain by Christopher Columbus, and over the next two centuries many European inventors experimented with the substance but found it unsuited for practical applications, the reason being that rubber, in its natural state, is brittle

when cold and sticky when hot. It was a struggling American inventor, Charles Goodyear, who discovered through a kitchen accident the secret to making rubber at once dry, soft, and pliant.

Goodyear believed that rubber might be made more useful if it was "tanned," or "cured," as is leather to extend its life. One February evening in 1839, he was experimenting in his home kitchen, adding various chemicals to "cure" rubber. A mixture of sulfur and rubber dropped from his spoon onto the hot surface of the stove. Too busy to wipe it up, he went about his research while the rubber melted, then later cooled and solidified. When Goodyear did scoop up the congealed mass, he was astonished by its smoothness, dryness, and flexibility. That night, in an intense winter cold, he nailed the piece of "gum" outside the kitchen door. In the morning, he brought it in, flexed it, and was jubilant. It was not brittle. It had retained its elasticity. Charles Goodyear had discovered that sulfur "cures," or "vulcanizes," rubber.

Additional experimentation was required to perfect the process of vulcanization. But Goodyear was out of money. He had already expended an enormous amount of time, and all his savings, in quest of a better rubber. He and his wife and five children were destitute and dependent upon relatives for food and housing. He pawned family belongings and sold his children's schoolbooks with the justification, as he wrote in 1855 in *Gum-Elastic and Its Varieties,* that "the certainty of success warranted extreme measures of sacrifice." But Charles Goodyear did not succeed commercially. He was imprisoned for debt, and when he died, in 1860, he left his family with some $200,000 in unpaid bills and loans.

After Goodyear's death, ten years passed before rubber became America's dream product. And that happened through the efforts of a man whose name was strikingly similar to Goodyear's.

Dr. Benjamin Franklin Goodrich, a Civil War surgeon turned businessman, started the B. F. Goodrich Company in Akron, Ohio, in 1870. At that time, there were still few known applications for rubber. But Goodrich was convinced of rubber's potential. He had watched a close friend's house destroyed by fire because a leather fire hose burst. And in the oil fields of Pennsylvania he had seen the need for a rubber hose to transport oil. He also knew from his medical training that rubber could have numerous applications in surgery and rehabilitative therapy.

Gifted and debonair, Goodrich had no difficulty persuading businessmen to invest in his newly formed rubber company. Within a few months, the Akron plant was producing the world's first rubber hoses. The company's heavy-duty, cotton-covered fire hose quickly became the firm's best-selling product.

The year 1871 also witnessed several other rubber firsts: gaskets, bottle stoppers, preserving-jar rings, and rollers for the popular clothes wringers used by housewives. For outside the house, the chief product was the garden hose. Leather hoses suffered from several drawbacks: When repeatedly wet

and dried, leather ages and cracks; it becomes brittle through extended exposure to sunlight; and its elasticity is severely limited, with the potential of frequent ruptures. Goodrich's rubber, on the other hand, was impervious to moisture and temperature, and it had an inherent strength that withstood high internal water pressure with minimum chance of rupture. Through the 1880s, professional and weekend gardeners only too gladly relinquished the tin watering can for the rubber hose, a blessing for the gardener as well as for the lawn.

Wheelbarrow: A.D. 200, China

The wheelbarrow holds a distinctive place in the history of man-made devices. It illustrates a phenomenon known as independent invention—that is, the wheelbarrow was developed in different places at different periods, and was used for different purposes. The Chinese and European wheelbarrows are of particular interest.

The earliest form of wheelbarrow was designed around A.D. 200 by Chuko Liang, a general in the Chinese Imperial Army. Its purpose was to transport large quantities of military supplies along narrow embankments. The device's immense single wheel measured about four feet in diameter. It had a dozen spokes, and was positioned so that the center of gravity of the load could be directly above the wheel axle. Historians believe that General Liang adapted the wheelbarrow from a smaller, two-wheeled handcart already in use in China for carrying rice and vegetables.

Two-wheeled handcarts were known throughout the East and West as early as 1000 B.C., but it appears that the need never arose, as it did in China in Liang's time, to construct a one-wheeled device to traverse a severely narrow track of ground.

From transporting military supplies, the Chinese wheelbarrow was used to remove dead and wounded soldiers from battlefields. Then it was enlarged and slightly modified to carry civilians about town, with a capacity to accommodate about four adults or six children at a time. These larger wheelbarrows were usually pulled by a donkey and guided from behind by a driver.

The Chinese had two poetically descriptive names for the wheelbarrow: "wooden ox" and "gliding horse." Commenting on the mechanical advantage of the device for a load of given weight, a fifth-century historian wrote: "In the time taken by a man to go six feet, the Wooden Ox would go twenty feet. It could carry the food supply for one man for a whole year, and yet after twenty miles the porter would not feel tired."

The European wheelbarrow originated during the Middle Ages. Whereas the Chinese wheelbarrow had its single wheel in the center, directly under the load, so that the pusher had only to steer and balance it, the European version had the wheel out in front. This meant that the load was supported by both the wheel and the pusher.

Mortar wheelbarrow and garden variety c. 1880. Woodcut of medieval laborer transporting stones in a Western-style wheelbarrow.

Historians believe that the European invention was an adaptation of an earlier vehicle, the hod, a wooden basket suspended between two poles and carried in front and back by two or four men. Somewhere around the twelfth century, an anonymous inventor conceived the idea of replacing the leading carriers by a single small wheel; thus, the Western wheelbarrow was created.

The European wheelbarrow was not as efficient as the Chinese. Nonetheless, workmen building the great castles and cathedrals on the Continent suddenly had a new, simple device to help them cart materials. Most manuscripts from the twelfth to the fifteenth centuries that contain illustrations of wheelbarrows invariably show them loaded with bricks and stones, in the service of builders. In this respect, the European wheelbarrow's function was quite different from that of the Chinese version. And indeed, the forward placement of the wheel meant that a man using the European wheelbarrow had to lift a large portion of the load, besides pushing and balancing it. Thus, unlike the Chinese invention, the Western wheelbarrow was unsuited for carrying a burden over long distances. Consequently, it never became a vehicle for human transportation.

Until the seventeenth century, when frequent trading began between Europe and China, each had its own distinct form of wheelbarrow. But then European traders to the Orient returned with astonishing tales of the loads that could be carried effortlessly over long distances with the Chinese wheelbarrow. That design began to appear in Western countries. Today both models are available, depending on individual work requirements.

Chapter 7

For the Nursery

Fairy Tales: 16th Century, Italy and France

Rape, child abuse, and abandonment are the stuff of contemporary headlines and feature films. But they are also themes central to many of our most beloved fairy tales—as they were originally conceived.

The original "Sleeping Beauty" does not end happily once the princess is awakened with a kiss; her real troubles just begin. She is raped and abandoned, and her illegitimate children are threatened with cannibalism. And in the authentic version of "Little Red Riding Hood," the wolf has yet to digest the grandmother when he pounces on Red, ripping her limb to limb. Many artists of the day, believing that the two violent deaths were too much for children to endure, refused to illustrate the tale. To make it more palatable, one illustrator introduced a hunter, who at the last minute slays the wolf, saving at least Little Red.

In the present century, numerous critics continue to argue that many fairy tales and nursery rhymes read to children—and repeated by them— are quintessentially unsavory, with their thinly veiled themes of lunacy, drunkenness, maiming of humans and animals, theft, gross dishonesty, and blatant racial discrimination. And the stories do contain all these elements and more—particularly if they are recounted in their original versions.

Why did the creators of these enduring children's tales work with immoral and inhumane themes?

One answer centers around the fact that from Elizabethan times to the early nineteenth century, children were regarded as miniature adults. Families were confined to cramped quarters. Thus, children kept the same late

hours as adults, they overheard and repeated bawdy language, and were not shielded from the sexual shenanigans of their elders. Children witnessed drunkenness and drank at an early age. And since public floggings, hangings, disembowelments, and imprisonment in stocks were well attended in town squares, violence, cruelty, and death were no strangers to children. Life was harsh. Fairy tales blended blissful fantasy with that harsh reality. And exposing children to the combination seemed perfectly natural then, and not particularly harmful.

One man more than any other, Charles Perrault, is responsible for immortalizing several of our most cherished fairy tales. However, Perrault did not originate all of them; as we'll see, many existed in oral tradition, and some had achieved written form. "Sleeping Beauty," "Cinderella," and "Little Red Riding Hood" are but three of the stories penned by this seventeenth-century Frenchman—a rebellious school dropout who failed at several professions, then turned to fairy tales when their telling became popular at the court of King Louis XIV.

Charles Perrault was born in Paris in 1628. The fifth and youngest son of a distinguished author and member of the French parliament, he was taught to read at an early age by his mother. In the evenings, after supper, he would have to render the entire day's lessons to his father in Latin. As a teenager, Perrault rebelled against formal learning. Instead, he embarked on an independent course of study, concentrating on various subjects as mood and inclination suited him. This left him dilettantishly educated in many fields and well-prepared for none. In 1651, to obtain a license to practice law, he bribed his examiners and bought himself academic credentials.

The practice of law soon bored Perrault. He married and had four children—and the same number of jobs in government. Discontent also with public work, he eventually turned to committing to paper the fairy tales he told his children. Charles Perrault had found his métier.

In 1697, his landmark book was issued in Paris. Titled *Tales of Times Passed,* it contained eight stories, remarkable in themselves but even more noteworthy in that all except one became, and remained, world renowned. They are, in their original translated titles: "The Sleeping Beauty in the Wood," "Little Red Riding Hood," "Blue Beard," "The Master Cat: or Puss in Boots," "Diamonds and Toads," "Cinderella: or, The Little Glass Slipper," and "Hop o' my Thumb." The eighth and least famous tale, *"Riquet à la Houppe,"* was the story of a deformed prince's romance with a beautiful but witless princess.

Perrault did more than merely record stories that were already part of popular oral and written tradition. Although an envious contemporary criticized that Charles Perrault had "for authors an infinite number of fathers, mothers, grandmothers, governesses and friends," Perrault's genius was to realize that the charm of the tales lay in their simplicity. Imbuing them with magic, he made them intentionally naive, as if a child, having heard the

tales in the nursery, was telling them to friends.

Modern readers, unacquainted with the original versions of the tales recorded by Perrault and others, may understandably find them shocking. What follows are the origins and earliest renditions of major tales we were told as children, and that we continue to tell our own children.

"Sleeping Beauty": 1636, Italy

"The Sleeping Beauty in the Wood" was the opening tale in Charles Perrault's 1697 book. It is the version we still tell today, but it did not represent the complete original story; Perrault's recounting omits many of the beautiful princess's horrifying ordeals. The first written version of the tale was published in Italy in 1636 by Giambattista Basile in his collection *Pentamerone*.

In this Neapolitan "Sleeping Beauty," a great king is forewarned by wise men that his newborn daughter, Talia, is in peril from a poison splinter in flax. Although the king bans flax from the palace, Talia, as a young girl, happens upon a flax-spinning wheel and immediately catches a splinter beneath her fingernail, falling dead.

Grief-stricken, the king lays his daughter's body on a velvet cloth, locks the palace gates, and leaves the forest forever. At this point, our modern version and the original diverge.

A nobleman, hunting in the woods, discovers the abandoned palace and the insensate body of the princess. Instead of merely kissing her, he rapes her and departs. Nine months later, the sleeping Talia gives birth to twins, a boy and a girl. Named Sun and Moon, they are looked after by fairies. One day, the male infant sucks on his mother's finger and the poisonous splinter is dislodged, restoring Talia to consciousness.

Months pass, and the nobleman, recollecting his pleasurable encounter with the fair-haired sleeping beauty, revisits the palace and finds her awake. He confesses to being the father of Talia's children, and they enjoy a week-long affair before he leaves her again—for his wife, whom he conveniently never mentions.

The original story at this point gets increasingly, if not gratuitously, bizarre. The nobleman's wife learns of her husband's bastard children. She has them captured and assigns them to her cook, with orders that their young throats be slashed and their flesh prepared in a savory hash. Only when her husband has half-finished the dish does she gleefully announce, "You are eating what is your own!"

For a time, the nobleman believes he has eaten his children, but it turns out that the tenderhearted cook spared the twins and substituted goat meat. The enraged wife orders that the captured Talia be burned alive at the stake. But Sleeping Beauty is saved at the last moment by the father of her children.

Little Red Riding Hood and the Wolf. A gentle 1872 depiction of a gory tale.

"Little Red Riding Hood": 1697, France

This tale is the shortest and one of the best-known of Perrault's stories. Historians have found no version of the story prior to Perrault's manuscript, in which both Granny and Little Red are devoured. The wolf, having consumed the grandmother, engages Red in what folklorists claim is one of the cleverest, most famous question-and-answer sequences in all children's literature.

Charles Dickens confessed that Little Red was his first love, and that as a child he had longed to marry her. He later wrote that he bitterly deplored "the cruelty and treachery of that dissembling Wolf who ate her grandmother without making any impression on his appetite, and then ate her [Little Red], after making a ferocious joke about his teeth."

In fact, many writers objected to Perrault's gruesome ending and provided their own. In a popular 1840 British version, Red, about to be attacked by the wolf, screams loudly, and "in rushed her father and some other faggot makers, who, seeing the wolf, killed him at once."

During that same period, French children heard a different ending. The wolf is about to pounce on Red, when a wasp flies through the window and stings the tip of his nose. The wolf's cries of pain alert a passing hunter, who lets fly an arrow "that struck the wolf right through the ear and killed him on the spot."

Perhaps the goriest of all versions of the tale emerged in England at the end of the nineteenth century. This popular telling concludes with the wolf collecting the grandmother's blood in bottles, which he then induces the unsuspecting Red to drink. It is interesting to note that while all the revisions endeavor to save Red, none of them spares the grandmother.

The Grimm brothers, one hundred twenty years after Perrault, provided

yet another version—the only one that spares Granny. The wolf, logy after dining on Granny and Red, falls asleep. His thunderous snores attract the attention of a hunter, who enters the house, guesses what has transpired, and rips open the wolf's stomach with a pair of scissors. Out jumps Red, exclaiming, "How dark it was inside the wolf!" Then an exhausted, disheveled, and silent grandmother steps out. And the wolf is chased away.

Folklorists believe that before Perrault immortalized "Little Red Riding Hood" by committing it to paper in his skillful style, the story existed as oral tradition, perhaps as early as the Middle Ages.

"Cinderella": 9th Century, China

The Cinderella story is believed to be the best-known fairy tale in the world. It is a tale that may have existed for at least a thousand years in various written and oral forms—most of which involved the brutal mutilation of women's feet in vain attempts to claim the mystery slipper.

The tale as recounted to children today—in which a poor cinder girl is able to attend a grand ball through the benevolence of a fairy godmother— is due entirely to Charles Perrault. Were it not for his skilled retelling, the Western world might instead know only the trials of "Rashin Coatie," the lovely, impoverished daughter in a popular Scottish version.

According to that tale, the girl's three ugly stepsisters force her to wear garments of rushes (hence her name). Instead of a fairy godmother to grant wishes, Rashin Coatie has a magic calf, which her wicked stepmother vindictively slaughters and cooks. The grief-stricken Rashin Coatie, desiring to attend a ball, wishes for a new dress upon the dead calf's bones. Attired in the "grandest" gown, she wins the heart of a prince, and hurrying home, loses a beautiful satin slipper.

Since the prince will marry whoever fits into the slipper, the stepmother cuts off the toes of her eldest daughter; the foot is still too large, so she hacks off the heel. The prince accepts the ugly (secretly mutilated) daughter, only to be told later by a bird that the foot inside the shoe is not intact— and that Rashin Coatie is the beauty he is after. The prince marries her, and "they lived happily all their days."

In many old European versions of the story, the ugliest daughter's foot is mangled to fit into a slipper of satin, cloth, leather, or fur. And a bird of some sort always alerts the prince to the deception. In the French tale that Perrault heard as a child, the shoe is believed to have been of variegated fur (*vair* in French) rather than of glass (*verre*). It was Perrault's genius to perceive the merits of a glass slipper—one that could not be stretched and could be seen through. His awareness of the salient aspect of glass is apparent in his choice of title: "Cinderella: or, The Little Glass Slipper."

In Europe, the earliest Cinderella-type tale is attributed to Giambattista Basile. It appeared in his *Pentamerone,* under the title "The Hearth Cat." A widely traveled poet, soldier, courtier, and administrator from Naples,

Basile composed fifty stories, all supposedly related to him by Neapolitan women. His Cinderella, named Zezolla, is a victim of child abuse.

The Basile story opens with the unhappy Zezolla plotting to murder her wicked stepmother; she eventually breaks the woman's neck. Unfortunately, her father marries an even more vindictive woman, with six vicious daughters who consign Zezolla to toil all day at the hearth.

Desiring to attend a gala *festa,* she wishes upon a magic date tree and instantly finds herself in regal attire, astride a white horse, with twelve pages in attendance. The king is bewitched by her loveliness. But at midnight, he is left holding an empty slipper—which fits no one in the land except, of course, Zezolla.

Although this earlier Italian version is strikingly similar to Charles Perrault's, historians believe that Perrault was unfamiliar with Giambattista Basile's published fairy tales, and was acquainted only with the oral French version of the story.

Who, though, told the *first* Cinderella story?

The earliest-dated version of such a story appears in a Chinese book written between A.D. 850 and 860. In the Oriental tale, Yeh-hsien is mistreated by an ill-tempered stepmother, who dresses her in tattered clothes and forces her to draw water from dangerously deep wells.

The Chinese Cinderella keeps a ten-foot-long magic fish in a pool by her home. Disguised in her daughter's tattered rags, the stepmother tricks, catches, and kills the fish. Cinderella, desiring clothes to attend a festival, wishes upon the fish's bones and is suddenly outfitted in magnificent feathers and gold.

There is no prince or king at the Chinese festival. But on hurriedly leaving the affair, Cinderella does lose a golden slipper, which was "light as down and made no noise even when treading on stone." Eventually, the shoe falls into the hands of the wealthiest merchant in the province. A considerable search leads him to Cinderella, who fits into the slipper and becomes as beautiful "as a heavenly being." They marry while an avalanche of heavy stones buries the wicked stepmother and her ugly daughter.

This ninth-century Chinese story was recorded by Taun Ch'eng-shih, one of history's earliest folktale collectors. He wrote that he had first learned the story from a servant who had been with his family for years. No more is known about the story's origin; it bears many obvious similarities with later Western versions. Today seven hundred different Cinderella tales have been collected.

"Puss in Boots": 1553, Italy

"Le Chat Botte," as told by Charles Perrault in 1697, is the most renowned tale in all folklore of an animal as man's helper. But Puss, in earlier and later versions of the story, is a role model for the true con artist. To acquire riches for his destitute master, the quick-witted cat, decked out in a splendid

The earliest Cinderella-like tale tells of the mistreated Yeh-hsien who goes from rags to riches by way of a magic fish, a lost slipper, and marriage to a wealthy merchant.

pair of boots, lies, cheats, bullies, and steals. As the story ends, every one of his conniving stratagems has succeeded brilliantly, and the reader leaves Puss, dashingly attired, mingling in high court circles. Crime pays, suggests the story.

Once again, the story first appeared in Basile's *Pentamerone*. A Neapolitan beggar dies, leaving his son a cat. The son complains bitterly about the meager inheritance, until the cat promises, "I can make you rich, if I put my mind to it."

As in Perrault's tale, the Italian cat, *Il Gatto,* lies and schemes his way to wealth. He even cons the king into offering the princess in marriage to his master; and he coaxes until the king provides a dowry large enough so the master may purchase a sprawling estate. But while Perrault's tale ends there, Basile's does not.

The master had sworn to the cat that as recompense, upon the animal's death, its body would be preserved in a magnificent gold coffin. As a test, *Il Gatto* plays dead. He then suffers the humiliation of hearing his master joke about the feline's ludicrous attire and immoral behavior, and he uncovers the man's true plan: to hurl the corpse by the paws out the window. *Il Gatto,* livid, leaps up and storms out of the house, never to be seen again.

The animal fares better in Perrault's closing line: "The Cat became a great Lord, and never ran more after mice, but for his diversion."

The resemblance between the Italian tale and Perrault's is striking on many counts; except that *Il Gatto* was bootless and the master's estate was purchased with dowry money. Nonetheless, folklorists feel confident that Perrault was unfamiliar with Basile's book.

There was, however, an even earlier Italian version of the story, which may or may not have influenced both Perrault and Basile.

In Venice in 1553, Gianfrancesco Straparola, a storyteller from Caravaggio, near Milan, published a tale of a remarkable cat in *The Delightful Nights*. He claimed that the story, as well as all others in the two-volume work, was written down "from the lips of ten young girls." It is quite similar to Perrault's version, differing in only minor details. And Straparola's book, unlike Basile's, was published in France during Perrault's lifetime.

Over the centuries, in various countries, the tale has appeared in children's books somewhat softened, to make the roguish cat more of a Robin Hood–like prankster, stealing from the rich to give to the poor.

"Hansel and Gretel": 1812, Germany

This story, in which two children outwit a witch who is about to destroy them, comes down to us from the brothers Jacob and Wilhelm Grimm, who began recording folktales told to them by villagers and farmers near the town of Kassel, Germany, about 1807.

The brothers collected 156 stories in all, many of them similar to tales preserved by Charles Perrault, such as "Cinderella" and "Puss in Boots." "Hansel and Gretel" was told to the brothers by a young girl, Doretchen Wild, who years later became Wilhelm Grimm's wife.

The fairy story gained wider popularity after German composer Engelbert Humperdinck made it the basis of a children's opera, first produced in Munich in 1893. However, the opera—as well as subsequent versions of the story—omits the most traumatizing aspect of the traditional tale: the parents' deliberate abandonment of their children to the wild beasts of the forest.

"Hansel and Gretel" was not only known through German oral tradition. A version circulating in France as early as the late seventeenth century had a house made not of gingerbread but of gold and jewels, in which a young girl is held captive by a giant whom she eventually shoves into his own fire. But it was the brothers Grimm who immortalized the tale for future generations.

In Germany, the story lost popularity following the atrocities of Hitler. Shortly after the war, when a major exhibition of children's books was presented in Munich, many people objected to the story's celebration of incinerating an opponent in an oven.

"Snow White and the Seven Dwarfs": 1812, Germany

Jacob and Wilhelm Grimm's stay in the Germany town of Kassel, in order to collect oral-tradition fairy tales, resulted in more than one marriage. Whereas Wilhelm married the girl who told him "Hansel and Gretel," his sister, Lotte, married into the Hassenpflug family, who had told the Grimms "Snow White and the Seven Dwarfs."

The brothers Grimm were the first to artfully combine the elements of blossoming youth, fading beauty, and female rivalry into an enduring fairy tale. But theirs was not the first published version of such a story. The *Pentamerone* contains a tale of a beautiful seven-year-old girl named Lisa who falls unconscious when a comb sticks in her hair. Placed in a glass coffin (as is Snow White), Lisa continues to mature (as does Snow White, who is also seven years old when she is abandoned), growing more and more lovely. A female relative, envious of Lisa's beauty, vows to destroy her (as the jealous queen swears to accomplish Snow White's death). The woman opens the coffin, and while dragging Lisa out by the hair, dislodges the comb, restoring the beauty to life.

Basile's story appears to be the earliest recorded Snow White–like fairy tale. It is uncertain whether the Grimms, writing their version of "Snow-drop" (as they named the girl) two hundred years later, were familiar with the Italian legend.

It was the Grimm version that Walt Disney brought to the screen in 1938 in the first feature-length cartoon.

Many early translators of the Grimm story omitted a gory fact: The queen not only orders Snow White killed but also, as proof of the death, demands that her heart be brought to the palace. Disney reinstated this original detail, but he chose to leave out a more gruesome one. In the German story, the queen, believing the heart returned by the huntsman is Snow White's (it's from a boar), salts and actually eats the organ. And the original fairy tale ends with the defeated queen being forced to don slippers made of iron, which are heated red hot in a fire. In an agonized frenzy, she dances herself to death.

"The Princess on the Pea": 1835, Copenhagen

Charles Perrault and the brothers Grimm wrote what are known as "classic" fairy tales. By comparison, the nineteenth-century author Hans Christian Andersen recounted what folklorists call "art" fairy tales. They were cultivated in the period of German Romanticism, and though rooted in folk legend, they are more personal in style, containing elements of autobiography and social satire.

Andersen, born in 1805 on the Danish island of Funen, was the son of a sickly shoemaker and an illiterate washerwoman. His own life was some-

thing of a fairy tale, for he rose from street urchin to darling of European society. He published *Tales Told for Children* in Copenhagen in 1835, but belittled his fairy tales as "those trifles," being prouder of his concurrently published first novel, *Improvisatoren*, which quickly settled into oblivion.

In a traditional Swedish version of the tale—one that predates Andersen's immortal telling—the princess, to test the legitimacy of her nobility, sleeps on seven mattresses, with a pea between each. And she is subjected to a number of additional tests, in which such items as nuts, grains, pinheads, and straw are placed between her mattresses—all to discern if she is sensitive enough to detect their uncomfortable bulge, and thus prove herself of royal birth.

The heightened sensitivity of royals was also the source of folktales in the East. The earliest such Eastern story appears in Book XII of the *Katha Sarit Sagara* of Somadeva the Kashmiri, who lived in the third century A.D. In that tale, three brothers of a wealthy Brahman vie to see who is the most sensitive. While sleeping on a pile of seven mattresses, the youngest brother awakens in agony, with a crooked red indentation along his skin. Investigators examine the bed and locate a single human hair beneath the bottommost mattress.

The version of "The Princess on the Pea" told today is a slight modification of Andersen's original, which he said he had first heard as a child. Andersen placed his princess on a bed of twenty straw mattresses and twenty featherbeds, with a single pea at the bottom. When the Danish story was first rendered into English in 1846, the translator, Charles Boner, feeling that one pea under forty mattresses stretched credulity, added two peas. Thus, the modern numbers are: forty mattresses and three peas. What Boner never explained, unfortunately, is the logic that led him to conclude that the addition of two peas makes the story more believable.

"Goldilocks and the Three Bears": 1831, England

A fascinating early version of the Goldilocks story was written in 1837 by British poet laureate Robert Southey, under the title "Story of the Three Bears." Southey's Goldilocks was neither young nor beautiful; rather, she was an angry, hungry, homeless gray-haired crone, perhaps in her mid-sixties, who broke into the bears' well-appointed home for food and lodging. The character's evolution from an ill-tempered wiry-haired curmudgeon, to a silver-haired beauty, and finally to a radiant golden-haired maiden occurred over many years and at the hands of several writers.

Southey claimed that he had heard the tale from an uncle. And once the poet published the story, it gained wide acceptance. British readers assumed that "Story of the Three Bears" was an original creation of the Southey family. So did historians until only a few decades ago.

In 1951, an old manuscript was discovered in the Toronto Public Library's Osborne Collection of Early Children's Books. Home-printed and bound,

177

the booklet was titled "The Story of Three Bears metrically related, with illustrations locating it at Cecil Lodge in September 1831." Subtitled "The celebrated nursery tale," it had been put into verse and embellished with drawings as a birthday gift for a little boy, Horace Broke, by his thirty-two-year-old maiden aunt, Eleanor Mure. That was six years before the tale appeared under Robert Southey's name.

The two stories contain strong similarities. In Eleanor Mure's version, the unwelcome intruder to the bears' home is also an "angry old woman," but the bowls in the parlor contained not Southey's porridge but milk turned sour. In Southey's version, when the homeless old woman is discovered in bed by the bears, she jumps out the window, never to be seen again. But in Mure's earlier tale, the incensed bears resort to several cruel tactics to rid themselves of the hag:

> On the fire they throw her, but burn her they couldn't,
> In the water they put her, but drown there she wouldn't.

Worse arrives. In desperation, the bears impale the old woman on the steeple of St. Paul's church.

Researchers can only surmise that Robert Southey's uncle picked up the salient details of Eleanor Mure's story. What is indisputable, however, is that the British poet laureate introduced the fairy tale to a generation of English readers.

Who transformed the rickety old woman to a radiant young Goldilocks?

Twelve years after the publication of Southey's story, another British writer, Joseph Cundall, published *Treasury of Pleasure Books for Young Children.* In an introductory note, Cundall explained to his readers: "I have made the intruder a little girl instead of an old woman"; then he justified the transformation by adding, "because there are so many other stories of old women." And he named the girl Silver-Hair.

The character was known by that name for several years, appearing in a variety of children's books.

Then in 1868, in *Aunt Friendly's Nursery Book,* the intruder to the bears' home is once again transformed: "There lived in the same forest a sweet little girl who was called Golden Hair." Thirty-six years later, in 1904, in *Old Nursery Stories and Rhymes,* the intruder's appearance remained unaltered, but her name was changed to fit her tresses: "The little girl had long golden hair, so she was called Goldilocks." And Goldilocks she has remained.

"Bluebeard": 1697, France

In Charles Perrault's "La Barbe Bleue," the main character is a rich seigneur who forbids his new bride to open one door in his immense castle. She disobeys, discovers the bodies of his former wives, and is herself rescued from death only at the last minute.

Similar stories, involving a forbidden room, a wife's curiosity, and her eleventh-hour rescue, exist throughout the folklore of Europe, Africa, and the East. But Perrault's 1697 version is believed to be based in part on a true case: the heinous crimes of the fifteenth-century marshal of France Gilles de Rais, and his conviction for torturing and killing one hundred forty young boys, whom he first sexually molested. De Rais's celebrated trial for satanism, abduction, and child murder stunned Europe in the 1400s, and the case was still a source of discussion in Perrault's day. De Rais fascinated Perrault.

Baron Gilles de Rais was born in September 1404 at Champtoce, France. As a young man, he distinguished himself in battle against the British, and he was assigned to Joan of Arc's guard and fought at her side. Inheriting vast wealth, he maintained a court more lavish than that of the king of France, and at age thirty-one he took up the practices of alchemy and satanism, hoping to enhance his power and riches.

He also began the ritualistic killing of children. Each murder was initiated with a feast and the drinking of a stimulant. Then the child was taken to an upper room, bound, and told in detail how he was to be sexually abused and slaughtered. This was done so that de Rais could delight in the youth's terror. Eventually, after the actual debauchery and torture, the child was usually beheaded.

De Rais was obsessed with angelic-looking children. He erected on his estate a personal "Chapel of the Holy Innocents" and staffed it with hand-selected choirboys. As rumors raged throughout the countryside concerning the mysterious disappearances of children, one mother, in 1438, publicly accused Gilles de Rais of her son's death. That prompted scores of similar accusations.

De Rais was arrested two years later and brought to trial. Under threat of torture, he confessed, blaming his crimes on an adolescence of parental overindulgence. He was hanged and burned at Nantes, on October 26, 1440.

Charles Perrault drew upon several monstrous aspects of the de Rais case. And he replaced its pedophiliac elements with details from a sixth-century trial of a multiple wife-murderer. "Bluebeard" was a fairy tale of a unique nature, one that would set a model for other grotesque tales based on actual murders. One of the most popular in that genre to follow the Perrault story involved a bloodthirsty count named Dracula.

Dracula: 1897, England

The nineteenth-century Irish writer Bram Stoker came serendipitously upon the subject matter for his novel *Dracula* while engaged in research at the British Museum. He discovered a manuscript of traditional Eastern European folklore concerning Vlad the Impaler, a fifteenth-century warrior prince of Walachia. According to Romanian legend, the sadistic Prince

Vlad took his meals al fresco, amidst a forest of impaled, groaning victims. And Vlad washed down each course with his victims' blood, in the belief that it imbued him with supernatural strength.

Vlad's crimes were legend. On red-hot pokers, he impaled male friends who had fallen from favor, and women unfaithful to him were impaled, then skinned alive. Imprisoned himself, he tortured mice and birds for amusement. His mountaintop retreat, known as Castle Drakula, suggested the title for Stoker's novel.

Although Stoker had found his model for Dracula, it was a friend, a professor from the University of Budapest, who suggested a locale for the fiction by relating lore of the vampires of Transylvania. The novelist traveled to the area and was immediately impressed with its dark, brooding mountains, morning fogs, and sinister-looking castles.

Dracula was an immense success when published in 1897, wrapped in a brown paper cover. And the novel was responsible for reviving interest in the Gothic horror romance, which has continued into the present day in books and films.

Frankenstein: 1818, Switzerland

Mary Shelley's novel *Frankenstein: The Modern Prometheus,* evolved from several evenings of storytelling in June 1816, at the Villa Diodati near Geneva, Switzerland. The nineteen-year-old Mary engaged in a storytelling competition with her twenty-four-year-old husband, Percy Bysshe Shelley; her eighteen-year-old stepsister, Claire Clarement (then carrying the child of her lover, Lord Byron); the twenty-eight-year-old Byron; and his personal physician, twenty-three-year-old John Polidori.

During a rainy week, Byron suggested that they entertain themselves by writing original ghost stories. Mary's inspiration came one evening as she sat by the fireplace, listening to Shelley and Byron argue over the source of human life and whether it could be artificially created. Electric current was the focus of considerable scientific research at the time, and the two poets debated the possibility of electrically reanimating a corpse, imbuing it with what they called "vital warmth."

When the discussion concluded late in the evening, Shelley retired. But Mary, transfixed in speculation, was unable to sleep. For an 1831 edition of *Frankenstein,* Mary Shelley vividly recalled her burst of inspiration:

> I saw—with shut eyes but acute mental vision—the pale student of unhallowed arts kneeling beside the thing he had put together. . . . I saw the hideous phantasm of a man stretched out, and then, on the working of some powerful engine, show signs of life and stir with an uneasy, half-vital motion. . . .
>
> Swift as light and as cheering was the idea that broke in upon me. . . .

On the morrow I announced that I had thought of a story. I began the day with the words, "It was on a dreary night in November," making only a transcript of the grim terrors of my waking dream.

The Wonderful Wizard of Oz: 1900, United States

Born in Chittenango, New York, in 1856, Lyman Frank Baum began his career as a journalist but switched to writing children's books, more than sixty of them before his death in 1919, in Hollywood. His first book, *Father Goose*, published in 1899, was a commercial success, and he followed it the next year with a novel that would quickly become a classic.

The Wonderful Wizard of Oz was conceived one evening in 1899 when Baum was improvising a story to entertain his sons and several neighborhood children. He imagined a girl named Dorothy, swept from her Kansas home and deposited in a strange and magical land, where she encounters a scarecrow, a tin woodsman, and a cowardly lion. Suddenly, a neighborhood girl, Tweety Robbins, interrupted Baum to ask the name of the magical land.

The masterful storyteller was momentarily stumped. Years later, in an interview published in the *St. Louis Republic*, Baum divulged the origin of the immortal name Oz. Next to him that night had been a three-tiered filing cabinet, the first drawer labeled A–G, the second H–N, and the last O–Z. "Oz," he said, "it at once became."

Though Baum told that yarn often, his later biographers believe it might reflect a bit of his own imaginative fabrication. For when he first submitted the manuscript for the book to his publisher in 1899, the story was titled *The Emerald City*, that being the name of the magical land. During the publishing process, Baum retitled the book to *From Kansas to Fairyland*, then *The City of the Great Oz*. But Oz, even at that late date, was the name not of the kingdom but only of the wizard.

Finally, he arrived at a title that pleased himself and his publisher: *The Wonderful Wizard of Oz*. Only then, enamored with the idea of naming the land Oz, did he hurriedly pencil through the manuscript that the Emerald City was located "in the land of Oz."

Baum wrote thirteen more Oz books, and the popular series was continued with another book after his death. He did invent the name Oz, and his biographers have posited three of their own plausible theories for its origin:

- That Baum modified the name of the biblical region of Uz, Job's homeland.
- That, delighting in the "Ohs" and "Ahs" his tales elicited from children, he respelled the latter exclamation Oz.
- That he slightly altered Charles Dickens's pseudonym, "Boz," for he greatly admired the British author's novels.

Nursery Rhymes: Antiquity, Europe and Asia

Although the concept of rhymes is ancient, only in the 1820s did the term "nursery rhyme" come into use. Previously, such verses were simply known as "songs" or "ditties," and in the 1700s, specifically, as "Tom Thumb songs" or "Mother Goose rhymes." In America, in the next century, "Mother Goose rhymes" would win out as the generic name for all children's verse, regardless of authorship.

There have been many attempts to censor the sadistic phrases found in several popular rhymes—for example, "She cut off their tails with a carving knife." And many groups have claimed that certain rhymes, replete with adult shenanigans, are entirely unfit for children. The fact is, most nursery rhymes were never intended for children. That is why the adjective "nursery" was not used for centuries. It first appeared in the year 1824, in an article for a British magazine titled "On Nursery Rhymes in General."

If the rhymes originally were not for the nursery, what was their function?

Some rhymes were stanzas taken from bawdy folk ballads. Others began as verses based on popular street games, proverbs, or prayers. And many originated as tavern limericks, spoofs of religious practices, social satire, and the lyrics of romantic songs. They don't read precisely that way today because in the early 1800s many "nursery" rhymes were sanitized to satisfy the newly emerging Victorian morality.

In their definitive work *The Oxford Dictionary of Nursery Rhymes*, Iona and Peter Opie write: "We can say almost without hesitation that, of those pieces which date from before 1800, the only true rhymes composed especially for the nursery are the rhyming alphabets, the infant amusements (verses which accompany a game), and the lullabies. . . . The overwhelming majority of nursery rhymes were not in the first place composed for children."

However, rhymes in their bawdy versions were often recited to children, because children were treated as miniature adults. Then, in the early 1800s, many rhymes were cleaned up, subsumed under the rubric "nursery," and ascribed to a pseudonymous Mother Goose. Who was this woman? Or man?

Mother Goose: 1697, France

According to an early New England legend, the original Mother Goose was a Boston widow, Elizabeth Goose, born in 1665. On marrying Isaac Goose at age twenty-seven, she immediately became the stepmother of ten children, then bore six of her own. The association of Mistress Goose with the name Mother Goose stems from an alleged volume of rhymes published in 1719 by one of her sons-in-law and titled *Mother Goose's Melodies for Children*. Widespread as this legend was—and the people involved were real—no copy of the book has ever been found.

"Hush-a-Bye, Baby." Inspired by the American Indian custom of hanging cradles from birch trees.

More cogent evidence suggests that the original Mother Goose was actually a man: Charles Perrault.

Perrault's seminal 1697 book, containing eight popular stories, bore the subtitle "Tales of My Mother Goose." That is the first time the term appeared in print. Whether Perrault concocted the name or adapted it from "Frau Gosen," a woman in German folklore, is unknown. What most folklorists believe is that the same man who immortalized such fairy tales as "Cinderella" and "Sleeping Beauty" also popularized a fictitious mother of rhymes who came to be known to children throughout the world.

"Hush-a-Bye, Baby": 1765, New England

> Hush-a-bye, baby, on the tree top,
> When the wind blows, the cradle will rock;
> When the bough breaks, the cradle will fall,
> Down will come baby, cradle, and all.

In the category of rhymes known as lullabies, "Hush-a-bye" is the best known in both America and England. It first appeared in a 1765 book, *Mother Goose's Melody*, along with a footnote which indicates that its anonymous author intended it to be more than merely a lullaby: "This may serve

"Ride a Cock-Horse." The "fine lady" may have been a "Fiennes lady," one Celia Fiennes of Banbury Cross.

as a Warning to the Proud and Ambitious, who climb so high that they generally fall at last."

The slight historical evidence that exists indicates that the author was a young Pilgrim who sailed to America on the *Mayflower*. He was impressed by the way Indian squaws hung birchbark cradles containing their infants on tree branches. Such a tree, containing several cradles, is thought to have inspired the rhyme. According to the written record, "Hush-a-Bye" is the first poem created on American soil.

"Ride a Cock-Horse": Pre–18th Century, England

> *Ride a cock-horse to Banbury Cross,*
> *To see a fine lady upon a white horse;*
> *Rings on her fingers and bells on her toes,*
> *And she shall have music wherever she goes.*

Banbury Cross appears in many nursery rhymes. Not because the British village of Banbury was a favorite locale of writers, but for the simple reason that a major seventeenth-century publisher, Master Rusher, lived in Banbury and frequently altered the wording in submitted manuscripts to promote his hometown.

One phrase, "bells on her toes," suggests to historians that the rhyme

may have been part of oral tradition as early as the fifteenth century. In England at that time, small decorative bells, fastened to the long tapering toes of shoes, were high fashion.

Two women have been identified as candidates for the "fine lady" on a white horse. One, not surprisingly, is the famous Lady Godiva, the eleventh-century noblewoman of Coventry, who is supposed to have ridden naked on a white horse to protest high taxation. The other woman is Celia Fiennes, daughter of a member of Parliament in the 1690s. Lady Fiennes's family owned a castle in Banbury, and she was famous for her marathon horseback rides through the English countryside. Some authorities believe that the phrase "To see a fine lady" originally read "To see a Fiennes lady."

"Baa, Baa, Black Sheep": Pre-1765, Europe

Baa, baa, black sheep,
Have you any wool?
Yes, sir, yes, sir,
Three bags full . . .

Throughout its two-hundred-year history, this rhyme has remained essentially unaltered. It contains no hidden symbolism or significance, and from the start it was sung to the old French tune *"Ah vous dirai je,"* or, in America, the tune "A, B, C, D, E, F, G." The rhyme was employed by Rudyard Kipling in 1888 as the framework for his story "Baa, Baa, Black-Sheep."

"Little Boy Blue": Pre-1760, England

Little Boy Blue,
Come blow your horn,
The sheep's in the meadow,
The cow's in the corn . . .

The little boy is believed to represent the influential sixteenth-century statesman and cardinal Thomas Wolsey, who dominated the government of England's King Henry VII from 1515 to 1529.

A butcher's son, Wolsey was educated at Oxford, then became a priest. He was an energetic and highly self-confident man, and easily persuaded the pleasure-loving young monarch to surrender more and more of the chores of state. It was on Henry's recommendation that Pope Leo X promoted the power-hungry Wolsey first to bishop, a year later to archbishop, and the following year to cardinal. A meteoric rise. Wolsey used his ubiquitous secular and ecclesiastical power to amass a fortune second only to the king's.

Though sworn to priestly chastity, he fathered at least two illegitimate children. The overbearing cardinal made many enemies, but his immediate downfall was his failure to persuade Pope Clement VII to grant Henry an annulment of his marriage to Catherine of Aragon. The king, in an about-face, charged his lord chancellor with *praemunire*, or having overstepped his authority, and stripped him of all titles and power.

Wolsey, as a boy in Ipswich, tended his father's sheep. And his fall from grace and loss of authority are believed to be mirrored in Little Boy Blue's sudden disappearance and consequent inability to blow his own horn.

"The First Day of Christmas": Pre-1780, London

The first day of Christmas,
My true love sent to me
A partridge in a pear tree. . . .

The rhyme, known technically as a "chant," first appeared in a 1780 children's book published in London. However, the verse was of older oral tradition—a so-called memory-and-forfeits game. Children, in a circle, individually recited the rhyme's many verses, and for each mistake they were forced to relinquish a sweet. For more than a century, it was employed in classrooms as a teaching rhyme, intended to improve a child's memory skills.

"Cock-a-Doodle-Doo!": Early 17th Century, England

Cock-a-doodle-doo!
My dame has lost her shoe,
My master's lost his fiddling stick,
And doesn't know what to do.

Although the verse's authorship is unknown, its early popularity in England is associated with a gruesome event that took place in Hertfordshire at the end of the reign of Elizabeth I.

The event, as recounted in a 1606 pamphlet, tells of the bludgeoning murder of a three-year-old boy, witnessed by his slightly older sister, whose tongue was cut out to prevent her from naming the culprit. Several years later, the speechless girl was playing a popular street game of the day known as "mock the cock." When other children taunted her to speak, she allegedly opened her mouth and miraculously uttered the "Cock-a-doodle-doo!" rhyme, ensuring it immortality in the oral tradition.

"Hark, Hark": 16th Century, England

Hark, Hark,
The dogs do bark,
The beggars are coming to town;
Some in rags,
And some in jags,
And one in a velvet gown.

Our contemporary social problem of homeless individuals, particularly in metropolises, is mirrored in the history of this verse.

The words were frequently quoted during the reign of Queen Elizabeth in the sixteenth century, when hordes of homeless men and women flocked to London to beg for food and drink. City folk feared that their homes would be burglarized, and farmers on the outskirts of town often were victimized by the down-and-out, who dressed "in rags," and some of whom, mentally disturbed individuals suffering delusions of grandeur, imagined themselves dressed in such finery as "a velvet gown."

"There Was a Little Girl": 1850s, United States

There was a little girl,
And she had a little curl,
Right in the middle of her forehead . . .

The rhyme, about a girl who is alternatively "very, very good" and "horrid," was written in the late 1850s by the poet Henry Wadsworth Longfellow, on a day when his young daughter, Edith, stubbornly refused to have her hair curled.

For many years, Longfellow denied authorship, pointing to the inelegance of several of the rhyme's words and to the fact that the style of composition was not his. However, before his death in 1882, he acknowledged having hastily composed the verse, and retrospectively admitted, "When I recall my juvenile poems and prose sketches, I wish that they were forgotten entirely."

"Hey Diddle Diddle": Post-1569, Europe

Hey diddle diddle,
The cat and the fiddle,
The cow jumped over the moon . . .

187

Any rhyme in which a cow jumps over the moon and a dish runs away with a spoon is understandably classified in the category "nonsense rhymes." The verse, meant to convey no meaning but only to rhyme, was composed entirely around a European dance, new in the mid-1500s, called "Hey-didle-didle." The object was to have something metrical to sing while dancing.

"Humpty Dumpty": 15th Century, England

> *Humpty Dumpty sat on a wall,*
> *Humpty Dumpty had a great fall.*
> *All the king's horses,*
> *And all the king's men,*
> *Couldn't put Humpty together again.*

Scholars of linguistics believe this rhyme may be five hundred years old and may have mocked a nobleman who fell from high favor with a king, the fifteenth-century British monarch Richard III. From England the rhyme spread to several European countries, where its leading character changed from "Humpty Dumpty" to "Thille Lille" (in Sweden), "Boule, Boule" (in France), and "Wirgele-Wargele" (in Germany).

In the 1600s, "humpty dumpty" became the name of a hot toddy of ale and brandy, and one hundred fifty years later, it entered British vernacular as "a short clumsy person of either sex."

"Jack and Jill": Pre-1765, England

> *Jack and Jill went up the hill*
> *To fetch a pail of water;*
> *Jack fell down and broke his crown,*
> *And Jill came tumbling after.*

A 1765 British woodcut illustrating this rhyme shows two boys, named Jack and Gill; there is no mention or depiction of a girl named Jill. Some folklorists believe the boys represent the influential sixteenth-century cardinal Thomas Wolsey and his close colleague, Bishop Tarbes.

In 1518, when Wolsey was in the service of Henry VII, Western Europe was split into two rival camps, France and the Holy Roman Empire of the Hapsburgs. Wolsey and Tarbes traveled back and forth between the enemies, attempting to negotiate a peace. When they failed, full-scale war erupted. Wolsey committed British troops against France, and to finance the campaign he raised taxes, arousing widespread resentment. The rhyme is thought to parody his "uphill" peace efforts and their eventual failure.

"Jack Be Nimble": Post–17th Century, England

> *Jack be nimble,*
> *Jack be quick,*
> *Jack jumped over*
> *The candle stick.*

The verse is based on both an old British game and a once-popular means of auguring the future: leaping over a lit candle.

In the game and the augury, practiced as early as the seventeenth century, a lighted candle was placed in the center of a room. A person who jumped over the flame without extinguishing it was supposed to be assured good fortune for the following year. The custom became part of traditional British festivities that took place on November 25, the feast day of St. Catherine, the fourth-century Christian martyr of Alexandria.

"This Is the House That Jack Built": Post-1500s, Europe

> *This is the house that Jack built.*
>
> *This is the malt*
> *That lay in the house that Jack built.*
>
> *This is the rat,*
> *That ate the malt*
> *That lay in the house that Jack built. . . .*

This is an example of an "accumulative rhyme," in which each stanza repeats all the previous ones, then makes its own contribution.

The origin of "The House That Jack Built" is thought to be a Hebrew accumulative chant called "Had Gadyo," which existed in oral tradition and was printed in the sixteenth century, although the subject matter in the two verses is unrelated. The point of an accumulative rhyme was not to convey information or to parody or satirize a subject, but only to tax a child's powers of recall.

"Little Jack Horner": Post-1550, England

> *Little Jack Horner*
> *Sat in the corner,*
> *Eating a Christmas pie . . .*

At the end of this rhyme, when Jack pulls a plum from the pie and

Jack Horner extracting the deed for Mells Manor.

exclaims "What a good boy am I!" he is actually commenting on his deviousness, for the tasty plum is a symbol for something costly that the real "Jack" stole.

Legend has it that the original Jack Horner was Thomas Horner, sixteenth-century steward to Richard Whiting, abbot of Glastonbury in Somerset, the richest abbey in the British kingdom under King Henry VIII.

Abbot Richard Whiting suspected that Glastonbury was about to be confiscated by the crown during this period in history, known as the Dissolution of Monasteries. Hoping to gain favor with the king, Whiting sent Thomas Horner to London with a gift of a Christmas pie.

It was no ordinary pie. Beneath the crust lay the title deeds to twelve manor houses—a token that the abbot hoped would placate King Henry. En route to London, Horner reached into the pie and extracted one plum of a deed—for the expansive Mells Manor—and kept it for himself.

Soon after King Henry dissolved the abbot's house, Thomas Horner took up residence at Mells Manor, and his descendants live there to this day—though they maintain that their illustrious ancestor legally purchased the deed to the manor from Abbot Whiting.

Interestingly, Richard Whiting was later arrested and tried on a trumped-up charge of embezzlement. Seated in the corner of the jury was his former steward, Thomas Horner. The abbot was found guilty and hanged, then drawn and quartered. Horner not only was allowed to retain Mells Manor but was immortalized in one of the world's best-known, best-loved nursery rhymes.

"Ladybird, Ladybird": Pre–18th Century, Europe

> *Ladybird, ladybird,*
> *Fly away home,*
> *Your house is on fire*
> *And your children all gone.*

Today the rhyme accompanies a game in which a child places a ladybug on her finger and recites the verse. If the insect does not voluntarily fly away, it is shaken off. According to an eighteenth-century woodcut, that is precisely what children did in the reign of George II.

The rhyme, though, is believed to have originated as an ancient superstitious incantation. Composed of slightly different words, it was recited to guide the sun through dusk into darkness, once regarded as a particularly mysterious time because the heavenly body vanished for many hours.

"London Bridge": Post–11th Century, England

> *London Bridge is broken down,*
> *Broken down, broken down,*
> *London Bridge is broken down,*
> *My fair lady.*

The first stanza of this rhyme refers to the actual destruction, by King Olaf of Norway and his Norsemen in the eleventh century, of an early timber version of the famous bridge spanning the Thames. But there is more to the story than that.

Throughout Europe during the Middle Ages, there existed a game known as Fallen Bridge. Its rules of play were virtually identical in every country. Two players joined hands so that their elevated arms formed a bridge. Other players passed beneath, hoping that the arms did not suddenly descend and trap them.

In Italy, France, Germany, and England, there are rhymes based on the game, and "London Bridge" is one example. But the remainder of the long, twelve-stanza poem, in which all attempts to rebuild London Bridge fail, reflects an ancient superstition that man-made bridges, which unnaturally span rivers, incense water gods.

Among the earliest written records of this superstition are examples of living people encased in the foundations of bridges as sacrifices. Children were the favored sacrificial victims. Their skeletons have been unearthed in the foundations of ancient bridges from Greece to Germany. And British

London Bridge, c. 1616. To appease water gods children were buried in bridge foundations.

folklore makes it clear that to ensure good luck, the cornerstones of the first nontimber London Bridge, built by Peter of Colechurch between 1176 and 1209, were splattered with the blood of little children.

"See-Saw, Margery Daw": 17th Century, British Isles

> *See-saw, Margery Daw,*
> *Jacky shall have a new master;*
> *Jacky shall have but a penny a day,*
> *Because he can't work any faster.*

This was originally sung in the seventeenth century by builders, to maintain their to-and-fro rhythm on a two-handed saw. But there is a ribald meaning to the words. "Margery Daw" was then slang for a slut, suggesting that the rugged, hard-working builders found more in the rhyme to appreciate than meter.

A more explicit version of the verse, popular in Cornwall, read: "See-saw, Margery Daw / Sold her bed and lay upon straw," concluding with: "For wasn't she a dirty slut / To sell her bed and lie in the dirt?"

Later, the rhyme was adopted by children springing up and down on a see-saw.

"Mary Had a Little Lamb": 1830, Boston

> Mary had a little lamb,
> Its fleece was white as snow;
> And everywhere that Mary went
> The lamb was sure to go.

These are regarded as the best-known four lines of verse in the English language. And the words "Mary had a little lamb," spoken by Thomas Edison on November 20, 1877, into his latest invention, the phonograph, were the first words of recorded human speech.

Fortunately, there is no ambiguity surrounding the authorship of this tale, in which a girl is followed to school by a lamb that makes "the children laugh and play." The words capture an actual incident, recorded in verse in 1830 by Mrs. Sarah Josepha Hale of Boston, editor of the widely read *Ladies' Magazine*.

Mrs. Hale (who launched a one-woman crusade to nationalize Thanksgiving Day; see page 64) was also editor of *Juvenile Miscellany*. When she was told of a case in which a pet lamb followed its young owner into a country schoolhouse, she composed the rhyme and published it in the September–October 1830 issue of the children's journal. Its success was immediate—and enduring.

"Mary, Mary": 18th Century, England

> Mary, Mary, quite contrary,
> How does your garden grow?
> With silver bells and cockle shells,
> And pretty maids all in a row.

The rhyme originated in the eighteenth century and there are two schools of thought concerning its meaning, one secular, the other ecclesiastic.

The "silver bells," argue several Catholic writers, are "sanctus bells" of mass; the "cockle shells" represent badges worn by pilgrims; and the "pretty maids all in a row" are ranks of nuns marching to church services. Mary is of course the Blessed Virgin. This argument is as old as the rhyme.

But the popular secular tradition has it that the original "Mary" was Mary, Queen of Scots; that the phrase "quite contrary" referred to her well-documented frivolous French ways; and that the "pretty maids" were her renowned "Four Marys," the ladies-in-waiting Mary Seaton, Mary

Fleming, Mary Livingston, and Mary Beaton. The cockle shells were decorations on an elaborate gown given to her by the French dauphin. This argument is also as old as the rhyme.

"Three Blind Mice": 1609, London

> *Three blind mice, see how they run!*
> *They all run after the farmer's wife,*
> *Who cut off their tails with a carving knife,*
> *Did you ever see such a thing in your life,*
> *As three blind mice?*

The verse is regarded as the best-known example of a "round" in the world, and it is the earliest printed secular song still sung today. From the time of its creation, it was a round, a verse in which multiple voices repeat a rhyme, each voice a line behind the previous speaker. Rounds were regarded as educational tools to improve children's powers of concentration.

"Three Blind Mice" first appeared on October 12, 1609, in *Deuteromelia; or, The seconde part of Musicks melodie,* by Thomas Ravenscroft, a teenage chorister at St. Paul's church. He is taken to be the song's creator.

"Old Mother Hubbard": Pre-1805, London

> *Old Mother Hubbard*
> *Went to the cupboard*
> *To fetch her poor dog a bone;*
> *But when she came there*
> *The cupboard was bare*
> *And so the poor dog had none.*

When this long, fourteen-stanza rhyme was first published in London in June 1805, it quickly sold over ten thousand copies, to become an immediate best-seller, with several reprintings. Overnight, Mother Hubbard became an integral part of nursery rhyme literature.

The comedic verse was written in 1804 by Sarah Catherine Martin, an early love of Prince William Henry, who later became King William IV. Her manuscript is on display at Oxford University's Bodleian Library.

Sarah Martin, a vibrant, vivacious woman, composed the verse during a stay at the home of her future brother-in-law, John Pollexfen Bastard, an MP for Kitley, Devon. The Bastard family maintained that one day, while John Bastard was attempting to write a letter, Sarah Martin garrulously chattered away, until he ordered her to "run away and write one of your stupid little rhymes." She did.

Was Sarah Martin's creation original?

Not entirely. She apparently based her poem on a little-known rhyme first published in 1803 and titled "Old Dame Trot, and Her Comical Cat." The rhymes are too similar to be merely coincidental:

> *Old Dame trot,*
> *Some cold fish had got,*
> *Which for pussy,*
> *She kept in Store,*
> *When she looked there was none*
> *The cold fish had gone,*
> *For puss had been there before.*

Other stanzas of the rhymes also parallel each other:

Mother Hubbard	Dame Trot
She went to the baker's	*She went to the butcher's*
To buy him some bread;	*To buy her some meat,*
But when she came back	*When she came back*
The poor dog was dead.	*She lay dead at her feet.*

"Dame Trot" was published by a T. Evans one year before Sarah Martin composed her verse. But historians have discovered that the verse about the "comical cat" had already been known for about a hundred years, and was included in a 1706 book, *Pills to Purge Melancholy.* Moreover, Sarah Martin did not originate the character of Mother Hubbard. She was a popular satirical cartoon figure as early as 1590, when she appeared in a satire, *Mother Hubbard's Tale.* The character is believed to have been modeled on the eighth-century French martyr St. Hubert, patron saint of hunters and dogs. Little is known about St. Hubert. He was bishop of Tongres-Maestricht and died at Tervueren on May 30, 727, following injuries incurred while hunting.

Historians are forced to conclude that Sarah Martin had been told the "Dame Trot" rhyme as a child, and that she was familiar with the satirical Mother Hubbard. When she hurried off to compose one of her "stupid little rhymes"—drawing on a little-known cartoon character, a little-read comic cat poem, and a long-forgotten patron saint—Sarah Martin combined memory and imagination to immortalize a nursery rhyme.

"Little Miss Muffet": 16th Century, England

> *Little Miss Muffet*
> *Sat on a tuffet,*
> *Eating her curds and whey;*
> *There came a big spider,*

Who sat down beside her
And frightened Miss Muffet away.

Of all nursery rhymes, this appears most frequently in children's books. It was written in the sixteenth century by, appropriately, an entomologist with a special interest in spiders, Dr. Thomas Muffet, the author of a scholarly work, *The Silkwormes and their flies.*

As Longfellow had composed "There Was a Little Girl" for his daughter Edith, Dr. Muffet wrote "Little Miss Muffet" for his young daughter Patience. At that time, a "tuffet" was a three-legged stool, and "curds and whey" was a milk custard.

"Ring-a-Ring o' Roses": Pre–18th Century, England

Ring-a-ring o' roses,
A pocket full of posies,
A-tishoo! A-tishoo!
We all fall down.

The rhyme first appeared in an 1881 book, *Mother Goose,* though in oral tradition it is much older. And for all its apparent innocence and playfulness as a child's game, the verse is about something deathly serious: the Great Plague of London in 1664–65, which resulted in more than 70,000 deaths at a time when the city's population numbered only 460,000.

The disease, caused by the bacillus *Pasteurella pestis,* was transmitted to humans in crowded urban areas by rat fleas. In the rhyme, "ring o' roses" refers to the circular rosy rash that was one of the plague's early symptoms. And the phrase "pocket full of posies" stands for the herbs people carried in their pockets, believing they offered protection against the disease. The final two lines, "A-tishoo! A-tishoo! / We all fall down," tell of the plague's fatal sneeze, which preceded physical collapse; literally, the victim fell down dead.

"Sing a Song of Sixpence": Pre-1744, England

Sing a song of sixpence,
A pocket full of rye;
Four and twenty blackbirds,
Baked in a pie.

A sixteenth-century Italian cookbook, *The Manner of Cuisine of What Meat for What Affair,* offers a recipe for actually baking live birds between crusts of a pie. If the instructions are followed, the book promises, "the birds may be alive and flie out when it is cut up." The purpose of such a pie was

to create a "diverting Hurley-Burley amongst the Guests."

In fact, it was not uncommon in the sixteenth century for a chef to hide surprises inside a dinner pie. (See "Little Jack Horner," page 189.) The rhyme, first published in England in 1744, is thought to be a straightforward attempt to capture a then-popular baking curiosity in verse.

Children's Literature: 1650, Europe

Before the mid-seventeenth century, books written expressly for children were virtually nonexistent. Literate children from poor and wealthy families alike had to content themselves with adult books. One of the most popular was *Aesop's Fables*, a sixth-century B.C. Greek work that had existed for centuries in French translation and was first rendered into English in 1484.

That book, which anthropomorphizes animals, remained the only truly suitable adult literature for children until 1578. That year, a German author and publisher, Sigmund Feyerabend, issued a *Book of Art and Instruction for Young People*. This landmark volume, a picture book, was a collection of woodcut illustrations of contemporary European life, fables, and German folktales, with a text consisting mainly of extended captions. The volume was an immense success, and Feyerabend, a pioneer publisher of quality books, is honored today with the largest of all annual book fairs, held each autumn in Frankfurt, his hometown.

Another favorite book enjoyed by children in the late 1500s—though not intended for them—was John Foxe's 1563 *Actes and Monuments*, popularly titled "The Book of Martyrs." Replete with text and illustrations of raging infernos consuming sinners, of saints in the agonizing throes of martyrdom, and of sundry Christians being stoned, flogged, and beheaded, the book was among the volumes most widely read, by adults and youths, in the late sixteenth century.

Not until 1657 would a truly important children's book of text reach print: *Orbis Sensualium Pictus*, a Latin volume of text with illustrations, by Czech educator Johannes Amos Cemenius; it was published in Nuremberg, Germany. Cemenius was the first author to appreciate the importance of combining words, diagrams, and pictures as a children's learning aid. The book's subtitle, "A Nomenclature of All the Chief Things in the World," conveys a sense of its encyclopedic scope and educational tone. This seminal volume had an enormous effect on subsequent books for young readers, and in many ways it was a forerunner of the modern encyclopedia.

The widespread use of the printing press eventually made the production of small, inexpensive children's books a reality. In the seventeenth century, the popular "chapbooks" appeared. Sold by "chapmen" along European roads and on town street corners, the thin volumes, of about ten pages, were poorly illustrated and printed, but their low cost won them wide readership. They featured medieval folktales, poems, jokes, and humorous anecdotes of an uncensored, and sometimes ribald, nature. Their all-too-

rapid death knell was sounded by the 1662 Act of Uniformity, which ushered in a wave of stern puritanism and strict moral sanctions on printed materials.

It was in this repressive climate that historians locate the true birth of children's literature—that is, the regular, rather than occasional, appearance of books written expressly for children. The books, later called "heaven and hell" tomes, were dogmatic, moralistic, and intended to strike terror and shape behavior in the young. The predominant theme was that life on earth led irrevocably to an eternity in hell—except for the mercy of God. The books' illustrations, often showing children suffering in hell, were reinforced by verses such as:

> *Children that make*
> *Their Parents to Bleed*
> *May live to have*
> *Children to revenge*
> *That deed.*

For many decades, the only relief children had from this fire-and-brimstone literature lay in alphabet and arithmetic textbooks. Escape came at the close of the 1600s and in the form of the fairy tale—and in particular, as we have seen, with the 1697 publication of Charles Perrault's classic, *Tales of Times Passed: Tales of My Mother Goose.* For generations, such folklore had been transmitted through oral tradition; Perrault committed the legends to print, and in a style so vivid and imaginative that eight tales at least were at once immortalized. Reading to youngsters in the nursery would never again be the same.

Chapter 8

In the Bathroom

Bathroom: 8000 B.C., Scotland

Men inquire, "Where can I wash my hands?" and women ask, "Is there a place to powder my nose?" Schoolchildren stammer, "May I be excused?" while travelers abroad beg for directions to the nearest "comfort station," which the British call a "WC." What everyone is really asking for is, of course, the location of the nearest . . . well, rest room.

The point being that we have developed scores of euphemisms for the toilet, as well as for bodily functions performed there. And the trend does not merely reflect modern civility. Even in less formally polite medieval times, castles and monasteries had their "necessaries."

Erasmus of Rotterdam, the sixteenth-century scholar and humanist, who wrote one of history's early etiquette books, provides us with some of the first recorded rules of behavior for the bathroom and bodily functions. He cautions that "It is impolite to greet someone who is urinating or defecating." And on breaking wind, he advises the offender to "let a cough hide the explosive sound. . . . Follow the law: Replace farts with coughs."

The history of the bathroom itself begins in Scotland ten thousand years ago. Although early man, aware of the toxicity of his own wastes, settled himself near a natural source of moving water, it was the inhabitants of the Orkney Islands off Scotland who built the first latrine-like plumbing systems to carry wastes from the home. A series of crude drains led from stone huts to streams, enabling people to relieve themselves indoors instead of outside.

In the Near East, hygiene was a religious imperative for the ancient Hindus, and as early as 3000 B.C., many homes had private bathroom facilities. In the Indus River Valley of Pakistan, archaeologists have uncovered private and public baths fitted with terra-cotta pipes encased in brickwork, with taps to control water flow.

The most sophisticated early bathrooms belonged to the royal Minoan families in the palace at Knossos on Crete. By 2000 B.C., Minoan nobility luxuriated in bathtubs filled and emptied by vertical stone pipes cemented at their joints. Eventually, these were replaced by glazed pottery pipes which slotted together very much like present-day ones. The pipes carried hot and cold water, and linkage drained waste from the royal palace—which also boasted a latrine with an overhead reservoir, which qualifies as history's first flush toilet. (See "Modern Flush Toilet," page 203.) The reservoir was designed to trap rainwater, or in its absence, to be hand-filled by buckets of water drawn from a nearby cistern.

Bathroom technology continued among the ancient Egyptians. The homes of Egyptian aristocrats, by 1500 B.C., were outfitted with copper pipes that carried hot and cold water. And whole-body bathing was an integral part of religious ceremonies. Priests, curiously, were required to immerse themselves in four cold baths a day. The religious aspects of bathing were carried to greater lengths by the Jews under Mosaic law, for whom bodily cleanliness was equated with moral purity. Under the rule of David and Solomon, from about 1000 to 930 B.C., complex public waterworks were constructed throughout Palestine.

Spas: 2nd Century B.C., Rome

It was the Romans, around the second century B.C., who turned bathing into a social occasion. They constructed massive public bath complexes which could rival today's most elaborate and expensive health clubs. With their love of luxury and leisure, the Romans outfitted these social baths with gardens, shops, libraries, exercise rooms, and lounge areas for poetry readings.

The Baths of Caracalla, for example, offered Roman citizens a wide range of health and beauty options. In one immense complex there were body oiling and scraping salons; hot, warm, and cold tub baths; sweating rooms; hair shampooing, scenting, and curling areas; manicure shops; and a gymnasium. A selection of cosmetics and perfumes could also be purchased. After being exercised, washed, and groomed, a Roman patron could read in the adjoining library or stop into a lecture hall for a discussion of philosophy or art. A gallery displayed works of Greek and Roman art, and in another room, still part of the complex, slaves served platters of food and poured wine.

If this sounds like the arrangement in such a celebrity spa as the Golden Door, it was; only the Roman club was considerably larger and catered to

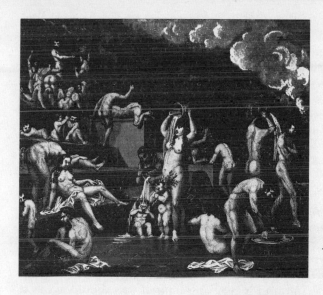

Roman spa. Men and women used separate facilities but later mixed bathing became the fashion.

a great many more members—often twenty-five hundred at one time. And that was just the men's spa. Similar though smaller facilities were often available to women.

Though at first men and women bathed separately, mixed bathing later became the fashion. It lasted well into the early Christian era, until the Catholic Church began to dictate state policy. (From written accounts, mixed bathing did not result in the widespread promiscuity that occurred a thousand years later when public baths reemerged in Europe. During this early Renaissance period the Italian word *bagnio* meant both "bath" and "brothel.")

By A.D. 500, Roman bathing spa luxury had ended.

From the decline of the Roman Empire—when invading barbarians destroyed most of the tiled baths and terra-cotta aqueducts—until the later Middle Ages, the bath, and cleanliness in general, was little known or appreciated. The orthodox Christian view in those times maintained that all aspects of the flesh should be mortified as much as possible, and wholebody bathing, which completely exposed the flesh, was regarded as entertaining temptation and thus sinful. That view prevailed throughout most of Europe. A person bathed when he or she was baptized by immersion, and infrequently thereafter. The rich splashed themselves with perfume; the poor stunk.

With the demise of bathing, public and private, went the niceties of indoor bathroom technology in general. The outhouse, outdoor latrines and trenches, and chamber pots reemerged at all levels of society. Christian prudery, compounded by medical superstition concerning the health evils of bathing, all but put an end to sanitation. For hundreds of years, disease was commonplace; epidemics decimated villages and towns.

In Europe, the effects of the 1500s Reformation further exacerbated the disregard for hygiene. Protestants and Catholics, vying to outdo each other in shunning temptations of the flesh, exposed little skin to soap and water throughout a lifetime. Bathroom plumbing, which had been sophisticated two thousand years earlier, was negligible to nonexistent—even in grand European palaces. And publicly performed bodily functions, engaged in whenever and wherever one had the urge, became so commonplace that in 1589 the British royal court was driven to post a public warning in the palace:

> Let no one, whoever, he may be, before, at, or after meals, early or late, foul the staircases, corridors, or closets with urine or other filth.

In light of this warning, Erasmus's 1530 advice—"It is impolite to greet someone who is urinating or defecating"—takes on its full significance.

A hundred years later, etiquette books were still giving the same advice for the same public problem. *The Gallant Ethic, in which it is shown how a young man should commend himself to polite society,* written around 1700, suggests: "If you pass a person who is relieving himself you should act as if you had not seen him." A French journal of the day provides a glimpse of the extent of the public sanitation problem. "Paris is dreadful. The streets smell so bad that you cannot go out. . . . The multitude of people in the street produces a stench so detestable that it cannot be endured."

The sanitation problem was compounded by the chamber pot. With no plumbing in the average home, wastes from the pots were often tossed into the street. Numerous cartoons of the period illustrate the dangers of walking under second-story windows late at night, the preferred time to stealthily empty the pots. This danger, as well as continually fouled gutters, is supposed to have instituted the custom of a gentleman's escorting a lady on the inside of a walkway, removed from the filth.

Legally, the contents of chamber pots were supposed to be collected early in the morning by "night-soil men." They transported the refuse in carts to large public cesspools. But not every family could afford to pay, or wait, for the service.

By the 1600s, plumbing technology had reappeared in parts of Europe—but not in the bathroom. The initial construction of the seventeenth-century palace at Versailles—which shortly after its completion would house the French royal family, one thousand noblemen, and four thousand attendants—included no plumbing for toilets or bathrooms, although the system of cascading and gushing outdoor water fountains was grand.

The dawning of the industrial revolution in Britain in the 1700s did nothing to help home or public sanitation. The rapid urbanization and industrialization caused stifling overcrowding and unparalleled squalor. Once-picturesque villages became disease-plagued slums.

It was only after a debilitating outbreak of cholera decimated London in the 1830s that authorities began campaigning for sanitation facilities at

Medieval woodcut depicting the danger from a chamber pot being illegally emptied.

home, in the workplace, and along public streets and in parks. For the remainder of the century, British engineers led the Western world in constructing public and private plumbing firsts. The bathroom, as we take it for granted today, had started to emerge, with its central feature, the modern flush toilet.

Modern Flush Toilet: 1775, England

That essential convenience of modern living the flush toilet was enjoyed by Minoan royalty four thousand years ago and by few others for the next thirty-five centuries. One version was installed for Queen Elizabeth in 1596, devised by a courtier from Bath who was the queen's godson, Sir John Harrington. He used the device, which he called "a privy in perfection," to regain the queen's favor, for she had banished him from court for circulating racy Italian fiction.

Harrington's design was quite sophisticated in many respects. It included a high water tower on top of the main housing, a hand-operated tap that permitted water to flow into a tank, and a valve that released sewage into a nearby cesspool.

Chamber pots with toilet stands flanking an eighteenth-century flush toilet mechanism.

Unwisely for Harrington, he wrote a book about the queen's toilet, titled *The Metamorphosis of Ajax*—Ajax being a pun on the word "jake," then slang for chamber pot. The book's earthy humor incensed Elizabeth, who again banished her godson, and his flush toilet became the butt of jokes and fell into disuse.

The next flush device of distinction appeared in 1775, patented by a British mathematician and watchmaker, Alexander Cumming. It differed from Harrington's design in one significant aspect, which, though small in itself, was revolutionary. Harrington's toilet (and others that had been devised) connected directly to a cesspool, separated from the pool's decomposing contents by only a loose trapdoor; the connecting pipe contained no odor-blocking water. Elizabeth herself had criticized the design and complained bitterly that the constant cesspool fumes discouraged her from using her godson's invention.

In Cumming's improved design, the soil pipe immediately beneath the bowl curved backward so as, Cumming's patent application read, "to constantly retain a quantity of water to cut off all communication of smell from below." He labeled the feature a "stink trap," and it became an integral part of all future toilet designs.

The modern flush toilet had been invented. But more than a hundred years would pass before it would replace the chamber pot and the outhouse, to become a standard feature in British and American bathrooms.

Toilet Paper: 1857, United States

The first commercially packaged toilet paper, or bathroom tissue, in America was introduced by businessman Joseph Gayetty in 1857. But the product, available in packages of individual sheets, sold poorly and soon virtually

disappeared from grocery store shelves. At the time, the majority of Americans could not comprehend wasting money on perfectly clean paper when their bathrooms and outhouses were amply stocked with last year's department store catalogues, yesterday's newspapers, and sundry fliers, pamphlets and advertisements, which also provided reading material.

In England, an attempt to market toilet paper was made in 1879 by British manufacturer Walter Alcock. Whereas Gayetty produced individual flat sheets of paper, Alcock conceived the idea of a roll of "tear sheets," introducing the first perforated toilet roll. Invention was one thing, but marketing an unmentionable product in the Victorian age was another. Alcock spent nearly a decade struggling to get his product mass-produced, advertised, and accepted by a public at a pinnacle of prudery.

Across the Atlantic, in upstate New York, two enterprising bearded brothers were also attempting to interest the public in their line of paper products, which included rolled bathroom tissue. They would succeed in the field where Alcock and Gayetty failed.

Edward and Clarence Scott were born three years apart in rural Saratoga County, New York. In 1879, the year Alcock had perfected his perforated roll in England, the Scotts were living in Philadelphia, beginning a business of paper products, which, because they were generally indispensable, disposable, and unreusable, promised to make a fortune. And the one item that seemed indisputably to embody all three attributes best was toilet paper.

The Scotts' timing was better than Joseph Gayetty's.

In the 1880s, many home owners, hotels, and restaurants were installing full-service indoor plumbing for sinks, showers, and toilets. Major cities were laying down public sewer systems. In Boston, the Tremont House had earlier boasted of being the first hotel to offer guests convenient indoor flush toilets and baths: "8 privies and 8 bathing rooms" (though all of them were in the basement). Philadelphia had the distinction of being the city with the most fully plumbed bathrooms and bathtubs (1,530 tubs in 1836), which drew water from the Schuykill Water Works. In lower Manhattan, tenements were shooting up, in which several families shared plumbed bathroom facilities. And manufacturers and stores were highlighting the latest in European toilet seats, the oval "Picture Frame," as well as the newest toilet bowl, the one-piece ceramic "Pedestal Vase," which took the gold medal in bathroom design when it was unveiled at the 1884 British Health Exhibition. The bathroom was changing. The climate was set for toilet paper.

Unlike Gayetty's bathroom tissue, available only in large five-hundred-sheet packages, the Scotts' product came in small rolls. It sold in plain brown wrappers and fit conveniently into the American bathroom, which at the time was truly, as euphemistically called, "the smallest room in the house."

From unlabeled brown wrappers, the product evolved to the prestigiously named Waldorf Tissue, then simply to ScotTissue, each roll bearing the slogan "soft as old linen."

Like British bathroom tissue advertising, the Scotts' early ad campaigns were low-keyed, in deference to the public's sensibilities concerning the product. Waldorf Tissue seemed fittingly appropriate to rest beside a Pedestal Vase overhung by an oval Picture Frame. But following World War I, the company attempted to corner the American bathroom tissue market with more aggressive advertising, which sought to create snob appeal by impugning competitors' brands. Typical was an advertisement that read: "They have a pretty house, Mother, but their bathroom paper hurts." The market, however, was large enough to support numerous competitors, for as the brothers had realized, toilet paper truly was indispensable, disposable, and unreusable.

Paper Towels. It was a factory production error in 1907 that resulted in America's first commercially packaged, tear-off paper towels.

By that year, the Scott brothers' paper company was a business success. Their high-quality soft bathroom tissue arrived from a large paper mill in so-called parent rolls, which were then cut down to convenient bathroom-size packages. One order from the mill proved to be defective. The parent roll was excessively heavy and wrinkled. Unfit for bathroom tissues, the product was scheduled to be returned when a member of the Scott family suggested perforating the thick paper into small towel-size sheets. The product, he suggested, could be advertised as disposable "paper towels."

America's first commercially packaged paper towel was named Sani-Towel in 1907, and it sold primarily to hotels, restaurants, and railroad stations for use in public washrooms. There was a simple, economic resistance to paper towels on the part of home owners: Why pay for a towel that was used once and discarded, when a cloth towel could be washed and reused indefinitely? But as the price of paper towels gradually decreased, home owners found them more readily disposable, and in 1931 the brand Sani-Towel was renamed ScotTowels; a roll of two hundred sheets sold for a quarter. Whereas toilet tissue became a necessity of the bathroom, paper towels would become a great convenience in almost every room in the house.

Kleenex Tissues: 1924, United States

Today we use the tissue as a disposable handkerchief, but that was not its original purpose as conceived by its manufacturer following World War I.

In 1914, cotton was in short supply. A new, remarkably absorbent substitute was developed for use as a surgical bandage on the battlefield and in wartime hospitals and first-aid stations. An even more highly absorbent form of the material found use as an air filter in GIs' gas masks. The cotton-like wadding, produced by Kimberly-Clark and called Cellucotton, was

manufactured in such immense quantities that following the war, huge surpluses crowded warehouses.

The company sought a peacetime use for the product it had spent years perfecting. One later application for Cellucotton would be in a new feminine napkin, Kotex, but its first postwar spin-off was as a glamour product: a cold-cream tissue, used by Hollywood and Broadway stars to remove makeup.

Named Kleenex Kerchiefs, the "Sanitary Cold Cream Remover" was heavily promoted as a disposable substitute for cloth facial towels, and a package of one hundred sold for sixty five cents. Magazine advertisements featured such celebrities as Helen Hayes, Gertrude Lawrence, and Ronald Colman. And American women were told that Kleenex Kerchiefs were the "scientific way," as well as the glamorous way, to remove rouge, foundation, powder, and lipstick.

The star-studded campaign worked perfectly. For five years, Kleenex sales increased steadily. But an unexpected phenomenon occurred. Consumer mail poured into the company's headquarters, praising the product as a disposable handkerchief. Men questioned why it was not promoted that way, and wives complained that husbands were blowing their noses in their cold-cream Kerchiefs.

Consumer mail increased late in 1921. That year, a Chicago inventor, Andrew Olsen, had devised a revolutionary new **pop-up tissue box,** which Kimberly-Clark had put into production, in which two separate layers of tissue paper were interfolded. Named Serv-a-Tissue, the product won even more nose-blowing converts for its quick, easy accessibility, a genuine plus for capturing a sudden, unexpected sneeze.

Kimberly-Clark's management, confused and divided, decided in 1930 to test-market the twofold purpose of the tissue. A group of consumers in Peoria, Illinois, was enticed to redeem one of two coupons, with alternative headlines: "We pay [a free box of tissues] to prove there is no way like Kleenex to remove cold cream," or: "We pay to prove Kleenex is wonderful for handkerchiefs." The coupons were good for redemption at local drug and department stores. When the votes were tallied, the numbers were decisive: sixty-one percent of the coupon-redeemers had responded to the handkerchief ad.

The company began to promote tissues as disposable handkerchiefs. The campaign worked so well that management conceived more than a dozen additional household uses for Kleenex, such as dusting and polishing furniture, wiping food residue from the inside of pots and pans, draining grease from French-fried potatoes, and cleaning car windshields. In fact, a 1936 insert in a Kleenex tissue package listed forty-eight handy uses for their product. People, though, still wanted them mainly for blowing their noses.

Siberian hogs provided bristles for toothbrushes until the introduction of nylon in 1938.

Toothbrush: 3000 B.C., Egypt

The first toothbrush used by ancients was the "chew stick," a pencil-size twig with one end frayed to a soft, fibrous condition. Chew sticks were initially rubbed against the teeth with no additional abrasive such as toothpaste, and they have been found in Egyptian tombs dating to 3000 B.C.

Chew sticks are still used in some parts of the world. Many African tribes fray twigs only from a certain tree, the *Salvadore persica,* or "toothbrush tree." And the American Dental Association discovered that frayed sticks often serve as toothbrushes for people living in remote areas of the United States; in the South, they're known as "twig brushes." They can be every bit as effective as a modern nylon-bristled toothbrush. Dentists reported on one elderly man living near Shreveport, Louisiana, who had used frayed white elm sticks all his life and had plaque-free teeth and healthy gums.

The first bristle toothbrush, similar to today's, originated in China about 1498. The bristles, hand plucked from the backs of the necks of hogs living in the colder climates of Siberia and China (frigid weather causes hogs to grow firmer bristles), were fastened into handles of bamboo or bone. Traders to the Orient introduced the Chinese toothbrush to Europeans, who found hog bristles too irritatingly firm.

At the time, those Europeans who brushed their teeth (and the practice was not at all commonplace) preferred softer horsehair toothbrushes. The father of modern dentistry, Dr. Pierre Fauchard, gives the first detailed account of the toothbrush in Europe. In his 1723 dental textbook, *La Chirurgien Dentiste*, he is critical of the ineffectiveness of horsehair brushes (they were *too* soft), and more critical of the large portion of the population who never, or only infrequently, practiced any kind of dental hygiene. Fauchard recommends daily vigorous rubbing of the teeth and gums with a small piece of natural sponge.

Toothbrushes made of other animal hair, such as badger, experienced brief vogues. But many people preferred to pick their teeth clean after a meal with a stiff quill (as the Romans had done), or to use specially manufactured brass or silver toothpicks.

In many cases, metal toothpicks were less of a health hazard than hard natural-hair toothbrushes. For once the nineteenth-century French bacteriologist Louis Pasteur posited his theory of germs, the dental profession realized that all animal-hair toothbrushes (which retain moisture) eventually accumulate microscopic bacterial and fungal growth, and that the sharp ends of the bristles piercing a gum could be the source of numerous mouth infections. Sterilizing animal-hair brushes in boiling water could permanently leave them overly soft or destroy them entirely. And good animal-hair toothbrushes were too expensive to be frequently replaced. The solution to the problem did not arrive until the third decade of this century.

Nylon-Bristle Toothbrush: 1938, United States

The discovery of nylon in the 1930s by Du Pont chemists set in motion a revolution in the toothbrush industry. Nylon was tough, stiff, resilient, and resistant to deformation, and it was also impervious to moisture, so it dried thoroughly, discouraging bacterial growth.

The first nylon-bristle brush was marketed in the United States in 1938, under the name Dr. West's Miracle Tuft Toothbrush. Du Pont called the artificial fibers Exton Bristles, and through a widespread advertising campaign the company informed the American public that "The material used in manufacturing Exton is called nylon, a word so recently coined that you will not find it in any dictionary." And the company played up nylon's many advantages over hog hair, stressing, too, that while hog-hair bristles often pulled free of the brush, to lodge annoyingly between teeth, nylon bristles were more securely fastened to the brush head.

However, those first nylon bristles were so extraordinarily stiff that they were hard on gums. In fact, gum tissue tore so readily that dentists at first resisted recommending nylon brushes. By the early 1950s, Du Pont had perfected a "soft" nylon, which they introduced to the public in the form

of the Park Avenue Toothbrush. A person could pay ten cents for a hard-bristle brush, forty-nine cents for the fancier, softer Park Avenue model.

Not only did nylon toothbrushes improve dental hygiene; they also went a long way to spare hogs around the world pain. In 1937, for example, the year before nylon bristles were introduced, the United States alone imported a whopping 1.5 million pounds of hog bristles for toothbrushes.

The next technological advance came in 1961, when the Squibb Company introduced the first **electric toothbrush,** under the name Broxodent. It had an up-and-down brush action and was endorsed by the American Dental Association.

A year later, General Electric designed a cordless electric toothbrush, battery operated and rechargeable. GE scientists tested the brushes on scores of dogs and assured stockholders that "dogs actually liked to have their teeth brushed," concluding, drolly, that no other dogs in history so aptly fitted the adage "clean as a hound's tooth."

Today people around the world favor the simple, hand-operated nylon-bristle toothbrush. However, as inexpensive and easily replaceable as the brushes are, the American Dental Association claims that four out of five Americans hang on to their brushes to the point where the bent bristles are unfit for cleaning teeth and are likely to cut gums.

Toothpaste: 2000 B.C., Egypt

The first toothpaste mentioned in recorded history was devised by Egyptian physicians about four thousand years ago. Highly abrasive and puckeringly pungent, it was made from powdered pumice stone and strong wine vinegar and brushed on with a chew stick. By modern standards, it was considerably more palatable than early Roman toothpaste, made from human urine—which in liquid form served also as a mouthwash. First-century Roman physicians maintained that brushing with urine whitened teeth and fixed them more firmly in the sockets.

Upper-class Roman women paid dearly for Portuguese urine, the most highly prized, since it was alleged to be the strongest on the Continent. Dental historians believe that may have been true, but only because the liquid came by land all the way from Portugal. Urine, as an active component in toothpastes and mouthwashes, continued to be used into the eighteenth century. What early dentists were unwittingly making use of was urine's cleansing ammonia molecules, which would later be used in modern dental pastes.

With the fall of the Roman Empire, dental skills and hygiene rapidly deteriorated in Europe. For five hundred years, families palliated their own dental aches and pains with homemade poultices and makeshift extractions.

The writings of the Persian physician Rhazes in the tenth century mark a reawakening of dental hygiene, as well as a breakthrough. Rhazes was the

Dental surgery and hygiene. Human urine was a popular Roman toothpaste to whiten teeth and prevent cavities. In the tenth century cavities were drilled and filled.

first doctor to recommend **filling cavities.** He used a glue-like paste made of alum (containing ammonium and iron) and mastic, a yellowish resin from a small Mediterranean evergreen tree in the cashew family. At the time, mastic was a main ingredient in varnishes and adhesives.

Sophisticated as Rhazes' filling material was, drilling out a cavity to accept a filling required a high degree of dexterity in the dentist and superhuman fortitude in the patient. The major drawback of those early drills was the excruciatingly slow rotation of the bit. The dentist, holding the metal spike between his thumb and index finger, manually worked it back and forth, all the while forcefully bearing downward.

Not until the eighteenth century was there a mechanical drill, about the size of a hand-held clock and with a clock's inner rotary mechanism. And not until George Washington's personal dentist, John Greenwood, adapted his mother's spinning wheel to rotate a bit was there an even moderately rapid, foot-pedaled dental drill. Unfortunately, the intense heat generated by its quick rotation was itself a drawback; although this was compensated for by a shorter period of discomfort. (Whereas Greenwood's drill rotated about five hundred times a minute, modern water-cooled models spin in excess of a half-million turns a minute.)

Whitening Teeth. In Europe, attitudes about dental hygiene began changing in the fourteenth century.

In 1308, barber-surgeons, the main extractors of teeth, banded into guilds. Apart from extraction, the chief dental operation of the barber-

211

surgeon was whitening teeth. Brilliantly white teeth were prized, and a barber-surgeon would first file a patient's teeth with a coarse metal instrument, then dab them with aquafortis, a solution of highly corrosive nitric acid. This produced white teeth for a while, but it also thoroughly destroyed the enamel, causing massive dental decay in mid-life. Still, in the pursuit of vanity, acid cleaning of teeth continued in Europe into the eighteenth century.

The rough-and-ready surgery performed by barber-surgeons gave rise to the once-common sight of the red-and-white-striped barber's pole. It came about in this way. The teeth-extracting surgeons also cut hair, trimmed beards, and practiced the alleged panacea of bloodletting. During a bloodletting, it was customary for the patient to squeeze a pole tightly in one hand, so that the veins would swell and the blood gush freely. The pole was painted red to minimize bloodstains, and when not in use, it hung outside the shop as advertisement, wrapped round with the white gauze used to bandage bloodlet arms. The red-and-white pole eventually was adopted as the official trademark of barber-surgeon guilds. The gilt knob later added to the top of the pole represented the brass basin that served the profession's dual aspects of letting blood and whipping up shaving lather. When surgeons and barbers split, the barbers got the pole.

The price paid for artificially whitened teeth was cavities, adding to normal dental decay, one of humankind's oldest miseries. Terrified of tooth extraction, people often suffered intense and chronic pain—and many of these people were history's major policymakers. It is surprising that history books omit the fact that, for instance, Louis XIV and Elizabeth I (to mention only two policy-shaping figures) often had to render major decisions while in intense dental agony. Louis, in 1685, signed the revocation of the Edict of Nantes (which had granted religious freedom), causing thousands to emigrate, while he was in the throes of a month-long tooth infection. It had developed into a raw, unhealing opening between the roof of his mouth and his sinuses.

Elizabeth, on the other hand, suffered chronically from deep, massive cavities but feared the misery of extraction. In December 1578, an unrelenting tooth pain kept her awake night and day for two weeks, necessitating drugs that were themselves heavily disorienting. She finally consented to extraction after the bishop of London volunteered to have one of his own good teeth pulled in her presence so she might witness that the pain was not unendurable. Throughout the weeks of misery, she had continued to oversee legislation that affected the lives of millions of subjects.

In more recent times, George Washington suffered throughout his adult life from decayed teeth, gum inflammation, and the inadequacies of eighteenth-century dental treatment. From the age of twenty-two, he lost his teeth one by one, and he acquired a succession of dentures that nearly destroyed his gums. From a wealth of documentation, it is clear that America's first President endured almost continual pain and found chewing nearly

impossible later in life, and that the likely cause of his eventual deafness was the unnatural posture he forced on his lower jaw in an attempt to give his face a natural appearance. A volume of speculative history could be written on the effects of severe and protracted dental pain on policy-making.

Fluoride Toothpaste. It would be hard to imagine that the toothpaste sitting on a modern-day bathroom sink does not contain some fluoride compound, most likely sodium monofluorophosphate. But the use of fluorides to reduce cavities is not a twentieth-century phenomenon, though fluoride toothpastes are.

In 1802, in several regions surrounding Naples, Italian dentists observed yellowish-brown spots on their patients' teeth. The spots turned out to have resulted from an interaction between natural variations in human tooth enamel and a high level of fluorides occurring in local soil and water. What no Neapolitan dentist could ignore was the fact that the spotted teeth, however unsightly, were cavity-free. By the 1840s, in both Italy and France, dentists were suggesting that people from an early age suck regularly on lozenges made with fluoride and sweetened with honey.

The first scientific trials with fluoridated drinking water took place in America in 1915. The results were so encouraging that in time fluorides found their way into water, mouthwashes, and toothpastes, substantially reducing the incidence of cavities.

Dentures: 800 B.C., Etruria

The Etruscans, who inhabited Italy in the area that is modern Tuscany, are regarded as the best dentists of the ancient world. They extracted decayed teeth, replacing them with full or partial dentures, in which individual teeth were realistically carved from ivory or bone and bridgework was crafted in gold. Upon a person's death, good, intact teeth were surgically removed to be incorporated into even more authentic-looking dentures for the upper classes. Dental historians claim that the Etruscans' skill in designing dentures and fashioning false teeth (which was passed on only in part to the Romans) was not matched until the nineteenth century.

By comparison, medieval and early Renaissance dentists could be primitive in their practices and beliefs. They taught that cavities were caused by "tooth worms" boring outward (a theory depicted in numerous extant illustrations), and though they extracted rotted teeth, they often made little effort to replace them, leaving patients with gaping holes for a lifetime. The rich purchased good, sturdy teeth from the mouths of the poor. Pulled for a negotiated fee, the teeth were set in "gums" of ivory.

Keeping uppers in place required ingenuity in the dentist and continual vigilance and great vanity in the patient. Fashionable women in the 1500s had their gums pierced with hooks to secure denture wires. In the next century, it was possible to keep uppers in place through the use of springs,

so sturdy that constant pressure was needed to keep the mouth shut. A momentary lapse in concentration and the jaws suddenly flew apart.

Denture appearance began to improve around the time of the French Revolution.

Parisian dentists made the first durable, realistic-looking porcelain teeth, baked in one piece. The fashion was adopted in America by Dr. Claudius Ash. Ash deplored the practice of collecting teeth from the battlefield. Horror stories abounded of the unscrupulous operations of "teeth robbers," who pillaged their bounty from wounded soldiers not yet dead. Thousands of Europeans sported "Waterloo" dentures, and as late as the 1860s, thousands of Americans wore "Civil War" plates, while barrels of additional young American soldiers' teeth were shipped to Europe. Porcelain teeth eventually put an end to that practice.

As porcelain greatly improved the appearance of false teeth, vulcanized rubber, perfected in the late 1800s, paved the way for the first comfortable-to-wear, easy-to-fashion base to hold teeth. Concurrent with these two nineteenth-century innovations was the introduction of the anaesthetic nitrous oxide, or "laughing gas," ushering in the era of painless dentistry. For the first time in human history, decayed, aching teeth could be extracted painlessly and replaced with comfortable, durable, and attractive dentures. By the 1880s, demand for false teeth was enormous. Only in the next century would the miracle of plastics improve their appearance.

Razor: 20,000 Years Ago, Asia and Africa

Although we think of early man as a bearded creature, archaeologists have evidence that men shaved their faces as far back as twenty thousand years ago. Cave drawings clearly depict bearded and beardless men, and gravesites have yielded sharpened flints and shells that were the first razors. And as soon as man mastered working with iron and bronze, razors were hammered from these metals.

Throughout recorded history, a man's hirsute facial growth and how he has dealt with it was an important factor in the lives of king and peasant, soldier and tradesman. Among ancient Egyptians, a clean-shaven face was a symbol of status, and members of royalty took their collections of bronze razors with them to the grave. The Greeks shaved daily, and though Romans thought the practice sissified, they used razors on the battlefield, for in hand-to-hand combat a full beard was a detriment. It was the Roman word for beard, *barba*, that gave us the term "barber."

In the Americas, Indian men stoically pulled out their beards hair by hair, using clam shells as tweezers. One American who used a razor selectively was General Ambrose Everett Burnside, commander of the Union Army of the Potomac during the Civil War. His most distinguished feature, which launched a trend, was his profuse side-whiskers, growing down along the ears to the cheeks, and known as "burnsides." Around the turn of the

Look sharp. Ancient Egyptians used bronze straight razors, and American Indians tweezed their whiskers between halves of a clam shell. Gillette's safety razor and disposable blades marked the first shaving breakthrough.

century, the word experienced a linguistic transposition, which has never been satisfactorily explained, to become **sideburns.**

By General Burnside's era, the shaving razor had changed little in appearance from the ancient Egyptian instrument. There had already been several attempts, however, to design a safer razor.

Safety Razor: 1762, France

For centuries, a young man (or woman) learned painfully, through nicking and gashing the skin, how to shave safely with a sharp straight razor. The first instrument specifically designed as a safety razor appeared in France in 1762, invented by a professional barber, Jean Jacques Perret. It employed a metal guard, placed along one edge of the blade, to prevent the blade from accidentally slicing into the shaver's skin. About seventy years later, in Sheffield, England, an improved design debuted, which was lighter-weight and less cumbersome to use. The modern T-shaped razor was an American invention of the 1880s, but its irreplaceable blade had to be sharpened regularly.

The first real shaving revolution was launched almost single-handedly by a traveling salesman–inventor named King Gillette.

Born in Fond du Lac, Wisconsin, in 1855, Gillette was tall, broad-shouldered, aristocratically handsome, and fiercely determined to succeed. He set out not to give shavers a better razor but to give the world an entirely new social order. In 1894, he published *The Human Drift*, a rambling, socialistic blueprint for reform, which he dedicated "To All Mankind." Per-

215

haps every man and woman who shaves today should be thankful that the book was a complete failure.

Gillette turned elsewhere for his fortune. A friend, William Painter, inventor of the throwaway bottle cap, suggested that the failed author and traveling salesman devise an item that, like the bottle cap, was used once, discarded, then replaced.

The idea intrigued Gillette. For a year, at his home in Brookline, Massachusetts, he repeatedly ran through the alphabet, listing household and business items in frequent use.

Nothing clicked until one morning in 1895. Gillette started to shave and found his razor edge dull beyond use. The instrument would have to be taken to a barber or a cutler for professional sharpening, a familiar, disruptive routine. He later wrote: "As I stood there with the razor in my hand, my eyes resting on it as lightly as a bird settling down on its nest, the Gillette razor and disposable blade were born."

The concept was simple, but the technology took more than six years to perfect. Toolmakers Gillette contacted told him that small, inexpensive, paper-thin steel blades were impossible to manufacture. Engineers at the Massachusetts Institute of Technology advised him to simply drop the project. One MIT professor, though, William Nickerson, inventor of a push-button system for elevators, decided in 1901 to collaborate with Gillette.

The first fruits of their joint effort went on sale in 1903—a batch of fifty-one razors (at five dollars apiece) and 168 disposable blades. Word of the razor's safety and convenience spread so rapidly that production could not keep pace with demand.

In 1906, Americans bought 300,000 razors and half a million blades, each package bearing Gillette's portrait and signature. And when America entered World War I, the government placed an order for 3.5 million razors and 36 million blades—enough to keep the entire American armed forces clean-shaven. The war introduced men from all parts of the globe to Gillette's invention, and on returning home from the battlefield they wanted Gillette razors and a steady supply of disposable blades.

King Gillette retired in 1931, a millionaire many times over. That same year, the razor blade was confronted by the first significant challenger in its long and exclusive history: the electric shaver.

Electric Shaver: 1931, United States

While serving in the U.S. Army, Jacob Schick was issued a Gillette razor and blades. He had no complaint with the product. It always provided a close, comfortable shave—except when water was unavailable, or soap, or shave cream; or if cold winter water could not be heated. Once, laid up in an Alaskan base with a sprained ankle, he had to crack a layer of surface ice every morning to dip his razor into water.

After the war, Schick set out to invent what he called a "dry razor," operated by an electric motor.

A major drawback was that most reliable, powerful motors were larger, and heavier, than a breadbox. For five years, Schick worked to perfect his own small electric motor, which he patented in 1923.

But obstacles continued to thwart his best efforts. Financial backers he approached shaved satisfactorily with Gillette razors and blades, as did millions of people worldwide; was an electric razor really necessary? Schick thought so. He mortgaged his home, sank into debt, and produced his first commercial electric razor, with a steep twenty-five-dollar price tag, in 1931—the depths of the Depression.

That first year, Jacob Schick sold only three thousand shavers.

The next year, he made a small profit, which he reinvested in national advertising. By repeating that policy year after year, in 1937 he sold almost two million electric shavers, in the United States, Canada, and England. The electric razor might not have been one of life's necessities, but it was one of the twentieth century's electric novelties, and Jacob Schick had proved that a market existed for the shavers.

Just as Schick had competed with the name Gillette in the '30s, in the '40s such names as Remington and Sunbeam competed with Schick. Remington, in 1940, made industry history when it introduced the two-headed shaver. Named the Dual, it pioneered the modern trend toward multiheaded shavers. And that same year, Remington created something of a minor sensation when it announced an electric shaver designed expressly for women—who for centuries had plucked, waxed, dipilatoried, and scraped off unwanted body hair, receiving little mention in the documented history of shaving.

Soap: 600 B.C., Phoenicia

A staple of every bathroom, soap has served a variety of cleansing and medicinal purposes since its discovery. It has been in and out of vogue, praised as the acme of civilization by one nation while scorned as an excess of fastidiousness by a neighbor.

About four thousand years ago, the Hittites of Asia Minor cleaned their hands with the ash of the soapwort plant suspended in water. In the same era, the Sumerians in Ur concocted alkali solutions to wash themselves. Technically, neither of these preparations was soap, though close to the actual product, which was developed in 600 B.C. by the seafaring Phoenicians. In the process that today is known as saponification, the Phoenicians boiled goat fat, water, and ash high in potassium carbonate, permitting the liquid to evaporate to form solid, waxy soap. (See also "Detergent," page 152.)

Over the next twenty centuries, the fortunes of soap would follow closely the beliefs of Western hygiene—and religion. During the Middle Ages, for

example, when the Christian Church warned of the evils of exposing the flesh, even to bathe, production of soap virtually came to a halt. And when medical science later identified bacteria as a leading cause of disease, soap production soared. Throughout all those years, soap, variously scented and colored, was essentially the same product as that developed by the Phoenicians. Not until a factory accident in 1879 would a new and truly novel soap surface, so to speak.

Floating Soap. One morning in 1878, thirty-two-year-old Harley Procter decided that the soap and candle company founded by his father should produce a new, creamy white, delicately scented soap, one to compete with the finest imported castile soaps of the day.

As suppliers of soap to the Union Army during the Civil War, the company was suited to such a challenge. And Procter's cousin James Gamble, a chemist, soon produced the desired product. Named simply White Soap, it yielded a rich lather, even in cold water, and had a smooth, homogeneous consistency. Procter's and Gamble's White Soap was not yet christened Ivory, nor did it then float.

Soap production began, and the product sold well. One day, a factory worker overseeing soap vats broke for lunch, forgetting to switch off the master mixing machine. On returning, he realized that too much air had been whipped into the soapy solution. Reluctant to discard the batch, he poured it into hardening and cutting frames, and bars of history's first air-laden, floating soap were delivered to regional stores.

Consumer reaction was almost immediate. The factory was swamped with letters requesting more of the remarkable soap that could not be lost under murky water because it bobbed up to the surface. Perceiving they were beneficiaries of a fortunate accident, Harley Procter and James Gamble ordered that all White Soap from then on be given an extra-long whipping.

White Soap, though, was too prosaic a label for such an innovative product.

Mulling over a long list of possible names one Sunday morning in church, Harley Procter was inspired by a single word when the pastor read the Forty-fifth Psalm: "All thy garments smell of myrrh, and aloes, and cassia, out of the ivory palaces, whereby they have made thee glad."

The first bars of Ivory Soap debuted in October 1879, the same month that Thomas Edison successfully tested the incandescent light bulb—two events seemingly unrelated. But the astute businessman Harley Procter foresaw that the electric light would virtually snuff out his profitable candle trade, so he decided to heavily promote history's first floating soap.

It was Procter's idea to etch a groove across the middle of each economy-size bar of Ivory. It enabled homemakers to decide for themselves whether they wanted one large laundry-size bar or two smaller toilet-size cakes. And the company would only have to manufacture a single item.

In an effort to test Ivory's quality, Procter sent the soap to chemistry

professors and independent laboratories for analyses. One report in particular impressed him. It stated that the soap had few impurities—only 56/100 of one percent. Procter flipped the negative statement into a positive one, which became the hallmark of the company's campaign: Ivory Soap was "99 and 44/100 percent pure."

From a psychological standpoint, the phrase was a stroke of advertising genius, for the concepts of purity and floatability did much to reinforce each other—and to sell soap. To further dramatize the soap's purity and mildness, Procter introduced the "Ivory Baby," supplying shopkeepers with life-size cardboard display posters. Madison Avenue, then and now, claims that the campaign to persuade American home owners to purchase Ivory Soap was one of the most effective in the history of advertising.

As a young man, Harley Procter had promised himself that if he was a success in business, he'd retire at age forty-five. He became such a success because of the floating soap that he permitted himself the luxury of retiring a year early, at forty-four.

Shampoo: 1890s, Germany

The main function of a shampoo is to remove the scalp's natural sebum oil from the hair, for it is the oil that causes dirt and hairdressing preparations to stick tenaciously. Ordinary soap is not up to the task, for it deposits its own scum.

The job is easy for a detergent, but detergents were not discovered until late in the last century, or manufactured in any sizable quantity until the 1930s. How, then, over the centuries did people effectively clean their hair?

The ancient Egyptians started one trend with the use of water and citrus juice, the citric acid effectively cutting sebum oil. Homemade citrus preparations, scented, and occasionally blended with small quantities of soap, were popular for centuries.

A detergent-like alternative appeared in Europe in the late Middle Ages. It involved boiling water and soap with soda or potash, which provides the mixture with a high concentration of negatively charged hydroxyl ions, the basis of good modern-day shampoos. Similar to shampoo yet closer to soap, these brews were homemade and their formulas handed down from generation to generation.

Ironically, the word "shampoo" originated in England at about the same time German chemists were discovering the true detergents that would become modern shampoos. In the 1870s, the British government had taken control of India from the ruling British East India Company, granting the Hindu-speaking Indians progressively more power in local affairs. Indian fashion and art, as well as Hindu phrases, were the vogue in England. In that decade, au courant British hairdressers coined the word "shampoo," from the Hindu *champo*, meaning "to massage" or "to knead."

Shampoo was not a bottled liquid to be purchased in a store. It was a

wet, soapy hair and scalp massage available to patrons of fashionable British salons. The cleansing preparations, secretly guarded by each salon, were brewed on the premises by hairdressers employing variations on the traditional formula of water, soap, and soda. Technically, the first true detergent-based shampoo was produced in Germany in the 1890s. When, after World War I, the product was marketed as commercial hair-cleansing preparations, the label "shampoo" was awaiting them.

One man, John Breck, helped launch the shampoo business in America, turning his personal battle against baldness into a profitable enterprise.

In the early 1900s, the twenty-five-year-old Breck, captain of a Massachusetts volunteer fire department, was beginning to lose his hair. Although several New England doctors he consulted assured him there was no cure for baldness, the handsome, vain young firefighter refused to accept the prognosis.

Preserving his remaining hair became an obsession. He developed home hair-restoring preparations and various scalp-massage techniques, and in 1908 opened his own scalp-treatment center in Springfield. When his shampoos became popular items among local beauty salons, Breck expanded his line of hair and scalp products, as well as the region he serviced. He introduced a shampoo for normal hair in 1930, and three years later, shampoos for oily and dry hair. By the end of the decade, Breck's hair care business was nationwide, becoming at one point America's leading producer of shampoos. Of all his successful hair preparations, though, none was able to arrest his own advancing baldness.

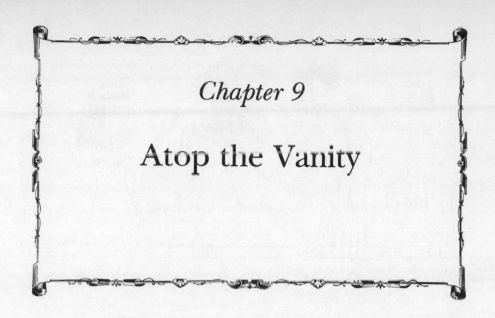

Chapter 9

Atop the Vanity

Cosmetics: 8,000 Years Ago, Middle East

A thing of beauty may be a joy forever, but keeping it that way can be a costly matter. American men and women, in the name of vanity, spend more than five billion dollars a year in beauty parlors and barbershops, at cosmetic and toiletry counters.

Perhaps no one should be surprised—or alarmed—at this display of grooming, since it has been going on for at least eight thousand years. Painting, perfuming, and powdering the face and body, and dyeing the hair, began as parts of religious and war rites and are at least as old as written history. Archaeologists unearthed palettes for grinding and mixing face powder and eye paint dating to 6000 B.C.

In ancient Egypt by 4000 B.C., beauty shops and perfume factories were flourishing, and the art of makeup was already highly skilled and widely practiced. We know that the favorite color for eyeshade then was green, the preferred lipstick blue-black, the acceptable rouge red, and that fashionable Egyptian women stained the flesh of their fingers and feet a reddish orange with henna. And in those bare-breasted times, a woman accented veins on her bosom in blue and tipped her nipples gold.

Egyptian men were no less vain—in death as well as life. They stocked their tombs with a copious supply of cosmetics for the afterlife. In the 1920s, when the tomb of King Tutankhamen, who ruled about 1350 B.C., was opened, several small jars of skin cream, lip color, and cheek rouge were discovered—still usable and possessing elusive fragrances.

In fact, during the centuries prior to the Christian era, every recorded

221

Egyptian woman at her toilet. Lipstick was blue-black, eye shadow green, bare nipples were tipped in gold paint.

culture lavishly adorned itself in powders, perfumes, and paints—all, that is, except the Greeks.

Unlike the Romans, who assimilated and practiced Egyptian makeup technology, the Greeks favored a natural appearance. From the time of the twelfth-century Dorian invasions until about 700 B.C., the struggling Greeks had little time for languorous pleasures of self-adornment. And when their society became established and prosperous during the Golden Age of the fifth century B.C., it was dominated by an ideal of masculinity and natural ruggedness. Scholastics and athletics prevailed. Women were chattels. The male, unadorned and unclothed, was the perfect creature.

During this time, the craft of cosmetics, gleaned from the Egyptians, was preserved in Greece through the courtesans. These mistresses of the wealthy sported painted faces, coiffed hair, and perfumed bodies. They also perfumed their breath by carrying aromatic liquid or oil in their mouths and rolling it about with the tongue. The breath freshener, apparently history's first, was not swallowed but discreetly spit out at the appropriate time.

Among Greek courtesans we also find the first reference in history to blond hair in women as more desirable than black. The lighter color connoted innocence, superior social status, and sexual desirability, and courtesans achieved the shade with the application of an apple-scented pomade of yellow flower petals, pollen, and potassium salt.

In sharp contrast to the Greeks, Roman men and women were often unrestrained in their use of cosmetics. Roman soldiers returned from Eastern duty laden with, and often wearing, Indian perfumes, cosmetics, and a blond hair preparation of yellow flour, pollen, and fine gold dust. And there is considerable evidence that fashionable Roman women had on their vanity virtually every beauty aid available today. The first-century epigram-

matist Martial criticized a lady friend, Galla, for wholly making over her appearance: "While you remain at home, Galla, your hair is at the hair-dresser's; you take out your teeth at night and sleep tucked away in a hundred cosmetics boxes—even your face does not sleep with you. Then you wink at men under an eyebrow you took out of a drawer that same morning."

Given the Roman predilection for beauty aids, etymologists for a long time believed that our word "cosmetic" came from the name of the most famous makeup merchant in the Roman Empire during the reign of Julius Caesar: Cosmis. More recently, they concluded that it stems from the Greek *Kosmetikos*, meaning "skilled in decorating."

Eye Makeup: Pre–4000 B.C., Egypt

Perhaps because the eyes, more than any other body part, reveal inner thoughts and emotions, they have been throughout history elaborately adorned. The ancient Egyptians, by 4000 B.C., had already zeroed in on the eye as the chief focus for facial makeup. The preferred green eye shadow was made from powdered malachite, a green copper ore, and applied heavily to both upper and lower eyelids. Outlining the eyes and darkening the lashes and eyebrows were achieved with a black paste called kohl, made from powdered antimony, burnt almonds, black oxide of copper, and brown clay ocher. The paste was stored in small alabaster pots and, moistened by saliva, was applied with ivory, wood, or metal sticks, not unlike a modern eyebrow pencil. Scores of filled kohl pots have been preserved.

Fashionable Egyptian men and women also sported history's first **eye glitter.** In a mortar, they crushed the iridescent shells of beetles to a coarse powder, then they mixed it with their malachite eye shadow.

Many Egyptian women shaved their eyebrows and applied false ones, as did later Greek courtesans. But real or false, eyebrows that met above the nose were favored, and Egyptians and Greeks used kohl pencils to connect what nature had not.

Eye adornment was also the most popular form of makeup among the Hebrews. The custom was introduced to Israel around 850 B.C. by Queen Jezebel, wife of King Ahab. A Sidonian princess, she was familiar with the customs of Phoenicia, then a center of culture and fashion. The Bible refers to her use of cosmetics (2 Kings 9:30): "And when Jehu was come to Jezreel, Jezebel heard of it; and she painted her face . . ." From the palace window, heavily made up, she taunted Jehu, her son's rival for the throne, until her eunuchs, on Jehu's orders, pushed her out. It was Jezebel's cruel disregard for the rights of the common man, and her defiance of the Hebrew prophets Elijah and Elisha, that earned her the reputation as the archetype of the wicked woman. She gave cosmetics a bad name for centuries.

Rouge, Facial Powder, Lipstick: 4000 B.C., Near East

Although Greek men prized a natural appearance and eschewed the use of most cosmetics, they did resort to rouge to color the cheeks. And Greek courtesans heightened rouge's redness by first coating their skin with white powder. The large quantities of lead in this powder, which would whiten European women's faces, necks, and bosoms for the next two thousand years, eventually destroyed complexions and resulted in countless premature deaths.

An eighteenth-century European product, Arsenic Complexion Wafers, was actually eaten to achieve a white pallor. And it worked—by poisoning the blood so it transported fewer red hemoglobin cells, and less oxygen to organs.

A popular Greek and Roman depilatory, orpiment, used by men and women to remove unwanted body hair, was equally dangerous, its active ingredient being a compound of arsenic.

Rouge was hardly safer. With a base made from harmless vegetable substances such as mulberry and seaweed, it was colored with cinnabar, a poisonous red sulfide of mercury. For centuries, the same red cream served to paint the lips, where it was more easily ingested and insidiously poisonous. Once in the bloodstream, lead, arsenic, and mercury are particularly harmful to the fetus. There is no way to estimate how many miscarriages, stillbirths, and congenital deformities resulted from ancient beautifying practices—particularly since it was customary among early societies to abandon a deformed infant at birth.

Throughout the history of cosmetics there have also been numerous attempts to prohibit women from painting their faces—and not only for moral or religious reasons.

Xenophon, the fourth-century B.C. Greek historian, wrote in *Good Husbandry* about the cosmetic deception of a new bride: "When I found her painted, I pointed out that she was being as dishonest in attempting to deceive me about her looks as I should be were I to deceive her about my property." The Greek theologian Clement of Alexandria championed a law in the second century to prevent women from tricking husbands into marriage by means of cosmetics, and as late as 1770, draconian legislation was introduced in the British Parliament (subsequently defeated) demanding: "That women of whatever age, rank, or profession, whether virgins, maids or widows, who shall seduce or betray into matrimony, by scents, paints, cosmetic washes, artificial teeth, false hair, shall incur the penalty of the law as against witchcraft, and that the marriage shall stand null and void."

It should be pointed out that at this period in history, the craze for red rouge worn over white facial powder had reached unprecedented heights in England and France. "Women," reported the British *Gentlemen's Magazine* in 1792, with "their wooly white hair and fiery red faces," resembled

"skinned sheep." The article (written by a man for a male readership) then reflected: "For the single ladies who follow this fashion there is some excuse. Husbands must be had. . . . But the frivolity is unbecoming the dignity of a married woman's situation." This period of makeup extravagance was followed by the sober years of the French Revolution and its aftermath.

By the late nineteenth century, rouge, facial powder, and lipstick—six-thousand-year-old makeup staples enjoyed by men and women—had almost disappeared in Europe. During this lull, a fashion magazine of the day observed: "The tinting of face and lips is considered admissible only for those upon the stage. Now and then a misguided woman tints her cheeks to replace the glow of health and youth. The artificiality of the effect is apparent to everyone and calls attention to that which the person most desires to conceal. It hardly seems likely that a time will ever come again in which rouge and lip paint will be employed."

That was in 1880. Cosmetics used by stage actresses were homemade, as they had been for centuries. But toward the closing years of the century, a complete revival in the use of cosmetics occurred, spearheaded by the French.

The result was the birth of the modern cosmetics industry, characterized by the unprecedented phenomenon of store-bought, brand-name products: Guerlain, Coty, Roger & Gallet, Lanvin, Chanel, Dior, Rubinstein, Arden, Revlon, Lauder, and Avon. In addition—and more important—chemists had come to the aid of cosmetologists and women, to produce the first safe beautifying aids in history. The origins of brand names and chemically safe products are explored throughout this chapter.

Beauty Patch and Compact: 17th Century, Europe

Smallpox, a dreaded and disfiguring disease, ravaged Europe during the 1600s. Each epidemic killed thousands of people outright and left many more permanently scarred from the disease's blisters, which could hideously obliterate facial features. Some degree of pockmarking marred the complexions of the majority of the European population.

Beauty patches, in the shapes of stars, crescent moons, and hearts—and worn as many as a dozen at a time—achieved immense popularity as a means of diverting attention from smallpox scars.

In black silk or velvet, the patches were carefully placed near the eyes, by the lips, on the cheeks, the forehead, the throat, and the breasts. They were worn by men as well as women. According to all accounts, the effect was indeed diverting, and in France the patch acquired the descriptive name *mouche*, meaning "fly."

Patch boxes, containing emergency replacements, were carried to dinners and balls. The boxes were small and shallow, with a tiny mirror set in the lid, and they were the forerunner of the modern powder compact.

The wearing of beauty patches evolved into a silent, though well-

communicated, language. A patch near a woman's mouth signaled willing flirtatiousness; one on the right cheek meant she was married, one on the left, that she was betrothed; and one at the corner of the eye announced smoldering passion.

In 1796, the medical need for beauty patches ceased. An English country doctor, Edward Jenner, tested his theory of a vaccine against smallpox by inoculating an eight-year-old farm boy with cowpox, a mild form of the disease. The boy soon developed a slight rash, and when it faded, Jenner inoculated him with the more dangerous smallpox. The child displayed no symptoms. He had been immunized.

Jenner named his procedure "vaccination," from the Latin for cowpox, *vaccinia*. As use of the vaccine quickly spread throughout Europe, obliterating the disease, beauty patches passed from practical camouflage to cosmetic affectation. In this latter form, they gave birth to the penciled-on beauty mark. And the jeweled patch boxes, now empty, were used to hold compacted powder.

Nail Polish: Pre–3000 B.C., China

The custom of staining fingernails, as well as fingers, with henna was common in Egypt by 3000 B.C. But actual fingernail paint is believed to have originated in China, where the color of a person's nails indicated social rank.

The Chinese had by the third millennium B.C. combined gum arabic, egg white, gelatin, and beeswax to formulate varnishes, enamels, and lacquers. According to a fifteenth-century Ming manuscript, the royal colors for fingernails were for centuries black and red, although at an earlier time, during the Chou Dynasty of 600 B.C., gold and silver were the royal prerogative.

Among the Egyptians, too, nail color came to signify social order, with shades of red at the top. Queen Nefertiti, wife of the heretic king Ikhnaton, painted her fingernails and toenails ruby red, and Cleopatra favored a deep rust red. Women of lower rank were permitted only pale hues, and no woman dared to flaunt the color worn by the queen—or king, for Egyptian men, too, sported painted nails.

This was particularly true of high-ranking warriors. Egyptian, Babylonian, and early Roman military commanders spent hours before a battle having their hair lacquered and curled, and their nails painted the same shade as their lips.

Such ancient attention to fingernails and toenails suggests to cosmetics historians that **manicuring** was already an established art. The belief is supported by numerous artifacts. Excavations at the royal tombs at Ur in southern Babylonia yielded a manicure set containing numerous pieces in solid gold, the property of a doubtless well-groomed Babylonian nobleman

who lived some four thousand years ago. Well-manicured nails became a symbol of culture and civilization, a means of distinguishing the laboring commoner from the idle aristocrat.

Creams, Oils, Moisturizers: 3000 B.C., Near East

It is not surprising that oils used to trap water in the skin and prevent desiccation developed in the hot, dry desert climate of the Near East. More than two thousand years before the development of soap, these moisturizers also served to clean the body of dirt, the way cold cream removes makeup.

The skin-softening oils were scented with frankincense, myrrh, thyme, marjoram, and the essences of fruits and nuts, especially almonds in Egypt. Preserved Egyptian clay tablets from 3000 B.C. reveal special formulations for particular beauty problems. An Egyptian woman troubled by a blemished complexion treated her face with a mask of bullock's bile, whipped ostrich eggs, olive oil, flour, sea salt, plant resin, and fresh milk. An individual concerned with the advancing dryness and wrinkles of age slept for six nights in a facial paste of milk, incense, wax, olive oil, gazelle or crocodile dung, and ground juniper leaves.

Little has really changed over the centuries. A glance at any of today's women's magazines reveals suggestions of cucumber slices for blemishes, moist tea bags for tired eyes, and beauty masks of honey, wheat germ oil, aloe squeezed from a windowsill plant, and comfrey from the herb garden.

In the ancient world, the genitalia of young animals were believed to offer the best chances to retard aging and restore sexual vigor. Foremost among such Near East concoctions was a body paste made of equal parts of calf phallus and vulva, dried and ground. The preparation—in its composition, its claims, and its emphasis on the potency of infant animal tissue— is no more bizarre than such modern youth treatments as fetal lamb cell injections. Our contemporary obsession with beauty and sexual vigor into old age, and the belief that these desiderata can be bottled, have roots as ancient as recorded history—and probably considerably older.

Of the many ancient cosmetic formulas, one, cold cream, has come down to us through the centuries with slight variation.

Cold Cream: 2nd Century, Rome

First, there is something cold about cold cream. Formulated with a large quantity of water, which evaporates when the mixture comes in contact with the warmth of the skin, the cream can produce a slight cooling sensation, hence its name.

Cold cream was first made by Galen, the renowned second-century Greek physician who practiced in Rome.

In A.D. 157, Galen was appointed chief physician to the school of gladiators in Pergamum, and he went on to treat the royal family of Rome.

While he prepared medications to combat the serious infections and abscesses that afflicted gladiators, he also concocted beauty aids for patrician women. As recorded in his *Medical Methods,* the formula for cold cream called for one part white wax melted into three parts olive oil, in which "rose buds had been steeped and as much water as can be blended into the mass." As a substitute for the skin-softening and -cleansing properties of cold cream, Galen recommended the oil from sheep's wool, lanolin, known then as *despyum.* Although many earlier beauty aids contained toxic ingredients, cold cream, throughout its long history, remained one of the simplest and safest cosmetics.

In more recent times, three early commercial creams merit note for their purity, safety, and appeal to women at all levels of society.

In 1911, a German pharmacist in Hamburg, H. Beiersdorf, produced a variant of cold cream which was intended to both moisturize and nourish the skin. He named his product **Nivea,** and it quickly became a commercial success, supplanting a host of heavier beauty creams then used by women around the world. The product still sells in what is essentially its original formulation.

Jergens Lotion was the brainstorm of a former lumberjack. Twenty-eight-year-old Andrew Jergens, a Dutch immigrant to America, was searching for a way to invest money he had saved while in the lumber business. In 1880, he formed a partnership with a Cincinnati soapmaker, and their company began to manufacture a prestigious toilet soap. Jergens, from his years in the lumber trade, was aware of the benefits of hand lotion and formulated one bearing his own name. His timing couldn't have been better, for women were just beginning to abandon homemade beauty aids for marketed preparations. The product broke through class barriers, turning up as readily on the vanity in a Victorian mansion as by the kitchen sink in a humbler home.

The third moderately priced, widely accepted cream, **Noxzema,** was formulated by a Maryland school principal turned pharmacist. After graduating from the University of Maryland's pharmacy school in 1899, George Bunting opened a drugstore in Baltimore. Skin creams were a big seller then, and Bunting blended his own in a back room and sold it in small blue jars labeled "Dr. Bunting's Sunburn Remedy."

When female customers who never ventured into the sun without a parasol began raving about the cream, Bunting realized he had underestimated the benefits of his preparation. Seeking a catchier, more encompassing name, he drew up lists of words and phrases, in Latin and in English, but none impressed him. Then one day a male customer entered the store and remarked that the sunburn remedy had miraculously cured his eczema. From that chance remark, Dr. Bunting's Sunburn Remedy became Noxzema, and a limited-use cold cream became the basis of a multimillion-dollar business.

Mirror: 3500 B.C., Mesopotamia

The still water of a clear pool was man's first mirror. But with the advent of the Bronze Age, about 3500 B.C., polished metal became the favored material, and the Sumerians in Mesopotamia set bronze mirrors into plain handles of wood, ivory, or gold. Among the Egyptians, the handles were of elaborate design, sculpted in the shapes of animals, flowers, and birds. Judging from the numerous mirrors recovered in Egyptian tombs, a favorite handle had a human figure upholding a bronze reflecting surface.

Metal mirrors were also popular with the Israelites, who learned the craft in Egypt. When Moses wished to construct a laver, or ceremonial washbasin, for the tabernacle, he commanded the women of Israel to surrender their "looking-glasses," and he shaped "the laver of brass, and the foot of it of brass."

In 328 B.C., the Greeks established a school for mirror craftsmanship. A student learned the delicate art of sand polishing a metal without scratching its reflective surface. Greek mirrors came in two designs: disk and box.

A disk mirror was highly polished on the front, with the back engraved or decorated in relief. Many disk mirrors had a foot, enabling them to stand upright on a table.

A box mirror was formed from two disks that closed like a clamshell. One disk was the highly polished mirror; the other disk, unpolished, served as a protective cover.

The manufacturing of mirrors was a flourishing business among the Etruscans and the Romans. They polished every metal they could mine or import. Silver's neutral color made it the preferred mirror metal, for it reflected facial makeup in its true hues. However, around 100 B.C., gold mirrors established a craze. Even head servants in wealthy households demanded personal gold mirrors, and historical records show that many servants were allotted a mirror as part of their wages.

Throughout the Middle Ages, men and women were content with the polished metal mirror that had served their ancestors. Not until the 1300s was there a revolution in this indispensable article of the vanity.

Glass Mirror. Glass had been molded and blown into bottles, cups, and jewelry since the start of the Christian era. But the first glass mirrors debuted in Venice in 1300, the work of Venetian gaffers, or glass blowers.

The gaffer's craft was at an artistic pinnacle. Craftsmen sought new technological challenges, and glass mirrors taxed even Venetian technicians' greatest skills. Unlike metal, glass could not be readily sand-polished to a smooth reflecting surface; each glass sheet had to be poured perfectly the first time. The technology to guarantee this was crude at first, and early glass mirrors, although cherished by those who could afford them and cov-

A Roman vanity, centered around a hand-held mirror. Mirrors were of polished metals until the 1300s.

eted by those who could not, cast blurred and distorted images.

Image (and not that reflected in a mirror) was all-important in fourteenth-century Venice. Wealthy men and women took to ostentatiously wearing glass mirrors about the neck on gold chains as pendant jewelry. While the image in the glass might be disappointingly poor, the image of a mirror-wearer in the eyes of others was one of unmistakable affluence. Men carried swords with small glass mirrors set in the hilt. Royalty collected sets of glass mirrors framed in ivory, silver, and gold, which were displayed more than they were used. Early mirrors had more flash than function, and given their poor reflective quality, they probably served best as bric-a-brac.

Mirror quality improved only moderately until 1687. That year, French gaffer Bernard Perrot patented a method for rolling out smooth, undistorted sheets of glass. Now not only perfectly reflective hand mirrors but also full-length looking glasses were produced. (See also "Glass Window," page 156.)

Hair Styling: 1500 B.C., Assyria

In the ancient world, the Assyrians, inhabiting the area that is modern northern Iraq, were the first true hair stylists. Their skills at cutting, curling, layering, and dyeing hair were known throughout the Middle East as non-pareil. Their craft grew out of an obsession with hair.

The Assyrians cut hair in graduated tiers, so that the head of a fashionable courtier was as neatly geometric as an Egyptian pyramid, and somewhat similar in shape. Longer hair was elaborately arranged in cascading curls and ringlets, tumbling over the shoulders and onto the breasts.

Hair was oiled, perfumed, and tinted. Men cultivated a neatly clipped beard, beginning at the jaw and layered in ruffles down over the chest. Kings, warriors, and noblewomen had their abundant, flowing hair curled by slaves, using a fire-heated iron bar, the first **curling iron.**

The Assyrians developed hair styling to the exclusion of nearly every other cosmetic art. Law even dictated certain types of coiffures according to a person's position and employment. And, as was the case in Egypt, high-ranking women, during official court business, donned stylized fake beards to assert that they could be as authoritative as men.

Baldness, full or partial, was considered an unsightly defect and concealed by wigs.

Like the Assyrians, the Greeks during the Homeric period favored long, curly hair. They believed that long hair, and difficult-to-achieve hair styles, distinguished them from the barbarians in the north, who sported short, unattended hair. "Fragrant and divine curls" became a Greek obsession, as revealed by countless references in prose and poetry.

Fair hair was esteemed. Most of the great Greek heroes—Achilles, Menelaus, Paris, to mention a few—are described as possessing light-colored locks. And those not naturally blond could lighten or redden their tresses with a variety of harsh soaps and alkaline bleaches from Phoenicia, then the soap center of the Mediterranean.

Men in particular took considerable measures to achieve lighter hair shades. For temporary coloring, they dusted hair with a talc of yellow pollen, yellow flour, and fine gold dust. Menander, the fourth-century B.C. Athenian dramatist, wrote of a more permanent method: "The sun's rays are the best means for lightening the hair, as our men well know." Then he describes one practice: "After washing their hair with a special ointment made here in Athens, they sit bareheaded in the sun by the hour, waiting for their hair to turn a beautiful golden blond. And it does."

In 303 B.C., the first professional barbers, having formed into guilds, opened shops in Rome.

Roman social standards mandated well-groomed hair, and tonsorial neglect was often treated with scorn or open insult. Eschewing the Greek ideal of golden-blond hair, Roman men of high social and political rank

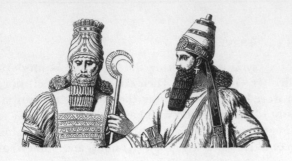

A tonsorial obsession.
Assyrians oiled,
perfumed, tinted and
curled their tresses.
Only a coiffed soldier
was fit for battle.

favored dark-to-black hair. Aging Roman consuls and senators labored to conceal graying hair. The first-century Roman naturalist Pliny the Elder wrote candidly of the importance of dark hair dyes. A preferred black dye was produced by boiling walnut shells and leeks. But to prevent graying in the first place, men were advised to prepare a paste, worn overnight, of herbs and earthworms. The Roman antidote for baldness was an unguent of crushed myrtle berries and bear grease.

Not all societies favored blond or dark hair. Early Saxon men (for reasons that remain a mystery) are depicted in drawings with hair and beards dyed powder blue, bright red, green, or orange. The Gauls, on the other hand, were known to favor reddish hair dyes. And in England when Elizabeth I was arbiter of fashion, prominent figures of the day—male and female— dyed their hair a bright reddish orange, the queen's color. An ambassador to court once noted that Elizabeth's hair was "of a light never made by nature."

Although men and women had powdered their hair various colors since before the Christian era, the practice became the rule of fashion in sixteenth-century France. The powder, liberally applied to real hair and wigs, was bleached and pulverized wheat flour, heavily scented. By the 1790s, at the court of Marie Antoinette, powdering, and all forms of hair dressing generally, reached a frenzied peak. Hair was combed, curled, and waved, and supplemented by mounds of false hair into fantastic towers, then powdered assorted colors. Blue, pink, violet, yellow, and white—each had its vogue.

At the height of hair powdering in England, Parliament, to replenish the

public treasury, taxed hair powders. The returns were projected at a quarter of a million pounds a year. However, political upheaval with France and Spain, to say nothing of a capricious change in hair fashion that rendered powdering passé, drastically reduced the revenue collected.

Modern Hair Coloring: 1909, France

Permanent coloring of the hair has never been a harmless procedure. The risk of irritation, rash, and cellular mutations leading to cancer are present even with today's tested commercial preparations. Still, they are safer than many of the caustic formulations used in the past.

The first successful attempt to develop a safe commercial hair dye was undertaken in 1909 by French chemist Eugène Schueller. Basing his mixture on a newly identified chemical, paraphenylenediamine, he founded the French Harmless Hair Dye Company. The product initially was not an impressive seller (though it would become one), and a year later Schueller conceived a more glamorous company name: L'Oréal.

Still, most women resisted in principle the idea of coloring their hair. That was something done by actresses. As late as 1950, only 7 percent of American women dyed their hair. By comparison, the figure today is 75 percent. What brought about the change in attitude?

In large measure, the modern hair-coloring revolution came not through a safer product, or through a one-step, easy-to-use formulation, but through clever, image-changing advertising.

The campaign was spearheaded largely by Clairol.

A New York copywriter, Shirley Polykoff, conceived two phrases that quickly became nationwide jargon: "Does She or Doesn't She?" and "Only Her Hairdresser Knows for Sure." The company included a child in every pictorial advertisement, to suggest that the adult model with colored hair was a respectable woman, possibly a mother.

Ironically, it was the double entendre in "Does She or Doesn't She?" that raised eyebrows and consequently generated its own best publicity. "Does she or doesn't she what?" people joked. *Life* magazine summarily refused to print the advertisement because of its blatant suggestiveness. To counter this resistance, Clairol executives challenged *Life*'s all-male censor panel to test the advertisement on both men and women. The results were astonishing, perhaps predictable, and certainly revealing. Not a single woman saw sexual overtones in the phrase, whereas every man did.

Life relented. The product sold well. Coloring hair soon ceased to be shocking. By the late 1960s, almost 70 percent of American women—and two million men—altered their natural hair color. Modern-day Americans had adopted a trend that was popular more than three thousand years ago. The only difference in the past was that the men coloring their hair outnumbered the women.

Wigs: 3000 B.C., Egypt

Although the Assyrians ranked as the preeminent hair stylists of the ancient world, the Egyptians, some fifteen hundred years earlier, made an art of wigs. In the Western world, they originated the concept of using artificial hair, although its function was most often not to mask baldness but to complement formal, festive attire.

Many Egyptian wigs survive in excellent condition in museums today. Chemical analyses reveal that their neatly formed plaits and braids were made from both vegetable fiber and human hair.

Some decorative hairpieces were enormous. And weighty. The wig Queen Isimkheb, in 900 B.C., wore on state occasions made her so top-heavy that attendants were required to help her walk. Currently in the Cairo Museum, the wig was chemically tested and found to be woven entirely of brown human hair. As is true of other wigs of that time, its towering style was held in place with a coating of beeswax.

Blond wigs became a craze in Rome, beginning in the first century B.C. Whereas Greek courtesans preferred bleaching or powdering their own hair, Roman women opted for fine flaxen hair from the heads of German captives. It was made into all styles of blond wigs. Ovid, the first-century Roman poet, wrote that no Roman, man or woman, had ever to worry about baldness given the abundance of German hair to be scalped at will.

Blond wigs eventually became the trademark of Roman prostitutes, and even of those who frequented them. The dissolute empress Messalina wore a "yellow wig" when she made her notorious rounds of the Roman brothels. And Rome's most detestable ruler, Caligula, wore a similar wig on nights when he prowled the streets in search of pleasure. The blond wig was as unmistakable as the white knee boots and miniskirt of a contemporary streetwalker.

The Christian Church tried repeatedly to stamp out all wearing of wigs, for whatever purpose. In the first century, church fathers ruled that a wigged person could not receive a Christian blessing. In the next century, Tertullian, the Greek theologian, preached that "All wigs are such disguises and inventions of the devil." And in the following century, Bishop Cyprian forbade Christians in wigs or toupees to attend church services, declaiming, "What better are you than pagans?"

Such condemnation peaked in A.D. 692. That year, the Council of Constantinople excommunicated Christians who refused to give up wearing wigs.

Even Henry IV, who defied the Church in the twelfth century over the king's right to appoint bishops and was subsequently excommunicated, adhered to the Church's recommended hair style—short, straight, and unadorned. Henry went so far as to prohibit long hair and wigs at court. Not until the Reformation of 1517, when the Church was preoccupied with the

A cartoon captures the burden of false hair in an era when wigs were weighty and required hours of attention.

more pressing matter of losing members, did it ease its standards on wigs and hair styles.

By 1580, wigs were again the *dernier cri* in hair fashion.

One person more than any other was responsible for the return of curled and colored wigs: Elizabeth I, who possessed a huge collection of red-orange wigs, used mainly to conceal a severely receding hairline and thinning hair.

Wigs became so commonplace they often went unnoticed. The fact that Mary, Queen of Scots wore an auburn wig was unknown even by people well acquainted with her; they learned the truth only when she was beheaded. At the height of wig popularity in seventeenth-century France, the court at Versailles employed forty full-time resident wigmakers.

Once again, the Church rose up against wigs. But this time the hierarchy was split within its own ranks, for many priests wore the fashionable long curling wigs of the day. According to a seventeenth-century account, it was not uncommon for wigless priests to yank wigs off clerics about to serve mass or invoke benediction. One French clergyman, Jean-Baptiste Thiers from Champrond, published a book on the evils of wigs, the means of spotting wig wearers, and methods of sneak attack to rip off false hair.

The Church eventually settled the dispute with a compromise. Wigs were permitted on laymen and priests who were bald, infirm, or elderly, although

never in church. Women received no exemption.

In eighteenth-century London, wigs worn by barristers were so valuable they were frequently stolen. Wig stealers operated in crowded streets, carrying on their shoulders a basket containing a small boy. The boy's task was to suddenly spring up and seize a gentleman's wig. The victim was usually discouraged from causing a public fuss by the slightly ridiculous figure he cut with a bared white shaven head. Among barristers, the legal wig has remained part of official attire into the twentieth century.

Hairpin: 10,000 Years Ago, Asia

A bodkin, a long ornamental straight pin, was used by Greek and Roman women to fasten their hair. In shape and function it exactly reproduced the slender animal spines and thistle thorns used by earlier men and women and by many primitive tribes today. Ancient Asian burial sites have yielded scores of hairpins of bone, iron, bronze, silver, and gold. Many are plain, others ornately decorated, but they all clearly reveal that the hairpin's shape has gone unchanged for ten thousand years.

Cleopatra preferred ivory hairpins, seven to eight inches long and studded with jewels. The Romans hollowed out their hairpins to conceal poison. The design was similar to that of the pin Cleopatra is reputed to have used in poisoning herself.

The straight hairpin became the U-shaped bobby pin over a period of two centuries.

Wig fashion at the seventeenth-century French court necessitated that a person's real hair be either clipped short or pinned tightly to the head. Thus "bobbed," it facilitated slipping on a wig as well as maintaining a groomed appearance once the wig was removed. Both large straight pins and U-shaped hairpins were then called "bobbing pins." In England, in the next century, the term became "bobby pin." When small, two-pronged pins made of tempered steel wire and lacquered black began to be mass-produced in the nineteenth-century, they made straight hairpins virtually obsolete and monopolized the name bobby pin.

Hair Dryer: 1920, Wisconsin

The modern electric hair dryer was the offspring of two unrelated inventions, the vacuum cleaner and the blender. Its point of origin is well known: Racine, Wisconsin. And two of the first models—named the "Race" and the "Cyclone"—appeared in 1920, both manufactured by Wisconsin firms, the Racine Universal Motor Company and Hamilton Beach.

The idea of blow-drying hair originated in early vacuum cleaner advertisements.

In the first decade of this century, it was customary to promote several functions for a single appliance, especially an electrical appliance, since

electricity was being touted as history's supreme workhorse. The stratagem increased sales; and people had come to expect multifunction gadgets.

The vacuum cleaner was no exception. An early advertisement for the so-called Pneumatic Cleaner illustrated a woman seated at her vanity, drying her hair with a hose connected to the vacuum's exhaust. With a why-waste-hot-air philosophy, the caption assured readers that while the front end of the machine sucked up and safely trapped dirt, the back end generated a "current of pure, fresh air from the exhaust." Although early vacuum cleaners sold moderately well, no one knows how many women or men got the most out of their appliance.

The idea of blow-drying hair had been hatched, though. What delayed development of a hand-held electric hair dryer was the absence of a small, efficient, low-powered motor, known technically among inventors as a "fractional horsepower motor."

Enter the blender.

Racine, Wisconsin, is also the hometown of the first electric milk shake mixer and blender. (See page 111.) Although a blender would not be patented until 1922, efforts to perfect a fractional horsepower motor to run it had been under way for more than a decade, particularly by the Racine Universal Motor Company and Hamilton Beach.

Thus, in principle, the hot-air exhaust of the vacuum cleaner was married to the compact motor of the blender to produce the modern hair dryer, manufactured in Racine. Cumbersome, energy-inefficient, comparatively heavy, and frequently overheating, the early hand-held dryer was, nonetheless, more convenient for styling hair than the vacuum cleaner, and it set the trend for decades to come.

Improvements in the '30s and '40s involved variable temperature settings and speeds. The first significant variation in portable home dryers appeared in Sears, Roebuck's 1951 fall–winter catalogue. The device, selling for $12.95, consisted of a hand-held dryer and a pink plastic bonnet that connected directly to the blower and fitted over the woman's head.

Hair dryers were popular with women from the year they debuted. But it was only in the late 1960s, when men began to experience the difficulty of drying and styling long hair, that the market for dryers rapidly expanded.

Comb: Pre–4000 B.C., Asia and Africa

The most primitive comb is thought to be the dried backbone of a large fish, which is still used by remote African tribes. And the comb's characteristic design is apparent in the ancient Indo-European source of our word "comb," *gombhos,* meaning "teeth."

The earliest man-made combs were discovered in six-thousand-year-old Egyptian tombs, and many are of clever design. Some have single rows of straight teeth, some double rows; and others possess a first row thicker and longer than the second. A standard part of the Egyptian man's and woman's

vanity, the instrument served the dual function of combing hair and of pinning a particular style in place.

Archaeologists claim that virtually all early cultures independently developed and made frequent use of combs—all, that is, except the Britons.

Dwelling along the coastline of the British Isles, these early peoples wore their hair unkempt (even during occupation by the Romans, themselves skilled barbers). They are believed to have adopted the comb only after the Danish invasions, in 789. By the mid-800s, the Danes had settled throughout the kingdom, and it is they who are credited with teaching coastal Britons to comb their hair regularly.

In early Christian times, combing hair was also part of religious ceremonies, in a ritualistic manner similar to washing the feet. Careful directions exist for the proper way to comb a priest's hair in the sacristy before vespers. Christian martyrs brought combs with them into the catacombs, where many implements of ivory and metal have been found. Religious historians suspect that the comb at one time had some special symbolic significance; they point to the mysterious fact that during the Middle Ages, many of the earliest stained-glass church windows contain unmistakable images of combs.

Magic, too, came to surround the comb. In the 1600s, in parts of Europe, it was widely accepted that graying hair could be restored to its original color by frequent strokes with a lead comb. Although it is conceivable that soft, low-grade, blackened lead might actually have been microscopically deposited on strands of hair, slightly darkening them, there is more evidence to suggest that the comber dyed his hair, then attributed the results to the instrument. The suspicion is supported by the fact that in the last few decades of the century, the term "lead comb"—as in "He uses a lead comb"—was the socially accepted euphemism for dyeing gray hair.

There were no real changes in comb design until 1960, when the first home electric styling comb originated in Switzerland.

Perfume: Pre–6000 B.C., Middle and Far East

Perfume originated at ancient sacred shrines, where it was the concern of priests, not cosmeticians. And in the form of incense, its original function, it survives today in church services.

The word itself is compounded from *per* and *fumus,* Latin for "through the smoke." And that precisely describes the manner in which the fragrant scents reached worshipers: carried in the smoke of the burning carcass of a sacrificial animal.

Foraging man, preoccupied with the quest for food, believed the greatest offering to his gods was part of his most precious and essential possession, a slaughtered beast. Perfume thus originated as a deodorizer, sprinkled on a carcass to mask the stench of burning flesh. The Bible records that when Noah, having survived the Flood, burned animal sacrifices, "the Lord smelled the sweet odor"—not of flesh but of incense.

Incense, used to mask the stench of sacrificial burning flesh, evolved into perfume.

In time, through symbolic substitution, the pungent, smoky fragrances themselves became offerings. Burning such resinous gums as frankincense, myrrh, cassia, and spikenard signified the deepest homage a mortal could pay to the gods. Perfume thus passed from a utilitarian deodorizer of foul smells to a highly prized commodity in its own right. No longer in need of heavy, masking scents, people adopted light, delicate fragrances of fruits and flowers.

This transition from incense to perfume, and from heavy scents to lighter ones, occurred in both the Far East and the Middle East some six thousand years ago. By 3000 B.C., the Sumerians in Mesopotamia and the Egyptians along the Nile were literally bathing themselves in oils and alcohols of jasmine, iris, hyacinth, and honeysuckle.

Egyptian women applied a different scent to each part of the body. Cleopatra anointed her hands with *kyaphi*, an oil of roses, crocus, and violets; and she scented her feet with *aegyptium*, a lotion of almond oil, honey, cinnamon, orange blossoms, and tinting henna.

Although the men of ancient Greece eschewed the use of facial cosmetics, preferring a natural appearance, they copiously embraced perfumes—one scent for the hair, another for the skin, another for clothing, and still a different one to scent wine.

Greek writers around 400 B.C. recommended mint for the arms, cinnamon or rose for the chest, almond oil for the hands and feet, and extract of marjoram for the hair and eyebrows. Fashionable young Greeks carried the use of perfumes to such extremes that Solon, the statesman who devised the democratic framework of Athens, promulgated a law (soon repealed) prohibiting the sale of fragrant oils to Athenian men.

From Greece, perfumes traveled to Rome, where a soldier was considered unfit to ride into battle unless duly anointed with perfumes. Fragrances of wisteria, lilac, carnation, and vanilla were introduced as the Roman Empire conquered other lands. From the Far and Middle East, they acquired a preference for cedar, pine, ginger, and mimosa. And from the Greeks, they learned to prepare the citric oils of tangerine, orange, and lemon.

Guilds of Roman perfumers arose, and they were kept busy supplying both men and women with the latest scents. Called *unguentarii,* perfumers occupied an entire street of shops in ancient Rome. Their name, meaning "men who anoint," gave rise to our word "unguent."

The *unguentarii* concocted three basic types of perfume: solid unguents, which were scents from only one source, such as pure almond, rose, or quince; liquids, compounded from squeezed or crushed flowers, spices, and gums in an oil base; and powdered perfumes, prepared from dried and pulverized flower petals and spices.

Like the Greeks, the Romans lavished perfume upon themselves, their clothes, and their home furnishings. And their theaters. The eighteenth-century British historian Edward Gibbon, writing on Roman customs, observed, "The air of the amphitheater was continually refreshed by the playing of fountains, and profusely impregnated by the grateful scents of aromatics."

The emperor Nero, who set a fashion in the first century for rose water, spent four million sesterces—the equivalent of about $160,000 today—for rose oils, rose waters, and rose petals for himself and his guests for a single evening's fete. And it was recorded that at the funeral in A.D. 65 of his wife, Poppaea, more perfume was doused, splashed, and sprayed than the entire country of Arabia could produce in a year. Even the processional mules were scented. (Perhaps especially the mules.)

Such fragrance excesses incensed the Church. Perfume became synonymous with decadence and debauchery, and in the second century, church fathers condemned the personal use of perfumes among Christians.

After the fall of the Roman Empire, perfume was manufactured primarily in the Middle and Far East. One of the costliest Eastern perfumes, reintroduced to Europe by the eleventh-century Crusaders, was "rose attar," the essential oil from the petals of the damask rose. Two hundred pounds of feather-light rose petals produced a single ounce of attar.

It was the Crusaders, returning with exotic fragrances, who reawakened Europe's interest in perfumes and perfume making. And at that point in perfume's history, a new element entered the arena: animal oils. From the

East, pharmacists learned that small portions of four highly unlikely animal secretions cast intoxicating effects on humans. The oils were musk, ambergris, civet, and castor—the fundamental essences of modern perfumes.

These are unlikely ingredients for perfume because they are sexual and glandular secretions, which in themselves can be overpowering, unpleasant, and even nauseating. Their origins with respect to perfume are only partially known.

Musk. Musk derives from a particular deer, *Moschus moschiferus,* a small, shy denizen of the rhododendron and birch thickets of western China. Fully grown males weigh only twenty-two pounds.

It is the male that carries, in the front of his abdomen, a sac that secretes a sexual signal, similar in function to the spray of a tomcat. Centuries ago, Eastern hunters, noticing a sweet, heavy fragrance throughout local forests, eventually isolated the source of the odor, and the diminutive deer have been hunted ever since. After the deer is killed, the sac is removed, dried, and sold to perfumers. Essential musk oil can be detected in amounts as small as 0.000,000,000,000,032 ounce. That is one meaning of "essential."

Ambergris. This highly odorous, waxy substance is cast off from the stomach of the sperm whale. It is the basis of the most expensive perfume extracts and, like musk, is worth the equivalent of gold.

The great mammal *Physeter catodon* lives on a diet of cuttlefish, a squidlike sea mollusk that contains a sharp bone, the cuttlebone, which is used in bird cages for sharpening the beaks of parakeets. Ambergris is secreted to protect the whale's intestinal lining from this abrasive bone.

As an oil, it floats, and often coats the nets of fishermen. It was early Arab fishermen who first appreciated ambergris's sweet odor and its great fixative qualities in extending the life of a perfume. Ambergris, for example, is able to delay significantly the rate of volatility of other perfume oils with which it is mixed. Today both musk and ambergris can be synthesized, and the perfume trade has voluntarily refused to purchase ambergris out of consideration for the survival of the sperm whale.

Civet. This is a soft, waxy substance secreted by the civet cat, a nocturnal, flesh-eating animal of Africa and the Far East, with spotted yellowish fur.

Civet is a glandular secretion of both male and female cats of the family *Viverra civetta.* The waxy substance is formed near the genitalia, and it can be collected from captive cats about twice a week. It possesses a revoltingly fecal odor, but when blended with other perfume essences, it becomes both extremely agreeable and strongly fixative. Exactly how ancient perfumers of the Far East discovered this fact remains a puzzling mystery.

Castor. This scent is derived from both Russian and Canadian beavers of the family *Castor fiber.* The secretion collects in two abdominal sacs in both

males and females. Extremely diluted, castor (or castoreum) is itself agreeable, but its primary use is as a scent-extending fixative. The fixating qualities that mark all four of these animal essences are a function of their high molecular weight. The heavy molecules act as anchors, impeding a perfume's predominant scents from rising too quickly above the liquid's surface and escaping into the air.

Cologne: 1709, Germany

An Italian barber, Jean-Baptiste Farina, arrived in Cologne, Germany, in 1709 to seek his fortune in the fragrance trade. Among his special concoctions was an alcohol-based blend of lemon spirits, orange bitters, and mint oil from the pear-shaped bergamot fruit. His creation was the world's first eau de Cologne, "water of Cologne," named after the city founded in A.D. 50 by Agrippina, wife of the Roman emperor Claudius.

While the city of Cologne was famous in the Middle Ages for its great cathedral, containing the shrine of the Magi, after Farina's creation it became known throughout Europe as the major producer of cologne. The first cologne fragrance enjoyed a tremendous success, particularly among French soldiers stationed in that city in the mid-1700s during the Seven Years' War. The Farina family prospered. Several members moved to Paris and started another successful perfume business, which in the 1860s was taken over by two French cousins, Armand Roger and Charles Gallet. Broadening the Farina line of toiletries, the cousins sold them under their combined names, Roger & Gallet.

Soon, in the trade, "cologne," "toilet water," and "perfume" acquired well-defined meanings. A perfume became any mixture of ethyl alcohol with 25 percent of one or more fragrant essential oils. Toilet water was a thinner dilution of the same ingredients, containing approximately 5 percent essential oils. And cologne was a further alcoholic dilution, with 3 percent fragrant oils. Those definitions apply today, although a particularly rich (and pricey) perfume can contain up to 42 percent of the precious oils.

The French dominated the perfume industry well into the nineteenth century—and beyond.

It was François Coty, a Corsican whose real surname was Sportuno, who, watching U.S. infantrymen sending home vast quantities of perfume following World War I, grasped the full possibilities of the American obsession with French fragrances. By selling name-brand products in smaller quantities and at cheaper prices, Coty appealed to new sectors of society and ushered in the first form of mass production in the perfume industry. Also capitalizing on the American desire for French perfumes, Jeanne Lanvin took her creation Mon Péché, which had failed in Paris, and in 1925 turned it into an immediate and resounding success in America under the name My Sin.

Shalimar. The same year that My Sin debuted, two French brothers, Pierre

and Jacques Guerlain, created Shalimar, Sanskrit for "temple of love." The brothers were inspired when a rajah, visiting Paris, enthralled them with a tale of courtship in the Shalimar gardens of Lahore, Pakistan. In the gardens, replete with fragrant blossoming trees imported from around the world, Shah Jahan, a seventeenth-century emperor of India, courted and married Mumtaz Mahal. After her death, he built the magnificent Taj Mahal mausoleum as her memorial.

Chanel No. 5. The superstitious fashion designer Gabrielle ("Coco") Chanel associated good luck with the number five. In 1921, she introduced to the world her new fragrance, announcing it on the fifth day of the fifth month and labeling the perfume No. 5.

At that time, the perfume was unlike others on the market in that it did not have the distinctive floral "feminine" scent then popular. That, in fact, played a large measure in its appeal to the "boyish" flappers of the Jazz Age. The revolutionary No. 5, with its appropriate timing and scent, turned out to be a lucky number all around for its creator, earning her fifteen million dollars. Americans took immediately to the perfume, and Marilyn Monroe once replied to a journalist who asked her what she wore to bed: "Chanel No. 5."

Avon: 1886, New York

The modern cosmetics industry in America was not dominated entirely by foreigners. It is true that Chanel, Coty, and Guerlain hailed from France, Helena Rubinstein from Krakow, Poland; Elizabeth Arden (born Florence Nightingale Graham) from Canada; Max Factor from Russia. But Avon was strictly an American phenomenon, and a unique and pioneering one at that.

The first Avon Lady was actually a man, young door-to-door salesman David McConnell from upstate New York. He launched Avon Calling in 1886, offering women cosmetics in the comfort and privacy of their own homes. But perfumes and hand creams were not McConnell's initial merchandise.

At the age of sixteen, McConnell had begun selling books door-to-door. When his fare was not well received, he resorted to the then-popular advertising gimmick of offering a free introductory gift in exchange for being allowed to make a sales pitch. A complimentary vial of perfume, he thought, would be an ideal entrée, and he blended the original scent himself, with the aid of a local pharmacist.

Fate stepped in. As a later door-to-door salesman discovered that his free soapy steel-wool pads (see "S.O.S. Pads," page 102) were preferred by housewives over his actual pot-and-pan wares, McConnell learned that women adored his perfume and remained indifferent to his books. Thus, he abandoned books and organized the New York–based California Perfume

Company, named in honor of a friend and investor from California. The door-to-door approach seemed tailor-made for cosmetics, particularly in rural areas, where homemakers, in horse-and-buggy days, had poor access to better stores.

The first female Avon Lady was Mrs. P. F. E. Albee, a widow from Winchester, New Hampshire. She began her chime-ringing career selling the company's popular Little Dot Perfume Set, and she recruited other women, training them as door-to-door salespeople. The company was rechristened Avon for the simple reason that the New York State town in which David McConnell lived, Suffern on the Ramapo, reminded him of Shakespeare's Stratford-on-Avon.

By 1897, McConnell had twelve women employees selling a line of eighteen fragrances. And the numbers kept growing and growing. Today, despite the scores of expensive, prestigious American and foreign brand-name cosmetics, Avon ranks first in sales nationwide, with more than half a million Avon Ladies ringing doorbells from coast to coast.

Chapter 10

Through the Medicine Chest

Medication: 3500 B.C., Sumer

Because early man viewed illness as divine punishment and healing as purification, medicine and religion were inextricably linked for centuries. You became ill because you lost favor with a god, and you regained that god's grace, and your health, by a physical and spiritual purging. This notion is apparent in the origin of our word "pharmacy," which comes from the Greek *pharmakon*, meaning "purification through purging."

By 3500 B.C., the Sumerians in the Tigris-Euphrates valley had developed virtually all of our modern methods of administering drugs. They used gargles, inhalations, suppositories, enemas, poultices, snuffs, decoctions, infusions, pills, troches, lotions, ointments, and plasters.

The first drug catalogue, or pharmacopoeia, was written at that time by an unknown Sumerian physician. Preserved in cuneiform script on a single clay tablet are the names of dozens of drugs to treat ailments that still afflict us today. As a gargle, salt dissolved in water; as a general disinfectant for wounds, soured wine; as an astringent, potassium nitrate, obtained from the nitrogenous waste products in urine. And to relieve a fever, pulverized willow bark, nature's equivalent of aspirin.

The Egyptians added to the ancient medicine chest.

The Ebers Papyrus, a scroll dating from 1900 B.C. and named after the German Egyptologist Georg Ebers, reveals the trial-and-error know-how acquired by early Egyptian physicians. Constipation was treated with a laxative of ground senna pods and castor oil; for indigestion, a chew of pep-

permint leaves and carbonates (known today as antacids); and to numb the pain of tooth extraction, Egyptian doctors temporarily stupefied a patient with ethyl alcohol.

The scroll also provides a rare glimpse into the hierarchy of ancient drug preparation. The "chief of the preparers of drugs" was the equivalent of a head pharmacist, who supervised the "collectors of drugs," field workers who gathered essential minerals and herbs. The "preparers' aides" (technicians) dried and pulverized ingredients, which were blended according to certain formulas by the "preparers." And the "conservator of drugs" oversaw the storehouse where local and imported mineral, herb, and animal-organ ingredients were kept.

By the seventh century B.C., the Greeks had adopted a sophisticated mind-body view of medicine. They believed that a physician must pursue the diagnosis and treatment of the *physical* (body) causes of disease within a scientific framework, as well as cure the *supernatural* (mind) components involved. Thus, the early Greek physician emphasized something of a holistic approach to health, even if the suspected "mental" causes of disease were not recognized as stress and depression but interpreted as curses from displeased deities. Apollo, chief god of healing, and Prometheus, a Titan who stole fire from heaven to benefit mankind, ruled over the preparation of all medications.

Modern Drugs. The modern era of pharmacology began in the sixteenth century, ushered in by the first major discoveries in chemistry. The understanding of how chemicals interact to produce certain effects within the body would eventually remove much of the guesswork and magic from medicine.

The same century witnessed another milestone: publication in Germany in 1546 of the first modern pharmacopoeia, listing hundreds of drugs and medicinal chemicals, with explicit directions for preparing them. Drugs that had previously varied widely in concentrations, and even in constituents, were now stringently defined by the text, which spawned versions in Switzerland, Italy, and England.

Drugs had been launched on a scientific course, but centuries would pass before superstition was displaced by scientific fact. One major reason was that physicians, unaware of the existence of disease-causing pathogens such as bacteria and viruses, continued to dream up imaginary causative evils. And though new chemical compounds emerged, their effectiveness in treating disease was still based largely on trial and error. When a new drug worked, no one really knew why, or more challenging still, how.

As we will see in this chapter, many standard, common drugs in the medicine chest developed in this trial-and-error environment. Such is the complexity of disease and human biochemistry that even today, despite enormous strides in medical science, many of the latest sophisticated additions to our medicine chest shelves were accidental finds.

Vaseline: 1879, Brooklyn, New York

In its early days, Vaseline had a wide range of uses and abuses. The translucent jelly was gobbed onto fishermen's hooks to lure trout. Stage actresses dabbed the glistening ointment down their cheeks to simulate tears. Because Vaseline resists freezing, Arctic explorer Robert Peary took the jelly with him to the North Pole to protect his skin from chapping and his mechanical equipment from rusting. And because the compound does not turn rancid in steamy tropical heat, Amazonian natives cooked with Vaseline, ate it as a spread on bread, and even exchanged jars of the stuff as money.

The reports of myriad uses from all latitudes and longitudes did not surprise Vaseline's inventor, Robert Augustus Chesebrough, a Brooklyn chemist, who lived to the age of ninety-six and attributed his longevity to Vaseline. He himself ate a spoonful of it every day.

In 1859, Robert Chesebrough was searching not for a new pharmaceutical unguent but for a way to stave off bankruptcy. At a time when kerosene was a major source of home and industrial power, his Brooklyn-based kerosene business was threatened by the prospect of cheaper petroleum fuel from an oil boom in Pennsylvania.

The young Brooklyn chemist journeyed to Titusville, Pennsylvania, heart of the oil strike, with the intention of entering the petroleum business. His chemist's curiosity, though, was piqued by a pasty paraffin-like residue that stuck annoyingly to drilling rods, gumming them into inactivity. The field workers Chesebrough questioned had several unprintable names for the stuff that clogged their pumps, but no one had a hint as to its chemical nature. Workers had discovered one practical use for it: rubbed on a wound or burn, the paste accelerated healing.

Chesebrough returned to Brooklyn not with an oil partnership but with jars of the mysterious petroleum waste product. Months of experimentation followed, in which he attempted to extract and purify the paste's essential ingredient.

That compound turned out to be a clear, smooth substance he called "petroleum jelly." Chesebrough became his own guinea pig. To test the jelly's healing properties, he inflicted various minor, and some major, cuts, scratches, and burns on his hands and arms. Covered with the paste extract, they seemed to heal quickly and without infection. By 1870, Chesebrough was manufacturing the world's first Vaseline Petroleum Jelly.

There are two views on the origin of the name Vaseline, and Chesebrough seems to have discouraged neither. In the late 1800s, his friends maintained that he dreamed up the name, during the early days of purifying the substance, from the practice of using his wife's flower vases as laboratory beakers. To "vase" he tagged on a popular medical suffix of that day, "line." However, members of the production company he formed claimed that Chesebrough more scientifically compounded the word from the German *wasser*, "water," and the Greek *elaion*, "olive oil."

As he had been the product's chief guinea pig, Robert Chesebrough also became its staunchest promoter. In a horse and buggy, he traveled the roads of upper New York State, dispensing free jars of Vaseline to anyone who promised to try it on a cut or burn. The public's response was so favorable that within a half year Chesebrough employed twelve horse-and-buggy salesmen, offering the jelly for a penny an ounce.

New Englanders, though, were dabbing Vaseline on more than cuts and burns. Housewives claimed that the jelly removed stains and rings from wood furniture, and that it glisteningly polished and protected wood surfaces. They also reported that it gave a second life to dried leather goods. Farmers discovered that a liberal coating of Vaseline prevented outdoor machinery from rusting. Professional painters found that a thin spread of the jelly prevented paint splatters from sticking to floors. But the product was most popular with druggists, who used the pure, clean ointment as a base for their own brands of salves, creams, and cosmetics.

By the turn of the century, Vaseline was a staple of home medicine chests. Robert Chesebrough had transformed a gummy, irksome waste product into a million-dollar industry. In 1912, when a disastrous fire swept through the headquarters of a large New York insurance company, Chesebrough was proud to learn that the burn victims were treated with Vaseline. It became a hospital standard. And the then-burgeoning automobile industry discovered that a coating of the inert jelly applied to the terminals of a car battery prevented corrosion. It became an industry standard. And a sports standard too. Long-distance swimmers smeared it on their bodies, skiers coated their faces, and baseball players rubbed it into their gloves to soften the leather.

Throughout all these years of diverse application, Vaseline's inventor never missed his daily spoonful of the jelly. In his late fifties, when stricken with pleurisy, Chesebrough instructed his private nurse to give him regular whole-body Vaseline rubdowns. He liked to believe that, as he joked, he "slipped from death's grip" to live another forty years, dying in 1933.

Listerine: 1880, St. Louis, Missouri

Developed by a Missouri physician, Joseph Lawrence, Listerine was named in honor of Sir Joseph Lister, the nineteenth-century British surgeon who pioneered sanitary operating room procedures. Shortly after its debut in 1880, the product became one of America's most successful and trusted commercial mouthwashes and gargles.

In the 1860s, when the science of bacteriology was still in its infancy, Lister campaigned against the appalling medical hygiene of surgeons. They operated with bare hands and in street clothes, wearing shoes that had trekked over public roads and hospital corridors. They permitted spectators to gather around an operating table and observe surgery in progress. And as surgical dressings, they used pads of pressed sawdust, a waste product

*Before Lister pioneered sanitary operating conditions, postoperative mortality in
many hospitals ran as high as 90 percent.*

from mill floors. Although surgical instruments were washed in soapy water,
they were not heat-sterilized or chemically disinfected. In many hospitals,
postoperative mortality was as high as 90 percent.

The majority of doctors, in England and America, scoffed at Lister's plea
for "antiseptic surgery." When he addressed the Philadelphia Medical
Congress in 1876, his speech received a lukewarm reception. But Lister's
views on germs impressed Dr. Joseph Lawrence. In his St. Louis laboratory,
Lawrence developed an antibacterial liquid, which was manufactured locally
by the Lambert Pharmacal Company (later to become the drug giant
Warner-Lambert).

In 1880, to give the product an appropriately antiseptic image, the com-
pany decided to use the name of Sir Joseph Lister, then the focus of con-
troversy on two continents. Surgeons, employing many of Lister's hygienic
ideas, were beginning to report fewer postoperative infections and com-
plications, as well as higher survival rates. "Listerism" was being hotly de-
bated in medical journals and the popular press. Listerine arrived on the
scene at the right time and bearing the best possible name.

The mouthwash and gargle was alleged to "Kill Germs By Millions On
Contact." And Americans, by millions, bought the product. Early adver-

tisements pictured a bachelor, Herb, "an awfully nice fellow, with some money," who also "plays a swell game of bridge." But Herb's problem, according to the copy, was that "he's *that* way."

Halitosis, not homosexuality, was Herb's problem. But in the early years of this century, it was equally unspeakable. Americans began the Listerine habit for sweetening their breath, to the extent that as late as the mid-1970s, with scores of competing breath-freshening sprays, mints, gargles, and gums on the market, Listerine still accounted for the preponderance of breath-freshener sales in the United States.

Then Joseph Lawrence's early belief in the potency of his product was medically challenged. A 1970s court order compelled Warner-Lambert to spend ten million dollars in advertising a disclaimer that Listerine could not prevent a cold or a sore throat, or lessen its severity.

Band-Aid: 1921, New Brunswick, New Jersey

At the 1876 Philadelphia Medical Congress, Dr. Joseph Lawrence was not the only American health worker impressed with Sir Joseph Lister's germ-disease theory. A thirty-one-year-old pharmacist from Brooklyn, Robert Johnson, had his life changed by the eminent British surgeon's lecture.

Lister deplored the use of pressed sawdust surgical dressings made from wood-mill wastes. He himself disinfected every bandage he used in surgery by soaking it in an aqueous solution of carbolic acid.

Johnson, a partner in the Brooklyn pharmaceutical supply firm of Seabury & Johnson, was acquainted with the sawdust dressings, as well as with an array of other nonsterile paraphernalia used in American hospitals. He persuaded his two brothers—James, a civil engineer, and Edward, an attorney—to join him in his attempt to develop and market a dry, prepackaged, antiseptic surgical dressing along the lines that Lister had theoretically outlined at the congress.

By the mid-1880s, the brothers had formed their own company, Johnson & Johnson, and produced a large dry cotton-and-gauze dressing. Individually sealed in germ-resistant packages, the bandages could be shipped to hospitals in remote areas and to doctors on military battlefields, with sterility guaranteed.

The Johnson brothers prospered in the health care field. In 1893, they introduced American mothers to the fresh scent of Johnson's Baby Powder, including it as a giveaway item in the multipurpose Maternity Packets sold to midwives.

On the horizon, though, was the sterile product that soon would appear in home medicine chests worldwide.

It was in 1920 that James Johnson, the firm's president, heard of a small homemade bandage created by one of his employees, Earle Dickson. A cotton buyer in the company's purchasing department, Dickson had recently married a young woman who was accident-prone, frequently cutting or

burning herself in the kitchen. The injuries were too small and minor to benefit from the company's large surgical dressings. As Earle Dickson later wrote of the Band-Aid: "I was determined to devise some manner of bandage that would stay in place, be easily applied and still retain its sterility."

To treat each of his wife's injuries, Dickson took a small wad of the company's sterile cotton and gauze, placing it at the center of an adhesive strip. Tiring of making individual bandages as they were needed, Dickson conceived of producing them in quantity, and of using a crinoline fabric to temporarily cover the bandages' sticky portions. When James Johnson watched his employee strip off two pieces of crinoline and easily affix the bandage to his own finger, Johnson knew the firm had a new first-aid product.

The name Band-Aid, which would eventually become a generic term for small dressings, was suggested by a superintendent at the company's New Brunswick plant, W. Johnson Kenyon. And those first adhesive bandages were made by hand, under sterile conditions, in assembly line fashion.

Sales were initially poor. One of the company's strongest promoters of the Band-Aid Brand Adhesive Bandage was Dr. Frederick Kilmer, head of the company's research department (and father of the poet Joyce Kilmer). Kilmer had been responsible for the development and marketing of Johnson's Baby Powder in the 1890s, and in the 1920s he joined the campaign to promote Band-Aids. He published medical and popular articles on the product's ability to prevent infection and accelerate healing of minor cuts and burns. One of the company's cleverest advertising ploys was to distribute an unlimited number of free Band-Aids to Boy Scout troops across the country, as well as to local butchers.

The popularity of Band-Aids steadily increased. By 1924, they were being machine-produced, measuring three inches long by three quarters of an inch wide. Four years later, Americans could buy Band-Aids with aeration holes in the gauze pad to increase airflow and accelerate healing.

Band-Aids' inventor, Earle Dickson, went on to enjoy a long and productive career with Johnson & Johnson, becoming a vice president and a member of the board of directors. As for his invention, the company estimates that since the product was introduced in 1921, people around the world have bandaged themselves with more than one hundred billion Band-Aids.

Witch Hazel: Post–7th Century, England

A mild alcoholic astringent applied to cleanse cuts, witch hazel was made from the leaves and bark of the witch hazel plant, *Hamamelis*. The shrub, whose pods explode when ripe, was used both practically and superstitiously in Anglo-Saxon times.

Because the plant's yellow flowers appear in late autumn, after the branches are bare of leaves and the bush is seemingly dead, the inhabitants

of the British Isles ascribed supernatural powers to the witch hazel tree. They believed, for instance, that a witch hazel twig, in a high priest's skilled hands, could single out a criminal in a crowd.

A more practical application of a pliant witch hazel twig was as a divining rod to locate underground water in order to sink wells. In fact, the word "witch" in the plant's name comes from the Anglo-Saxon *wice*, designating a tree with pliant branches.

The Anglo-Saxons' interest in the witch hazel plant led to the assumption that they developed the first witch hazel preparation. What is known with greater confidence is that American Indian tribes taught the Pilgrims how to brew witch hazel bark as a lotion for soothing aches, bruises, and abrasions.

For the next two hundred years, families prepared their own supplies of the lotion. Its uses in America were numerous: as an antiseptic, a facial cleanser and astringent, a topical painkiller, a deodorant, a base for cosmetic lotions, and as a cooling liquid (similar to today's splashes) in hot weather, for the rapid evaporation of witch hazel's alcohol stimulates the cooling effect of sweating.

In 1866, a New England clergyman, Thomas Newton Dickinson, realized that a profitable market existed for a commercial preparation. He located his distilling plant in Essex, Connecticut, on the banks of the Connecticut River, adjacent to fields of high-quality American witch hazel shrubs, *Hamamelis virginiana*.

In the 1860s, Dickinson's Witch Hazel was sold by the keg to pharmacists, who dispensed it in bottles to customers. The keg bore the now-familiar "bull's-eye" trademark, and Dickinson's formula for witch hazel proved so successful that it is basically unchanged to this day. It is one product that has been in medicine chests for at least three hundred years, if not longer.

Vick's VapoRub: 1905, Selma, North Carolina

Before the turn of the century, the most popular treatments for chest and head colds were poultices and plasters. They were not all that different from the mint and mustard formulations used in the Near East five thousand years ago. Unfortunately, both the ancient and the modern preparations, which were rubbed on the chest and forehead, frequently resulted in rashes or blisters, for their active ingredients, which produced a tingling sensation of heat, often were skin irritants.

There was another popular cold remedy, but one potentially more dangerous. Physicians recommended, with caution, that children suffering from the croup or a cold inhale hot herbal vapors. These temporarily opened the nasal passages while a child's head was over the steam, but many a child (and adult) received facial burns from overly hot water. Before gas and electric stoves would provide a measured and steady source of energy to

boil water, coal or wood fires could abruptly vary in intensity, producing a sudden geyser of scalding steam.

Many a druggist sought to produce a skin-tingling, sinus-opening ointment that combined the best aspects of plasters and vapors with none of their drawbacks. For Lunsford Richardson, a druggist from Selma, North Carolina, two events occurred that led him to the perfect product. The first was the popularity of petroleum jelly as a safe, neutral base for salves and cosmetics. The second was the introduction in America of menthol, a waxy, crystalline alcohol extract from oil of peppermint, which released a pungent vapor.

Menthol had first caught the public's attention in 1898 in the form of a sore-muscle balm named Ben-Gay. Developed by, and named after, a French pharmacist, Jules Bengué, the product combined menthol's heat-producing effects with an analgesic pain reliever, salicylate of methyl, in a base of lanolin. Touted in Europe and America as a remedy for gout, rheumatoid arthritis, and neuralgia, Bengué's balm was also reported to clear the sinuses during a head cold.

Richardson listened to testimonials for Ben-Gay from his own customers. In 1905, he blended menthol with other ingredients from the drugstore shelf into a base of petroleum jelly, producing Richardson's Croup and Pneumonia Cure Salve, a forehead and chest rub. Vaporized by body heat, the chemicals opened blocked air passages at the same time they stimulated blood circulation through skin contact. That year, Richardson could not work fast enough to fill orders from cold sufferers and other druggists.

Searching for a catchier name for his already popular product, Richardson turned to his brother-in-law, a physician named Joshua Vick. It was in Vick's drugstore that Richardson had begun his career in pharmacology, and it was in Vick's backroom laboratory that Richardson concocted his vapor rub. He named the product in honor of his relative and mentor.

Richardson advertised in newspapers, with coupons that could be redeemed for a trial jar of Vick's VapoRub. And he persuaded the U.S. Post Office to allow him to institute a new mailing practice, one that has since kept home mailboxes full, if not overflowing: Advertisements for Vick's VapoRub were addressed merely to "Boxholder," the equivalent of today's "Occupant." Before then, all mail had to bear the receiver's name.

Sales were strong. Then a tragic twist of fate caused them to skyrocket.

In the spring of 1918, a flu epidemic erupted in U.S. military bases. It was carried by troops to France, then to Spain, where the virus became more virulent, earning it the name Spanish Flu. It spread to China. By the fall of that year, an even deadlier strain broke out in Russia.

The death toll was enormous. The flu killed one half of one percent of the entire population of the United States and England, 60 percent of the Eskimos in Nome, Alaska. In just six weeks, 3.1 percent of the U.S. recruits at Camp Sherman died. Ocean liners docked with up to 7 percent fewer passengers than had embarked. The epidemic was characterized aptly by

what fourteenth-century Italian author Giovanni Boccaccio said of an earlier scourge: "How many valiant men, how many fair ladies, breakfasted with their kinsfolk and that same night supped with their ancestors in the other world."

World War I had taken four years to claim the lives of nine million military personnel. The 1918 pandemic, in one year, killed twenty-five million people worldwide, making it history's worst plague.

Not surprisingly, the influenza drove up the sales of all kinds of cold medications. Aspirin, cough syrups and drops, and decongestants were, of course, ineffective against the flu bug, which mysteriously vanished in 1919, perhaps having mutated and passed into swine. But these drug sales, as well as those of Vick's VapoRub, set new industry records. Vick's, in 1918, broke the million-dollar mark.

Deodorants: 3500 B.C., Near East

The problem of body odor is ancient, as are man's attempts to solve it. From the dawn of written history, 5,500 years ago in Sumer, every major civilization has left a record of its efforts to produce deodorants.

The early Egyptians recommended following a scented bath with an underarm application of perfumed oils. They developed special citrus and cinnamon preparations that would not turn rancid in the semitropical climate and thus be themselves offensive. Through experimentation, the Egyptians discovered that the removal of underarm hair significantly diminished body odor. Centuries later, scientists would understand why: hair greatly increases the surface area on which bacteria, odorless themselves, can live, populate, die, and decompose to offend.

Both the Greeks and the Romans derived their perfumed deodorants from Egyptian formulas. In fact, throughout most of recorded history, the only effective deodorant—aside from regular washing—was perfume. And it merely masked one scent with another. For a time.

The link between sweat and odor was to be more clearly understood once the sweat glands were discovered in the nineteenth century.

Scientists learned that human perspiration is produced by two kinds of sweat glands, the apocrine and the eccrine. The first structures exist over the entire body's surface at birth, giving babies their distinctive scent. Most of these glands gradually disappear, except for those concentrated in the armpit, around the anus, and circling the breast nipples. The glands are relatively inactive during childhood, but begin to function in puberty, switched on by the sex hormones. In old age, they may wither and atrophy.

Most of the body's sweat, though, is produced by the eccrine glands, abundant over the body's surface. Eccrine sweat is copious—and cooling. In extreme heat, and with high water intake, human subjects have been measured to secrete up to three gallons of sweat in twenty-four hours.

The eccrine glands also function in response to nervousness, fever, stress, and the eating of spicy foods. And sweat caused by emotional stress is

From Egyptian scented oils to Mum, the first modern antiperspirant, the search for an effective deodorant spanned five millennia.

particularly perfusive in the armpits, on the palms of the hands, and on the soles of the feet. But most perspiration evaporates or is absorbed effectively by clothing.

It is because the armpits remain warm and moist that they create a hospitable environment for bacteria. Convincing scientific evidence shows that armpit odor arises mainly, though not exclusively, from bacteria that thrive in secretions of the apocrine glands. One study collected fresh human apocrine sweat and showed that it was odorless. Kept for six hours at room temperature (with bacteria multiplying and dying), it acquired its characteristic odor. When sweat from the same source was refrigerated, no odor developed.

Thus, ancient to modern perfumed deodorizers never tackled the source of the problem: persistent underarm moisture. Deprived of moisture, by an "antiperspirant," bacteria cannot multiply.

Antiperspirants: 1888, United States

The first product marketed specifically to stem underarm moisture, and thus odor, was Mum, introduced in 1888. The formulation used a compound of zinc in a cream base. No scientist then, and none now, really understands how certain chemicals such as zinc thwart the production of sweat. None-

255

theless, Mum worked, and its popularity in America convinced drug companies that a vast market existed for antiperspirants.

In 1902, Everdry debuted, followed in 1908 by Hush. These were the first antiperspirants to use another drying compound, aluminum chloride, which is found in most modern formulations.

For many years, Americans remained so sensitive to the issue of antiperspirants that they asked for them in drugstores with the same hushed confidentiality with which they requested prophylactics. The first antiperspirant to boldly speak its name with national magazine advertising, in 1914, bore the echoic name Odo-Ro-No. It claimed to remedy excessive perspiration, keeping women "clean and dainty." Deodorant advertisements that followed also emphasized dryness, though none mentioned what dryness actually prevented.

Then, in 1919, the pioneering Odo-Ro-No again led the way. For the first time, a deodorant ad asserted that "B.O." existed, and that it was socially shocking and offensive.

Amazingly, during these early days, antiperspirants were advertised exclusively to and used mainly by women, who considered them as essential as soap. It was not until the 1930s that companies began to target the male market.

After nearly a hundred years of studying the action of antiperspirants, how do scientists *suspect* they work?

One popular theory holds that "drying" elements such as aluminum and zinc penetrate a short distance into the sweat ducts. There they act as corks, blocking the release of water. Pressure mounts in the ducts, and through a biofeedback mechanism, the pressure itself stops further sweating.

Unfortunately, antiperspirants act only on the eccrine glands, not on the apocrine glands, the principal culprits in causing body odor. This is why no antiperspirant is effective for extended periods of time. The best routine for combating underarm odor combines the timeless custom of washing, with the ancient Egyptian practice of shaving underarm hair, and the application of a modern antiperspirant: something old, something borrowed, and something new.

Antacids: 3500 B.C., Sumer

Considering his largely uncooked diet, early man may have suffered more severe indigestion than people do today. We know that from the time people began to record their thoughts on clay tablets, they consulted physicians for comfort from stomach upset. The earliest remedies, found among the Sumerians, included milk, peppermint leaves, and carbonates.

What Sumerian physicians had discovered by trial and error was that alkaline substances neutralize the stomach's natural acid. Today's antacids work by offering the positively charged ions in the stomach's hydrochloric acid negative, neutralizing ions. This, in turn, inhibits the release of pepsin,

another potent component of the digestive juice, which can be highly irritating to the stomach's lining.

The Sumerians' most effective antacid was baking soda, or sodium bicarbonate (also known as bicarbonate of soda). For centuries, it served as a major ingredient in a host of homemade stomach remedies. The only thing that has somewhat diminished its use in commercial antacids today is the link between sodium intake and hypertension.

Pure baking soda's first significant brand-name competitor appeared in 1873: Phillips' Milk of Magnesia. Created by a former candlemaker turned chemist, Charles Phillips of Glenbrook, Connecticut, it combined a powdered antacid with the laxative magnesia. The product, taken in small doses, won immediate acceptance as a soothing remedy for stomach discomfort.

Alka-Seltzer: 1931, United States

The Alka-Seltzer story began in the winter of 1928, when Hub Beardsley, president of the Dr. Miles Laboratories, visited the offices of a local newspaper in Elkhart, Indiana. There was a severe flu epidemic that year. Many of Beardsley's own employees were out sick. But Beardsley learned that no one on the newspaper's staff had missed a day of work as the result of influenza. The paper's editor explained that at the first hint of a cold symptom, he dosed staff members with a combination of aspirin and baking soda.

Beardsley was impressed. Both medications were ancient, but their combination was novel. Since his laboratories specialized in home-medicine-chest remedies, he decided to test the formula. He asked his chief chemist, Maurice Treneer, to devise an attractive new tablet. Of course, what Treneer created—the pill that went "plop, plop, fizz, fizz"—was more novel than the combination of aspirin and baking soda, and the gimmick was instrumental in popularizing the product.

Beardsley took a supply of the experimental tablets with him on a Mediterranean cruise. His wife reported that they cured her headaches. Beardsley himself found they soothed the ravages of excessive shipboard dining and drinking. And fellow passengers who tried the tablets claimed they cured seasickness.

The fizzing tablet, which prompted a hung-over W. C. Fields to joke, "Can't anyone do something about that racket!" bowed in 1931, during the Depression. Radio promotion was heavy. But Alka-Seltzer's sales really skyrocketed in 1933, when Americans emerged parched from the dry spell of Prohibition.

Ironically, one of Alka-Seltzer's original two ingredients, aspirin, is a strong stomach irritant for many people. This awareness caused Miles Laboratories to introduce an aspirin-free tablet called Alka-2 Antacid in the mid-1970s.

Today a wide variety of non-sodium, non-aspirin antacids neutralize

stomach acid. A glance at the medicine chest shelf will reveal that the modern components are aluminum, calcium, bismuth, magnesium, and phosphates, and the one ancient ingredient is dried milk solids.

Cough Drops: 1000 B.C., Egypt

A cough's main purpose is to clear the air passage of inhaled foreign matter, chemical irritants, or, during a head cold, excessive bodily secretions. The coughing reflex is part voluntary, part involuntary, and drugs that reduce the frequency and intensity of coughs are called cough suppressors or, technically, antitussives.

Many of these modern suppressor chemicals—like the narcotic codeine—act in the brain to depress the activity of its cough center, reducing the urge to cough. Another group, of older suppressors, acts to soothe and relax the coughing muscles in the throat. This is basically the action of the oldest known cough drops, produced for Egyptian physicians by confectioners three thousand years ago.

It was in Egypt's New Kingdom, during the Twentieth Dynasty, that confectioners produced the first hard candies. Lacking sugar—which would not arrive in the region for many centuries—Egyptian candymakers began with honey, altering its flavor with herbs, spices, and citrus fruits. Sucking on the candies was found to relieve coughing. The Egyptian ingredients were not all that different from those found in today's sugary lozenges; nor was the principle by which they operated: moistening an irritated dry throat.

The throat-soothing candy underwent numerous minor variations in different cultures. Ingredients became the distinguishing factor. Elm bark, eucalyptus oil, peppermint oil, and horehound are but a few of the ancient additives. But not until the nineteenth century did physicians develop drugs that addressed the source of coughing: the brain. And these first compounds that depressed the brain's cough reflex were opiates.

Morphine, an alkaloid of opium, which is the dried latex of unripe poppy blossoms, was identified in Germany in 1805. Toward the close of the century, in 1898, chemists first produced heroin (diacetylmorphine), a simple morphine derivative. Both agents became popular and, for a time, easily available cough suppressants. A 1903 advertisement touted "Glyco-Heroin" as medical science's latest "Respiratory Sedative."

But doctors' increasing awareness of the dangers of dependency caused them to prescribe the drugs less and less. Today a weaker morphine derivative, codeine (methylmorphine), continues to be used in suppressing serious coughs. Since high doses of morphine compounds cause death by arresting respiration, it is not hard to understand how they suppress coughing.

Morphine compounds opened up an entirely new area of cough research. And pharmacologists have successfully altered opiate molecules to produce

Turn of the century remedies: Throat atomizer (top), nasal model; various lozenges for coughs, hoarseness, halitosis, and constipation; syringe, for when tablets fail.

synthetic compounds that suppress a cough with less risk of inducing a drug euphoria or dependency.

But these sophisticated remedies are reserved for treating serious, life-threatening coughs and are available only by prescription. Millions of cold sufferers every winter rely on the ancient remedy of the cough drop. In America, two of the earliest commercial products, still popular today, appeared during the heyday of prescribing opiate suppressors.

Smith Brothers. Aside from Abraham Lincoln, the two hirsute brothers who grace the box of Smith Brothers Cough Drops are reputed to be the most reproduced bearded faces in America. The men did in fact exist, and they were brothers. Andrew (on the right of the box, with the longer beard) was a good-natured, free-spending bachelor; William was a philanthropist and an ardent prohibitionist who forbade ginger ale in his home because of its suggestive alcoholic name.

In 1847, their father, James Smith, a candymaker, moved the family from St. Armand, Quebec, to Poughkeepsie, New York, and opened a restaurant. It was a bitter winter, and coughs and colds were commonplace. One day, a restaurant customer in need of cash offered James Smith the formula for what he claimed was a highly effective cough remedy. Smith paid five dollars for the recipe, and at home, employing his candymaking skills, he produced a sweet hard medicinal candy.

As Smith's family and friends caught colds, he dispensed his cough lozenges. By the end of the winter, word of the new remedy had spread to towns along the wind-swept Hudson River. In 1852, a Poughkeepsie newspaper carried the Smiths' first advertisement: "All afflicted with hoarseness, coughs, or colds should test [the drops'] virtues, which can be done without the least risk."

Success spawned a wave of imitators: the "Schmitt Brothers"; the "Smythe Sisters"; and even another "Smith Brothers," in violation of the family's copyright. In 1866, brothers William and Andrew, realizing the family

needed a distinctive, easily recognizable trademark, decided to use their own stern visages—not on the now-familiar box but on the large glass bowls kept on drugstore counters, from which the drops were dispensed. At that time, most candies were sold from counter jars.

In 1872, the Smith brothers designed the box that bore—and bears—their pictures. The first factory-filled candy package ever developed in America, it launched a trend in merchandising candies and cough drops. A confectioner from Reading, Pennsylvania, William Luden, improved on that packaging a few years later when he introduced his own amber-colored, menthol-flavored Luden's Cough Drops. Luden's innovation was to line the box with waxed paper to preserve the lozenges' freshness and flavor.

As cold sufferers today open the medicine chest for Tylenol, NyQuil, or Contac, in the 1880s millions of Americans with sore throats and coughs reached for drops by the Smith brothers or Luden. William and Andrew Smith acquired the lifelong nicknames "Trade" and "Mark," for on the cough drop package "trademark" was divided, each half appearing under a brother's picture. The Smiths lived to see production of their cough drops soar from five pounds to five tons a day.

Suntan Lotion: 1940s, United States

Suntan and sunscreen lotions are modern inventions. The suntanning industry did not really begin until World War II, when the government needed a skin cream to protect GIs stationed in the Pacific from severe sunburns. And, too, the practice of basking in the sun until the body is a golden bronze color is largely a modern phenomenon.

Throughout history, people of many cultures took great pains to avoid skin darkening from sun exposure. Opaque creams and ointments, similar to modern zinc oxide, were used in many Western societies; as was the sun-shielding parasol. Only common field workers acquired suntans; white skin was a sign of high station.

In America, two factors contributed to bringing about the birth of tanning. Until the 1920s, most people, living inland, did not have access to beaches. It was only when railroads began carrying Americans in large numbers to coastal resorts that ocean bathing became a popular pastime. In those days, bathing wear covered so much flesh that suntan preparations would have been pointless. (See "Bathing Suit," page 321.) Throughout the '30s, as bathing suits began to reveal increasingly more skin, it became fashionable to bronze that skin, which, in turn, introduced the real risk of burning.

At first, manufacturers did not fully appreciate the potential market for sunning products, especially for sunscreens. The prevailing attitude was that a bather, after acquiring sufficient sun exposure, would move under an umbrella or cover up with clothing. But American soldiers, fighting in the scorching sun of the Philippines, working on aircraft carrier decks, or

stranded on a raft in the Pacific, could not duck into the shade. Thus, in the early 1940s, the government began to experiment with sun-protecting agents.

One of the most effective early agents turned out to be red petrolatum. It is an inert petroleum by-product, the residue that remains after gasoline and home heating oil are extracted from crude oil. Its natural red color, caused by an intrinsic pigment, is what blocks the sun's burning ultraviolet rays. The Army Air Corps issued red petrolatum to wartime fliers in case they should be downed in the tropics.

One physician who assisted the military in developing the sunscreen was Dr. Benjamin Green. Green believed there was a vast, untapped commercial market for sunning products. After the war, he parlayed the sunscreen technology he had helped develop into a creamy, pure-white suntan lotion scented with the essence of jasmine. The product enabled the user to achieve a copper-colored skin tone, which to Green suggested a name for his line of products. Making its debut on beaches in the 1940s, Coppertone helped to kick off the bronzing of America.

Eye Drops: 3000 B.C., China

Because of the eye's extreme sensitivity, eye solutions have always been formulated with the greatest care. One of the earliest recorded eye drops, made from an extract of the mahuang plant, was prepared in China five thousand years ago. Today ophthalmologists know that the active ingredient was ephedrine hydrochloride, which is still used to treat minor eye irritations, especially eyes swollen by allergic reactions.

Early physicians were quick to discover that the only acceptable solvent for eye solutions and compounds was boiled and cooled sterile water. And an added pinch of boric acid powder, a mild antibacterial agent, made the basis of many early remedies for a host of eye infections.

The field of ophthalmology, and the pharmacology of sterile eye solutions, experienced a boom in the mid-1800s. In Germany, Hermann von Helmholtz published a landmark volume, *Handbook of Physiological Optics*, which debunked many antiquated theories on how the eye functioned. His investigations on eye physiology led him to invent the ophthalmoscope, for examining the eye's interior, and the ophthalmometer, for measuring the eye's ability to accommodate to varying distances. By the 1890s, eye care had never been better.

In America at that time, a new addition to the home medicine chest was about to be born. In 1890, Otis Hall, a Spokane, Washington, banker, developed a problem with his vision. He was examining a horse's broken shoe when the animal's tail struck him in the right eye, lacerating the cornea. In a matter of days, a painful ulcer developed, and Hall sought treatment from two ophthalmologists, doctors James and George McFatrich, brothers.

Part of Otis Hall's therapy involved regular use of an eye solution, con-

taining muriate of berberine, formulated by the brothers. His recovery was so rapid and complete that he felt other people suffering eye ailments should be able to benefit from the preparation. Hall and the McFatriches formed a company to mass-produce one of the first safe and effective commercial eye drop solutions. They brand-named their muriate of berberine by combining the first and last syllables of the chemical name: Murine.

Since then, numerous eye products have entered the medicine chest to combat "tired eyes," "dryness," and "redness." They all contain buffering agents to keep them close to the natural acidity and salinity of human tears. Indeed, some over-the-counter contact lens solutions are labeled "artificial tears." The saltiness of tears was apparent to even early physicians, who realized that the human eye required, and benefited from, low concentrations of salt. Ophthalmologists like to point out that perhaps the most straightforward evidence for the marine origin of the human species is reflected in this need for the surface of the eye to be continually bathed in salt water.

Dr. Scholl's Foot Products: 1904, Chicago

It seems fitting that one of America's premier inventors of corn, callus, and bunion pads began his career as a shoemaker. Even as a teenager on his parents' Midwestern dairy farm, William Scholl exhibited a fascination with shoes and foot care.

Born in 1882, one of thirteen children, young William spent hours stitching shoes for his large family, employing a sturdy waxed thread of his own design. He demonstrated such skill and ingenuity as the family's personal cobbler that at age sixteen his parents apprenticed him to a local shoemaker. A year later, he moved to Chicago to work at his trade. It was there, fitting and selling shoes, that William Scholl first realized the extent of the bunions, corns, and fallen arches that plagued his customers. Feet were neglected by their owners, he concluded, and neither physicians nor shoemakers were doing anything about it.

Scholl undertook the task himself.

Employed as a shoe salesman during the day, he worked his way through the Chicago Medical School's night course. The year he received his medical degree, 1904, the twenty-two-year-old physician patented his first arch support, "Foot-Eazer." The shoe insert's popularity would eventually launch an industry in foot care products.

Convinced that a knowledge of proper foot care was essential to selling his support pads, Scholl established a podiatric correspondence course for shoe store clerks. Then he assembled a staff of consultants, who crisscrossed the country delivering medical and public lectures on proper foot maintenance.

Scholl preached that bad feet were common across the country because only one American in fifty walked properly. He recommended walking two

miles a day, with "head up, chest out, toes straight forward," and he advised wearing two pairs of shoes a day, so each pair could dry out. To further promote foot consciousness, he published the physician-oriented *The Human Foot: Anatomy, Deformities, and Treatment* (1915) and a more general guide, *Dictionary of the Foot* (1916).

Scholl's personal credo—"Early to bed, early to rise, work like hell and advertise"—certainly paid off handsomely for him in the long run. But in the early days, his advertising, featuring naked feet, prompted many complaints about the indecency of displaying publicly feet clad only in bunion pads or perched atop arch supports.

Scholl created a national surge in foot consciousness in 1916 by sponsoring the Cinderella Foot Contest. The search for the most perfect female feet in America sent tens of thousands of women to their local shoe stores. Competing feet were scrutinized, measured, and footprinted by a device designed by Scholl. A panel of foot specialists selected Cinderella, and her prize-winning footprint was published in many of the country's leading newspapers and magazines. As Scholl had hoped, thousands of American women compared their own imperfect feet with the national ideal and rushed out to buy his products. Across the country, in pharmacies, department stores, and five-and-ten-cent stores, the yellow-and-blue Dr. Scholl's packages became part of the American scene.

William Scholl died in 1968, at age eighty-six. He maintained till the end, as he had throughout his life, that while other people boasted of never forgetting a face, he never forgot a foot.

Laxatives: 2500 B.C., Near East

"Preoccupation with the bowel," a medical panel recently reported, "seems to be the concern of a significant proportion of our population." The physicians based their assessment on the number of prescription and over-the-counter laxatives consumed by Americans each year, generating profits of a half billion dollars annually.

But concern for proper bowel function is not new. The history of pharmacology shows that ancient peoples were equally concerned with daily and regular bowel behavior. And early physicians concocted a variety of medications to release what nature would not.

The earliest recorded cathartic, popular throughout Mesopotamia and along the Nile, was the yellowish oil extracted from the castor bean. Castor oil served not only as a laxative, but also as a skin-softening lotion and as a construction lubricant for sliding giant stone blocks over wooden rollers.

By 1500 B.C., the Assyrians' knowledge of laxatives was extensive. They were familiar with "bulk-forming" laxatives such as bran; "saline" laxatives, which contain sodium and draw water into the bowel; and "stimulant" laxatives, which act on the intestinal wall to promote the peristaltic waves of muscular contraction that result in defecation. These are the three major

forms of modern laxative preparations.

Archaeologists believe that there is good reason why people throughout history have displayed somewhat of an obsession with bowel functioning. Prior to 7000 B.C., man was nomadic, a hunter-gatherer, existing primarily on a diet of fibrous roots, grains, and berries. A high-fiber diet. This had been his ancestors' menu for tens of thousands of years. It was the only diet the human stomach experienced, and that the stomach and intestines were experienced in handling.

Then man settled down to farming. Living off the meat of his cattle and their milk, he shocked the human bowel with a high-fat, lower-fiber diet. Ever since, people have been troubled by irregular bowel function and sought remedying cathartics. Perhaps only today, with the emphasis on high-fiber foods, is the human bowel beginning to relax.

In the intervening millennia, physicians worked hard to find a variety of laxatives, and to mix them with honey, sugar, and citrus rinds to make them more palatable. One druggist, in 1905, hit upon the idea of combining a laxative with chocolate, and he caught the attention of the American market.

In his native Hungary, Max Kiss was a practicing pharmacist, familiar with a chemical, phenolphthalein, that local wine merchants were adding to their products. The practice was at first thought to be innocuous. But soon the merchants, and the wine-drinking public, discovered that a night's overindulgence in wine created more than a hangover in the morning.

The chemical additive turned out to be an effective laxative. And when Max Kiss emigrated to New York in 1905, he began combining phenol-phthalein with chocolate as a commercial laxative. He initially named the product Bo-Bo, a name inadvisably close to the slang expression for the laxative's target. Kiss reconsidered and came up with Ex-Lax, his contraction for "Excellent Laxative."

The chocolate-tasting product was a welcomed improvement over such standard cathartics as castor oil. Especially with children. Production of the laxative candy eventually rose to 530 million doses a year, making the preparation an integral part of the early-twentieth-century American medicine chest.

Eyeglasses: 13th Century, Italy

Ancient peoples must have needed eyeglasses to aid their vision at some point in life, but the invention did not appear until the close of the thirteenth century. Until that time, those unfortunate people born with defective eyesight, and the aged, had no hope of being able to read or to conduct work that demanded clear vision.

The inventor of spectacles most likely resided in the Italian town of Pisa during the 1280s. He is believed to have been a glass craftsman. Although his exact identity has never been conclusively established, two men, Alessandro Spina and Salvino Armato, coevals and gaffers—glass blowers—are

the most likely candidates for the honor.

The evidence slightly favors Salvino Armato. An optical physicist originally from Florence, the thirty-five-year-old Armato is known to have impaired his vision around 1280 while performing light-refraction experiments. He turned to glassmaking in an effort to improve his sight, and he is thought to have devised thick, curved correcting lenses.

History records two early references to eyeglasses in Armato's day. In 1289, an Italian writer, Sandro di Popozo, published *Treatise on the Conduct of the Family*. In it, he states that eyeglasses "have recently been invented for the benefit of poor aged people whose sight has become weak." Then he makes it clear that he had the good fortune to be an early eyeglass wearer: "I am so debilitated by age that without them I would no longer be able to read or write." Popozo never mentions the inventor by name.

The second reference was made by an Italian friar, Giordano di Rivalto. He preached a sermon in Florence on a Wednesday morning in February 1306, which was recorded and preserved: "It is not yet twenty years since there was found the art of making eye glasses, one of the best arts and most necessary that the world has." The friar then discussed the inventor, but without mentioning his name, concluding only with the remark, "I have seen the man who first invented and created it, and I have talked to him."

Concave and Convex Lenses. Whoever the inventor of eyeglasses was, the evidence is unequivocal that the innovation caught on quickly. By the time Friar Giordano mentioned spectacles in his sermon, craftsmen in Venice, the center of Europe's glass industry, were busily turning out the new "disks for the eyes." The lenses in these early glasses were convex, aiding only farsighted individuals; amazingly, more than a hundred years would pass before concave lenses would be ground to improve vision for the nearsighted.

Eyeglass technology traveled to England. By 1326, spectacles were available for scholars, nobility, and the clergy. Glasses were not ground individually; rather, a person peered through the various lenses stocked in a craftsman's shop, selecting those that best improved vision. Physicians had not yet endorsed glasses, and there were still no calibrating procedures such as eye charts and eye testing.

In the mid-fourteenth century, Italians began to call glass eye disks "lentils." This was because of their resemblance in shape to the popular Italian legume the lentil, which is circular, with biconvex surfaces. The Italian for "lentils" is *lenticchie*, and for more than two hundred years eyeglasses were known as "glass lentils." Not surprisingly, "lentil" is the origin of our word "lens."

One early problem with eyeglasses was how to keep them on, for rigid arms looping over the ears were not invented until the eighteenth century. Many people resorted to leather straps tied behind the head; others devised small circles of cord that fitted over each ear; still others simply allowed

Leonardo da Vinci, designer of the first contact lens; metal-framed spectacles for reading; the lentil bush, whose small biconvex seeds inspired the word "lens."

the spectacles to slide down the nose until they came to rest at the most bulbous embankment.

Spectacles with concave lenses to correct for myopia were first made in the fifteenth century. Because they corrected for poor distance vision, in an era when most eyeglasses were used for reading, they were deemed less essential for pursuits of the mind and consequently were rarer and more costly than convex lenses.

Cost, though, was no concern of the recklessly extravagant Cardinal Giovanni de' Medici, second son of Lorenzo the Magnificent, who in 1513 became Pope Leo X. Though at times the severely nearsighted cardinal was so desperate for money that he pawned palace furniture and silver, he purchased several pairs of concave-lens eyeglasses to improve his marksmanship in hunting game and fowl. Four years after he became pope, he sat for a portrait by Raphael that became the first depiction in art of concave correcting lenses.

Despite the many drawbacks of early eyeglasses, they had a profound effect on people from seamstresses to scholars, extending working life into old age. And with the arrival of the printing press, and the wealth of books and newspapers it spawned, eyeglasses began the transition from one of life's luxuries to one of its necessities.

Modern Frames and Bifocals. The first "temple" spectacles with rigid sides were manufactured by a London optician, Edward Scarlett, in 1727. They were hailed by one French publication as "lorgnettes that let one breathe," since the anchoring side arms made breathing and moving about possible without fear of the glasses falling off the nose.

Starting in the 1760s, Benjamin Franklin experimented with designing bifocal lenses, so that on trips he could glance up from reading to enjoy

the scenery. But bifocals would not come into common use until the 1820s, freeing people who needed both reading and distance lenses from alternating two pairs of glasses.

Whereas eyeglasses were something of a status symbol in the centuries in which they were rare and costly, by the nineteenth century, when glasses were relatively inexpensive and commonplace, wearing them became decidedly unfashionable. Particularly for women. Glasses were worn in private, and only when absolutely necessary were they used in public.

Today we take for granted that eyeglasses are lightweight, but one of their early drawbacks was their heaviness. Temple spectacles sculpted of bone, real tortoiseshell, or ivory rested so firmly on the ears and the bridge of the nose that corrected vision could be impaired by headaches. And the burden was significantly increased by the pure glass lenses the frames supported. Even temple spectacles of lightweight wire frames contained heavy glass lenses. It was only with the advent of plastic lenses and frames in this century that eyeglasses could be worn throughout the day without periodic removal to rest the ears and nose.

Sunglasses: Pre–15th Century, China

Smoke tinting was the first means of darkening eyeglasses, and the technology was developed in China prior to 1430. These darkened lenses were not vision-corrected, nor were they initially intended to reduce solar glare. They served another purpose.

For centuries, Chinese judges had routinely worn smoke-colored quartz lenses to conceal their eye expressions in court. A judge's evaluation of evidence as credible or mendacious was to remain secret until a trial's conclusion. Smoke-tinted lenses came to serve also as sunglasses, but that was never their primary function. And around 1430, when vision-correcting eyeglasses were introduced into China from Italy, they, too, were darkened, though mainly for judicial use.

The popularity of sunglasses is really a twentieth-century phenomenon. And in America, the military, which played a role in the development of sunscreens, also was at the forefront of sunglass technology.

In the 1930s, the Army Air Corps commissioned the optical firm of Bausch & Lomb to produce a highly effective spectacle that would protect pilots from the dangers of high-altitude glare. Company physicists and opticians perfected a special dark-green tint that absorbed light in the yellow band of the spectrum. They also designed a slightly drooping frame perimeter to maximally shield an aviator's eyes, which repeatedly glanced downward toward a plane's instrument panel. Fliers were issued the glasses at no charge, and the public soon was able to purchase the model that banned the sun's rays as Ray-Ban aviator sunglasses.

What helped make sunglasses chic was a clever 1960s' advertising campaign by the comb and glass firm of Foster Grant.

Woodcut of a sixteenth-century book collector in corrective spectacles; smoked lenses, the earliest sunglasses.

Bent on increasing its share of the sunglass market, the company decided to emphasize glamour. It introduced the "Sunglasses of the Stars" campaign, featuring the sunglassed faces of such Hollywood celebrities as Peter Sellers, Elke Sommer, and Anita Ekberg. Magazine advertisements and television commercials teased: "Isn't that . . . behind those Foster Grants?" Soon any star in sunglasses, whatever the actual brand, was assumed to be wearing Foster Grants.

Well-known fashion designers, as well as Hollywood stars, escalated the sunglass craze in the '70s with their brand-name lines. A giant industry developed where only a few decades earlier none existed. As women since ancient times had hidden seductively behind an expanded fan or a dipped parasol, modern women—and men—discovered an allure in wearing sunglasses, irrespective of solar glare.

Contact Lenses: 1877, Switzerland

The first person to propose a contact lens system was the Italian painter, sculptor, architect, and engineer Leonardo da Vinci. In his sixteenth-century *Code on the Eye,* da Vinci described an optical method for correcting poor vision by placing the eye against a short, water-filled tube sealed at the end with a flat lens. The water came in contact with the eyeball and refracted light rays much the way a curved lens does. Da Vinci's use of water as the best surface to touch the eye is mirrored today in the high water content of soft contact lenses.

The acute sensitivity of the human eye means that only an extremely

smooth foreign surface can come in contact with it. For centuries, this eliminated contact lenses of glass, which even after polishing remained fairly coarse.

In the 1680s, French opticians attempted a novel approach to the problem. They placed a protective layer of smooth gelatin over the eyeball, then covered it with a small fitted glass lens. The gelatin represented an attempt to use a medium with high water content. The French lens possessed a major flaw, for it frequently fell out of the wearer's eye. It remained experimental.

The first practical contact lenses were developed in 1877 by a Swiss physician, Dr. A. E. Fick. They were hard lenses. Thick, actually. And not particularly comfortable. The glass was either blown or molded to the appropriate curvature, polished smooth, then cut into a lens that covered not only the cornea but the entire eyeball. Wearing them took a serious commitment to vanity. Fick's lenses, however, demonstrated that vision, in most cases, could be corrected perfectly when refracting surfaces were placed directly on the eye. And they proved that the eye could learn to tolerate, without irreparable damage, a foreign object of glass.

Glass remained the standard material of hard lenses until 1936. That year, the German firm I. G. Farben introduced the first Plexiglas, or hard plastic, lens, which quickly became the new standard of the industry. It was not until the mid-1940s that American opticians produced the first successful corneal lens, covering only the eye's central portion. The breakthrough ushered in the era of modern contact lens design. Since that time, scientists have ingeniously altered the physical and chemical composition of lenses, often in an attempt to achieve a surface that duplicates, as closely as possible, the composition of the human eye.

Today factors other than high water content are regarded as essential in a good lens (such as permeability to oxygen so that living eye cells may breathe). Still, though, with an instinctive belief in the comfort of water against the eye, many wearers seek out lenses that are up to 80 percent liquid—even though a lens of less water content might provide better vision correction. Da Vinci, with his 100 percent liquid lens, perhaps realized the psychological appeal of having only water touch the delicate surface of the eyeball.

Stimulants: Pre-2737 B.C., China

To achieve altered states of consciousness in religious rites, ancient man used naturally occurring plant stimulants. One of the earliest, and mildest, of recorded stimulants was strongly brewed tea. Although the origins of the beverage are shrouded in Oriental folklore, the legendary Chinese emperor Shen Nung is said to have discovered the kick of tea. An entry in Shen's medical diary, dated 2737 B.C., declares that tea not only "quenches thirst" but "lessens the desire to sleep."

Tea's stimulant, of course, is caffeine. And the drug, in the form of coffee, became one of the most widely used, and abused, early pick-me-ups. After the discovery of the effects of chewing coffee beans in Ethiopia in A.D. 850, the drug became an addiction in the Near and Middle East. And as coffee spread throughout Europe and Asia, its stimulant effect merited more social and medical comment than its taste.

Caffeine's use today continues stronger than ever. Aside from occurring naturally in coffee, tea, and chocolate, caffeine is added to cola drinks and a wide range of over-the-counter drugs. If your medicine chest contains Anacin-3, Dexatrim, Dristan Decongestant, Excedrin, NoDoz, or Slim (to mention a few), you have a caffeine-spiked analgesic or diet aid on the shelf.

Why is caffeine added?

In decongestants, it counters the soporific effects of the preparations' active compounds. In analgesics, caffeine actually enhances (through a mechanism yet unknown) the action of painkillers. And in diet aids, the stimulant is *the* active ingredient that diminishes appetite. Safe in moderate doses, caffeine can kill. The lethal dose for humans is ten grams, or about one hundred cups of coffee consumed in four hours.

In this century, a new and considerably more potent class of synthetic stimulants entered the medicine chest.

Amphetamines. These drugs were first produced in Germany in the 1930s. Their chemical structure was designed to resemble adrenaline, the body's own fast-acting and powerful stimulant. Today, under such brand names as Benzedrine, Dexedrine, and Preludin (to list a few), they represent a multimillion-dollar pharmaceutical market.

Commonly known as "speed" or "uppers," amphetamines were discovered to give more than an adrenaline rush. They produce a degree of euphoria, the ability to remain awake for extended periods, and the suppression of appetite by slowing muscles of the digestive system. For many years, they replaced caffeine as the primary ingredient in popular dieting aids. While their role in weight loss has greatly diminished, they remain a medically accepted mode of treatment for hyperactivity in children and such sleep disorders as narcolepsy.

In the 1930s, amphetamines existed only in liquid form and were used medically as inhalants to relieve bronchial spasms and nasal congestion. Because of their easy availability, they were greatly abused for their stimulant effects. And when they were produced in tablets, the drugs' uses and abuses skyrocketed. During World War II, the pills were issued freely to servicemen and widely prescribed to civilians in a cavalier way that would be regarded today as irresponsibility bordering on malpractice.

By the 1960s, physicians recognized that amphetamines carried addictive risks. The condition known as amphetamine psychosis, which mimics classic paranoid schizophrenia, was identified, and by the end of the decade, legislation curtailed the use of the drugs. Any amphetamine on a medicine chest shelf today is either a prescription drug or an illegal one.

Sedatives: 1860s, Germany

Apples and human urine were the main and unlikely ingredients that composed the first barbiturate sedatives, developed in Germany in the 1860s. And the drugs derived their classification title "barbiturate" from a Munich waitress named Barbara, who provided the urine for their experimental production.

This bizarre marriage of ingredients was compounded in 1865 by German chemist Adolph Baeyer. Unfortunately, the specific reasoning, or series of events, that led him to suspect that the malic acid of apples combines with the urea of urine to induce drowsiness and sleep has been lost to history. What is well documented, however, is the rapid public acceptance of sedatives—to calm anxiety, cure insomnia, and achieve a placid euphoria.

The period from Baeyer's discovery to the commercial production of barbiturates spans almost four decades of laboratory research. But once the chemical secrets were unlocked and the ingredients purified, the drugs began to appear rapidly. The first barbiturate sleeping drug, barbital, bowed in 1903, followed by phenobarbital, then scores of similarly suffixed drugs with varying degrees of sedation. Drugs like Nembutal and Seconal acquired street names of "yellow jackets" and "nebbies" and spawned a large illicit drug trade.

All the barbiturates worked by interfering with nerve impulses within the brain, which, in turn, "calmed the nerves." Insomniacs alone, in America estimated to number over fifty million, created a huge market. But while sedatives provided a needed respite from wakefulness for many people, they often became addictive.

Of the many prescription sedatives found in American medicine chests today, one in particular merits mention for its outstanding use and abuse.

Valium. In 1933, drug researchers discovered a new class of nonbarbiturate sedatives. Known as benzodiazepines, they would soon acquire commercial brand names such as Librium and Valium, and Valium would go on to top the federal government's list of the twenty most abused drugs in America, surpassing both heroin and cocaine.

During the first decade following their discovery, benzodiazepines did not attract much attention from drug companies. The belief was that barbiturates were safe, effective, and not terribly addictive, and thus there was no need for an entirely new class of sedating drugs.

Then medical opinion changed. In the mid-1950s, experiments revealed that benzodiazepines, in substantially smaller doses than barbiturate sedatives, were capable of inducing sleep in monkeys. In addition, the drugs not only sedated; they also diminished aggressive tendencies. Drug companies, learning of the surprising laboratory results with monkeys, began conducting human tests, and in 1960 the world was introduced to the first nonbarbiturate sedative, Librium. Three years later, Valium debuted.

Known as "minor tranquilizers" (compared with the more potent Thorazine, a "major" tranquilizer), Librium and Valium began to be prescribed in record quantities. The reputation of barbiturates by that time had been grimly besmirched, and the new drugs seemed safer, less addictive. They were liberally dispensed as antianxiety agents, muscle relaxants, anticonvulsants, sleeping pills, and as a harmless treatment for the symptoms of alcohol withdrawal. Valium became an industry in itself.

In time, of course, medical opinion again changed. The benzodiazepines are extremely important and useful drugs, but they, too, possess a great potential for abuse. Today chemists are attempting to tailor-make a new classification of nonaddictive sedatives and painkillers with only a single-purpose function. In the meantime, Americans continue to consume more than five billion sedatives a year, making Valium and its sister drugs almost as familiar a medicine chest item as aspirin.

Aspirin: 1853, France

For a fever, physicians in the ancient world recommended a powder made from the bark of the willow tree. Today we know that the bark contains a salicylic compound, related to aspirin, though not as effective, and causing greater gastrointestinal irritation and possible bleeding.

Aspirin, acetylsalicylic acid, is a man-made variation of the older remedy. It is the world's most widely used painkiller and anti-inflammatory drug, and it was prepared in France in 1853, then forgotten for the next forty years—rediscovered only when a German chemist began searching for a cure for his father's crippling arthritis.

Alsatian chemist Charles Frederick von Gerhardt first synthesized acetylsalicylic acid in 1853, at his laboratory at the University of Montpellier. But from his own limited testing, he did not believe the drug to be a significant improvement over the then-popular salicin, an extract from the bark of the willow tree and the meadowsweet plant, a botanical relative of the rose. Aspirin was ignored, and sufferers of fevers, inflammations, and arthritis continued to take salicin.

In 1893, a young German chemist, Felix Hoffman, at the Farbenfabriken Bayer drug firm, had exhausted all the known drugs in attempting to ease his father's rheumatoid arthritis. Hoffman knew of the synthetic type of salicin, and in desperation prepared a batch and tested it on his father. To his astonishment, the man-made derivative palliated the disease's crippling symptoms and almost completely ameliorated its pain.

Chemists at Bayer, in Düsseldorf, realized Hoffman had hit on an important new drug. Deciding to produce the compound from the meadowsweet plant, *Spiraea ulmaria*, the company arrived at the brand name Aspirin by taking the "a" from *acetyl*, "spir" from the Latin *Spiraea*, and "in" because it was a popular suffix for medications.

First marketed in 1899 as a loose powder, Aspirin quickly became the

world's most prescribed drug. In 1915, Bayer introduced Aspirin tablets. The German-based firm owned the brand name Aspirin at the start of World War I, but following Germany's defeat, the trademark became part of the country's war reparations demanded by the Allies. At the Treaty of Versailles in June 1919, Germany surrendered the brand name to France, England, the United States, and Russia.

For the next two years, drug companies battled over their own use of the name. Then, in a famous court decision of 1921, Judge Learned Hand ruled that since the drug was universally known as aspirin, no manufacturer owned the name or could collect royalties for its use. Aspirin with a capital *A* became plain aspirin. And today, after almost a century of aspirin use and experimentation, scientists still have not entirely discovered how the drug achieves its myriad effects as painkiller, fever reducer, and anti-inflammatory agent.

Chapter 11

Under the Flag

Uncle Sam: 1810s, Massachusetts

There was a real-life Uncle Sam. This symbol of the United States government and of the national character, in striped pants and top hat, was a meat packer and politician from upstate New York who came to be known as Uncle Sam as the result of a coincidence and a joke.

The proof of Uncle Sam's existence was unearthed only a quarter of a century ago, in the yellowing pages of a newspaper published May 12, 1830. Had the evidence not surfaced, doubt about a real-life prototype would still exist, and the character would today be considered a myth, as he was for decades.

Uncle Sam was Samuel Wilson. He was born in Arlington, Massachusetts, on September 13, 1766, a time when the town was known as Menotomy. At age eight, Sam Wilson served as drummer boy on the village green, on duty the April morning of 1775 when Paul Revere made his historic ride. Though the "shot heard round the world" was fired from nearby Lexington, young Sam, banging his drum at the sight of redcoats, alerted local patriots, who prevented the British from advancing on Menotomy.

As a boy, Sam played with another youthful patriot, John Chapman, who would later command his own chapter in American history as the real-life Johnny Appleseed. At age fourteen, Sam joined the army and fought in the American Revolution. With independence from Britain won, Sam moved in 1789 to Troy, New York, and opened a meat-packing company. Because

of his jovial manner and fair business practices, he was affectionately known to townsfolk as Uncle Sam.

It was another war, also fought against Britain on home soil, that caused Sam Wilson's avuncular moniker to be heard around the world.

During the War of 1812, government troops were quartered near Troy. Sam Wilson's fair-dealing reputation won him a military contract to provide beef and pork to soldiers. To indicate that certain crates of meat produced at his warehouse were destined for military use, Sam stamped them with a large "U.S."—for "United States," though the abbreviation was not yet in the vernacular.

On October 1, 1812, government inspectors made a routine tour of the plant. They asked a meat packer what the ubiquitously stamped "U.S." stood for. The worker, himself uncertain, joked that the letters must represent the initials of his employer, Uncle Sam. The error was perpetuated. Soon soldiers began referring to all military rations as bounty from Uncle Sam. Before long, they were calling all government-issued supplies property of Uncle Sam. They even saw themselves as Uncle Sam's men.

The first Uncle Sam illustrations appeared in New England newspapers in 1820. At that time, the avuncular figure was clean-shaven and wore a solid black top hat and black tailcoat. The more familiar and colorful image of Uncle Sam we know today arose piecemeal, almost one item at a time, each the contribution of an illustrator.

Solid red pants were introduced during Andrew Jackson's presidency. The flowing beard first appeared during Abraham Lincoln's term, inspired by the President's own beard, which set a trend at that time. By the late nineteenth century, Uncle Sam was such a popular national figure that cartoonists decided he should appear more patriotically attired. They adorned his red pants with white stripes and his top hat with both stars and stripes. His costume became an embodiment of the country's flag.

Uncle Sam at this point was flamboyantly dressed, but by today's standards of height and weight he was on the short side and somewhat portly.

It was Thomas Nast, the famous German-born cartoonist of the Civil War and Reconstruction period, who made Uncle Sam tall, thin, and hollow-cheeked. Coincidentally, Nast's Uncle Sam strongly resembles drawings of the real-life Sam Wilson. But Nast's model was actually Abraham Lincoln.

The most famous portrayal of Uncle Sam—the one most frequently reproduced and widely recognized—was painted in this century by American artist James Montgomery Flagg. The stern-faced, stiff-armed, finger-pointing figure appeared on World War I posters captioned: "I Want You for U.S. Army." The poster, with Uncle Sam dressed in his full flag apparel, sold four million copies during the war years, and more than half a million in World War II. Flagg's Uncle Sam, though, is not an Abe Lincoln likeness, but a self-portrait of the artist as legend.

A nineteenth-century meat-packing plant in upstate New York; birthplace of the Uncle Sam legend.

During these years of the poster's peak popularity, the character of Uncle Sam was still only a myth. The identity of his prototype first came to light in early 1961. A historian, Thomas Gerson, discovered a May 12, 1830, issue of the New York *Gazette* newspaper in the archives of the New-York Historical Society. In it, a detailed firsthand account explained how Pheodorus Bailey, postmaster of New York City, had witnessed the Uncle Sam legend take root in Troy, New York. Bailey, a soldier in 1812, had accompanied government inspectors on the October day they visited Sam Wilson's meat-packing plant. He was present, he said, when a worker surmised that the stamped initials "U.S." stood for "Uncle Sam."

Sam Wilson eventually became active in politics and died on July 31,

1854, at age eighty-eight. A tombstone erected in 1931 at Oakwood Cemetery in Troy reads: "In loving memory of 'Uncle Sam,' the name originating with Samuel Wilson." That association was first officially recognized during the administration of President John F. Kennedy, by an act of the Eighty-seventh Congress, which states that "the Congress salutes 'Uncle Sam' Wilson of Troy, New York, as the progenitor of America's National symbol of 'Uncle Sam.' "

Though it may be stretching coincidence thin, John Kennedy and Sam Wilson spoke phrases that are strikingly similar. On the eve of the War of 1812, Wilson delivered a speech, and a plan, on what Americans must do to ensure the country's greatness: "It starts with every one of us giving a little more, instead of only taking and getting all the time." That plea was more eloquently stated in John Kennedy's inaugural address: "ask not what America will do for you—ask what you can do for your country."

Johnny Appleseed: 1810s, Massachusetts

Sam Wilson's boyhood playmate John Chapman was born on September 26, 1774, in Leominster, Massachusetts. Chapman displayed an early love for flowering plants and trees—particularly apple trees. His interest progressed from a hobby, to a passion, to a full-fledged obsession, one that would transform him into a true American folk character.

Though much lore surrounds Chapman, it is known that he was a devoted horticulturist, establishing apple orchards throughout the Midwest. He walked barefoot, inspecting fields his sapling trees had spawned. He also sold apple seeds and saplings to pioneers heading farther west, to areas he could not readily cover by foot.

A disciple of the eighteenth-century Swedish mystic Emanuel Swedenborg, John Chapman was as zealous in preaching Scripture as he was in planting apple orchards. The dual pursuits took him, barefooted, over 100,000 square miles of American terrain. The trek, as well as his demeanor, attire, and horticultural interests, made him as much a recognizable part of the American landscape as his orchards were. He is supposed to have worn on his head a tin mush pan, which served both as a protection from the elements and as a cooking pot at his impromptu campsites.

Frontier settlers came to humorously, and sometimes derisively, refer to the religious fanatic and apple planter as Johnny Appleseed. American Indians, though, revered Chapman as a medicine man. The herbs catnip, rattlesnake weed, horehound, and pennyroyal were dried by the itinerant horticulturist and administered as curatives to tribes he encountered, and attempted to convert.

Both Sam Wilson and John Chapman played a part in the War of 1812. While Wilson, as Uncle Sam, packaged rations for government troops, Chapman, as Johnny Appleseed, traversed wide areas of northern Ohio barefoot, alerting settlers to the British advance near Detroit. He also

warned them of the inevitable Indian raids and plundering that would follow in the wake of any British destruction. Later, the town of Mansfield, Ohio, erected a monument to John Chapman.

Chapman died in March of 1845, having contracted pneumonia from a barefoot midwinter journey to a damaged apple orchard that needed tending. He is buried in what is known today as Johnny Appleseed Park, near the War Memorial Coliseum in Fort Wayne, Indiana, the state in which he died.

Although Johnny Appleseed never achieved the fame of his boyhood playmate Uncle Sam, Chapman's likeness has appeared on commemorative U.S. stamps. And in 1974, the New York and New England Apple Institute designated the year as the Johnny Appleseed Bicentennial. Chapman's most enduring monuments, however, are the apple orchards he planted, which are still providing fruit throughout areas of the country.

American Flag: Post-1777, New England

So much patriotism and sacrifice are symbolized by the American flag that it is hard for us today to realize that the star-spangled banner did not have a single dramatic moment of birth. Rather, the flag's origin, as that of the nation itself, evolved slowly from humble beginnings, and it was shaped by many hands—though probably not those of Betsy Ross. The latest historical sleuthing indicates that her involvement, despite history book accounts, may well have been fictive. And no authority today can claim with certainty who first proposed the now-familiar design, or even when and where the Stars and Stripes was first unfurled.

What, then, can we say about the origin of a flag that the military salutes, millions of schoolchildren pledge allegiance to, and many home owners hang from a front porch pole every Fourth of July?

It is well documented that General George Washington, on New Year's Day of 1776, displayed over his camp outside Boston an improvised "Grand Union Flag." It combined both British and American symbols. One upper corner bore the two familiar crosses—St. George's for England, and St. Andrew's for Scotland—which had long been part of the British emblem. But the background field had thirteen red and white stripes to represent the American colonies. Since the fighting colonists, including Washington, still claimed to be subjects of the British crown, it's not surprising that their homemade flag should carry evidence of that loyalty.

The earliest historical mention of an entirely American "Stars and Stripes" flag—composed of thirteen alternating red and white stripes, and thirteen stars on a blue field—is in a resolution of the Continental Congress dated June 14, 1777. Since Congress, and the country, had more urgent matters to resolve than a finalized, artistic flag design, the government stipulated no specific rules about the flag's size or arrangement of details. It even

Francis Scott Key, composer of "The Star-Spangled Banner."

failed to supply Washington's army with official flags until 1783, after all the major war battles had ended.

During the Revolutionary War, the American army and navy fought under a confused array of local, state, and homemade flags. They were adorned variously with pine and palmetto trees, rattlesnakes, eagles, stripes of red, blue, and yellow, and stars of gold—to mention a few.

In fact, it was not until 1814, nearly forty years after its authorization by Congress, that the flag began to be widely discussed by Americans as a symbol of the country. In that year, an American flag bearing fifteen stars flew over Fort Henry at Baltimore, inspiring Francis Scott Key to write "The Star-Spangled Banner."

Where in the gradual, piecemeal evolution of the American flag does the figure of the Philadelphia seamstress born Elizabeth Griscom belong?

Betsy Ross. When John Ross, an upholsterer, was killed in a munitions explosion in 1776, his wife, Betsy, took over operation of their tailoring business. The Ross store was on Philadelphia's Arch Street, not far from the State House, on Chestnut Street, where history was being made almost daily.

According to legend, Betsy Ross was visited at her shop by General George Washington in June of 1776. They were supposed to have discussed various flag designs. And Washington allegedly settled for one composed of seven red and six white stripes, and thirteen five-pointed white stars arranged in a circle—though he had requested six-pointed stars. Betsy Ross is said to have convinced him that it would be easier for her to cut out five-pointed

stars. When the general departed, legend has it, the seamstress commenced stitching the official American flag.

Historians find it significant that not a single one of the numerous flags that flew at different times and places during the Revolutionary War is of the design alleged to be the handiwork of Betsy Ross.

Further, the tale recounted in history books was told by Betsy Ross herself—on her deathbed in 1836, and to her eleven-year-old grandson, William J. Canby. Betsy Ross at the time was eighty-four years old. Canby, in turn, did not publicly relate the tale until 1870, when he presented it at a meeting of the Pennsylvania Historical Society. That was thirty-four years after he had heard it as a boy, and almost a hundred years after the incident was alleged to have occurred.

Historical records verify that George Washington was in Philadelphia in June of 1776. But in his written itinerary there is no mention of a meeting with a local seamstress. Nor in Washington's diary is there any evidence of his concern with the design of an official American flag. In fact, Congress had not yet convened a committee to tackle any flag design, nor at the time was there congressional talk of replacing the Grand Union Flag. Washington had made personal modifications in that flag, combining American with British features, but he had not expressed a desire to abandon it entirely. The consensus among historians who have investigated the Betsy Ross legend is that it's no more than that—a legend: a nonverifiable story handed down from generation to generation. And one begun by the lady herself.

History and legend, though, have a way of blending in the crucible of time. Betsy Ross's deathbed tale has inextricably rooted itself in the heart of American folklore. And whether in time it is unequivocally proved or disproved, it almost assuredly will be told and retold.

Pledge of Allegiance: 1892, Rome, New York

The pledge of allegiance to the American flag is neither an old verse nor one composed by the Republic's founding fathers. It was written especially for children in the summer of 1892, to commemorate that year's celebration of Columbus Day in public schools throughout the country.

The pledge's first appearance in print was on September 8, 1892, in *The Youth's Companion*, an educational publication. It is estimated that more than ten million American schoolchildren recited it that Columbus Day. In its original form, it read: "I pledge allegiance to my Flag and the Republic for which it stands—one nation indivisible—with liberty and justice for all."

Its author was an editor of *The Youth's Companion*, Francis Bellamy of Rome, New York. Bellamy intended his verse to be a one-time recitation. But its immediate popularity among the nation's schoolchildren and teachers transformed it first into an annual Columbus Day tradition, then into a

daily classroom ritual. It became one of the earliest verses memorized by schoolchildren.

Since its debut, Bellamy's pledge has undergone two alterations. In 1923, the United States Flag Association replaced the somewhat ambiguously personal "my flag" wording with the more explicitly patriotic "the Flag of the United States of America." And in 1954, President Dwight D. Eisenhower signed a bill that introduced a religious note to the pledge, with the addition of the words "under God."

Washington, D.C.: 1790

Although much has been written about the selection of Washington, D.C., as the nation's capital, little has appeared concerning one of the early motivating factors for locating the center of government in an area that then was a remote swampland. This part of the story involves the desire of congressmen for a safe haven where they could peacefully conduct business without harassment by disgruntled civilians and soldiers.

The idea for a national capital city in a remote, inconvenient area originated at a June 1783 meeting of the Congress in the Old City Hall in Philadelphia. While several factors contributed to the decision, one in particular galvanized Congress to action.

The War of Independence had recently been concluded. The treasury was flat broke. The new nation had no credit, still lacked a President, and was heavily in debt to its soldiers for back pay. On June 20, a large and angry mob of unpaid soldiers invaded Philadelphia to present their grievances to Congress. It was not the first such violent confrontation. That day, though, a number of agitated congressmen—some angry, others frightened—expressed their weariness with such direct public intrusions. They launched a movement to establish a federal city where lawmakers could transact the business of state without civilian intimidation.

Several locations were considered. New Englanders, led by Alexander Hamilton of New York, sought a capital in the north. Southerners, represented by Thomas Jefferson of Virginia, argued for a location in the south. In 1790, in an attempt to placate both sides, the recently elected President, George Washington, chose a site eighteen miles up the Potomac River from his home in Mount Vernon—a location then midway between north and south. In addition, the area was between the thriving seaports of Alexandria, Virginia, and Georgetown, Maryland. No one denied, however, that the ten-mile-square site was a bog.

After several years of planning, in September 1793 President Washington himself laid the cornerstone for the first U.S. Capitol. Office buildings were quickly erected. By 1800, the U.S. government had officially moved headquarters from Philadelphia to Washington.

No one was pleased with the new city.

Congressmen complained that it was *too* isolated. A wilderness. They and

their families resisted constructing homes there; as did government employees. Groups of citizens petitioned that the capital city be relocated to a more desirable, prestigious, and accessible location. What had been conceived by Washington as a "city of magnificent distances" was now disparagingly attacked by congressmen as a "capital of miserable huts," "a mudhole." Abigail Adams, wife of the first President to occupy the presidential mansion, expressed a desire to move out, lamenting, "We have not the least convenience."

By the close of Thomas Jefferson's term of office, in 1809, the population of the nation's new city was scarcely five thousand. To foreign heads of state, America's capital was a nightmare. With a dearth of cultural institutions and personal conveniences, and with the Potomac continually muddying the dirt streets, foreign ambassadors stationed in the capital actually collected "hardship pay" from their governments.

The advent of the steam engine and the telegraph quelled some of the complaints. These inventions put the city in touch with the outside world. But the real change of attitude toward the new capital, in the minds of both ordinary citizens and government officials, resulted from a national tragedy.

In August 1814, the British invaded the city. They burned the President's mansion, the Capitol, and the Navy Arsenal. Americans were incensed. And they were united, too, against an enemy that had attempted to destroy the nation's capital—even if that capital was inaccessible, inhospitable, and undesirable to live in.

All clamor to relocate the city ceased. An immense and patriotic rebuilding effort began. Jefferson donated his own extensive collection of books to replace the destroyed contents of the Library of Congress. And the badly charred wooden planks of the President's mansion were painted a shimmering white, conferring upon it for all time the title the **White House.**

In 1874, Frederick Law Olmsted, the designer of New York's Central Park, began landscaping the Capitol grounds with trees from various states and foreign countries. Contributing to that effort in 1912, the Japanese government presented the United States with a gift of three thousand cherry trees, whose blossoming thereafter would signal the city's annual Cherry Blossom Festival. By then, of course, the site on the Potomac once intended to keep citizens from lobbying Congress had become the home of lobbyists.

Mount Rushmore: 1923, South Dakota

The faces originally to be carved into Mount Rushmore were not the fatherly countenances of four famous Presidents but the romanticized visages of three Western legends: Kit Carson, Jim Bridger, and John Colter. Planned as a tourist attraction to draw money into South Dakota's economy, the monument, as originally conceived, might scarcely have achieved its goal.

The full story of the origin of Mount Rushmore begins sixty million years ago, when pressures deep within the earth pushed up layers of rock. The forces created an elongated granite-and-limestone dome towering several thousand feet above the Dakota prairie lands. The first sculpting of the mountain was done by nature. The erosive forces of wind and water fashioned one particularly protuberant peak, which was unnamed until 1885.

That year, a New York attorney, Charles E. Rushmore, was surveying the mountain range on horseback with a guide. Rushmore inquired about the impressive peak's name, and the guide, ribbing the city lawyer, answered, "Hell, it never had a name. But from now on we'll call the damn thing Rushmore." The label stuck. And later, with a gift of five thousand dollars, Charles Rushmore became one of the earliest contributors to the presidential memorial.

The origin of the sculpture is better documented and more inspiring than that of the mountain's name.

The idea to transform a gigantic mountaintop into a colossus of human figures sprang from the mind of a South Dakota historian, Doane Robinson. In 1923, Robinson presented to the state his plan to simultaneously increase South Dakota's tourism, strengthen its economy, and immortalize three "romantic western heroes." A commission then sought the skills of renowned sculptor John Gutzon de la Mothe Borglum, an authority on colossi.

Idaho born, Borglum started as a painter, then switched to sculpture, and his fame grew in proportion to the size of his works. The year Doane Robinson conceived the idea for a Mount Rushmore memorial, Borglum accepted a commission from the United Daughters of the Confederacy to carve a head of General Robert E. Lee on Stone Mountain in Georgia.

Mount Rushmore, though, beckoned with the greater challenge.

Borglum opposed sculpting Western heroes. The notion was overly provincial, he argued. A colossus should capture prominent figures. In a letter dated August 14, 1925, Borglum proposed the faces of four influential American Presidents.

Construction on the 6,200-foot-high wilderness peak was fraught with dangers. And the mountain itself was inaccessible except by foot or horseback, which necessitated countless climbs to lug up drills and scaffolding. But for Borglum, two features made the remote Rushmore peak ideal. The rocks faced southeast, ensuring maximum sunlight for construction, and later for viewing. And the peak's inaccessibility would protect the monument from vandals.

Bitter winters, compounded by a chronic shortage of funds, continually threatened to terminate construction. Weathered surface rock had to be blasted away to expose suitably firm stone for sculpting. The chin of George Washington, for instance, was begun thirty feet back from the original mountain surface, and Theodore Roosevelt's forehead was undertaken only after one hundred twenty feet of surface rock were peeled away.

Borglum worked from a scale model. Critical "points" were measured on the model, then transferred to the mountain to indicate the depth of rock to be removed point by point.

In 1941, fourteen years after construction began—and at a total cost of $990,000—a new world wonder was unveiled. There stood George Washington, whom Borglum selected because he was "Father of the Nation"; Abraham Lincoln, "Preserver of the Union"; Thomas Jefferson, "The Expansionist"; and Theodore Roosevelt, "Protector of the Working Man."

The figures measure sixty feet from chin to top of head. Each nose is twenty feet long, each mouth eighteen feet wide, and the eyes are eleven feet across. "A monument's dimensions," Borglum believed, "should be determined by the importance to civilization of the events commemorated."

Gutzon Borglum died on March 6, 1941, aged seventy-four. The monument was essentially completed. His son, also a sculptor, added the finishing touches.

Boy Scouts of America: 1910, Chicago

A good deed performed by an anonymous boy prompted a wealthy Chicago businessman to found the scouting movement in America. The boy was already a scout, a British scout, a member of an organization begun in England by Colonel Robert Baden-Powell. (The scouts' motto, "Be Prepared," is not only a forceful exhortation but also something of a tribute to Baden-Powell's initials, a coincidence he enjoyed calling attention to, since practically no one else noticed.)

While serving his country in Africa during the turn-of-the-century Boer War, Baden-Powell complained that young recruits from England lacked strength of character and resourcefulness. On returning home, he assembled twenty-two boys, to imbue them with the attributes of loyalty, courage, and leadership. And in 1908, he published *Scouting for Boys*, a stalking and survival manual, which formally marked the start of the British Boy Scouts.

The social and political upheaval in Edwardian England provided a climate for scouting. Britons were anxious about their country's national decline, the poor physical condition of large segments of the urban population, and the increasing vulnerability of British colonies abroad. The idea of training thousands of young boys to be loyal, resourceful, law-abiding citizens met with unanimous approval.

A year after the British scouting movement had been launched, William Boyce, a Chicago publisher visiting London, found himself lost on a dark, foggy night. The youth who came to Boyce's aid identified himself only as a "boy scout." Boyce was impressed with the boy's courtesy and resolve to be of assistance; and he was astonished by the boy's refusal to accept a tip. Boyce would later comment that he had never met an American youth who'd decline an earned gratuity. He was sufficiently intrigued with the British scouting movement to meet with its master, Baden-Powell.

On February 10, 1910, Boyce established the Boy Scouts of America, modeled on the British organization. Its immediate acceptance by parents, educators, and the young men who joined the movement in the tens of thousands guaranteed scouting's success. Within a year, the scouts had their "On my honor" oath, a score of merit badges, and the scout's law, comprising a string of twelve attributes to aspire to. By 1915, there were a half-million American boy scouts, with troops in every state.

American Presidents were involved with scouting from the start. William Taft began the tradition that every President automatically becomes an honorary scout. Theodore Roosevelt went a step further after his presidency by becoming head scoutmaster of Troop 39, Oyster Bay, New York.

And while all Presidents became scouts, some scouts became Presidents. The first one to do so had been a member of Troop 2 of Bronxville, New York, from 1929 to 1931—John F. Kennedy. And the first Eagle Scout to become President began his scouting career in 1924 as a member of Troop 15, Grand Rapids, Michigan—Gerald R. Ford.

By the late 1920s, scouting was so popular throughout the country that parents began to inquire if their younger children might not be permitted to join the movement. To satisfy that request, early in 1930 the **Cub Scout** program was formally launched; by year's end, its membership stood at 847,051 and climbing.

Girl Scouts of the U.S.A.: 1912, Savannah, Georgia

Born Juliette Daisy Gordon in Savannah in 1860, the founder of the Girl Scouts exhibited a flair for organization at an early age. As a teenager, she formed the Helpful Hands Club, a youth organization that made and repaired clothes for needy children. At age twenty-six, Juliette married a wealthy Englishman, William Mackay Low, and the couple took up residence in England. Undaunted by advancing deafness, Juliette Low established herself as a popular London party giver.

It was at a party in 1911 that she was introduced to Colonel Robert Baden-Powell. The colonel's enthusiasm for scouting must have been contagious. Three years earlier, he had inspired William Boyce to institute the American Boy Scouts. He had only recently encouraged his sister, Agnes, to launch an equivalent female movement, the British Girl Guides. At the party, Baden-Powell, accompanied by Agnes, imbued Juliette Low with the scouting zeal.

So much so, in fact, that within weeks of the meeting, Juliette Low was a London Girl Guide leader. The following year, she brought the idea home to Savannah, Georgia. On March 12, 1912, eighteen young girls from a local school became America's first Girl Guides. The next year, their name was formally changed to Girl Scouts.

By the time of Juliette Low's death, on January 17, 1927, there were

The British surrender at Yorktown as Washington's band plays "Yankee Doodle."

more than 140,000 Girl Scouts, with troops in every state. And the tradition had been started that the wives of American Presidents automatically become honorary Girl Scouts.

"Yankee Doodle": 1750s, England

> *Yankee Doodle came to town,*
> *Riding on a pony;*
> *He stuck a feather in his cap*
> *And called it macaroni.*

Today this song is played as a short, incidental piece of music, and when sung, it's mostly by a child as a nursery rhyme. But in the eighteenth century, "Yankee Doodle" was a full-fledged national air of many stanzas, a lively expression of American patriotism, usually played by a military band. This despite the fact that the melody and lyrics originated with the British as a derisive slur to colonists. In London, prior to the American Revolution, a version of "Yankee Doodle" expressed growing anti-American sentiment.

Musicologists and historians have struggled with the origin and interpretation of the song. It's known that British Redcoats prided themselves on always being dapperly and uniformly attired. Colonial soldiers were by comparison a ragamuffin lot, each dressing in whatever clothes he owned. An early version of "Yankee Doodle" clearly mocks Americans' shabby

dress, and the derision is carried into later versions in the term "macaroni."

In eighteenth-century England, "macaroni" ridiculed an English dandy who affected foreign mannerisms and fashions, particularly ones French or Italian. A "macaroni" believed he was stylishly attired when by the vogue of the day his outfit was outlandish. Thus, the archetype Yankee Doodle character, by sticking a feather in his cap, believes he has become fashionable when in fact his appearance is comical. In singing the song, the British poked fun at what they viewed as New England's country bumpkins.

The song's authorship is clouded by at least a dozen vying claims. Many historians believe the original melody and lyrics were composed by a British surgeon, Dr. Richard Schuckburg, around 1758. Others maintain it was an impromptu composition on American soil by British soldiers, who then carried it home to England.

Whoever the composer, in America the musical insult fell on deaf ears. The colonists warmly embraced the tune, many times modifying its lyrics, though never deleting "macaroni." In April 1767, the melody was highlighted in an American comic opera composed by Andrew Barton and titled *The Disappointment: or, The Force of Credulity*. By the close of the Revolutionary War, George Washington's troops had turned the once defiant insult into a rousing celebratory salute. At the surrender of the British at Yorktown, Washington's band struck up a chorus of "Yankee Doodle" to mortify the defeated British Lord Cornwallis and his men. Out of this sentiment, somewhat akin to "He who laughs last" or "They'll eat their words," the tune "Yankee Doodle" became for several decades a national air.

"The Star-Spangled Banner": 1814, Baltimore

America acquired the song that is its national anthem about thirty-eight years after the country won its independence from England. It is somewhat ironic that the melody is British, and came from a song extolling the pleasures of wine and amours. The American lyrics were of course penned by lawyer and poet Francis Scott Key. But Key directed that his lines be sung to the British melody "To Anacreon in Heaven," Anacreon being the sixth-century B.C. Greek poet known for his lyric love verse.

Why did the patriotic Francis Scott Key choose a British melody?

During Key's time, "To Anacreon in Heaven" was one of the most popular songs in England and America. At least eighty-five American poems were fitted to the tune. And Key himself, in 1805—nine years before he'd write "The Star-Spangled Banner"—set a poem, "When the Warrior Returns," to the British melody. (That poem, interestingly, contained an image that the poet would soon reshape and immortalize: "By the light of the star-spangled flag.") Thus, Key was well acquainted with the melody, its popularity, and its musical cadence.

During the War of 1812, Key was a Washington lawyer in his thirties. Under a brief truce, he was sent aboard a British vessel in Chesapeake Bay

to acquire the release of a captured American physician. By the time the lengthy negotiations were completed, the truce had ceased and British ships were bombarding Fort McHenry, which guarded the city of Baltimore.

Key witnessed the fiery battle. By morning, the American flag of fifteen stars and stripes was still flying over the fort. Inspired by the sights and sounds of that night of September 13, 1814, Key composed a poem, "The Defense of Fort McHenry," which was published the following week.

Americans almost immediately regarded the poem, sung to Key's suggested melody, as their national anthem. But, surprisingly, the anthem was not officially adopted until March 3, 1931, by a presidential proclamation of Herbert Hoover. Today the Stars and Stripes flag that inspired Francis Scott Key is preserved in the Smithsonian Institution.

"America the Beautiful": 1895, Colorado

It was a New Jersey church organist, a New England poet, and the breathtakingly beautiful vista of Colorado mountain peaks that combined to give America a song that could have been, and almost was, its national anthem.

The poet, Katherine Lee Bates, was born in 1859 in Falmouth, Massachusetts, and was a professor of English literature at Wellesley College. Visiting Colorado in the early 1890s, she was inspired by the majestic view from the summit of Pikes Peak to compose a poem opening with the line "O beautiful for spacious skies." The completed work was printed in Boston on July 4, 1895.

Popular poems were frequently set to existing melodies. Katherine Bates's composition was fitted to a religious song, "Materna," at the time already thirteen years old. It had been written by an organist, choirmaster, and Newark, New Jersey, music dealer, Samuel A. Ward. He composed the song in 1882 to be sung in his parish church. Its opening line was "O Mother dear, Jerusalem," metrically identical to Katherine Bates's "O beautiful for spacious skies."

Both Katherine Bates and Samuel Ward lived to see their creation achieve nationwide popularity. Throughout the 1920s, when the country still had no official national anthem, there were numerous attempts to persuade Congress to elevate "America the Beautiful" to that status. Not until 1931, when "The Star-Spangled Banner" was adopted, did the debate quiet down, and it still has not been totally silenced. The issue then and now is not with lyrics but with the higher tessitura of Francis Scott Key's song. "America the Beautiful" is simply easier for most people to sing.

"The Marines' Hymn": Pre-1920, Mexico and France

There is some humorous incongruity in the fact that the hearty, forceful "Marines' Hymn," belted out vigorously by generations of America's toughest fighters, derives from a frivolous, lighthearted comic opera by French composer Jacques Offenbach.

288

How did opéra bouffe come to represent American military might?

During the Mexican-American War, an anonymous member of the Marine Corps stationed in Mexico composed a historical poem (most likely in 1847). It opened with references to the glorious days of the last Aztec emperor, Montezuma, recounted his people's demise, then proceeded to relate the Marine's mission in Mexico to fight for "freedom and liberty." The poem, somewhat altered, was eventually published in the Marines' newspaper, *The Quantico Leatherneck,* and for several decades Marines sang the words to an old Spanish folk tune.

During that period, Jacques Offenbach composed the comic opera *Geneviève de Brabant.* The lightweight, sentimental work contained one song, "Two Men in the Army," which in melody, lyrics, and slapstick staging thrilled Parisian audiences, as well as American operagoers who heard it at the Metropolitan Opera House in October 1868. Excerpted from the opera, the song achieved independent popularity in France and America.

What happened next was a combination of mental forgetting and musical fitting. In time, people simply forgot that the frequently sung "Two Men in the Army" had ever been an opera duet (certainly the opera itself was forgotten). New generations of Marines sang "Two Men," and its robust marching rhythm was found to fit closely the meter of their popular military poem. Neither Marine nor music historians have successfully determined exactly when enlisted men dropped the old Spanish folk melody in favor of the more driving beat of the Offenbach tune.

What is documented is that the now-familiar words and music were first published jointly in New York in August 1919. A year later, the United States Marine Corps copyrighted the song, titled "The Marines' Hymn." While several opera composers incorporated nationalistic melodies into their works (as did Donizetti in the overture to *Roberto Devereux*), Offenbach's is the first opera melody to become a popular patriotic song.

"Dixie": 1859, New England

It became the national anthem of the Confederacy, but "Dixie" was composed by a Northerner, Daniel Decatur Emmett, who specialized in writing songs for blackface minstrel shows. One of his shows, staged in New York's Mechanic's Hall on April 4, 1859, contained a number the playbill listed as "Mr. Dan Emmett's original Plantation Song and Dance, *Dixie's Land.*"

A group of peripatetic musicians, Bryant's Minstrels, carried the song to New Orleans in 1860. They introduced it to the South in their musical *Pocahontas,* based loosely on the relationship between the American Indian princess and Captain John Smith. The song's immediate success led them to include it in all their shows, and it became the minstrels' signature number.

Eventually, the term "Dixie" became synonymous with the states below the Mason-Dixon line. When the song's composer, a staunch Union sympathizer, learned that his tune "Dixie" was played at the inauguration of

Jefferson Davis as president of the Confederate States of America, he said, "If I had known to what use they were going to put my song, I'll be damned if I'd have written it." For a number of years, people whistled "Dixie" only in the South.

Abraham Lincoln attempted to change that. On April 10, 1865, the day following Lee's surrender to Grant at Appomattox, President Lincoln delivered a speech outside the White House. He jokingly addressed the South's monopoly of the song, saying, "I had heard that our adversaries over the way had attempted to appropriate it. I insisted yesterday that we had fairly captured it." Lincoln then suggested that the entire nation feel free to sing "Dixie," and he instructed the military band on the White House lawn to strike up the melody to accompany his exit.

West Point Military Academy: 1802, New York

The origin of West Point Military Academy dates back to the Revolutionary War, when the colonists perceived the strategic significance of the Hudson River, particularly of an S-shaped curve along the bank in the region known as West Point.

To control the Hudson was to command a major artery linking New England with the other colonies. General George Washington and his forces gained that control in 1778, occupying the high ground at the S-shaped bend in the river. Washington fortified the town of West Point that year, and in 1779 he established his headquarters there.

During the war, Washington realized that a crash effort to train and outfit civilians every time a conflict arose could never guarantee America's freedom. The country needed professional soldiers. At the end of the war, in 1783, he argued for the creation of an institution devoted exclusively to the military arts and the science of warfare.

But in the atmosphere of confidence created by victory, no immediate action was taken. Washington came and went as President (1789–1797), as did John Adams (1797–1801). It was President Thomas Jefferson who signed legislation in 1802 establishing the United States Military Academy at West Point, New York. With a class of only ten cadets, the academy opened its doors on Independence Day of that year—and none too soon.

War broke out again, faster than anyone had imagined it would. The War of 1812 refocused attention on the country's desperate need for trained officers. James Madison, then President, upped the size of the Corps of Cadets to 250, and he broadened the curriculum to include general scientific and engineering courses.

The academy was girded for the next conflict, the Civil War of 1861. Tragically, and with poignant irony, the same officers who had trained diligently at West Point to defend America found themselves fighting against each other. During the Civil War, West Point graduates—Grant, Sherman, Sheridan, Meade, Lee, Jackson, and Jefferson Davis—dominated both sides

of the conflict. In fact, of the war's sixty major battles, West Pointers commanded both sides in fifty-five. Though the war was a tragedy for the country as a whole, it was particularly traumatic for the military academy.

In this century, the institution witnessed changes in three principal areas. Following the school's centennial in 1902, the curriculum was expanded to include English, foreign languages, history, and the social sciences. And following World War II, in recognition of the intense physical demands of modern warfare, the academy focused on physical fitness, with the stated goal to make "Every cadet an athlete." Perhaps the biggest change in the academy's history came in 1976, when it admitted females as cadets.

From a Revolutionary War fortress, the site at the S-bend in the Hudson became a flourishing center for military and academic excellence—all that General George Washington had intended and more.

Statue of Liberty: 1865, France

The Statue of Liberty, refurbished for her 1986 centennial, is perhaps the most renowned symbol of American patriotism throughout the world. It is the colossal embodiment of an idea that grew out of a dinner conversation between a historian and a sculptor.

In 1865, at a banquet in a town near Versailles, the eminent French jurist and historian Édouard de Laboulaye discussed Franco-American relations with a young sculptor, Frédéric-Auguste Bartholdi. De Laboulaye, an ardent admirer of the United States, had published a three-volume history of the country and was aware of its approaching independence centennial. When the historian suggested that France present America with an impressive gift, sculptor Bartholdi immediately envisioned a massive statue. But at the time, the idea progressed no further than discussion.

A trip later took Bartholdi to Egypt. Strongly influenced by ancient colossi, he attempted to persuade the ruling authorities for a commission to create a large statue to grace the entrance of the newly completed Suez Canal. But before he could secure the assignment, war erupted between France and Prussia, and Bartholdi was summoned to fight.

The idea of a centennial statue for America was never far from the sculptor's mind. And in 1871, as he sailed into the bustling mouth of New York Harbor on his first visit to the country, his artist's eyes immediately zeroed in on a site for the work: Bedloe's Island, a twelve-acre tract lying southwest of the tip of Manhattan. Inspired by this perfect pedestal of an island, Bartholdi completed rough sketches of his colossus before the ship docked. The Franco-American project was undertaken, with the artist, engineers, and fund-raisers aware that the unveiling was a mere five years away.

The statue, to be named "Liberty Enlightening the World," would be 152 feet high and weigh 225 tons, and its flowing robes were to consist of more than three hundred sheets of hand-hammered copper. France offered to pay for the sculpture; the American public agreed to finance its rock-

Construction of the Statue of Liberty in 1885.

concrete-and-steel pedestal. To supervise the immense engineering feat, Bartholdi enlisted the skills of French railroad builder Alexandre-Gustave Eiffel, who later would erect the tower that bears his name. And for a fittingly noble, wise, and maternal face for the statue, Bartholdi turned to his mother, who posed for him.

From the start, the French contributed generously. Citizens mailed in cash and checks, and the government sponsored a special "Liberty" lottery, with profits going toward construction costs. A total of $400,000 was raised, and the esteemed French composer Charles Gounod created a cantata to celebrate the project.

In America, the public was less enthusiastic. The disinterest centered around one question: Did the country really need—or want—such a monumental gift from France? Publisher Joseph Pulitzer spearheaded a drive for funds in his paper the *World*. In March 1885, Pulitzer editorialized that it would be "an irrevocable disgrace to New York City and the American Republic to have France send us this splendid gift without our having provided so much as a landing place for it." He lambasted New York's millionaires for lavishing fortunes on personal luxuries while haggling over the pittances they were asked to contribute to the statue's pedestal. In two months, Pulitzer's patriotic editorials and harangues netted a total of $270,000.

The deadline was not met. When the country's 1876 centennial arrived, only segments of the statue were completed. Thus, as a piecemeal preview, Liberty's torch arm was displayed at the Philadelphia Centennial celebrations, and two years later, at the Paris Fair, the French were treated to a view of Liberty's giant head.

Constructing the colossus in France was a herculean challenge, but dis-

292

mantling it and shipping it to America seemed an almost insurmountable task. In 1884, the statue's exterior and interior were taken apart piece by piece and packed into two hundred mammoth wooden crates; the half-million-pound load was hauled by special trucks to a railroad station, where a train of seventy cars transported it to a shipyard. In May 1885, Liberty sailed for America aboard the French warship *Isère*.

When, on October 28, 1886, President Grover Cleveland presided over the statue's inauguration ceremonies, Lady Liberty did not yet bear her now-immortal poem. The verse "Give me your tired, your poor, / Your huddled masses yearning to breathe free . . ." was added in 1903, after the statue was closely identified with the great flow of immigrants who landed on nearby Ellis Island.

The moving lines are from a sonnet, "The New Colossus," composed in 1883 by New York City poet Emma Lazarus. A Sephardic Jew, whose work was praised by the Russian novelist Ivan Turgenev, Lazarus devoted much of her life to the cause of Jewish nationalism. She tackled the theme of persecution in poems such as "Songs of a Semite," and in a drama, *The Dance to Death,* based on the accusation leveled against Jews of poisoning water wells and thus causing Europe's fourteenth-century Black Death.

But her sonnet "The New Colossus" was almost completely ignored by the critics of the day and the public. She had written it for a literary auction held at New York's Academy of Design, and it expressed her belief in America as a refuge for the oppressed peoples of the world. Sixteen years after her death from cancer in 1887, the sonnet's final five lines were etched in bronze and in the memory of a nation.

Chapter 12

On the Body

Shoes: Pre–2000 B.C., Near East

Although some clothing originated to shelter the body, most articles of attire, from earliest times, arose as statements of status and social rank. Color, style, and fabric distinguished high priest from layman, lawmaker from lawbreaker, and military leader from his followers. Costume set off a culture's legends from its legions. In fact, costume is still the most straightforwardly visible means of stating social hierarchy. As for the contributions made to fashion by the dictates of modesty, they had virtually nothing to do with the origin of clothing and stamped their particular (and often peculiar) imprint on attire centuries later.

Shoes, as we'll see, though eminently practical, are one early example of clothes as categorizer.

The oldest shoe in existence is a **sandal**. It is constructed of woven papyrus and was discovered in an Egyptian tomb dating from 2000 B.C. The chief footwear of ancient people in warm climates, sandals exhibited a variety of designs, perhaps as numerous as styles available today.

Greek leather sandals, *krepis*, were variously dyed, decorated, and gilded. The Roman *crepida* had a thicker sole and leather sides, and it laced across the instep. The Gauls preferred the high-backed *campagus,* while a rope sandal of hemp and esparto grass, the *alpargata,* footed the Moors. From tombs, gravesites, and ancient paintings, archaeologists have catalogued hundreds of sandal designs.

Although sandals were the most common ancient footwear, other shoes

were worn. The first recorded nonsandal shoe was a leather wraparound, shaped like a moccasin; it tightened against the foot with rawhide lacing and was a favorite in Babylonia around 1600 B.C.

A similar snug-fitting leather shoe was worn by upper-class Greek women starting around 600 B.C., and the stylish colors were white and red. It was the Romans, around 200 B.C., who first established shoe guilds; the professional shoemakers were the first to fashion footwear specifically for the right and left feet.

Roman footwear, in style and color, clearly designated social class. Women of high station wore closed shoes of white or red, and for special occasions, green or yellow. Women of lower rank wore natural-colored open leather sandals. Senators officially wore brown shoes with four black leather straps wound around the leg up to midcalf, and tied in double knots. Consuls wore white shoes. There were as yet no brand names, but there were certain guild cobblers whose products were sought for their exceptional craftsmanship and comfortable fit. Their shoes were, not surprisingly, more costly.

The word "shoe" changed almost as frequently over the ages as shoe styles. In the English-speaking world, "shoe" evolved through seventeen different spellings, with at least thirty-six variations for the plural. The earliest Anglo-Saxon term was *sceo*, "to cover," which eventually became in the plural *schewis*, then *shooys*, and finally "shoes."

Standard Shoe Size. Until the first decade of the fourteenth century, people in the most civilized European societies, including royalty, could not acquire shoes in standard sizes. And even the most expensive custom-made shoes could vary in size from pair to pair, depending on the measuring and crafting skills of particular cobblers.

That began to change in 1305. Britain's King Edward I decreed that for a standard of accuracy in certain trades, an inch be taken as the length of three contiguous dried barleycorns. British cobblers adopted the measure and began manufacturing the first footwear in standard sizes. A child's shoe measuring thirteen barleycorns became commonly known as, and requested by, size 13. And though shoes cut for the right and left foot had gone out of existence after the fall of the Roman Empire, they reemerged in fourteenth-century England.

A new style surfaced in the fourteenth century: shoes with extremely long spiked toes. The vogue was carried to such lengths that Edward III enacted a law prohibiting spikes' extending two inches beyond the human toe. For a while, people observed the edict. But by the early 1400s, the so-called crakows had attained tips of eighteen inches or more, with wearers routinely tripping themselves.

The crakows, arriving in the creative atmosphere that nurtured the Renaissance, ushered in a new shoe-style trendiness, as one fashion extreme replaced another. The absurdly long, pointed toe, for example, was usurped

by a painfully short, comically broad-boxed toe that in width could accommodate an extra set of digits.

In the seventeenth century, the oxford, a low calf-leather shoe laced up the front through three or more eyelets, originated with cobblers in the academic town of Oxford, England.

In America at the time, shoe design took a step backward. The first colonial cobblers owned only "straight lasts," that is, single-shape cutting blocks, so right and left footwear was unavailable. The wealthy resorted to British imports. Shoe selection, price, and comfort improved in the mid-eighteenth century when the first American shoe factory opened in Massachusetts. These mass-produced shoes were still cut and stitched by hand, with leather sewn at home by women and children for a shameful pittance, then assembled at the factory.

Complete mechanization of shoemaking, and thus true mass production, was slow in coming. In 1892, the Manfield Shoe Company of Northampton, England, operated the first machines capable of producing quality shoes in standard sizes and in large quantities.

Boots: 1100 B.C., Assyria

Boots originated as footwear for battle. The Sumerians and the Egyptians sent soldiers into combat barefoot, but the Assyrians, around 1100 B.C., developed a calf-high, laced leather boot with a sole reinforced by metal.

There is evidence that the Assyrians, as well as the Hittites, both renowned as shoemakers, had right- and left-footed military boots. One translation of a Hittite text tells of Telipinu, god of agriculture, in a foul temper because he inadvertently put "his right boot on his left foot and his left boot on his right foot."

The Assyrian infantry boot was not readily adopted by Greek or Roman soldiers. From fighting barefoot, they progressed to sandals with hobnail soles for additional grip and wear. It was primarily for extended journeys on foot that Greek and Roman men outfitted themselves in sturdy boots. In cold weather, they were often lined with fur and adorned at the top by a dangling animal paw or tail.

Boots also became the customary footwear for nomadic horse-riding communities in cold mountainous regions and on the open steppes. Their sturdiness, and the slight heel that held the foot in the stirrup, guaranteed boots a role as combat gear. In the 1800s, cobblers in Hesse, Germany, introduced knee-high military boots called Hessians, of polished black leather with a tassel, similar to the Romans' animal tail, hanging from the top. And during the same period, British shoemakers, capitalizing on a military victory, popularized Wellingtons, high boots named for Arthur Wellesley, the "Iron Duke" of Wellington, who presided over Napoleon's defeat at Waterloo.

French high heels c. 1850 and a gentleman's boots, the earliest shoes to sport elevated heels.

Boots have been in and out of fashion over the centuries. But one aspect of the boot, its pronounced heel, gave birth to the fashion phenomenon of high-heeled shoes.

High Heels: 16th Century, France

High heels did not appear overnight. They grew inch by inch over decades, with the upward trend beginning in sixteenth-century France. And though the term "high heels" would later become a rubric for women's elevated footwear, the shoes were first worn by men. In the sixteenth century, there was comparatively little development in women's shoes because they were hidden under long gowns.

The advantage of an elevated heel on a shoe was first appreciated in horseback riding; a heel secured the foot in the stirrup. Thus, riding boots were the first shoes routinely heeled. And during the Middle Ages, when overcrowding and poor sanitation made human and animal waste street obstacles, boots with thick soles and elevated heels offered a few inches of practical protection as well as a psychological lift.

It was for the purpose of rising above public filth, in fact, that **clogs** were developed during the Middle Ages. They originated in Northern Europe as an *over*shoe, made partly or wholly of wood, with a thick base to protect the wearer's good leather shoes from street debris. In warmer months, they were often worn in place of a snug-fitting leather shoe.

A German shoe called a **pump** became popular throughout Europe in the mid-1500s. The loose slipper, plain or jeweled, had a low heel, and historians believe its name is onomatopoeic for the "plump, plump" sound

its heel made in flapping against a wood floor. A later woman's slipper, the scuff, would be thus named.

In the mid-1600s, male boots with high heels were de rigueur in France. The fad was started, and escalated, by the Sun King, Louis XIV. In his reign of seventy-three years, the longest in European history, France attained the zenith of its military power and the French court reached an unprecedented level of culture and refinement. None of Louis's towering achievements, though, could compensate psychologically for his short height. The monarch at one point had inches added to the heels of his shoes. In a rush to emulate their king, noble men and women at court instructed bootmakers to heighten their own heels. The homage forced Louis into higher heels. When, in time, Frenchmen descended to their anatomical heights, women courtiers did not, thus launching a historic disparity in the heel heights of the sexes.

By the eighteenth century, women at the French court wore brocaded high-heeled shoes with elevations up to three inches. American women, taking the fashion lead from Paris, adopted what was known as the "French heel." It helped launch a heel polarization in the United States. As women's heels climbed higher and grew narrower, men's heels (though not on boots) correspondingly descended. By the 1920s, "high heel" no longer denoted a shoe's actual heel height but connoted an enticing feminine fashion in footwear.

Loafers. The laceless, slip-on loafer is believed to have evolved from the Norwegian clog, an early overshoe. It is known with greater certainty that the Weejun loafer was named by a cobbler from Wilton, Maine, Henry Bass, after the final two syllables of "Norwegian."

Bass began making sturdy, over-the-ankle shoes in 1876 for New England farmers. He eventually expanded his line to include a lumberjack shoe and specialty footwear on request. He constructed insulated hiking boots for both of Admiral Byrd's successful expeditions to the South Pole, and lightweight flying boots for Charles Lindbergh's historic transatlantic flight. In 1936, Henry Bass was shown a Norwegian slipper moccasin that was fashionable at the time in Europe. He secured permission from the Norwegian manufacturer to redesign the shoe for the American market, and the finished loafer launched his Bass Weejun line of footwear. By the late 1950s, the Bass Weejun was the most popular hand-sewn moccasin ever made, a collegiate status symbol in the ancient tradition of the shoe as statement of social position.

Sneakers: 1910s, United States

The rubber-bottomed athletic shoe whose silent footsteps earned it the name "sneaker" had to await a technological breakthrough: the vulcanization of rubber by Charles Goodyear in the 1860s. Goodyear proved that the natural gum from the rubber plant did not have to be sticky when warm

and brittle when cold. Mixed with sulfur, rubber became a dry, smooth, pliant substance, perfect for footwear such as rain galoshes, one of its first successful uses in apparel in the late 1800s.

Before the turn of the century rubber was on the soles of leather shoes. And vulcanized rubber soles were being glued to canvas tops to produce what manufacturers advertised as a revolution in athletic footwear. In 1917, U.S. Rubber introduced Keds, the first popularly marketed sneaker, with a name that suggested "kids" and rhymed with *ped,* the Latin root for "foot." Those first sneakers were neither all white, nor white soles with black canvas; rather, the soles were black and the canvas was a conservative chestnut brown, because that was the popular color for men's leather shoes.

The substantive design of sneakers varied little until the early 1960s. Then a former college runner and his coach made a serendipitous observation that ushered in the era of the modern, waffle-soled sneaker. As a miler at the University of Oregon, Phil Knight had preferred to run in European sneakers, lighter in weight than American models. Believing that other track and field athletes would opt to better their performances with high-quality footwear, Knight and coach Bill Bowerman went into the sneaker business in 1962, importing top-notch Japanese models.

The shoes' reduced weight was an undeniable plus, but Bowerman felt further improvement was possible, especially in the area of traction, a major concern of athletes. Yet he was uncertain what constituted an optimum sole topography. Many manufacturers relied on the shallow peak-and-trough patterns developed for automobile traction. One morning, operating the waffle iron in his home kitchen, Bowerman was inspired to experiment. Stuffing a piece of rubber into the iron, he heated it, producing a deeply waffle-shaped sole pattern that soon would become a world standard for sneakers. In addition to the sole, the new sneakers featured three other innovations: a wedged heel, a cushioned mid-sole as protection against shock, and nylon tops that were lighter and more breathable than the older canvas.

To promote the waffle-soled nylon shoes, named Nikes after the winged Greek goddess of victory, Knight turned to runners in the Olympic trials held in Eugene, Oregon, in 1972. Several marathoners raced in the custom-designed shoes, and advertising copy hailed the sneakers as having been on the feet of "four of the top seven finishers," omitting to mention that the runners who placed first, second, and third were wearing West Germany's Adidas sneakers. Nonetheless, waffle-soled sneakers, in a variety of brands, sold so well that by the end of the decade the flatter-soled canvas shoes had been left in the dust.

Pants: Post–15th Century, Italy

St. Pantaleone was a fourth-century Christian physician and martyr known as the "all-merciful." Beheaded under orders of Roman emperor Diocletian, he became the patron saint of Venice, and a reliquary containing his blood

(allegedly still liquid) is housed in the Italian town of Ravello. Pantaleone is probably the only saint to be dubiously honored by having an article of clothing named after him—though how the attribution came about involves folklore more than fact. His name literally means "all lion" (*pan,* "all"; *leone,* "lion"), and though he was a clever and pious physician, he passed inexplicably into Italian folklore as a lovable but simpleminded buffoon, decidedly unsaintly in character.

It is the comic Pantaleone of folklore, through behavior and attire, who eventually gave his name to pants. An abject slave to money, he starved servants until their skeletons cast no shadow, and though he valued a gentlemanly reputation, he flirted with women, who publicly mocked him. These traits are embodied in a gaunt, swarthy, goateed Pantaleone of the sixteenth-century Italian *commedia dell'arte.* The character wore a pair of trousers, tight from ankle to knee, then flaring out like a petticoat.

The comedy genre was carried by bands of traveling actors to England and France. And the Pantalone character always appeared in exaggerated trousers. In France, the character and his pants came to be called *Pantalon;* in England, *Pantaloon.* Shakespeare helped popularize the British term in *As You Like It.*

In the eighteenth century, when pantaloons—by then a stylized form of knee breeches—reached the shores of America, their name was shortened to "pants." And in this century, the fashion industry, when referring to stylish women's trousers, has further abbreviated the word to "pant."

Whereas St. Pantaleone circuitously lent his name to pants, the ancient Celts donated their word for men's leg coverings, *trews,* to "trousers," while the Romans contributed their word for a baggy type of breeches, *laxus,* meaning "loose," to "slacks." The one convenience all these ancient leg coverings lacked was pockets.

Pockets. Simple and indispensable as pockets are, it is hard to imagine that they did not exist before the late 1500s. Money, keys, and personal articles were wrapped in a piece of cloth, an impromptu purse, and tucked into any convenient part of a person's costume.

One popular place for a man in the 1500s to carry his personal effects was his codpiece. These frontal protrusions, which fell from fashion when their exaggerated size became ludicrous and cumbersome, originated as a convenient opening, or fly, to trousers. Fashion of the day dictated that the fastened flap be stuffed with cloth, and it became an ideal place to carry the special cloth containing a man's valuables. When the codpiece went out of fashion, the cloth did not move far: it became a small bag, drawn up at the top with a string, that hung from a man's waist. The cloth was on its way to becoming the lining that is a pocket.

The first pockets in trousers appeared near the close of the 1500s. They evolved in two steps. At first, an opening was made as a side seam in a man's tight-fitting trousers. Into the opening a man inserted the cloth pouch

From drawstring bag to waist purse, the evolution of pants pockets.

containing his belongings. The independent pouch soon became a permanent, sewn-in feature of trousers.

Once introduced, pockets proved their convenience and utility. In the next century, they became a design feature of men's and women's capes and coats. At first, they were located down at the hem of an overcoat; only later did they move up to the hip.

Suspenders. Before suspenders were used to hold up pants, they were worn around the calf to support socks, not yet elasticized to stay up on their own. Trouser suspenders were introduced in England in the eighteenth century. First called "gallowses," then "braces," the straps, worn over the shoulders, buttoned to trousers. They were given their graphic name "suspenders" by eighteenth-century New Englanders who adopted the British fashion.

Knickers. Like early breeches, knickers were a form of loose-fitting trousers gathered just below the knee. Their name originated as an abbreviation of Knickerbocker, a Dutch surname prevalent among the early settlers of New Amsterdam. The loose trousers were worn by early immigrants. But they did not achieve their nickname until nineteenth-century writer Washington Irving created the fictitious author Diedrich Knickerbocker.

In his humorous two-volume 1809 work, *A History of New York from the Beginning of the World to the End of the Dutch Dynasty*, Knickerbocker, a

301

phlegmatic Dutch burgher, wrote about Dutchmen clad in breeches that buckled just below the knee. Many examples were illustrated throughout the text. Americans copied the costume, especially as pants for young boys.

Leotard. Similar to the centuries-old tight-fitting hose worn by men throughout Europe, leotards were named for nineteenth-century French trapeze artist Jules Léotard. In the clinging costume that became his trademark, Léotard astonished audiences with his aerial somersault, as well as his risqué outfit. He enjoyed a large female following. And he advised men that if they also wished "to be adored by the ladies," they should "put on a more natural garb, which does not hide your best features."

Bloomers. A pair of baggy trousers gathered at the ankles and worn with a short belted tunic was sported by Amelia Jenks Bloomer of Homer, New York, in 1851. She had copied the pants costume from a friend, Elizabeth Smith Miller. But it was Mrs. Bloomer, an early feminist and staunch supporter of reformer Susan B. Anthony, who became so strongly associated with the masculine-type outfit that it acquired her name.

Pants, then men's wear, appealed to Amelia Bloomer. She advocated female dress reform on the grounds that the large hoop skirts of her day (essentially seventeenth-century farthingales, in which the hoop had dropped from the hips to the hem) were immodest, drafty, and cumbersome—not only to maneuver in but also to manage when attending to bodily functions. Matters were made worse by the stiff linen and horsehair crinoline in vogue in the 1840s, worn to further exaggerate the femininity of a dress.

Amelia Bloomer refused to wear the popular fashion. Starting in 1851, she began to appear in public in baggy pants and short tunic. And as more women joined the campaign for the right to vote, Mrs. Bloomer turned the trousers into a uniform of rebellion. The pants trend received additional impetus from the bicycle craze of the '80s and '90s. Skirts frequently caught in a bike's cogs and chains, resulting in minor or serious accidents. Bloomers became ideal riding attire, challenging the long tradition of who in the family wore the pants.

Blue Jeans: 1860s, San Francisco

Before jeans were blue, even before they were pants, jeans was a twilled cotton cloth, similar to denim, used for making sturdy work clothes. The textile was milled in the Italian town of Genoa, which French weavers called Genes, the origin of our word "jeans."

The origin of blue jeans, though, is the biography of a seventeen-year-old immigrant tailor named Levi Strauss. When Strauss arrived in San Francisco during the gold rush of the 1850s, he sold much-needed canvas for tents and covered wagons. An astute observer, he realized that miners

went through trousers, literally and quickly, so Strauss stitched some of his heavy-duty canvas into overalls.

Though coarse and stiff, the pants held up so well that Strauss was in demand as a tailor.

In the early 1860s, he replaced canvas with denim, a softer fabric milled in Nimes, France. Known in Europe as *serge de Nimes,* in America the textile's name was pronounced "denim." And Strauss discovered that dying neutral-colored denim pants indigo blue to minimize soil stains greatly increased their popularity. Cowboys, to achieve a snug fit, put on a pair of Strauss's pants, soaked in a horse-watering trough, then lay in the sun to shrink-dry the material.

While denim pants resisted tearing, miners complained that the weight of tools often caused pockets to split at the seams. Strauss solved that problem by borrowing an idea from a Russian-Jewish tailor, Jacob Davis. In 1873, copper rivets appeared at each pocket seam, as well as one rivet at the base of the fly to prevent the crotch seam from opening when a miner squatted panning for gold.

That crotch rivet, though, generated a different kind of complaint. Miners, unencumbered by the etiquette of underwear, found that squatting too near a campfire heated the rivet to give a painful burn. The crotch rivet was abandoned.

Pocket rivets remained in place until 1937, when complaints of still a different nature were voiced. Children in many parts of the country routinely wore jeans to school. And principals reported that back-pocket rivets were scratching and gouging wooden desks and benches beyond repair. Pocket rivets were abandoned.

Blue jeans, strictly utilitarian, first became a fashion item in 1935. That year, an advertisement appeared in *Vogue*. It featured two society women in snug-fitting jeans, and it kicked off a trend named "western chic." The fad was minor compared to the one that erupted out of the designer-jeans competition of the 1970s. The pants once intended for work became the costume of play, creating a multimillion-dollar industry. At the height of the designer-jeans war, Calvin Klein jeans, for instance, despite their high price of fifty dollars (or because of it), were selling at the rate of 250,000 pairs a week.

Shirt: Post–16th Century, Europe

Fashion historians point out that the modern waist-length, tuck-in shirt originated in response to pants, as the blouse came into being to complement the skirt. Previously, a man's or woman's "shirt" was an inclusive body covering, reaching to below the knees or longer and belted at the waist. Pants, and, later, skirts, made below-the-waist shirt material redundant, thus, in effect, creating the need for new garments.

The male shirt came first, in the 1500s in Western Europe. It was worn

directly over the flesh, for the undershirt would not appear as a standard article of attire until the 1800s. The **blouse,** on the other hand, emerged much later, in the second half of the nineteenth century. It was loose, with high collar, full sleeves, and fitted cuffs.

As women were beginning to hang blouses in their closets, a new garment appeared which complemented the shirt, and later the blouse: the **cardigan sweater.**

A collarless wool sweater that buttoned down the front, it was named for James Thomas Brudenell, seventh earl of Cardigan. On October 25, 1854, as a major in the British Army during the Crimean War, Brudenell led his men in the famous charge of the Light Brigade. The earl was one of the few survivors. Although the event was immortalized in a poem by Tennyson, the seventh earl of Cardigan is remembered today only for the knitted woolen sweater he wore and popularized.

Button-down Collar. In the 1890s, the standard attire of a British polo player was white flannel trousers, white wool sweater, and long-sleeved white shirt. The shirt had a full, straight collar. Untethered, the collar tended to flap in response to a breeze or the up-and-down jouncing of a horse. Players routinely asked seamstresses to batten down their collars, and two buttons became the most popular solution to the problem.

In 1900, John Brooks, son of the founder of the Brooks Brothers clothing concern, observed the button-down collars. He dubbed the look the "Polo collar," and a new shirt was added to the Brooks Brothers line.

The style became a classic. And the word "button-down" found its way into the language: in a literal sense, as in Mary McCarthy's short story "The Man in the Button-Down Shirt"; and figuratively, as in the title of a comedy album, *The Button-Down Mind of Bob Newhart.* Although it was traditionally popular to name collars after the people who popularized them—the Lord Byron collar, the Peter Pan collar, the Nehru collar, the Windsor collar—the Polo collar became best known by its function: button-down.

Lacoste Shirt. Whereas a polo match inspired John Brooks to create the button-down collar, an alligator-skin suitcase in the window of a Boston store inspired French tennis star René Lacoste to produce a line of shirts bearing a crocodile trademark.

In 1923, on an American tour with the French Davis Cup tennis team, the nineteen-year-old Lacoste spotted the alligator luggage in a store window. He boasted to teammates that he'd treat himself to the expensive bag if he won his upcoming matches. Lacoste lost. And he did not buy the alligator-skin bag. In jest, his teammates took to calling him *le crocodile.*

René Lacoste retired from tennis in 1929. Four years later, when he began designing tennis shirts, he patented his former nickname as a trademark. And although the garments today are popularly called "alligator shirts," the name's a misnomer. Lacoste had researched his reptiles. The

Neckties originated in France as a fashion affectation and quickly spawned a variety of styles, knots, and names (clockwise): Puff, Windsor, Four-in-Hand, and the Bowtie.

long-snouted animal on the shirt is technically a crocodile, of the zoological family *Crocodylidae*. An alligator is a reptile with a shorter, blunter snout, a subspecies of the crocodiles.

Necktie: 17th Century, France

This functionless, decorative, least comfortable of mens attire is of military origin.

The first recorded neckwear appeared in the first century B.C. In the heat of day, Roman soldiers wore *focale*—scarves soaked in water and wrapped around the neck to cool down the body. This completely utilitarian garment, however, never caught on sufficiently—in either a practical or a decorative sense—to become a standard article of menswear.

The origin of the modern necktie is traceable to another military custom.

In 1668, a regiment of Croatian mercenaries in the service of Austria appeared in France wearing linen and muslin scarves about their necks. Whether the scarves were once functional, as were *focale,* or merely a decorative accent to an otherwise bland military uniform, has never been established. History does record that fashion-conscious French men and women were greatly taken with the idea. They began to appear in public wearing neckwear of linen and lace, knotted in the center, with long flowing ends. The French called the ties *cravates,* their name for the "Croats" who inspired the sartorial flair.

The fashion spread quickly to England. But the fad might have died out

if the extravagant, pleasuring-loving British monarch Charles II had not by his own example made neckwear a court must. And had the times not been ripe for a lighthearted fashion diversion. Londoners had recently suffered through the plague of 1665 and the devastating citywide fire of 1666. The neckwear fad swept the city almost as fast as the flames of the great conflagration.

The trend was reinforced in the next century by Beau Brummel, who became famous for his massive neckties and innovative ways of tying them. In fact, the proper way to tie neckwear became a male obsession, discussed, debated, and hotly argued in conversation and the press. A fashion publication of the day listed thirty-two different knots. Knots and ties were named for famous people and fashionable places, such as the racecourse at Ascot. Since that time, neckwear in some form—belt-long or bowtie-short, plain or fancy, rope-narrow or chest-broad—has been continually popular.

The **bow tie,** popularized in America in the 1920s, may also have originated among Croatian men.

For many years, fashion historians believed the small, detachable bow tie developed as one of many variations on longer neckwear. But that was opened to debate by the discovery that, for centuries, part of the costume of men in areas of Croatia consisted of bow ties. They were made from a square handkerchief, folded along the diagonal, pulled into a bow knot, then attached with a cord around the neck.

Suit: 18th Century, France

Today a man may wear a sport jacket and slacks of different fabric and color, but the outfit is never called a suit. By modern definition, a suit consists of matching jacket and trousers, occasionally with a vest. But this was not the suit's original definition. Nor was a suit worn as business attire.

The tradition of a man's suit originated in France, in the eighteenth century, with the fashion of wearing a coat, waistcoat, vest, and trousers of different fabrics, patterns, and colors. The cut was loose, bordering on baggy, and the suit was intended as informal country wear and known as a "lounge suit." In the 1860s, it became fashionable to have all components of a suit made in matching fabric.

Because country lounge suits were also worn for horseback riding, tailors were often requested to slit the jacket up the back—the origin of the **back slit** in modern suits. Another suit feature originated for utilitarian purposes: the **lapel hole,** truly a buttonhole and not intended for a flower, since on cold days a man turned up the collar of his lounge suit and buttoned it closed.

Gentlemen found lounge suits so comfortable, they began wearing them in the city as well. Tailors improved the cut, and by the 1890s, the leisure lounge suit had become respectable business attire.

Tuxedo: 1886, Tuxedo Park, New York

On the night the tuxedo made its debut, slightly more than a hundred years ago, it should have been pronounced scandalous attire, inappropriate for a formal occasion. The tailless coat was after all an affront to the customary black tie and tails of the day, formal wear that originated among English dandies in the early 1800s. However, the coat was designed and worn by a family whose name and position tempered the social reaction.

The tuxedo story begins in the summer of 1886, in Tuxedo Park, New York, a hamlet about forty miles north of Manhattan. Pierre Lorillard IV, a blueblood New Yorker of French extraction, heir to the Lorillard tobacco fortune, sought something less formal than tails to wear to the annual Autumn Ball. He commissioned a tailor to prepare several tailless jackets in black, modeled after the scarlet riding jackets then popular with British fox hunters. There is some evidence that Lorillard was inspired by the fashionable Edward VII, who as Prince of Wales had ordered the tails cut off his coat during a visit to India because of oppressive heat.

On the night of the ball, Pierre Lorillard suddenly experienced a lack of daring and declined to wear the jacket of his design. Instead, his son, Griswold, and several of Griswold's friends, donned the tailless black dinner jackets, and with a nod to the British riding coat that had inspired the creation, they wore scarlet vests.

In the 1880s' highly restrictive code of proper attire, the splash of scarlet and the affront of taillessness should probably have done more than just raise eyebrows. The ad hoc costume might well have passed quickly into oblivion, had it not been designed by a Lorillard and worn by a Lorillard, in a town built on land owned largely by the Lorillard family. Under the circumstances, the informal wear was copied and eventually became standard evening attire.

The American Formalwear Association claims that the Lorillards' act of rebellion launched a multimillion-dollar industry. In 1985, for instance, the sale and rental of tuxedos and their accessories grossed $500 million. Eighty percent of all rentals were for weddings, the next-largest rental category being high school proms.

For weddings and proms, one standard tuxedo accessory has become the **cummerbund,** a wide sash worn around the waist. It originated in India as part of a man's formal dress. The Hindu name for the garment was *kumarband,* meaning "loin band," since it was once worn lower down on the abdomen as a token of modesty. In time, the garment moved up the body to the waist, and it was appropriated by the British, who Anglicized the name to cummerbund.

The tuxedo took its name, of course, from the town in which it bowed. And today the word "tuxedo" has formal and glamorous connotations. But the term has a frontier origin, going back to the Algonquian Indians who

once inhabited the area that is now Tuxedo Park. The regional Algonquian sachem, or chief, was named P'tauk-Seet (with a silent *P*), meaning "wolf." In homage, the Indians referred to the area as P'tauk-Seet. Colonists, though, often phoneticized Indian words, and a 1765 land survey of the region reveals that they recorded P'tauk-Seet as "Tucksito." By the year 1800, when Pierre Lorillard's grandfather began acquiring land in the area, the name had already become Tuxedo. Thus, "tuxedo" derives from the Indian for "wolf," which may or may not say something about a man who wears one.

Hats: Antiquity, Europe and Asia

The similarities in sound and spelling between the words "hat," a head covering, and "hut," a primitive home, are not coincidental.

Long before Western man designed clothes for the body, he constructed thatched shelters. A *haet,* or *hutt,* offered protection from the elements and from the darkness of night. And when he protected his head—from heat, rain, or falling debris—the covering, whatever its composition, was also labeled *haet* or *hutt,* both of which etymologists translate as "shelter" and "protection."

The association between a head covering and a primitive home goes further than hat equals hut. The earliest inhabitants of the British Isles wore a conical hat made of bound rush, called a *cappan.* They lived in a shelter, also constructed of rush, known as a *cabban.* The two terms are, respectively, the origins of our words "cap" and "cabin." The evolution of language is replete with examples of peoples borrowing words for existing objects to christen new creations.

The first recorded use of a hat with a brim was in Greece in the fifth century B.C. Worn by huntsmen and travelers for protection from sun and rain, the felt *petasos* was wide-brimmed, and when not on the head it hung down the back on a cord. The *petasos* was copied by the Etruscans and the Romans, and was popular well into the Middle Ages.

The Greeks also wore a brimless hat shaped like a truncated cone. They copied the design from the Egyptians and named it *pilos,* for "felt," the material of its construction. It appeared with variations throughout European cultures, and with the rise of universities in the late Middle Ages, the *pileus quadratus,* or four-sided felt hat, became the professional head covering for scholars—and later, as the **mortarboard,** was worn by high school and college students at graduation ceremonies.

Hats today are more popular with women than with men, but this was not always the case. In classical times, women rarely wore them, while men kept them on indoors and in churches and cathedrals. The customs continued into the sixteenth century, when the popularity of false hair and the mushrooming size of wigs made wearing hats inconvenient if not impossible.

As the fad of wigs died out, men resumed the practice of wearing hats, though never again with the devotion of the past. And three customs underwent complete reversals: a man never wore a hat indoors, in church, or in the presence of a lady.

It was at this time, the late 1700s, that women in large numbers began to wear hats—festooned with ribbons, feathers, and flowers, and trimmed in lace. Previously, if a European woman wore a hat at all, it was a plain cap indoors, a hood outside.

Women's hats that tied under the chin became **bonnets.** The word "bonnet" already existed, but throughout the late Middle Ages it denoted any small, soft hat; only in the eighteenth century did it come to signify a particular kind of feminine headwear. Milan became the bonnet capital of Europe, with Milanese hats in great demand. So much so that all women's headwear fell under the British rubric "millinery," and a Milaner craftsman became a milliner.

Top Hat: 1797, England

John Etherington, a London haberdasher with a fashionable shop on the Strand, emerged from his store in the twilight hours of January 15, 1797, wearing a new hat of his own design. The London *Times* reported that Etherington's black stovepipe hat drew a crowd so large that a shoving match erupted; one man was pushed through a storefront window. Etherington was arrested for disturbing the peace. Within a month, though, he had more orders for top hats than he could fill.

British costume historians contend that Etherington's was the world's first top hat. Their French counterparts claim that the design originated a year earlier in Paris and that John Etherington pilfered it. The only evidence supporting the Parisian origin, however, is a painting by French artist Charles Vernet, *Un Incroyable de 1796,* which depicts a dandy in an Etherington-like stovepipe hat. Though artists traditionally have presaged trends, the British believe the painting may be more an example of an artist's antedating a work.

Fedora. A soft felt crown with a center crease and a flexible brim mark the fedora, whose name is derived from a hat worn by a character in an 1882 French play. Written by playwright Victorien Sardou, whose dramas were the rage of Paris in the nineteenth century, *Fedora* was composed for its star, Sarah Bernhardt, and it established a new trend in hats. A fedora, with a veil and feather, became a favorite woman's bicycling hat.

Panama. Though it would seem logical that the Panama hat originated in the Central American capital it is named for, it did not. The lightweight straw hat, made of finely plaited jipajapa leaves, originated in Peru. Panama became a major distribution center. North American engineers first en-

countered the hats in Panama, during the 1914 construction of the Panama Canal, and considered them a local product.

Derby. In 1780, Edward Smith Stanley, the twelfth earl of Derby, instituted an annual race for three-year-old horses, the Derby, to be held at Epsom Downs, near London. Popular at that time among men were stiff felt hats with dome-shaped crowns and narrow brims. Regularly worn to the Derby, the hats eventually acquired the race's name.

Stetson. In the 1860s, Philadelphia haberdasher John B. Stetson was searching for a way to earn a profit from his hat business. Recalling a vacation to the Midwest and the number of wealthy cattle ranchers he'd met there, Stetson decided to produce an oversized hat fit for "cattle kings." The "ten-gallon" Western cowboy hat, named "The Boss of the Plains," transformed Stetson's business into a success and became a classic symbol of the Wild West and of the men—and women—who tamed it. Buffalo Bill, General Custer, and Tom Mix wore Stetsons, as did Annie Oakley and Calamity Jane.

Gloves: 10,000 Years Ago, Northern Europe

Gloves evolved from the desire to protect the hands from cold and from heavy manual labor. Among the numerous examples discovered in parts of Northern Europe are "bag gloves," sheaths of animal skin that reach to the elbow. These mittens are at least ten thousand years old.

The earliest peoples to inhabit the warm lands bordering the Mediterranean used gloves for construction and farming. Among these southerners, the Egyptians, around 1500 B.C., were the first to make gloves a decorative accessory. In the tomb of King Tutankhamen, archaeologists retrieved a pair of soft linen gloves wrapped in layers of cloth, as well as a single tapestry glove woven with colored threads. Strings around the tops of the gloves indicate they were tied to the wrist. And the separate fingers and thumb leave no doubt that hand-shaped gloves were used at least 3,500 years ago.

Regardless of the warmth of the climate, every major civilization eventually developed both costume and work gloves. In the fourth century B.C., the Greek historian Xenophon commented on the Persian production of exquisitely crafted fur costume gloves; and in Homer's *Odyssey*, Ulysses, returning home, finds his father, Laertes, laboring in the garden, where "gloves secured his hands to shield them from the thorns."

It was the Anglo-Saxons, calling their heavy leather hand covering *glof,* meaning "palm of hand," who gave us the word "glove."

Purse: Pre–8th Century B.C., Southern Europe

If you purse your lips, you are contracting them into wrinkles and folds, similar in appearance to the mouth of a drawstring bag, ancient people's earliest purse. But it was the material from which those early bags were made, hide, or *byrsa* in Greek, that is the origin of the word "purse."

The Romans adopted the Greek drawstring *byrsa* unaltered, Latinizing its name to *bursa*. The early French made it *bourse*, which also came to mean the money in the purse, and then became the name of the stock exchange in Paris, the Bourse.

Until pockets appeared in clothing in the sixteenth century, men, women, and children carried purses—sometimes no more than a piece of cloth that held keys and other personal effects, or at the other extreme, elaborately embroidered and jeweled bags.

Handkerchief: Post–15th Century, France

During the fifteenth century, French sailors returned from the Orient with large, lightweight linen cloths that they had seen Chinese field-workers use as protective head covers in the sun. Fashion-minded French women, impressed with the quality of the linen, adopted the article and the practice, naming the headdress a *couvrechef,* meaning "covering for the head." The British took up the custom and Anglicized the word to "kerchief." Since these coverings were carried in the hand until needed in sunlight, they were referred to as "hand kerchiefs."

Since upper-class European women, unlike Chinese in the rice paddies, already carried sun-shielding parasols, the hand kerchief was from the start a fashion affectation. This is evident in numerous illustrations and paintings of the period, in which elaborately decorated hand kerchiefs are seldom worn but prominently carried, waved, and demurely dropped. Hand kerchiefs of silk, some with silver or gold thread, became so costly in the 1500s that they often were mentioned in wills as valuables.

It was during the reign of Elizabeth I that the first lace hand kerchiefs appeared in England. Monogrammed with the name of a loved one, the articles measured four inches square, and had a tassel dangling from one corner. For a time, they were called "true love knots." A gentleman wore one bearing his lady's initials tucked into his hatband; and she carried his love knot between her breasts.

When, then, did the Chinese head cover, which became the European hand kerchief, become a handkerchief, held to the nose? Perhaps not long after the hand kerchief was introduced into European society. However, the nose-blowing procedure was quite different then than today.

Throughout the Middle Ages, people cleared their noses by forcefully exhaling into the air, then wiped their noses on whatever was handy, most

often a sleeve. Early etiquette books explicitly legitimize the practice. The ancient Romans had carried a cloth called a *sudarium*, meaning "sweat cloth," which was used both to wipe the brow on hot days and to blow the nose. But the civility of the *sudarium* fell with the Roman Empire.

The first recorded admonitions against wiping the nose on the sleeve (though not against blowing the nose into the air) appear in sixteenth-century etiquette books—during the ascendancy of the hand kerchief. In 1530, Erasmus of Rotterdam, a chronicler of customs, advised: "To wipe your nose with your sleeve is boorish. The hand kerchief is correct, I assure you."

From that century onward, hand kerchiefs made contact, albeit tentatively at first, with the nose. The nineteenth-century discovery of airborne germs did much to popularize the custom, as did the machine age mass production of inexpensive cotton cloths. The delicate hand kerchief became the dependable handkerchief.

Fan: 3000 B.C., China and Egypt

Peacock-feather fans, and fans of papyrus and palm fronds: these decorative and utilitarian breeze-stirrers developed simultaneously and independently about five thousand years ago in two disparate cultures. The Chinese turned fans into an art; the Egyptians, into a symbol of class distinction.

Numerous Egyptian texts and paintings attest to the existence of a wealthy man's "fan servant" and a pharaoh's "royal fan bearer." Slaves, both white-skinned and black-skinned, continually swayed huge fans of fronds or woven papyrus to cool masters. And the shade cast on the ground by opaque fans was turf forbidden to commoners. In semitropical Egypt, the intangibles of shade and breeze were desiderata that, owing to the vigilance of slaves, adorned the wealthy as prestigiously as attire.

In China, fans cooled more democratically. And the fans themselves were considerably more varied in design and embellishment. In addition to the iridescent peacock-feather fan, the Chinese developed the "screen" fan: silk fabric stretched over a bamboo frame and mounted on a lacquered handle. In the sixth century A.D., they introduced the screen fan to the Japanese, who, in turn, conceived an ingenious modification: the folding fan.

The Japanese folding fan consisted of a solid silk cloth attached to a series of sticks that could collapse in on each other. Folding fans, depending on their fabric, color, and design, had different names and prescribed uses. Women, for instance, had "dance" fans, "court" fans, and "tea" fans, while men carried "riding" fans and even "battle" fans.

The Japanese introduced the folding fan to China in the tenth century. At that point, it was the Chinese who made a clever modification of the Japanese design. Dispensing with the solid silk cloth stretched over separate sticks, the Chinese substituted a series of "blades" in bamboo or ivory.

These thin blades alone, threaded together at their tops by a ribbon, con- stituted the fan, which was also collapsible. Starting in the fifteenth century, European merchants trading in the Orient returned with a wide variety of decorative Chinese and Japanese fans. By far the most popular model was the blade fan, or *brise*, with blades of intricately carved ivory strung together with a ribbon of white or red silk.

Safety Pin: 1000 B.C., Central Europe

In the modern safety pin, the pinpoint is completely and harmlessly con- cealed in a metal sheath. Its ancestor had its point cradled away, though somewhat exposed, in a curved wire. This bent, U-shaped device originated in Central Europe about three thousand years ago and marked the first significant improvement in design over the straight pin. Several such pins in bronze have been unearthed.

Straight pins, of iron and bone, had been fashioned by the Sumerians around 3000 B.C. Sumerian writings also reveal the use of eye needles for sewing. Archaeologists, examining ancient cave drawings and artifacts, con- clude that even earlier peoples, some ten thousand years ago, used needles, of fish spines pierced in the top or middle to receive the thread.

By the sixth century B.C., Greek and Roman women fastened their robes on the shoulder and upper arm with a *fibula*. This was an innovative pin in which the middle was coiled, producing tension and providing the fastener with a spring-like opening action. The *fibula* was a step closer to the modern safety pin.

In Greece, straight stick pins were used as ornamental jewelry. "Stilettos," in ivory and bronze, measuring six to eight inches, adorned hair and clothes. Aside from belts, pins remained the predominant way to fasten garments. And the more complex wraparound and slip-on clothing became, the more numerous were the fastening pins required. A palace inventory of 1347 records the delivery of twelve thousand pins for the wardrobe of a French princess.

Not surprisingly, the handmade pins were often in short supply. The scarcity could drive up prices, and there are instances in history of serfs taxed to provide feudal lords with money for pins. In the late Middle Ages, to remedy a pin shortage and stem the overindulgence in and hoarding of pins, the British government passed a law allowing pinmakers to market their wares only on certain days of the year. On the specified days, upper- and lower-class women, many of whom had assiduously saved "pin money," flocked to shops to purchase the relatively expensive items. Once the price of pins plummeted as a result of mass machine production, the phrase "pin money" was equally devalued, coming to mean "a wife's pocket money," a pittance sufficient to purchase only pins.

The esteemed role of pins in the history of garments was seriously un- dermined by the ascendancy of the functional button.

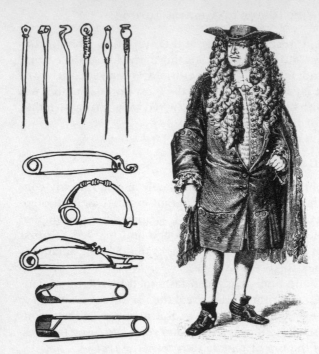

Garment pins from the Bronze Age (top); three Roman safety pins, c. 500 B.C. (middle); modern version. Pinned garments gave way to clothes that buttoned from neck to hem.

Button: 2000 B.C., Southern Asia

Buttons did not originate as clothes fasteners. They were decorative, jewelry-like disks sewn on men's and women's clothing. And for almost 3,500 years, buttons remained purely ornamental; pins and belts were viewed as sufficient to secure garments.

The earliest decorative buttons date from about 2000 B.C. and were unearthed at archaeological digs in the Indus Valley. They are seashells, of various mollusks, carved into circular and triangular shapes, and pierced with two holes for sewing them to a garment.

The early Greeks and Romans used shell buttons to decorate tunics, togas, and mantles, and they even attached wooden buttons to pins that fastened to clothing as a broach. Elaborately carved ivory and bone buttons, many leafed with gold and studded with jewels, were retrieved from European ruins. But nowhere, in illustration, text, or garment fragment, is there the slightest indication that an ancient tailor conceived the idea of opposing a button with a buttonhole.

When did the noun "button" become a verb? Surprisingly, not until the thirteenth century.

Buttonhole. The practice of buttoning a garment originated in Western Europe, and for two reasons.

In the 1200s, baggy, free-flowing attire was beginning to be replaced

with tighter, form-fitting clothing. A belt alone could not achieve the look, and while pins could (and often did), they were required in quantity; and pins were easily misplaced or lost. With sewn-on buttons, there was no daily concern over finding fasteners when dressing.

The second reason for the introduction of buttons with buttonholes involved fabric. Also in the 1200s, finer, more delicate materials were being used for garments, and the repeated piercing of fabrics with straight pins and safety pins damaged the cloth.

Thus, the modern, functional button finally arrived. But it seemed to make up for lost time with excesses. Buttons and buttonholes appeared on every garment. Clothes were slit from neck to ankle simply so that a parade of buttons could be used to close them. Slits were made in impractical places—along sleeves and down legs—just so the wearer could display buttons that actually buttoned. And buttons were contiguous, as many as two hundred closing a woman's dress—enough to discourage undressing. If searching for misplaced safety pins was time-consuming, buttoning garments could not have been viewed as a time-saver.

Statues, illustrations, and paintings of the fourteenth and fifteenth centuries attest to button mania. The mode peaked in the next century, when buttons, in gold and silver and studded with jewels, were sewn on clothing merely as decorative features—as before the creation of the buttonhole.

In 1520, French king Francis I, builder of Fontainebleau castle, ordered from his jeweler 13,400 gold buttons, which were fastened to a single black velvet suit. The occasion was a meeting with England's Henry VII, held with great pomp and pageantry on the Field of Cloth of Gold near Calais, where Francis vainly sought an alliance with Henry.

Henry himself was proud of his jeweled buttons, which were patterned after his rings. The buttoned outfit and matching rings were captured on canvas by the German portrait painter Hans Holbein.

The button craze was somewhat paralleled in this century, in the 1980s, though with zippers. Temporarily popular were pants and shirts with zipped pockets, zipped openings up the arms and legs, zipped flaps to flesh, and myriad other zippers to nowhere.

Right and Left Buttoning. Men button clothes from right to left, women from left to right. Studying portraits and drawings of buttoned garments, fashion historians have traced the practice back to the fifteenth century. And they believe they understand its origin.

Men, at court, on travels, and on the battlefield, generally dressed themselves. And since most humans are right-handed, the majority of men found it expeditious to have garments button from right to left.

Women who could afford the expensive buttons of the day had female dressing servants. Maids, also being predominantly right-handed, and facing buttons head-on, found it easier to fasten their mistresses' garments if the buttons and buttonholes were sewn on in a mirror-image reversal. Tailors complied, and the convention has never been altered or challenged.

*Judson's original hook-and-eye
zipper; created to replace shoelaces.*

Zipper: 1893, Chicago

The zipper had no ancient counterpart, nor did it originate in a sudden blaze of ingenuity. It emerged out of a long and patient technological struggle, requiring twenty years to transform the idea into a marketplace reality, and an additional ten years to persuade people to use it. And the zipper was not conceived as a clothes fastener to compete with buttons, but as a slide to close high boots, replacing the long, buttonhooked shoelaces of the 1890s.

On August 29, 1893, a mechanical engineer living in Chicago, Whitcomb Judson, was awarded a patent for a "clasp-locker." At the time, there was nothing in the patent office files that even remotely resembled Judson's prototype zipper. Two clasp-lockers were already in use: one on Judson's own boots, the other on the boots of his business partner, Lewis Walker.

Although Judson, who held a dozen patents for motors and railroad brakes, had an established reputation as a practical inventor, he found no one interested in the clasp-locker. The formidable-looking device consisted of a linear sequence of hook-and-eye locks, resembling a medieval implement of torture more than it did a modern time-saver.

To drum up interest, Judson put the clasp-locker on display at the 1893 Chicago World's Fair. But the twenty-one million viewers who poured into the fairgrounds flocked to the world's first electric Ferris wheel and the titillating "Coochee-Coochee" sideshow, featuring the belly dancer Little Egypt. The world's first zipper was ignored.

Judson and Walker's company, Universal Fastener, did receive an order from the United States Postal Service for twenty zipper mail bags. But the zippers jammed so frequently that the bags were discarded. Although Whit-

comb Judson continued making improvements on his clasp fastener, perfection of the device fell to another inventor: Swedish-American engineer Gideon Sundback. Abandoning Judson's hook-and-eye design, Sundback, in 1913, produced a smaller, lighter, more reliable fastener, which was the modern zipper. And the first orders for Sundback's zippers came from the U.S. Army, for use on clothing and equipment during World War I.

At home, zippers appeared on boots, money belts, and tobacco pouches. Not until around 1920 did they begin to appear on civilian clothing.

The early zippers were not particularly popular. A metal zipper rusted easily, so it had to be unstitched before a garment was washed and sewed back in after the garment had dried. Another problem involved public education: Unlike the more evident insertion of a button into a buttonhole, something even a child quickly mastered, the fastening of a zipper was not obvious to the uninitiated. Zippered garments came with small instruction manuals on the operation and maintenance of the device.

In 1923, the B. F. Goodrich Company introduced rubber galoshes with the new "hookless fasteners." Mr. Goodrich himself is credited with coining the echoic name "zipper," basing it on the "z-z-z-zip" sound his own boots made when closing. Goodrich renamed his new product "Zipper Boots," and he ordered 150,000 zippers from the Hookless Fastener Company, which would later change its name to Talon. The unusual name "zipper," as well as increased reliability and rustproofing, greatly helped popularize zippers.

Concealed under a flap, the zipper was a common fastener on clothing by the late '20s. It became a fashion accessory in its own right in 1935, when renowned designer Elsa Schiaparelli introduced a spring clothing collection which *The New Yorker* described as "dripping with zippers." Schiaparelli was the first fashion designer to produce colored zippers, oversized zippers, and zippers that were decorative and nonfunctional.

After a slow birth and years of rejection, the zipper found its way into everything from plastic pencil cases to sophisticated space suits. Unfortunately, Whitcomb Judson, who conceived a truly original idea, died in 1909, believing that his invention might never find a practical application.

Velcro: 1948, Switzerland

For several decades, it appeared that no invention could ever threaten the zipper's secure position in the garment industry. Then along came Velcro, one man's attempt to create synthetic burs like the small prickly thistle balls produced as seedpods on cocklebur bushes.

During an Alpine hike in 1948, Swiss mountaineer George de Mestral became frustrated by the burs that clung annoyingly to his pants and socks. While picking them off, he realized that it might be possible to produce a fastener based on the burs to compete with, if not obsolete, the zipper.

Today a Velcro fastener consists of two nylon strips, one containing

thousands of tiny hooks, the other, tiny eyes. Pressing the strips together locks the hooks into the eyes. To perfect that straightforward idea required ten years of effort.

Textile experts de Mestral consulted scoffed at the idea of man-made burs. Only one, a weaver at a textile plant in Lyon, France, believed the idea was feasible. Working by hand on a special undersized loom, he managed to produce two strips of cotton fabric, one with tiny hooks, the other with smaller eyes. Pressed together, the strips stuck adequately and remained united until they were pulled apart. De Mestral christened the sample "locking tape."

Developing equipment to duplicate the delicate handwork of the weaver required technological advances. Cotton was replaced by the more durable nylon, for repeated opening and closing of the original strips damaged the soft hooks and eyes. One significant breakthrough came when de Mestral discovered that pliant nylon thread, woven under infrared light, hardened to form almost indestructible hooks and eyes. By the mid-1950s, the first nylon locking tape was a reality. For a trademark name, de Mestral choose *vel* from "velvet," simply because he liked the sound of the word, and *cro* from the French *crochet,* the diminutive for "hook."

By the late '50s, textile looms were turning out sixty million yards of Velcro a year. And although the nylon fastener did not replace the zipper, as de Mestral hoped it would, it found diverse zipper-like applications—sealing chambers of artificial hearts, securing gear in the gravity-free environment of space, and of course zipping dresses, bathing suits, and diapers. The list is endless, though not yet as endless as George de Mestral had once envisioned.

Umbrella: 1400 B.C., Mesopotamia

An emblem of rank and distinction, the umbrella originated in Mesopotamia 3,400 years ago as an extension of the fan. For these early umbrellas did not protect Mesopotamians from rain, a rarity in their desert land, but from harsh sun. And umbrellas continued to serve primarily as sunshades for centuries, a fact evident in the word "umbrella," derived from the Latin *umbra,* "shade." In many African societies today, an umbrella bearer walks behind the tribal chief to shield his head from sun—reflecting the ancient Egyptian and Mesopotamian tradition.

By 1200 B.C., the Egyptian umbrella had acquired religious significance. The entire canopy of the sky was believed to be formed by the body of the celestial goddess Nut. Spanning the earth as a vast umbrella, she touched the ground only with her toes and fingertips. Her star-studded belly created the night sky. Man-made umbrellas became earthly embodiments of Nut, held only above heads of nobility. An invitation to stand in the penumbra of the royal umbrella was a high honor, the shade symbolizing the king's

protection. Palm fronds, feathers, and stretched papyrus were the materials for umbrellas, as they were for fans.

The Greeks and the Romans borrowed liberally from Egyptian culture, but they regarded the umbrella as effeminate. It was rarely used by men. There are numerous derisive references by sixth-century B.C. Greek writers concerning men who carry sunshields "as women do." For many centuries, the only occasion when a Greek man might excusably be seen holding an umbrella in public was to protect the head of a female companion.

The situation was entirely opposite for women. Greek women of high rank carried white parasols. And once a year they engaged in the Feast of Parasols, a fertility procession staged at the Acropolis.

But it was Roman women, with their own parasol celebration, who began the practice of oiling paper sunshades to waterproof them. Roman historians record that a drizzle at an outdoor amphitheater could result in hundreds of women lifting view-obstructing umbrellas, to the annoyance of male spectators. Debate arose over the use of rain umbrellas at public events, and in the first century A.D., the issue was put before Emperor Domitian, who ruled in favor of women's protecting themselves with oiled parasols.

Sun parasols and rain umbrellas remained predominantly female accessories of dress well into the eighteenth century in Europe—and beyond that time in America. Men wore hats and got soaked. More than a casual attempt to escape the elements was seen as unmanly. The sixteenth-century French author Henri Estienne summed up the European sentiment toward men with umbrellas: "If French women saw men carrying them, they would consider them effeminate."

It was a British gentleman, Jonas Hanway, who made umbrellas respectable raingear for men. He accomplished that transformation only through dogged perseverance, humiliation, and public ridicule.

Hanway acquired a fortune in trading with Russia and the Far East, then retired at age thirty-eight, devoting himself to founding hospitals and orphanages. And to popularizing the umbrella, a passion of his.

Beginning in 1750, Hanway seldom ventured outdoors, rain or shine, without an umbrella. He always caused a sensation. Former business associates suddenly viewed him as epicene; street hooligans jeered as he passed; and coachmen, envisioning their livelihood threatened by the umbrella as a legitimate means of shelter from the rain, steered through puddles to splash him with gutter mud.

Undaunted, Hanway carried an umbrella for the final thirty years of his life. Gradually, men realized that a one-time investment in an umbrella was cheaper than hailing a coach every time it rained—in London, a considerable savings. Perhaps it was the economics of the situation, or a case of familiarity breeding indifference, but the stigma of effeminacy long associated with the umbrella lifted. Before Jonas Hanway's death in 1786, umbrellas were toted on rainy days by British gentlemen and, in fact, referred to as "Hanways."

Modern Rainwear: 1830, Scotland

The history of rainwear is as old as the history of clothing itself. Early man, to protect himself from rain, fashioned water-repellent cloaks and head coverings by weaving waxy leaves and grass and stitching together strips of greased animal hide. The water-repellent coatings applied to materials varied from culture to culture.

The ancient Egyptians, for instance, waxed linen and oiled papyrus, while the Chinese varnished and lacquered paper and silk. But it was the South American Indians who paved the way for convenient, lightweight, truly effective rubberized raingear.

In the sixteenth century, Spanish explorers to the New World observed natives coating their capes and moccasins with a milky white resin from a local tree, *Hevea brasiliensis.* The pure white sap coagulated and dried, leaving the coated garment stiff but pliant. The Spaniards named the substance "tree milk," and copying the Indians' method of bleeding trees, they brushed the liquid on their coats, capes, hats, pants, and the soles of their boots. The garments effectively repelled rain, but in the heat of day the repellent became gummy, accumulating dried grass, dirt, and dead leaves which, by the cool of evening, were encrusted in the coating.

The sap was taken back to Europe. Noted scientists of the day experimented to improve its properties. In 1748, French astronomer François Fresneau developed a chemical method that rendered the tree sap, when painted on fabric, more pliant and less gummy, but the chemical additives themselves had an intolerably unpleasant odor.

Another failed experiment at least gave the sap a name. In 1770, Joseph Priestley, the great British chemist and the discoverer of oxygen, was working to improve the milky latex. Coincidentally, he observed that a piece of congealed sap would rub out graphite marks, which suggested a practical name. It was not until 1823 that a fifty-seven-year-old Scottish chemist, Charles Macintosh, made a monumental discovery that ushered in the era of modern rubberized rainwear.

Experimenting at his Glasgow laboratory, Macintosh found that natural rubber readily dissolved in coal-tar naphtha, a volatile, oily liquid produced by the "fractional" distillation of petroleum (the fraction that boils off between gasoline and kerosene). By cementing naphtha-treated thicknesses of rubber to cloth, Macintosh created rainproof coats that smelled only of rubber; the public referred to them as macintoshes.

Footwear made of naphtha-treated rubber acquired the name "galoshes," a term already in use for high boots. The word derived from the Roman expression for the heavy thonged sandals of the Gauls. The shoes, which tied with crisscrossed wrappings that reached to midcalf, were called *gallica solea,* which translated as "Gaulish shoes," or, eventually, "galoshes."

Bathing Suit: Mid-19th Century, Europe

The origin of the bathing suit as a distinct piece of attire began in the mid-1800s. Prior to that time, recreational bathing was not a popular pastime; if a man or woman took a dip, it was in an undergarment or in the nude.

One major development helped change bathing practices and create a need for the bathing suit. European physicians in the 1800s began to advocate recreational bathing as a tonic for "nerves"—a term that encompassed something as temporary as lovesickness or as terminal as tubercular meningitis. The cure was the "waters"—mineral, spring, or ocean. By the tens of thousands, Europeans, who for centuries had equated full-body bathing with death, waded, soaked, and paddled in lakes, streams, and surf.

The bathing suits that emerged to fill this need followed the design of street dress. Women, for example, wore a costume of flannel, alpaca, or serge, with a fitted bodice, high neck, elbow-length sleeves, and a knee-length skirt, beneath which were bloomers, black stockings, and low canvas shoes. Wet, the bathing suit could weigh as much as the bather. Fatalities recorded in England and America attest to the number of waterlogged bathers caught in an undertow. The male outfit was only somewhat less cumbersome and dangerous.

These garments were strictly *bathing* suits, as opposed to the later, lighter *swimming* suits.

From about the 1880s, women could take a safer ocean dip in a "bathing machine." The contraption, with a ramp and a dressing chamber, was wheeled from the sand into shallow water. A lady undressed in the machine, donned a shapeless full-length flannel gown fastened at the neck by a drawstring, and descended the ramp into the ocean. An awning, known as a "modesty hood," hid her from males on the beach. Bathing machines were vigilantly guarded by female attendants, called "dippers," whose job was to hasten the pace of male lingerers.

Shortly before America's entry into World War I, the clinging one-piece suit became popular—though it had sleeves and reached to the knees; the women's model also sported a skirt. The suit revolution was made possible in large measure by the textile know-how of a Danish-American named Carl Jantzen.

Born in Aarhus, Denmark, in 1883, Jantzen immigrated to America and in 1913 became a partner in Oregon's Portland Knitting Mills. The firm produced a line of woolen sweaters, socks, caps, and mittens. Jantzen was experimenting with a knitting machine in 1915, attempting to produce a tighter, lighter-weight woolen sweater with exceptional stretch, when he developed an elasticized rib-knit stitch.

The wool knit was suppose to go into the production of sweaters. But a friend on the Portland Rowing Team asked Jantzen for an athletic outfit

A bikini, as depicted in a fourth-century Roman mosaic. A nineteenth-century bathing outfit; dangerous when wet.

with more "give." Jantzen's skin-tight, rib-knit stretch suits were soon worn by every member of the team.

The Portland company changed its name to Jantzen Knitting Mills and adopted the slogan: "The suit that changed bathing to swimming."

Bikini. Swimsuits became more revealing in the 1930s. From backless designs with narrow shoulder straps, women's attire quickly progressed to the two-piece halter-neck top and panties. The bikini was the next step. And through its name, the fashion is forever linked with the start of the nuclear age.

On July 1, 1946, the United States began peacetime nuclear testing by dropping an atom bomb on the chain of Marshall Islands in the Pacific Ocean known as Bikini Atoll. The bomb, similar to the type that a year earlier devastated Hiroshima and Nagasaki, commanded worldwide media attention.

In Paris, designer Louis Réard was preparing to introduce a daringly skimpy two-piece swimsuit, still unnamed. Newspapers were filled with details of the bomb blast. Réard, wishing his suit to command media attention, and believing the design was itself explosive, selected a name then on the public's lips.

On July 5, four days after the bomb was dropped, Réard's top model, Micheline Bernardi, paraded down a Paris runway in history's first bikini. In 1946, the swimsuit seemed to stir more debate, concern, and condemnation than the bomb.

Off-the-Rack Clothes: 18th Century, Europe

Given today's wide selection of men's and women's attire in department stores and boutiques, it is hard to imagine a time when ready-made, ready-to-wear clothing did not exist. But off-the-rack garments have been a reality and a convenience for less than two hundred years. And high-quality ready-made clothes appeared only a hundred years ago. Previously, clothes were made when needed, by a professional tailor or a female member of the family.

The first ready-to-wear clothes were men's suits. Loose, shapeless, and cheap, the garments sold in London in the early 1700s. Eschewed by men of style, and derided by professional tailors, who feared a loss of business, the ill-fitting suits were purchased by laborers and the lower classes, who were pleased to own a suit for special occasions, however ill-fitting.

With London's lower classes significantly outnumbering the city's gentlemen, and with many of the former aspiring to emulate the latter, it is not surprising that ready-made suits sold at a brisk pace. Within a decade, they were being produced in Liverpool and Dublin.

Tailors' guilds attempted to thwart the trend. They expelled guild members who made the suits, while petitioning Parliament to outlaw ready-to-wear apparel. Parliament declined to enter into the imbroglio. And as more people purchased ready-made clothes, more tailors abandoned the guilds to satisfy the growing demand.

In the 1770s, the men's ready-to-wear phenomenon hit Paris, Europe's fashion center. Tailors competed for business among themselves by bettering the fit and quality of suits. And superior garments attracted a higher-class clientele. By the end of the decade, a half-dozen French firms featured suits as well as coats, the second ready-made item manufactured. The clothes were a particular favorite of sailors, whose brief time in port precluded multiple fittings for custom-made garments.

Women for many years continued to make their own clothes. They even resisted the concept of clothes produced by strangers, who possessed no knowledge of their personal style preferences and private body dimensions.

But the many conveniences of clothes ready-made over homemade—from a wider selection of styles, colors, and fabrics to the immense savings in time spent sewing—eventually won women over. The first large firm manufacturing ready-made clothes for women and children opened in Paris in 1824 and was called La Belle Jardinière because of its proximity to a flower market. In America around this time, 1830, Brooks Brothers of New Bedford, Massachusetts, began making ready-to-wear men's clothing.

Two inventions of the day helped turn the manufacture of off-the-rack clothes into the multibillion-dollar industry it is today. The sewing machine (see page 147) permitted rapid mass production of garments; for the first time in history, clothes were not hand sewn. The second breakthrough

involved the adoption of a scale of standardized clothing sizes for men, women, and children.

Until around 1860, clothes were cut to size in one of two ways. A new garment was made by copying an existing one, which usually entailed unstitching and opening up fabric. Or a rough shape of the garment was cut out of muslin, basted on the wearer, and recut and reshaped in this manner until it fit satisfactorily. Then the perfected muslin pattern was copied in the garment's actual and more expensive fabric. The tedious process is still employed for many couture creations, but it was unsuitable for mass production.

Standardized sizes, in the form of "graded paper patterns," became an industry reality in the 1860s. No longer was it necessary for a customer to hold up three or four rack garments and guess which one would give the best fit.

Home seamstresses also turned to paper patterns, which were featured in magazines and store catalogues and sold through the mail. By 1875, paper patterns were selling at the rate of ten million a year. It became chic to wear a pattern-cut garment. Queen Victoria, who could well afford custom-tailored clothes for the royal family, ordered for her sons suits fashioned from Butterick patterns, the most popular name of the day.

There was a certain democracy to ready-to-wear clothes. They did not exactly prove that all people were created equal, but they did reassure that most people, rich and poor, came in a limited number of sizes. More important, for the first time in history, fashion was no longer the prerogative of the wealthy few but available to everyone.

Designer Labels: 19th Century, France

Dior. Blass. Klein. Givenchy. De la Renta. Von Furstenberg. Cassini. Cardin. Lauren. Gucci.

History records the names of today's fashion designers, but nowhere in its pages are the names of the tailors, dressmakers, and seamstresses who clothed royalty and nobility throughout the ages. They must have existed. Fashion certainly did. France and Milan were recorded as two of Europe's earliest fashion centers. But what was important prior to the late eighteenth century was the garment itself—the style, detailing, color, fabric, and, too, the person who paraded it; everything except the designer.

Who originated designer clothes and paved the way for the phenomenon of the name label?

Her name was Rose Bertin, the first fashion designer to achieve fame, recognition, and a page in the history books. Born Marie-Jeanne in Abbeville, France, in the mid-1700s, she might not have became famous, despite talent, had it not been for a series of fortunate encounters.

Rose Bertin began her career as a milliner in Paris in the early 1770s. Her stylish hats caught the attention of the duchess of Chartres, who became

her patron and presented her to Empress Maria Theresa. The Hungarian queen was displeased with the style of dress worn by her daughter, Marie Antoinette, and Rose Bertin was commissioned to make over the woman who would become perhaps France's most extravagant and famous queen. Rose's lavish costumes for the dauphine dazzled the French court, though they distressed the empress, who complained that her daughter now dressed with the excesses of a stage actress.

As queen, Marie Antoinette devoted increasingly more time and money to fashion. And as her extravagances rose to the level of a national scandal, Rose Bertin's salon became the fashion center of Paris. She dressed not only Marie Antoinette, meeting with the queen twice weekly to create new gowns, but most of the French aristocracy, as well as the queens of Sweden and Spain, the duchess of Devonshire, and the czarina of Russia.

Rose Bertin's prices were exorbitant. Even the fermenting revolution did nothing to lower the prices, the demand for gowns, and the queen's commitment to fashion—which may have led to the arrest that resulted in her beheading.

Early in June 1791, prior to the planned escape of Marie Antoinette and her husband, set for the twentieth of the month, the queen ordered from Rose Bertin a large number of traveling outfits to be completed as quickly as possible. The discovery of the order is believed to have confirmed suspicions that the royal couple was about to flee the country.

The queen, of course, was caught, imprisoned, and guillotined in 1793. Rose Bertin fled to Frankfurt, then moved to London, where she continued to design clothes for European and Asian nobility. She died in 1812, during the reign of Napoleon.

Her worldwide fame helped draw attention to the people who design clothes. In Paris, salons and individual designers began to attach their own names to the fashions they created. And one Parisian designer, Charles Worth, introduced in 1846 the concept of using live models to display name-brand clothes—which were now protected by copyright from reproduction. Those events marked the birth of haute couture. And it was that nineteenth-century phenomenon, coupled with the concurrent rise of off-the-rack ready-wear, that made designer labels a possibility, then a profitable reality.

Chapter 13

Into the Bedroom

Bedroom: 3500 B.C., Sumer

One third of the history of humankind has never been written, for it occurred in the eight nightly hours kings, queens, and commoners spent in bed over their lifetime. It's as if between saying good night and sitting down for breakfast, humankind ceased to exist. But in those ignored—and seemingly lost—hours, man was conceived and born, sired future generations, and died. To venture into the bedroom is to enter a realm rich in its own lore, language, trivia, and erotica.

A special room in a house set aside for a bed first appeared in the royal palaces at Sumer about 3500 B.C. One significant fact about ancient Sumerian bedrooms is that there was usually only one to a home, regardless of the immensity of the residence and the number of its inhabitants. The head of the household occupied the bedroom and its bed, while his wife, children, servants, and guests slept around the house on couches, on lounges, or on the floor. Pillows existed for everyone, but they were hard, curved headrests of wood, ivory, or alabaster, intended primarily to protect a styled coiffure overnight.

The Egyptians were better bedded—though their pillows were no softer. Palaces in the fourth millennium B.C. allowed for a "master bedroom," usually fitted with a draped, four-poster bed, and surrounding narrow "apartments" for a wife and children, each with smaller beds.

The best Egyptian bedrooms had double-thick walls and a raised platform for the bed, to insulate the sleeper from midnight cold, midday heat, and

low drafts. Throughout most of the ancient world, beds were for sleeping at night, reclining by day, and stretching out while eating.

Most Egyptian beds had canopies and draped curtains to protect from a nightly nuisance: mosquitoes. Along the Nile, the insects proved such a persistent annoyance that even commoners slept beneath (or wrapped cocoon-like in) **mosquito netting.** Herodotus, regarded as the "father of history," traveled throughout the ancient world recording the peoples and behaviors he encountered. He paints a picture of a mosquito-infested Egypt that can elicit sympathy from any person today who struggles for a good night's sleep in summer:

> In parts of Egypt above the marshes the inhabitants pass the night upon lofty towers, as the mosquitoes are unable to fly to any height on account of the winds. In the marshy country, where there are no towers, each man possesses a net. By day it serves him to catch fish, while at night he spreads it over the bed, and creeping in, goes to sleep underneath. The mosquitoes, which, if he rolls himself up in his dress or in a piece of muslin, are sure to bite through the covering, do not so much as attempt to pass the net.

Etymologists find a strong association between the words "mosquito" and "canopy." Today "canopy" suggests a splendid drape, but to the ancient Greeks, *konops* referred to the mosquito. The Romans adopted the Greeks' mosquito netting and Latinized *konops* to *conopeum*, which the early inhabitants of Britain changed to *canape*. In time, the name came to stand for not the mosquito itself but the bed draping that protected from the insect.

Whereas the Egyptians had large bedrooms and beds, the Greeks, around 600 B.C., led a more austere home life, which was reflected in the simplicity of their bedrooms. The typical sleeping chamber of a wealthy Greek man housed a plain bed of wood or wicker, a coffer for valuables, and a simple chair. Many Spartan homes had no actual bedroom because husbands, through military duty, were separated from wives for a decade or longer. A Spartan youth at age twenty joined a military camp, where he was required to sleep. If married, he could visit his wife briefly after supper, but he could not sleep at home until age thirty, when he was considered a full citizen of Greece.

Roman bedrooms were only slightly less austere than those of the Greeks. Called *cubicula* (giving us the word "cubicle"), the bedroom was more a closet than a room, closed by a curtain or door. These cubicles surrounded a home's or palace's central court and contained a chair, chamber pot, and simple wooden bed, often of oak, maple, or cedar. Mattresses were stuffed with either straw, reeds, wool, feathers, or swansdown, depending on a person's finances. Mosquito netting was commonplace.

Though some Roman beds were ornately carved and outfitted with expensive linens and silk, most were sparsely utilitarian, reflecting a Roman work ethic. On arising, men and women did not bathe (that took place

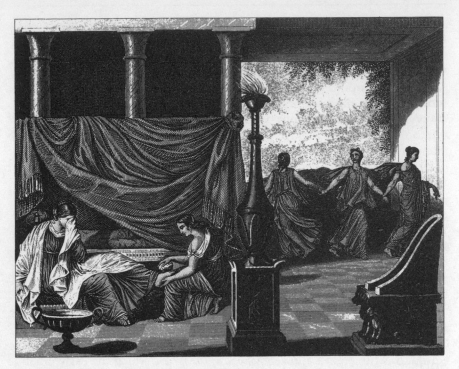

Canopy derives from the Greek word for mosquito, and canopied beds protected ancient peoples from the nightly nuisance.

midday at public facilities; see page 200), nor did breakfast consist of anything more than a glass of water. And dressing involved merely draping a toga over undergarments that served as nightclothes. For Romans prided themselves on being ready to commence a day's work immediately upon arising. The emperor Vespasian, for instance, who oversaw the conquest of Britain and the construction of the Colosseum, boasted that he could prepare himself for imperial duties, unaided by servants, within thirty seconds of waking.

Making a Bed. The decline of the bed and the bedroom after the fall of the Roman Empire is aptly captured in the phrase "make the bed." This simple expression, which today means no more than smoothing out sheets and blankets and fluffing a pillow or two, was a literal statement throughout the Dark Ages.

From about A.D. 500 onward, it was thought no hardship to lie on the floor at night, or on a hard bench above low drafts, damp earth, and rats. To be indoors was luxury enough. Nor was it distasteful to sleep huddled closely together in company, for warmth was valued above privacy. And, too, in those lawless times, safety was to be found in numbers.

Straw stuffed into a coarse cloth sack could be spread on a table or bench by a guest in a home or an inn, to "make a bed." And since straw was routinely removed to dry out, or to serve a daytime function, beds were made and remade.

The downward slide of beds and bedroom comfort is reflected in another term from the Middle Ages: bedstead. Today the word describes a bed's framework for supporting a mattress. But to the austere-living Angles, Saxons, and Jutes, a bedstead was merely the location on the floor where a person bedded down for the night.

Hardship can be subtly incorporated into custom. And throughout the British Isles, the absence of comfortable beds was eventually viewed as a plus, a nightly means of strengthening character and body through travail. Soft beds were thought to make soft soldiers. That belief was expressed by Edgar, king of the Scots, at the start of the 1100s. He forbade noblemen, who could afford comfortable down mattresses, to sleep on any soft surface that would pamper them to effeminacy and weakness of character. Even undressing for bed (except for the removal of a suit of mail armor) was viewed as a coddling affectation. So harshly austere was Anglo-Saxon life that the conquering Normans regarded their captives as only slightly more civilized than animals.

Spring Mattress: Late 18th Century, England

Mattresses once were more nightmarish, in the bugs and molds they harbored, than a sleeper's worst dreams. Straw, leaves, pine needles, and reeds—all organic stuffings—mildewed and rotted and nurtured bedbugs. Numerous medieval accounts tell of mice and rats, with the prey they captured, nesting in mattresses not regularly dried out and restuffed. Leonardo da Vinci, in the fifteenth century, complained of having to spend the night "upon the spoils of dead creatures" in a friend's home. Physicians recommended adding such animal repellents as garlic to mattress stuffing.

Until the use of springs and inorganic stuffings, the quest for a comfortable, critter-free mattress was unending. Indeed, as we've seen, one reason to "make a bed" anew each day was to air and dry out the mattress stuffing.

Between da Vinci's time and the birth of the spring mattress in the eighteenth century, numerous attempts were made to get a comfortable, itch-free night's repose. Most notable perhaps was the 1500s French **air mattress.** Known as a "wind bed," the mattress was constructed of heavily waxed canvas and equipped with air valves for inflation by mouth or mechanical pump. The brainchild of upholsterer William Dujardin, history's first air mattress enjoyed a brief popularity among the French nobility of the period, but cracking from repeated or robust use severely shortened its lifetime. A number of air beds made from more flexible oilcloth were available in London in the seventeenth century, and in Ben Jonson's 1610

Adjustable sick bed, incorporating a chamber pot.

play *The Alchemist,* a character states his preference for air over straw, declaring, "I will have all my beds blown up, not stuffed."

British patents for springs—in furniture and carriage seats—began to appear in the early eighteenth century. They were decidedly uncomfortable at first. Being perfectly cylindrical (as opposed to conical), springs when sat upon snaked to one side rather than compressing vertically; or they turned completely on their sides. And given the poor metallurgical standards of the day, springs might snap, poking hazardously through a cushion.

Spring mattresses were attempted. But they presented complex technological problems since a reclining body offers different compressions along its length. Springs sturdy enough to support the hips, for instance, were unyielding to the head, while a spring made sensitive for the head was crushed under the weight of the hips.

By the mid-1850s, the conical innerspring began to appear in furniture seats. The larger circumference of its base ensured a more stable vertical compression. An early mention of sleeping on conical innersprings appeared in an 1870s London newspaper: "Strange as it may seem, springs can be used as an excellent sleeping arrangement with only a folded blanket above the wires." The newspaper account emphasized spring comfort: "The surface is as sensitive as water, yielding to every pressure and resuming its shape as soon as the body is removed."

Early innerspring mattresses were handcrafted and expensive. One of the first patented in America, by an inventor from Poughkeepsie, New York, was too costly to arouse interest from any United States bedding manufacturer. For many years, innerspring-mattress beds were found chiefly in luxury hotels and in ocean liners such as the *Mauretania, Lusitania,* and *Titanic.* As late as 1925, when U.S. manufacturer Zalmon Simmons conceived of his "Beautyrest" innerspring mattress, its $39.50 price tag was

330

more than twice what Americans paid for the best hair-stuffed mattress of the day.

Simmons, however, cleverly decided not to sell just a mattress but to sell *sleep* "scientific sleep," at that. Beautyrest advertisements featured such creative geniuses of the era as Thomas Edison, Henry Ford, H. G. Wells, and Guglielmo Marconi. The company promoted "scientific sleep" by informing the public of the latest findings in the relatively new field of sleep research: "People do not sleep like logs; they move and turn from twenty-two to forty-five times a night to rest one set of muscles and then another."

With several of the most creative minds of the day stressing how they benefited from a good night's sleep, it is not surprising that by 1929, Beautyrest, the country's first popular innerspring mattress, had annual sales of nine million dollars. Stuffed mattresses were being discarded faster than trashmen could collect them.

Electric Blanket: 1930s, United States

Man's earliest blankets were animal skins, or "choice fleeces," as they are referred to in the *Odyssey*. But our word "blanket" derives from a later date and a different kind of bed covering. French bed linens (and bedclothes) during the Middle Ages consisted largely of undyed woolen cloth, white in color and called *blanquette,* from *blanc,* meaning "white." In time, the word evolved to "blanket" and it was used solely for the uppermost bed covering.

The first substantive advance in blankets from choice fleeces occurred in this century and as a spinoff from a medical application of electricity. In 1912, while large areas of the country were still being wired for electric power, American inventor S. I. Russell patented an electric heating pad to warm the chests of tubercular sanitarium patients reclining outdoors. It was a relatively small square of fabric with insulated heating coils wired throughout, and it cost a staggering $150.

Almost immediately, the possibility for larger, bed-sized electric blankets was appreciated; and not only for the ailing. But cost, technology, and safety were obstacles until the mid-1930s. The safety of electric blankets remained an issue for many years. In fact, most refinements to date involved generating consistent heat without risking fire. One early advance involved surrounding heating elements with nonflammable plastics, a spin-off of World War II research into perfecting electrically heated flying suits for pilots.

Birth Control: 6 Million Years Ago, Africa and Asia

The term "birth control" was coined in 1914 by Irish-American nurse Margaret Sanger, one of eleven children herself, who is regarded as the "mother of planned parenthood." But the concept is ancient, practiced in early

societies, and it arose out of an astonishing biological change that occurred in the female reproductive cycle some six million years ago.

The change involved estrus, or heat. At that time, females, in the lineage that would become *Homo sapiens,* began to switch from being sexually receptive to males only during limited periods of estrus to continuous arousal and receptivity. Thus, from conceiving young only during a brief season (nature's own birth control), the female evolved to bearing young year round.

Anthropologists theorize this development went hand in hand with the emerging trait of walking erect. To achieve balance for upright posture, the pelvic canal narrowed; this meant difficult and often fatal pregnancies. Natural selection began to favor females with a proclivity for giving premature birth—that is, for having babies small enough to negotiate the narrowed canal. These premature babies required longer postnatal care and consequently kept their mothers busier. Thus, the female became increasingly dependent on the male for food and protection. And she guaranteed herself and her offspring these necessities by offering the male in return sexual favors for longer and longer periods of time. Those females with only limited periods of estrus gradually died off. Soon entire generations carried the gene for continuous sexual arousal and receptivity. And with this development came the notion of controlling unwanted conception.

For tens of thousands of years, the only contraceptive method was coitus interruptus, in which the man withdraws to ejaculate outside the woman's body: the biblical sin of Onan. With the emergence of writing about 5,500 years ago, a record of birth control methods—from the bizarre to the practical—entered history.

Every culture sought its own foolproof method to prevent conception. In ancient China, women were advised to swallow quicksilver (mercury) heated in oil. It may well have worked, since mercury is highly toxic and probably poisoned the fetus—and to a lesser extent, the mother.

A less harmful procedure was practiced by Egyptian women. Before intercourse, a woman was advised to insert a mixture of crocodile dung and honey into her vagina. While the viscous honey might have served as a temporary obstacle to impede sperm from colliding with an egg, it is more likely that the salient ingredient was dung: its sharp acidity could alter the pH environment necessary for conception to occur, killing the sperm. In effect, it was history's first **spermicide.**

Egyptian birth control methods are the oldest on record. The Petri Papyrus, written about 1850 B.C., and the Eber Papyrus, composed three hundred years later, describe numerous methods to avert pregnancy. For the man, in addition to coitus interruptus there was coitus obstructus, which is full intercourse, with the ejaculate forced into the bladder through the depression of the base of the urethra. (The papryi also contain an early mention of how women handled menstruation: Egyptian women used a homemade tampon-shaped device composed of shredded linen and crushed

acacia branch powder, later known as gum arabic, an emulsion stabilizer used in paints, candy, and medicine.)

Contraceptive methods assumed additional importance in the free-spirited Rome of the second and third centuries A.D. Soranus of Ephesus, a Greek gynecologist practicing in Rome, clearly understood the difference between contraceptives, which prevent conception from occurring, and abortifacients, which eject the egg after it's fertilized. And he taught (correctly, though dangerously) that permanent female sterility could be achieved through repeated abortions. He also advised (incorrectly) that immediately following intercourse, women cough, jump, and sneeze to expel sperm; and he hypothesized infertile or "safe" days in the menstrual cycle.

Spermicides were a popular birth control method in the Near and Middle East. In ancient Persia, women soaked natural sea sponges in a variety of liquids believed to kill sperm—alcohol, iodine, quinine, and carbolic acid—and inserted them into the vagina before intercourse. Syrian sponges, from local waters, were highly prized for their absorptivity, and perfumed vinegar water, highly acidic, was a preferred spermicide.

In the ancient world, physical, as opposed to chemical, means of birth control were also available:

Cervical Cap. From about the sixth century B.C., physicians, invariably males, conceived of countless cap-like devices for the female to insert over the opening of the cervix. Greek doctors advised women to scoop out the seeds of a pomegranate half to obtain a sperm-blocking cap. Centuries later, Casanova—the Italian gambler, celebrated lover, and director of the French state lotteries, who told all in his twelve-volume memoirs—presented his mistresses with partially squeezed lemon halves. The lemon shell acted as a physical barrier, and its juice as an acidic spermicide.

A highly effective cervical cap appeared in Germany in 1870. Designed by the anatomist and physician Wilhelm Mensinga, the cap was a hollow rubber hemisphere with a watch spring around the head to secure it in place. Known as the "occlusive pessary," or popularly as the "Dutch cap," it was supposed to be 98 percent effective—as good as today's diaphragms.

IUD. The scant documentation of the origin of intrauterine devices is attributable to their mysterious function in preventing conception. It is known that during the Middle Ages, Arabs used IUDs to thwart conception in camels during extended desert journeys. Using a hollow tube, an Arab herder slid a small stone into a camel's uterus. Astonishingly, not until the late 1970s did doctors begin to understand how an IUD works. The foreign object, metal or plastic today, is treated as an invader in the uterus and attacked by the body's white blood cells. Part of the white cells' arsenal of weapons is the antiviral compound interferon. It's believed that interferon kills sperm, preventing conception.

The Arab practice with camels led to a wide variety of foreign objects

being inserted into animal and human uteruses: beads of glass and ebony, metals, buttons, horsehair, and spools of silver threads, to mention a few. However, the first truly effective metal-coil IUD was the "silver loop," designed in 1928 by the German physician Ernst Frafenberg. Measuring about three fifths of an inch in diameter, the loop had adequate elasticity, though as with many later IUDs, some women developed pelvic inflammation.

Throughout history, there were physicians in all cultures who advised women to douche immediately after intercourse, believing this alone was an effective contraceptive measure. But modern research has shown that within ten seconds after the male ejaculates, some sperm may already have swum from the vaginal canal into the cervix, where douching is ineffective.

From crocodile dung to douching, all ancient contraceptive methods were largely hit or miss, with the onus of preventing conception falling upon the female. Then, in the sixteenth century, an effective means of male contraception arose: the condom.

Condom: 16th and 17th Centuries, Italy and England

Prior to the sixteenth century, did no physician think of simply placing a sheath over the penis during intercourse?

It must be stated that sheaths in earlier times were thick. They interfered with a man's pleasure. And most doctors were men. Thus, sheaths were seldom recommended or used. That may be overstating the case, but only slightly. Penile sheaths did exist. There is evidence that the Romans, and possibly the Egyptians, used oiled animal bladders and lengths of intestine as sheaths. However, their purpose was not primarily to prevent the woman from becoming pregnant but to protect the man against catching venereal disease. When it came to birth control, men preferred to let women take the lead.

Italian anatomist Gabriel Fallopius, the sixteenth-century physician who first described the two slender tubes that carry ova from the ovaries to the uterus, is generally regarded as the "father of the condom"—an anachronistic title since Dr. Condom would not make his contribution to the device for another hundred years.

In the mid-1500s, Fallopius, a professor of anatomy at the University of Padua, designed a medicated linen sheath that fit over the glans, or tip of the penis, and was secured by the foreskin. It represents the first clearly documented prophylactic for the male member. Soon sheaths appeared for circumcised men. They were a standard eight inches long and tied securely at the base with a pink ribbon, presumably to appeal to the female. Fallopius's invention was tested on over one thousand men, "with complete success," as the doctor himself reported. The euphemism of the day labeled them "overcoats."

Fallopius initially conceived of the sheath not as a contraceptive device

but as a means of combating venereal disease, which then was on an epidemic rise. It is from this sixteenth-century European outbreak that sailors to the New World are believed to have introduced the *Treponema pallidum* bacterium of syphilis to native Indians.

Penile sheaths in the sixteenth century were dullingly thick, made from animal gut and fish membranes in addition to linen. Since they interfered with the pleasure of intercourse and only occasionally prevented disease—being improperly used, and reused unwashed—they were unpopular with men and regarded with derision. A French marquis sarcastically summed up the situation when he called a cattle-intestine sheath he'd tried "armor against love, gossamer against infection."

How did Fallopius's overcoats get to be named condoms?

Legend has it that the word derives from the earl of Condom, the knighted personal physician to England's King Charles II in the mid-1600s. Charles's pleasure-loving nature was notorious. He had countless mistresses, including the most renowned actress of the period, Nell Gwyn, and though he sired no legitimate heirs, he produced innumerable bastards throughout the realm.

Dr. Condom was requested to produce, not a foolproof method of contraception, but a means of protecting the king from syphilis. His solution was a sheath of stretched and oiled intestine of sheep. (It is not known if he was aware of Fallopius's invention of a hundred years earlier. It is part of condom lore that throughout the doctor's life, he discouraged the use of his name to describe the invention.) Condom's sheath caught the attention of noblemen at court, who adopted the prophylactics, also against venereal disease.

The fact that sexually transmitted disease was feared far more than siring illegitimate children can be seen in several dictionary definitions of condoms in the seventeenth and eighteenth centuries. *A Classical Dictionary of the Vulgar Tongue*, for instance, published in London in 1785, defines a condom as "the dried gut of a sheep, worn by men in the act of coition, to prevent venereal infection." The entry runs for several additional sentences, with no mention of contraception.

Only in this century, when penicillin laid to rest men's dread of syphilis, did the condom come to be viewed as protection primarily against pregnancy.

A condom made of vulcanized rubber appeared in the 1870s and from the start acquired the popular name **rubber.** It was not yet film thin, sterile, and disposable. A man was instructed to wash his rubber before and after intercourse, and he reused one until it cracked or tore. Effective and relatively convenient, it was still disliked for its dulling of sensation during intercourse. Thinner modern latex rubber would not be introduced until the 1930s.

Rubbers were denounced by religious groups. In New York in the 1880s, the postal service confiscated more than sixty-five thousand warehouse

condoms about to sold through the mail, labeling them "articles for immoral purposes," and police arrested and fined more than seven hundred people who manufactured and promoted the goods.

Vasectomy; Sperm and Egg: 1600s, England and Netherlands

In the century when Dr. Condom supposedly introduced sheaths to England, fellow British physicians performed the first vasectomy. Although the means of cutting and cauterizing the male tubes was crude, the surgery was supposed to be effective—though never reversible, as a vasectomy usually is today.

It was also in the seventeenth century that a major human reproductive principle was confirmed—the union of sperm and egg.

Early physicians did not realize that conception required a sperm to collide with a female's egg. For centuries, no one even suspected that an egg existed. Men, and only men, were responsible for the continuation of the species. Physicians assumed that the male ejaculate contained *homunculi*, or "tiny people," who grew into human beings after being deposited in a woman's uterus. Contraceptive methods were a means of halting the march of homunculi to the nurturing uterus. In the sixteenth century, Gabriel Fallopius described the tubes connecting the ovaries to the uterus, and in 1677 a Dutch haberdasher constructed the first quality microscope and identified sperm cells, half the reproductive story.

Antonie van Leeuwenhoek was born in 1632 in Delft, the Netherlands. He plied the haberdashery trade and in his spare time experimented with grinding glass to make lenses. In producing microscopes of high resolution and clarity, Leeuwenhoek almost single-handedly established the field of microbiology.

Continually sliding new specimens under his superior lenses, Leeuwenhoek made numerous important discoveries. He observed that aphids reproduced by parthenogenesis or "virgin birth," in which female eggs hatch without male fertilization. Using his own blood, he gave the first accurate description of red blood cells; and using his own saliva, he recorded the myriad bacteria that inhabit the human mouth. Using his own ejaculate (which drew public cries of immorality), he discovered sperm. Clearly, semen was not composed of homunculi; sperm had to unite with an egg, and women did make half the contribution to the production of offspring, a role that in the past had often been denied them.

The Pill: 1950s, Shrewsbury, Massachusetts

No event in the history of contraception has had a more profound effect on birth control than the introduction of an oral contraceptive. "The pill," as it quickly became known, contains hormone-like substances that enter

the bloodstream and disrupt the production of ova and ovulation. Although birth control pills were predicted in the mid-nineteenth century, they did not become a reality until the 1950s, the result of pioneering medical research and the encouragement of Margaret Sanger, organizer of the planned parenthood movement in the United States.

The pill originated in an unexpected discovery made in the tropical jungles of Mexico in the 1930s. There, chemistry professor Russell Marker, on leave from Pennsylvania State College, was experimenting with a group of plant steroids known as sapogenins, which produce a soaplike foam in water. He discovered a chemical process that transformed the sapogenin diosgenin into the human female sex hormone progesterone. The wild Mexican yam, *cabeza de negro,* proved to be a rich source of the hormone precursor.

At that time, progesterone was used to treat menstrual disorders and prevent miscarriages. But the drug was available only from European pharmaceutical companies, and methods of preparing it were laborious and costly. Still, Marker was unable to acquire financial backing from an American pharmaceutical company to pursue synthetic progesterone research.

He rented a laboratory in Mexico City, collected ten tons of yams, and at his own expense isolated pure diosgenin. Back in the United States, he synthesized more than 2,000 grams of progesterone, which at the time was worth $160,000. The synthesis was far simpler than the traditional methods, and in time it would bring down the price of sex steroids from eighty dollars to one dollar a gram.

Researchers in the late 1940s began to reevaluate the possibility of an inexpensive oral contraceptive. Chemist Gregory Pincus at the Worchester Foundation for Experimental Biology in Shrewsbury, Massachusetts, tested a yam-derived ovulation inhibitor, norethynodrel, on 1,308 volunteers in Puerto Rico in 1958. It established menstrual regularity and was an effective contraceptive. Searle Pharmaceuticals applied for FDA approval to market norethynodrel. Despite intense opposition from religious groups opposed to birth control, research and marketing efforts continued, and in 1960, women across America were introduced to Enovid, history's first oral contraceptive.

Although there was considerable social condemnation of the pill, sales figures revealed that in the privacy of their homes across the country, women were not reluctant to take it regularly. By the end of 1961, a half-million American women were on the pill, and that number more than doubled the following year.

Since that time, drug companies have worked to develop a variety of safer versions of oral contraceptives, with fewer side effects. None of today's oral contraceptives, taken by approximately seventy million women worldwide, contains the original yam derivative norethynodrel. Researchers believe that oral contraceptives will remain women's major birth control aid until the introduction, projected for the 1990s, of an antipregnancy vaccine that will offer several years' immunization against conception.

Planned Parenthood. A woman who encouraged chemist Gregory Pincus to perfect the pill was Margaret Sanger. Born in 1883, Sanger had ten brothers and sisters and witnessed the difficult life of her Irish mother, characterized by continual pregnancy and childbirth, chronic poverty, and an early death. As a maternity nurse on Manhattan's Lower East Side at the turn of the century, she was equally dismayed by the high rate of unwanted pregnancies and self-induced abortions. She believed that fewer children, spaced further apart, could help many families attain a better standard of living. But when Sanger attempted to learn more about family planning, she discovered that sound information simply did not exist.

There was a straightforward reason. The Comstock Act of 1873, named after Anthony Comstock, a postal inspector and leader of the New York Society for the Suppression of Vice, had labeled all contraceptive information "obscene." As a result, it ceased being published. Physicians Sanger interviewed were reluctant even to discuss artificial birth control for fear of being quoted and later prosecuted under the Comstock Act.

To acquire what information existed, she traveled throughout Europe in 1913, returning home the following year armed with literature and methodology. She published contraceptive information in her own monthly magazine, *Woman Rebel,* which earned her nine counts of defiance against the Comstock law and resulted in her journal's being barred from the U.S. mails. In 1916, she opened the world's first birth control clinic, in the Brownsville section of Brooklyn, offering women accurate and practical advice on avoiding pregnancy and planning the size of a family.

New York City police soon closed the clinic as a "public nuisance." Diaphragms, condoms, and literature were confiscated. And Margaret Sanger went to prison. The U.S. Court of Appeals eventually ruled that doctors could provide prophylactic devices to women strictly for the "cure and prevention of disease," not for contraception. In 1927, Margaret Sanger organized the first World Population Conference, and twenty years later she launched the International Planned Parenthood Federation.

In the early 1950s, she visited the Massachusetts laboratory of Dr. Gregory Pincus. She convinced him of the need for a simple oral contraceptive, and she championed his invention up until her death in 1966. By then, the pill was six years old and four million American women were consuming 2,600 tons of birth control pills annually.

Nightgown and Pajamas: Post–16th Century, France and Persia

Late in the sixteenth century, when tight-corseted, multilayered clothes and powdered wigs reigned as vogue, it became a luxury for both men and women at day's end to slip into something more comfortable. In that era, the term "nightgown" originated in Europe to describe a full-length unisex

frock, fastened in front, with long sleeves. Intended also for warmth before there was central heating, a nightgown was often of velvet or wool, lined and trimmed in fur. For the next hundred fifty years, men and women wore the same basic garment to bed, with differences existing only in feminine embellishments of lace, ribbon, or embroidery.

A substantive divergence in styles began in the eighteenth century with the emergence of the **negligee** for women. The term arose as differences in styles and fabrics of men's and women's nightgowns grew more pronounced. A woman's negligee—a tighter garment in silk or brocade with ruffles or lace, often belted at the waist—not only was for sleeping but also was informal wear for lounging in the privacy of the home. The notion of relaxing in a negligee—that is, of performing no household work—is inherent in the word's origin: *neglegere,* Latin for "to neglect," compounded from *neg* and *legere,* meaning "not to pick up."

The man's plainer, baggier nightgown grew shorter in the same century, to become a "night shirt." It was not uncommon for a man to relax at home in trousers and a night shirt, and even to wear the shirt during the day as an undergarment. One popular pair of lounging trousers was imported from Persia. Loose-fitting and modeled after the harem pants worn by Eastern women, they were named pajamas, derived from *pae,* Persian for "leg garment," and *jama,* "clothing." The night shirt and Persian trousers, originally uncoordinated in color, fabric, and print, evolved into the more stylized pajama ensemble we know today.

Underwear: Mid-1800s, Europe

Unmentionables. Indescribables. Unwhisperables. These are among the many euphemisms men's and women's underwear acquired during its relatively brief history. In the ancient world, beneath loose robes and togas, underwear was not recognized as a standard article of attire.

Prior to the nineteenth century, underwear (if worn at all) was simple: a loose chemise and some type of drawers. In some cases, an undergarment was designed as an integral part of a particular outfit. Intended to be seen by no one except the wearer, an undergarment, in style and fit, was of minor concern. A notable exception, during the periods when a woman's waist and bust were, respectively, artificially cinched and distended, was the corset, which was literally engineered to achieve its effect.

Fashion historians record a major change in underwear and the public's attitude toward it beginning around the 1830s. Undergarments became heavier, longer, and a routine part of dress. For the first time in history, *not* to wear underclothing implied uncleanliness, coarseness, lower-class disregard for civility, or licentious moral character. This transformation is believed to have resulted from a confluence of three factors: the blossoming of Victorian prudishness and its corresponding dictates of modesty in attire; the introduction of finer, lighter dress fabrics, which in themselves called

Advertisement for 1880s woolen underwear, believed to possess miraculous health benefits.

for underclothing; and the medical professions' awareness of germs, which, combined with a body chill, led to illness.

This last factor was of particular significance. Physicians advised against catching "a chill" as if it were as tangible an entity as a virus, and the public developed an almost pathological fear of exposing any body part except the face to the reportedly germ-laden air. Pasteur had recently proved the germ theory of disease and Lister was campaigning for antiseptics in medicine. The climate, so to speak, called for underwear.

Underclothing then was white, usually starched, often scratchy, and made chiefly from cambric batiste, coarse calico, or flannel. From about the 1860s, women's undergarments were designed with an emphasis on attractiveness, and silk first became a popular underwear fabric in the 1880s.

Woolen underwear, invariably scratchy, swept Europe and America in the same decade, ushered in by the medical profession.

What came to be called the Wool Movement began in Britain under Dr. Gustav Jaeger, a former professor of physiology at Stuttgart University and founder of Jaeger Company, manufacturers of wool clothing. Dr. Jaeger advocated the health benefits of wearing coarse, porous wool in contact with the skin, since it allowed the body to "breathe." The wool could never be dyed. In England, a "wool health culture" sprung up, with distinguished followers such as Oscar Wilde and George Bernard Shaw (the latter for a time wore only wool next to his skin). Wool underwear, corsets, and petticoats became popular, and in America, so-called knickers, similar to the newly introduced bloomers, were also of wool. For more than two decades, the Wool Movement caused underwear discomfort on both sides of the Atlantic.

In 1910, American men welcomed a minor underwear innovation: the X-shaped overlapping frontal fly. And in 1934, men's underwear was revolutionized with the introduction of the **Jockey Brief.** The Wisconsin firm of Cooper and Sons copied the design from a men's swimsuit popular the

previous year on the French Riviera. The first Jockey style, named No. 1001, proved to be so popular that it soon was replaced by the more streamlined No. 1007, which became known as the Classic Jockey Brief, with the word "Jockey" stitched around the elastic waistband.

Brassiere: 2500 B.C., Greece

Throughout history, as the female bust has gone in and out of clothing fashion, so, too, have the breasts themselves gone in and out of public view. Around 2500 B.C., Minoan women on the Greek isle of Crete, for instance, wore bras that lifted their bare breasts entirely out of their garments.

On the other hand, in the male-oriented ancient classical world, Greek and Roman women strapped on a breast band to minimize bust size, a fashion reintroduced centuries later by church fathers. In fact, from its birth in Greece 4,500 years ago, the bra, or the corset, has been the principal garment by which men have attempted to reshape women to their liking.

In certain periods, devices were designed to enlarge breasts considered inadequate by the standard of the day. The first public advertisements for what would become known as "falsies" appeared in nineteenth-century Paris. The "bust improver" consisted of wool pads which were inserted into a boned bodice. Later in the same century, French women could purchase the first rubber breast pads, called "lemon bosoms" because of their shape and size. Throughout these decades, brassieres were extensions of corsets.

The first modern brassiere debuted in 1919. It was the needlework of New York socialite Mary Phelps Jacobs, the woman responsible for the demise of the corset.

Fashionable women of that day wore a boxlike corset of whalebone and cordage that was uncomfortable and impeded movement. Mary Jacobs's concern, though, was not comfort but appearance. In 1913, she purchased an expensive sheer evening gown for a society affair. The gown clearly revealed the contour of her corset, so Mrs. Jacobs, with the assistance of her French maid, Marie, devised a brief, backless bra from two white handkerchiefs, a strand of ribbon, and cord. Female friends who admired the lightweight, impromptu fashion received one as a gift. But a letter from a stranger, containing a dollar and a request for "your contraption," prompted the socialite to submit sketches of her design to the U.S. Patent Office.

In November 1914, a patent was awarded for the Backless Brassiere. Aided by a group of friends, Mary Jacobs produced several hundred handmade garments; but without proper marketing, the venture soon collapsed. By chance, she was introduced socially to a designer for the Warner Brothers Corset Company of Bridgeport, Connecticut. Mary Jacobs mentioned her invention, and when the firm offered $1,500 for patent rights, she accepted. The patent has since been valued at $15 million.

341

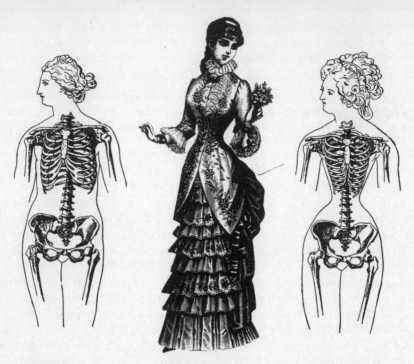

Before the bra. A nineteenth-century depiction of the harmful skeletal effects from tight corseting.

Innovations on Mary Jacobs's design followed. Elastic fabric was introduced in the '20s, and the strapless bra, as well as standard cup sizes, in the '30s. The woman largely responsible for sized bras was Ida Rosenthal, a Russian-Jewish immigrant who, with the help of her husband, William, founded Maidenform.

During the "flapper era" of the '20s, fashion dictated a flat-chested, boyish look. Ida Rosenthal, a seamstress and dress designer, bucked the trend, promoting bust-flattering bras. Combining her own design experience and paper-patterns, she grouped American women into bust-size categories and produced a line of bras intended to lift the female figure through every stage from puberty to maturity. Her belief that busts would return to fashion built a forty-million-dollar Maidenform industry. Asked during the '60s, when young women were burning bras as a symbol of female liberation, if the action signaled the demise of the brassiere business, Ida Rosenthal answered, "We're a democracy. A person has the right to be dressed or undressed." Then she added, "But after age thirty-five a woman hasn't got the figure to wear no support. Time's on my side."

Hosiery: 4th Century B.C., Rome

Sock. Hose. Stocking. However we define these related words today, or choose to use them interchangeably in a sentence, one thing is certain: originally they were not the items they are now. The sock, for instance, was a soft leather slipper worn by Roman women and effeminate men. Hose covered the leg but not the foot. The word "stocking" does not appear in the vocabulary of dress until the sixteenth century, and its evolution up the leg from the foot took hundreds of years.

The history of men's and women's "socks" begins with the birth of garments that were "put on" rather than merely "wrapped around."

The first "put on" items were worn by Greek women around 600 B.C.: a low, soft sandal-like shoe that covered mainly the toes and heel. (See page 294.) Called a *sykhos*, it was considered a shameful article for a man to wear and became a favorite comic theater gimmick, guaranteed to win a male actor a laugh.

Roman women copied the Greek *sykhos* and Latinized its name to *soccus*. It, too, was donned by Roman mimes, making it for centuries standard comedy apparel, as baggy pants would later become the clown's trademark.

The *soccus* sandal was the forerunner both of the word "sock" and of the modern midcalf sock. From Rome, the soft leather *soccus* traveled to the British Isles, where the Anglo-Saxons shortened its name to *soc*. And they discovered that a soft *soc* worn inside a coarse boot protected the foot from abrasion. Thus, from its home inside the boot, the *soc* was on its way to becoming the modern sock. Interestingly, the Roman *soccus* also traveled to Germany, where it was worn inside a boot, its spelling abbreviated to *socc*, which until the last century meant both cloth footwear and a lightweight shoe.

Hose. In ancient times in warm Mediterranean countries, men wore wraparound skirts, having no need for the leg protection of pants. In the colder climates of Northern Europe, though, Germanic tribes wore loose-fitting trousers reaching from waist to ankle and called *heuse*. For additional warmth, the fabric was commonly crisscrossed with rope from ankle to knee, to shield out drafts.

This style of pants was not unique to Northern Europeans. When Gaius Julius Caesar led his Roman legions in the first-century B.C. conquest of Gaul, his soldiers' legs were protected from cold weather and the thorns and briers of northwestern forests by *hosa*—gathered leg coverings of cloth or leather worn beneath the short military tunic. The word *hosa* became "hose," which for many centuries denoted gathered leg coverings that reached down only to the ankles.

Logically, it might seem that in time, leg hose were stitched to ankle socks

to form a new item, stockings. However, that is not what happened. The forerunner of modern stockings are neither socks nor hose but, as we're about to see, *undones*.

Stockings: 5th Century, Rome

By A.D. 100, the Romans had a cloth foot sock called an *udo* (plural, *udones*). The earliest mention of the garment is found in the works of the poet and epigrammatist M. Valerius Martialis, who wrote that in *udones,* the "feet will be able to take refuge in cloth made of goat's hair."

At that time, the *udo* fitted over the foot and shinbone. Within a period of one hundred years, Roman tailors had extended the *udo* up the leg to just above the knee, to be worn inside boots. Men who wore the stocking without boots were considered effeminate; and as these knee-length *udones* crept farther up the leg to cover the thigh, the stigma of effeminacy for men who sported them intensified.

Unfortunately, history does not record when and why the opprobrium of effeminacy attached to men wearing stockings disappeared. But it went slowly, over a period of one hundred years, and Catholic clergymen may well have been the pioneering trendsetters. The Church in the fourth century adopted above-the-knee stockings of white linen as part of a priest's liturgical vestments. Fifth-century church mosaics display full-length stockings as the vogue among the clergy and laity of the Roman Empire.

Stockings had arrived and they were worn by men.

The popularity of form-fitting stockings grew in the eleventh century, and they became trousers known as "skin tights." When William the Conqueror crossed the English Channel in 1066 and became the Norman king of England, he and his men introduced skin tights to the British Isles. And his son, William Rufus, wore French stocking pants (not much different in design from today's panty hose) of such exorbitant cost that they were immortalized in a poem. By the fourteenth century, men's tights so accurately revealed every contour of the leg, buttocks, and crotch that churchmen condemned them as immodest.

The rebellious nature of a group of fourteenth-century Venetian youths made stocking pants even more scandalous, splitting teenagers and parents into opposing camps.

A fraternity of men calling themselves La Compagna della Calza, or The Company of the Hose, wore short jackets, plumed hats, and motley skin tights, with each leg a different color. They presented public entertainments, masquerades, and concerts, and their brilliant outfits were copied by youths throughout Italy. "Young men," complained one chronicler of the period, "are in the habit of shaving half their heads, and wearing a close-fitting cap." And he reported that decent people found the "tight-fitting hose . . . to be positively immodest." Even Geoffrey Chaucer commented critically on the attire of youth in *The Canterbury Tales.* Skin-tight, bicolored stock-

From a fourteenth-century British illustration of an attendant handing stocking to her mistress. It's the first pictorial evidence of a woman wearing stockings.

ings may indeed have been the first rebellious fashion statement made by teenagers.

The stockings discussed so far were worn by priests, warriors, and young men. When did women begin to roll on stockings?

Fashion historians are undecided. They believe that women wore stockings from about A.D. 600. But because long gowns concealed legs, there is scant evidence in paintings and illustrated manuscripts that, as one eighteenth-century writer expressed it, "women had legs."

Among the earliest pictorial evidence of a woman in stockings is an illustrated 1306 British manuscript which depicts a lady in her boudoir, seated at the edge of the bed, with a servant handing her one of a pair of stockings. The other stocking is already on her leg. As for one of the earliest references to the garment in literature, Chaucer, in *The Canterbury Tales*, comments that the Wife of Bath wore stockings "of fine skarlet redde."

Still, references to women's stockings are extremely rare up until the sixteenth century. Female legs, though undoubtedly much admired in private, were something never to be mentioned in public. In the sixteenth century, a British gift of silk stockings for the queen of Spain was presented with full protocol to the Spanish ambassador, who drawing himself haughtily erect, proclaimed: "Take back thy stockings. And know, foolish sir, that the Queen of Spain hath no legs."

In Queen Elizabeth's England, women's stockings fully enter history, and

with fashion flair. In extant texts, stockings are described as colored "scarlet crimson" and "purple," and as "beautified with exquisite embroideries and rare incisions of the cutters art." In 1561, the third year of her reign, Elizabeth was presented with her first pair of knitted silk stockings, which converted her to silk to the exclusion of all other stocking fabrics for the remainder of her life.

It was also during Elizabeth's reign that the Reverend William Lee, in 1589, invented the "loome" for machine-knitting stockings. The Reverend Lee wrote that for the first time, stockings were "knit on a machine, from a single thread, in a series of connected loops." That year, the hosiery industry began.

Nylon Stockings: May 15, 1940, United States

Because of the public-relations fanfare surrounding the debut of nylon stockings, there is no ambiguity concerning their origin. Perhaps there should have been skepticism, though, of the early claim that a pair of stockings would "last forever."

The story begins on October 27, 1938, when the Du Pont chemical company announced the development of a new synthetic material, nylon, "passing in strength and elasticity any previously known textile fibers." On the one hand, the breakthrough meant that the hosiery industry would no longer be periodically jeopardized by shortages of raw silk for silk stockings. But manufacturers also feared that truly indestructible stockings would quickly bankrupt the industry.

While the "miracle yarn" was displayed at the 1939 World's Fair, women across America eagerly awaited the new nylon stockings. Test wearers were quoted as saying the garments endured "unbelievable hours of performance."

Du Pont had shipped selected hosiery manufacturers spools of nylon yarn, which they agreed to knit according to company specifications. The mills then allotted nylon stockings to certain stores, on the promise that none be sold before "Nylon Day," slated as May 15 of that year, 1940.

The hysteria that had been mounting across the country erupted early on that mid-May morning. Newspapers reported that no consumer item in history ever caused such nationwide pandemonium. Women queued up hours before store doors opened. Hosiery departments were stampeded for their limited stock of nylon stockings. In many stores, near riots broke out. By the close of that year, three million dozen pairs of women's nylons had been sold—and that number could have been significantly higher if more stockings were available.

At first, the miracle nylons did appear to be virtually indestructible. Certainly that was true in comparison to delicate silk stockings. And it was also true because, due to nylons' scarcity, women doubtless treated the one or two pairs they managed to buy with greater care than they did silk stockings.

In a remarkably short time, silk stockings were virtually obsolete. And nylon stockings became simply "nylons." Women after all had legs, and never before in history were they so publicly displayed and admired.

Sex-Related Words: Post–11th Century, England and France

With the conquest of England in 1066 by William of Normandy, the Anglo-Saxon language of the British Isles underwent several alterations. As the French-speaking Normans established themselves as the ruling caste, they treated the native Saxons and their language as inferior. Many Saxon words were regarded as crude simply because they were spoken by Saxons. Some of these words, once inoffensive, survived and passed eventually into English as coarse, impolite, or foul expressions. Etymologists list numerous examples of "polite" (Norman) and "impolite" (Saxon) words:

Norman	Anglo-Saxon
Perspiration	*Sweat*
Dine	*Eat*
Deceased	*Dead*
Desire	*Want*
Urine	*Piss*
Excrement	*Shit*

The mother tongue of the twelve kings and queens from William I (who ruled from 1066 to 1087) to Richard II (from 1377 to 1399) was the Normans' French, though the Anglo-Saxons' English continued to be spoken. When the two tongues blended into a new language, Middle English, which became the official language of the court in 1362 and the language for teaching in the universities at Oxford and Cambridge in 1380, we inherited many double expressions. In addition to those listed above, the Norman "fornicate" came to be the respectable replacement for the Saxon "fuck," which itself derived from the Old English word *fokken*, meaning "to beat against."

The Normans, of course, had obtained their word "fornicate" from an earlier language, and etymologists trace the origin to *fornix*, Latin for a small, vaulted-ceiling basement room that could be rented for a night. For in Roman Christian times, prostitutes practiced their trade secretly in such underground rooms, much the way a modern prostitute might rent a motel room. *Fornix* first became a noun synonymous with "brothel," then a verb meaning "to frequent a brothel," *fornicari*, and finally the name of the activity conducted therein.

The word "prostitute" comes to us from the Latin *prostitutus*, meaning

"offered for sale." It not only reflects that a hooker charges for services, but as the verb "to prostitute," connotes sacrificing one's integrity for material gain. "Prostitute" was itself a euphemism for the Old English word "whore," a term that once merely suggested desire.

"Hooker" is believed to be associated with General Joseph ("Fighting Joe") Hooker of Civil War fame. To bolster the morale of his men, General Hooker is supposed to have allowed prostitutes access to his troops in camp, where they became known as "Hooker's girls." When a section of Washington was set aside for brothels, it acquired the name Hooker's Division, and the local harlots became hookers.

The term "gay," synonymous today with "homosexual," dates back to thirteenth-century France, when *gai* referred to the "cult of courtly love"— that is, homosexual love—and a "lover" was a *gaiol*. Troubadour poetry of that period explicitly discusses this "cult" love. In the following centuries, the word was appropriated to describe first a prostitute, then any social undesirable, and lastly, in a homophobic British culture, to describe both homosexuality and the homosexual himself. Its first public use in the United States (aside from pornographic fiction) was in a 1939 Hollywood comedy, *Bringing Up Baby*, when Cary Grant, sporting a dress, exclaimed that he had "gone gay."

Chapter 14

From the Magazine Rack

Magazines in America: 1741, New England

Newspapers were developed to appeal to the general public; magazines, on the other hand, were intended from the start to deliver more narrowly focused material to special-interest groups, and they experienced a difficult birth. In America, early magazines failed so quickly and frequently that the species was continually endangered, several times extinct.

The origin of the magazine, following the development of the printing press in fifteenth-century Germany, was straightforward: printed single-page leaflets expanded into multipage pamphlets that filled the middle ground between newspapers and books. History's first magazine was the 1633 German periodical *Erbauliche Monaths-Unterredungen,* or *Edifying Monthly Discussions,* started by Johann Rist, a poet and theologian from Hamburg. Strongly reflecting its publisher's dual vocations, the "monthly" appeared whenever Rist could spare the time to write and print it, and its edifying contents strictly embodied the author's own views. It lasted, on and off, for five years—an eternity for early magazines.

Magazines for light reading, for diversion, and for exclusively female readership began appearing by the mid-seventeenth century. Two are notable for having established a format that survives to this day.

A 1672 French publication, *Mercure Galant,* combined poems, colorful anecdotes, feature articles, and gossip on the nobles at court. And in 1693, a British publisher took the bold step of introducing a magazine devoted to "the fairer sex." *Ladies' Mercury* offered advice on etiquette, courtship,

Magazines originated to fill the middle ground between newspapers and books.

and child rearing, plus embroidery patterns and home cosmetic preparations, along with dollops of light verse and heavy doses of gossip—a potpourri of how-tos, delights, and inessentials that could not be found in newspapers or books. The magazine found itself a niche and set forth a formula for imitators.

While "penny weeklies" thrived in centuries-old Europe, in the nascent American colonies they encountered indifferent readership, reluctant authorship, and seemingly insurmountable circulation problems that turned many a weekly into a semiannual.

Due to competitive forces, America's first two magazines, both political, were issued within three days of each other. In February 1741, Benjamin Franklin's *General Magazine, and Historical Chronicle, For all the British Plantations in America* was narrowly beaten to publication by the rival effort of publisher Andrew Bradford: *American Magazine, or A Monthly View of the Political State of the British Colonies.* A fierce quarrel ensued and both Philadelphia periodicals quickly folded; Bradford's after three months, Franklin's after six.

Numerous other magazines were started—spanning spectrums from poetry to prose, fact to fiction, politics to how-to—and most of them failed. Noah Webster lamented in 1788, "The expectation of failure is connected

with the very name of a Magazine." And the *New-York Magazine,* one of the longest-lived of the eighteenth-century ventures, went to its inevitable demise editorializing: "Shall every attempt of this nature desist in these States? Shall our country be stigmatised, odiously stigmatised, with want of taste for literature?"

Why such failure?

Three factors are to blame: broadly, the reader, the writer, and the mails.

The American reader: In 1741, the year Benjamin Franklin's magazine debuted, the population of the colonies was only about one million, whites and blacks, many of both races illiterate. This sparse population was scattered over an area measuring more than twelve hundred miles north to south along the seaboard, and at some points, a thousand miles westward. And in most regions the roads were, as one publication stated, "wretched, not to say shameful." Stagecoach travel between the major cities of Boston and New York took eight to ten days. Thus, it's not surprising that during the eighteenth century, no American magazine achieved a readership higher than fifteen hundred; the average number of subscribers was about eight hundred.

The American writer: Only less discouraging than a small and scattered readership was the unwillingness of eighteenth-century writers to contribute to magazines, which they viewed as inferior to books and newspapers. Consequently, most of the early American magazines reprinted material from books, newspapers, and European magazines. As the editor of the moribund *New-York Magazine* bemoaned, "In the present state of this Western World, voluntary contributions are not to be depended on."

The American mails: Horse-carried mail was of course faster than mail delivered by stagecoach, but magazines (and newspapers) in the eighteenth century were admitted to the mails only at the discretion of local postmasters. In fact, many of America's early magazine publishers were postmasters, who readily franked their own products and banned those of competitors. This gave postmasters immense power over the press, and it led to corruption in political campaigns, forcing politicians to pay regional postmasters in order to appear in print. Even the honorable Benjamin Franklin, appointed postmaster of Philadelphia in 1737, discriminated in what publications his post riders could carry.

Furthermore, the cost of a magazine was compounded by a commonplace postal practice: For more than fifty years, many American periodicals arrived by mail only if a subscriber paid a fee to both the local post rider and the regional postmaster. This practice was actually legalized in the Postal Ordinance Act of 1782. Publishers advertised that subscribers would receive issues "by the first opportunity," meaning whenever and however a magazine could be delivered.

One further problem bedeviled early American magazine publishers, one that has since been palliated but not solved: the delinquent customer. Today it is common practice to pay in advance or in installments, or to charge a

magazine subscription. But in the eighteenth century, a subscriber paid weeks or months after receiving issues—which, given the vagaries of the mail, never arrived, or arrived late or damaged. Poor incentives for paying debts. And there were no such intimidations as a collection agency or a credit rating.

The dilemma led publishers to strange practices. Desperate for payment, they often stated in their magazines that in lieu of cash they would accept wood, cheese, pork, corn, and other products. Isaiah Thomas, editor of the 1780s *Worcester Magazine,* wrote in an issue that his family was short on butter and suggested how delinquent subscribers could quickly clear their arrears: "The editor requests all those who are indebted to him for Newspapers and Magazines, to make payment—butter will be recieved in small sums, if brought within a few days."

In the face of so many fatal odds, why did American publishers continue to issue new magazines? Because they looked toward Europe and were reminded of the lucrative and prestigious possibilities of periodicals—if only the problems of readership, authorship, and the mails could be solved.

Ladies' Home Journal: 1883, Pennsylvania

In the year of America's centennial, a twenty-six-year-old Philadelphia newspaperman, Cyrus Curtis, conceived a family-oriented horticulture magazine, *Tribune and Farmer,* to sell for fifty cents for a year's subscription. Mrs. Curtis persuaded her husband to allot her space for a short regular column, which she proposed to title "Woman and the Home." He reluctantly consented. Mr. Curtis's magazine folded; his wife's contribution split off to become the *Ladies' Home Journal,* still in strong circulation today.

Issues in the early 1880s contained comparatively few pages—of recipes, household hints, needlepoint patterns, gardening advice, poems, and occasionally a short story. Unpretentious, inexpensively printed, the thin magazine offered great variety, and Mrs. Curtis, editing under her maiden name, Louise Knapp, clearly recognized her audience as America's middle-class homemakers. At the conclusion of its first year, the *Journal* had a circulation of 2,500, an impressive number for that day.

Cyrus Curtis, having abandoned his own publishing venture, concentrated on increasing the circulation of his wife's magazine. The older problems of limited readership and unreliable mail distribution no longer plagued publishers, but snagging the best writers of the day was a continuing challenge. Especially for a magazine whose hallmark was household hints. Curtis soon discovered that many established authors—Louisa May Alcott, for one—reserved their work for prestigious journals, even if the pay was slightly less.

For Cyrus Curtis, a breakthrough came when he learned that an offer to contribute to an author's favorite charity often was enough to win an article for his wife's magazine. Thus, Louisa May Alcott came to head the

Journal's "List of Famous Contributors," which Curtis publicized. This, and an aggressive advertising campaign, capped by a contest with cash prizes, caused circulation in 1887 to shoot up to 400,000; correspondingly, the magazine's size expanded to a handsome thirty-two pages per monthly issue.

In the 1890s, the magazine's appeal to American women was due in part to its newfound tone of intimacy. Editor Edward Bok, a bachelor, had instituted a chatty, candid personal-advice column, "Side Talks with Girls," which he himself initially wrote under the pseudonym Ruth Ashmore. Its phenomenal success—the first column drew seven hundred letters from women seeking counsel on matters from courtship to health—spawned "Side Talks with Boys" and "Heart to Heart Talks," and established "advice" and "self-improvement" features as magazine staples. And while other magazines of the day featured identical cover illustrations issue after issue, the *Journal* daringly changed its cover images monthly, setting another modern trend.

Not all the magazine's features were lighthearted and chatty. The *Journal* uncovered a major advertising hoax.

At the turn of the century, there was no national agency to screen the miracle claims made for scores of over-the-counter syrups and sarsaparillas. The federal government and the medical profession were continually battling companies nostrum by nostrum, claim by outrageous claim. Considerable controversy surrounded the top-selling Lydia E. Pinkham Vegetable Compound, a panacea for a spectrum of female woes. Advertisements for the product claimed that Miss Lydia herself was toiling away—"in her laboratory at Lynn, Massachusetts"—improving the compound. The *Ladies' Home Journal* proved that Lydia was actually in Pine Grove Cemetery near Lynn, where she had been resting for twenty years. To prove it, the magazine published a picture of the dated tombstone. No Watergate coup, to be sure, but the article heightened public awareness of falsehood in advertising, and the following year, 1906, Congress passed the long-awaited Federal Food and Drug Act.

The *Ladies' Home Journal* could rightfully boast that it became the first magazine in America to attain a circulation of one million readers.

Good Housekeeping: 1885, Massachusetts

The hallmark of the 1880s *Good Housekeeping: A Family Journal Conducted in the Interests of the Higher Life of the Household* was that it invited readers' contributions and sponsored contests. One of the earliest requests for contributions offered $250 for the best article on "How to Eat, Drink and Sleep as Christians Should." And initial contests awarded cash prizes for the most effective "Bug Extinguisher," the best "Bed Bug Finisher," and the most potent "Moth Eradicator," highlighting an entomological concern that apparently was of pressing significance to readers.

The thirty-two-page biweekly, which sold for $2.50 a year, was the brain-child of Massachusetts political writer and poet Clark Bryan. Scrapbookish in design, the magazine featured word puzzles and quizzes in addition to advice on home decorating, cooking, and dressmaking. Bryan's reliance on reader-written articles precluded an elite roster of contributors, but it helped immensely to popularize the homey periodical, offering a subscriber the opportunity to see his or her name and views in print. Each issue led with one of Bryan's own poems, but in 1898, after battling a serious illness, the magazine's founder committed suicide.

The magazine survived and thrived. And it continued to feature poems—by such writers as Amy Lowell, Edna St. Vincent Millay, Alfred Noyes, and Ogden Nash. By 1908, *Good Housekeeping* boasted a readership of 200,000 and was still printing articles like "Inexpensive Christmas Gifts," the kind Bryan had favored.

Clark Bryan did not live to see the words "Good Housekeeping" adapted as the country's first national badge of consumerism. Yet the Good House-keeping **Seal of Approval** arose out of Bryan's founding philosophy. To test the numerous recipes, spot-removing practices, salves, and labor-saving gadgets that subscribers recommended to other readers, the magazine set up its own Experimental Station in 1900. The station's home economists and scientists also tested products of the magazine's advertisers and published ads only for products that won approval. The concept was novel, innovative, much needed, and it rapidly gained the respect of readers. By 1909, the magazine had instituted its official Seal of Approval, an elliptical graphic enclosing the words "Tested and Approved by the Good House-keeping Institute Conducted by *Good Housekeeping Magazine.*" A guarantee of a product's quality and availability, the phrase passed into the American vernacular, where it was applied not only to consumer merchandise but colloquially to any person, place, or thing that met with approval.

Cosmopolitan: 1886, New York

Bearing the motto "The world is my country and all mankind are my countrymen," *Cosmopolitan* was born in Rochester, New York, in 1886, the idea of writer and publisher Paul J. Schlicht. The handsome magazine, with its high yearly subscription price of four dollars, was not at all successful. In accordance with its motto, the periodical featured articles on such disparate subjects as how ancient people lived, climbing Mount Vesuvius, the life of Mozart, plus European travel sketches and African wild animal adventures.

After a financial struggle, Schlicht sold the magazine to a former West Point cadet and diplomat to China, forty-year-old John Walker, a New Yorker. Although Walker was both praised and criticized for introducing "the newspaper ideas of timeliness and dignified sensationalism into periodical literature," under his leadership *Cosmopolitan* prospered. He raised the prestige of the magazine in 1892 by hiring the respected literary figure

William Dean Howells as a coeditor. And the first issue under Howells's stewardship was impressive: it carried a poem by James Russell Lowell; an article by Henry James; an essay by Thomas Wentworth Higginson, Emily Dickinson's mentor; and a feature by Theodore Roosevelt.

To further increase the magazine's circulation, Walker undertook a railroad tour of New England cities. New subscribers received as gifts the memoirs of either Grant or Sherman, and successful student salesmen of *Cosmopolitan* subscriptions won college scholarships. By 1896, the magazine held a secure place among the country's leading illustrated periodicals.

Walker's "dignified sensationalism" was not quite dignified enough for the subtler literary tastes of coeditor Howells, who resigned. But Walker's philosophy was appreciated by the public and by the Hearst Corporation, which acquired the magazine in 1905. Compared to its competitors, *Cosmopolitan* was expensive: thirty-five cents an issue during the '20s. But people did not seem to mind spending the money for dignified sensationalism, as well as for features by Theodore Dreiser and Stephen Crane. President Coolidge remarked when he selected the magazine to publish his newly completed autobiography, "When you pay thirty-five cents for a magazine, that magazine takes on in your eyes the nature of a book and you treat it accordingly."

Vogue: 1892, New York

To the American woman in the 1890s, *Vogue* depicted a sophisticated new world. George Orwell, the British literary critic and satirist, wrote that few of the magazine's pages were devoted to politics and literature, the bulk featured "pictures of ball dresses, mink coats, panties, brassieres, silk stockings, slippers, perfumes, lipsticks, nail polish—and, of course, of the women, unrelievedly beautiful, who wear them or make use of them."

In fact, it was for those women who "make use of them" that the magazine was designed.

Vogue began in 1892 as a society weekly for wealthy New Yorkers. The names of most of the two hundred fifty stockholders of its publishing company were in the Social Register, including a Vanderbilt, a Morgan, and a Whitney. According to its philosophy, the weekly was to be "a dignified, authentic journal of society, fashion, and the ceremonial side of life," with its pages uncluttered by fiction, unsullied by news.

The first issues were largely social schedules on soirees and coming-out parties. For the cover price of ten cents, average folk could ogle the galas, betrothals, marriages, travel itineraries, and gossip of New York's elite. The magazine mentioned Delmonico's with respect, and reported from the theater, concert hall, and art gallery with approval or disdain. Its avid coverage of golf suggested the sport was already a national craze.

Vogue was not for everyone. Its unique brand of humor—as when it printed: "Now that the masses take baths every week, how can one ever

distinguish the gentleman?''—often confounded or infuriated its more thoughtful readers. And the early magazine was edited by the brilliant but eccentric Josephine Redding, described as "a violent little woman, square and dark, who, in an era when everyone wore corsets, didn't." Renowned for her hats, which she was never seen to remove, she once, when confined to bed by illness, received her staff in a nightgown and a hat.

Vogue scored a coup in 1895, publishing detailed drawings of the three-thousand-dollar trousseau of Consuelo Vanderbilt, whose impending marriage to the duke of Marlborough was the Charles-and-Diana event of the day. No lesser magazine of that era would ever have been given access to the material.

In 1909, *Vogue* was purchased by publisher Condé Nast. Under his leadership, the magazine became primarily a fashion journal, still for the elite. An editorial that year proclaimed as the purpose of the magazine to "hold the mirror up to the mode, but to hold it at such an angle that only people of distinction are reflected therein." In the 1930s, Nast introduced *Mademoiselle,* geared for women aged seventeen to thirty, then *Glamour,* edited for the young career woman. But *Vogue* remained the company's proud centerpiece, America's preeminent chronicler of fashion and the fashionable, labeled by *Time* as "No. 1" in its field.

House Beautiful: 1896, Illinois

Its name was taken from a poem by Robert Louis Stevenson, "The House Beautiful," and that was the exact title of the original 1896 magazine. *The* was dropped in 1925.

Begun as a journal of "Simplicity and Economy" by Eugene Klapp, a Chicago engineer who had a flair for architecture and literature, the magazine cost a then-reasonable ten cents. It contained short, readable articles on home building and decorating, and the magazine's first page announced its philosophy: "A little money spent with careful thought by people of keen artistic perception will achieve a result which is astonishing." In other words, beauty and elegance were affordable to the average home owner. When Eugene Klapp joined the military in 1899, the magazine came into the capable hands of Harvard-educated Herbert Stone.

Possessing an abhorrence of pretension, Stone was perfectly suited to the magazine's homey philosophy. He oversaw a series of critical articles under the rubric "The Poor Taste of the Rich." The intent of the series was to assure readers "That Wealth Is Not Essential to the Decoration of a House," and to enlighten them to the fact "That the Homes of Many of Our Richest Citizens Are Furnished in Execrable Taste." The critical articles came amply illustrated with photographs of the offending mansions, and the names of the affluent residents were not withheld. The series generated considerable publicity but, interestingly, no lawsuits.

In 1898, *House Beautiful* instituted an annual competition for the best

design of a three-thousand-dollar home, regularly upping the limit to keep pace with inflation and prosperity. And when apartment house living gained ascendancy in the 1910s, the magazine offered the first articles on the special requirements in furnishing and decorating this new type of space. In reflecting such trends, the magazine's articles became a social barometer of middle-class American living; for example, the single title "Three-Bedroom House with Two-Car Garage for $8,650" (April 1947) could conjure up an era and its people's expectations.

Herbert Stone served as editor for sixteen years, but in 1915, returning home from a European holiday on the *Lusitania,* he drowned when the ship was sunk by a German submarine.

National Geographic: 1888, Washington, D.C.

With its yellow-boarded cover and timeless photographic essays, *The National Geographic Magazine* became an American institution soon after its introduction in October 1888. From the start, subscribers saved back issues, for quality nature photography (in black and white) was something of a new phenomenon, elevating the magazine to the nondisposable status of a book.

The landmark publication originated with the National Geographic Society as a means of disseminating "geographic knowledge." From the premier issue, the magazine specialized in maps of exotic rivers, charts of rain forest precipitation, reports on volcanology and archaeology, and adventurous forays by eminent scientists and explorers into foreign lands. In the era before air travel, *National Geographic* transported thousands of readers to regions they would never visit and most likely had never imagined existed. The adventure was to be had for a five-dollar membership in the society, with a year's subscription to the magazine.

An early president of the society was inventor Alexander Graham Bell. With the magazine's membership static at about thirteen hundred in 1897, Bell undertook the challenge of creating a new audience. Solicitation now took the form of a personal invitation to membership in the National Geographic Society, beginning, "I have the honor to inform you that you have been recommended for membership." A subscriber was assured that his or her money funded scientific exploration in new parts of the globe.

Bell also encouraged his contributing authors to humanize their adventure stories, enabling the reader to participate vicariously in the hardships and exhilarations of exploration. Peary, Cook, Amundsen, Byrd, and Shackleton were just a few of the renowned explorers who wrote firsthand accounts of their harrowing adventures. The society contributed to many expeditions, and a grateful Byrd once wrote, "Other than the flag of my country, I know of no greater privilege than to carry the emblem of the National Geographic Society." By 1908, pictures occupied more than half of the magazine's eighty pages.

But what significantly transformed *National Geographic* and boosted its

popularity was the advent of color photographs and illustrations.

The first color pictures appeared in the November 1910 issue: thirty-nine bright and exotic images of Korea and China, most of them full-page. Reader response was so great that following issues featured color photo spreads of Japan and Russia, and colored drawings of birds, which became a staple of the magazine. It claimed many photographic innovations: the first flashlight photographs of wild animals in their natural habitats, the first pictures taken from the stratosphere, and the first natural-color photographs of undersea life. One of the most popular single issues appeared in March 1919. Titled "Mankind's Best Friend," it contained magnificent color illustrations of seventy-three breeds of dogs.

From readers' admiring letters, the editors learned that while subscribers enjoyed studying the colorful dress of foreign peoples, they preferred even more the undress of bare-breasted natives in obscure parts of the globe. By 1950, *National Geographic* held a firm position among the top ten monthly periodicals in the world.

Scientific American: 1845, New York

A shoemaker at age fifteen and an amateur fiddler, Rufus Porter was also a tireless inventor—of cameras, clocks, and clothes-washing machines. Somewhere between his experiments with an engine lathe and electroplating in the summer of 1845, the native New Yorker launched a slender weekly newspaper, *Scientific American,* devoted to new inventions, including many of his own. A year later, bored with his latest endeavor, Porter sold his paper for a few hundred dollars.

The purchasers, Orson Munn and Alfred Beach, immediately increased the weekly from four to eight pages and broadened its scope to include short articles on mechanical and technical subjects. In those early years, *Scientific American* virtually ignored the fields of biology, medicine, astronomy, and physics.

Many of its technical articles were futuristic, some solid, others fanciful. In 1849, for instance, the magazine prematurely heralded the advent of subway transportation. In "An Underground Railroad in Broadway," the editors outlined plans for a subterranean tunnel to run the length of New York City's Broadway, with "openings in stairways at every corner." Since electric power was not yet a reality, the subway envisioned by the editors was quite different from today's: "The cars, which are to be drawn by horses, will stop ten seconds at every corner, thus performing the trip up and down, including stoppages, in about an hour."

When New York newspapers ridiculed the idea, editor Beach secured legislative approval to build instead an underground pneumatic tube system. In February 1870, workmen actually began digging a tunnel in lower Manhattan from Warren to Murray streets. As conceived, a car accommodating

eighteen passengers would fit snugly into the pneumatic tube. A compressed-air engine would blow it downtown, then, with the engine reversed, the car would be sucked uptown. Construction was still proceeding when the city's government, convinced that some sort of subway was feasible and essential, announced plans for a five-million-dollar elevated steam train.

The magazine's early contributors were among the greatest inventors of the period. Samuel Morse wrote about his dot-and-dash code, and Thomas Edison, who walked three miles to get his monthly copy of the journal, composed a feature in 1877 about his new "Talking Machine," the phonograph. The magazine's stated goal was "to impress the fact that science is not inherently dull, but essentially fascinating, understandable, and full of undeniable charm"—a goal that it achieved early in its history.

Life: 1936, New York

In November 1936, after months of experimentation and promotion, Henry Luce's *Life* magazine appeared on newsstands throughout the country. For a dime, a reader was entertained and enlightened by ninety-six pages of text and photographs: the first picture was of an obstetrician slapping a baby to consciousness and was captioned "Life Begins." The issue sold out within hours, and customers clamored to add their names to dealers' waiting lists for the next installment.

Although *Life* was the most successful picture magazine in history, it was not the first picture magazine, nor was it the first *Life*. Luce's product took its name from a picture periodical that debuted in 1883, the creation of an illustrator named John Mitchell.

Mitchell graduated from Harvard College with a degree in science and studied architecture in Paris. In 1882, he settled in New York City and decided to start a "picture weekly" that would make use of a new zinc etching method of reproducing line drawings directly instead of having them first engraved on wood blocks. Mitchell's *Life* was a magazine of humor and satire, and a showcase for many of his own comic illustrations. In its pages in 1877, Charles Dana Gibson, not yet twenty-one, introduced Americans to the serenely beautiful, self-reliant "Gibson Girl." Until the Depression, Mitchell's *Life* was one of America's most successful ten-cent weeklies.

Enter Henry Luce.

In 1936, Luce was searching for a catchy title for his soon-to-be-launched photographic picture magazine—which at the time was tentatively named *Look*. Luce purchased the name *Life* from Mitchell's illustrated humor magazine for $92,000.

Luce's *Life*, relating the news in photographs, found an eager audience in the millions of Americans enthralled with motion pictures. Images, rather than text, were a new and graphic way to convey a story, and *Life*'s gutsy and artful pictures read like text. The magazine's "picture essays" brought

to maturity the field of photojournalism. Within only a few weeks of its October 1936 debut, *Life* was selling a million copies an issue, making it one of the most successful periodicals in history.

Look: 1937, New York

Around the time Henry Luce was changing the proposed name of his picture magazine from *Look* to *Life,* newspaperman Gardner Cowles, Jr., was hard at work independently developing a similar periodical, to be called *Look. Look,* though, was no imitator of *Life,* nor were the magazines competitors— at first. In fact, Gardner Cowles and Henry Luce traded ideas on their projects. For a time, Luce was even an investor in *Look.*

Look actually evolved from the Sunday picture section of the Des Moines, Iowa, *Register and Tribune,* a newspaper owned by the Cowles family since early in the century. In 1925, the paper surveyed its readers and discovered that they preferred pictures to text. Thus, the newspaper began running series of photographs that told a story instead of a single picture with text. These "picture stories" were so successful that in 1933 the *Register and Tribune* began syndicating them to twenty-six other newspapers. It was then that Cowles formulated plans for a picture magazine.

Although Gardner Cowles and Henry Luce agreed on the power of visual images, their early magazines were fundamentally different. *Life,* an "information" weekly, was printed on slick stock and emphasized news, the arts, and the sciences, with an occasional seasoning of sex. *Look,* first a monthly, then a biweekly, was printed on cheaper paper and focused on personalities, pets, foods, fashions, and photo quizzes. As *Look* matured, it

grew closer in concept to *Life* and the two magazines competed for readers—with each magazine finding enough loyal followers to keep it thriving and competing for many years.

Ebony: 1945, Illinois

While *Look* and *Life* were top sellers, a new and significantly different American magazine appeared, capturing the readership of more than a quarter of the black adults in the country.

John Johnson, head of the Johnson Publishing Company, founded *Ebony* in 1945 specifically for black World War II veterans, who were returning home in large numbers. Johnson felt that these men, ready to marry and father children, needed wider knowledge of the world and could benefit from reading stories about successful blacks.

Johnson had already displayed a talent for persuading powerful whites to take him and his projects seriously. His first publishing venture had been a magazine called *Negro Digest.* He had raised the capital to launch that periodical, and when white magazine distributors refused to believe that a magazine for blacks could succeed, Johnson coaxed hundreds of his acquaintances to ask for the magazine at newsstands. And after several places agreed to stock *Negro Digest* on a trial basis, Johnson's friends then purchased all the copies. Chicago's white distributors, concluding that readership for a black magazine existed, welcomed Johnson's digest. Within months, circulation of *Negro Digest* rose to fifty thousand, and in 1943, when the magazine was a year old, Johnson persuaded Eleanor Roosevelt to write an article titled "If I Were a Negro." It generated so much publicity nationwide that before year's end, the circulation of *Negro Digest* trebled.

With *Ebony,* the black readership was strong but white advertisers shied away from the magazine. Johnson's breakthrough came with the Zenith Corporation. The electronics company's president, Commander Eugene McDonald, had journeyed to the North Pole with Admiral Peary and a black explorer, Matthew Henson. When Johnson approached Commander McDonald, he displayed an issue of *Ebony* featuring a story about Henson and the Peary expedition. The commander's nostalgia induced him to honor Johnson's request, and Zenith's advertisements in *Ebony* undermined the white wall of resistance. With *Ebony, Negro Digest,* and another publication, *Jet,* John Johnson captured a combined readership of twelve million, nearly half the black adults in America.

Esquire: 1933, New York

The immediate inspiration for *Esquire* was a publication that debuted in October 1931, *Apparel Arts,* a handsome quarterly for the men's clothing trade edited by Arnold Gingrich. *Apparel Arts* was popular but expensive;

Gingrich figured that American men might flock in large numbers to a version of the fashion magazine that could sell for a dime. He considered calling the spin-off *Trend, Stag,* or *Beau.* Then one day he glanced at an abbreviation in his attorney's letterhead, "Esq.," and had his title.

Gingrich felt certain that a market existed for *Esquire* because of reports from clothing stores that customers stole counter copies of *Apparel Arts.* It was customary for stores to display the thick quarterly, allowing customers to order from among its merchandise. Several East Coast stores had already asked Gingrich if he could produce an inexpensive, giveaway fashion brochure that customers could take home and browse through at leisure. Instead of a handout, Gingrich conceived of the ten-cent *Esquire,* and he prepared a dummy copy by cutting and pasting pictures and articles from back issues of its parent, *Apparel Arts.*

The first issue of *Esquire,* in October 1933, was an attractive, glossy quarterly of 116 pages, one third of them in color, but costing fifty cents. Although industry experts had predicted that a men's fashion magazine could sell no more than 25,000 copies, clothing stores alone ordered 100,000 copies of the initial issue; Gingrich immediately decided to make the magazine a monthly.

In addition to fashion, the premier issue included articles, short stories, and sports pieces bearing impressive bylines: Ernest Hemingway, John Dos Passos, Dashiell Hammett, and Gene Tunney. And *Esquire* continued as a magazine of fashion and literary distinction, featuring writings by Thomas Mann, D. H. Lawrence, André Maurois, and Thomas Wolfe. Hemingway first published "The Snows of Kilimanjaro" in its pages, F. Scott Fitzgerald contributed original stories, Arthur Miller wrote "The Misfits" for the magazine, which also introduced new plays by William Inge and Tennessee Williams. By 1960, the magazine that had been conceived as a free clothing store handout was generating yearly advertising revenue in excess of seven million dollars and had a circulation of almost a million. One can only speculate on its success had Arnold Gingrich called it *Stag.*

Reader's Digest: 1922, New York

The son of a Presbyterian minister from St. Paul, Minnesota, DeWitt Wallace had an idea for a small family digest that might at best earn him five thousand dollars a year. He believed that people wished to be well informed, but that no reader in 1920 had the time or money to read the scores of magazines issued weekly. Wallace proposed to sift out the most noteworthy articles, condense them for easy reading, and gather them into a handy periodical the size of a novella.

From back issues of other magazines, Wallace prepared his dummy. Two hundred copies of the prototype, already named *Reader's Digest,* were mailed to New York publishers and other potential backers. No one expressed the least interest. So Wallace and his fiancée, Lila Bell Acheson, the daughter

of another Presbyterian minister, rented an office in New York's Greenwich Village and formed the Reader's Digest Association. They condensed magazine articles, and prepared a mimeographed circular soliciting subscriptions, which they mailed to several thousand people on their wedding day, October 15, 1921. When they returned from their honeymoon two weeks later, the Wallaces found they had fifteen hundred charter subscribers at three dollars each. They then set to work on issue number one of *Reader's Digest,* dated February 1922.

With success came an unanticipated problem.

At first, other magazines readily granted the *Digest* permission to reprint articles without fees. It was publicity. But as circulation increased, the *Digest* was suddenly viewed as a competitor, cannibalizing copy and cutting into advertising revenue and readership. Soon many of the country's major magazines refused the Wallaces reprint rights.

In 1933, to maintain the appearance of a digest, DeWitt Wallace instituted a controversial practice. He commissioned and paid for original articles to be written for other magazines, with the proviso that he be permitted to publish excerpts. Critics lambasted them as "planted articles," while Wallace more benignly called them "cooperatively planned." Magazines with small budgets welcomed the articles, but larger publications accused Wallace of threatening the free flow of ideas and determining the content of too many publications. The practice was discontinued in the 1950s. By that time, the wholesome family digest that praised a life of neighborliness and good works was earning thirty million dollars a year, and had recently launched a new venture, the Reader's Digest Condensed Book Club. In the next decade, its circulation would climb to fifteen million readers.

TV Guide: 1953, Pennsylvania

The magazine that would achieve a weekly circulation of seventeen million readers and change the way Americans watched television was born out of a telephone conversation.

In November 1952, Merrill Panitt, a television columnist for the *Philadelphia Inquirer* and an administrative assistant at Triangle Publications, received a phone call from his employer at Triangle, Walter H. Annenberg. The influential businessman had spotted a newspaper advertisement for a new weekly magazine, *TV Digest.* Annenberg instructed Panitt to learn more about the proposed publication and discover if there were any others like it around the country. Before that phone call was concluded, Annenberg had convinced himself to publish a national television magazine with local program listings. By the time he had hung up, he had laid out in principle what was to become one of America's top-selling periodicals.

Panitt learned that local television magazines existed in at least New York City, Philadelphia, Chicago, and Los Angeles. Annenberg moved quickly

to acquire these publications, while contemplating what to name his own venture.

Panitt began the work of assembling a national editorial staff. Since there was no reservoir of stories or photos to fall back on, assignments were issued quickly. Red Smith, later to win a Pulitzer Prize, was hired to contribute a regular sports column.

At the Philadelphia headquarters, the editors had no trouble in deciding whom to put on their first cover. There had never been a television show as popular as *I Love Lucy*. It was a national phenomenon. President Eisenhower delayed an address to the nation rather than run against *Lucy*, and since the show aired on the night America's department stores remained opened till nine-thirty, stores across the country installed television sets, hoping to win back shoppers who were staying home by the tens of thousands rather than miss their favorite program. Since the entire country had followed Lucy's pregnancy and her baby's birth on television, the editors decided to highlight the baby, Desidero Alberto Arnaz IV, and to place Lucy's familiar face in the magazine's upper-right-hand corner.

TV Guide made its debut in April 1953, in ten different editions, with regional program listings. Although that first issue was a resounding success, weekly circulation began a strange and unanticipated decline. No one at the new publication had taken into account a social practice of the '50s: With the majority of American homes lacking air-conditioning, television viewing declined precipitously in the summer months, while families opted for outdoor recreation, even if it was only to rock on the front porch to catch a breeze.

With the approach of fall, the circulation of *TV Guide* rose steadily, and the editors made an innovative move in devoting one issue to the shows scheduled for the new 1953–54 season. That first Fall Preview Issue sold out at newsstands and supermarkets and started a tradition. In fact, the annual Fall Preview quickly became *TV Guide*'s biggest issue in advertising revenue and circulation. Today, headquartered in Radnor, Pennsylvania, the magazine publishes 108 local editions, covering every state but Alaska.

Time: 1923, New York

Almost titled *Chance* or *Destiny*, the most popular news weekly in the history of publishing, *Time*, sprang out of a close collegiate friendship between two extraordinarily different men.

Briton Hadden, born in Brooklyn in 1898 of well-to-do parents, had shown an interest in journalism since childhood, when he entertained his family with poems and stories and his classmates with a newspaper, the *Daily Glonk*. He secured his first professional writing position, with the *New York World*, after informing its editor, who had tried to dismiss him, "You're interfering with my destiny."

Whereas Hadden was extroverted and prankish, Henry Luce was serious

and pragmatic. He was the son of a Presbyterian missionary who had founded two American universities in China, where Luce was born. Family members were required to spend at least an hour a day in some effort that benefited mankind.

Henry Luce met Briton Hadden at the Hotchkiss School in Lakeville, Connecticut, and an immediate and intense bond developed between the young men. Hadden edited the school newspaper, the *Hotchkiss Record,* while Luce published the *Hotchkiss Literary Monthly,* contributing essays and poetry. At Yale University, their friendship strengthened, with Hadden as chairman of the *Yale News* and Luce its managing editor. They jointly interrupted their college careers in 1918 to enlist in the Student Army Training Corps, and it was then that they conceived the idea of founding a national news weekly.

The magazine the two men eventually produced in 1923 was considerably different from the *Time* of today.

They had drawn up a prospectus for a publication that featured condensed rewrites of information that appeared in daily newspapers—mainly the *New York Times.* The prospectus read: "TIME collects all available information on all subjects of importance. The essence of all this information is reduced to approximately 100 short articles, none of which are over 400 words. No article will be written to prove any special case." For capital, the two twenty-four-year-old men had turned to the wealthy families of their Yale friends. The mother of one classmate wrote out a check for twenty thousand dollars, though uncertain the venture would succeed; before her death, the investment had appreciated to more than a million dollars.

From a foot-high stack of newspapers, the two men and their small staff produced the first issue of *Time,* which appeared in March 1923. Its thirty-two pages contained more than two hundred concise rehashed "items," as Hadden dubbed the separate pieces, ranging in length from a mere three lines to one hundred lines. The cover portrait was a simple charcoal sketch of a recently retired congressman, Joseph Gurney Cannon. That first issue, it was written, met with "a burst of total apathy on the part of the U.S. press and public." And when Hadden and Luce asked a prominent figure for advice on their first issue, he answered, "Let the first be the last."

Undaunted, the two young editors revamped their magazine and its cover, introducing around the cover portrait a red margin which would become a *Time* trademark. But most important, they hired a staff to perform its own original reporting and writing. And the magazine acquired a reputation for its own variously acerbic, supercilious, and humorous writing style. *Time*'s writers coined words, committed puns, inverted syntax, and interjected tropes, epithets, and esoteric terms into nearly every paragraph.

These eccentricities came to be called the "*Time* style." Many of the magazine's phrases entered the American vernacular: "Tycoon," a phonetic spelling of the Japanese *taikun,* meaning "mighty lord," used only infre-

quently in English, gained immense popularity. To a lesser degree, the magazine familiarized Americans with "pundit," from the Hindu *pandit,* meaning "learned one," and "kudos" (from the Greek *kydos,* meaning "glory"), employed by *Time* editors mainly to refer to honorary degrees. Forgotten *Time* neologisms include tobacconalia, improperganda, and radiorating.

The magazine that had been the dream of two college boys become a national, then an international, phenomenon.

When Hadden died in 1929 of a streptococcus infection—a week before the sixth anniversary of *Time*'s founding and not long after his thirty-first birthday—he left stock worth over a million dollars. In a boxed announcement on the first page of the next issue, a brokenhearted Henry Luce wrote of his college friend in the succinct, convoluted prose that had become the magazine's hallmark: "Creation of his genius and heir to his qualities, *Time* attempts neither biography nor eulogy of Briton Hadden."

The organization founded by Henry Luce would go on to fill home magazine racks with a selection of periodicals that made publishing history.

Fortune appeared in February 1930. The small business section of *Time* could not accommodate the wealth of material its staff produced weekly, and in 1928, Henry Luce suggested that the company launch a periodical of restricted circulation to use *Time*'s business pages' surplus.

Christened *Fortune* by Luce, the new magazine was a success from the start. As it grew in size, readership, and scope, its founder prided himself on the periodical's record for accuracy amidst the torrent of facts and figures it regularly published. The magazine's editors were so confident of that accuracy that in May 1937 they offered readers five dollars for every factual error they could find in *Fortune*'s pages. Not many readers nibbled at the five-dollar bait. But when the amount was doubled, nearly a thousand letters poured in. The editors conceded to two "major" errors, twenty-three "minor" ones, and forty discrepancies they labeled "small points." They paid out four thousand dollars, then withdrew the offer because of the time involved in reading, checking, and answering readers' allegations.

Following *Time* (1923), *Fortune* (1930), and *Life* (1936), the Luce publishing empire again made magazine history in 1954, with *Sports Illustrated,* and in 1973, with *People.* These two periodicals transformed the hackneyed journalism of the traditional sports and fan magazines into a new level of quality and popularity. In sifting through a magazine rack today, it is hard not to come upon a publication that owes its existence to the company started by two college classmates and lifelong friends, Briton Hadden and Henry Luce.

Newsweek: 1933, New York

The Depression year of 1933 was a bleak period for starting a news weekly, especially since *Time* seemed to have captured that particular audience. Nonetheless, *Newsweek* was launched that year, in which one American

worker in four was unemployed, when businesses were failing at the rate of 230 a day, and when newspapers were called "Hoover blankets" and were valued as much for their warmth as for their information.

Newsweek was founded by a disgruntled *Time* staffer. Thomas Martyn, an Englishman, had been hired by Hadden and Luce as *Time*'s first foreign news editor, under the mistaken notion that he was an experienced writer on world affairs. After gaining his first professional writing experience at *Time*, Martyn moved on to the *New York Times*, then he quit the newspaper to draw up a prospectus for his own news weekly.

Thomas Martyn gave both personal and professional reasons for starting his own periodical: He wished to "run Henry Luce out of business," but he also firmly believed he could produce a better magazine. As he once wrote: "I think there's room for another news magazine that isn't quite as acid, that does a more thorough job of reporting, that can dig out the facts behind the news and give the news more meaning."

Armed with an editorial staff of twenty-two, and a suitcase full of newspapers clips to serve as basic source material, Martyn published the first issue of *News-Week* on February 17, 1933, for ten cents a copy. The magazine's multi-image cover, containing pictures of seven important news events, one for each day of the week, thoroughly confused newsstand customers. Even when Martyn switched to a single cover photograph for each issue, sales did not significantly increase.

Surviving four years of severe financial hardships, in 1937 the magazine modified its name to *Newsweek.* And abandoning the digest-like format, the editors announced a "three-dimensional editorial formula" consisting of the breaking news itself, a background perspective on the news story, and an interpretation of its significance.

To accomplish this comprehensive approach to news, the magazine established its own information-gathering network of correspondents and bureaus. And that same year, *Newsweek* began the tradition (later followed by *Time*) of clearly separating fact from opinion by having writers sign columns of commentary so they would not be confused with neutral reporting. The new approach paid off, and by 1968, though *Newsweek* had certainly not "run Henry Luce out of business," it had topped its major rival, *Time,* in advertising pages, establishing a trend that would continue into the 1980s.

Chapter 15

At Play

Marbles: 3000 B.C., Egypt

In his 1560 masterpiece *Children's Games,* Flemish painter Pieter Brueghel the Elder depicts children of his era at play: spinning hoops, patting mud pies, tossing jacks, dressing dolls, teetering on stilts, and shooting marbles— some eighty activities in all. It is clearly displayed that many games played today were enjoyed by children five hundred years ago. And several of those games, one being marbles, were part of the daily play of Egyptian children 4,500 years earlier.

With marbles, as with many ancient games, it is important to differentiate between adults' divination and children's diversion. For many toys, as we'll see, originated to augur the fortunes of kings and tribes, and only through disuse were bequeathed to youngsters.

Marbles, in the form of the knucklebones of dogs and sheep, existed in the Near East as auguries more than a thousand years before they became toys. Archaeologists have deduced the transformation from religious article to toy based in part on where ancient marbles were unearthed: among the ruins of a temple or in a child's tomb. Thus, the oldest game marbles are taken to be a set of rounded semiprecious stones buried with an Egyptian child around 3000 B.C. in a gravesite at Nagada.

On the Greek island of Crete, Minoan youths played with highly polished marbles of jasper and agate as early as 1435 B.C. And it is the Greeks, from their term for a polished white agate, *marmaros,* who gave us the word "marble."

In the ancient world, a marble's composition often reflected the economic and technologic state of a culture. For the advanced and cultured Minoans,

Marbles: A children's game and an adult augury that existed in every culture.

marbles of semiprecious stone were standard, whereas ordinary stone and pellets of clay formed the marbles of the austere-living inhabitants of the British Isles (even among the ruling class); even more primitive peoples used olives, hazelnuts, chestnuts, and rounded galls from the oak tree. Rustic as many Celtic, Saxon, and African tribes were, their children did not want when it came to marbles. The game developed independently in virtually every ancient culture.

Marbles was a popular game among Roman children. The first Roman emperor, Caesar Augustus, would descend from his litter in order to join street children shooting marble pebbles and galls. Even clear glass marbles, fused from silica and ash, were manufactured in ancient Rome. Despite the numerous marble artifacts obtained from ruins and the many references to the sport in extant texts, rules on how the game was played do not exist.

Tops: 3000 B.C., Babylonia

It would take modern minds schooled in the kinematics of rotation to understand the complex forces that combine to keep a top spinning upright. But it did not require a probing mind, or a knowledge of mechanics, to discover that a conical object, given a twist, executed a fascinating blur of

Medieval German top; the top as a mechanical motor.

motion. Clay tops, their sides etched with animal and human forms, were spun by Babylonian children as early as 3000 B.C. The unearthed artifacts appear to have been toys, since they were discovered in children's gravesites alongside sets of marbles.

A decorated top is more interesting to watch as its rotation slows and its images become discernible, and the earliest known toy tops were all scored or painted with designs. The ancient Japanese painted tops intricately, and they were the first to create holes around the circumference of the clay toys to produce tops that hummed and whistled.

Hula Hoop: 1000 B.C., Near East

In 1958, a hula hoop craze swept the United States. Hoops of brightly colored plastic, placed round the waist, were fiercely rotated by wriggling the hips. Stores sold out stock as quickly as it arrived. Within six months, Americans bought twenty million hula hoops, at $1.98 apiece. And doctors treated young and old alike for back and neck injuries and warned of greater dangers.

The hula hoop game, though, was not new; nor were the medical warnings. Both originated centuries ago.

Children in ancient Egypt, and later in Greece and Rome, made hoops from dried and stripped grapevines. The circular toys were rolled on end, propelled along by a rod, tossed into the air and caught around the body, and swung round the waist. In an ancient British game, "kill the hoop," the center of the rolling toy became the target for hurled darts. South American cultures devised play hoops from the sugarcane plant.

370

Historians of children's games record a "hula" hoop craze that swept England during the fourteenth-century Edwardian era. Children and adults twirled hoops made of wood or metal round their waists, and physicians treated the accompanying aches, pains, and dislocated backs. As with the modern craze, many adult deaths by heart failure were attributed to excessive hoop twirling, and the British medical profession warned that "hoops kill," a macabre reversal of "kill the hoop."

The name "hula" did not become associated with the game until the 1700s. Then hula was a sensuous, mimetic Hawaiian dance, performed sitting or standing, with undulating hip gestures. Originally a religious dance, performed to promote fecundity, honor Hawaiian gods, and praise the tribal chief, the hula, with its explicit sensuality—accented by bare-breasted female dancers in short *pa'us* skirts and men in briefer *malos* loincloths—shocked missionaries from Britain and New England. They discouraged men from dancing the hula and compelled native women to replace the skimpy *pa'us* with the long grass *holokus*. The dance's hip gyrations so perfectly matched the motions required to rotate a toy hoop that "hula" became the name of the game.

Yo-Yo: 1000 B.C., China

In the sixteenth century, hunters in the Philippines devised a killer *yo-yo* of large wood disks and sturdy twine. The weapon was hurled, and its twine ensnared an animal by the legs and tripped it to the ground for an easy kill. The *yo-yo* was a hunter's aid, similar to the Australian boomerang, in that both devices were intended to incapacitate prey at a distance, and its name was a word from Tagalog, an Indonesian language and the chief native tongue of the Philippine people. The *yo-yo* was no toy.

In the 1920s, an enterprising American named Donald Duncan witnessed the Philippine *yo-yo* in action. Scaling down the size of the weapon, he transformed it into a child's toy, retaining the Tagalog name. But Duncan's yo-yo was not the first double-disk-and-twine game.

Yo-yo-like toys originated in China about 1000 B.C. The Oriental version consisted of two disks sculpted from ivory, with a silk cord wound around their connecting central peg. The Chinese toys eventually spread to Europe, where in England the plaything was known as a "quiz," while in France it was a "bandalore." These European yo-yos were richly decorated with jewels and painted geometrical patterns that while bobbing created mesmerizing blurs.

Kite: 1200 B.C., China

Kites originated in China as military signaling devices. Around 1200 B.C., a Chinese kite's color, its painted pattern, and particularly the air movements it was forced to execute communicated coded messages between camps.

The ancient Chinese became so proficient in constructing huge, lightweight kites that they attempted, with marginal success, to employ them as one-man aircraft. The flier, spread-eagled upon the upper surface of a bamboo-and-paper construction, held hand grips and hoped for a strong and steady wind.

Ancient Chinese silk prints and woodcuts show children flying small kites of ingenious design, whose variety of weighted tails indicates that the aerodynamic importance of tails was appreciated early in kite construction. From China, kites traveled to India, then to Europe, and in each new land their initial application was in military communications, where they complemented older signaling devices such as hillside beacon fires and coded bursts of smoke.

By the twelfth century, European children were flying "singing" kites, which whistled by means of small holes in the kite's body and the use of multiple vibrating cords. Kites carrying atmospheric measuring equipment played a vital role in the science of meteorology, and knowledge gleaned from centuries of kite construction helped establish the field of aerodynamics. Today the kite survives in all cultures as a toy.

Frisbee: Pre-1957, Connecticut

It was the Frisbie Pie Company of Bridgeport, Connecticut, whose name—and lightweight pie tins—gave birth to the modern Frisbee.

In the 1870s, New England confectioner William Russell Frisbie opened a bakery that carried a line of homemade pies in circular tin pans embossed with the family surname. Bridgeport historians do not know if children in Frisbie's day tossed empty tins for amusement, but sailing the pans did become a popular diversion among students at Yale University in the mid-1940s. The school's New Haven campus was not far from the Bridgeport pie factory, which served stores throughout the region. The campus fad might have died out had it not been for a Californian, Walter Frederick Morrison, with an interest in flying saucers.

The son of the inventor of the sealed-beam automobile headlight, Morrison was intrigued with the possibility of alien visits from outer space, a topic that in the '50s captured the minds of Hollywood film makers and the American public. Hoping to capitalize on America's UFO mania, Morrison devised a lightweight metal toy disk (which he'd later construct of plastic) that in shape and airborne movements mimicked the flying saucers on movie screens across the country. He teamed up with the Wham-O Company of San Gabriel, California, and on January 13, 1957, the first toy "Flyin' Saucers" debuted in selected West Coast stores.

Within a year, UFOs in plastic were already something of a hazard on California beaches. But the items remained largely a Southern California phenomenon.

To increase sales, Wham-O's president, Richard Knerr, undertook a pro-

Frisbee originated on an American college campus in the 1940s, but it had a historical antecedent.

motional tour of Eastern college campuses, distributing free plastic UFOs. To his astonishment, he discovered students at two Ivy League schools, Yale and Harvard, playing a lawn game that involved tossing metal pie tins. They called the disks "Frisbies" and the relaxation "Frisbie-ing." The name appealed to Knerr, and unaware of the existence of the Frisbie Pie Company, he trademarked the word "Frisbee" in 1959. And from the original pie tin in the sky, a national craze was launched.

Rattles: 1360 B.C., Egypt

Dried gourds and clay balls stuffed with pebbles were people's earliest rattles, which were used not for play but to frighten off evil spirits. Rattling was invoked by tribal priests at the time of a birth, sickness, or death, transitions in which early peoples believed they were especially susceptible to evil intrusions. Societies that bordered the sea constructed religious rattles from bivalve shells filled with pebbles.

The first rattles designed for children's amusement appeared in Egypt near the beginning of the New Kingdom, around 1360 B.C., and several are displayed in that country's Horniman Museum. Many were discovered in children's tombs; all bear indications that they were intended to be shaken by children: Shaped like birds, pigs, and bears, the clay rattles are protec-

373

tively covered in silk, and they have no sharp protuberances. A pig's ears, for instance, were always close to the head, while birds never had feet, legs, or pointed beaks. Many rattles are painted or glazed sky blue, a color that held magical significance for the Egyptians.

Today, in tribal Africa, rattles are still made from dried seed pods. And their multiple uses are ancient: making music, frightening demons, and amusing children.

Teddy Bear: 1902, United States

Despite the popularity today of toy bears with names such as Bear Mitzvah, Lauren Bearcall, and Humphrey Beargart, the classic bear is still the one named Teddy, who derived his moniker from America's twenty-sixth President.

In 1902, an issue of the *Washington Star* carried a cartoon of President Theodore Roosevelt. Roosevelt, drawn by Clifford Berryman, stood rifle in hand, with his back turned to a cowering bear cub; the caption read: "Drawing the line in Mississippi." The reference was to a trip Roosevelt had recently taken to the South in the hope of resolving a border dispute between Louisiana and Mississippi.

For recreation during that trip, Roosevelt had engaged in a hunting expedition sponsored by his Southern hosts. Wishing the President to return home with a trophy, they trapped a bear cub for him to kill, but Roosevelt refused to fire. Berryman's cartoon capturing the incident received nationwide publicity, and it inspired a thirty-two-year-old Russian-immigrant toy salesman from Brooklyn, Morris Michtom, to make a stuffed bear cub. Michtom placed the cub and the cartoon in his toy-store window. Intended as an attention-getting display, the stuffed bear brought in customers eager to purchase their own "Teddy's Bear." Michtom began manufacturing stuffed bears with button eyes under the name Teddy's Bear, and in 1903 he formed the Ideal Toy Company.

The American claim to the creation of the Teddy Bear is well documented. But German toy manufacturer Margaret Steiff also began producing stuffed bear cubs, shortly after Morris Michtom. Steiff, who at the time already headed a prosperous toy company, claimed throughout her life to have originated the Teddy Bear.

Margaret Steiff, who would become a respected name in the stuffed-toy industry, was a polio victim, confined to a wheelchair. In the 1880s in her native Germany, she began hand-sewing felt animals. As German toy manufacturers tell it, shortly after the Clifford Berryman cartoon appeared, an American visitor to the Steiff factory showed Margaret Steiff the illustration and suggested she create a plush toy bear. She did. And when the bears made their debut at the 1904 Leipzig Fair, her firm was overwhelmed with orders. It seems that the Teddy Bear was an independent American and

President Theodore Roosevelt inspired the teddy bear, which became the most popular children's toy of the 1910s.

German creation, with the American cub arriving on the toy scene about a year earlier.

The stuffed bear became the most popular toy of the day. During the first decade of this century, European and American manufacturers produced a variety of toy bears, which ranged in price from ninety-eight cents to twelve dollars, and factories supplied them with sweaters, jackets, and overcoats. For a while, it appeared that dolls were about to become obsolete.

Crossword Puzzle: 1913, New York

The concept of the crossword puzzle is so straightforwardly simple that it is hard to believe the puzzles were not invented prior to this century, and that "crossword" did not enter American dictionaries as a legitimate word until 1930.

The crossword puzzle was the brainchild of an English-born American journalist. In 1913, Arthur Wynne worked on the entertainment supplement, *Fun,* of the Sunday edition of the *New York World.* One day in early December, pressured to devise a new game feature, he recalled a Victorian-era word puzzle, Magic Square, which his grandfather had taught him.

Magic Square was a child's game, frequently printed in nineteenth-century British puzzle books and American penny periodicals. It consisted of a group of given words that had to be arranged so the letters read alike vertically and horizontally. It exhibited none of the intricate word criss-crossings and blackened squares that Wynne built into his game. And where Magic Square gave a player the words to work with, Wynne created a list

of Down and Across "clues," challenging the player to deduce the appropriate words.

In the December 21 edition of the *World*, American readers were confronted with the world's first crossword puzzle. The Sunday feature was not billed as a new invention, but was only one of a varied group of the supplement's "mental exercises." And compared to the taxing standards of today's crossword puzzles, Wynne's was trivially simple, containing only well-known words suggested by straightforward clues. Nonetheless, the game struck the public's fancy.

Within months, Wynne's "mental exercise" was appearing in other newspapers, and by the early 1920s, every major U.S. paper featured its own crossword puzzle. The publishing firm of Simon & Schuster released the first book of crossword puzzles, and in 1924, crossword books held the top four positions on the national best-seller list. Booksellers nationwide experienced an unexpected bonus: dictionaries were selling at a faster rate than at any previous time in history.

In 1925, Britain succumbed to crossword mania, with one publication observing that "the puzzle fad becomes a well-entrenched habit." Soon the puzzles began to appear in almost every language except those, like Chinese, that do not lend themselves to a letter-by-letter vertical and horizontal word construction. Crossword puzzles were such an international phenomenon by the early '30s that women's dresses, shoes, handbags, and jewelry were patterned with crossword motifs. While other games have come and gone, crossword puzzles have continued to become more and more challenging. Regularly enjoyed by more than fifty million Americans today, the crossword puzzle is rated as the most popular indoor game in the country.

Board Games: 3000 B.C., Mesopotamia

In 1920, British archaeologist Sir Leonard Woolley discovered among the ruins of the ancient Mesopotamian city of Ur a gaming board considered to be the oldest in the world. Each player had seven marked pieces, and moves were controlled by the toss of six pyramidal dice, two of the four corners tipped with inlay. Three dice were white, three lapis lazuli. Though the game's rules are unknown, the board is on display at the British Museum and its markings suggest it was played like backgammon.

Vying for the record as oldest board game is *senet*, the most popular game in Egypt some 4,300 years ago. Played by peasants, artisans, and pharaohs, the game consisted of a race across a papyrus playing board, with each player moving five ivory or stone pieces. The game was such a popular pastime that it was placed in the tombs of pharaohs; Tutankhamen's game of *senet* was discovered when his tomb was opened in the 1920s.

Board games began as a form of divination, with a scored board and its marked pieces the equipment of sages and soothsayers. The historical crossover point from religion to recreation is unknown for many games.

But as late as 1895, when the French army attacked the capital of Madagascar, the island's queen and her advisers turned for a prophetic glimpse of the battle's outcome to the ancient board game of *fanorona,* a relative of checkers. The advances, retreats, and captures of the game's white and black pieces represented divine strategy, which was followed even in the face of imminent defeat.

Chess. One of the oldest board games to survive to the present day, chess was thought to have been devised by a Hindu living in northwest India in the late fifth century A.D. Or by the ancient Persians, since they played a similar game at that time, and since the expression "checkmate" derives from the Arabic phrase *al shah mat,* meaning "the king is dead."

Recently, however, the discovery in the Soviet Union of two ivory chessmen dating to the second century A.D. preempts the Indian and Persian claims.

In the eleventh century, Spain became the first European country introduced to chess, and through the travels of the Crusaders the game became a favorite of the cultured classes throughout Europe.

Checkers. The game of checkers began in Egypt as a form of wartime prognostication about 2000 B.C. and was known as *alquerque.* There were "enemy" pieces, "hostile" moves, and "captures." Examples of the game have been found in Egyptian tombs, and they, along with wall paintings, reveal that *alquerque* was a two-player game, with each player moving as many as a dozen pieces across a checkered matrix. Adopted and modified slightly by the Greeks and the Romans, checkers became a game for aristocrats.

Parcheesi: 1570s, India

The third all-time top-selling board game in America, Parcheesi originated in sixteenth-century India as the royal game—a male chauvinist's delight.

The game's original "board" was the royal courtyard of Mogul emperor Akbar the Great, who ruled India from 1556 to 1605. The game's pawns, moving in accordance with a roll of the emperor's dice, were India's most beautiful young women, who stepped from one marked locale to another among the garden's lush flowering shrubs.

The dice were cowries, brightly colored, glossy mollusk shells, which once served as currency. A shell landing with its opening upward counted as one step for a pawn. The country's most exquisite women vied for the honor of being pieces in the emperor's amusement of *pacisi,* Hindu for "twenty-five," the number of cowrie shells tossed in a roll.

During the Victorian era, the India entertainment was converted into a British board game, Pachisi. Its scallop-shaped path, traversed by ivory pawns, was a replica of the footpaths in Akbar's garden. In America, as

Parcheesi, the game became a favorite of such figures as Calvin Coolidge, Thomas Edison, and Clara Bow, and it was trademarked in 1894 by the firm of Selchow & Righter, which would later manufacture Scrabble. The board's center, marked "Home," a pawn's ultimate goal, originally was Akbar's ornate garden throne. One of the Indian *pacisi* gardens survives today at the palace in Agra.

Monopoly: 1933, Pennsylvania

Two of the most enduring modern board games—one known technically as a "career" game, the other as a "word" game—are, respectively, Monopoly and Scrabble. Both entertainments were conceived in the Depression years of the early 1930s, not as a means of making a fortune but merely to occupy their creators' days of unemployment and discontent.

In reaction to the poverty of the Great Depression, Charles B. Darrow, an unemployed engineer from Germantown, Pennsylvania, created the high-stakes, buying-and-selling real estate game of Monopoly.

Financially strapped and emotionally depressed, Darrow spent hours at home devising gaming board amusements to occupy himself. The real-life scarcity of cash made easy money a key feature of his pastimes, and the business bankruptcies and property foreclosures carried daily in newspapers suggested play "deeds," "hotels," and "homes" that could be won—and lost—with the whimsy of a dice toss. One day in 1933, the elements of easy money and ephemeral ownership congealed as Darrow recalled a vacation, taken during better times, in Atlantic City, New Jersey. The resort's streets, north to Baltic and south to Pacific avenues, became game board squares, as did prime real estate along the Boardwalk, on Park Place, and in Marvin Gardens.

Darrow's friends and family so enjoyed playing the homemade entertainment that in 1934 they persuaded him to approach the Massachusetts game firm of Parker Brothers. Company executives test-played Monopoly, then unanimously rejected it on the grounds that the concept was dull, the action slow-paced, and the rules hopelessly complex.

Darrow persevered. And at Wanamaker's department store in Philadelphia, he found an executive who not only enjoyed playing the game but offered to stock it in the store. With loans from family and friends, Darrow had five thousand Monopoly games manufactured and delivered to Wanamaker's. When Parker Brothers discovered that Monopoly sets were selling swiftly, they replayed the game and found that it was imaginative, fast-paced, and surprisingly easy to master. The game was copyrighted in 1935, and soon the company's plant was turning out twenty thousand Monopoly sets a week.

However, top company executives still harbored reservations. They believed the game was strictly for the adult market and merely a fad, which would not last more than three years. In December 1936, convinced that

the game's popularity had run its course, George Parker, the company president, ordered the manufacturing plant to "cease absolutely to make any more boards or utensil boxes. We will stop making Monopoly against the possibility of a very early slump."

The slump, of course, never came. And the unemployed Charles Darrow became a millionaire from royalties as his game gained popularity in twenty-eight countries and nineteen languages. There was evidence that the capitalist board game was even played in the Soviet Union: Six Monopoly sets displayed at the American National Exhibition in Moscow in 1959 all mysteriously disappeared. Today Monopoly is one of the two longest- and best-selling board games of this century, the other being Scrabble.

Scrabble: 1931, New England

Like Monopoly's inventor, Charles Darrow, the man who conceived Scrabble, Alfred Butts, was left unemployed by the Depression. Unlike Darrow, who translated poverty into a game of fantasy fortune, Butts amused himself at home with pure escapism, translating the national mania for crossword puzzles into a challenging board game that, not surprisingly, he named Criss Cross.

As conceived in 1931, Criss Cross consisted of a hundred wooden tiles, each painted with a letter of the alphabet. But the game's final rules, and each letter's point value, based on its frequency of use, took Butts almost a decade to refine.

Alfred Butts was in no hurry. For Criss Cross was strictly a home entertainment for his family and friends. It was one friend, James Brunot, from Newton, Connecticut, who in 1948 convinced Butts of the game's commercial potential and persuaded him to copyright it as Scrabble.

Scrabble, in a test playing, interested the game-manufacturing firm of Selchow & Righter, who had already scored a best-seller with Parcheesi. Echoing Parker Brothers' belief that Monopoly would be a short-lived fad, Selchow & Righter were convinced that Scrabble, a faddish spin-off of crossword puzzles, would sell for no more than two years. Instead, it became the second all-time top-selling board game in America (between Monopoly and Parcheesi), was translated into more than half a dozen languages and issued in a Braille version for the blind, and continues to sell strongly today.

Silly Putty: 1940s, Connecticut

In the early 1940s, the U.S. War Production Board sought an inexpensive substitute for synthetic rubber. It would be used in the mass production of jeep and airplane tires, gas masks, and a wide variety of military gear. The board approached General Electric, and a company engineer, James Wright, was assigned to investigate the possibility of chemically synthesizing a cheaper, all-purpose rubber.

Working with boric acid and silicone oil, Wright succeeded in creating a rubber-like compound with highly unusual properties. The pliant goo stretched farther than rubber, rebounded 25 percent more than the best rubber ball, was impervious to molds and decay, and withstood a wide range of temperatures without decomposing. And it possessed the novel property, when flattened across newspaper print or a comic book image, of lifting the ink onto itself.

Unfortunately, Wright's substance had no real industrial advantages over synthetic rubber, and it became an in-house curiosity at General Electric's laboratory in New Haven, Connecticut. Dubbed "nutty putty," it was demonstrated to visitors, and in 1945 the company mailed samples to several of the world's leading engineers, challenging them to devise a practical use for the strange-behaving substance.

No scientist succeeded. Rather, it took a former advertising copywriter, Paul Hodgson, operating a New Haven toy store, to realize that the putty had a future not as an industrial marvel but as a marvelous toy.

Hodgson, who had recently moved from Montreal, had the good fortune to be at a New Haven party where a wad of nutty putty was demonstrated; it kept a group of adults amused for hours. Entering into an agreement with General Electric, Hodgson bought a large mass of the stuff for $147 and hired a Yale student to separate it into one-ounce balls, to be marketed inside colored plastic eggs. That year, 1949, Silly Putty outsold every other item in Hodgson's toy store. And once mass-produced, it became an overnight novelty sensation, racking up sales during the '50s and '60s of over six million dollars a year.

Americans wrote to the manufacturer of their own uses for the substance: it collected cat fur and lint, cleaned ink and ribbon fiber from typewriter keys, lifted dirt from car seats, and placed under a leg, stabilized teetering furniture. Though the list was endless, no one then or now discovered a really practical application for the unsuccessful rubber substitute.

Slinky: Mid-1940s, United States

As Silly Putty was a failed war effort to develop an inexpensive rubber, Slinky, the spring that descends steps with grace, elegance, and stealth, was the failed attempt of an engineer to produce an antivibration device for ship instruments.

In the early 1940s, marine engineer Richard James was experimenting with various kinds of delicate, fast-responding springs. His goal was to develop a spring that would instantaneously counterbalance the wave motion that rocks a ship at sea. A set of such springs, strategically placed around a sensitive nautical instrument, would keep its needle gauges unaffected by pitching and yawing. In attempting to improve on existing antivibration devices, Richard James stumbled upon a fascinating toy.

One day in his home laboratory, James accidentally knocked an experi-

mental spring off a shelf. It did not fall summarily to the floor, but literally crawled, coil by coil, to a lower shelf, onto a stack of books, down to the tabletop, and finally came to rest, upright, on the floor. A quick experiment revealed that the spring was particularly adept at descending stairs. It was Richard James's wife, Betty, who realized that her husband's invention should be a toy. After two days of thumbing through a dictionary, she settled on what she felt was the best adjective in the English language to describe the spring's snake-like motion: slinky.

Betty James still runs the company she founded with her husband in 1946 to market Slinkys. And in an unusual reversal of roles, Slinky the toy has been put to practical uses. Carried by communications soldiers in Vietnam, Slinky was tossed over a high tree branch as a makeshift radio antenna. Slinky was incorporated into a spring device used to pick pecans from trees. And Slinky has gone aloft in the space shuttle to test the effects of zero gravity on the physical laws that govern the mechanics of springs. In space, Slinky behaves like neither a spring nor a toy but as a continuously propagating wave.

Toys That Glow in the Dark: 1603, Italy

There are various toy amulets, as well as religious artifacts, made of a milky white plastic that, when exposed to light, then moved into darkness, glows a greenish white. That magical property was first produced, fittingly, by a seventeenth-century alchemist in a quest to transform base metals into gold.

Vincenzo Cascariolo was a cobbler in Bologna, Italy. Experimenting in the centuries-old tradition of alchemy, he sought the "philosopher's stone" to transmute relatively worthless metals such as iron and copper into silver or gold. In 1603, Cascariolo combined barium sulfate with powdered coal, heated the mixture, spread it over an iron bar, and let the coating cool.

To his disappointment, the iron did not become gold. But when Cascariolo placed the coated bar on a darkened shelf for storage, he was astonished by its sudden glow. Though the light eventually faded, Cascariolo learned that repeated exposure to sun "reanimated" the bar. The alchemist believed that he had stumbled upon a means of capturing the sun's golden rays; and his chemicals did briefly store a form of solar energy. He hailed his discovery as the first step in producing a philosopher's stone.

Throughout Italy, his compound became known as *lapis solaris*, or "sun stone," and it was a great novelty. Particularly with the clergy. Crucifixes, miniature icons of saints, and rosary beads were painted, varnished, and compounded with *lapis solaris*, to imbue them with eerie halos. The belief developed that prayers recited in the presence of a glowing amulet were more readily answered. And the market for objects that glowed in the dark expanded throughout Christian countries. The alchemist had not succeeded in transmuting iron to gold, but he had spawned a gold mine in religious

artifacts that would only lose their mysterious aura centuries later, when physicists explained how molecules absorb and radiate light through the process of chemiluminescence.

Roller Skates: 1759, Belgium

The first practical pair of roller skates, called *skaites,* was built by a Belgian musical instrument maker, Joseph Merlin, in 1759. Each skate had only two wheels, aligned along the center of the shoe, and Merlin constructed the skates in order to make a spectacular entrance at a costume party in the Belgian city of Huy. The crude design, which strapped to the feet, was based on the ice skates of Merlin's day.

A master violinist, Merlin intended to roll into the party while playing his violin. Unfortunately, he had neglected to master the fine art of stopping on skates, and he crashed into a full-length mirror, breaking it and his violin; his entrance was indeed spectacular. Merlin's accident underscored the technological drawback of all early "wheeled feet": starting and stopping were not so much decisions of the skater as of the skates. The crude wheels, without ball bearings, resisted turning, then abruptly turned and resisted stopping, then jammed to a halt on their own.

When, in the 1850s, skate technology improved, roller skating began to compete in popularity with ice skating, though marginally at first. German composer Jakob Liebmann Beer, who achieved fame as Giacomo Meyerbeer, wrote a mid-1800s opera, *Le Prophète,* which contained an ice-skating scene that was performed on the improved roller skates. The opera was a great success in its own right, but many people attended to witness the much-publicized roller-skating scene. And an Italian ballet of the period, *Winter Pastimes; or, The Skaters,* choreographed and composed by Paul Taglioni, also became famous for its ice-skating episode executed on roller skates.

Interestingly, during these decades, roller skates were seldom depicted on stage as an entertainment themselves, but mimicked ice skating. Part of the reason was that until 1884, when ball-bearing wheels were introduced, roller skating was difficult, dangerous, and not a widely popular pastime.

Piggy Bank: 18th Century, England

Since dogs bury bones for a rainy day, and since they have been man's best friend for fourteen thousand years, why not a dog-shaped bank for coins? Since horses were indispensable to the development of commerce and finance, why not a horse bank? On the other hand, squirrels are well-known hoarders, and we talk of "squirreling away" valuables; why not a bank in the shape of a squirrel?

Instead, for almost three hundred years, the predominant child's bank has been a pig with a slot in its back. Pigs are not known for their parsimony. A proverb warns of the futility of attempting to make a silk purse from a

sow's ear. And Scripture admonishes against throwing pearls to swine—as exemplified by dropping hard-earned cash into a piggy bank.

How did a pig come to symbolize the act of saving money? The answer is: by coincidence.

During the Middle Ages, mined metal was scarce, expensive, and thus rarely used in the manufacture of household utensils. More abundant and economical throughout Western Europe was a type of dense, orange clay known as *pygg*. It was used in making dishes, cups, pots, and jars, and the earthenware items were referred to as pygg.

Frugal people then as now saved cash in kitchen pots and jars. A "pygg jar" was not yet shaped like a pig. But the name persisted as the clay was forgotten. By the eighteenth century in England, pygg jar had become pig jar, or pig bank. Potters, not usually etymologists, simply cast the bank in the shape of its common, everyday name.

Firecrackers: 10th Century, China

Sparklers, flares, and full-fledged fireworks originated in tenth-century China, when a cook, toiling in a kitchen, mixed several ingredients and produced history's first man-made explosion of sparks. It is often stated that the anonymous cook was attempting to produce a better gunpowder. But in fact, there was no such thing as gunpowder at that time. Moreover, it was the cook's concoction—of sulfur, charcoal, and saltpeter—that served as the Chinese origin of fireworks *and* gunpowder.

Historians have not determined what dish the cook was attempting to prepare. But the three above-mentioned ingredients, explosive when combined, were commonplace in a Chinese kitchen. Saltpeter, or potassium nitrate, served as preserving and pickling salt; sulfur was used to intensify the heat of a fire; and as fuel, charred firewood and coal provided an abundant source of charcoal.

The Chinese soon discovered that if the explosive ingredients were packed into hollowed-out bamboo, the confined explosion rocketed skyward, to spectacular effect. The accompanying light and bang proved perfect for ceremoniously frightening off evil spirits, and for celebrating weddings, victories, eclipses of the moon, and the New Year. The Chinese called their early fireworks "arrows of flying fire."

Though the Chinese had all the ingredients for gunpowder, they never employed the explosive for military purposes. That violent application fell, ironically, to a thirteenth-century German monk of the Franciscan order, Berthold Schwarz, who produced history's first firearms.

The Chinese were more interested in using explosives for celebrations—and in attempting to fly. One inventor, Wan-hu, built a plane consisting of two kites, propelled by forty-two rocket-like fireworks, and seated himself in its center in a chair. Unfortunately, when the rockets were simultaneously ignited, the paper kites, the wooden chair, and the flesh of the inventor

For eight centuries firework displays were limited to shades of yellow and reddish amber.

were reduced to the common ingredient ash.

By the beginning of the seventeenth century, European fireworks technicians could create elaborate flares that exploded into historic scenes and figures of famous people, a costly and lavish entertainment that was popular at the French royal palace at Versailles. For eight centuries, though, the colors of firework explosions were limited mainly to yellows and reddish amber. It was not until 1830 that chemists produced metallic zinc powders that yield a greenish-blue flare. Within the next decade, combinations of chemicals were discovered that gave star-like explosions in, first, pure white, then bright red, and later a pale whitish blue. The last and most challenging basic color to be added to the fireworks palette, in 1845, was a brilliant pure blue. By midcentury, all the colors we enjoy today had arrived.

Dolls: 40,000 Years Ago, Africa and Asia

Long before Mattel's Barbie became the toy industry's first "full-figure" doll in 1958, buxom female figurines, as fertility symbols, were the standard dolls of antiquity. And they were the predecessors of modern dolls. These figures with ample bosoms and distended, childbearing bellies were sculpted in clay some forty thousand years ago by *Homo sapiens sapiens,* the first modern humans.

As early man developed mythologies and created a pantheon of gods, male and female, dolls in wax, stone, iron, and bronze were sculpted in the likenesses of deities. In India, for instance, around 2900 B.C., miniatures

384

of Brahma rode a goose; Shiva, a bull; and his wife, Durga, a tiger. At the same time, in Egypt, collections of dolls were boxed and buried with a high-ranking person; these ushabti dolls were imagined to be servants who would cater to the needs of the deceased in the afterlife.

The transition from dolls as idols to dolls as toys began when figurines came to represent ordinary human beings such as Egyptian servants. For while it would have been sacrilegious for a child in antiquity to play with a clay idol, it became acceptable when that figurine represented a mere mortal. These early toy dolls, which arose independently in the Near and Middle East and the Orient, never took the form of infants, as do modern dolls; rather, they were miniatures of adults.

Other features distinguished these original toy dolls. Whereas today's infant doll is usually of indeterminate sex (the gender suggested by incidentals such as hair length or color of dress), the gender of an ancient doll was never ambiguous. In general, female dolls were voluptuous and buxom, while males were endowed with genitalia. It was thought natural that a human representation of an adult should be accurate in detail.

Both the Greeks and the Romans by 500 B.C. had toy dolls with movable limbs and human hair. Joints at the hips, shoulders, elbows, and knees were fastened with simple pins. Most Greek dolls of the period were female—to be played with by young girls. And although Roman craftsmen fashioned wax and clay dolls for boys, the figures were always of soldiers. Thus, at least 2,500 years ago, a fundamental behavioral distinction between the sexes was laid down. Several Greek gravestones exist with inscriptions in which Greek girls who had died in youth bequeathed their collections of dolls to friends.

The transition from adult dolls to infant dolls is not clearly documented.

Existing evidence suggests that the infant doll evolved in ancient Greece once craftsmen began to fashion "babies" that fitted into the arms of adult "mother" dolls. This practice existed in third century B.C. Greece, and in time, the popularity of the infant outgrew that of the adult doll. Modern psychological studies account for the transition. A female child, given the choice of playing with an adult or infant doll, invariably selects the infant, viewing it as her "own baby" and seeing herself as "mother", thereby reenacting the early relationship with her own mother.

By the dawn of the Christian era, Greek and Roman children were playing with movable wooden dolls and painted clay dolls, were dressing dolls in miniature clothes and rearranging furniture in a dollhouse.

Barbie Doll. The Barbie doll was inspired by, and named after, Barbie Handler, daughter of Ruth Handler, a toy manufacturer born in 1917 in Denver, Colorado. With her husband, Elliot, a designer of dollhouses, Ruth Handler founded the Mattel toy company in 1945.

American dolls then were all of the cherub-faced-infant variety. Mrs. Handler, observing that her daughter preferred to play with the more

Popular dolls of the 1890s. Bisque China head and muslin body (left); jointed, dressed dolls (middle, top); wooden doll (bottom); basic jointed doll, undressed.

shapely teenage paper dolls, cutting out their wide variety of fashion clothes, decided to fill a void in toyland, and designed a full-figured adult doll with a wardrobe of modish outfits.

The Barbie doll, bowing in 1958, helped turn Mattel into one of the world's largest toy manufacturers. And the doll's phenomenal overnight success spawned a male counterpart in 1961: Ken, named after the Handlers' son. The dolls became such a part of the contemporary American scene that in 1976, the year of the United States bicentenary, Barbie dolls were sealed into time capsules and buried, to be opened a hundred years thence as social memorabilia for the tricentenary.

China Doll. Traditionally, dolls' heads were sculpted of wood, terra cotta, alabaster, or wax. In Europe in the 1820s, German Dresden dolls with porcelain heads and French bisque dolls with ceramic heads became the rage. The painted ceramic head had originated in China centuries earlier, and many manufacturers—as well as mothers and their young daughters—had observed and complained that the dolls' exquisite ceramic faces occasionally were marred by brownish-black speckles. The source of these imperfections remained a confounding mystery until the early 1980s.

The solution unfolded when a sixteen-year-old British girl who made reproduction antique China dolls noticed that if she touched the dolls' heads when painting them, black speckles appeared after the ceramic was

386

fired. She took her problem to a doctor, who enlisted a team of scientific detectives. That the problem disappeared if the girl wore gloves suggested sweat from her hands as the source of the trouble.

X-ray fluorescence showed that the black speckles consisted not only of the normal body salts found in sweat but also of sulfides. The girl's diet was scrupulously studied and found to contain small but regular quantities of garlic—in sauces, soups, and meat dishes. Garlic is high in sulfides. When she abstained from garlic, the problem ceased.

The British researchers further investigated the sweat from the girl's hands. It contained sulfur metabolites of garlic, which in most people are broken down and excreted in urine. These metabolites were reacting with iron in the clay to produce the speckles. Medical studies revealed that the girl had a subtle, harmless metabolic deficiency, which would never have shown up had she done less unusual work. The researchers concluded that the cloudy speckles occasionally found on ceramic faces of antique dolls probably had a similar origin: A small percentage of humans do not sufficiently metabolize sulfides, and certain ceramic-doll makers literally left fingerprints of their deficiency.

Chapter 16

In the Pantry

Potato Chip: 1853, Saratoga Springs, New York

As a world food, potatoes are second in human consumption only to rice. And as thin, salted, crisp chips, they are America's favorite snack food. Potato chips originated in New England as one man's variation on the French-fried potato, and their production was the result not of a sudden stroke of culinary invention but of a fit of pique.

In the summer of 1853, American Indian George Crum was employed as a chef at an elegant resort in Saratoga Springs, New York. On Moon Lake Lodge's restaurant menu were **French-fried potatoes,** prepared by Crum in the standard, thick-cut French style that was popularized in France in the 1700s and enjoyed by Thomas Jefferson as ambassador to that country. Ever since Jefferson brought the recipe to America and served French fries to guests at Monticello, the dish was popular and serious dinner fare.

At Moon Lake Lodge, one dinner guest found chef Crum's French fries too thick for his liking and rejected the order. Crum cut and fried a thinner batch, but these, too, met with disapproval. Exasperated, Crum decided to rile the guest by producing French fries too thin and crisp to skewer with a fork.

The plan backfired. The guest was ecstatic over the browned, paper-thin potatoes, and other diners requested Crum's potato chips, which began to appear on the menu as Saratoga Chips, a house specialty. Soon they were packaged and sold, first locally, then throughout the New England area. Crum eventually opened his own restaurant, featuring chips. At that time,

potatoes were tediously peeled and sliced by hand. It was the invention of the mechanical potato peeler in the 1920s that paved the way for potato chips to soar from a small specialty item to a top-selling snack food.

For several decades after their creation, potato chips were largely a Northern dinner dish. In the 1920s, Herman Lay, a traveling salesman in the South, helped popularize the food from Atlanta to Tennessee. Lay peddled potato chips to Southern grocers out of the trunk of his car, building a business and a name that would become synonymous with the thin, salty snack. Lay's potato chips became the first successfully marketed national brand, and in 1961 Herman Lay, to increase his line of goods, merged his company with Frito, the Dallas-based producer of such snack foods as Fritos Corn Chips.

Americans today consume more potato chips (and Fritos and French fries) than any other people in the world; a reversal from colonial times, when New Englanders consigned potatoes largely to pigs as fodder and believed that eating the tubers shortened a person's life—not because potatoes were fried in fat and doused with salt, today's heart and hypertension culprits, but because the spud, in its unadulterated form, supposedly contained an aphrodisiac which led to behavior that was thought to be life shortening. Potatoes of course contain no aphrodisiac, though potato chips are frequently consumed with passion and are touted by some to be as satisfying as sex.

Pretzel: A.D. 610, Northern Italy

The crisscross-shaped pretzel was the creation of a medieval Italian monk, who awarded pretzels to children as an incentive for memorizing prayers. He derived the shape of his confection from the folded arms of children in prayer. That origin, as popular folklore has it, is supported by the original Latin and Italian words for "pretzel": the Latin *pretiole* means "little gift," and the Italian *bracciatelli* means "small arms." Thus, pretzels were gifts in the shape of praying arms.

From numerous references in art and literature, as well as extant recipes, we know that the pretzel was widely appreciated in the Middle Ages, and that it was not always baked firm and crisp but was frequently chewy. A recipe for moist, soft pretzels traveled in the thirteenth century from Italy to Germany, where the baked good was first called, in Old High German, *bretzitella,* then *brezel*—the immediate predecessor of our word.

The pretzel is one of the few foods to have played a role in the history of warfare. Early in the sixteenth century, Asian armies under the Turkish-Mongol emperor Babar swept into India and parts of Europe. A wave of Turkish forces encountered resistance at the high stone wall surrounding the city of Vienna. Following several unsuccessful attempts to scale the wall, the Turks planned to tunnel secretly beneath it, and to avoid detection, they dug at night.

Snack foods.
Instruments to prepare
homemade potato chips
(top); A monk shaped
the pretzel after the
folded arms of children
in prayer.

Turkish generals, however, were unfamiliar with the working hours of Viennese pretzel makers, who to ensure the freshness of their specialty, baked from midnight to daybreak. A group of bakers, toiling in kitchen cellars, heard suspicious digging and alerted the town council; the local military thwarted the invasion. Viennese pretzel bakers were honored for their part in the victory with an official coat of arms that displays a pretzel, still the bakers' emblem today.

Popcorn: 3000 B.C., Americas

Not all corn pops. Ideally, a corn kernel should have at least 14 percent water content so that under heat, the water expands to steam, causing the nugget to explode into a puffy white mass.

The art involved in popping corn is at least five thousand years old, perfected by the American Indians. They clearly appreciated the difference between sweet corn (for immediate eating), field corn (as cattle feed), and so-called Indian corn, which has sufficient water content for popping.

Popped corn was a native Indian dish and a novelty to the early explorers of the New World. Columbus and his men purchased popcorn necklaces from natives in the West Indies, and in the 1510s, when Hernando Cortés invaded the territory that today is Mexico City, he discovered the Aztecs wearing amulets of stringed popcorn in religious ceremonies. The dish derives its echoic name "popcorn" from the Middle English word *poppe*, meaning "explosive sound."

The Indians developed three methods for popping high-moisture corn. They might skewer an ear of popping corn on a stick and roast it over a fire, gathering up kernels that popped free of the flames. Alternatively, the kernels were first scraped from the cob, then thrown directly into a low fire; again, those that jumped free were eaten. The third method was the

most sophisticated. A shallow clay cooking vessel containing coarse sand was heated, and when the sand reached a high temperature, corn kernels were stirred in; cooking, they popped up to the surface of the sand.

Legend has it that the Plymouth Pilgrims enjoyed popcorn at the first Thanksgiving dinner in 1621. It is known that Indian chief Massasoit of the Wampanoag tribe arrived with ninety of his braves bearing various foods. Massasoit's brother, Quadequina, is supposed to have contributed several deerskin bags of corn already popped.

Popping corn was simplified in the 1880s with the introduction of specially designed home and store popping machines. But at the time, corn could be purchased only in enormous quantities, and often still on the cob. The 1897 Sears, Roebuck catalogue, for instance, advertised a twenty-five-pound sack of popping corn, on cobs, for one dollar. The problem with buying popping corn in quantity was that storage depleted the kernels of their essential water content. Today food scientists know that if the internal moisture falls below about 12 percent, kernels open only partially or not at all. Charred, unpopped kernels are now called "duds" and are rare, which was not the case in the nineteenth century, when they were cursed as "old maids."

The first electric corn popper in America appeared in 1907, at a time when electrical appliances were new, often large, and not always safe. A magazine advertisement for the device pointedly addresses these two drawbacks: "Of the host of electrical household utensils, the new corn popper is the daintiest of them all," and "children can pop corn on the parlor table all day without the slightest danger or harm."

The advent of electric popping machines, and the realization during the Depression that popcorn went a long way in stretching the family food budget, heightened the food's popularity. But it was in the lobbies of movie theaters that popcorn became big business. By 1947, 85 percent of the nation's theaters sold the snack, and 300,000 acres of Midwestern farmland were planted annually with Indian popping corn.

The arrival of television in the '50s only increased Americans' demands for corn, to pop in the kitchen between programs. A mid-decade poll showed that two out of three television watchers munched popcorn as often as four nights a week. Not all brands, though, were of equivalent quality; some yielded an annoyingly high number of duds. It was the quest to produce a high-quality popcorn that led Orville Redenbacher, a graduate in agronomy from Purdue University, to experiment with new hybrids of Indian popcorn.

Agronomy, the science and economics of crop production, was an established field of study by the 1950s, having contributed to improved management of America's farmlands. In 1952, Redenbacher and a college friend, Charles Bowman, produced a corn whose kernels seldom failed to pop—and popped into larger, puffier morsels. But the quality hybrid was comparatively expensive, and popcorn companies that Redenbacher approached declined to sell his product, believing that snack food had to be

low-priced. Convinced that popcorn lovers hated duds as much as he did, Redenbacher began packaging his corn and selling it to retail grocers. Its quality proved worth the price, for it became America's best-selling popcorn, contributing substantially to the 192 million pounds of corn popped annually in electric poppers, in fireplaces, and atop stoves. Today the average American consumes almost two pounds of popcorn a year.

Peanuts: 1800s, United States

As a plant, the peanut is prehistoric; as a snack food, it is comparatively modern. And its name is a misnomer, for the nugget is not a nut (which grows aboveground on trees) but a legume, a member of the bean family, and one whose seed pods grow underground.

Native to South America, peanut plants were brought from Brazil to North America—to the area that today is Virginia—centuries before Columbus's arrival. They flourished throughout the Southeast, where they were grown mainly for feeding pigs, chickens, and turkeys. Only poor Southern families and slaves ate peanuts, which were commonly known as "goobers," from the Bantu word *nguba*. By the 1850s, "goober" was also a derisive term for any backwoodsman from Virginia, Alabama, or Georgia, and the latter state, for its prodigious peanut crop, became known as the Goober State. It was not until the American Civil War that Northerners really got to taste peanuts.

In the 1860s, when Union forces converged on the South, thousands of hungry soldiers found themselves gladly eating a new kind of pea-size bean from an unfamiliar vine. Soldiers brought the vine, *Arachis hypogaea*, which bears yellow flowers and brittle pods, home with them, but the peanut remained little more than a culinary curiosity in the North. In the 1880s, showman P. T. Barnum began marketing peanuts in nickel-size bags at his circuses, and as Americans took to the circus, they also took to peanuts; as popcorn would become the quintessential movie snack, peanuts became part of the three-ring experience.

Peanut, as a word and a food, entered our lives in other ways. At public entertainments throughout the 1880s and 1890s, the euphemism "peanut gallery" gained currency to designate the remote seats reserved for blacks at circuses, theaters, and fairs. Not until the 1940s would the phrase, reiterated on television's *Howdy Doody* show, gain wide recognition simply as a grandstand for children. And peanut butter was an 1890s "health food" invention of a St. Louis physician; etymologists do not find the term linked with "jelly" until the 1920s, when the classic sandwich became a national dietary mainstay.

Peanuts were introduced into China in 1889 by American missionaries, who brought along crates of the beans to fortify their conversion efforts. Each Chinese couple who submitted to Christian baptism was rewarded with a quart of peanuts, a trifling amount—or "peanuts," a connotation

that originated in the American South in the 1830s, since blacks would work, literally, for peanuts. Once introduced into China, the new delicacy was cultivated in every province, and the peanut, around the turn of the century, became an American embellishment to traditional Oriental cuisine.

At that time, two young Italians emigrated to America and established a peanut empire that did much to popularize the bean as a nutritious snack food.

Planters Peanuts. Amedeo Obici and Mario Peruzzi arrived from Italy and settled with friends in Wilkes-Barre, Pennsylvania, opening a small fruit and nut stand. Their roasted peanuts were popular, but manual daily cranking of the roasting machine required effort and endurance. Experimenting with motors, Obici perfected the automatic peanut roaster that became the cornerstone of his business. Billing himself as "Obici, Peanut Specialist," he attracted customers from neighboring towns with his machine-roasted and salted nuts, and in 1906 he and his partner formed the Planters Peanut Company.

To publicize the lowly peanut, as well as to create a distinctive company trademark, in 1916 the two men sponsored a contest. The winning entry was a fourteen-year-old boy's crayon drawing titled "Little Peanut Person." It won the boy five dollars, and an in-house artist, adding a monocle, cane, and top hat, turned the cartoon into Mr. Peanut. The amusing figure, in capturing the public imagination, elevated the peanut to a fun food, to be enjoyed even after the circus collapsed its tent and left town.

In the South during those years, a famed agronomist at the Tuskegee Institute in Alabama—George Washington Carver—was popularizing the peanut through his own research and recipes, the latter including two foods that would become American firsts and standards: peanut ice cream and peanut butter cookies. Before his death in 1943, Carver created more than three hundred products from the versatile peanut and its by-products: mayonnaise, cheese, chili sauce, shampoo, bleach, axle grease, linoleum, metal polish, wood stain, adhesives, plastics, ink, dyes, shoe polish, creosote, salve, shaving cream, soap, and several kinds of peanut butter. In a short time, the goober had come a long way.

Filberts. True nuts of the birch tree family, filberts were enjoyed by the Romans, who ate them fresh and dried. Etymologists believe the sweet-flavored nut was named by early Christians for St. Philibert, a French abbot who died in 684 and whose feast day, August 20, falls during the nut-harvesting season. The Old Norman expression for the food was *noix de filbert,* or "nut of Philibert." Traditionally, the Britons eat filberts with figs, the Chinese with tea, while Americans have long relegated filberts to boxes of mixed nuts.

Walnuts. The walnut's history goes back to ancient Persia, where the two-

Peanuts, once animal fodder, were greatly popularized by Mr. Peanut. (Clockwise) Walnut, peanut, pistachio, and almond.

lobed seed was so rare and so highly valued that it once served as currency. Cultivation of the nut has been traced from Persia to Carthage to Rome, then throughout Europe and to the New World.

A product of the tree of the genus *Juglans,* the walnut derived its name from a medieval British pejorative. To the British, people and things foreign to their soil were often disparaged as "Welsh." When the first walnuts arrived in the Isles, they were initially referred to as *wealh hnutu,* "Welsh nut," which in Middle English became *walnot.*

In America, the walnut was prized by the native Indians and the early colonists, and in seasons of surplus harvest the nuts also served as fodder for swine. Today the United States is the world's major walnut producer, followed by France, Italy, and China.

Almonds.　One of the two nuts mentioned in the Bible (the other is the pistachio), the almond was cultivated in ancient Mesopotamia, where its sweet-smelling oil served as an early body moisturizer, hair conditioner, and perfume. As early as 2500 B.C., almonds were grown in Greece, and seeds have been found in the palace at Knossos on Crete. A favorite dessert dish for the Greeks, the almond was called *amygdale,* and by the Romans *amygdala,* which today is the anatomical term for any almond-shaped body structure, such as the tonsil.

Almonds are the oldest, most widely cultivated and extensively used nuts in the world. In the United States, the earliest almonds were harvested from trees originating in Mexico and Spain, whose seeds were planted by missionaries to California. Most of those early trees, however, died off when the missions were abandoned. The current California crop is based on trees brought from the East in 1843. Today the state's groves produce more almonds than all other locations in the world combined.

Pistachio. Indigenous to Persia and Syria, the pale yellow-green pista-chio—*pistah* in ancient Persian—was widely cultivated throughout the Near East, and its trees were planted in the royal gardens of Babylonia during the eighth century B.C. The nut was exploited for its oil, as well as being eaten fresh and used in Persian confections. Pistachios fetched high prices in ancient Rome as delicacies, eaten at the conclusion of a meal as dessert. In Gaul, dessert was synonymous with nuts, and the origin of our word "dessert" is the Old French verb *desservir*, "to clear the table," signaling the serving of the nut course.

Cracker Jack: 1893, Chicago

Billed at the 1893 Chicago World's Fair as "Candied Popcorn and Peanuts," Cracker Jack was the brainchild of a German immigrant, F. W. Rueckheim. He concocted a confection that combined the proven popularity of candy with Americans' growing acceptance of popcorn and peanuts as snack foods.

With a savings of two hundred dollars from farm wages, in 1871 Rueck-heim opened a small popcorn stand in Chicago. The successful business eventually led him to expand his fare to include peanuts, caramels, marsh-mallows, and molasses taffy. In the early 1890s, the confectioner reasoned that if customers so enjoyed popcorn, peanuts, and molasses taffy individ-ually, they might prefer a combination of the three. This succotash of sweets was not entirely original and daring, for molasses-coated "popcorn balls" had been a candy favorite in the Northeast since the 1870s. Peanuts, though, a salient ingredient in Rueckheim's creation, were a novelty circus snack at the time.

Company legend has it that a friend tasted Rueckheim's new confection, exclaimed, "That's crackerjack!" and the product's name was born. It's a likely possibility. In that era, "cracker" was a Northeastern vernacularism meaning "excellent"; "Jack" was a breezy address for a man whose name was unknown; and both "crackajack" and "crackerjack" were abbreviated expressions for the approving phrase "Cracker, Jack!"

A box of Cracker Jack did not always include a prize. At first, a box carried a discount coupon toward a subsequent purchase; a child's prize in the form of a trinket entered the box in 1913. Three years later, a sailor boy, Jack, and his black-and-white dog, Bingo, began to appear in product advertisements, then as the company trademark. The real-life "Jack," the inspiration for the logo, was Rueckheim's grandson Robert, who at the age of eight died of pneumonia. The sailor boy image acquired such meaning for the founder of Cracker Jack that he had it carved on his tombstone, which can still be seen in St. Henry's Cemetery, Chicago. Today every ounce of machine-packaged Cracker Jack contains exactly nine peanuts, fewer than Rueckheim prescribed in 1893, when the circus nut was something of a novelty.

Hot Dog: 1500 B.C., Babylonia

The history of the hot dog begins 3,500 years ago with the Babylonians, who stuffed animal intestines with spiced meats. Several civilizations adopted, modified, or independently created the dish; the Greeks called it *orya,* the Romans *salsus,* the origin of our word "sausage."

Homer, in the *Odyssey,* sang the gastronomical praises of sausage, its first reference in literature: "As when a man beside a great fire has filled a sausage with fat and blood and turns it this way and that and is very eager to get it quickly roasted . . ."

The decline of the sausage preceded that of the Roman Empire. According to the oldest known Roman cookbook, written in A.D. 228, sausage was a favorite dish at the annual pagan festival Lupercalia, held February 15 in honor of the pastoral god Lupercus. The celebration included sexual initiation rites, and some writers have suggested that sausage served as more than just a food. The early Catholic Church is known to have outlawed the Lupercalia and made eating sausage a sin. And when Constantine the Great, the fourth-century emperor of Rome, embraced Christianity, he, too, banned sausage consumption. As would happen in the twentieth century with liquor prohibition, the Roman populace indulged in "bootlegged" sausage to such an extent that officials, conceding the ban was unenforceable, eventually repealed it.

The evolution of the broad sausage to a slender hot dog began during the Middle Ages. Butchers' guilds in various European city-states coveted regional sausage formulas, producing their own distinctive shapes, thicknesses, and brands, with names denoting the places of origin. *Wiener wurst*— "Vienna sausage"—eventually gave birth to the German-American terms "wiener" and "wienie."

Shape and size were not the only distinguishing national features to emerge. Mediterranean countries specialized in hard, dry sausages that would not spoil in warm weather. In Scotland, oatmeal, a common and copious food, became one of the earliest cereal fillers for sausage, starting a practice that then, as now, made pork or beef all too often a secondary ingredient. In Germany, sausages were thick, soft, and fatty, and it was in that country that the "frank" was born in the 1850s.

In 1852, the butchers' guild in Frankfurt introduced a sausage that was spiced, smoked, and packed in a thin, almost transparent casing. Following tradition, the butchers dubbed their creation "frankfurter," after their hometown. The butchers also gave their new, streamlined sausage a slightly curved shape. German folklore claims this was done at the coaxing of a butcher who owned a pet dachshund that was much loved in the town. He is supposed to have convinced co-workers that a dachshund-shaped sausage would win the hearts of Frankfurters.

Three facts are indisputable: the frankfurter originated in the 1850s, in

the German city from which it derived its name; it possessed a curved shape; and it was alternatively known as a "dachshund sausage," a name that trailed it to America.

In America, the frankfurter would also become known as the hot dog, today its worldwide name.

Two immigrants from Frankfurt, Germany, are credited with independently introducing the sausage to America in the 1880s: Antoine Feuchtwanger, who settled in St. Louis, Missouri; and Charles Feltman, a baker who sold pies from a pushcart along Coney Island's rustic dirt trails. It was Feltman who would become an integral part of the hot dog's history.

In the early 1890s, when Coney Island inns began to serve a variety of hot dishes, Feltman's pie business suffered from the competition. Friends advised him to sell hot sandwiches, but his small pie wagon could not accommodate a variety of foods and cooking equipment. Instead, the pieman decided to specialize in one hot sandwich, his hometown's sausage, the frankfurter.

Installing a small charcoal stove in his pushcart, Feltman boiled the sausages in a kettle and advertised them as "frankfurter sandwiches," which he served with the traditional German toppings of mustard and sauerkraut. The sandwiches' success enabled Charles Feltman to open his own Coney Island restaurant, Feltman's German Beer Garden, and the amusement resort became identified with the frankfurter. With business booming, in 1913 Feltman hired a young man, Nathan Handwerker, as a roll slicer and part-time delivery boy, for eleven dollars a week. The move would open a new chapter in the hot dog's unfolding history.

Nathan's Franks. By 1913, Coney Island was a plush resort and an important entertainment center. Two avid frankfurter eaters along the beachfront were a local singing waiter named Eddie Cantor and his prominent-profiled accompanist, Jimmy Durante. Both worked for little money and resented the fact that the prospering Charles Feltman had raised the price of his "franks" to a dime. The struggling vaudevillians suggested to Nathan Handwerker that instead of working for Feltman, he go into competition with him, selling franks for half the price.

In 1916, Nathan did just that. With savings of three hundred dollars, he purchased an open-front Coney Island concession on the corner of Surf and Stillwell avenues and introduced the nickel frank, using a spiced meat formula devised by his wife, Ida. And to promote his product, Nathan employed a clever stratagem. He offered doctors at nearby Coney Island Hospital free franks if they would eat them at his stand wearing their professional whites and with stethoscopes prominently displayed. Doctors, then unassailably revered, proved an advertisement for the quality and salubriousness of Nathan's franks that—together with the nickel price—almost sank the competition. To assist in serving the steady stream of customers, Nathan hired a perky, redheaded teenager, Clara Bowtinelli, who

Hot dog and hamburger, today American specialities, have German roots.

did not last long. A talent agent who frequented the concession took an interest in her, shortened her surname to Bow, and she was headed to Hollywood to become the glamorous "It Girl" of silent films.

"Hot Dog." In 1906, slender, streamlined sausages were still something of a novelty in America, and they went by a variety of names: frankfurters, franks, wieners, red hots, and dachshund sausages. By this time, a refreshments concessionaire, Harry Stevens, had already made the sausage a familiar food at New York City baseball games. At the Polo Grounds—the home of the New York Giants—Stevens's vendors worked the bleachers, bellowing, "Get your red-hot dachshund sausages!"

In the stands one summer day in 1906 was a syndicated Hearst newspaper cartoonist, Tad Dorgan. The dog-like curve of the frank and the vendors' "barking" call inspired Dorgan to sketch a cartoon of a real dachshund, smeared with mustard, sandwiched in a bun. As the story is told, back at his office, Dorgan refined the cartoon, and unable to spell "dachshund," he settled on "dog," captioning the picture "Get your hot dogs!"

The name not only stuck, it virtually obsoleted its predecessors. And it quickly spawned a string of neologisms: the exclamatory approval "hot dog!"; the more emphatic "hot diggity dog!"; the abbreviated "hot diggity!" which inspired the song lyrics "Hot diggity, dog diggity, zoom what you do to me"; the noun for a daredevil, "hot dogger"; and the verb for going fast or making tracks, "to hot dog," which decades later became a surfing term.

398

It was the universal acceptance of the term "hot dog" that caused the world to regard the frank or wiener as a thoroughly American invention. And America fast became the major producer of hot dogs: today 16.5 billion are turned out each year, or about seventy-five hot dogs for each man, woman, and child in the country.

The man responsible for the term "hot dog," Thomas Aloysius Dorgan, who signed his illustrations TAD, was a major American cartoonist. There have been retrospectives of his work, and several cartoon museums around the country feature Dorgan collections. Historians, archivists, and curators of cartoon museums generally credit Dorgan with originating "hot dog," but their numerous searches to date have not produced the verifying cartoon.

Hamburger: Middle Ages, Asia

The hamburger has its origin in a medieval culinary practice popular among warring Mongolian and Turkic tribes known as Tartars: low-quality, tough meat from Asian cattle grazing on the Russian steppes was shredded to make it more palatable and digestible. As the violent Tartars derived their name from the infernal abyss, Tartarus, of Greek mythology, they in turn gave their name to the phrase "catch a tartar," meaning to attack a superior opponent, and to the shredded raw meat dish, **tartar steak,** known popularly today by its French appellation, *steak tartare*.

Tartar steak was not yet a gourmet dish of capers and raw egg when Russian Tartars introduced it into Germany sometime before the fourteenth century. The Germans simply flavored shredded low-grade beef with regional spices, and both cooked and raw it became a standard meal among the poorer classes. In the seaport town of Hamburg, it acquired the name "Hamburg steak."

The Hamburg specialty left Germany by two routes and acquired different names and means of preparation at its points of arrival.

It traveled to England, where a nineteenth-century food reformer and physician, Dr. J. H. Salisbury, advocated shredding all foods prior to eating them to increase their digestibility. Salisbury particularly believed in the health benefits of beef three times a day, washed down by hot water. Thus, steak, regardless of its quality, was shredded by the physician's faddist followers and the Hamburg steak became **Salisbury steak,** served on a plate, not in a bun.

In the 1880s, the Hamburg steak traveled with a wave of German immigrants to America, where it acquired the name "hamburger steak," then merely "hamburger." Exactly when and why the patty was put in a bun is unknown. But when served at the 1904 St. Louis World's Fair, it was already a sandwich, with its name further abbreviated to "hamburg." And some three decades before McDonald's golden arch would become the gateway

to hamburger Mecca, the chain of White Castle outlets popularized the Tartar legacy.

Sandwich: 1760, England

The sandwich, as well as the Sandwich Islands (now the Hawaiian Islands), were named for a notorious eighteenth-century gambler, John Montagu, fourth earl of Sandwich, and British first lord of the Admiralty for the duration of the American Revolution.

Montagu's tenure of office was characterized by graft, bribery, and mismanagement, and his personal life, too, was less than exemplary. Although married, he kept a mistress, Margaret Reay, by whom he had four children. Because of his high military rank, when English explorer Captain James Cook discovered the Hawaiian archipelago, the islands were named in the earl's honor.

An inveterate gambler, Montagu refused to leave the gaming tables even for meals. In 1762, when he was forty-four years old and the country's foreign secretary, he spent twenty-four straight hours gambling, ordering sliced meats and cheeses served to him between pieces of bread. The repast, which enabled him to eat with one hand and gamble with the other, had for some time been his playing trademark, and that notorious episode established it as the "sandwich."

Montagu's sandwich was not the first food served between slices of bread. The Romans in the pre-Christian era enjoyed a light repast that they called an *offula*, which was a sandwich-like snack between meals. Perhaps it is not surprising that the Romans ate food between slices of bread; they were master bread bakers in the ancient world. A typical Roman loaf of bread, weighing one pound, was shaped into a mound and cooked in either of two ways: atop the stove, as *panis artopicius*, "pan bread"; or baked in an earthenware vessel, as *panis testustis*, "pot bread." Historians in the second century B.C. pointedly observed that Roman women deplored ovens and left the baking of bread to freed slaves.

Bread itself originated with the Egyptians about 2600 B.C., when bakers made a momentous discovery. If they did not immediately bake a grain-and-water recipe called gruel, but first let it ferment, the resultant product was a higher, lighter bread. With this discovery of leavening, Egyptian bakers expanded their skills to include more than fifty different loaves, including whole wheat and sourdough breads.

Centuries later, the Westphalian Germans would create a variation on sour rye bread and pejoratively name it **pumpernickel,** from *pumpern,* "to break wind," and *Nickel,* "Old Nick the devil." The earliest instance of "pumpernickel" in print appeared in 1756 in *A Grand Tour of Germany,* by a travel writer named Nugent. He reported that the Westphalian loaf "is of the very coarsest kind, ill baked, and as black as a coal, for they never

sift their flour." The sour rye bread was considered so difficult to digest that it was said to make even Satan break wind.

Melba Toast: 1892, London

The opera singer who gave her stage name to a dry, brittle crisp of toast—and to a dessert—was born Helen Porter Mitchell in 1861 in Melbourne, Australia. Adapting the name of her hometown, the coloratura soprano introduced it as her stage name in 1887 when she performed as Gilda in Verdi's *Rigoletto* at Brussels. By the 1890s, Nellie Melba was adored by opera lovers around the world and worshiped by French chef Auguste Escoffier.

In 1892, Melba was staying at London's Savoy Hotel, where Escoffier reigned as head chef. After attending her Covent Garden performance as Elsa in Wagner's *Lohengrin,* he was inspired to create a dish for the diva, who regularly dined at the Savoy. Sculpting from a block of ice the wings of a swan, and coating them with iced sugar, he filled the center with vanilla ice cream topped with peaches. The dish was to recall the opera's famous scene in which Lohengrin, knight of the Holy Grail, arrives to meet Elsa in a boat pulled by a swan, singing, *"Nun sei bedankt, mein lieber Schwan"* ("Only you to thank, my beloved swan").

Chef Escoffier initially called his creation *peches au cygne,* "swan peaches." Later, on the occasion of the opening of London's Carlton Hotel, he improved on the dessert by adding raspberry sauce, and renamed it **Peach Melba.** The soprano, always weight conscious, breakfasted at the Savoy on tea and dry toasted bread as thin as Escoffier could slice it. Thus, her name came to represent both a low-calorie diet crisp and a decidedly nondietary dessert.

Ketchup: 300 B.C., Rome

Though we think of ketchup as strictly a tomato-based sauce, it was defined for centuries as any seasoned sauce of puree consistency and was one of civilization's earliest condiments. First prepared by the Romans in 300 B.C., it consisted of vinegar, oil, pepper, and a paste of dried anchovies, and was called *liquamen.* The Romans used the sauce to enhance the flavor of fish and fowl, and several towns were renowned for their condiment factories. Among the ruins of Pompeii were small jars bearing an inscription translated as: "Best strained liquamen. From the factory of Umbricus Agathopus."

Though the Roman puree is the oldest "ketchup" on record, it is not the direct antecedent of our modern recipe. In 1690, the Chinese developed a tangy sauce, also for fish and fowl. A brine of pickled fish, shellfish, and spices, it was named *ke-tsiap,* and its popularity spread to the Malay archipelago, where it was called *kechap.*

Early in the eighteenth century, British seamen discovered the natives of Singapore and Malaysia using *kechap* and brought samples of the puree back to their homeland. English chefs attempted to duplicate the condiment, but, unfamiliar with its Eastern spices, they were forced to make substitutions such as mushrooms, walnuts, and cucumbers. Mistakenly spelled "ketchup," the puree became an English favorite, and a popular 1748 cookbook, *Housekeeper's Pocketbook*, by a Mrs. Harrison, cautions the homemaker "never to be without the condiment." It was so popular in England that Charles Dickens, in *Barnaby Rudge,* smacked his lips over "lamb chops breaded with plenty of ketchup," and Lord Byron praised the puree in his poem "Beppo."

When and where did tomatoes enter ketchup?

Around 1790, in New England.

It could not have been much earlier, because prior to that decade, colonists suspected the tomato of being as poisonous as its botanical relatives deadly nightshade and belladonna. Although the Aztecs had cultivated the tomato (technically a berry and a fruit), calling it *tamatl,* and the Spaniards had sampled it as a *tomate,* early botanists correctly recognized it as a member of the family *Solanaceae,* which includes several poisonous plants (but also the potato and the eggplant). The Italians (who would later make the tomato an indispensable part of their cuisine) called it *mala insana,* "unhealthy apple," and food authorities can only conclude that many peoples, unfamiliar with the plant, ate not its large red berries but its leaves, which are toxic.

In America, Thomas Jefferson, one of the first in the United States to cultivate the tomato, is credited with exonerating and legitimizing the fruit. One of the earliest recipes for "tomata catsup" appeared in the 1792 *The New Art of Cookery,* by Richard Brigg. And though acceptance of the tomato and its ketchup was slow, by the mid-1800s the fruit and its puree were kitchen staples. A popular cookbook of the day, Isabella Beeton's *Book of Household Management,* counseled housewives: "This flavoring ingredient is one of the most useful sauces to the experienced cook, and no trouble should be spared in its preparation."

But preparation of homemade ketchup was time-consuming. Tomatoes had to be parboiled and peeled, and the puree had to be continually stirred. It is little wonder that in 1876, homemakers eagerly purchased America's first mass-produced, bottled ketchup, from the factory of German-American chef and businessman Henry Heinz. Heinz Tomato Catsup, billed as "Blessed relief for Mother and the other women in the household!" was an immediate success in its wide-base, thin-neck, cork-sealed bottle, and both the bottle design and the ingredients in the puree have hardly changed in over a hundred years.

Following the success of ketchup, Henry Heinz produced a variety of pickles, relishes, fruit butters, and horseradishes. But his company as yet had no identifiable slogan. In the early 1890s, while riding in a New York City elevated subway car, Heinz spotted a sign above a local store: "21

Styles of Shoes." In a moment of inspiration, he reworked the phrase, upped the number, and created what would become one of the most famous numerical slogans in advertising: "57 Varieties." At that time, the company actually produced sixty-five different products; Henry Heinz simply liked the way the number 57 looked in print.

Worcestershire Sauce. In the mid-1800s, British nobleman Sir Marcus Sandys returned to his native England from service in India as governor of the province of Bengal. A noted epicure, Sandys had acquired a recipe for a tangy sauce, a secret blend of spices and seasonings which was doused liberally on many Indian dishes.

From his estate in Worcester, England, Sandys commissioned two chemists, John Lea and William Perrins, to prepare bottles of the sauce for private use in his household and as gifts for friends. Its popularity prompted Lea and Perrins, with Sandys's permission, to manufacture it under the name "Worcester Sauce." It debuted in America, though, as "Worcestershire Sauce," shire being the British equivalent to county, and Worcestershire being the county seat of Worcester. Americans took readily to the condiment, if not to the pronunciation of its name.

A.1. Steak Sauce. As the white sauce béchamel was created by Louis de Béchamel, steward to France's King Louis XIV, A.1. Steak Sauce was the brainchild of another royal chef, and was created to please the palate of another European monarch: England's King George IV. Indolent, devious, and profligate, and by his own assessment "rather too fond of women and wine," George was redeemed in later public opinion for his superb taste in paintings and his recognition of the literary genius of Jane Austen and Walter Scott. He was also an epicure, whose gastronomic demands challenged his chief chef, Brand. Brand continually devised new dishes and sauces, and one spicy condiment for meats consisted of soy, vinegar, anchovy, and shallots. Popular legend has it that on tasting the new sauce, the king approvingly declared, "This sauce is A-1!"

There may be truth to the tale. During George's reign, from 1820 to 1830, Lloyds of London began numerically classifying ships for insurance purposes, with "A Number 1" being the highest rating, for the most insurable vessels. The phrase caught on with London businessmen and the general public, who used it to label everything from prime real estate to quality theater fare, often in the abbreviated form "A-1." It came to signify any person, place, or thing that was "tops" or "first class."

Following the monarch's death, Brand resigned and began to manufacture his condiment privately. It was exported to America, but during World War 1, British shipments became infrequent and sporadic. The American-based spirits company of Heublein finally reached an agreement with the Brand Company of England, and A.1. Steak Sauce went into production in Hartford, Connecticut. During Prohibition, with no legal home market

for Heublein's line of liquors, it was A.1. Steak Sauce—"The Dash That Makes The Dish"—that kept the company from bankruptcy. Today Brand's condiment is one of the top-selling meat sauces in America.

Mayonnaise. A Spanish condiment made of raw egg yolk and olive oil was popular on Minorca, one of the Balearic Islands, beginning in the eighteenth century. While neighboring Majorca would acquire fame when composer Frédéric Chopin sojourned there, Minorca would become known in Europe for its sauce, which was sampled by the French duke Richelieu in the island's major port of Mahón.

Richelieu returned to France with the recipe for what he humbly labeled "sauce of Mahón." But adopted by French chefs as a high-quality condiment reserved for the best meats, the sauce was renamed *mahonnaise*. Even when "mayonnaise" arrived in America in the early 1800s, it was regarded as a delicate French creation, and one difficult to prepare.

Two breakthroughs transformed the haute sauce to a popular sandwich spread: the arrival of the electric blender, which simplified its preparation; and inexpensive bottled dressings. Richard Hellman, the German-born owner of a Manhattan delicatessen, perceived that there was a market for a quality premixed brand of mayonnaise, and in 1912 he began selling his own version in one-pound wooden "boats." A year later, he packaged the product in large glass jars. It's ironic but understandable that as the condiment became increasingly commonplace, spread on BLTs and burgers, it lost its former luster as haute mahonnaise, the exotic sauce of Mahón.

Tabasco Sauce. Amidst the coastal marshes of Louisiana's fabled Cajun country is a prehistoric geological phenomenon known as Avery Island. An upthrust salt dome six miles in circumference, the island is covered with meadows and was the site of America's first salt mine, which still produces a million and a half tons of salt a year. Avery Island is also the birthplace of Tabasco sauce, named by its creator, Edmund McIhenny, after the Tabasco River in southern Mexico, because he liked the sound of the word.

In 1862, McIhenny, a successful New Orleans banker, fled with his wife, Mary Avery McIhenny, when the Union Army entered the city. They took refuge on Avery Island, where her family owned a salt-mining business. Salt, though, was vital in preserving meat for the war's troops, and in 1863 Union forces invaded the island, capturing the mines. The McIhennys fled to Texas, and returning at war's end, found their plantation ruined, their mansion plundered. One possession remained: a crop of capsicum hot peppers.

Determined to turn the peppers into income, Edmund McIhenny devised a spicy sauce using vinegar, Avery Island salt, and chopped capsicum peppers. After aging the mixture in wooden barrels for several days, he siphoned off the liquid, poured it into discarded empty cologne bottles, and tested it on friends. In 1868, McIhenny produced 350 bottles for Southern

Marco Polo (left) and the Oriental origin of spaghetti, meaning "little strings."

wholesalers. A year later, he sold several thousand bottles at a dollar apiece, and soon opened a London office to handle the increasing European demand for Cajun Tabasco sauce.

Clearly contradicting the standing joke that there is no such thing as an empty Tabasco bottle, the McIhenny company today sells fifty million two-ounce bottles a year in America alone. And the sauce, made from Edmund McIhenny's original recipe, can be found on food-store shelves in over a hundred countries. Each year, 100,000 tourists visit Avery Island to witness the manufacturing of Tabasco sauce, and to descend into the cavernous salt mines, which reach 50,000 feet down into geological time.

Pasta: Pre-1000 B.C., China

We enjoy many foods whose Italian names tell us something of their shape, mode of preparation, or origin: *espresso* (literally "pressed out"), *cannelloni* ("big pipes"), *ravioli* ("little turnips"), *spaghetti* ("little strings"), *tutti-frutti* ("every fruit"), *vermicelli* ("little worms"), *lasagna* ("baking pot"), *parmesan* ("from Parma"), *minestrone* ("dished out"), and *pasta* ("dough paste"). All these foods conjure up images of Italy, and all derive from that country except one, pasta (including vermicelli and spaghetti), which was first prepared in China at least three thousand years ago, from rice and bean flour.

Tradition has it that the Polo brothers, Niccolo and Maffeo, and Niccolo's son, Marco, returned from China around the end of the thirteenth century with recipes for the preparation of Chinese noodles. It is known with greater certainty that the consumption of pasta in the form of spaghetti-like noodles and turnip-shaped ravioli was firmly established in Italy by 1353, the year Boccaccio's *Decameron* was published. That book of one hundred fanciful

405

tales, supposedly told by a group of Florentines to while away ten days during a plague (hence the Italian name *Decamerone,* meaning "ten days"), not only mentions the two dishes but suggests a sauce and cheese topping: "In a region called Bengodi, where they tie the vines with sausage, there is a mountain made of grated parmesan cheese on which men work all day making spaghetti and ravioli, eating them in capon's sauce."

For many centuries, all forms of pasta were laboriously rolled and cut by hand, a consideration that kept the dish from becoming the commonplace it is today. Spaghetti pasta was first produced on a large scale in Naples in 1800, with the aid of wooden screw presses, and the long strings were hung out to dry in the sun. The dough was kneaded by hand until 1830, when a mechanical kneading trough was invented and widely adopted throughout Italy.

Bottled spaghetti and canned ravioli originated in America, the creation of an Italian-born, New York–based chef, Hector Boiardi. He believed Americans were not as familiar with Italian food as they should be and decided to do something about it.

A chef at Manhattan's Plaza Hotel in the 1920s, Boiardi began bottling his famous meals a decade later under a phoneticized spelling of his surname, Boy-ar-dee. His convenient pasta dinners caught the attention of John Hartford, an executive of the A & P food chain, and soon chef Boiardi's foods were appearing on grocery store shelves across the United States. Though much can be said in praise of today's fresh, gourmet pastas, served *primavera, al pesto,* and *alla carbonara,* Boy-ar-dee's tomato sauce dishes, bottled, canned, and spelled for the masses, created something of a culinary revolution in the 1940s; they introduced millions of non-Italian Americans to their first taste of Italian cuisine.

Pancake: 2600 B.C., Egypt

The pancake, as a wheat flour patty cooked on a flat hot stone, was known to the Egyptians and not much different from their unleavened bread. For prior to the advent of true baking, pancakes and bread were both flat sheets of viscous gruel cooked atop the stove.

The discovery of leavening, around 2600 B.C., led the Egyptians to invent the oven, of which many examples remain today. Constructed of Nile clay, the Egyptian oven tapered at the top into a truncated cone and was divided inside by horizontal shelves. At this point in time, bread became the leavened gruel that baked and rose inside the oven, while gruel heated or fried on a flat-topped stove was the pancake—though it would not be cooked in a pan for many centuries.

The pancake became a major food in the ancient world with the advent of Lenten shriving observances in A.D. 461. Shriving was the annual practice of confession and atonement for the previous year's sins, enacted as preparation for the holy Lenten season. The three-day period of Sunday, Mon-

day, and Shrove Tuesday (the origin of *Mardi Gras*—literally "fat Tuesday"—the day before the start of Lent) was known as Shrovetide and marked by the eating of the "Shriving cake," or pancake. Its flour symbolized the staff of life; its milk, innocence; and its egg, rebirth.

In the ninth century, when Christian canon law prescribed abstinence from meat, the pancake became even more popular as a meat substitute. And by the thirteenth century, a Shrove Tuesday pancake feast had become traditional in Britain, Germany, and Scandinavia, with many extant rhymes and jingles accompanying the festivities, for example:

> *Shrove Tuesday, Shrove Tuesday,*
> *'Fore Jack went to plow*
> *His mother made pancakes,*
> *She scarcely knew how.*

The church bell calling the shriving congregation became known as the "pancake bell," and Shrove Tuesday as Pancake Day. A verse from *Poor Robin's Almanac* for 1684 runs: "But hark, I hear the pancake bell / And fritters make a gallant smell."

The most famous pancake bell in Western Europe was that of the Church of Sts. Peter and Paul in Olney, England. According to British tradition, an Olney woman in the fifteenth century, making pancakes when the bell tolled, unwittingly raced to church with the frying pan and its contents in her hand. The tale developed into an annual race to the church, with townswomen flipping flapjacks all the way, and it has survived into modern times, with the course a distance of four hundred and fifteen yards. Women competing must be at least eighteen years old, wear an apron and a head scarf, and somersault pancakes three times during the race. In 1950, a group of American women from Liberal, Kansas, members of the local Jaycees, staged their own version of the British pancake race.

The earliest American pancakes were of corn meal and known to the Plymouth Pilgrims as "no cakes," from the Narragansett Indian term for the food, *nokehick,* meaning "soft cake." Etymologists trace the 1600s' "no cake" to the 1700s' "hoe cake," so named because it was cooked on a garden-hoe blade. And when cooked low in the flames of a campfire, often collecting ash, it became an "ashcake" or "ashpone." In the next century, the most popular pancakes in America were those of a talented black cook, Nancy Green, the country's Aunt Jemima.

Aunt Jemima. The story of America's first commercially successful pancake mix begins in 1889 in St. Joseph, Missouri, where a local newspaperman, Chris Rutt, conceived the idea for a reliable premixed self-rising flour. Rutt loved to breakfast on pancakes, but lamented the fact that batter had to be made from scratch each morning. He packaged a formulation of flour, phosphate of lime, soda, and salt in plain brown paper sacks and sold it to

The prototype for Aunt Jemima; A crowd in 1882 watches a short-order cook prepare pancakes.

grocers. The product, despite its high quality, sold poorly, and Rutt realized that he needed to jazz up his packaging.

Enter Aunt Jemima.

One evening in autumn 1889, Rutt attended a local vaudeville show. On the bill was a pair of blackface minstrel comedians, Baker and Farrell, and their show-stopping number was a rhythmic New Orleans–style cakewalk to a tune called "Aunt Jemima," with Baker performing in an apron and red bandanna, traditional garb of a Southern female chef. The concept of Southern hospitality appealed to Rutt, and he appropriated the song's title and the image of the Southern "mammy" for his pancake product.

Sales increased, and Rutt sold his interests to the Davis Milling Company, which decided to promote pancake mix at the 1893 Chicago World's Fair. Initiating a dynamic concept that scores of advertisers have used ever since, the company sought to bring the Aunt Jemima trademark to life. Searching among Chicago's professional cooks, the company found a warm, affable black woman, Nancy Green, then employed by a local family. As the personification of Aunt Jemima, Nancy Green served the fair's visitors more than a million pancakes, and a special detail of policemen was assigned to prevent crowds from rushing the concession. Nancy Green helped establish the pancake in America's consciousness and kitchens, touring the country as Aunt Jemima until her death in 1923, at age eighty-nine.

Betty Crocker: 1921, Minnesota

Although there was a real-life "Aunt Jemima," the Betty Crocker who for more than sixty years has graced pantry shelves never existed, though she accomplished much.

In 1921, the Washburn Crosby Company of Minneapolis, a forerunner of General Mills, was receiving hundreds of requests weekly from home-makers seeking advice on baking problems. To give company responses a more personal touch, the management created "Betty Crocker," not a woman but a signature that would appear on outgoing letters. The surname Crocker was selected to honor a recently retired company director, William Crocker, and also because it was the name of the first Minneapolis flour mill. The name Betty was chosen merely because it sounded "warm and friendly." An in-house handwriting contest among female employees was held to arrive at a distinctive Betty Crocker signature. The winning entry, penned by a secretary in 1921, still appears on all Betty Crocker products.

American housewives took so believingly and confidingly to Betty Crocker that soon more than her signature was required.

In 1924, Betty Crocker's voice (that of an actress) debuted on America's airwaves in the country's first cooking program, something of early radio's equivalent to Julia Child, and it was an overnight success. Within months, the program was broadcast from thirteen stations, each with its own Betty Crocker reading from the same company-composed script. The *Betty Crocker Cooking School of the Air* would eventually become a nationwide broadcast, running uninterrupted for twenty-four years.

Although most American housewives believed Betty Crocker was a real person, no one had yet seen her picture, because none existed until 1936. That year, to celebrate the fifteenth birthday of the Betty Crocker name, a portrait was commissioned from a prominent New York artist, Neysa McMein. In an act of artistic egalitarianism, Neysa McMein did not use a single company woman to sit for the portrait. Instead, all the women in the company's Home Service Department assembled, and the artist, as the company stated, "blended their features into an official likeness."

That first Betty Crocker visage reigned unaltered until 1955, when the company "updated" the portrait. Instead of aging the appropriate nineteen years, Betty actually appeared younger in her 1955 portrayal. And she continued to grow more youthful and contemporary, in her official 1965 portrait and in the most recent one, painted in 1980, in which she appears as a modern professional woman.

For a fictitious woman, Betty Crocker acquired enviable fame. During World War II, she served the country at the request of the United States Department of State with a patriotic radio show, *Your Nation's Rations*. She went on to write several best-selling cookbooks, narrate films, record recipes on cassette tapes, and become a one-woman cottage industry, something of a prototypal Jane Fonda.

Duncan Hines: 1948, Kentucky

While there was never a Betty Crocker, and only an Aunt Jemima impersonator, there was a flesh-and-blood, real-life Duncan Hines—though he never baked a cake professionally in his life. Duncan Hines only *wrote* about food.

In 1936, Hines published *Adventures in Good Eating,* a pocket-sized guidebook to the best restaurants along America's highways. With the burgeoning craze for automobile travel in the '30s, Hines's book became a runaway success. Sales figures suggested that every car in America had a copy of the guide in its glove compartment. Restaurants across the country coveted their hard-earned sign that boasted "Recommended by Duncan Hines."

A native of Bowling Green, Kentucky, Duncan Hines traveled fifty thousand miles a year for the sole purpose of sampling highway fare and updating his guidebook. In the late 1940s, when New York businessman Roy Park surveyed housewives to identify a trusted food authority to endorse a new line of baked goods, he found there was no competition: The name Duncan Hines was not only trusted, it was better known across America than that of the incumbent Vice President, Alben Barkley—even in Barkley's home state of Kentucky.

In 1948, Roy Park and Duncan Hines teamed up to form Hines-Park Foods, Inc. Park was president, and Duncan Hines signed a contract permitting his name to be used on the company's line of boxed baked goods. So respected was the Hines name that within three weeks of their introduction, the cake mixes had swallowed up 48 percent of the national market.

One could argue, of course, that the man behind the Duncan Hines brand was every bit the corporate ruse of an Aunt Jemima or a Betty Crocker, a harmless deception. And a popular way to personalize a product. Certainly no one ever seriously believed there was an aristocrat named Lady Kenmore, or if one existed, that she ever endorsed appliances.

Pie: 5th Century B.C., Greece

Although baking bread and confections began in ancient Egypt, there is no evidence that civilization's first bakers ever stumbled on the idea of stuffing a dough shell with meat, fish, or fruit. That culinary advance was made in ancient Greece, where the *artocreas,* a hash-meat pie with only a bottom crust, endured for centuries. Two features distinguished those early pies from today's: They had no top crust, and fillings were never fruit or custard, but meat or fish.

The first pies made with two layers of crust were baked by the Romans. Cato the Elder, a second-century B.C. Roman statesman who wrote a treatise on farming, *De Agricultura,* loved delicacies and recorded a recipe for his

era's most popular pie, *placenta*. Rye and wheat flour were used in the crust; the sweet, thick filling consisted of honey, spices, and cheese made from sheep's milk; and the pie was coated with oil and baked atop aromatic bay leaves.

The first Western reference to a fruit pie—and a true dessert pie—appears surprisingly late in history: during the sixteenth-century reign of England's Elizabeth I. Though home bakers may have used fruits such as apples and peaches, it is known that the queen requested pitted and preserved cherries as substitutions for the traditional fillings of meat or fish. Before the Elizabethan era, "pie" meant "meat pie," a meal's main course. The word's antecedent, *pi*, referred to any confusing jumble or mixture of things: meats to the early Britons, and to the earlier Greeks, a perplexing and endless array of digits generated by dividing a circle's circumference by its diameter.

Once the dessert fruit pie appeared, its references and fillings proliferated. Interestingly (perhaps following the queen's lead), the preferred fillings initially were not cut fruits but berries, a 1610s British favorite being the dark-blue hurtleberry, which resembles a blueberry but has ten nutlike seeds; in America by 1670, it was called the huckleberry, the basis for huckleberry pie and the quintessentially American name of an adventuresome boy surnamed Finn.

Cookie: 3rd Century B.C., Rome

Today's cookies are crisp or chewy, round or oval, plain or studded with nuts, raisins, and/or chocolate chips. In the ancient past, such options did not exist; a cookie was a thin unleavened wafer, hard, square, bland, and "twice baked." Its origin and evolution are evident in its names throughout history.

The cookie began in Rome around the third century B.C. as a wafer-like biscuit—*bis coctum* in Latin, literally "twice baked," signifying its reduced moisture compared to that of bread or cake. To soften the wafer, Romans often dipped it in wine.

But it was precisely the wafer's firmness and crispness that earned it the echoic Middle English name *craken*, "to resound," for on breaking, it "crackled." The *craken* became the "cracker," which in concept is considerably closer to the modern food the Roman cookie most closely resembled. Though neither the *bis coctum* nor the *crahon* would satisfy a sweet craving, both were immensely popular foods in the ancient world because their low moisture content served effectively as a preservative, extending their home shelf life. As pies for centuries were meat pies, cookies were plain biscuits; sweetness did not become a cookie hallmark until after the Middle Ages.

The modern connotation of "cookie" is believed to have derived from a small, sweet Dutch wedding cake known as *koekje,* a diminutive of *koek,* Dutch for a full-sized "cake." Made in numerous variations and never "twice

baked," the sweeter, softer, moister *koekje,* etymologists claim, at least gave us the words "cooky" and "cookie," and probably the dessert itself.

In America, "cooky" and "cookie" became vernacularisms in the early 1700s. But the written history of the sweet remained scant compared to that of other foods, primarily because cookies did not become truly popular—and certainly not brand-name sweet temptations—until about a hundred years ago. As we'll see, several of those early commercial successes are still selling today.

Animal Cookies: 1890s, England

For Christmas 1902, thousands of American children received a new and edible toy: animal-shaped cookies in a small rectangular box imprinted to resemble a circus cage. The box's string handle made it easy to carry and suitable as a play purse, but the white string had been added by National Biscuit Company (Nabisco) to encourage parents to hang the boxes of Animal Crackers as decorative Christmas tree gifts.

The design of the animal cookies had originated in England in the 1890s, but the American manufacturer displayed advertising genius with the package design. Labeled "Barnum's Animals" in the decade when P. T. Barnum was popularizing the "Greatest Show on Earth," the box immediately captured the imaginations of children and adults. And whereas British animal crackers came in only a handful of shapes, the American menagerie boasted a circus of seventeen different creatures (though the cookies came in eighteen distinct shapes): bison, camel, cougar, elephant, giraffe, gorilla, hippopotamus, hyena, kangaroo, lion, monkey, rhinoceros, seal, sheep, tiger, zebra, and sitting bear. The eighteenth shape was a walking bear.

Although a box of Animal Crackers contained twenty-two cookies, no child that Christmas of 1902 or thereafter was guaranteed a full representation of the zoo. This was because the machine-filled boxes could randomly contain, say, a caravan of camels and a laugh of hyenas but not so much as a lone kangaroo.

The randomness added an element of expectancy to a gift box of Animal Crackers, a plus the company had not foreseen. And soon parents were writing to Nabisco and revealing another unanticipated phenomenon (either trivial or of deep psychological import): Children across America nibbled away at the animals in a definite order of dismemberment: back legs, forelegs, head, and lastly the body.

Fig Newton. Whereas the shapes of Animal Crackers made them a novelty and a success, there was another cookie of the same era that caught the imaginations of Americans for its originality of concept.

In 1892, a Philadelphia inventor named James Mitchell devised a machine that extruded dough in a firm wraparound sandwich that could hold a filling—but a filling of what? Mitchell approached the Kennedy Biscuit

Works in Cambridgeport, Massachusetts, and after testing his machine, they decided in 1895 to manufacture a stuffed cookie containing the company's first and most successful jam: figs. The snack's name generated debate. Management agreed it should include the word "fig" and, for local marketing purposes, the familiar name of a nearby town. "Fig Bostons" and "Fig Shrewsburys" did not sound as appealing as the suggestion made by an employee who lived in Newton, Massachusetts. Thus was named the newest sweet in American cookie jars at the turn of the century.

Oreo. Following the success of Animal Crackers, Nabisco attempted several other cookie creations. Two of them were to be eaten once and forgotten; one would become the world's all-time favorite seller.

On April 2, 1912, an executive memo to plant managers announced the company's intentions: "We are preparing to offer to the trade three entirely new varieties of the highest class biscuit." The memo predicted superior sales for two of the cookies. One, the "Mother Goose Biscuit," would be an imaginative variation on the company's successful Animal Crackers, "A biscuit bearing impressions of the Mother Goose legends." How could Goldilocks, Little Red Riding Hood, and Cinderella cookies fail? (No one questioned if there was something macabre in cannibalizing beloved little girls, or stopped to consider which appendages children would eat first.)

The second cookie with great expectations was, according to the memo, "a delicious, hard, sweet biscuit of beautiful design" exotically named "Veronese." The third new entry would consist of "two beautifully embossed, chocolate flavored wafers with a rich cream filling," to be named the "Oreo Biscuit." Relatively few people ever got to taste a "Mother Goose" or a "Veronese," but from Nabisco's soaring sales figures, it appeared that every American was eating Oreos. Today the cookie outsells all others worldwide, more than five billion being consumed each year in the United States alone.

From its original name of "Oreo Biscuit," the cookie became the "Oreo Creme Sandwich," and in 1974, the "Oreo Chocolate Sandwich Cookie." What no archivist at Nabisco knows with certainty is the origin of the term Oreo. Two educated guesses have been offered: that the first chairman of the National Biscuit Company, Adolphus Green, coined the word from *oros,* Greek for "mountain," since the cookie as originally conceived was to have a peaked, mountain-like top; or that the name was suggested by the French for "gold," *or,* since on the original package, the cookie's name was scrolled in gold letters.

Graham Cracker: 1830s, New England

The graham cracker originated as a health food, and in Britain it is still known as a "digestive biscuit." It is also probably the only cookie or cracker to have sprung from a faddish health craze and religious movement, Grahamism, which swept New England in the 1820s and 1830s.

The Reverend Sylvester Graham was a Connecticut eccentric, congenitally prone to poor health. He married his nurse and became a self-styled physician and temperance leader, preaching impassioned lectures on white bread's evils, nutritional and spiritual. Derided by Ralph Waldo Emerson as the "poet of bran," the Reverend Graham did advocate many healthful things, if fanatically: little consumption of oil; no red meat, alcohol, or refined flour; frequent bathing and exercise; and brushing the teeth daily. He believed that the way to bodily health and spiritual salvation lay in diet, and his disciples, "Grahamites," in accordance with his philosophy of "Grahamology," followed a strict vegetarian diet, drank only water, and slept with windows open even in winter.

His teachings against commercial breads, cereals, and flour—in favor of coarse bran—incurred the wrath of New England bakers. They frequently harassed Graham on speaking tours and picketed outside his hotels. In 1837, he published a treatise urging Americans to eat only home-baked breads, pastries, and crackers, and his name became associated with a variety of unprocessed products: graham flour, graham cereal, and the graham cracker. Eventually, bakers adopted a more conciliatory attitude, and capitalizing on Graham's popularity, they, too, offered a line of whole-wheat goods, including the graham cracker.

Due to Grahamism, a new breakfast trend developed in America. One of the Reverend Graham's New York followers, Dr. James Caleb Jackson, advocated **cold breakfast cereal,** a bold reversal of the traditional hot morning gruel, but one that quickly caught on. The food would not become a true American tradition, however, until the 1890s, when another health-conscious physician, Dr. John Kellogg, who breakfasted daily on seven graham crackers, created his own "Battle Creek health foods," the first being Granola, followed in 1907 by Corn Flakes. The prototype of packaged cold cereals was Dr. James Caleb Jackson's own effort, Granula, a "granular" bran whose name was a compression of "Graham" and "bran." As for "Dr." Sylvester Graham, despite a low-fat, high-carbohydrate, and high-fiber diet, he remained a sickly man and died at age fifty-seven.

Chocolate Chip Cookie: Post-1847, United States

Although history does not unambiguously record the origin of the chocolate chip cookie, we can be certain that there was no such confection prior to 1847, for before that time, chocolate existed only as a liquid or a powder, not as a solid.

The route to the chocolate chip cookie began in Mexico around 1000 B.C. The Aztecs brewed a chocolate ceremonial drink, *xocoatl,* meaning "bitter water," made from pulverized indigenous cocoa beans. In the Nahuatl dialects of Mexico, *xocoatl* became *chocolatl.* Spaniards introduced the New World drink to Europe, where chocolate remained a beverage

until 1828. That year, a Netherlands confectioner, C. J. Van Houten, attempting to produce a finer chocolate powder that would more readily mix with milk or water, discovered the cocoa bean's creamy butter. In 1847, the British confection firm of Fry and Sons produced the world's first solid eating chocolate. Chocolate chips became a reality; the cookie a possibility.

Legend has it that the first chocolate chip cookies were baked around 1930 at the Toll House Inn, on the outskirts of Whitman, Massachusetts.

Built in 1708 as a tollgate for travelers halfway between Boston and New Bedford, the house was purchased in the late 1920s by a New England woman, Ruth Wakefield, and renovated as an inn. In her role of resident cook and baker, Mrs. Wakefield added chocolate pieces to her basic butter cookies, creating the Toll House Inn cookie, which would become a national product. For chocolate bits, Mrs. Wakefield laboriously diced the Nestlé Company's large Semi-Sweet Chocolate Bar. The company, impressed with her recipe, requested permission to print it on the chocolate bar's wrapper, in exchange for supplying Mrs. Wakefield with a lifetime supply of free chocolate.

For almost a decade, housewives and professional bakers had to hand-dice Nestlé's chocolate bars to make Toll House cookies. To ease the chore, the company scored the bar and even sold a special chopper. Finally, in 1939, with Toll House cookies a national craze, Americans were introduced to Morsels, the commercially packaged chocolate chip, an innovation that further popularized the cookie and became its generic name. From *bis coctum* to *craken* to chocolate chip, the cookie had come a long way.

Doughnut: 16th Century, Holland

For over two hundred fifty years, doughnuts, which originated with Dutch bakers, did not have holes in the center; the hole was an American modification that, once introduced, redefined the shape of the pastry.

The deep-fried batter doughnut originated in sixteenth-century Holland, where it was known as an *olykoek,* or "oil cake," named for its high oil content. Made with sweetened dough and sometimes sugared, the oil cake was brought to America by Pilgrims who had learned to make the confection during their stay in Holland in the first two decades of the 1600s. Small, the size of a walnut, the round oil cake in New England acquired the name "dough nut," while a related long twisted Dutch pastry of fried egg batter became known as the cruller, from the Dutch *krullen,* "curl."

The hole in the doughnut's center appeared in the first half of the nineteenth century, the independent creation of the Pennsylvania Dutch and, farther east, a New England sailor. Hanson Gregory, a sea captain from Maine, is said to have poked holes in his mother's doughnuts in 1847, for the practical reason (also stated by the Pennsylvania Dutch) that the increased surface area allowed for more uniform frying and eliminated the

pastry's soggy center. Today Hanson Gregory's contribution of the hole is remembered in his hometown of Rockport, Maine, by a bronze plaque, suggesting that in America, fame can be achieved even for inventing nothing.

Chewing Gum: 1860s, Staten Island, New York

The action of chewing gum, through exercising the muscles of the jaw, relieves facial tension, which in turn can impart a general feeling of bodily relaxation. Gum is part of the U.S. Armed Forces' field and combat rations, and soldiers consume gum at a rate five times the national average. Thus, it seems fitting that the man responsible for the chewing gum phenomenon was a military general: Antonio López de Santa Anna, the despised Mexican commander responsible for the massacre at the Alamo.

Santa Anna had reason to chew gum.

In the 1830s, when Texas attempted to proclaim its independence from Mexico, a Mexican army of five thousand men, led by Santa Anna, attacked the town of San Antonio. The one hundred fifty native Texans forming the garrison retreated into Fort Alamo. The Mexican general and his men stormed the fort, killing all but two women and two children. A few weeks later, charging under the battle cry "Remember the Alamo!" American forces under General Sam Houston defeated Santa Anna and forced Mexico to accept Texas's secession. Texas became a state in 1845, and Santa Anna, one of the few Mexican commanders not executed for his war crimes, entered the United States and settled on Staten Island, New York.

The exiled general brought with him a large chunk of chicle, the dried milky sap or latex of the Mexican jungle tree the sapodilla. Known to the Aztecs as *chictli*, the tasteless resin had been a favorite "chew" of Santa Anna. On Staten Island, the former general introduced chicle to a local photographer and inventor, Thomas Adams, who imported a large quantity of the gummy resin, then tried and failed to convert it chemically into an inexpensive synthetic rubber. To recoup a portion of his investment, Adams, recalling how avidly his own son Horatio, as well as Santa Anna, enjoyed chewing chicle, decided to market it as an alternative to the then-popular wads of paraffin wax sold as chew.

Thomas Adams's first small tasteless chicle balls went on sale in a Hoboken, New Jersey, drugstore in February 1871 for a penny apiece. The unwrapped balls, packaged in a box labeled "Adams New York Gum—Snapping and Stretching," were sold along the East Coast by one of Adams's sons, a traveling salesman. Chicle proved to be a superior chew to wax, and soon it was marketed in long, thin strips, notched so a druggist could break off a penny length. It had the jaw-exercising consistency of taffy.

The first person to flavor chicle, in 1875, was a druggist from Louisville, Kentucky, John Colgan. He did not add the candy-like oils of cherry or peppermint, but the medicinal balsam of tolu, an aromatic resin from the bark of a South American legume tree, *Myroxylon toluiferum*, familiar to

children in the 1870s as a standard cough syrup. Colgan named his gum Taffy-Tolu, and its success spawned other flavored chicles.

Thomas Adams introduced a sassafras gum, then one containing essence of licorice and named Black Jack, which is the oldest flavored chewing gum on the market today. And in 1880, a manufacturer in Cleveland, Ohio, introduced a gum that would become one of the industry's most popular flavors: peppermint. In the same decade, Adams achieved another first: the chewing gum vending machine. The devices were installed on New York City elevated-train platforms to sell his tutti-frutti gum balls.

It was in the 1890s that modern processing, packaging, and advertising made chewing gum truly popular. Spearheading that technology was a soap salesman turned chewing gum manufacturer, William Wrigley, Jr.

Wrigley's first two brands, Lotta Gum and Vassar, were soon forgotten. But in 1892, he introduced Wrigley's Spearmint, followed the next year by Juicy Fruit, both of which became America's top-selling turn-of-the-century chewing gums. Wrigley was a tireless gum advertiser. Following his personal motto—"Everybody likes something for nothing"—and his business philosophy—"Get them hooked"—in 1915 he collected every telephone directory in the country and mailed four free sticks of gum to each of the 1.5 million listed subscribers. Four years later, he repeated the kindness and the ploy, even though the number of American phone subscribers exceeded seven million.

Popular as gum chewing was with many people, it was not without its detractors. The puritanical-minded saw it as a vice; snuff habitués dismissed it as sissified; teachers claimed it disrupted a child's classroom concentration; parents warned that swallowed gum caused intestinal blockage; and physicians believed excessive chewing dried up the salivary glands. As late as 1932, engineering genius Nikola Tesla, inventor of the alternating-current electrical system, solemnly voiced that concern: "By exhaustion of the salivary glands, gum puts many a foolish victim in the grave."

What we buy today is not General Santa Anna's original taffy-like chicle, but a gentler synthetic polymer, polyvinyl acetate, itself tasteless, odorless, and unappetizingly named, which Americans chew at the rate of ten million pounds a year.

Chiclets and Bubble Gum. Two men who entered the burgeoning chewing gum business in the 1880s were brothers Frank and Henry Fleer, each pursuing a different goal that would result in an industry classic.

Frank Fleer sought to create a gum with high surface tension and "snapback," which could be blown into large bubbles. Snap-back, or a gum's elasticity, is a crucial parameter; low snap-back, and a burst bubble explodes over the chin and nose without contracting; high snap-back, and the bulk of the gum retreats to the lips. His first bubble gum effort, with the tongue-twisting title Blibber-Blubber Bubble Gum, failed because Blibber-Blubber burst before achieving a large bubble. In addition, the gum was too "wet,"

making a burst bubble stick to the skin.

Brother Henry Fleer was tackling a different challenge: to develop a brittle white candy coating that could encapsulate pellets of chicle. Henry's task was the easier, and in the 1910s his product emerged, as Chiclets. Not until 1928 did brother Frank succeed in producing a sturdy, "dry" gum that blew bubbles twice the size of his earlier product. Double Bubble was an immediate success among Americans of varied ages. But what delighted Frank Fleer even more was that during World War II, American GIs introduced the gum to Eskimo populations in Alaska, where it quickly displaced their centuries-old traditional "chew," whale blubber.

Ice Cream: 2000 B.C., China

Ice cream is rated as Americans' favorite dessert and we consume it prodigiously. Annual production amounts to fifteen quarts a year for every man, woman, and child in the United States, and if water ice, sherbet, sorbet, spumoni, and gelato are added, the figure jumps to twenty-three quarts per person. But then ice cream was a dessert phenomenon from the time of its creation, four thousand years ago, in China, even if that first treat was more of a pasty milk ice than a smooth icy cream.

At that point in ancient history, the milking of farm animals had recently begun in China, and milk was a prized commodity. A favorite dish of the nobility consisted of a soft paste made from overcooked rice, spices, and milk, and packed in snow to solidify. This milk ice was considered a symbol of great wealth.

As the Chinese became more adept at preparing frozen dishes—they imported and preserved snow from mountain elevations—they also developed **fruit ices.** A juice, often including the fruit's pulp, was either combined with snow or added to milk ice. By the thirteenth century, a variety of iced desserts were available on the streets of Peking, sold from pushcarts.

After China, ice milk and fruit ice appeared in fourteenth-century Italy, with credit for the desserts equivocally divided between Marco Polo and a Tuscan confectioner, Bernardo Buontalenti. Those European recipes were secrets, guarded by chefs to the wealthy, and with refrigeration a costly ordeal of storing winter ice in underground vaults for summer use, only the wealthy tasted iced desserts.

From Italy, frozen desserts traveled to France. When the Venetian Catherine de'Medici married the future King Henry II of France in 1533, she used fruit ices to demonstrate to the rest of Western Europe her country's culinary sophistication. During a month-long wedding celebration, her confectioners served a different ice daily, with flavors including lemon, lime, orange, cherry, and wild strawberry. She also introduced into France a semifrozen dessert made from a thick, sweetened cream, more akin to modern ice cream than to Chinese milk ice.

Ice cream became fully freezable in large quantities in the 1560s as the

An 1868 ice cream vendor, or "hokey pokey" man.

result of a technical breakthrough. Blasius Villafranca, a Spanish physician living in Rome, discovered that the freezing point of a mixture could be attained rapidly if saltpeter was added to the surrounding bath of snow and ice. Florentine confectioners began to produce the world's first solidly frozen, full-cream ices. Within a decade, a molded, multiflavored dessert of concentric hemispheres bowed in France as the *bombe glacée*.

Italian immigrants relocating throughout Europe sold ice cream and ices from ice-cooled pushcarts, and the desserts came within reach of the masses. By 1870, the Italian ice cream vendor was a familiar sight on London streets, called by British children the "hokey pokey" man, a corruption of the vendor's incessant cry, *"Ecco un poco"*—"Here's a little." Even in America, an ice cream vendor was known by that expression until the 1920s—until, that is, confectioner Harry Burt from Youngstown, Ohio, marketed the

419

first chocolate-covered vanilla ice cream bar on a stick, naming it a "Good Humor Sucker." Thus was born the Good Humor man.

Ice Cream Soda. The city of Philadelphia holds the distinction of being the point of entry of ice cream into the United States, as well as the home of the carbonated soda water concoction known as the ice cream soda or float.

It was Thomas Jefferson who tasted ice cream while ambassador to France, and returned to Philadelphia with a recipe. We know that Jefferson highly valued his "cream machine for making ice," and that Dolley Madison's White House dinners became renowned for their strawberry *bombe glacée* centerpiece desserts. By the early 1800s, Philadelphia was the country's "ice cream capital"—because of the quantity of ice cream produced there; because of a much-loved vanilla-and-egg flavor called "Philadelphia"; and because of the city's famous public ice cream "houses," which would later be known as "parlors." The ice cream soda was officially introduced and served in 1874 at the fiftieth anniversary of the city's Franklin Institute.

Ice Cream Sundae and Whipped Cream. From extant menus, food historians feel certain that the ice cream sundae debuted in the mid-1880s, about a decade after the ice cream soda, and that its name originated as a fanciful spelling of "Sunday," the only day of the week that the dish was sold. Why only on Sunday?

Two theories have been advanced. In parts of New England during the 1880s, certain religious restrictions prevented the sale and consumption of soda water (believed to be akin to spirits) on the holiest day of the week. Subtracting carbonated water from an ice cream soda leaves scoops of ice cream and syrup, a new dish fit for a Sunday. Two cities—Evanston, Illinois, and Norfolk, Virginia—claim to be the home of the sundae, each offering as proof ice cream parlor menus of the day.

The second theory, less widely held, is that the sundae originated independent of the ice cream soda, and that it was always topped with chocolate syrup. The syrup was expensive, so for most families, the dish became a special one-day-a-week (Sunday) treat.

Whipped cream was not a standard sundae or ice cream soda topping for many decades, because the cream had to be beaten by hand. That changed in the early 1930s when Charles Goetz, a senior chemistry major at the University of Illinois, discovered a way to saturate cream with nitrous oxide or laughing gas, a breakthrough that produced not only the first spray-on whipped cream, but also spray-can shaving lather.

As a high school student, Goetz worked part-time in an ice cream parlor, where he was frequently put to whipping cream. In 1931, as a college senior, he also worked part-time, but in the university's Diary Bacteriology Department, improving milk sterilization techniques. One day it occurred to him that bacteria might not develop and multiply in milk if the milk was

stored under high gas pressure. Experimenting, he discovered that milk released from a pressurized vessel foamed. As Goetz later wrote of his finding: "It was evident to me that if cream were used the foamed product would be whipped cream."

There was a problem: every gas Goetz tested imparted its own undesirable flavor to the whipped cream. It was through a local dentist that he learned of odorless, tasteless, nonflammable nitrous oxide, used as an anesthetic in extracting teeth. Laughing gas led him to produce the world's first commercial whipped cream from a can, ushering in the age of aerosols, which from a financial standpoint was nothing to laugh at.

Ice Cream Cone: 1904, St. Louis, Missouri

For centuries, ice cream was served in saucers and dishes and heaped on top of waffles, but there is no evidence for the existence of an edible pastry cone until 1904, at the St. Louis World's Fair. Organized to commemorate the hundredth anniversary of the Louisiana Purchase, the fair cost fifteen million dollars (the same price as the Louisiana Purchase) and had a host of special attractions, including the John Philip Sousa Military Band and the first demonstration of electric cooking; it also offered its thirteen million visitors a large number of food concessions. Side by side in one area were a Syrian baker, Ernest Hamwi, specializing in waffles, and a French-American ice cream vendor, Arnold Fornachou.

Enter legend.

As one version of the story goes, Fornachou, a teenager studying to become a watch repairman, ran out of paper ice cream dishes and rolled one of Hamwi's waffles into a cone, creating a new sensation. The alternate version credits Ernest Hamwi. An immigrant pastry chef from Damascus, Hamwi offered fairgoers a zalabia, a wafer-thin Persian confection sprinkled with sugar. He is supposed to have come to Fornachou's aid with rolled zalabias.

Nonetheless, several newspaper accounts of the day unequivocally record that ice cream cones, or "World's Fair cornucopias," became a common sight at the St. Louis Exhibition. Cones were rolled by hand until 1912, when Frederick Bruckman, an inventor from Portland, Oregon, patented a machine for doing the job. In little more than a decade, one third of all the ice cream consumed in the United States was eaten atop cones.

References

In a work such as this, which is indebted to so many journals, magazines, newspapers, trade books, encyclopedias, and corporate archive files, it would be impractical to cite a reference for each and every fact. What would better serve a reader interested in any particular topic discussed in this book, I felt, is a list of the sources that I used in writing each chapter. That material is provided here, along with comments, when appropriate, as to a particular source's availability (or lack of it), for considerable information, especially that deriving from folklore, was culled from private communications with cultural and social anthropologists, as well as from many dusty, out-of-print volumes borrowed from the bowels of libraries and archives.

To ensure accuracy, I have attempted to employ a minimum of two sources for the origin of a particular superstition, custom, or belief. In dealing with subjects that arose in prehistoric times and for which there are no unequivocal archaeological records (e.g., the origin of the "evil eye" superstition or the practice of the handshake), I sought out consensus opinions among folklorists. When these authorities substantially disagreed within their own discipline, I have labeled the information in the text as speculative and open to various interpretations, and have often presented two views.

A word about folklore, since it plays a crucial role in the origins of many of the "everyday things" discussed in the early chapters of this book.

No field of learning, perhaps, is more misunderstood than folklore, often defined as "the learning of nonliterate societies transmitted by oral tradition." In the United States, the word "folklore" itself often conjures up an image of long-haired folk singers or grizzled old-timers spinning questionable yarns about a Paul Bunyan or a Johnny Appleseed.

Contrary to popular opinion, the field is an intellectual subject with its own substantial, worldwide body of scholarship. Professional folklorists distinguish between genuine folk tradition, founded on actual historic figures, and embellished, largely fictive, imitation of those traditions. While serious students of folklore do not always agree on the boundaries of their discipline, they tend to follow one of three approaches to their material: the Humanistic Perspective, which emphasizes the human carrier of "oral literature"; the Anthropological Perspective, which focuses on cultural norms, values, and laws that form a consistent pattern in a nonliterate society; and the Psychoanalytic Perspective, which views the materials of folklore neither aesthetically nor functionally but behavioristically. In the last category, myths, dreams, jokes, and fairy tales express hidden layers of unconscious wishes and fears. In assembling many chapters of this book, it was necessary to borrow from each of these three perspectives.

Throughout the following references, I acknowledge my indebtedness to the many professionals who generously offered their time and advice, and who in numerous instances also provided me with articles, reprints, and books.

1 From Superstition

Superstitions are defined as irrational beliefs, half beliefs, or practices that influence human behavior. In attempting to compile the origins of many of our most cherished superstitions, I've relied on numerous sources for a consensus view. I wish to express gratitude to folklorist Dr. Alan Dundes, Department of Anthropology, University of California, Berkeley, for his thoughtful opinions, his collection of published papers on the origins of things as disparate as American Indian folklore and the Cinderella fairy tale, and his suggestions on other avenues of research. His article "Wet and Dry, the Evil Eye: An Essay in Semitic and Indo-European Worldview" is a definitive work on that superstitious belief and a prime example of a multiperspective approach to folklore material.

Additional works by Dr. Dundes that relate to this chapter: *Interpreting Folklore,* 1980, Indiana University Press; *Scared Narratives,* 1984, University of California Press; *The Study of Folklore,* edited by Dundes et al., 1965, Prentice-Hall.

Two volumes highly recommended for their scholarship, readability, and breadth of material are: *A Treasury of Superstitions,* by Dr. Claudia de Lys, 1957, Philosophical Library (reprinted in 1976 by Citadel Press under the title *A Giant Book of Superstitions*). A noted social anthropologist, Dr. de Lys spent more than three decades assembling the origins of superstitious beliefs from around the world. Though her treatment of each subject is brief, it is nonetheless quite comprehensive on a particular superstition's possible roots. For the lay reader interested in a single volume covering the majority of superstitious practices, the de Lys book would be the most satisfying.

The second recommended volume, of a still more popular nature, is *Superstitious? Here's Why!*, coauthored by Dr. de Lys and Julie Forsyth Batchelor, 1966, Harcourt Brace. Aimed primarily at young readers, the book is a selective condensation of Dr. de Lys's scholarly material.

The reader interested in curious worldwide folktales that underlie many superstitious practices can turn to *Superstition and the Superstitious*, Eric Maple, 1972, A. S. Barnes; *Superstition in All Ages*, Jean Meslier, Gordon Press, a 1972 reprint of the original 1890 edition; and the thorough *Encyclopedia of Superstitions*, M. A. Radford, revised by Christina Hole, 1949, Philosophical Library; 1969, Greenwood Press; 1975, Hutchinson, London. The Radford book is particularly insightful concerning the rabbit's foot superstition and the significance of the rabbit and hare to early societies, especially with reference to the origin of Easter customs.

A general overview of American folklore, including home-grown superstitious beliefs, appears in *American Folklore*, Richard Dorson, 1959, University of Chicago Press.

Highly recommended in this area are two books by folklorist Jan Harold Brunvand: *Study of American Folklore*, 1968, Norton; and *The Mexican Pet: Urban Legends*, 1986, Norton. Brunvand, a former editor of the *Journal of American Folklore*, explores the reasons why myths and superstitious beliefs take hold of the human imagination. He is often concerned with the humanistic perspective to folklore material, stressing the tale and the teller for their inherent worth and enjoyment, but he also ventures into the psychoanalytic realm, exploring legends and beliefs that derive from primal and universal human fears such as suffocation, castration, and blinding.

Many superstitious beliefs have religious roots—the supposed good fortune deriving from a horseshoe, for instance, is linked to a legend surrounding St. Dunstan. In such cases, I have attempted to substantiate the folklore story, whole or in part, using two encyclopedic books on religious figures: *The Oxford Dictionary of Popes*, J. N. D. Kelly, 1986, Oxford University Press; and *The Avenel Dictionary of Saints*, Donald Attwater, 1981, Avenel Books. Each volume is exhaustive and fascinating in its own right. In this same vein, I found helpful *Christianity or Superstition*, by Paul Bauer, 1966, Marshall Morgan and Scott.

2 By Custom

This chapter concerns the origins of why we do what we do, and its content derives in large part from studies in folklore, cultural anthropology, and etymology, for the original meaning of a word (such as "honeymoon") often says much about the tradition surrounding the practice it describes. I am indebted to Dr. Barbara Kirshenblatt-Gimblett, folklorist and chairperson of Performing Arts at New York University, for her many helpful references.

Through the influence of tradition we perform many actions so habitually

that their origins and original significance are seldom, if ever, questioned. Dr. R. Brasch, a rabbinical scholar, insightfully investigates numerous human customs, from marriage practices to death traditions, in *How Did It Begin,* 1976, David McKay. His book, unfortunately out of print, is well worth a visit to a local library. Rabbi Brasch's linguistics background—he is a student of twelve languages, among them Babylonic-Assyrian, Arabic, Syriac, and Persian—provides a firm foundation for many subjects explored in this chapter.

A comprehensive book to browse, from which I gleaned many facts and verified others, is *Funk and Wagnalls Standard Dictionary of Folklore, Mythology, and Legend,* edited by Maria Leach and Jerome Fried, 1980.

For birthday practices: *The Lore of Birthdays,* Ralph and Adeline Linton, 1952, Henry Schuman. For a fascinating history of the song "Happy Birthday to You" and the legal dispute surrounding its authorship and subsequent royalty rights, see *New York Times,* "Dr. Patty S. Hill of Columbia University Dies," May 26, 1946; and *Louisville* (Kentucky) *Courier,* "Their Song Becomes a Universal One," Rhea Talley, February 15, 1948. For a capsule overview of the song, see *The Book of World-Famous Music,* James Fuld, 3rd edition, 1985, Dover.

Additional information on the origins of birthday practices was obtained through personal communications with the research staff at Hallmark Cards.

Two highly readable books on a wide variety of human customs are: *Why You Say It,* Webb B. Garrison, 1953, Abingdon Press; and *Why We Do It,* Edwin Daniel Wolfe, Books for Libraries Press, a 1968 reprint of the 1929 original. An excellent overview of the origins of customs throughout the world is *Curiosities of Popular Customs,* William S. Walsh, 1966, Gale.

For marriage customs: Here I recommend that the interested reader borrow from something old—*The Customs of Mankind,* Lillian Eichler Watson, Greenwood Press, a 1970 reprint of the 1925 original; and something new—*The Bride,* by Barbara Tober, 1984, Abrams. Christian aspects of wedding practices are expertly presented by theologian John C. McCollister in *The Christian Book of Why,* 1983, Jonathan David Publishers. The volume, written in a question-and-answer format, provides concise explanations of how and why various customs arose in ancient times and persist into the present. In addition to marriage customs, McCollister, a university professor and Lutheran minister, examines the origins of sacred artifacts, modes of prayer and worship, and festivals and dietary laws.

A particularly thorough book on the customs of wearing and exchanging rings is *Rings Through the Ages,* James R. McCarthy, 1945, Harper & Brothers.

On regional New England practices: *Customs and Fashions in Old New England,* Alice Morse Earle, 1893, Scribner, reprinted by Charles E. Tuttle, 1973.

On Old World practices: *Peasant Customs and Savage Myths from British Folklorists,* Richard Dorson, 1968, Chicago University Press, 2 volumes.

3 On the Calendar

Several excellent books exist that are devoted entirely to the origins of holidays. The three that I found most comprehensive, readable, and scholarly in the presentation of material are: *The American Book of Days,* George W. Douglas, revised by Jane M. Hatch and Helen D. Compton, 1978, H. W. Wilson Company. *All About American Holidays,* Maymie Krythe, 1962, Harper & Brothers. *Celebrations: The Complete Book of American Holidays,* by Robert J. Myer with the editors of Hallmark Cards, 1972, Doubleday. I am also indebted to the research staff at Hallmark Cards, Kansas City, Missouri, for a considerable amount of material on the origins of holidays, holiday foods and customs, as well as for figures on the numbers of greeting cards sold on major and minor observances.

Several holidays deserve particular note.

Mother's Day: The committee of the International Mother's Day Shrine in West Virginia was generous in providing material on Miss Anna Jarvis, the founder of the holiday. Additional information on Mother's Day observances came from Public Broadcasting Television, Morgantown, West Virginia; and from WBOY-TV, Clarksburg, West Virginia. The National Restaurant Association provided figures on the number of families that eat out on various national holidays. Howard Wolfe, in *Mother's Day and the Mother's Day Church,* 1962, Kingsport Press, provided further insight into the life and ambitions of Anna Jarvis.

Thanksgiving: The best single source I located on the origins of this national holiday is *Thanksgiving: An American History,* by Diana K. Applebaum, 1984, Facts on File. Also helpful was *The Mayflower,* by Vernon Heaton, 1980, Mayflower Books.

Easter: While the first three books in this section give a rather comprehensive account of Easter and its traditions, a volume devoted entirely to the holy day is *The Easter Book,* Francis X. Weiser, 1954, Harcourt Brace. Additional Easter lore was provided by the PASS Dye Company of Newark, N.J., founded in the 1870s and one of the first commercial ventures to market prepackaged powdered Easter egg dyes.

The history and significance of eggs in early times, particularly among the Egyptians, Phoenicians, Persians, Greeks, and Romans, is detailed in *Easter Eggs,* Victor Houart, 1982, Stephen Green Press. An overview of the feast from pagan holiday to Christian holy day is contained in *Easter and Its Customs,* Christina Hole, 1961, M. Barrows Company.

Groundhog Day: An excellent article separating fact from fiction and locating the origin of this observance is "A Groundhog's Day Means More to Us Than It Does to Him," Bil Gilbert, *Smithsonian,* May 1985.

Bibliographic material on saints Patrick, Valentine, and Nicholas (the original Santa) is derived from *The Oxford Dictionary of Popes* and *The Avenel Dictionary of Saints,* op. cit.

Christmas: Christmas customs are numerous, diverse, and international and have been culled from many sources, including several of the above. In addition, the origin of the song "Rudolph, the Red-Nosed Reindeer" was provided by the Montgomery Ward department store chain, for which the lyrics were written in 1939.

Three sources deal with Christmas in America: *The American Christmas*, James H. Barnett, 1954, Macmillan; *Christmas on the American Frontier, 1800–1900*, John E. Baur, 1961, The Caxton Printers; and to a lesser extent, *A Treasury of American Folklore*, B. A. Botkin, editor, 1944, Crown. These references indicate the religious resistance among early colonists to the festive observance of Christ's birthday.

Also helpful in creating the section on Christmas customs were the excellent overviews presented in *Christmas Customs and Traditions: Their History and Significance*, Clement A. Miles, 1976, Dover; and *1001 Christmas Facts and Fancies*, Alfred C. Hattes, 1954, A. T. De La Mare. An international view of the holiday is found in *Christmas Customs Around the World*, Herbert Wernecke, 1979, Westminster Press.

A fine reference on the calendar and the origin of the week is *The Seven Day Circle: The History and Meaning of the Week*, Eviatar Zerubavel, 1985, The Free Press.

A highly readable and comprehensive book on holidays and customs, out of general circulation but still available in limited number from the publisher, is *Days and Customs of All Faiths*, by Howard Harper, 1957, Fleet Publications.

4 At the Table

This chapter opens with a discussion of the origins of etiquette, then proceeds to explore the evolution of eating with a knife, fork, and spoon, as well as such practices as blowing the nose. The classic, pioneering work that examines the links between such social graces and behavioral control is *The History of Manners: The Civilizing Process*, Volume 1, by Swiss sociologist Norbert Elias, translated by Edmund Jephcott and published by Pantheon, 1978 (a reprint of the 1939 original). Elias draws from a dazzling array of sources, including medieval etiquette and manners books, eighteenth-century novels, travel accounts, song lyrics, and paintings. Many of the quotations in this chapter I borrow from Elias.

A more readable, though not less scholarly, account of table manners is *The Best of Behavior: The Course of Good Manners from Antiquity to the Present as Seen Through Courtesy and Etiquette Books*, by Esther B. Aresty, 1970, Simon and Schuster. Both books are enjoyable, amusing, and highly recommended.

The opening remarks in this chapter on the decline in table manners in all segments of modern society are based on "Table Manners: A Casualty

of the Changing Times," William R. Greer, *New York Times,* October 16, 1985.

The early seminal books, by century, on which the information in this chapter is based are:

c. 2500 B.C., Egypt, *The Instructions of Ptahhotep*
c. 950 B.C., the writings of King Solomon and King David
c. 1000, Hebrew Household Books, the first writings on manners to appear in Western Europe
c. 1430, Italy, *How a Good Wife Teaches Her Daughter* and *How a Wise Man Teaches His Son*

Sources on specific manners include:

On nose blowing: The following three accounts treat the practice and detail acceptable standards of the day, and the last two shed light on the development and use of handkerchiefs (a topic covered in depth in Chapter 12): *Fifty Table Courtesies,* Bonvieino da Riva, 1290; *On civility in children,* Erasmus of Rotterdam, 1530; "On the Nose, and The Manner of Blowing the Nose and Sneezing," The Venerable Father La Salle, 1729.

On dining manners: *Fifty Table Courtesies* and *On civility in children,* op. cit.

On the use of cutlery (revealing the gradual acceptance of the fork): "On Things to Be Used at Table," The Venerable Father La Salle, 1729.

A history of the knife, fork, and spoon appears in *Setting Your Table,* by Helen Sprackling, 1960, Morrow; as well as in *The Story of Cutlery,* by J. B. Himsworth, 1953, Ernest Benn.

Concerning the section "Table Talk": *Why You Say It,* Webb B. Garrison, and *Why We do It,* Edwin Daniel Wolfe, op. cit. I have also consulted *Thereby Hangs a Tale: Stories of Curious Word Origins,* Charles Earle Funk, 1950, Harper & Row, Harper Colophon Edition, 1985. An excellent book that includes the origins of cutlery names and dinnerware is *Word Origins and Their Romantic Stories,* Wilfred Funk, 1978, Crown.

A reference for Wedgwood Ware is *Entrepreneurs: The Men and Women Behind Famous Brand Names and How They Made It,* by Joseph and Suzy Fucini, 1985, G. K. Hall. The book, whose title is self-explanatory, provides fascinating reading on scores of individuals and the products they created, with information presented in concise, encapsulated form. I employed this reference to double check facts and flesh out information on several topics, including Culligan Water Softeners (Chapter 5), and Carrier Air Conditioners and Burpee Seeds (Chapter 6).

5 Around the Kitchen

In this and the following chapter, which deal with everyday inventions and gadgets found in the kitchen and throughout the home, I am indebted to the research staff at the Division of Patents and Trademarks of the U.S.

Department of Commerce; to the National Inventors Hall of Fame, in Arlington, Virginia; and to individual companies that provided historical information on their products. Before providing specific references by product, I would direct the interested reader to four excellent general works, covering a wide variety of inventors, gadgets, and corporations.

The Fifty Great Pioneers of American Industry, Editors of Ncwsfront Year, 1964, Maplewood Press. *Eureka! The History of Invention,* edited by De Bono, 1974, Holt, Rinehart & Winston. *The Great Merchants: America's Foremost Retail Institutions and the People Who Made Them Great,* Thomas Mahoney and Leonard Sloane, 1955, Harper & Brothers. *Pioneers of American Business,* Sterling G. Slappey, 1970, Grossett.

On the origin and use of Teflon: Personal communications with the National Inventors Hall of Fame for material on Teflon's inventor, Dr. Roy J. Plunkett. A detailed description of Teflon's development is in "Polytetrafluoroethylene," W. E. Hanford and R. M. Joyce, *Journal of the American Chemical Society,* Volume 68, 1946. Dr. Plunkett's own description of his discovery appears in *The Flash of Genius,* Alfred B. Garrett, 1963, Van Nostrand. I also wish to thank the Du Pont Company of Wilmington, Delaware, for material on Dr. Plunkett and Teflon.

On the microwave oven: Personal communications with the Raytheon Company, Microwave and Power Tube Division, Waltham, Massachusetts. Two excellent accounts of the development of microwave cooking, one an article, the other a book, appear in "The Development of the Microwave Oven," Charles W. Behrens, *Appliance Manufacturers,* November 1976; and *The Creative Ordeal: The Story of Raytheon,* Otto J. Scott, 1974, Atheneum. A recent account of the pioneering efforts that led to the discovery of microwave radiation for cooking is in *Breakthroughs!* by P. Nayak and J. Kettringham, 1986, Rawson, Chapter 8.

On the paper bag: Personal communications with the Kraft and Packaging Papers Division of the American Paper Institute, as well as with the National Inventors Hall of Fame.

On the history and evolution of the friction match: *Eureka!,* op. cit. And material provided by the Diamond Match Company of Springfield, Massachusetts.

An invaluable book in assembling the material in this chapter and Chapter 6 was *The Housewares Story,* by Earl Lifshey, 1973, published by the National Housewares Manufacturers Association, Chicago. This fascinating volume details the early marketing of numerous household products (e.g., orange juicers, bathroom scales, kitchen stools) that for reasons of space I was unable to include. A highly recommended work.

The National Inventors Hall of Fame also provided information on Leo H. Baekeland and Bakelite; Charles Goodyear and rubber; Charles Martin Hall and his 1885 discovery of the electrolytic method of producing inexpensive aluminum, which eventually brought the metal into wide use; and Samuel F. B. Morse. Additional information on the choice of the distress

signal SOS is from the International Maritime Organization, and from "Mayday for Morse Code," *Science,* March 1986.

On plastics discussed in this chapter and Tupperware: *Eureka!* op. cit., and *Plastics: Common Objects, Classic Designs,* by Sylvia Katz, 1984, Abrams. Ms. Katz covers the history of the plastics industry, beginning in the 1840s, and detailing the material's uses in decorative objects, combs, furniture, and toys. Another lively history of the subject is *Art Plastic: Designed for Living,* by Andrea DiNoto, 1984, Abbeville Press. Her text is geared toward readers with little knowledge of the scientific techniques involved in the manufacture of plastic. Material on the "miracle" plastic, nylon, is from personal communications with the Du Pont Company, and from *Du Pont Dynasty: Behind the Nylon Curtain,* by Gerard Colby, 1984, Lyle Stuart.

On blenders and food processors: Communications with Mrs. Fred Waring helped clarify many conflicting accounts of her husband's involvement in the development of the Waring Blendor. Also of assistance in assembling this material was information from Oster and Hamilton Beach, and from *Topsellers,* by Molly Wade McGrath, 1983, Morrow. I am indebted to Dave Stivers, archivist of Nabisco for directing me to Ms. McGrath's book and for generously providing me with more material on products than I could possibly use in this volume. Also, *New Processor Cooking,* by Jean Anderson, 1983, Morrow.

On Pyrex: Material provided by Corning Glass Works, Corning, New York. (Also see references in Chapter 6 under "Glass Window.")

On disposable paper cups: In addition to abovementioned general references on inventions, *Why Did They Name It?* by Hannah Campbell, 1964, Fleet Press. This is a gem of a book, highly recommended, and still available in limited number from the publisher in New York. Ms. Campbell provides entertaining histories of the brand names that have become an integral part of the American home. The book began as a series of articles published in *Cosmopolitan* magazine in the 1960s.

One final and excellent source covering a variety of gadgets found in the kitchen, bathroom, and around the home: *The Practical Inventor's Handbook,* Orville Green and Frank Durr, 1979, McGraw-Hill.

6 In and Around the House

A delightful, informative book on the history and comforts of the home in Western culture is *Home: A Short History of an Idea,* by Witold Rybczynski, 1986, Viking. The book considers the home before the advent of electrical gadgets, after such convenience devices were introduced and proudly displayed as prestige acquisitions, then in modern times, when the decorating vogue has been a nostalgia for past simplicity in which "The mechanical paraphernalia of contemporary living has been put away, and replaced by brass-covered gun boxes, silver bed-side water carafes, and leather-bound books."

As pertains to this chapter, Mr. Rybczynski paints a picture of home comfort and what it has meant in different times. He writes, "In the seventeenth century, comfort meant privacy, which lead to intimacy and, in turn, to domesticity. The eighteenth century shifted the emphasis to leisure and ease, the nineteenth to mechanically aided comforts—light, heat, and ventilation. The twentieth-century domestic engineers stressed efficiency and convenience." This general discussion has been fleshed out in detail, invention by invention, through a number of sources listed below.

On lighting the home, from oil lamps in prehistoric times to fluorescent tubes, I found the most detailed single volume to be *The Social History of Lighting*, by William T. O'Dea, 1958, Routledge & Kegan Paul, London.

On types of glass and glass windows: "A History of Glassmaking," John Harris, *New Scientist*, May 22, 1986. *This Is Glass*, generously provided by the Corning Glass Works of Corning, New York, and published by the company. Also, *Glass Engineering Handbook*, E. B. Shand, 1980, McGraw-Hill. And "Safety Glass: Its History, Manufacturer, Testing, and Development," J. Wilson, *Journal of the Society of Glass Technology*, Volume 16, 1932.

Once again, an indispensable book on home convenience inventions is *The Housewares Story*, op. cit. Capsule descriptions of home inventions and inventors are found in the voluminous and entertaining *The Ethnic Almanac*, Stephanie Bernardo, 1981, Doubleday; a book that provides hours of fascinating browsing.

On brooms, carpet sweepers, and vacuum cleaners: An overview appears in *The Housewares Story*, op. cit. The Bissell sweeper can be found in *Great American Brands*, David Powers Cleary, 1981, Fairchild. *Fabulous Dustpan: The Story of the Hoover Company*, by Frank Garfield, 1955, World Publishing. Also on the vacuum cleaner: *Everybody's Business: An Almanac*, edited by Milton Moskowitz et al., 1982, Harper & Row; a thoroughly entertaining book to browse. Additional material was provided by the Fuller Brush Company.

On the sewing machine and Elias Howe and Isaac Singer: *Brainstorms and Thunderbolts: How Creative Genius Works*, by Carol O. Madigan and Ann Elwood, 1983, Macmillan. *The Patent Book: An Illustrated Guide and History for Inventors, Designers and Dreamers*, James Gregory and Kevin Mulligan, 1979, A & W Publishers.

For a general discussion of the evolution of lawns, "Points of Origin: From Flowery Medieval Greensward to Modern Canned Meadow," Michael Olmert, *Smithsonian*, May 1983.

On the wheelbarrow: *Everyday Inventions*, M. Hooper, 1976, Taplinger; an excellent and comprehensive reference. And *The Encyclopedia of Inventions*, edited by Donald Clark, 1977, Galahad Books.

On rubber and the garden hose: *Charles Goodyear, Father of the Rubber Industry*, L. M. Fanning, 1955, Mercer Publishing Co.; *Everyday Inventions*, op. cit.; plus information provided by the B. F. Goodrich Company of Akron, Ohio.

On Burpee seeds: Personal communications, and the Burpee company catalogues, plus *Entrepreneurs,* op. cit.

On the lawnmower: *Eureka!* and *The Encyclopedia of Inventions,* op. cit.

7 For the Nursery

It would have been impossible to assemble the material for this chapter without two definitive references on nursery rhymes and fairy tales: *The Classic Fairy Tales,* Iona and Peter Opie, 1974, Oxford University Press; and *The Oxford Dictionary of Nursery Rhymes,* Iona and Peter Opie, 1959, Oxford University Press. The Opies' thoroughness of research has virtually monopolized this field of investigation; every additional reference I consulted on nursery rhymes and fairy tales expressed an indebtedness to the Opies' works.

To flesh out the Opies' material on many historical points, I consulted: *Cinderella: A Folklore Casebook,* edited by Alan Dundes, 1982, Wildman Press. Dr. Dundes provides a fascinating glimpse of this fairy tale in numerous cultures over many centuries. *Jump Rope Rhymes,* Roger D. Abrahams, 1969, American Folklore Society. *American Non-singing Games,* Paul Brewster, 1954, University of Oklahoma Press. *Traditional Tunes of the Child Ballads,* Bertrand Bronson, 1959, Princeton University Press. *The Lore and Language of Schoolchildren,* Iona and Peter Opie, 1967, Oxford University Press. *The Interpretation of Fairy Tales,* Marie Louis von Franz, 1970, Spring Publications. And finally, another work by the Opies, *Children's Games in Street and Playground,* 1969, Oxford University Press.

Additional material on *The Wizard of Oz,* Bluebeard, and *Dracula* is from *Brainstorms and Thunderbolts,* by Carol O. Madigan and Ann Elwood, 1983, Macmillan.

8 In the Bathroom

A word on Thomas Crapper: According to British popular legend, Thomas Crapper is the inventor of the modern flush toilet, and several early and descriptive Victorian era names for his invention were the Cascade, the Deluge, and the Niagara. Crapper is referred to in many popular histories of the bathroom, but scant information is provided on his background and invariably no sources are listed.

After months of research for this book, I was fortunate enough to turn up what has to be the original source of the Thomas Crapper legend—which appears to be a purely fictive legend at that, perpetrated with droll British humor by author Wallace Reyburn. *Flushed with Pride: The Story of Thomas Crapper,* was published by Reyburn in 1969 in England by Macdonald & Co. and two years later in the United States by Prentice-Hall (now out

of print). The book reads for long stretches as serious biography, but the accumulation of toilet humor puns, double entendres, and astonishing co-incidences eventually reveals Wallace Reyburn's hoax.

In an attempt to shed light on this bit of bathroom lore, here are several references from Reyburn's "biography" of Thomas Crapper from which the reader can draw his or her own conclusions.

Crapper was born in the Yorkshire town of Throne in 1837, "the year in which Queen Victoria came to the throne." He moved to London and eventually settled on Fleet Street, where he perfected the "Crapper W.C. Cistern . . . after many dry runs." The installation of a flushing toilet at the royal palace of Sandringham was, according to Reyburn, "a high-water mark in Crapper's career." He became "Royal Plumber," was particularly close with his niece Emma Crapper, and had a friend named "B.S." (For another Reyburn hoax, on the bra, see References, page 439.) Reyburn's book did not serve as a source for this chapter; the materials that did:

Highly recommended is *Clean and Decent,* by Lawrence Wright, 1960, Viking. The book begins with the Minoan achievements in plumbing and flush toilets and their use of wooden toilet seats. It details the Egyptian contributions, including stone seats, and traces plumbing developments through the accomplishments of British engineers in the eighteenth and nineteenth centuries. Wright's book is thorough, and, revealingly, it makes no mention of Thomas Crapper.

Also of assistance in assembling material for this chapter were: *The Early American House,* by Mary Earl Gould, 1965, Charles E. Tuttle; "The Washtub in the Kitchen," by Bill Hennefrund, September 1947, *Nation's Business;* and *Medical Messiahs: A Social History of Health Quackery in 20th Century America,* James H. Young, 1967, Princeton University Press.

On the origins of the toothbrush, toothpaste, and dental practices: I am indebted to the American Dental Association for providing me with reprints of journal articles detailing the history of tooth and mouth care; particularly helpful was "The Development of the Toothbrush: A Short History of Tooth Cleansing," Parts I and II, by Peter S. Golding, *Dental Health,* Volume 21, Nos. 4 and 5, 1982.

The Du Pont Company provided numerous articles from *The Du Pont Magazine* on the development of nylon and nylon toothbrush bristles; most enlightening were "A Personal Possession: Plastic Makes the Modern Toothbrush," September 1937; "Introducing Exton Bristle: Dr. West's Miracle-Tuft Toothbrush," November 1938; and "Birth of a Toothbrush," October 1951.

An excellent, highly recommended overview is found in *Dentistry: An Illustrated History,* by Malvin E. Ring, 1986, Abrams. This is a colorful ac-count of dentistry from prehistoric times to the mid-twentieth century, enriched by excellent illustrations and photographs. Ring, a professor of dentistry at the State University of New York at Buffalo, focuses on the evolution of dental techniques from genuinely torturous procedures to

modern painless ones, nonetheless dreaded.

Two excellent volumes on the history of false teeth are *The Strange Story of False Teeth,* John Woodforde, 1972, Drake; and *Teeth, Teeth, Teeth,* Sydney Garfield, 1969, Simon and Schuster. The Hagley Museum and Library of Wilmington, Delaware, provided me with excellent articles on the development of dentistry.

On the history of shaving, the razor, and the electric razor: Squibb, Schick, and Gillette provided material on their individual products, while the interested reader is directed to the following popular accounts: *Great American Brands* and *Topsellers,* op. cit.; both of these references also cover the origin of tissues. Also highly readable and informative on Gillette razors and Kleenex tissues is *Why Did They Name It?* Hannah Campbell, op. cit. Ms. Campbell devotes two chapters of her book to the development of items found in the bathroom.

On the origin of soap, in particular floating soap: I wish to thank corporate archivist Edward Rider of Procter & Gamble for providing me with a voluminous amount of research, as well as copies of early advertisements for Ivory Soap.

9 Atop the Vanity

Although many sources were employed to assemble the facts in this chapter, three works in particular deserve mention for their thoroughness and scholarship; one on makeup, one on hair, one on fragrances.

On the origin and evolution of makeup: The single best source I located is unfortunately out of print but available for in-house reading at New York City's Lincoln Center Library: *A History of Makeup,* by M. Angeloglou, 1970.

On ancient to modern hair care, hair coloring, and wigs: *The Strange Story of False Hair,* by John Woodforde, 1972, Drake. Additional material was provided by personal communications with Clairol, and from statistics on hair coloring in *Everybody's Business,* op. cit.

On the development of incense and its transition to perfume, then into an industry: *Fragrance, The Story of Perfume from Cleopatra to Chanel,* Edwin T. Morris, 1984, Scribner. Mr. Morris, who teaches fragrance at the Fashion Institute of Technology in New York City, provides a fascinating overview of the subject from its early days in Mesopotamia, where the most prized scent was cedar of Lebanon, through the French domination of the modern perfume industry. For the reader interested in pursuing the subject further than I have detailed, this book is highly recommended. Helping me extend the material into modern times in America was the Avon company. Two popular accounts of the development of Avon are found in *Topsellers* and *Why Did They Name It?* op. cit.

An excellent general reference for the development of combs, hairpins, jewelry, and makeup is *Accessories of Dress,* by Katherine M. Lester and Bess V. Oerke, 1940, Manual Arts Press.

Although *The Encyclopedia of World Costume* by Doreen Yarwood (1978, Scribner) is predominantly concerned with the origins of articles of attire, it contains a lengthy and excellent section on the history of cosmetics.

10 Through the Medicine Chest

This chapter more than any previous one deals with brand-name items; individual companies were contacted, and they provided material on their products. While I thank them all, I especially wish to single out Chesebrough (Vaseline), Johnson and Johnson (Band-Aids), Scholl, Inc. (Dr. Scholl's Foot Care Products), Bausch & Lomb (contact lenses and eye care products), and Bayer (aspirin). What is provided below are easily available sources for the reader interested in pursuing specific topics further.

On the origin of drugs: *History Begins at Sumer,* Samuel Noah Kramer, 1981, University of Pennsylvania Press. Dr. Kramer provides translations of extant Sumerian clay tablets that serve as the first recorded catalogue of medications. In addition: *Barbiturates,* Donald R. Wesson, 1977, Human Science Press; *The Tranquilizing of America,* Richard Hughes, 1979, Harcourt Brace; *The Medicine Chest,* Byron G. Wels, 1978, Hammond Publications.

An excellent reference for over-the-counter drugs common to the home medicine chest is *The Essential Guide to Nonprescription Drugs,* David Zimmerman, 1983, Harper & Row. Augmenting information in this volume, I used *Chocolate to Morphine,* Andrew Weil and Winifred Rosen, 1983, Houghton Mifflin.

The single most comprehensive book I located on the development of the art and science of pharmacy is *Kremers and Undang's History of Pharmacy,* originally published in 1940 and revised by G. Sonnedecker, with the 4th edition issued in 1976 by Lippincott. Highly recommended.

The Little Black Pill Book, edited by Lawrence D. Chilnick, 1983, Bantam, provides informative discussions of various classes of medicine chest drugs. For a fascinating account of the 1918 influenza pandemic (as mentioned in the section on Vick's VapoRub), see *Great Medical Disasters,* Dr. Richard Gordon, 1983, Dorset, Chapter 19; as well as *Influenza: The Last Great Plague,* W. I. B. Beveridge, 1977, Neale Watson Academic Publications; and *The Black Death,* P. Ziegler, 1971, Harper & Row.

Miscellaneous references throughout the chapter to folk cures are often from the monthly "Folk Medicine" column by Carol Ann Rinzler, in *American Health Magazine.*

11 Under the Flag

I am indebted to the Troy, New York, Historical Society for excellent research material on Sam Wilson, America's original Uncle Sam. For the interested reader, I would recommend *Uncle Sam: The Man and The Legend,*

by Alton Ketchum, 1975, Hill and Wang.

On the Boy Scouts: Much historical material was provided by Boy Scouts of America, headquarters in Irving, Texas. Also, *The Official Boy Scouts Handbook,* William Hillcourt, 9th edition, 1983, published by the Boy Scouts of America. The best single source on Robert Baden-Powell, British founder of scouting, is *The Character Factory: Baden-Powell and the Origins of the Boy Scout Movement,* Michael Rosenthal, 1986, Pantheon Books. Although the scouting organization has always denied that the movement was initially intended to prepare boys for military service, Mr. Rosenthal clearly illustrates that the "good citizens" Baden-Powell hoped to fashion were only one step removed from good soldiers. And while scouting's founder insisted that the movement was "open to all, irrespective of class, colour, creed or country," it is equally clear that racial prejudice often crept into Baden-Powell's writings.

On Mount Rushmore: Historical material provided by the Mount Rushmore National Memorial, administered by the National Park Service, U.S. Department of the Interior. An excellent account of the origin and evolution of the momument is contained in *Mount Rushmore, Heritage of America,* 1980, by Lincoln Borglum (with Gweneth Reed DenDooven), son of the man who sculpted the mountain and who himself added the finishing touches upon his father's death. It is issued by K.C. Publications, Nevada. A more detailed history is found in *Mount Rushmore,* Gilbert C. Fite, 1952, University of Oklahoma Press.

On American songs: A superb and definitive book on four tunes is *Report: The Star-Spangled Banner, Hail Columbia, America and Yankee Doodle,* by Oscar Sonnect, 1972, Dover. The book is fascinating in that it traces the lore surrounding each song and in a scholarly fashion separates fact from fiction. An additional reference on the origin of songs is *The Book of World-Famous Music,* by James Fuld, op. cit. Since its first publication in 1966, the book has been a monument in music scholarship, with Fuld painstakingly tracing the origins of nearly one thousand of the world's best-known tunes back to their original printed sources. Long out of print, the book was updated by the author in 1984–85 and reissued by Dover in 1986. It makes for fascinating browsing.

Also used in compiling musical references in this chapter: *American Popular Music,* Mark W. Booth, 1983, Greenwood Press; and *A History of Popular Music in America,* Sigmund Spaeth, 1967, Random House.

On West Point: Material provided by the Public Affairs Office of the United States Military Academy. Also, *West Point,* issued by National Military Publications.

On the American flag: Though much has been written on the controversy surrounding who designed the country's first flag, one highly readable and scholarly work is *The History of the United States Flag,* Milo M. Quaife et al., 1961, Harper & Brothers. The book dispels many "flag myths," and in

clear and concise fashion it lays out all the hard facts that are known about this early symbol of the Republic.

An interesting book that explains how "continents, countries, states, counties, cities, towns, villages, hamlets, and post offices came by their names" is *The Naming of America*, Allan Wolk, 1977, Thomas Nelson Publishers.

For this chapter I make one final recommendation: *What So Proudly We Hail: All About Our American Flag, Monuments, and Symbols*, by Maymie R. Krythe, 1968, Harper & Row. This one volume covers the origins of such topics as Uncle Sam, the American flag, the Statue of Liberty, the Lincoln and Jefferson memorials and the Washington Monument, and the White House.

I wish to thank the Washington, D.C., Chamber of Commerce and the Convention and Visitors Association for providing material on the history of the nation's capital.

On the Statue of Liberty: *Statue of Liberty, Heritage of America*, Paul Weinbaum, 1980, K.C. Publications. I also wish to thank the Statue of Liberty–Ellis Island Foundation for generously providing me with historical material.

12 On the Body

Many separate items are covered in this chapter, and before providing specific references for each article of attire, I present several books that expertly cover the field.

The Encyclopedia of World Costume, by Doreen Yarwood, 1978, Scribner, is thorough and almost exhaustive on the subject of clothing. R. Turner Wilcox has written several books that provide detailed accounts of the origin and evolution of clothing: *The Mode in Costume*, 1958, Scribner; and in the same series, *Mode in Hats and Headdress* and *Mode in Footware*. Also, *History of Costumes*, Blanche Payne, 1965, Harper & Row.

Pictorial sources were: *What People Wore: A Visual History of Dress from Ancient Times to the Present*, Douglas Gorsline, 1952, Bonanza Books; and *Historical Costumes in Pictures*, Braun and Schneider, 1975, Dover. Another excellent Dover publication is *A History of Costume* by Carl Kohler, 1963. Also of assistance was *The Fashion Dictionary*, M. B. Picken, 1973, Funk and Wagnalls.

On the necktie: *Collars and Cravats, 1655–1900*, D. Colle, 1974, Rodale Press. Also, "Part II: Accessories Worn at the Neck," in *Accessories of Dress*, op. cit. This work also contains excellent sections on the origins of hats, veils, girdles, shoes, gloves, fans, buttons, lace, handbags, and handkerchiefs.

On off-the-rack clothing: While many of the above books deal with the subject, one highly thorough source is *Fashion for Everyone: The Story of Ready-to-Wear*, Sandra Ley, 1975, Scribner.

On the hat: In addition to the above general sources, *The History of the*

Hat, Michael Harrison, 1960, H. Jenkins, Ltd.

Vogue publishes a series of books that I found helpful:

Sportwear in Vogue Since 1910, C. Lee-Potter
Brides in Vogue Since 1910, Christina Probert
Shoes in Vogue Since 1910, Probert
Swimwear in Vogue Since 1910, Probert
Hats in Vogue Since 1910, Probert
Lingerie in Vogue Since 1910, Probert

On the zipper: I am indebted to the people at Talon, Meadville, Pennsylvania, for loaning me the only existing copies of material on the development of the zipper; particularly their own *A Romance of Achievement: History of the Zipper.* I also wish to thank the Chicago Historical Society for information on the presentation of the zipper at the 1893 Chicago World's Fair, and the B. F. Goodrich Company for information on early zipped boots and the origin of the name "zipper."

Additional material on swimwear and the bikini was provided by the Atlantic City Historical Society and by Neal Marshad Productions (they allowed me to view an informative film, *Thirty Years of Swimsuit History*); and the National Archives provided reprints of newspaper articles featuring the nuclear bomb blast on Bikini atoll.

On the umbrella: The single best source I located is *A History of the Umbrella,* T. S. Crawford, 1970, Taplinger. It is comprehensive, covering the earliest known umbrellas, which were sunshades, in Egypt and India, and it traces the development of the article through periods of waterproofing, through eras when an umbrella was never carried by a man, and into relatively modern times, when a British eccentric made the umbrella an acceptable male accessory of dress.

For the interested reader in the New York metropolitan area, the single best source of information on clothing is the Fashion Institute of Technology in Manhattan; its collection of materials (costumes and books) is the largest in the world. With time and patience, any question on fashion through the ages can be answered from its resources.

On fabric: *The Fabric Catalogue,* Martin Hardingham, 1978, Pocket Books. This volume provides the origin and history of every natural and man-made fiber and textile.

On the tuxedo: I wish to thank the Tuxedo Park, New York, Chamber of Commerce for historical material on this article on evening attire, as well as the Metropolitan Museum Costume Institute (like F.I.T., an invaluable source of information for this chapter).

On jeans: In addition to several general references cited above that contain information on blue jeans, I wish to thank the Levi Strauss Company for material.

On sneakers: Nike, through personal communications, as well as *Breakthroughs!* op. cit., Chapter 10.

Another excellent collection of books on individual items of attire is *The Costume Accessories Series*, published by Drama Books. By item:

Bags and Purses, Vanda Foster
Hats, Fiona Clark
Gloves, Valerie Cumming
Fans, Helene Alexander

By the same publisher: *A Visual History of Costume Series:*

The 16th Century, Jane Ashelford
The 17th Century, Valerie Comming
The 18th Century, Aileen Ribeiro
The 19th Century, Vanda Foster

Also, *The History of Haute Couture, 1850–1950*, Diana de Marley, Drama Books.

13 Into the Bedroom

According to popular legend, the brassiere was invented in Germany by Otto Titzling, a name every bit as suspicious-sounding as that of the alleged inventor of the flush toilet, Thomas Crapper. And this is not surprising, for the "biographies" of both characters were penned by the same British author, Wallace Reyburn. Whereas the Crapper book is titled *Flushed with Pride: The Story of Thomas Crapper* (see References, page 432), the book on the bra bears the title *Bust Up: The Uplifting Tale of Otto Titzling;* it was published by Macdonald in London, in 1971, and the following year in the United States by Prentice-Hall.

Did Titzling exist?

Surprisingly, Reyburn's book is cited in the references of several works on the history of clothing and costumes. In no less serious a volume than Doreen Yarwood's *The Encyclopedia of World Costume* (Scribner, 1978), the Reyburn work is listed uncritically as a source for information on "underware" (although the spelling of Titzling's name appears as "Tilzling"). After months of research, it became apparent to me that few people (if any) actually ever read Reyburn's fiction-cum-fact, *Bust Up*. That can be the only explanation of why it has been taken seriously by many people, why it has been quoted in references, and why it has crept into folklore. After locating one of the few surviving copies of the book (in the New York Public Library's collection of noncirculating books), I offer the reader several facts from Reyburn's work that should dispel the Titzling bra myth.

According to Reyburn, Titzling was born in Hamburg in 1884 and he invented the bra to free a buxom Wagnerian soprano, Swanhilda Olafsen, from the confines of a corset during performances. One is inclined to believe Reyburn until he points out that Titzling was assisted in his design efforts by a Dane, Hans Delving. With Hans Delving, Titzling prepared a

bra for Sweden's greatest female athlete, Lois Lung. Suspicious-sounding names continue to accumulate as Reyburn recounts how Titzling sued a Frenchman, Philippe de Brassiere, for infringement of patent rights. If Otto Titzling, Hans Delving, and Philippe de Brassiere did exist and pioneer the bra, their names certainly deserve to be immortalized.

An excellent work on the origin and evolution of the bed and bedroom is *The Bed,* by Wright Lawrence, 1962, Routledge and Kegan Paul, London. It served as the basis for the opening sections of this chapter.

On clothing found in the bedroom: A detailed account of the development of socks and stockings throughout the ages is *A History of Hosiery,* M. N. Grass, 1955, Fairchild. Facts on more intimate attire are found in *A History of Ladies' Underwear,* C. Saint Laurent, 1968, Michael Joseph Publishing; *Fashion in Underwear,* E. Ewing, 1971, Batsford; and *A History of Underclothes,* C. W. Cunnington, 1951, Michael Joseph.

On early bras and slips: *Corsets and Crinolines,* N. Waugh, 1970, Batsford.

Sexual facts and figures are from: *The Sex Researchers,* edited by M. Brecher, 1969, Little, Brown; and "20 Greatest Moments in Sex History," Philip Nobile, *Form,* May 1984.

On the Pill: "The Making of The Pill," Carl Djerassi, *Science,* November 1984.

On word meanings: *The Origin of Medical Terms,* Henry A. Skinner, 2nd edition, 1961, Hafner; *Christianity, Social Tolerance and Homosexuality,* John Boswell, 1980, University of Chicago Press.

14 From the Magazine Rack

I am indebted to many magazines for providing me with historical background on their founding. Available for the general reader from *Newsweek:* "A Draft of History," by the editors, 1983, and "Newsweek: The First 50 Years." I wish to thank the research staff at *TV Guide* in Radnor, Pennsylvania, for considerable material on their publication.

Perhaps the single most definitive work on the development of magazines in the United States is *A History of American Magazines,* by Frank Mott, published throughout the 1950s and 1960s in five volumes by Harvard University Press. Mott provides a picture of the early struggles of periodicals in this country, and he details the births, deaths, and triumphs of hundreds of publications from the 1700s into the present.

Additional materials used in this chapter: "Lunches with Luce," Gerald Holland, *Atlantic Monthly,* May 1971; "Time Inc.," Edwin Diamond, *New York Magazine,* November 19, 1984.

15 At Play

An excellent starting point for the reader interested in pursuing the origins of various toys is *Antique Toys and Their Background,* by Gwen White, 1971, Arco Publishing. It covers every imaginable child's toy, often in depth, and it contains an excellent bibliography.

Also of assistance to me in compiling this chapter were *Toys in America,* M. McClintock, 1961, Public Affairs Press; *The Encyclopedia of Toys,* C. E. King, 1978, Crown; *Scarne's Encyclopedia of Games,* John Scarne, 1973, Harper & Row; and *Children's Games in Street and Playground,* by Iona and Peter Opie, op. cit.

On firecrackers: An excellent volume is *A History and Celebration,* George Plimpton, 1984, Doubleday.

On dolls: *Dolls,* Max von Boehn, 1972, Dover; "The Case of the Black-Speckled Dolls," *New Scientist,* November 1985. This article uncovers the mystery surrounding dark markings that often mar the faces of China dolls.

A discussion of children's games popular in the Middle Ages, the Renaissance, and today is found in "Points of Origin," Michael Olmert, *Smithsonian,* December 1983. The same author covers games of chance and skill in his "Points of Origin" column, *Smithsonian,* October 1984.

On the Slinky: Personal communications with Betty James, head of the Slinky company and wife of the inventor of the toy, Richard James.

An interesting book of fact and speculation on the origin and development of the Frisbee is *Frisbee,* Stancil Johnson, 1975, Workman Publishing.

16 In the Pantry

On ice cream: I wish to thank the International Association of Ice Cream Manufacturers, Washington, D.C., for providing me with facts and figures on the origin and development of this dessert. Their 1984 publication *The Latest Scoop* (available by request) contains a wealth of statistics on the consumption of ice cream worldwide.

The Missouri Historical Society provided material on the origin of the ice cream cone at the 1904 St. Louis World's Fair.

At Nabisco, in Parsippany, New Jersey, corporate archivist Dave Stivers was of invaluable assistance not only on the subject of ice cream but also on cookies (Animal Crackers, Oreo), candies, and peanuts (particularly Planters).

The Portland, Oregon, Historical Society was of assistance in locating facts on the origin of the ice cream cone.

One final source on ice cream: An excellent overview of the subject is *The Great American Ice Cream Book,* by Paul Dickson, 1972, Atheneum.

The development of canned whipped cream is in *A Flash of Genius,* op. cit., under the chapter heading "Aeration Whipping Process."

On the hot dog: Max Rosey, publicist for Nathan's Famous, was of immense assistance in assembling the history of the sausage, as was Nathan's rival, the Stevens Company. Both the Brooklyn Public Library and the Long Island Historical Society provided material on the introduction and sale of hot dogs at Coney Island.

On the potato chip: George S. Bolster of Saratoga Springs, New York, as well as the Saratoga Springs Historical Society, suggested material for this section.

I also wish to thank Heinz and Betty Crocker for articles on the origins of their companies and products.

I used, and highly recommend, four excellent books on food: *Food*, by Waverley Root, 1980, Simon and Schuster; this is a fascinating volume, presenting facts and lore about fruits, vegetables, and food preparations in alphabetical order. Also comprehensive in scope is *The World Encyclopedia of Food*, L. Patrick Coyle, Jr., 1982, Facts on File. And *Food in Antiquity*, Don and Pat Brothwell, 1969, Praeger; *Food in History*, Reay Tannahill, 1973, Stein & Day.

Finally, I wish to thank all the people at Telerep involved with production of the weekly television series *The Start of Something Big;* particularly Al Masini, Noreen Donovan, Rosemary Glover, Jon Gottlieb, and Cindy Schneider. Noreen, Rosemary, Jon, and Cindy were of great assistance in helping me compile information on the origins of about two dozen items in this book, which also appeared in various episodes of the show. Al Masini is simply the most thoughtful, humane, and scrupulous television executive I have ever encountered, and I thoroughly enjoyed working with him on creating and executing the show.

Index

"Abbot," 42
Acetate, 129
Acrylics, 129
Adams, Abigail, 282
Adams, John, 290
Adams, Thomas, 416, 417
Air-conditioning, 159–60
Air-cooling system, home, 159
Albee, Mrs. P. F. E., 244
Albert, Prince, 70
Alcock, Walter, 205
Alcott, Louisa May, 352–53
Alka-Seltzer, 257–58
All Soul's Day, 64
Almonds, 394
Aluminum cookware, 101
Aluminum foil, 113–14
Ambergris, 241
"Amen," 41
American flag, 278–80
American Indians
 knocking on wood, 6–8
 New Year's Eve, 47–48
 popcorn, 390–91
American Water Supply Company, 123
"America the Beautiful" (song), 288
Amphetamines, 270
Andersen, Hans Christian, 19, 176–77

Anglo-Saxons, 9
Animal cookies, 412
Annenberg, Walter H., 363–64
Antacids, 256–58
Antiperspirants, 255–56
Anti-Saloon League, 123
A.1. Steak Sauce, 403
Apparel Arts (magazine), 361–62
Appliances
 air conditioner, 159–60
 blender, 111–13
 can opener, 115–16
 carpet sweeper, 140–42
 clothes irons, 143–46
 clothes washer and dryer, 146
 dishwasher, 103–4
 food processor, 114–15
 hair dryer, 236–37
 kitchen ranges, 98–99
 sewing machine, 147–49
 toaster, 117–18
 vacuum cleaner, 138–40, 236–37
April Fool's Day, 58
Aristotle, 10
Armato, Salvino, 264–65
Armstrong, Thomas, 152
Artemis, 32, 34
Ash, Claudius, 214

Aspirin, 272–73
Assyrians, 15
 boots, 296
 hair styling, 231
 laxatives, 263–64
Attila, king of the Huns, 28
Aunt Jemima, 407–8
Aurelian, Roman emperor, 68
Autry, Gene, 75
Avon, 243–44

"Baa, Baa, Black Sheep" (nursery
 rhyme), 185
Baby, New Year's, 49
Babylonia
 hot dog, 396–99
 New Year's Day, 45
 tops, 369–70
Baby Powder, Johnson's, 250
"Bacon, bring home the," 93
Baden-Powell, Col. Robert, 284, 285
Baekeland, Leo Hendrik, 128
Baeyer, Adolph, 271
Bags, brown paper, 107–8
Bailey, Pheodorus, 276
Bakelite, 128
Baking soda (sodium bicarbonate or
 bicarbonate of soda), 257
Balder, 12, 13
Band-Aid, 250–51
Banns, marriage, 25
Barber's pole, 212
Barber-surgeons, 211–12
Barbie doll, 385–86
Bartholdi, Frédéric-Auguste, 291, 292
Basile, Giambattista, 170, 172–76
Bass, Henry, 298
Bastard, John Pollexfen, 194
Bates, Katherine Lee, 288
Bathing, 200–01
Bathing suit, 321–22
Bathroom, 199–220. See also Cosmetics
 and toiletries
 flush toilet, 203–4
 Kleenex tissues, 206–7
 spas, 200–01
 toilet paper, 204–6
 toothbrush, 208–10
 toothpaste, 210–13
Baum, Lyman Frank, 181

Bausch & Lomb, 267
Bayer (drug firm), 272, 273
Beach, Alfred, 358
Beardsley, Hub, 257
Beauty patches, 225–26
Becket, Thomas à, 78
Becquerel, Antoine-Henri, 137
Bedroom, 326–27
Beds, 326–29
Bedstead, 329
Beiersdorf, H., 228
Belgium: roller skates, 382
Bell, Alexander Graham, 357
Bellamy, Francis, 280–81
Benedictus, Edouard, 158
Ben-Gay, 253
Bengué, Jules, 253
Bentz, Melitta, 120
Benzodiazepines, 271
Berryman, Clifford, 374
Berthier, L., 89–90
Berthollet, Count Claude Louis, 155–56
Bertin, Rose, 324–25
Best man, 21
Betty Crocker, 409
Bifocal lenses, 266–67
Biggin, 119–20
Bikinis, 322
Billiard balls, celluloid, 126, 127
Birth control, 331–38
 cervical cap, 333
 condoms, 334–36
 International Planned Parenthood
 Federation, 338
 IUDs (intrauterine devices), 333–34
 the pill, 336–38
 vasectomy, 336
Birthday cake, 31–33
Birthdays, 31–35
Bissell, Anna and Melville, 141–42
Black cat, 13–15
Black for mourning, 36–37
Black Jack chewing gum, 417
Blankets, electric, 331
Bleach, chlorine, 155–56
Bloomer, Amelia Jenks, 302
Bloomers, 302
Blouse, 304
"Bluebeard" (fairy tale), 178–79
Blue Jeans, 302–3

Board games, 376–77
Bobby pin, 236
Bodley, George, 98
Boiardi, Hector, 406
Bok, Edward, 353
Boleyn, Anne, 1
Bon Ami, 153
Boner, Charles, 177
Boniface, St., 69–70
Bonnets, 309
Books
 children's, 197–98
 etiquette, 83, 85, 87–88
Booth, H. Cecil, 138, 139
Boots, 296–97
Borglum, John Gutzon de la Mothe, 283–84
Boswell, James, 134
Bowing, 44
Bowls, 82
 Tupperware, 129–30
Bow tie, 306
Bowtinelli, Clara, 397–98
Boyce, William, 284–85
Boyle, Robert, 108–9, 121
Boy Scouts of America, 284–85
Brachhausen, Gustave, 139
Bradford, Andrew, 350
Bradford, William, 65, 70
Brand (chef), 403
Brandt, Hennig, 108
Brassiere, 341–42
Bread, 400–1
Breakfast cereal, cold, 414
Breath freshener, 222
Breck, John, 220
Bride. See Marriage and wedding customs
Brighteners, clothes, 154
"Bring home the bacon," 93
British Boy Scouts, 284
British Girl Guides, 285
Broken mirror superstition, 11
Brooks, John, 304
Brooks Brothers, 304, 323
Brooms, 142–43
Brown paper bag, 107–8
Broxodent, 210
Bruckman, Frederick, 421
Brummel, Beau, 306

Brunot, James, 379
Brushes, 142–43
 tooth, 208–9
Bryan, Clark, 354
Bubble gum, 417–18
Budding, Edwin, 162
Bunsen, Robert von, 135–36
Bunting, George, 228
Burger, Reinhold, 116
Burial customs, 35, 37
Burnside, Gen. Ambrose Everett, 214–15
Burpee, W. A., 163–64
Burpee seeds, 163–64
Burt, Harry, 419–20
Button-down collar, 304
Buttonholes, 314–15
Buttons, 314–15
Butts, Alfred, 379
Byron, Lord, 180

Caffeine, 270
Cake
 birthday, 31–33
 "take the," 94–95
 wedding, 25–27
Canby, William J., 280
Candles
 birthday, 33
 at death services, 36–38
 for lighting, 134–35
Can openers, 115–16
Canopy, 327
Cantor, Eddie, 397
Cardigan sweater, 304
Carnation, as Mother's Day gift, 59
Carpet sweeper, 140–42
Carrier, Willis, 160
Carter, Jimmy, 62
Carver, George Washington, 393
Cascariolo, Vincenzo, 381–82
Castor, 241–42
Castor oil, 263
Catholic Church. See also Christianity
 birthdays celebrations and, 33
 halo, 40
 New year's celebrations and, 47
 St. Valentine's Day, 50–51
 wigs and, 234–36
Cats, black, 13–15

Cavities, filling, 211
Cellophane, 129
Cellucotton, 206–7
Celluloid, 126–27
Celts, 3, 9. *See also* Druids
 Halloween, 62–63
Cemenius, Johannes Amos, 197
Central heating, 131–33
Cervical cap, 333
Chanel, Gabrielle (Coco), 243
Chanel No. 5 perfume, 243
Chapbooks, 197–98
Chapman, John, 274, 277–78
Charlemagne, Holy Roman Emperor,
 25
Charles V, King of France, 79
Charles IX, King of France, 58
Chaucer, Geoffrey, 344, 345
Checkers, 377
Chemex coffeemaker, 121
Cherry Blossom Festival (Washington,
 D.C.), 282
Chesebrough, Robert Augustus, 247–48
Chess, 377
Chewing gum, 416–18
Chew sticks, 208–13
Chiclets, 418
Children. *See also* Fairy tales; Nursery
 rhymes
 books for, 197–98
 table manners, 85–87
China
 chopsticks, 83
 "Cinderella" (fairy tale), 173
 eye drops, 261
 fans, 312, 313
 firecrackers, 383–84
 ice cream, 418
 kites, 371–72
 nail polish, 226–27
 New Year's Eve, 47
 pasta, 405–6
 stimulants, 269–70
 wheelbarrow, 166–67
 yo-yo, 371
China dolls, 386–87
Chlorine bleach, 155–56
Chocolate chip cookies, 414–15
Chopsticks, 83

Christ, 33
 Last Supper of, 13, 15–16
Christianity (Christians). *See also*
 Catholic Church
 birthdays and, 32–33
 Christmas, 67–69
 Easter, 55–58
 halo, 40
 ladder superstition, 17
 pancakes, 406–7
 prayer, 38–39
 superstition and, 4–5
Christmas, 67–75
 mistletoe custom, 68–69
 Santa Claus, 72–75
 Xmas as abbreviation for, 71
Christmas cards, 71–72
Christmas tree, 69–71
Cinderella (fairy tale), 172–73
Civet, 241
Clairol, 233
Claude, Georges, 136–37
Claudius II, Roman emperor, 50–51
Cleanser, 153
Clement of Alexandria, 224
Cleopatra, 236, 239
Clogs, 297
Clothes
 chlorine bleach, 155–56
 detergent, 152–54
 whiteners and brighteners, 154–55
Clothes dryers, 146
Clothes irons, 143–46
Clothes washers, 146
Clothing and accessories, 294–325
 bathing suit, 321–22
 bloomers, 302
 blue jeans, 302–3
 boots, 296–97
 brassiere, 341–42
 buttons and buttonholes for, 314–15
 designer labels, 324–25
 fans, 312–13
 gloves, 310
 handkerchief, 311–12
 hats, 308–10
 hosiery, 343–44
 knickers, 301–2
 leotard, 302

Clothing and accessories (*cont.*)
 neckties, 305–6
 nightgown, 338–39
 pants, 299–303
 pockets, 300–1
 purse, 311
 rainwear, 320
 ready-to-wear, 323–24
 safety pin for, 313
 shirts, 303–5
 shoes, 294–96
 sneakers, 298–99
 stockings, 344–47
 suits, 306
 suspenders, 301
 tuxedo, 307–8
 umbrella, 318–19
 underwear, 339–41
 Velcro fasteners for, 317–18
 zippers for, 316–17
Clover, four-leaf, 8
Cochrane, Josephine, 103, 104
"Cock-a-Doodle-Doo" (nursery rhyme),
 186
Codpiece, 300
Coffeepots, 119–21
Coffin, 37
Coin flip, 15
Cold cream, 227–28
"Cold shoulder, give the" 94
Cole, Sir Henry, 71–72
Colgan, John, 416–17
Collar, button-down, 304
Cologne, 242–43
Combs, 237–38
Compton, Arthur, 137
Comstock Act, 338
Conception, 336
Condom, earl of, 335
Condoms, 334–36
Confucius, 14, 83
Constantine I, Roman emperor, 55, 68,
 72, 396
Contact lenses, 268–69
Con-Tact paper, 149
Containers, Tupperware, 129–30
Contraceptive methods. *See* Birth
 control

Cookies, 411–15
 animal, 412
 chocolate chip, 414–15
 Fig Newtons, 412–13
 Oreos, 413
Cookware
 aluminum, 101
 porcelain, 100–01
 pressure cooker, 121–22
 Pyrex, 124–25
 Teflon, 105–7
Coppertone, 261
Corelly Ware, 125
Corning Glass Works, 121, 124–25
Cosmetics and toiletries, 221–28. *See
 also* Grooming implements and
 accessories
 Avon, 243–44
 beauty patch and compact, 225–26
 cold cream, 227–28
 cologne, 242–43
 creams, 227–28
 Egyptian, 221–23
 facial powder, 224
 Greek, 222–24
 hair styling and coloring, 231–33
 lipstick, 225
 moisturizers, 227
 nail polish, 226–27
 oils, 227
 perfume, 238–42
 Roman, 222–24
 rouge, 224–25
 shampoo, 219–20
 soap, 217–19
Cosmopolitan (magazine), 354–55
Coty, François, 242
Cough drops, 258–60
Cowboy hat, 310
Cowen, Joshua Lionel, 137–38
Cowles, Gardner, Jr., 360
Cox, Edwin W., 102
Cracker Jack, 395
Crakows, 295
Cramer, Stuart W., 159–60
Cranberries, 66
Cream, whipped, 420–21
Criss Cross, 379
Crompton, R. E., 133

Cromwell, Oliver, 70
Crossword puzzle, 375–76
Crum, George, 388
Crumbine, Samuel, 123
Cub Scout program, 285
Cuisinart, 114–15
Culligan, Emmett, 104–5
Cummerbund, 307
Cumming, Alexander, 204
Cundall, Joseph, 178
Cupid, 51
Curling iron, 231
Curtis, Cyrus, 352–53
Curtsy, 44
Customs, 21–44. *See also* Holidays and
 other celebrations; Marriage and
 wedding customs; Table manners
 and customs
 birthdays, 31–35
 bow and curtsy, 44
 divorce, 30–31
 funerals, 35–38
 greeting, 42–44
 halo, 40
 handshake, 42–43
 prayer, hands joined in, 38–39
 rosary, 39–40
 tipping one's hat, 43
Cutlery, stainless steel, 89–90

Darrow, Charles B., 378, 379
Da Vinci, Leonardo, 268, 329
Davis, Jacob, 303
Davis, Jefferson, 290
Death days, 32
Death traditions, 35–38
Dental hygiene, 208–13
Dentures, 213–14
Deodorants, 254–55
Derby hats, 310
Descroisilles, R., 119
Detergent, 152–54
Dewar, Sir James, 116
Diamond Match Company, 110
Diamond engagement rings, 22–24
Dickens, Charles, 171
Dickinson, Thomas Newton, 252
Dickson, Earle, 250–51
Dinnerware, Corelly Ware, 125
Dish, 82

Dishwasher, 103–4
Disney, Walt, 176
Divorce, 30–31
"Dixie" (song), 289–90
Dixie Cup, 123–24
Dodd, Sonora Smart, 60
Dogs, as "spit runners," 97–98
Doily, 82
Dolls, 384–87
Dorgan, Tad, 398, 399
Doughnuts, 415–16
Dowsing, J. H., 133
Dracula (Stoker), 179–80
Dresses. *See also* Clothes
 white wedding, 29–30
Drill, dental, 211
Drinking toasts, 91–92
Drugs. *See* Medicine-chest items
Druids
 four-leaf clover superstition, 8
 mistletoe, 68–69
Dryer
 clothes, 146
 hair, 236–37
Dubus-Bonnel, 157
Dujardin, William, 329
Duncan, Donald, 371
Dunstan, Saint, 4–5
Du Pont chemical company, 106, 129,
 209–10, 346
Durand, Peter, 115
Durante, Jimmy, 397
Dyes, hair, 232

Earthenware, 96–97
Easter, 55–58
Easter bunny, 55–56
Easter eggs, 56–57
Eastman, 127, 128
"Eat humble pie," 94
"Eat one's hat," 93–94
Ebers Papyrus, 245–46
Ebony (magazine), 361
Edison, Thomas, 136, 193, 359
Edward I, King of England, 79
Edward VII, King of Great Britain, 307
Eggs, Easter, 56–57
Egyptians, 15
 air-cooling system, 159
 "amen," 41

Egyptians (*cont.*)
 bathroom, 200
 bedrooms, 326–27
 birth control methods, 332–33
 birthday celebrations, 31–32
 board games, 376, 377
 cats, 13–14
 cosmetics, 221–23, 227
 cough drops, 258
 deodorants, 254
 fans, 312
 gloves, 310
 handshake, 42–43
 ladder superstition, 17
 lighting, 133
 marbles, 368–69
 marriage ring, 22
 mascara, 18–19
 medications, 245–46
 mirrors, 229
 pancakes, 406–8
 rattles, 373–74
 table manners and customs, 77
 "thumbs up" and "thumbs down"
 gestures, 9–10
 toothbrush, 208
 toothpaste, 210
 umbrella superstitions 16
 wigs, 234
Eisenhower, Dwight D., 281
Electric toothbrush, 210
Elizabeth I, Queen of England, 203,
 204, 212, 235, 346
Emmett, Daniel Decatur, 289
Engagement rings, diamond, 22–24
Erasmus, 86–87, 199, 202, 312
Esquire (magazine), 361–62
Etherington, John, 309
Etiquette. *See also* Table manners and
 customs
 books on, 83, 85, 87–88
Etruscans
 dentures, 213
 "thumbs up" and "thumbs down"
 gestures, 9–10
 wishbone superstition and, 5–6
"Evangelist," 42
Evil eye, 17–19
Ex-Lax, 264
Eye, evil, 17–19

Eye drops, 261–62
Eyeglasses, 264–67
Eye makeup, 18–19, 223

Fabergé, Peter Carl, 56–57
Facial powder, 224
Fairy tales, 168–79
 "Bluebeard," 178–79
 "Cinderella," 172–73
 "Goldilocks and the Three Bears,"
 177–78
 "Hansel and Gretel," 175
 "Little Red Riding Hood," 168, 169,
 171–72
 "The Princess on the Pea," 176–77
 "Puss in Boots," 173–75
 "Sleeping Beauty," 168–70
 "Snow White and the Seven Dwarfs,"
 176
Fallopius, Gabriel, 334–36
Fans (personal accessory), 312–13
Farina, Jean Baptiste, 242
Fashion. *See* Clothing and accessories
Fashion models, 325
Father Christmas, 73
Father's Day, 60–61
Fauchard, Pierre, 209
Feast days, 32
Fedora, 309
Feltman, Charles, 397
Fertilizer, lawn, 163
Feuchtwanger, Antoine, 397
Feyerabend, Sigmund, 197
Fiberglass, 157
Fick, A. E., 269
Fico, sign of the, 17
Fiennes, Celia, 185
Fifth Avenue parade, St. Patrick's Day,
 54–55
Fig newtons, 412–13
Filberts, 393
Finger, ring, 24–25
Finger bowls, 81
Firecrackers, 383–84
"First Day of Christmas, The" (nursery
 rhyme), 186
Flag, American, 278–80
Flagg, James Montgomery, 275
Flashlight, 137–38
Flatware, stainless steel, 89–90

Fleer, Frank and Henry, 417–18
Flour grinder, 96
Fluorescent tube, 137
Fluoride toothpaste, 213
Flush toilet, 203–4
Food processor, 114–15
Foods, 388–421
 A.1. Steak Sauce, 403
 almonds, 394
 Betty Crocker, 409
 bread, 400–1
 breakfast cereal, cold, 414
 chewing gum, 416–18
 cookies, 411–15
 Cracker Jack, 395
 doughnuts, 415–16
 Duncan Hines, 410
 filberts, 393
 fruit cies, 418
 hamburger, 399–40
 hot dog, 396–99
 ice cream, 418–21
 ice cream cone, 421
 ice cream soda, 420
 ice cream sundae and whipped cream,
 420–21
 ketchup, 401–3
 mayonnaise, 404
 Melba Toast, 401
 pancakes, 406–8
 pasta, 405–6
 Peach Melba, 401
 peanuts, 392–93
 pies, 410–11
 pistachio, 395
 popcorn, 390–92
 potato chips, 388–89
 pretzel, 389–90
 sandwich, 400
 Tabasco sauce, 404–5
 walnuts, 393–94
 Worcestershire Sauce, 403
Foot products, Dr. Scholl's, 262–63
Footwear, 294–99
Ford, Gerald R., 285
Fork, 78–79
 crossing knife and, 81
Formica, 129
Fornachou, Arnold, 421
"Fornicate," 347

Fortune (magazine), 366
Foster Grant, 267–68
Four-leaf clover, 8
Frafengerg, Ernst, 334
France
 aluminum ware, 101
 April Fool's Day, 58
 aspirin, 272–73
 clothes dryers, 146
 coffeepots, 119
 designer clothes, 324–25
 fairy tales, 169, 171, 178–79
 fork, 79
 handkerchief, 311–12
 high-heeled shoes, 297–98
 knives, 80–81
 neckties, 305–6
 safety razor, 215–16
 sewing machine, 147–48
 Statue of Liberty, 291–93
 suits, 306
 Teflon utensils, 105–7
 wallpaper, 149–50
Francis de Sales, Saint, 51
Francis I, king of France, 315
Frankenstein (Shelley), 180–81
Frankfurter, 396–97
Franklin, Benjamin, 266–67, 350
Frazer, Sir James, 47
French-fried potatoes, 388
Fresneau, François, 320
Friday the thirteenth, 13
Friendship ring, 22
Frigga, 13, 69
Frisbee, 327–73
Frisbie Pie Company, 372, 373
Fruit ices, 418
Fuller, Alfred Carl, 142, 143
Fuller brushes, 142, 143

"Gadget," 99–100
Gaius Diocletianus, Roman emperor, 72
Galen, 227–28
Galloway, Elijah, 152
Galoshes, 320
Gamble, James, 218
Games. *See* Toys and games
Garden hose, 165–66
Gardens, 161
Gaslight, 135–36

Gas ranges, 98–99
"Gay," 348
Gayetty, Joseph, 204
Gelasius, Pope, 51
General Electric, 137, 210, 379–80
George, Edwin, 163
George IV, king of England, 403
Gerhardt, Charles Frederick von, 272
Germany
 amphetamines, 270
 birthday cake and candles, 33
 Christmas tree, 69–70
 detergent, 152–54
 fairy tales, 175–76
 glass window, 156–57
 Groundhog Day, 49–50
 porcelain pots and pans, 100–01
 shampoo, 219–20
 whistling teakettle, 119
Gerson, Thomas, 276
Gibson, Charles Dana, 359, 360
"Gibson Girl," 359, 360
Gillen, Denver, 75
Gillette, King, 215–16
Girl Scouts of America, 285–86
"Give the cold shoulder," 94
Glamour (magazine), 356
Glass
 drinking, 82
 mirror, 229–30
 safety, 157–58
 window, 156–59
Gloves, 310
"God bless you," 10–11
Godey's Lady's Book, 66, 71
Godiva, Lady, 39, 185
Goetz, Charles, 420–21
Goldgar, Michael, 62
"Goldilocks and the Three Bears" (fairy
 tale), 177–78
Good Housekeeping (magazine), 353–54
Good Housekeeping Seal of Approval,
 354
"Good Morning to All" (song), 34–35
Goodrich, Benjamin Franklin, 164, 166
Goodrich, B. F., Company, 317
Goodyear, Charles, 165, 298–99
Goths, marriage customs, 21–22
Grace, saying, 92–93
Graham, Rev. Sylvester, 414

Graham crackers, 413–14
Grandparent's Day, 62
Granola, 414
Grass
 lawn, 160–62
 mowers, 162–63
 weed-free, 163
Greeks, 15, 19
 bedrooms and beds, 327
 birthdays, 31, 32
 brassiere, 341
 clothes irons, 143–46
 cosmetics, 222
 dolls, 385
 gardens, 161
 hair styling, 231–32
 hats, 308
 horseshoe superstition, 4, 5
 marriage and wedding customs, 29
 medicine, 246
 mirror practice of divination, 11
 mirrors, 229
 perfumes, 239–40
 pies, 410
Green, Adolphus, 413
Green, Benjamin, 261
Green, Nancy, 107, 408
Greenwood, John, 211
Greeting cards
 Christmas, 71–72
 Father's Day, 61
 Grandparent's Day, 62
 Mother's Day, 60
 Mother-in-Law's Day, 61
 Valentine's Day, 51–53
Greeting customs, 42–44
Gregoire, Marc, 106
Gregory, Hanson, 415–16
Gregory, Pope (the Great), 10–11
Grimm, Jacob and Wilhelm, 171–72,
 175, 176
Grinder, flour, 96
Grooming implements and accessories
 combs, 237–38
 electric shaver, 216–17
 hair dryer, 236–37
 hairpins, 236
 mirror, 229–30
 razor, 214–16
 wigs, 234–36

Groundhog Day, 49–50
Guerlain, Pierre and Jacques, 242–43

Hadden, Briton, 364–66
Hair coloring, 231–33
Hair dryer, 236–37
Hairpins, 236
Hair powdering, 232–33
Hair styling, 231–33
Hale, Sarah Josepha, 66–67, 193
Hall, Charles Martin, 101
Hall, Otis, 261–62
Halloween, 62–64
"Ham," pejorative use of, 94
Hamburger, 399–40
Hamilton Beach, 236, 237
Hamwi, Ernest, 421
Hand, Judge Learned, 273
Handkerchief, 311–12
Handler, Ruth, 385–86
Handshake, 42–43
Handwerker, Nathan, 397
"Hansel and Gretel" (fairy tale), 175
Hanway, Jonas, 319
"Happy Birthday to You" (song), 34–35
Hardie, Thomas, 105–7
Hare, Easter, 55–56
Hare's foot, 3
"Hark, Hark" (nursery rhyme), 187
Harrington, Sir John, 203–4
Hat(s), 308–10
 "eat one's," 93–94
 tipping of one's, 43
Hawthorne, Nathaniel, 161
Hearse, 37–38
Heater, electric, 133
Heating, central, 131–33
Hebrews
 marriage certificate, 30, 31
 mirrors, 229
Heinz, Henry, 402–3
Heinz Tomato Catsup, 402
Hellman, Richard, 404
Helmont, Jan Baptista van, 135
Henry VII, king of England, 185, 186, 315
Henry VIII, king of England, 1
Heroin, 258
Heublein company, 403–4

"Hey Diddle Diddle" (nursery rhyme), 187–88
Hill, Jessica, 35
Hill, Mildred, 34–35
Hill, Patty Smith, 34–35
Hines, Duncan, 410
Hippocrates, 10
Hodgson, Paul, 380
Hoffman, Felix, 272
Holbein, Hans, 315
Holidays and other celebrations, 45–75
 April Fool's Day, 58
 Christmas, 67–75
 Easter, 55–58
 Father's Day, 60–61
 Grandparent's Day, 62
 Groundhog Day, 49–50
 Halloween, 62–64
 Mother's Day, 58–60
 Mother-in-Law's Day, 61
 New Year's Day, 45–49
 St. Patrick's Day, 53–55
 St. Valentine's Day, 50–52
 Thanksgiving, 64–67
Holland
 bleaching method, 155
 doughnuts, 415
 St. Nicholas, 73
Holly, 69
Honeymoon, 28
"Hooker," 348
Hoover, Susan, 140
Hoover, William, 140
Hoover vacuum cleaners, 139–40
Horner, Thomas, 190
Horseshoe, 4–5
Horsley, John Calcott, 71–72
Hosiery, 343–44
Hot cross buns, 57–58
Hot dog, 396
House Beautiful (magazine), 356–57
Howe, Elias, 148–49
Howells, William Dean, 355
Howland, Esther, 52
Hubert, Conrad, 137–38
Hula hoop, 370–71
"Humpty Dumpty" (nursery rhyme), 188
Hunt, Walter, 148–49

"Hush-a-bye, Baby" (nursery rhyme), 183–84
Hyatt, John Wesley, 126, 127

Ice cream, 418–21
Ice cream cone, 421
Ice cream soda, 420
Ice cream sundae, 420
Ices, fruit, 418
Ideal Toy Company, 374
I. G. Farben, 269
Incandescent lamp, 136
India
 Parcheesi, 377–78
 rosary, 39–40
Indians. See American Indians
Instructions of Ptahhotep, The, 77
International Planned Parenthood
 Federation, 338
Ireland
 Halloween, 62–63
 St. Patrick's Day, 53–55
Irons, clothes, 143–46
Iroquois Indians, New Year's Eve, 47
Irving, Washington, 301
Israelites. See Hebrews
Italy
 condoms, 334–35
 eyeglasses, 264–67
 fairy tales, 170, 173–75
 fork, 78–79
 glass mirror, 229–30
 pants, 299–300
 pretzel, 389–90
 toys that glow in the dark, 381–82
IUDs (intrauterine devices), 333–34
Ivory Soap, 218–19

"Jack and Jill" (nursery rhyme), 188
"Jack Be Nimble" (nursery rhyme), 189
Jack-o'-lantern, 63–64
Jackson, James Caleb, 414
Jacobs, Mary Phelps, 341
Jaeger, Gustav, 340
James, Betty, 381
James, Richard, 380–81
Jantzen, Carl, 321–22
Japan, fans, 312–13

Jarvis, Anna, 59–60
Jefferson, Thomas, 66, 76–77, 281, 282, 284, 290, 388, 402
Jenner, Edward, 226
Jergens, Andrew, 228
Jergens Lotion, 228
Jews. See also Hebrews
 bathing, 200
Jezebel, queen, 223
Jockey brief, 340–41
Johnny Appleseed, 277–78
Johnson, John, 361
Johnson, Robert, 250
Johnson & Johnson, 250
Jones, Samuel, 109
Judas, 13, 15–16
Judson, Whitcomb, 316–17
Julius Caesar, 1, 8, 15, 46–47
Justy, Johann Heinrich Gottlob von, 100

Kamptulicon, 152
Kellog, John, 414
Kennedy, John F., 277, 285
Ketchup, 401–3
Key, Francis Scott, 279, 287
Kilmer, Frederick, 251
Kimberly-Clark, 206–7
Kinderfeste, 33
Kipling, Rudyard, 185
Kiss, Max, 264
Kisses, XXX for, 52
Kitchen, 96–130
 aluminum cookware, 101
 aluminum foil, 113–14
 blender, 111–13
 brown paper bag, 107–8
 can opener, 115–16
 coffeepots, 119–21
 dishwasher, 103–4
 disposable paper cups, 122–24
 earthenware, 96–97
 food processor, 114–15
 matches, 108–9
 microwave oven, 125–26
 porcelain pots and pans, 100–01
 Pyrex ware, 124–25
 ranges, 98–99
 S.O.S. pads, 102–3

Kitchen (*cont.*)
 Teflon, 105–7
 thermos bottle, 116–17
 toaster, 117–18
 Tupperware, 129–30
 turnspit, 97–98
 water softeners, 104–5
 whistling teakettle, 119
Kitchenware. *See* Cookware
Kites, 371–72
Klapp, Eugene, 356
Kleenex tissues, 206–7
Knerr, Richard, 372–73
Knickers, 301–2
Knife, 80–81 crossing fork and, 81
Knight, Phil, 299
Knocking on wood, 6–8
Kohl, 18
Koningsbronn foundry, 100
Krafft, A., 154

Laboulaye, Edouard de, 291
Lacoste, René, 304–5
Lacoste shirt, 304–5
Ladder, walking under a, 17
Ladies' Home Journal, 352–53
Ladies' Mercury (magazine), 349–50
Ladies' Magazine, 66
"Ladybird, Ladybird" (nursery rhyme), 191
Lamps
 fluorescent, 137
 gas, 135–36
 incandescent, 136
 oil, 133–34
Lanvin, Jeanne, 242
Lapel hole, 306
Lapis solaris, 381–82
Last Supper, 13, 15–16
Laughing gas (nitrous oxide), 214
Lavoisier, Antoine, 135
Lawn, 160–62
Lawn mower, 162–63
Lawrence, Joseph, 248–50
Laxatives, 263–64
Lay, Herman, 389
Lazarus, Emma, 293
Lea, John, 403
Lee, Rev. William, 346

Leeuwenhoek, Antonie de, 336
Leonardi da Vinci, 98
Leonardo Da Vinci, 134
Leotard, 302
Léotard, Jules, 302
Leo X, Pope, 266
"Let them eat cake," 95
Library of Congress, 282
Librium, 271–72
Liebig, Baron Justus von, 153
Life (magazine), 359–61
Lighting, indoor, 133–38
Lincoln, Abraham, 67, 275, 284, 290
Linoleum, 151–52
Lipstick, 225
Lister, Sir Joseph, 248–49
Listerine, 248–50
Literature. *See* Books
"Little Boy Blue" (nursery rhyme), 185–86
"Little Jack Horner" (nursery rhyme), 189–90
"Little Miss Muffet" (nursery rhyme), 195–96
"Little Red Riding Hood" (fairy tale), 168, 169, 171–72
Littleton, Jesse, 124
Loafers, 298
Loki, 12, 13
"London Bridge" (nursery rhyme), 191–92
Longfellow, Henry Wadsworth, 70, 187
Look (magazine), 360–61
L'Oréal, 233
Lorillard, Pierre, IV, 307
Louis XIV, king of France, 212, 298
Louvre, the, 132
Low, Juliette, 285
Luce, Henry, 359–60, 364–66
Lucifers, 109
Luck. *See* Superstitions
Lucretius, 26
Luden, William, 260
Lupercalia, 396
Lupercus, 50, 51
Luther, Martin, 70
Lyes, alkaline, 155
Lyman, William W., 116

McConnell, David, 243, 244
McFatrich, James and George, 261–62
McIhenny, Edmund, 404–5
Macintosh, Charles, 320
McMein, Neysa, 409
Mademoiselle (magazine), 356
Madison, James, 290
Magazines, 349–67
 Cosmopolitan, 354–55
 Ebony, 361
 Esquire, 361–62
 Fortune, 366
 Good Housekeeping, 353–54
 House Beautiful, 356–57
 Ladies' Home Journal, 352–53
 Life, 359–61
 Look, 360–61
 Mademoiselle, 356
 National Geographic, 357–58
 Newsweek, 366–67
 Reader's Digest, 362–63
 Scientific American, 358–59
 Time, 364–66
 TV Guide, 363–64
 Vogue, 355–56
Magic Square, 375–76
Magnetron, 125–26
Maidenform, 343
Makeup. *See* Cosmetics and toiletries
Manicuring, 226–27
Marbles, 368–69
Marches, wedding, 28–29
Marie Antoinette, Queen of France,
 95, 325
"Marines' Hymn, The," 288–89
Marker, Russell, 337
Marks, Johnny, 75
Marriage and wedding customs, 21–31
 banns, 25
 best man, 21
 carrying the bride over the
 threshold, 21
 certificate of marriage, 30–31
 diamond engagement rings, 22–24
 honeymoon, 28
 Northern Europe (around A.D.
 200), 21–22
 throwing shoes at the bride, 26–27
 wedding cake, 25–26, 27

Marriage and wedding customs (*cont.*)
 wedding march, 28–29
 wedding rings, 22, 24–25
 white wedding dress and veil, 29–30
Marsh, Albert, 133
Martin, Sarah Catherine, 194–95
Martyn, Thomas, 367
"Mary, Mary" (nursery rhyme),
 193–94
Mary, Queen of Scots, 193–94, 235
"Mary Had a Little Lamb" (nursery
 rhyme), 193
Mascara, 18–19
Massasoit, Chief, 65
Matchbooks, 110–11
Matches, friction, 108–11
Mattel toy company, 385–86
Mattressses, 329–31
May, Robert, 75
Mayonnaise, 404
Medici, Catherine de', 418
Medicine-chest items, 245–64
 Alka-Seltzer, 257–58
 antacids, 256–58
 antiperspirants, 255–56
 aspirin, 272–73
 Band-Aid, 250–51
 cough drops, 258–60
 deodorants, 254–55
 Dr. Scholl's foot products, 262–63
 eye drops, 261–62
 laxatives, 263–64
 Listerine, 248–50
 modern drugs, 246
 sedatives, 271–72
 stimulants, 269–70
 suntan lotion, 260–61
 vaseline, 247–48
 Vick's VapoRub, 252–54
 witch hazel, 251–52
Melba Toast, 401
Melitta filter system, 120
Melmac, 129
Menander, 231
Mendelssohn, Felix, 28, 29
Mensinga, Wilhelm, 333
Mercure Galant (magazine), 349
Merlin, Joseph, 382
Meyerbeer, Giacomo, 382

Michtom, Morris, 374
Microwave oven, 125–26
Miles Laboratories, 257
Mirror, 229–30
 broken, superstition surrounding, 11
Mistletoe, 68–69
Mitchell, James, 412–13
Mitchell, John, 359
Mithraism, 67–68
"Monk," 42
Monopoly (game), 378–79
Monroe, Marilyn, 243
"Monsignor," 42
Montagu, John, 400
Montgomery Ward department store,
 75
Moore, Clement Clarke, 73–74
Moore, Hugh, 122–24
Morphine, 258
Morrison, Walter Frederick, 372
Morse code, 102–3
Mortarboard, 308
Mosquito netting, 327
Mother's Day, 58–60
Mother Goose, 182–83
Mother Hubbard, 194–95
Mourning, black for, 36–37
Movie houses, air-conditioned, 160
Muffet, Thomas, 196
Muhammed, prophet, 14
Mum antiperspirant, 255–56
Mummer's Day Parade, 48
Munn, Orson, 358
Mure, Eleanor, 178
Musk, 241
My Sin perfume, 242

Nail polish, 226–27
Napkins, 81–82
Napoleon Bonaparte, 1, 58, 101, 122
Narwin, Michael, 152
Nast, Condé, 356
Nast, Thomas, 74, 275
Natalis Solis Invicti, 68
Nathan's franks, 397–98
National Biscuit Company (Nabisco),
 412, 413
National Geographic Magazine, The,
 357–58
Nativity, 67

Neanderthals, 1–2
 funerals, 35
Neckties, 305–6
Negligee, 339
Negro Digest, 361
Nekal detergent, 154
Nelson, Lord Horatio, 5
Neon light, 136–37
Nero, Roman emperor, 240
"New Colossus, The" (Lazarus), 293
Newsweek (magazine), 366–67
New Year's baby, 49
New Year's Day, 45–49
New Year's Eve, 47–48
New Year's resolutions, 48–49
New York World, 375–76
Nicholas, St., 72–74
Nicholas I, Pope, 23
Nickerson, William, 216
"Night Before Christmas, The"
 (Moore), 73–74
Nightgown, 338–39
Nike sneakers, 299
Nitrous oxide (laughing gas), 214
Nivea, 228
Nixon, Richard, 61
Norse mythology
 Friday the thirteenth in, 13
 number thirteen in, 12, 13
 stork myth, 19
Noxzema, 228
Number thirteen, 11–13
"Nun," 42
Nursery rhymes, 182–97
 "Baa, Baa, Black Sheep," 185
 "Cock-a-Doodle-Doo," 186
 "The First Day of Christmas," 186
 "Hark, Hark," 187
 "Hey Diddle Diddle," 187–88
 "Humpty Dumpty," 188
 "Hush-a-bye, Baby," 183–84
 "Jack and Jill," 188
 "Jack Be Nimble," 189
 "Ladybird, Ladybird," 191
 "Little Boy Blue," 185–86
 "Little Jack Horner," 189–90
 "Little Miss Muffet," 195–96
 "London Bridge," 191–92
 "Mary, Mary," 193–94
 "Mary Had a Little Lamb," 193

Nursery rhymes (*cont.*)
 "Mother Goose," 182–83
 "Old Dame Trot, and Her Comical
 Cat," 195
 "Old Mother Hubbard," 194–95
 "Ride a Cock-Horse," 184–85
 "Ring-a-Ring o' Roses," 196
 "See-Saw, Margery Daw," 192–93
 "Sing a Song of Sixpence," 196–97
 "There Was a Little Girl," 187
 "This Is the House That Jack Built,"
 189
 "Three Blind Mice," 194
Nut (Egyptian goddess), 16
Nylon, 129
Nylon-bristle toothbrush, 209–10
Nylon stockings, 346–47

Oak tree, superstition about, 6–7
Obici, Amedeo, 393
Odo-Ro-No, 256
Offenbach, Jacques, 288–89
Oil lamps, 133–34
"Old Dame Trot, and Her Comical
 Cat" (nursery rhyme), 195
"Old Mother Hubbard" (nursery
 rhyme), 194–95
Olmstead, Frederick Law, 282
Olsen, Andrew, 207
Opie, Iona and Peter, 182
Oral contraceptive (the pill), 336–38
Oreo cookies, 413
Orpiment, 224
Oster company blenders, 112–13
Oxford shoe, 296

Paint, ready-mixed, 150–51
Painter, William, 216
Pajamas, 339
Panama hat, 309–10
Pancakes, 406-8
Panitt, Merrill, 363, 364
Pantaleone, St., 299–300
Pantaloons, 300
Pants, 299–303
 with pockets, 300–1
 suspenders, 301
Paper, toilet, 204–6
Paper bags, brown, 107–8
Paper cups, disposable, 122–24

Paper towels, 206
Papin, Denis, 121–22
Parasols, 319
Parcheesi, 377–78
Park, Roy, 410
Parker Brothers, 378–79
Parkes, Alexander, 126–27
Parkesine, 127
Parry, Sir William, 115
"Parson," 41
Pasta, 405–6
"Pastor," 41
Patrick, Saint, 53
Peach Melba, 401
Peanuts, 392–93
Pennsylvania Germans (Dutch), 70
Percolator, coffee, 120
Perc-O-Toaster, 120
Perfume, 238-42
Perrault, Charles, 169–76, 178–79,
 183, 198
Perret, Jean Jacques, 215
Perrins, William, 403
Perrot, Bernard, 230
Persians
 birthday cake, 32
 walnuts, 393–94
Peruzzi, Mario, 393
Peter the Great, Tsar of Russia, 1
Petronius, 15
"Pew," 41
Phillips, Charles, 257
Phillips' Milk of Magnesia, 257
Photographic film, celluloid, 127
Pies, 410–11
 "eat humble pie," 94
 pumpkin, 65
Piggy bank, 382–83
Pilgrims
 Thanksgiving and, 64–66
 wishbone superstition, 6
Pill, the (oral contraceptive), 336–38
Pincus, Gregory, 337, 338
Pins, 313
Pistachio, 395
Planters Peanuts, 393
Plastic, 126–29
Plates, 82
Platters, 82
Pledge of allegiance, 280–81

Plexiglass, 129
Pliny the Elder, 232
Plunkett, Roy, 106–7
Pockets, 300–301
Poinsettia, 69
Polo collar, 304
Polyester, 129
Polykoff, Shirley, 233
"Pontiff," 42
Popcorn, 390–92
Poplawski, Stephen J., 111–12
Popozo, Sandro di, 265
Pop-up tissue box, 207
Porcelain-enamel cookware, 100–1
Porter, Rufus, 358
Post, Emily, 87–88
Potato chips, 388–89
Pots and pans
 aluminum, 101
 porcelain, 100–01
Prang, Louis, 72
Prayer, hands joined in, 38–39
Pressure cooker, 121–22
Presto company, 145
Pretzel, 389–90
Priestley, Joseph, 320
"Princess on the Pea, The" (fairy tale),
 176–77
Procter, Harley, 218–19
Proctor-Silex, 145
"Prostitute," 347–48
Public Cup Vendor Company, 123
Pulitzer, Joseph, 292
Pump (shoe), 297–98
Pumpernickel, 400–1
Pumpkin pie, 65
Puritans, 70–71
Purse, 311
Pusey, Joshua, 110
"Puss in Boots" (fairy tale), 173–75
Pyrex, 124–25
 Chemex coffeemaker, 121

Rabbit, Easter, 55–56
Rabbit's foot, 3
Racine Universal Motor Company,
 236, 237
Radar Range, 126
Rainwear, 320
Rais, Gilles de, 179

Ramsay, William, 136
Ranges, kitchen, 98–99
"Rashin Coatie" (fairy tale), 172
Rattles, 373–74
Ravenscroft, Thomas, 194
Ray-Ban aviator sunglasses, 267
Razor, 214–15
 safety, 215–16
Reader's Digest, 362–63
Reagan, Ronald, 164
Réard, Louis, 322
Redding, Josephine, 356
Redenbacher, Orville, 391–92
Regina Vacuum Cleaner Company,
 139
Remington shavers, 217
"Reverend," 41
Reynolds, Richard S., 113
Rhazes, 210–11
Richardson, Earl, 145
Richardson, Lunsford, 253
Richelieu, 404
Richelieu, Duc de, 80
"Ride a Cock-Horse" (nursery rhyme),
 184–85
Ring-a-Ring o' Roses, (nursery rhyme),
 196
Ring finger, 24–25
Rings
 engagement, diamond, 22–24
 friendship, 22
 wedding, 22, 24–25
Rist, Johann, 349
Rivalto, Giordano di, 265
Robinson, Doane, 283
Roller skates, 382
Romans, 9, 10
 bedrooms and beds, 327–28
 birthdays, 32
 bread, 400
 broken mirror superstition, 11
 candles, 134
 central heating, 131–32
 Christmas, 68
 coin-flipping practice, 15
 cookies, 411
 cosmetics, 222, 227–28
 dolls, 385
 drinking toasts, 91–92
 evil eye superstition, 17

Romans (*cont.*)
 funerals, 35–37
 glass window, 156
 hair styling, 231–32
 horseshoe superstition, 5
 hosiery, 343–44
 ketchup, 401
 Lex Ciconaria (Stork's Law), 19
 marriage and wedding customs,
 29–31
 marriage rings, 22, 25
 New Year's Day, 46–47
 perfume, 240
 pies, 410
 St. Valentine's Day, 50–51
 salt and, 15
 spas, 200–01
 stockings, 344–47
 table manners and customs, 78
 toothpaste, 210
 wedding cakes, 26
 wigs, 234
 wishbone superstition, 6
Roosevelt, Franklin D., 67, 121
Roosevelt, Theodore, 284, 285, 374
Rosary, 39–40
Rosenthal, Ida, 343
Ross, Betsy, 279–80
Rouge, 224–25
Rubber, vulcanization of, 165
Rubber hose, 164–66
"Rudolph, the Red-Nosed Reindeer"
 (poem, then song), 75
Rueckheim, F. W., 395
Rushmore, Charles E., 283
Rushmore, Mount, 282–84
Russell, S. I., 331
Rutt, Chris, 407–8

Safety glass, 157–58
Safety pin, 313–14
St. Patrick's Day, 53–55
St. Valentine's Day, 50–52
Salibury steak, 399
Salt, spilling, 15–16
Sandals, 294
Sandwiches, 400
Sandys, Sir Marcus, 403
Sanger, Margaret, 331, 338

Santa Anna, Gen., 416
Santa Claus, 72–75
Sardou, Victorien, 309
Saucer, 82
Saugus Pot, 100
Sauria, Charles, 109
Sausage, 396
Scandinavia
 honeymoon, 28
 number thirteen superstition, 12
 stork myth, 19
Scarlett, Edward, 266
Schwarz, Berthold, 383
Schiaparelli, Elsa, 317
Schick, Jacob, 216–17
Schlicht, Paul J., 354
Schlumbohm, Peter, 121
Scholl, William, 262–63
Schrotter, Anton von, 110
Schueller, Eugène, 233
Scientific American (magazine), 358–59
Scotland, bathroom, 199
Scott, Clarence, 205–6
Scott, Edward, 205–6
Scott, Orlando Mumford, 163
Scrabble, 379
Sears, Roebuck, 145, 237
"Seasoning," 94
Sedatives, 271–72
"See" (as in Holy See), 42
Seeds
 Burpee, 163–64
 grass, 163
"See-Saw, Margery Daw" (nursery
 rhyme), 192–93
Selchow & Righter, 379
Senet (game), 376
Serviettes, 81–82
Sewing machine, 147–49
Sex-related words, 347–48
Shakespeare, William, 91
Shalimar perfume, 242–43
Shampoo, 219–20
Shamrock, 54
Shaver, electric, 216–17
Shaving razors, 214–16
Shelley, Mary, 180–81
Shelley, Percy Bysshe, 180
Shen Nung, 269
Sherwin, Henry Alden, 150–51

Sherwin-Williams Company, 151
Shirts, 303–5
Shoes, 294–96
 high-heeled, 297–98
 thrown at the bride, 26–27
Sibthrope, John, 98
Sideburns, 215
Silly Putty, 379–80
Simmons, Zalmon, 330–31
"Sing a Song of Sixpence" (nursery
 rhyme), 196–97
Singer, Isaac, 148–49
Skin tights, 344
"Sleeping Beauty" (fairy tale), 168–70
Slinky, 380–81
Smallpox, 225
Smith, William and Andrew, 259–60
Smith Brothers Cough Drops, 259–60
Sneakers, 298–99
Sneezing, superstition surrounding,
 10–11
"Snow White and the Seven Dwarfs"
 (fairy tale), 176
Soap, 152–54, 217–19
Socks, 343
Socrates, 1
Sontheimer, Carl, 114
S.O.S. pads, 102–3
Southey, Robert, 177, 178
Spaghetti, 405–6
Spangler, James Murray, 139–40
Spanish flu epidemic, 253–54
Spas, 200–01
Spencer, Percy, 125–26
Sperm, 336
Spermicides, 332, 333
Spic-and-Span, 154
Spina, Alessandro, 264–65
Spoon, 79–80
Squanto, 64–65
Squibb Company, 210
Stainless steel cutlery, 89–90
Standish, Miles, Captain, 65
"Star-Spangled Banner, The" (national
 anthem), 287–88
Statue of Liberty, 100, 291–93
Steam heat, 132–33
Steam iron, 145–46
Steele, Sir Richard, 91

Steiff, Margaret, 374
Stetson, John B., 310
Stetson hats, 310
Stevens, Harry, 398
Stevenson, Robert Louis, 356
Stilwell, Charles, 107, 108
Stimulants, 269–70
Stockings, 344–47
Stoker, Bram, 179–80
Stone, Herbert, 356, 357
Stork-brings-baby myth, 19
Stoves, cooking, 97–99
Straparola, Gianfrancesco, 175
Strauss, Levi, 302–3
Strite, Charles, 118
Styrene, 129
Suit, man's, 306
 ready-to-wear, 323
Sumerians, 15
 antacids, 256–57
 bedroom, 326
 medications, 245
 mirrors, 229
Sunbeam, 145
Sundback, Gideon, 317
Sunglasses, 267–68
Suntan lotion, 260–61
Superstitions, 1–20
 black cat, 13–15
 broken mirror, 11
 evil eye, 17–19
 flip of a coin, 15
 four-leaf clover, 8
 Friday the thirteenth, 13
 "God bless you," 10–11
 horseshoe, 4–5
 knocking on wood, 6–8
 of Neanderthals, 1–2
 number thirteen, 11–13
 of primitive man, 2
 rabbit's foot, 3
 spilling salt, 15–16
 "thumbs up" and "thumbs down"
 gestures, 9–10
 umbrella indoors, 16
 walking under a ladder, 17
 wishbone, 5–6
 yawning, covering one's mouth
 when, 19–20

Suspenders, 301
Swan, Joseph, 136
Sweden, chlorine bleach, 155–56
Swimming suits, 321–22

Tabasco sauce, 404–5
"Table," 83
Table manners and customs
 "bring home the bacon," 93
 children's, 85–87
 chopsticks, 83
 crossing knife and fork, 81
 "eat humble pie," 94
 "eat one's hat," 93–94
 Emily Post, 87–88
 etiquette, 83, 85, 87–88
 fork, 78–79
 "give the cold shoulder," 94
 grace, saying, 92–93
 "ham," pejorative use of, 94
 knife, 80–81
 "let them eat cake," 95
 napkins, 81–82
 "seasoning," 94
 spoon, 79–80
 stainless-steel cutlery, 89–91
 "take the cake," 94–95
 "talk turkey," 95
 toast, drinking, 91–92
 Wedgwood ware, 88–89
"Take the cake," 94–95
"Talk turkey," 95
Tappan Company, 126
Tarbes, Bishop, 188
Tartar steak, 399
Taun Ch'eng-shih, 173
Tea, 269–70
Teakettle, whistling, 119
Teddy Bear, 374–75
Teeth, whitening, 211–12
Teflon cookware, 105–7
Tennant, Charles, 156
Tertullian, 22
Thanksgiving, 6, 64–67, 391
"There Was a Little Girl" (nursery
 rhyme), 187
Thermos bottle, 116–17
Thimmonier, Barthélemy, 147
Thirteen, number, 11–12

"This Is the House That Jack Built"
 (nursery rhyme), 189
Thomas, Isaiah, 352
Thompson, Benjamin, 98
"Three Blind Mice, (nursery rhyme),
 194
"Thumbs up" and "thumbs down"
 gestures, 9–10
Tide detergent, 154
Time (magazine), 364–66
"To Anacreon in Heaven" (song), 287
Toaster, 117–18
Toastmaster, 118
Toasts, drinking, 91–92
Toilet, flush, 203–4
Toilet paper, 204–6
Toiletries, See Cosmetics and toiletries
Toilet water, 242
Toll House cookies, 415
Tombstone, 37
Toothbrush, 208–10
 electric, 210
Toothpaste, 210–13
 fluoride, 213
Top hat, 309
Tops, 369–70
Totemism, 3
Tournament of Roses, 48
Towels, paper, 206
Toys and games, 368–87
 board games, 376–77
 checkers, 377
 chess, 377
 crossword puzzle, 375–76
 dolls, 384–87
 firecrackers, 383–84
 Frisbee, 327–73
 glow-in-the-dark toys, 381–82
 hula hoop, 370–71
 kites, 371–72
 marbles, 368–69
 Monopoly, 378–79
 Parcheesi, 377–78
 piggy bank, 382–83
 roller skates, 382
 scrabble, 379
 Silly Putty, 379–80
 Slinky, 380–81
 Teddy Bear, 374–75

Toys and games (*cont.*)
tops, 369–70
yo-yo, 371
Travers, Morris, 136
Trees
Christmas, 69–71
cults of, 6–8
Treneer, Maurice, 257
Trick-or-treating, 64
Trousers. *See* Pants
Tumblers, Tupperware, 129–30
Tupper, Earl, 129–30
Tupperware, 129–30
Tureen, 82
Turkey
"talk turkey," 95
Thanksgiving Day, 65
Turnspit, 97–98
Tuxedo, 307–8
TV Guide, 363–64
"Two Men in the Army" (song), 289

Umbrella, 318–19
superstitions surrounding, 16
Uncle Sam, 274–77
Underwear, 339–41
Underwood, William, 115

Vacuum cleaner, 138–40, 236–37
Valentine, bishop of Interamna (Saint),
50–51
Valentine cards, 51–53
Valium, 271–72
Van Houten, C. J., 415
Vasectomy, 336
Vaseline, 247–48
Veil, white wedding, 29–30
Velcro, 317–18
Verdun, Pierre, 114
Vernet, Charles, 309
"Vicar," 42
Vick, Joshua, 253
Vick's VapoRub, 252–54
Victoria, Princess, 28–29
Victoria, queen of Great Britain, 142,
324
Villafranca, Blasius, 419
Vinyl, 129
Vogue (magazine), 355–56

Wagner, Richard, 28, 29
Wakefield, Ruth, 415
Walker, John, 108, 110, 354–55
Walker, Lewis, 316
Walker, William B., 117
Wallace, DeWitt, 362–63
Wallpaper, 149–50
Walnuts, 393–94
Walton, Frederick, 152
Ward, Samuel A., 288
Waring, Fred, 111–12
Waring Blendor, 111–13
Warner, Ezra J., 115–16
War of 1812, 282, 287–88, 290
Washers, clothes, 146
Washington, D.C., 281–82
Washington, George, 66, 212–13,
278–81, 284, 290
Water softeners, 104–5
Wear-Ever cookware, 101
Webster, Noah, 350–51
Wedding customs. *See* Marriage and
wedding customs
Wedgwood, Josiah, 88–89
Wedgwood ware, 88–89
Weely, Henry W., 143
Westinghouse, 118–145
West Point Military Academy, 290–91
Wham-O Company, 372–73
Wheat, brides showered with, 25–26
Wheelbarrow, 166–67
Whipped cream, 420–21
Whistling teakettle, 119
White House, 282
Whiteners, clothes, 154–55
Whiting, Richard, Abbot, 190
Wigs, 234–36
Williams, Edward, 151
Wilson, Samuel, 274–77
Wilson, Woodrow, 60
Windows
glass, 156–59
origin of the word, 158–59
Windshields, safety-glass, 158
Winson, Frederick Albert, 98–99
Wishbone, 5–6
Witches
black cats and, 14
Friday the thirteenth and, 13
horseshoes and, 5

Witch hazel, 251–52
Wolsey, Thomas, Cardinal, 185, 186, 188
Wonderful Wizard of Oz (Baum), 181
Wood, Kenneth, 114
Wood, knocking on, 6–8
Woolley, Sir Leonard, 376
Worcester Magazine, 352
Worcestershire Sauce, 403
Worth, Charles, 325
Wright, James, 379–80
Wrigley, William, Jr., 417
Wynne, Arthur, 375–76

Xenophon, 224
Xmas as abbreviation for Christmas, 71
XXX for kisses, 52

"Yankee Doodle" (song), 286–87
Yawning, covering one's mouth when, 19–20
Youth's Companion, The, 280
Yo-yo, 371

Zahm, Matthew, 70
Zeolite, 105
Zippers, 316–17